# AMERICAN RELIGIONS

# AMERICAN RELIGIONS

## A Documentary History

### R. Marie Griffith
*Princeton University*

New York    Oxford
OXFORD UNIVERSITY PRESS
2008

Oxford University Press, Inc., publishes works that further Oxford University's
objective of excellence in research, scholarship, and education.

Oxford  New York
Auckland  Cape Town  Dar es Salaam  Hong Kong  Karachi
Kuala Lumpur  Madrid  Melbourne  Mexico City  Nairobi
New Delhi  Shanghai  Taipei  Toronto

With offices in
Argentina  Austria  Brazil  Chile  Czech Republic  France  Greece
Guatemala  Hungary  Italy  Japan  Poland  Portugal  Singapore
South Korea  Switzerland  Thailand  Turkey  Ukraine  Vietnam

Published by Oxford University Press, Inc.
198 Madison Avenue, New York, New York 10016
http://www.oup.com

Oxford is a registered  trademark of Oxford University Press

**Library of Congress Cataloging-in-Publication Data**

American religions : a documentary history / [compiled] by R. Marie Griffith.
  p. cm.
Includes bibliographical references.
ISBN-13: 978-0-19-517045-0
1. United States—Religion—Sources.   I. Griffith, R. Marie (Ruth Marie), 1967–

BL2525.A542 2007
200.973—dc22

2006048307

Printing number: 9 8 7 6 5 4 3 2

Printed in the United States of America
on acid-free paper

# CONTENTS

*Preface for Instructors*   x
*Acknowledgments*   xviii
*Introduction*   xx

## I.  COLONIAL SETTLEMENT TO THE 1730s   1

**1. Affirming Divine Providence: Explorers, Missionaries, and Colonizers Come to America**

*The Bull* Sublimis Deus (1537)   2
WILLIAM BRADFORD / *Of Plymouth Plantation* (1620–47)   3
JOHN COTTON / *Spirituall Milk for Boston Babes in Either England* (1656)   10

**2. Piety and Practice in the Colonial Era**

JOHN WINTHROP / *A Model of Christian Charity* (1630)   16
INCREASE MATHER / *Sleeping at Sermons Is a Great and a Dangerous Evil* (1682)   19

**3. Anxious Souls: Seeking Assurance in Puritan New England**

ANNE BRADSTREET / *To My Dear Children* (1867) and *To My Dear and Loving Husband* (1678)   23
SAMUEL SEWALL / *Diary* (1677–1727)   27

**4. Conflict and Violence, Gender and Ethnicity: Antinomianism and Indians**

*The Examination of Mrs. Anne Hutchinson* (1637)   37
MARY ROWLANDSON / *A Narrative of the Captivity and Restoration of Mrs. Mary Rowlandson* (1682)   63
WILLIAM PENN / *Letter to the Indians* (1681)   73

**5. Challenges to the Established Order: Baptists, Quakers, and Witch-Hunting**

ROGER WILLIAMS / *Letter to the Town of Providence on the Limits of Religious Liberty* (1654–55)   75

WILLIAM PENN / *A Persuasive to Moderation to* Church Dissenters, *in Prudence and Conscience* (1686)   76
COTTON MATHER / From *Wonders of the Invisible World* (1692)    80

II.   REVIVAL, REVOLUTION, AND THE
      ENLIGHTENMENT, 1740–1800    91

6. Debating Decorum and Religious Experience: Revivalism and the
   Great Awakening
JONATHAN EDWARDS / From *Some Thoughts Concerning the Present Revival of
                   Religion in New-England* (1743)    92
CHARLES CHAUNCY / From *Seasonable Thoughts on the State of Religion in New-
                  England* (1743)    102

7. Beyond New England: Southern Anglicanism, Methodist
   Perfection
CHARLES WOODMASON / *I Cor. 14 v. 40 Let All Things Be Done Decently and in
                    Order* (1770)    109
JOHN WESLEY / *A Plain Account of Christian Perfection* (1777)    115

8. Piety, Christian Love, and Resistance to Slavery
PHILLIS WHEATLEY / *On Being Brought from Africa to America* (1773), *On the
                   Death of the Rev. Mr. George Whitefield* (1770), and
                   *Thoughts on the Works of Providence* (1773)    121
JOHN WOOLMAN / From *The Journal of John Woolman* and *On Silent
                Worship*    127

9. Bringing Outsiders In: More Encounters with Indians, Early
   American Jews
DAVID BRAINERD / From *Journal* (1745)    138
*The Petition of the Philadelphia Synagogue to Council of Censors of
Pennsylvania* (1783)    148

10. Enlightenment Views of Religious Tolerance and Liberty
THOMAS JEFFERSON / *A Bill for Establishing Religious Freedom* (1779)    150
JAMES MADISON / *Memorial and Remonstrance Against Religious Assessments*
               (1785)    152
HANNAH ADAMS / From *An Alphabetical Compendium of the Various Sects Which
               Have Appeared in the World from the Beginning of the Christian
               Era to the Present Day* (1784)    157

## III.   FROM NEW REPUBLIC TO DIVIDED NATION, 1800–65   163

### 11. New Theologies Absorb Old Orthodoxies: Mormonism, Transcendentalism, Communitarianism

JOSEPH SMITH / *The Articles of Faith* (1842) and *Revelation* (1835)   164
RALPH WALDO EMERSON / *Harvard Divinity School Address* (1838)   172

### 12. Diverse Modes of Religious Conversion

ELIZABETH ANN BAYLEY SETON / *Letters* (1805)   183
CHARLES GRANDISON FINNEY / From *Memoirs* (1876)   189
BISHOP INNOCENT VENIAMINOV / *Instructions to the Priest-Monk Theophan* (1853)   196

### 13. Slave Religion and African American Resistance

JARENA LEE / From *The Life and Religious Experience of Jarena Lee* (1836)   197
FREDERICK DOUGLASS / From *Narrative of the Life of an American Slave* (1845)   213

### 14. Evangelicalism, Abolitionism, and Pro-Slavery Christianity

ANGELINA EMILY GRIMKÉ / *Appeal to the Christian Women of the South* (1836)   220
CATHARINE E. BEECHER / *Essay on Slavery and Abolitionism* (1837)   235
GEORGE D. ARMSTRONG / From *The Christian Doctrine of Slavery* (1857)   239

### 15. Europeans Attempt to Define Religion in America

ALEXIS DE TOCQUEVILLE / From *Democracy in America* (1835)   245
PHILIP SCHAFF / From *America* (1855)   262

## IV.   SCIENCE, IMMIGRATION, AND CONSUMER CAPITALISM, 1865–1920   283

### 16. Darwinism, the Social Gospel, and the Gospel of Wealth

JAMES WOODROW / *Evolution* (1884)   284
RUSSELL HERMAN CONWELL / From *Acres of Diamonds* (1890)   301
WALTER RAUSCHENBUSCH / From *A Theology for the Social Gospel* (1917)   309

### 17. Reshaping Aged Creed: Reform Judaism, New Thought, Black Protest

*Pittsburgh Platform* (1885)   321
RALPH WALDO TRINE / From *In Tune with the Infinite* (1897)   323

W. E. B. Du Bois / *The Sorrow Songs* (1903), *Credo* (1904), and *A Litany of Atlanta* (1906)   328

**18. Narratives of Americanization and Resistance**

Black Elk / From *Black Elk Speaks: Being the Life Story of a Holy Man of the Oglala Sioux* (1932)   341
Mary Antin / *The Promised Land* (1912)   352

**19. Conflicts of Immigration and Immigrants**

Josiah Strong / From *Our Country* (1886)   365
Alexis Toth / *Meeting with Archbishop John Ireland* (1889)   382
Mabel Potter Daggett / *The Heathen Invasion of America* (1912)   384

**20. Turning Outward: The Early Comparative Study of Religion**

James Freeman Clarke / *The Ten Religions and Christianity* (1891)   389
Swami Vivekananda / *Hinduism as a Religion* and *Farewell* (1893)   402
William James / From *The Varieties of Religious Experience* (1902)   411

## V.   FROM FUNDAMENTALISM TO CIVIL RIGHTS, 1920–65   417

**21. Fundamentalism, Liberalism, and Neo-orthodoxy**

Harry Emerson Fosdick / *Shall the Fundamentalists Win?* (1922)   418
Reinhold Niebuhr / From *The Irony of American History* (1952)   424

**22. Jewish Observance and Catholic Sacramentalism**

Abraham Joshua Heschel / From *God in Search of Man* (1955)   434
Thomas Merton / From *New Seeds of Contemplation* (1961)   447

**23. Alienation, Dissidence, and Rebellion Against Traditional Authorities**

Dorothy Day / From *The Long Loneliness* (1952)   462
Jack Kerouac / From *Dharma Bums* (1958)   486

**24. Black Encounters with World Religions and the Struggle Against Racism**

Howard Thurman / *What We May Learn from India* (1936) and *Howard and Sue Bailey Thurman Meet with Mahatma Gandhi* (1936)   492
Martin Luther King, Jr. / *Letter from Birmingham City Jail* (1963)   502
Malcolm X / *Letters from Abroad* (1964)   514

25. The "American Way of Life" and Its Critics
WILL HERBERG / From *Protestant-Catholic-Jew* (1955)   517

VI.   MULTIPLICITY, PLURALISM, AND CONFLICT
      AFTER 1965   535

26. The 1960s and Beyond: Theological Responses to Social and Political
    Crises
MARY DALY / From *Beyond-God the Father* (1973)   536
CORNEL WEST / *Christian Theological Mediocrity* (1984)   547
STANLEY HAUERWAS / *Gay Friendship: A Thought Experiment in Catholic Moral
              Theology* (1998)   550

27. Ritual, Practice, and Spiritual Poetry in a Pluralistic Society
AVERY DULLES, S.J. / *The Ways We Worship* (1998)   561
JOSEPH GOLDSTEIN AND JACK KORNFIELD / From *Seeking the Heart of
                 Wisdom* (1987)   571
JOY HARJO / *Eagle Poem* (1990)   584
LUCILLE CLIFTON / *spring song* (1987), *the light that came to lucille clifton*
        (1980), and *testament* (1980)   585

28. Religious Outings: Multiple Spiritual Personalities in a Post-Sixties
    America
MEL WHITE / From *Stranger at the Gate* (1994)   587

29. Religion and Conflict after 9/11
FRANKLIN GRAHAM / From *The Name* (2002)   602
*Letter to Franklin Graham from the Council on American-Islamic Relations*
(2002)   605
RICHARD RODRIGUEZ / *Danger and Grace—Sept. 11 and America's Religious
             Moment* (2002)   606

30. Privatization, Secularization, and Religious Flourishing: The
    Enduring Challenges of Religious Expression in America
ROBERT N. BELLAH / From *Habits of the Heart* (1985)   609
U.S. DEPARTMENT OF EDUCATION / *Religious Expression in Public Schools*
                 (1995)   624
JEFFREY L. STOUT / From *Democracy and Tradition* (2004)   627

# PREFACE FOR INSTRUCTORS

One of the best ways to approach the wildly complex history of religion in American culture is through the immediacy of primary sources. However elegantly written, a secondary interpretation does not have the same invigorating effect as the powerful first-person account of a great writer or even an ordinary one writing about extraordinary circumstances. Who, having steeped in their words, could forget Anne Bradstreet or Jonathan Edwards, Thomas Jefferson or Ralph Waldo Emerson, Frederick Douglass, Angelina Grimké, Abraham Joshua Heschel, Malcolm X, or Richard Rodriguez? Manifestly, no one can appreciate the passions of Puritan devotion without absorbing something of the narratives of seventeenth-century Anglo-Americans or grasp American evangelicalism, Judaism, Catholicism or anti-Catholic nativism, or Beat spirituality except by dynamic encounters with these multifarious movements. Whether living or textual, such encounters offer the chance to experience the forceful appeal of multiple outlooks that may be quite different from one's own.

Instructors recognize the pedagogical value of primary texts, yet we have had to rely mostly on our own resourcefulness in cobbling them together for introductory courses on American religion. Even after the tiresome task of putting together a course packet, students may balk—quite justifiably—at being required to purchase poorly bound materials in a lackluster and error-prone format notorious for missing pages, poor copy quality, and words sheared off at the margins. Whatever their short-term value, packets are virtually useless after a course is completed, not only because they so easily fall apart, but particularly since they generally lack the kind of contextual information that makes them usable in the future. The tightening of copyright laws, meanwhile, makes such packets increasingly expensive and frustrates the efforts of instructors to hold down book costs for budget-conscious students.

While some have hailed electronic technologies, such as document scanning and Internet text posting, as attractive solutions to the course-packet problem, such methods are also unpredictable, unevenly accessible, and liable to slipups owing to computer server downtimes, machine malfunctions, and other glitches. Judging from my own teaching experience, moreover, on-line documents appear to invite quick and rather distracted skimming more than serious reading and reflection, sound-bites indistinguishable from the mass media outpour of our time. For these reasons, documentary texts such as this one remain both desirable and necessary.

Today the number of widely used general textbooks on American religious history stands at six or more, yet new sourcebooks of primary materials on American religion have been noticeably scarce since Edwin Scott Gaustad first published his two-volume *Documentary History* (Eerdmans, 1982–83). Gaustad updated the volumes for republication in 1993 and again in 2003, aided in the latter instance by the renowned historian Mark A. Noll. These wide-ranging volumes continue to be vital standards in the field for any instructor of American religious history, and by adding documents on the history of Native Americans, African Americans, Jews, Catholics, women, and many other one-time "outsiders," they have helped immeasurably to expand the canon of American religious history. At a combined total of 1,600 pages and $78 (paperback), however, those volumes are difficult to assign to students.

While in no way pretending to displace those essential texts, I have intentionally compiled this book with both students and instructors in mind. There are far fewer readings in this volume than in the Gaustad-Noll readers, but the excerpts are sizable enough for serious discussion. In making it possible for students to read every selection in a single semester-long course, I hope to have successfully balanced breadth of coverage with depth of engagement. Hard choices had to be made, and the smaller number of selections inevitably means that some historically significant texts simply do not appear. On the other hand, the volume includes a wide range of voices that are religiously, socially, and ethnically diverse: theological conservatives and liberals, northerners and southerners, African Americans and Mexican Americans alongside Anglo-Americans, women alongside men. My hopeful conviction is that we best serve our students by balancing the study of classic texts with awareness of contemporary social realities and concerns. That has been my aim here.

For reasons of space, many readings have been shortened, and deletions are signaled in the text. Less visible, but not less important, is the fact that all footnotes from the original selections have been omitted. This is not to slight the importance of either the documentation or the discussions included in the notes, and scholarly readers are encouraged to consult the originals for such details. But in deliberately accentuating a broad range of readings while keeping the book manageable for student usage, I have taken the notes to be less than essential.

Like other instructors, I hope that students will continue to take advanced seminars on topics that are only briefly covered (or even breezed over) in a survey course, and others will surely want to seek additional readings on particular subjects of interest. Those readers who want fuller bibliographical information about the different themes and periods covered in this book will do well to seek out sources lists, such as the Suggested Reading sections in the most recent edition of Gaustad and Noll's *Documentary History,* along with the many fine textbooks on religion in American history that remain in print. For students who will read only what is required on a course syllabus, it is hoped that this volume provides a lively and consise introduction to the fascinating historical varieties of religion in U.S. history.

## HOW TO USE THIS BOOK

Introductory courses on American religion take many different approaches, as befits the vibrant and multifaceted role played by religion in our nation's history. Nonetheless, it is possible to categorize these courses into two predominant approaches. Many survey courses on American religion follow a strictly historical approach, moving step by step from the colonial period through the new millennium. This approach pays homage to the subfield's roots in departments of history and the vast influence of historians in its formation. The other major way of constructing an introductory course on American religion is thematic, an approach that is especially popular in religious studies circles that have been influenced by cultural studies, literary theory, anthropology, gender studies, and so-called area studies (Chicano studies, African American studies, and the like). Teachers of American religion often profess their interest in thematic approaches, yet concern about surrendering to presentist concerns moves many to sidestep such thematic frameworks.

The organizational logic behind this volume is both chronological and thematic, structured so as to meet the needs of the widest possible range of professors who teach introductory courses on American religion. The documents are organized in six chronologically framed sections that, taken together, stretch from colonial settlements to the early twenty-first century. Five themes are repeated in each chronological section: theological reflection; ritual, performance, and the body; devotional practices and spiritual autobiography; interreligious conflict, violence, encounter, and engagement; and wider conceptualizations of "religion." Readings in each section are briefly introduced and set in wider context.

To make this text as functional as possible, I have compiled sample syllabi for two model courses, the first oriented toward a historical approach and the second oriented toward a thematic approach. Sample syllabus 1, "The History of Religion in the United States," would follow the organization of this volume in a more or less direct order, while sample syllabus 2, "Religion in American Life," would proceed according to the internal themes that structure the volume. As the illustrative titles of these courses show, the first is apt to appeal to instructors whose teaching follows the approach of textbooks, such as Sydney Ahlstrom's *A Religious History of the American People*, Winthrop Hudson's *Religion in America* (revised by John Corrigan), and Edwin S. Gaustad's *The Religious History of America* (revised by Leigh Eric Schmidt). The second course model is aimed at readers who are more attuned to the approach of Catherine Albanese's *America: Religions and Religion*. Incidentally, in keeping both models in mind, I have not aimed at making this volume wholly compatible with any textbook that is now on the market. It ought to work as well for instructors who forego secondary textbooks (as I do) as for instructors who choose to assign them.

Whatever order one chooses to assign them, the readings are meant to balance canonical works with new (or newly discovered) voices, themes, and mat-

ters of concern to present students and teachers. The readings invariably include many important works written by the Anglo-Protestant men who have played such a pivotal public and intellectual role in our nation's religious history. Yet they also include works by a significant number of women, people of color, and non-Christian persons both alive and deceased: persons once believed to be at the margins of history, but who are increasingly recognized as crucial shapers of religion, culture, and national ideals. In this way, I hope to address the problem, noted among my colleagues in the field, of training increasingly diverse generations of college students to understand both the Protestant tradition that has loomed large over American history and the varieties of religious expression that have risen to challenge that tradition's public power. The readings also examine the ways in which religious groups have responded to such significant social factors as race and racism, sex and gender, and hierarchies of class and wealth.

I welcome constructive feedback for improving this volume in future editions.

R. Marie Griffith
Princeton, New Jersey

# SAMPLE SYLLABUS 1: THE HISTORY OF RELIGION IN THE UNITED STATES

This course model surveys the major religious traditions and movements in American history from the colonial period to the present. While it attempts to cover as many of these diverse traditions as possible, the syllabus focuses especially on those periods and groups that have most significantly shaped the development of the nation as a whole. It attends as well to the relationship between religion and society in various contexts.

The chief aims of this course are: (1) to develop a historical overview of the multiple religions practiced in North America, (2) to examine the interactions of these religions over time and across varied cultures, and (3) to test preconceived ideas pertaining to specific religious traditions (and perhaps to "religion" itself). Students ought to develop an interpretive perspective that takes into account the complex significance of religious people, practices, and ideas upon a diverse nation. A more general goal is to help students improve their ability to think as historians, measuring primary sources as textual evidence and placing these sources within broader social, intellectual, religious, and political contexts.

## CLASS SCHEDULE FOR COURSE MODEL #1

### Colonial Settlement to the 1730s

Class 1    Affirming Divine Providence: Explorers, Missionaries, and Colonizers Come to America (pages 2–15)

Class 2    Piety and Practice in the Colonial Era (pages 16–22)

Class 3    Anxious Souls: Seeking Assurance in Puritan New England (pages 23–36)

Class 4    Conflict and Violence, Gender and Ethnicity: Antinomianism, Indians (pages 36–74)

Class 5    Challenges to the Established Order: Baptists, Quakers, Witch-Hunting (pages 74–90)

### Revival, Revolution, and the Enlightenment

Class 6    Debating Decorum and Religious Experience: Revivalism and the Great Awakening (pages 92–109)

Class 7    Beyond New England: Southern Anglicanism, Methodist Perfection (pages 109–21)

Class 8    Piety, Christian Love, and Resistance to Slavery (pages 121–38)

Class 9    Bringing Outsiders In: More Encounters with Indians, Early American Jews (pages 138–50)

Class 10   Enlightenment Views of Religious Tolerance and Liberty (pages 150–62)

### From New Republic to Divided Nation, 1800–65

Class 11   New Theologies Absorb Old Orthodoxies: Mormonism, Transcendentalism, Communitarianism (pages 164–83)

Class 12   Diverse Modes of Religious Conversion (pages 183–97)

Class 13   Slave Religion and African American Resistance (pages 197–220)

Class 14   Evangelicalism, Abolitionism, and Pro-Slavery Christianity (pages 220–44)

Class 15   Europeans' Attempt to Define Religion in America (pages 245–81)

### Science, Immigration, and Consumer Capitalism, 1865–1920

Class 16   Darwinism, the Social Gospel, and the Gospel of Wealth (pages 284–321)

Class 17   Reshaping Aged Creeds: Reform Judaism, New Thought, Black Protest (pages 321–41)

Class 18   Narratives of Americanization and Resistance (pages 341–65)

Class 19   Conflicts over Immigration and Immigrants (pages 365–89)

Class 20   Turning Outward: The Early Comparative Study of Religion (pages 389–416)

## From Fundamentalism to Civil Rights, 1920–65

Class 21   Fundamentalism, Liberalism, and Neo-orthodoxy (pages 418–34)
Class 22   Jewish Observance and Catholic Sacramentalism (pages 434–61)
Class 23   Alienation, Dissidence, and Rebellion Against Traditional Authorities (pages 461–92)
Class 24   Black Encounters with World Religions and the Struggle Against Racism (pages 492–517)
Class 25   The "American Way of Life" and Its Critics (pages 517–33)

## Pluralism After 1965

Class 26   The 1960s and Beyond: Theological Responses to Social and Political Crises (pages 536–61)
Class 27   Ritual, Practice, and Spiritual Poetry in a Pluralistic Society (pages 561–87)
Class 28   Religious Outings: Multiple Spiritual Personalities in Post-Sixties America (pages 587–602)
Class 29   Religion and Conflict after 9/11 (pages 602–9)
Class 30   Privatization, Secularization, and Religious Flourishing: The Enduring Challenges of Religious Expression in America (pages 609–37)

# SAMPLE SYLLABUS 2:
# RELIGION IN AMERICAN LIFE

This course model takes a thematic approach to American religious history. While it focuses attention on those groups that have most significantly shaped the development of the nation as a whole, it allows for creative comparisons across space and time with both new arrivals (such as immigrants) and older but traditionally underanalyzed groups (such as Native Americans). Each segment of the course moves swiftly into the present while also attempting to make the past more familiar by stressing common themes and concerns. It attempts to balance "old" and "new" approaches to the study of American religion through its choice of themes and ordering of selections.

The chief aims of this course are: (1) to develop an appreciation of the multiple religions practiced in the United States, (2) to examine the interactions of these religions over time and across varied cultures, and (3) to test preconceived ideas pertaining to specific religious traditions (and perhaps to "religion" itself). Students ought to develop an interpretive perspective that takes into account the complex significance of religious people, practices, and ideas upon a diverse nation. A more general goal is to help students improve their ability to analyze

ongoing developments in American religion, gaining critical awareness of the ways in which religious groups have helped shape the landscape of American culture.

## CLASS SCHEDULE FOR COURSE MODEL #2

### Theological Reflection

Class 1    Affirming Divine Providence: Explorers, Missionaries, and Colonizers Come to America (pages 2–15)

Class 2    Debating Decorum and Religious Experience: Revivalism and the Great Awakening (pages 92–109)

Class 3    New Theologies Absorb Old Orthodoxies: Mormonism, Transcendentalism, Communitarianism (pages 164–83)

Class 4    Darwinism, the Social Gospel, and the Gospel of Wealth (pages 284–321)

Class 5    Fundamentalism, Liberalism, and Neo-orthodoxy (pages 418–34)

Class 6    The 1960s and Beyond: Theological Responses to Social and Political Crises (pages 536–61)

### Ritual, Performance, and the Body

Class 7    Piety and Practice in the Colonial Era (pages 16–22)

Class 8    Beyond New England: Southern Anglicanism, Methodist Perfection (pages 109–21)

Class 9    Diverse Modes of Religious Conversion (pages 183–97)

Class 10   Reshaping Aged Creeds: Reform Judaism, New Thought, Black Protest (pages 321–41)

Class 11   Jewish Observance and Catholic Sacramentalism (pages 434–61)

Class 12   Ritual, Practice, and Spiritual Poetry in a Pluralistic Society (pages 561–87)

### Devotional Practices and Spiritual Autobiography

Class 13   Anxious Souls: Seeking Assurance in Puritan New England (pages 23–36)

Class 14   Piety, Christian Love, and Resistance to Slavery (pages 121–38)

Class 15   Slave Religion and African American Resistance (pages 197–220)

Class 16   Narratives of Americanization and Resistance (pages 341–65)

Class 17   Alienation, Dissidence, and Rebellion Against Traditional Authorities (pages 461–92)

Class 18   Religious Outings: Multiple Spiritual Personalities in Post-Sixties America (pages 587–602)

# Interreligious Conflict, Violence, Encounter, and Engagement

Class 19   Conflict and Violence, Gender and Ethnicity: Antinomianism, Indians (pages 36–74)

Class 20   Bringing Outsiders In: More Encounters with Indians, Early American Jews (pages 138–50)

Class 21   Evangelicalism, Abolitionism, and Pro-Slavery Christianity (pages 220–44)

Class 22   Conflicts over Immigration and Immigrants (pages 365–89)

Class 23   Black Encounters with World Religions and the Struggle Against Racism (pages 492–517)

Class 24   Religion and Conflict after 9/11 (pages 602–9)

# Wider Conceptualizations of "Religion" in America

Class 25   Challenges to the Established Order: Baptists, Quakers, Witch-Hunting (pages 74–90)

Class 26   Enlightenment Views of Religious Tolerance and Liberty (pages 150–62)

Class 27   Europeans' Attempt to Define Religion in America (pages 245–81)

Class 28   Turning Outward: The Early Comparative Study of Religion (pages 389–416)

Class 29   The "American Way of Life" and Its Critics (pages 517–33)

Class 30   Privatization, Secularization, and Religious Flourishing: The Enduring Challenges of Religious Expression in America (pages 609–37)

# ACKNOWLEDGMENTS

Many people have helped this volume come to fruition. Warm thanks to Lexi Gelperin and Meaghan Petersack, both of whom helped obtain and photocopy documents. Lexi also read and commented on many of the documents from a student's perspective. The Interlibrary Loan and Article Express staffs at Princeton University's Firestone Library gave rapid and able assistance. I am grateful to Kathleen Crown for suggesting poetry selections that appear in the fifth section. Several instructors gave helpful feedback on the volume in manuscript form, among them John Baumann, Jason Bivins, Sandy Dwayne Martin, Sean McCloud, and Claudia Schippert. Robert Miller at Oxford University Press has shepherded this project from its inception, along with Emily Voigt and Sarah Calabi. Leigh Eric Schmidt remains my greatest source of intellectual engagement and support.

Stacked on my office desk throughout the writing of this project were several inspiring documentary volumes that came before: Peter G. Mode's *Source Book and Bibliographical Guide for American Church History* (1921); Smith, Handy, and Loetscher's three-volume *American Christianity: An Historical Interpretation with Representative Documents* (1960–1963); and the Gaustad and Gaustad-Noll volumes cited previously. Specialized fields within American religious history offer a few collections of primary sources; notable among them are Thomas A. Tweed and Stephen Prothero's important volume *Asian Religions in America: A Documentary History* (Oxford, 1999); Cornel West and Eddie S. Glaude, Jr.'s *African American Religious Thought: An Anthology* (Westminster John Knox Press, 2003); and Paul Harvey and Philip Goff's *Columbia Documentary History of Religion in America Since 1945* (Columbia University Press, 2005). I have gratefully mined all these sources in pursuing the complementary pedagogical aim of providing a broad introduction to the variety of religion in American history.

Besides my inevitable debts to these groundbreaking texts, I want to recognize the Young Scholars in American Religion program, funded by the Lilly Endowment and run through the Center for the Study of Religion and American Culture at IUPUI, for making accessible an excellent on-line collection of annotated course syllabi in American religion. Other course syllabi are also available on-line through the American Academy of Religion web site. In studying such documents, while talking about courses with other colleagues in the field, I have learned a great deal about the approaches that many of us utilize in trying to teach students about American religious history in meaningful, responsible, and interesting ways. It is clear that those who are working in this

field care deeply about our teaching and about our students, and I am glad to count myself among such a dedicated cohort.

Teachers and colleagues too numerous to name have shaped my own approach to American religious history. I thank all of them here, especially David D. Hall and the late William R. Hutchison.

# INTRODUCTION

Religion has distinctively influenced the development of American history. Its shaping effects have been clearly evident since the recorded histories of explorers and settlers arriving on this continent, although religion had already helped mark out the lives of the native peoples occupying the land. Christopher Columbus and those who came after him had a mix of motives for traveling to what was, for them, a new world. Ambitions for commercial success blended with hopes of Christianizing and civilizing newly encountered cultures. A little over a century later, the group of Christians known to generations of schoolchildren as the Pilgrims brought a fervent form of Reformed Protestantism, mixed with fresh memories of religious persecution, to this land. They and later English Puritan settlers imagined themselves to be God's laborers in the making of a Christian commonwealth, although this legacy would be challenged in countless ways over time.

No issue was more contentious in colonial America than religion, and generations of colonists developed a range of strategies for establishing particular religious forms, as well as for resisting them. Some were tried and even executed for teaching ideas that were deemed heretical by colonial leaders. Others were denounced and worse for supposedly softening the theology and practice of previous generations. To some observers, those very religious disagreements constituted the greatest single threat to the colonies' future. Little wonder, then, that the statesmen who sketched out plans for the new republic spent a great deal of time figuring out the most expedient way to circumscribe the power of religious authorities without infringing upon the civil rights of ordinary worshipers. In this way, the founders worked to enshrine guarantees of religious freedom for all Americans.

The First Amendment to the Constitution secured two types of freedom: freedom *from* the threat of any state-sponsored religious institution and freedom *for* the right to practice one's own religion without state interference. While Americans, then and later, debated the amendment's application and the founders' intentions, astute commentators recognized that the nation's experiment in religious freedom would advance the proliferation of creative religious entrepreneurs and new sects. Far from dooming religion to the dustbins of history, the founders' decision to make religion a matter of voluntary choice, rather than governmental compulsion, created the conditions under which the United States would become, by some measures, the most religious country in the world.

Consider the current scene. According to the 2004 General Social Survey, which biennially collects data in face-to-face interviews, 95.3 percent of all Americans claimed to believe in God.

- 72.6 percent claimed to pray at least several times a week, 58.5 percent of them daily;
- 72.3 percent claimed to believe in life after death;
- 65.5 percent said they find strength in their religion most days or every day;
- 48 percent claimed to feel God's presence "daily" or "many times a day";
- 35.6 percent claimed to have had a religious or spiritual experience that changed their lives;
- 47.7 percent said they considered themselves "strong" or "somewhat strong" in their religious preference;
- 32.8 percent called themselves "born-again" Christians; however,
- 74.2 percent noted that they had "only some" or "hardly any" confidence in organized religion.[1]

While researchers can and do debate the meaning of such statistics, study after study has confirmed that Americans in general are religious, far more so than any other modern Western nation. No one, whether identifying as religious or not, will uniformly celebrate all manifestations of religion in the world beyond his or her own ethos, but it is now impossible to overlook the prominent role played by religion in contemporary American culture. We all see it; the difficulty lies in understanding it.

*American Religions*, a collection of important primary source documents in American religious history, can be considered an introductory tool for helping to explain how we got from Columbus and the Pilgrims to the widespread religiosity that exists in the United States today. Dividing American history into six chronological sections and organizing each section along a grid of five overarching themes, the book aims to guide readers through a heritage of remarkable religious diversity so that salient questions may receive attention: Who were some of the major religious thinkers, writers, and leaders in American history? How did they respond to and participate in major historical moments and events, such as war, slavery, the suffrage and labor movements, anti-Communism, and civil rights? Who were the innovators whose efforts made possible new forms of religious belief and experience? How did ordinary American citizens and new immigrants practice religion? Why has religion continued to flourish long past the era in which many intellectuals expected it to die, and what effects has this flourishing religious life had on other aspects of our culture (political life, economic systems, or family structures, for instance)? In short, how did religious life in America come to look as it does today?

These are not easy questions to answer, and devising well-informed responses to them demands both careful study and reasoned deliberation. All of us tend to interpret history from the vantage of our upbringing and personal

experience, as well as what these circumstances teach us to be certainties about matters like religion. But probing the American religious past with care requires that we stretch beyond our own comfortable presumptions and concerns to enter other worlds, many of which may seem strange, unusual, or actually threatening to us. Even one's own religious ancestors may appear foreign: think of the gulf that separates today's liberal Congregationalists from the Puritan statesmen who executed those who were reckoned to be witches, or the disparity between evangelicals who embrace political activism in our time and those nineteenth-century forebears who were so certain of the world's imminent demise that they shunned virtually all worldly dealings. Upon close scrutiny, third- and fourth-generation Jews and Catholics may appear to have little in common with their immigrant ancestors, some of whom fought losing battles against the Americanization of their traditions. Latter-day Saint (LDS) leaders have been especially wary of this variance, excommunicating Mormon scholars who record historical details that are deemed unsavory and shameful to the church's current hierarchy (for instance, the greater tolerance for women's leadership and homosexual behavior demonstrated by earlier LDS generations).[2] But a similar dilemma exists for anyone who is cognizant of the inevitable fissures between present religious convictions and the ambiguous legacies of the past.

This volume necessarily points to some of these discontinuities, but it steers clear of evaluative judgments that would seek to chastise the present in light of the past, or vice versa. That is, I am not interested in forcing upon students a paradigm either of religion's noble progress in the United States or of its undignified decline. You will surely come to your own judgments about such matters, just as you will form opinions about the merits and demerits of distinctive worldviews that are represented in the text selections, but these evaluations should develop slowly and judiciously, remaining open to new evidence and interpretations and always taking the writer's context into account. All too many popular pundits show themselves to be narrow-minded on religious subjects, but to close one's mind in order to avoid complex thinking is to renounce an essential privilege of democratic citizenship: the opportunity to exchange, discuss, and debate ideas with persons who hold opposing views, intellectual engagement with the living as well as the dead. If this freedom of inquiry is one of the privileges of being an American, it is just as surely a duty—and one that is properly exercised in classrooms that are devoted to this country's religious history.

Since September 11, 2001, a landmark moment in recent U.S. history, news coverage of religion has considerably expanded and improved, while course offerings in religious studies have multiplied at many educational institutions. More and more Americans, of whatever religious persuasion (or lack thereof), recognize the import of understanding religion in broad historical and social context. One does not have to be a self-defined "religious" or "spiritual" person oneself to comprehend the necessity of moving beyond the platitudes by which many intellectuals once dismissed religion—Marx's "opiate of the masses" being the most famous example—toward greater insight into what writers sometimes call "lived religion," or the ways in which religion materializes and is practiced in

everyday life. Such insight requires an intentional openness to symbols and stories that are not necessarily one's own and a willingness to engage and try to understand the hopes and dreams that religious persons may hold for the future, for their children, their values, and their ideals about what it means to be human in a complicated, suffering world.

Religion, then, is not simply reducible to a set of easy assessments or formulas or dismissals. The word *religion* itself, from the Latin verb [*religare*] meaning "to bind, tie, fasten, or link together," has sundry connotations for different people today, but we may do well to think of it here in terms that are both intellectual and practical. Religion, that is, entails reflectively interpreting one's life and a complex world, as well as actively establishing relationships beyond oneself, respecting the social, cultural, and biological processes that define and impinge on our daily lives. What we mean when we use the term *religion* varies widely according to the situation, but what we are always talking about in some sense is the assemblage of practices, symbols, beliefs, myths, metaphors, behaviors, and indeed *feelings* or emotions that humans construct, utilize, or experience in order to comprehend their environment. To insist upon the human creativity involved in religion is surely not to take a theological stand, either for or against "God" or many gods. The study of religion as a general field is agnostic on this point, even if many of its students and scholarly practitioners are not. The purpose is merely to highlight the human activity that goes into any historical endeavor, including the practice of religion.

When it comes to exploring religion in as diverse an environment as America, no one volume of readings can be all-inclusive. Hence a final note on the selection of texts may be in order here. This volume's selections are delimited by the current U.S. borders, despite recent calls to include our neighbors to the north and south in the category of American religious history.[3] Moreover, many of the selected readings pertain especially to Protestantism for several reasons. First, there has been the simple numerical predominance of Christian adherence in this country over time, which means that any course on American religious history must stress these forms to some extent. More important, Protestant Christianity has unquestionably had the greatest impact on the formative myths that sustain us, such as the American Dream, Manifest Destiny and the mission impulse, the Melting Pot, resistance to traditional authorities, the emphasis on the new and innovative versus the traditional, the current therapeutic ethos of our country, and many others. As Alexis de Toqueville famously put it in the 1830s (reprinted in Section 3): "There is no country in the world in which the Christian religion retains a greater influence over the souls of men than in America." Most significant in this regard, perhaps, much of American political theory is deeply rooted in the theology of the Puritan-Calvinist-Reformed tradition. Because of this legacy, some have called America a "Christian nation," but like most scholars in the field, I do not agree with many of the implications entailed in the use of this phrase today. Still, the selections in this volume properly reflect the marked historical prevalence of certain Protestant groups.

At the same time, Americans have increasingly sensed the need to come to terms with religious multiplicity in America, especially in the context of recent

decades.[4] Since the middle of the twentieth century, but still more since the turn of the twenty-first, older patterns of white Protestant dominance have been dramatically shifting, with other groups growing numerically and rising to new prominence. For this reason, this volume aims to strike a fair balance between those movements that have most heavily shaped the longer course of American history and those that now appear to possess a greater capacity than ever before to shape the nation's religious future. Less well known figures also appear as a reminder that it is not only those with power who make and experience history. No selection of documents will please every audience, but I trust there are readings here to rouse students of wide-ranging backgrounds, inclinations, and commitments.

Historians always avoid prognostications, but no scholar of religion doubts the prominent place that religion will continue to hold in the future of the United States and the world beyond its borders. A strong course of instruction in American religious history will surely assist students in comprehending that future. This volume is one contribution to that educational venture.

## NOTES

1. James Allan Davis and Tom W. Smith, General Social Survey, 2004 (machine-readable data file). Principal investigator, James A. Davis; director and co-principal investigator, Tom W. Smith; co-principal investigator, Peter V. Marsden, NORC ed. Chicago: National Opinion Research Center, producer, 2002; Storrs, CT: Roper Center for Public Opinion Research, University of Connecticut, distributor. Microcomputer format and codebook prepared and distributed by MicroCase Corporation. On-line: http://www.thearda.com/Archive/Files/Codebooks/GSS2004_CB.asp

2. Maxine Hanks, ed., *Women and Authority: Re-emerging Mormon Feminism* (Salt Lake City, UT: Signature Books, 1992); D. Michael Quinn, *Same-Sex Dynamics in Nineteenth-Century America: A Mormon Example* (Urbana: University of Illinois Press, 1996). Hanks and Quinn, a seventh-generation Mormon, were among the eleven Mormon scholars and researchers who were excommunicated as apostates in September 1993 for airing controversial views about Mormon history, feminism, and gender equality.

3. Mark Noll has repeatedly argued for the inclusion of Canada in studies of Christianity; see especially Noll, *The Old Religion in a New World: The History of North American Christianity* (Grand Rapids, MI: Eerdmans, 2001); and *A History of Christianity in the United States and Canada* (Grand Rapids, MI: Eerdmans, 1992). While I am sympathetic to this call and equally so to the argument that Mexico, if not Central and South America, ought to be included in the designation "American," this book is aimed at the many survey courses that still focus on the religious history of the United States.

4. Diana Eck, *A New Religious America: How a "Christian Country" Has Become the World's Most Religiously Diverse Nation* (San Francisco: HarperSanFrancisco, 2001); William R. Hutchison, *Religious Pluralism in America: The Contentious History of a Founding Ideal* (New Haven, CT: Yale University Press, 2004).

# AMERICAN RELIGIONS

# Colonial Settlement to the 1730s

The land that would come to be called "America" was inhabited by large native populations when Columbus arrived in the late fifteenth century, motivated by a variety of religious, political, and economic aims. Columbus had presumed the need to convert the natives to Christianity, supposing they would be "more easily freed and converted to our holy faith by love than by force." Europeans continued to encounter these natives as more came to the New Land, and most likewise perceived this encounter as being fundamentally a meeting between Christians and non-Christians.

Tens of thousands of native Americans resided in Massachusetts alone, the place where historians of American religion have typically chosen to begin their accounts. Tragically, these populations were decimated by as much as 90% because the Europeans brought diseases to which the natives had no natural immunities. Indeed, the group known to us as the Pilgrims, arriving in 1620, established their settlement of Plimoth (Plymouth) on the site of a former native settlement.

In 1630, a group of English Puritans arrived and established the Massachusetts Bay Colony. They, too, faced enormous hardships in their new home, and many in these early generations struggled to understand what God demanded from them. Although they had experienced persecution in England, they soon began to see dangerous heresy in their own ranks. Several were banished from the early settlements, and some refugees went on to become important leaders in their own right.

The selections presented here provide a range of perspectives on religion in the early colonial settlements.

# SUBLIMIS DEUS

*Sublimis Deus*, a papal bull issued in 1537 by Paul III, addressed one of the most contentious issues in the early European efforts to colonize the Americas: what was to be done with the native peoples already living there? The pope, asked by Spanish church leaders to speak officially on this matter, attended to it in theological terms, proclaiming that God's love for the Indians (so-called by the explorers) entailed respectful treatment by all missionaries and conquerors who would encounter them. The document denounced the practice of taking Indians as slaves as contrary to Christian teaching, but urged the Spanish explorers to do all in their benevolent power to convert the Indians to Christianity. This brief document remains useful for understanding the theological controversies that accompanied the early European thrusts to civilize and convert the Indians as part of their overall program of territorial conquest and expansion.

## The Bull *Sublimus Deus*

### TRANSLATION

Paul III Pope    To all faithful Christians to whom this writing may come, health in Christ our Lord and the apostolic benediction.

The sublime God so loved the human race that He created man in such wise that he might participate, not only in the good that other creatures enjoy, but endowed him with capacity to attain to the inaccessible and invisible Supreme Good and behold it face to face; and since man, according to the testimony of the sacred scriptures, has been created to enjoy eternal life and happiness, which none may obtain save through faith in our Lord Jesus Christ, it is necessary that he should possess the nature and faculties enabling him to receive that faith; and that whoever is thus endowed should be capable of receiving that same faith. Nor is it credible that any one should possess so little understanding as to desire the faith and yet be destitute of the most necessary faculty to enable him to receive it. Hence Christ, who is the Truth itself, that has never failed and can never fail, said to the preachers of the faith whom He chose for that office "Go ye and teach all nations." He said all, without exception, for all are capable of receiving the doctrines of the faith.

The enemy of the human race, who opposes all good deeds in order to bring men to destruction, beholding and envying this, invented a means never

before heard of, by which he might hinder the preaching of God's word of Salvation to the people: he inspired his satellites who, to please him, have not hesitated to publish abroad that the Indians of the West and the South, and other people of whom We have recent knowledge should be treated as dumb brutes created for our service, pretending that they are incapable of receiving the catholic faith.

We, who, though unworthy, exercise on earth the power of our Lord and seek with all our might to bring those sheep of His flock who are outside, into the fold committed to our charge, consider, however, that the Indians are truly men and that they are not only capable of understanding the catholic faith but, according to our information, they desire exceedingly to receive it. Desiring to provide ample remedy for these evils, we define and declare by these our letters, or by any translation thereof signed by any notary public and sealed with the seal of any ecclesiastical dignitary, to which the same credit shall be given as to the originals, that, notwithstanding whatever may have been or may be said to the contrary, the said Indians and all other people who may later be discovered by Christians, are by no means to be deprived of their liberty or the possession of their property, even though they be outside the faith of Jesus Christ; and that they may and should, freely and legitimately, enjoy their liberty and the possession of their property; nor should they be in any way enslaved; should the contrary happen, it shall be null and of no effect.

By virtue of our apostolic authority We define and declare by these present letters, or by any translation thereof signed by any notary public and sealed with the seal of any ecclesiastical dignitary, which shall thus command the same obedience as the originals, that the said Indians and other peoples should be converted to the faith of Jesus Christ by preaching the word of God and by the example of good and holy living.

Given in Rome in the year of our Lord 1537. The fourth of June and of our Pontificate, the third year.

# WILLIAM BRADFORD

William Bradford (1590–1657) traveled on the *Mayflower* to New England's coast in 1620 and founded the Plymouth Colony, which he also served as governor. The group he led were radical Puritans, or Separatists, who did not so much believe in reforming the Church of England as in freeing themselves from it altogether and forming their own pure community. The group formed an independent church in Scrooby and then moved to Amsterdam and later Leiden before they finally set sail for North America. These "Pilgrims" lived in New England for a decade before the next group of English settlers, also Puritans but preferring to remain allied with the established church and reform it from within, arrived

to form the Massachusetts Bay Colony in 1630. Bradford began writing his book, *Of Plymouth Plantation*, in that year, and the text reveals the group's deep belief in God's providential protection.

# Of Plymouth Plantation

And first of the occasion and inducements thereunto; the which, that I may truly unfold, I must begin at the very root and rise of the same. The which I shall endeavour to manifest in a plain style, with singular regard unto the simple truth in all things; at least as near as my slender judgment can attain the same.

## CHAPTER I

### [The Separatist Interpretation of the Reformation in England, 1550–1607]

It is well known unto the godly and judicious, how ever since the first breaking out of the light of the gospel in our honourable nation of England, (which was the first of nations whom the Lord adorned therewith after the gross darkness of popery which had covered and overspread the Christian world), what wars and oppositions ever since, Satan hath raised, maintained and continued against the Saints, from time to time, in one sort or other. Sometimes by bloody death and cruel torments; other whiles imprisonments, banishments and other hard usages; as being loath his kingdom should go down, the truth prevail and the churches of God revert to their ancient purity and recover their primitive order, liberty and beauty.

But when he could not prevail by these means against the main truths of the gospel, but that they began to take rooting in many places, being watered with the blood of the martyrs and blessed from Heaven with a gracious increase; he then began to take him to his ancient stratagems, used of old against the first Christians. That when by the bloody and barbarous persecutions of the heathen emperors he could not stop and subvert the course of the gospel, but that it speedily overspread, with a wonderful celerity, the then best known parts of the world; he then began to sow errours, heresies and wonderful dissensions amongst the professors themselves, working upon their pride and ambition, with other corrupt passions incident to all mortal men, yea to the saints themselves in some measure, by which woeful effects followed. As not only bitter contentions and heartburnings, schisms, with other horrible confusions, but Satan took occasion and advantage thereby to foist in a number of vile ceremonies, with many unprofitable canons and decrees, which have since been as snares to many poor and peaceable souls even to this day.

So as in the ancient times, the persecutions |2| by the heathen and their emperors was not greater than of the Christians one against other:—the Arians and

other their complices against the orthodox and true Christians. As witnesseth Socrates in his second book. His words are these:

> The violence truly (saith he) was no less than that of old practiced towards the Christians when they were compelled and drawn to sacrifice to idols; for many endured sundry kinds of torment, often rackings and dismembering of their joints, confiscating of their goods; some bereaved of their native soil, others departed this life under the hands of the tormentor, and some died in banishment and never saw their country again, etc.

The like method Satan hath seemed to hold in these later times, since the truth began to spring and spread after the great defection made by Antichrist, that man of sin. . . .

But that I may come more near my intendment.

When as by the travail and diligence of some godly and zealous preachers, and God's blessing on their labours, as in other places of the land, so in the North parts, many became enlightened by the Word of God and had their ignorance and sins discovered unto them, and began by His grace to reform their lives and make conscience of their ways; the work of God was no sooner manifest in them but presently they were both scoffed and scorned by the profane multitude; and the ministers urged with the yoke of subscription, or else must be silenced. And the poor people were so vexed with apparitors and pursuivants and the commissary courts, as truly their affliction was not small. Which, notwithstanding, they bore sundry years with much patience, till they were occasioned by the continuance and increase of these troubles, and other means which the Lord raised up in those days, to see further into things by the light of the Word of God. How not only these base and beggarly ceremonies were unlawful, but also that the lordly and tyrannous power of the prelates ought not to be submitted unto; which thus, contrary to the freedom of the gospel, would load and burden men's consciences and by their compulsive power make a profane mixture of persons and things in the worship of God. And that their offices and callings, courts and canons, etc. were unlawful and antichristian; being such as have no warrant in the Word of God, but the same that were used in popery and still retained. Of which a famous author thus writeth in his Dutch commentaries, at the coming of King James into England:

> The new king (saith he) found there established the reformed religion according to the reformed religion of King Edward VI, retaining or keeping still the spiritual state of the bishops, etc. after the old manner, much varying and differing from the reformed churches in Scotland, France and the Netherlands, Emden, Geneva, etc., whose reformation is cut, or shapen much nearer the first Christian churches, as it was used in the Apostles' times.

|6| So many, therefore, of these professors as saw the evil of these things in these parts, and whose hearts the Lord had touched with heavenly zeal for His truth, they shook off this yoke of antichristian bondage, and as the Lord's free people joined themselves (by a covenant of the Lord) into a church estate, in the fellowship of the gospel, to walk in all His ways made known, or to be made known unto them, according to their best endeavours, whatsoever it should cost them, the Lord assisting them. And that it cost them something this ensuing history will declare. . . .

But after these things they could not long continue in any peaceable condition, but were hunted and persecuted on every side, so as their former afflictions were but as flea-bitings in comparison of these which now came upon them. For some were taken and clapped up in prison, others had their houses beset and watched night and day, and hardly escaped their hands; and the most were fain to flee and leave their houses and habitations, and the means of their livelihood.

Yet these and many other sharper things which afterward befell them, were no other than they looked for, and therefore were the better prepared to bear them by the assistance of God's grace and Spirit.

Yet seeing themselves thus molested, |7| and that there was no hope of their continuance there, by a joint consent they resolved to go into the Low Countries, where they heard was freedom of religion for all men; as also how sundry from London and other parts of the land had been exiled and persecuted for the same cause, and were gone thither, and lived at Amsterdam and in other places of the land. So after they had continued together about a year, and kept their meetings every Sabbath in one place or other, exercising the worship of God amongst themselves, notwithstanding all the diligence and malice of their adversaries, they seeing they could no longer continue in that condition, they resolved to get over into Holland as they could. Which was in the year 1607 and 1608. . . .

## CHAPTER II

### Of Their Departure into Holland and Their Troubles Thereabout, with Some of the Many Difficulties They Found and Met Withal. Anno 1608

Being thus constrained to leave their native soil and country, their lands and livings, and all their friends and familiar acquaintance, it was much; and thought marvelous by many. But to go into a country they knew not but by hearsay, where they must learn a new language and get their livings they knew not how, it being a dear place and subject to the miseries of war, it was by many thought an adventure almost desperate; a case intolerable and a misery worse than death. Especially seeing they were not acquainted with trades nor traffic (by which that country doth subsist) but had only been used to a plain country life and the innocent trade of husbandry. But these things did not dismay them, though they did sometimes trouble them; for their desires were set on the ways of God and to enjoy His ordinances; but they rested on His providence, and knew Whom they had believed. Yet |8| this was not all, for though they could not stay, yet were they not suffered to go; but the ports and havens were shut against them, so as they were fain to seek secret means of conveyance, and to bribe and fee the mariners, and give extraordinary rates for their passages. And yet were they often times betrayed, many of them; and both they and their goods intercepted and surprised, and thereby put to great trouble and charge, of which I will give an instance or two and omit the rest.

There was a large company of them purposed to get passage at Boston in Lincolnshire, and for that end had hired a ship wholly to themselves and made

agreement with the master to be ready at a certain day, and take them and their goods in at a convenient place, where they accordingly would all attend in readiness. So after long waiting and large expenses, though he kept not day with them, yet he came at length and took them in, in the night. But when he had them and their goods aboard, he betrayed them, having beforehand complotted with the searchers and other officers so to do; who took them, and put them into open boats, and there rifled and ransacked them, searching to their shirts for money, yea even the women further than became modesty; and then carried them back into the town and made them a spectacle and wonder to the multitude which came flocking on all sides to behold them. Being thus first, by these catchpoll officers rifled and stripped of their money, books and much other goods, they were presented to the magistrates, and messengers sent to inform the Lords of the Council of them; and so they were committed to ward. Indeed the magistrates used them courteously and showed them what favour they could; but could not deliver them till order came from the Council table. But the issue was that after a month's imprisonment the greatest part were dismissed and sent to the places from whence they came; but seven of the principal were still kept in prison and bound over to the assizes.

The next spring after, there was another attempt made by some of these and others to get over at another place. And it so fell out that they light of a Dutchman at Hull, having a ship of his own belonging to Zealand. They made agreement with him, and |9| acquainted him with their condition, hoping to find more faithfulness in him than in the former of their own nation; he bade them not fear, for he would do well enough. He was by appointment to take them in between Grimsby and Hull, where was a large common a good way distant from any town. Now against the prefixed time, the women and children with the goods were sent to the place in a small bark which they had hired for that end; and the men were to meet them by land. But it so fell out that they were there a day before the ship came, and the sea being rough and the women very sick, prevailed with the seamen to put into a creek hard by where they lay on ground at low water. The next morning the ship came but they were fast and could not stir until about noon. In the meantime, the shipmaster, perceiving how the matter was, sent his boat to be getting the men aboard whom he saw ready, walking about the shore. But after the first boatful was got aboard and she was ready to go for more, the master espied a great company, both horse and foot, with bills and guns and other weapons, for the country was raised to take them. The Dutchman, seeing that, swore his country's oath *sacremente*, and having the wind fair, weighed his anchor, hoised sails, and away.

But the poor men which were got aboard were in great distress for their wives and children which they saw thus to be taken, and were left destitute of their helps; and themselves also, not having a cloth to shift them with, more than they had on their backs, and some scarce a penny about them, all they had being aboard the bark. It drew tears from their eyes, and anything they had they would have given to have been ashore again; but all in vain, there was no remedy, they must thus sadly part. And afterward endured a fearful storm at sea, being fourteen days or more before they arrived at their port; in seven whereof they neither saw sun, moon nor stars, and were driven near the coast of Norway; the mariners themselves often despairing of life, and once with shrieks

and cries gave over all, as if the ship had been foundered in the sea and they sinking without recovery. But when man's hope and help wholly failed, the Lord's power and mercy appeared in their recovery; for the ship rose again and gave the mariners courage again to manage her. And if modesty would suffer me, I might declare with what fervent |10| prayers they cried unto the Lord in this great distress (especially some of them) even without any great distraction. When the water ran into their mouths and ears and the mariners cried out, "We sink, we sink!" they cried (if not with miraculous, yet with a great height or degree of divine faith), "Yet Lord Thou canst save! Yet Lord Thou canst save!" with such other expressions as I will forbear. Upon which the ship did not only recover, but shortly after the violence of the storm began to abate, and the Lord filled their afflicted minds with such comforts as everyone cannot understand, and in the end brought them to their desired haven, where the people came flocking, admiring their deliverance; the storm having been so long and sore, in which much hurt had been done, as the master's friends related unto him in their congratulations.

But to return to the others where we left. The rest of the men that were in greatest danger made shift to escape away before the troop could surprise them, those only staying that best might be assistant unto the women. But pitiful it was to see the heavy case of these poor women in this distress; what weeping and crying on every side, some for their husbands that were carried away in the ship as is before related; others not knowing what should become of them and their little ones; others again melted in tears, seeing their poor little ones hanging about them, crying for fear and quaking with cold. Being thus apprehended, they were hurried from one place to another and from one justice to another, till in the end they knew not what to do with them; for to imprison so many women and innocent children for no other cause (many of them) but that they must go with their husbands, seemed to be unreasonable and all would cry out of them. And to send them home again was as difficult; for they alleged, as the truth was, they had no homes to go to, for they had either sold or otherwise disposed of their houses and livings. To be short, after they had been thus turmoiled a good while and conveyed from one constable to another, they were glad to be rid of them in the end upon any terms, for all were wearied and tired with them. Though in the meantime they (poor souls) endured misery enough; and thus in the end necessity forced a way for them. . . .

## CHAPTER III

### Of Their Settling in Holland, and Their Manner of Living, and Entertainment There

Being now come into the Low Countries, they saw many goodly and fortified cities, strongly walled and guarded with troops of armed men. Also, they heard a strange and uncouth language, and beheld the different manners and customs of the people, with their strange fashions and attires; all so far differing from that of their plain country villages (wherein they were bred and had so long lived) as it seemed they were come into a new world. But these were not the

things they much looked on, or long took up their thoughts, for they had other work in hand and another kind of war to wage and maintain. For although they saw fair and beautiful cities, flowing with abundance of all sorts of wealth and riches, yet it was not long before they saw the grim and grisly face of poverty coming upon them like an armed man, with whom they must buckle and encounter, and from whom they could not fly. But they were armed with faith and patience against him and all his encounters; and though they were sometimes foiled, yet by God's assistance they prevailed and got the victory. . . .

## CHAPTER IV

### Showing the Reasons and Causes of Their Removal

After they had lived in this city [Leyden] about some eleven or twelve years (which is the more observable being the whole time of that famous truce between that state and the Spaniards) and sundry of them were taken away by death and many others began to be well stricken in years (the grave mistress of Experience having taught them many things), |15| those prudent governors with sundry of the sagest members began both deeply to apprehend their present dangers and wisely to foresee the future and think of timely remedy. In the agitation of their thoughts, and much discourse of things hereabout, at length they began to incline to this conclusion: of removal to some other place. Not out of any newfangledness or other such like giddy humor by which men are oftentimes transported to their great hurt and danger, but for sundry weighty and solid reasons, some of the chief of which I will here briefly touch.

And first, they saw and found by experience the hardness of the place and country to be such as few in comparison would come to them, and fewer that would bide it out and continue with them. For many that came to them, and many more that desired to be with them, could not endure that great labour and hard fare, with other inconveniences which they underwent and were contented with. But though they loved their persons, approved their cause and honoured their sufferings, yet they left them as it were weeping, as Orpah did her mother-in-law Naomi, or as those Romans did Cato in Utica who desired to be excused and borne with, though they could not all be Catos. For many, though they desired to enjoy the ordinances of God in their purity and the liberty of the gospel with them, yet (alas) they admitted of bondage with danger of conscience, rather than to endure these hardships. Yea, some preferred and chose the prisons in England rather than this liberty in Holland with these afflictions. But it was thought that if a better and easier place of living could be had, it would draw many and take away these discouragements. Yea, their pastor would often say that many of those who both wrote and preached now against them, if they were in a place where they might have liberty and live comfortably, they would then practice as they did.

Secondly. They saw that though the people generally bore all these difficulties very cheerfully and with a resolute courage, being in the best and strength of their years; yet old age began to steal on many of them; and their great and continual labours, with other crosses and sorrows, hastened it before the time.

So as it was not only probably thought, but apparently seen, that within a few years more they would be in danger to scatter, by necessities pressing them, or sink under their burdens, or both. And therefore according to the divine proverb, that a wise man seeth the plague when it cometh, and hideth himself, Proverbs xxii.3, so they like skillful and beaten soldiers were fearful either to be entrapped or surrounded by their enemies so as they should neither be able to fight nor fly. And therefore thought it better to dislodge betimes to some place of better advantage and less danger, if any such could be found. |16|

Thirdly. As necessity was a taskmaster over them so they were forced to be such, not only to their servants but in a sort to their dearest children, the which as it did not a little wound the tender hearts of many a loving father and mother, so it produced likewise sundry sad and sorrowful effects. For many of their children that were of best dispositions and gracious inclinations, having learned to bear the yoke in their youth and willing to bear part of their parents' burden, were oftentimes so oppressed with their heavy labours that though their minds were free and willing, yet their bodies bowed under the weight of the same, and became decrepit in their early youth, the vigour of nature being consumed in the very bud as it were. But that which was more lamentable, and of all sorrows most heavy to be borne, was that many of their children, by these occasions and the great licentiousness of youth in that country, and the manifold temptations of the place, were drawn away by evil examples into extravagant and dangerous courses, getting the reins off their necks and departing from their parents. Some became soldiers, others took upon them far voyages by sea, and others some worse courses tending to dissoluteness and the danger of their souls, to the great grief of their parents and dishonour of God. So that they saw their posterity would be in danger to degenerate and be corrupted.

Lastly (and which was not least), a great hope and inward zeal they had of laying some good foundation, or at least to make some way thereunto, for the propagating and advancing the gospel of the kingdom of Christ in those remote parts of the world; yea, though they should be but even as stepping-stones unto others for the performing of so great a work.

These and some other like reasons moved them to undertake this resolution of their removal; the which they afterward prosecuted with so great difficulties, as by the sequel will appear.

# JOHN COTTON

John Cotton (1584–1652) was one of the most influential Puritan leaders in the early days of New England settlement. As a clergyman in England, he had grown increasingly distressed over the state of the English church and became interested in the possibilities offered by New England settlement. He preached the final sermon to the group of Puritans who sailed with John Winthrop in 1630, and he sailed over himself during the sum-

mer of 1633. Shortly he was appointed teacher of the Boston church, and he continued to be one of the most respected and powerful members of the New England clergy until his death. His numerous writings set out the doctrinal matrix of New England orthodoxy. This widely circulated catechism, an instructional text for children and others who were acquiring Christian literacy, reveals the foundational theology that was promulgated by early New England Puritans.

## Spirituall Milk for Boston Babes in Either England

Q: What hath God done for you?

A: God hath made me, He keepeth me, and he can save me.

Q: Who is God?

A: God is a spirit of himself, and for himself.

Q: How many Gods be there?

A: There is but one God in three persons, the Father, the Son, and the Holy Ghost.

Q: How did God make you?

A: In my first parents, holy and righteous.

Q: Are you then born holy and righteous?

A: No, my first Father sinned and I in him.

Q: Are you then born a sinner?

A: I was conceived in sin, and born in iniquity.

Q: What is your birth-sin?

A: Adam's sin imputed to me and a corrupt nature dwelling in me.

Q: What is your corrupt nature?

A: My corrupt nature is empty of Grace, bent unto sin, and only unto sin, and that continually.

Q: What is sin?

A: Sin is the transgression of the Law.

Q: How many Commandments of the Law be there?

A: Ten.

Q: What is the first Commandment?

Transcribed by RMG, with modernized spelling, capitalization, and punctuation.

A: Thou shalt have no other Gods but me.

Q: What is the meaning of this Commandment?

A: That we should worship the only true God, and no other beside him.

Q: What is the second Commandment?

A: Thou shalt not make to thyself any graven image.

Q: What is the meaning of this Commandment?

A: That we should worship the true God with true worship; such as God hath ordained, not such as man hath invented.

Q: What is the third Commandment?

A: Thou shalt not take the name of the Lord thy God in vain.

Q: What is here meant by the Name of God?

A: God himself and the good things of God, whereby he is known as a man by his Name, as his Attributes, worship, word, and works.

Q: What is it not to take his Name in vain?

A: To make use of God, and the good things of God, to his glory, and our good, not vainly, not unreverently, not unprofitably.

Q: What is the fourth Commandment?

A: Remember that thou keep holy the Sabbath day.

Q: What is the meaning of this Commandment?

A: That we should rest from labor and much more from play on the Lord's day, that we may draw nigh to God in holy duties.

Q: What is the fifth Commandment?

A: Honor thy Father and thy Mother, that thy days may be long in the land, which the Lord thy God giveth thee.

Q: Who are here meant by father and mother?

A: All our Superiors, whether in family, school, church, and Commonwealth.

Q: What is the honor due to them?

A: Reverence, obedience, and (when I am able) recompense.

Q: What is the sixth Commandment?

A: Thou shalt do no murder.

Q: What is the meaning of this Commandment?

A: That we should not shorten the life or health of ourselves or others, but preserve both.

Q: What is the seventh Commandment?

A: Thou shalt not commit adultery.

Q: What is the sin here forbidden?

A: To defile ourselves or others with unclean lusts.

Q: What is the duty here commanded?

A: Chastity, to possess our vessels in holiness and honor.

Q: What is the eighth Commandment?

A: Thou shalt not steal.

Q: What is the stealth here forbidden?

A: To take away another man's goods, without his leave, or to spend our own without benefit to ourselves or others.

Q: What is the duty here commanded?

A: To get our goods honestly, to keep them safely, and to spend them thriftily.

Q: What is the ninth Commandment?

A: Thou shalt not bear false witness against thy neighbor.

Q: What is the sin here forbidden?

A: To lie falsely, to think or speak untruly of ourselves or others.

Q: What is the duty here required?

A: Truth and faithfulness.

Q: What is the tenth Commandment?

A: Thou shalt not covet.

Q: What is the coveting here forbidden?

A: Lust after the things of other men; and want of contentment with our own.

Q: Whether have you kept all these commandments?

A: No, I and all men are sinners.

Q: What is the wages of sin?

A: Death and damnation.

Q: How look you then to be saved?

A: Only by Jesus Christ.

Q: Who is Jesus Christ?

A: The eternal Son of God, who for our sakes became man, that he might redeem and save us.

Q: How doth Christ redeem and save us?

A: By his righteous life, and bitter death, and glorious resurrection to life again.

Q: How do we come to have part and fellowship with Christ in his death and resurrection?

A: By the power of his Word and Spirit, which brings us to Christ and keeps us in him.

Q: What is his Word?

A: The Holy Scriptures of the Prophets and Apostles, the Old and New Testament, Law and Gospel.

Q: How doth the Ministry of the Law bring you toward Christ?

A: By bringing me to know my sin, and the wrath of God against me for it.

Q: What are you thereby the nearer to Christ?

A: So I come to feel my cursed estate and need of a Saviour.

Q: How doth the Ministry of the Gospel help you in this cursed estate?

A: By humbling me yet more, and then raising me up out of this estate.

Q: How doth the Ministry of the Gospel humble you more?

A: By revealing the grace of the Lord Jesus, in dying to save sinners; and yet convincing me of my sin, in not believing in him, and of my utter insufficiency to come to him; and so I feel myself utterly lost.

Q: How then doth the Ministry of the Gospel raise you up out of this lost estate to come unto Christ?

A: By teaching me the value and the virtue of the death of Christ, and the riches of the grace to lost sinners. By revealing the promise of grace to such, and by ministering the Spirit of grace, to apply Christ, and his promise of grace unto myself, and to keep me in him.

Q: How doth the Spirit of grace apply Christ, and his promise of grace unto you, and keep you in him?

A: By begetting in me faith to receive him; prayer to call upon him; repentance to mourn after him; and new obedience to serve him.

Q: What is faith?

A: Faith is a grace of the Spirit; whereby I deny myself and believe on Christ's righteousness for salvation.

Q: What is prayer?

A: It is calling upon God in the name of Christ, by the help of the Holy Ghost, according to the will of God.

Q: What is repentance?

A: Repentance is a grace of the Spirit, whereby I loath my sins and myself for them, and confess them before the Lord, and mourn after Christ for the pardon of them, and for grace to serve him in newness of life.

Q: What is newness of life, or new obedience?

A: Newness of life is a grace of the Spirit, whereby I forsake my former lusts and vain company, and walk before the Lord in the light of his word, and in the communion of his Saints.

Q: What is the Communion of Saints?

A: It is the fellowship of the Church in the blessings of the covenant of grace, and the seals thereof.

Q: What is the Church?

A: It is a congregation of Saints joined together in the bond of the covenant, to worship the Lord and to edify one another, in all his holy ordinances.

Q: What is the bond of the covenant, in which the Church is joined together?

A: It is the profession of that covenant, which God hath made with his faithful people, to be a God unto them and to their seed.

Q: What doth the Lord bind his people to in this covenant?

A: To give up themselves and their seed, first to the Lord to be his people, and then to the elders and brethren of the Church, to set forward the worship of God, and the mutual edification.

Q: How do they give up themselves and their seed to the Lord?

A: By receiving through faith the Lord and his covenant, to themselves, and to their seed; and accordingly walking themselves, and training up their children in the ways of his covenant.

Q: How do they give up themselves and their seed to the elders and brethren of the Church?

A: By confession of their sins, and profession of their faith, and of their subjection to the gospel of Christ. And so they and their seed are received into fellowship of the Church and the seals thereof.

Q: What are the seals of the covenant now in the days of the gospel?

A: Baptism and the Lord's Supper.

Q: What is done for you in baptism?

A: In baptism the washing with water is a sign and seal of my washing with the blood and spirit of Christ, and thereby of my ingrafting into Christ; of the pardon and cleansing of my sins; of my rising up out of affliction; and also of my resurrection from the death at the last day.

Q: What is done for you in the Lord's Supper?

A: In the Lord's Supper the receiving of the bread broken, and the wine poured out, is a sign and seal of my receiving the communion of the body of Christ broken for me, and of his blood shed for me; and thereby of my growth in Christ, of the pardon and healing of my sins; of the fellowship of his Spirit; of my strengthening and quickening in grace; and of my sitting together with Christ on his throne of glory at the last judgment.

Q: What is the resurrection from the dead, which was sealed up to you in baptism?

A: When Christ shall come to his last judgment, all that are in the graves shall arise again, both the just and unjust.

Q: What is the last judgment, which is sealed up to you in the Lord's Supper?

A: At the last day we shall all appear before the judgment-seat of Christ, to give an account of our works, and to receive our reward according to them.

Q: What is the reward that shall then be given?

A: The righteous shall go into life eternal, and the wicked shall be cast into everlasting fire with the devil and his angels.

# JOHN WINTHROP

John Winthrop (1588–1649) was the first governor of the Massachusetts Bay Colony. As a Puritan, he had been deeply distressed by what he perceived to be the corruption of England's church and various signs of God's displeasure with the English people (including economic depression). He was glad to leave for New England, which he believed would be a divinely appointed refuge for authentic piety and the protection of the true church. He set sail on the flagship *Arbella* in April 1630, accompanied by three other ships and seven hundred hopeful passengers. Either shortly before setting sail or during the passage across the Atlantic Ocean, Winthrop composed his sermon, "A Model of Christian Charity," which set forth his vision of the group's covenant with God and the perilous experiment they ware undertaking. As a "city upon a hill" exposed to "the eyes of all people," the community must not waver from the highest standards of Christian behavior and love, warned Winthrop, lest they bring shame upon God and their faith.

## A Model of Christian Charity

God Almighty in His most holy and wise providence hath so disposed of the condition of mankind as in all times some must be rich, some poor; some high and eminent in power and dignity, others mean and in subjection.

The reason hereof:

First, to hold conformity with the rest of His works, being delighted to show forth the glory of His wisdom in the variety and difference of the creatures and the glory of His power, in ordering all these differences for the preservation and good of the whole, and the glory of His greatness: that as it is the glory of princes to have many officers, so this great King will have many stewards, counting Himself more honored in dispensing His gifts to man by man than if He did it by His own immediate hand.

Secondly, that He might have the more occasion to manifest the work of His Spirit: first, upon the wicked in moderating and restraining them, so that the rich and mighty should not eat up the poor, nor the poor and despised rise up against their superiors and shake off their yoke; secondly, in the regenerate, in exercising His graces in them—as in the great ones, their love, mercy, gentleness, temperance, etc., in the poor and inferior sort, their faith, patience, obedience, etc.

Thirdly, that every man might have need of other, and from hence they might be all knit more nearly together in the bond of brotherly affection. From

hence it appears plainly that no man is made more honorable than another or more wealthy, etc., out of any particular and singular respect to himself, but for the glory of his creator and the common good of the creature, man. Therefore God still reserves the property of these gifts to Himself (Ezek. 16. 17). He there calls wealth His gold and His silver, etc. (Prov. 3. 9). He claims their service as His due: "Honor the Lord with thy riches." All men being thus (by divine providence) ranked into two sorts, rich and poor, under the first are comprehended all such as are able to live comfortably by their own means duly improved, and all others are poor, according to the former distribution.

There are two rules whereby we are to walk, one towards another: justice and mercy. These are always distinguished in their act and in their object, yet may they both concur in the same subject in each respect: as sometimes there may be an occasion of showing mercy to a rich man in some sudden danger of distress, and also doing of mere justice to a poor man in regard of some particular contract.

There is likewise a double law by which we are regulated in our conversation, one towards another: in both the former respects, the law of nature and the law of grace, or the moral law or the law of the Gospel—to omit the rule of justice as not properly belonging to this purpose, otherwise than it may fall into consideration in some particular cases. By the first of these laws, man, as he was enabled so, withal [is] commanded to love his neighbor as himself; upon this ground stand all the precepts of the moral law, which concerns our dealings with men. To apply this to the works of mercy, this law requires two things: first, that every man afford his help to another in every want or distress; secondly, that he perform this out of the same affection which makes him careful of his own good according to that of our savior (Matt. 7. 12): "Whatsoever ye would that men should do to you." This was practiced by Abraham and Lot in entertaining the angels and the old man of Gibea.

The law of grace or the Gospel hath some difference from the former, as in these respects: first, the law of nature was given to man in the estate of innocency, this of the Gospel in the estate of regeneracy. Secondly, the former propounds one man to another as the same flesh and image of God, this as a brother in Christ also, and in the communion of the same spirit, and so teacheth us to put a difference between Christians and others. "Do good to all, especially to the household of faith." Upon this ground the Israelites were to put a difference between the brethren of such as were strangers though not of the Canaanites. Thirdly, the law of nature could give no rules for dealing with enemies, for all are to be considered as friends in the estate of innocency; but the Gospel commands love to an enemy. Proof: "If thine enemy hunger, feed him; love your enemies, do good to them that hate you" (Matt. 5. 44).

This law of the Gospel propounds likewise a difference of seasons and occasions. There is a time when a Christian must sell all and give to the poor as they did in the apostles' times; there is a time also when a Christian, though they give not all yet, must give beyond their ability, as they of Macedonia (II Cor. 8). Likewise, community of perils calls for extraordinary liberality, and so doth community in some special service for the church. Lastly, when there is no other means whereby our Christian brother may be relieved in this distress, we must help him beyond our ability, rather than tempt God in putting him upon help by miraculous or extraordinary means. . . .

1. For the persons, we are a company professing ourselves fellow members of Christ, in which respect only, though we were absent from each other many miles, and had our employments as far distant, yet we ought to account ourselves knit together by this bond of love, and live in the exercise of it, if we would have comfort of our being in Christ. This was notorious in the practice of the Christians in former times, as is testified of the Waldenses from the mouth of one of the adversaries, Aeneas Sylvius: *Mutuo solent amare penè antequam norint*—they used to love any of their own religion even before they were acquainted with them.

2. For the work we have in hand, it is by mutual consent, through a special overruling providence and a more than an ordinary approbation of the churches of Christ, to seek out a place of cohabitation and consortship, under a due form of government both civil and ecclesiastical. In such cases as this, the care of the public must oversway all private respects by which not only conscience but mere civil policy doth bind us; for it is a true rule that particular estates cannot subsist in the ruin of the public.

3. The end is to improve our lives to do more service to the Lord, the comfort and increase of the body of Christ whereof we are members, that ourselves and posterity may be the better preserved from the common corruptions of this evil world, to serve the Lord and work out our salvation under the power and purity of His holy ordinances.

4. For the means whereby this must be effected, they are twofold: a conformity with the work and the end we aim at; these we see are extraordinary, therefore we must not content ourselves with usual ordinary means. Whatsoever we did or ought to have done when we lived in England, the same must we do, and more also where we go. That which the most in their churches maintain as a truth in profession only, we must bring into familiar and constant practice: as in this duty of love we must love brotherly without dissumulation, we must love one another with a pure heart fervently, we must bear one another's burdens, we must not look only on our own things but also on the things of our brethren. Neither must we think that the Lord will bear with such failings at our hands as He doth from those among whom we have lived. . . .

Thus stands the cause between God and us: we are entered into covenant with Him for this work; we have taken out a commission, the Lord hath given us leave to draw our own articles. We have professed to enterprise these actions upon these and these ends; we have hereupon besought Him of favor and blessing. Now if the Lord shall please to hear us and bring us in peace to the place we desire, then hath He ratified this covenant and sealed our Commission, [and] will expect a strict performance of the articles contained in it. But if we shall neglect the observation of these articles which are the ends we have propounded, and dissembling with our God, shall fall to embrace this present world and prosecute our carnal intentions, seeking great things for ourselves and our posterity, the Lord will surely break out in wrath against us, be revenged of such a perjured people, and make us know the price of the breach of such a covenant.

Now the only way to avoid this shipwreck and to provide for our posterity is to follow the counsel of Micah: to do justly, to love mercy, to walk humbly with our God. For this end, we must be knit together in this work as one man. We must entertain each other in brotherly affection; we must be willing to

abridge ourselves of our superfluities, for the supply of others' necessities; we must uphold a familiar commerce together in all meekness, gentleness, patience and liberality. We must delight in each other, make others' conditions our own, rejoice together, mourn together, labor and suffer together: always having before our eyes our commission and community in the work, our community as members of the same body. So shall we keep the unity of the spirit in the bond of peace, the Lord will be our God and delight to dwell among us, as His own people, and will command a blessing upon us in all our ways, so that we shall see much more of His wisdom, power, goodness, and truth than formerly we have been acquainted with. We shall find that the God of Israel is among us, when ten of us shall be able to resist a thousand of our enemies, when He shall make us a praise and glory, that men shall say of succeeding plantations: "The Lord make it like that of New England." For we must consider that we shall be as a city upon a hill, the eyes of all people are upon us. So that if we shall deal falsely with our God in this work we have undertaken, and so cause Him to withdraw His present help from us, we shall be made a story and a by-word through the world: we shall open the mouths of enemies to speak evil of the ways of God and all professors for God's sake; we shall shame the faces of many of God's worthy servants, and cause their prayers to be turned into curses upon us, till we be consumed out of the good land whither we are going.

And to shut up this discourse with that exhortation of Moses, that faithful servant of the Lord, in his last farewell to Israel (Deut. 30): Beloved, there is now set before us life and good, death and evil, in that we are commanded this day to love the Lord our God, and to love one another, to walk in His ways and to keep His commandments and His ordinance and His laws and the articles of our covenant with Him, that we may live and be multiplied, and that the Lord our God may bless us in the land whither we go to possess it: but if our hearts shall turn away so that we will not obey, but shall be seduced and worship . . . other gods, our pleasures and profits, and serve them, it is propounded unto us this day, we shall surely perish out of the good land whither we pass over this vast sea to possess it.

> Therefore, let us choose life,
> that we, and our seed,
> may live; by obeying His
> voice and cleaving to Him,
> for He is our life and
> our prosperity.

# INCREASE MATHER

Increase Mather (1639–1723) was a prominent Puritan minister in Boston. The son of Richard Mather, who had immigrated to Massachusetts in 1635, Increase Mather was among the later generations of Puritans who

worried that they were not living up to the spiritual purity and intensity of the earliest settled generation. Like his peers and his son Cotton, who also became a noted church leader, Mather preached lengthy, sober sermons lamenting this supposed religious decline, sermons that later historians would term "jeremiads" (after the prophet Jeremiah). This sermon, from 1682, focuses upon the spiritual hazards of sleeping through sermons, a problem that must have irked preachers of that time no less than in our own.

# Sleeping at Sermons Is a Great and a Dangerous Evil

*Instr.* 1. *We may here take notice that the nature of man is woefully corrupted and depraved,* else they would not be so apt to sleep when the precious Truths of God are dispensed in his name, yea, and men are more apt to sleep then, than at another time. Some woeful creatures, have been so wicked as to profess they have gone to hear sermons on purpose, that so they might sleep, finding themselves at such times much disposed that way. This argueth as Satan's malice, so the great corruption and depravation of the nature of men, whence it is that they are inclined unto evil, and indisposed to the thing that good is. Yea, some will sit and sleep under the best preaching in the world. When Paul was alive, there was not a better preacher upon the earth than he. . . . But notwithstanding Paul's being so excellent a preacher, there were some that could sit and sleep under his ministry. When soul-melting sermons are preached about Christ the Saviour, that will sleep under them. When soul-awakening sermons are preached, enough to make rocks to rend and to bleed; when the word falls down from heaven like thunder, the voice of the Lord therein being very powerful and full of majesty, able to break the cedars of Lebanon, and to make the wilderness to shake; yet some will sit and sleep under it; such is the woeful corruption and desperate hardness of the hearts of the children of men.

*Instr.* 2. *Hence see, that there is great danger in those things which men are apt to look upon as little sins, yea as no sins at all.*

As for sleeping at sermons, some look upon it as no sin; others account it a peccadillo, a sin not worth taking notice of, or the troubling themselves about. But my text sheweth that danger and death is in it. We have solemn instances in the scripture, concerning those that have lost their lives, because they have been guilty of such miscarriages, as carnal reason will say are but little sins. . . . Behold! the severity of God, and let us tremble at it. Common sins, which almost every one is guilty of, are accounted small iniquities; but there is exceeding danger in following a multitude to do evil. . . .

---

Transcribed by RMG, pages 209–211, 212–216, 218–220; text modernization here is mine.

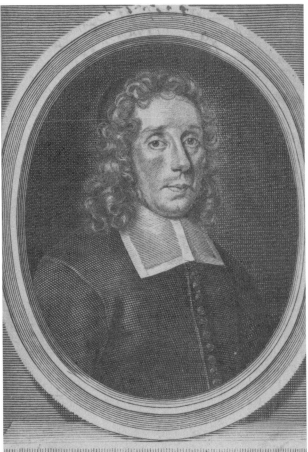

Engraving of the
Puritan minister
Increase Mather, an
illustration from
*Cases of Conscience
Concerning Evil Spirits*
(1693). *Courtesy of the
Library of Congress,
Prints & Photographs
Division.*

Instr. 3. If sleeping at sermons be such an evil as hath been evinced, there is then cause to fear that the Lord hath been contending with his people in this land, by awful judgments . . . ?

The late Synod, who convened on purpose, to enquire into the causes of the Lord's controversy with New-England, have mentioned this amongst many other provoking evils. And there is great reason to think, that, that holy God who will not hold the takers of his name in vain guiltless, hath been not a little displeased for this sin. Inasmuch as it is a common evil. I doubt it may be said, that there are many such offenders in almost every congregation throughout the land. I must confess to my exceeding joy, that there are as few sleepers at sermons in this congregation as in any that I have observed in the country; yet there are some and too many. It is a sin, which professors and Church-members (as well as others) are guilty of; and tis past doubt that it hath been for their sins in a more peculiar manner, even for the provoking of his sons and of his daughters that God hath sent the sword, fire, and death amongst us. This is a sin which is not punished by men but therefore the Lord himself will visit for it. And truly some of those awful judgments which we have sadly experienced seem to have

a special respect unto this sin. Those fearful and amazing voices in the heavens, even thunderings and lightnings which have caused many amongst us to be horribly afraid; and some have been taken up dead . . . , the thunder of God having killed them in a moment; hath not the Lord sent them usually upon the very day when sermons are wont to be preached, or upon the next day thereto; as if the Lord should say, if you will slight and sleep at my word, I'll make you to hear that which shall awake you with a witness. And doth not God threaten with a famine of his word? How many bereaved congregations are there? And some that have been a long time without the ministerial dispensation of the word and sacraments. Well may it be so, if people when they enjoyed a faithful ministry, shewed no more respect and reverence towards God speaking to them therein, then to sit and sleep under it.

Instr. 4. If sleeping at sermons be a great evil, then their iniquity is exceeding great in the sight of God, who do that in sermon time, which is worse then sleeping.

e.g. To play at sermon time, as wicked children who have no grace nor fear of God in their hearts, will sometimes do. If you do thus on the Sabbath day, you break the third and the fourth Commandment both at once; and then *how guilty! how guilty!* are you in the sight of the holy Lord God, who is in this dreadful place, but you are not aware of it. So for persons to sit laughing in the presence of God, when his word is spoken to them in his name, their sin and profaneness is exceeding great before the Lord. What dost thou think will become of thy immortal soul? Dost thou think that God will have mercy on thee? Repent of this wickedness, or I do most solemnly declare unto thee in his name, God will not have mercy on thee. He that made thee, will shew thee no favour. The Lord saith, he will look unto those that are of a contrite spirit who tremble at his word (Hai 66:2). Thou then, that are so far from trembling at the word of the Lord as to laugh when it is spoken to thee, the infinite Majesty, who have heaven for his throne, and the earth for his footstool, will not look upon thee; he abhors to see or to look upon such a profane wretch as thou art. But inasmuch as thou dost laugh at his word now, repent speedily or the time draweth on, when distress and anguish will take hold on thy soul, and then God will laugh at thy calamity, and mock when thy fear cometh. And therefore hear and fear now and do no more so wickedly. Remember the words of the Lord Jesus (Luk 6:26): *Woe to you that laugh now, for you shall mourn and weep.* So I say, woe to you that laugh at sermons now, for you shall mourn and never laugh more. When wilt thou say? Even when thy soul shall be with Dives, crying out, world without end. *I am tormented in this flame.* And O think how the devils will taunt and mock at thee and say, why don't you laugh now? Remember you heard such a minister of God preach, he brought you the glad tidings of eternal salvation, and the sad news of everlasting destruction, but you laughed when you heard him speaking after the most solemn and earnest manner; is it a laughing matter now, think you? Were they not the great truths of God that were spoken in his name? Then will tears of blood trickle down thy dry and damned cheeks forever and ever, because thou mayest not be so happy as to hear one sermon, or to have one offer of grace more, throughout the never-ending days of eternity. . . .

Some it may be will say, *but how shall we help it?*

Ans. 1. As helps against this evil, there are some things that men should remember to observe before they come to hear the Word. Beware of excessive toiling and moiling in the world, because that doth incline to sleepiness. And remember to be temperate in all things. When men overcharge themselves with meat and drink, and then come to hear the word preached, no wonder if they fall asleep, when they should be hearing for their souls' benefit. And if you find yourselves inclined to this evil, remember to pray much against it before you come to hear. I doubt common sleepers at sermons remember this. Did they pray earnestly against this infirmity the Lord would give them power and victory over it. You must be watchful in order unto prayer, and you must pray that you may become watchful.

2. At the time of Hearing, some things are to be done as helps against this evil.

Strive against it when first you begin to drowse, shake of a sleepy frame. Stir up yourselves to hear the word, as well as to call upon the name of God (Isai. 64:7). If sitting be an occasion of sleeping, rather stand up then sit and sleep and sin. And keep alive those thoughts in your hearts, which will be a means to prevent sleeping. E.g. The awful thoughts of the special presence of God. . . . Remember when you hear sermons preached, that God himself is speaking to you, in the way of his ordinance, though by mortal men like unto yourselves. The treasure is from heaven, though the vessel that brings it, be an earthen vessel. You should therefore receive the word of God, which you hear, not as the word of men but as the word of God (1 Thess. 2:13). . . . Men would be more like to stand trembling than to sit sleeping if they did believe and think of this. Again, if thou dost find thyself inclined to sleep under the hearing of the word, think how Satan is busy about thee, though mayest be sure he is near at hand, if thou growth sleepy at a sermon, and wilt thou give way to his temptations? Yea, think with thyself, if I should sleep now, I should sin. . . .

Oh consider what hath been spoken. And learn to hear the word of God with utmost attention and mind and intention of heart. So your souls shall live.

# ANNE BRADSTREET

Anne Bradstreet (c. 1612–72) came to New England aboard the *Arbella* in 1630. A deeply pious woman, she wrote a great deal of poetry that displayed extensive knowledge not only of theological matters, but of history and science as well. Her poems were first published in 1650, when her brother-in-law took them to a London press, and Bradstreet later revised and added several more poems to this early collection; the second edition came out posthumously in Boston in 1678 as *Several Poems* . . .

*By a Gentlewoman in New England.* The poems presented here demonstrate
some of the emotional complexity at the heart of Puritan spiritual practice.

# To My Dear Children

*This book by any yet unread,*
*I leave for you when I am dead,*
*That being gone, here you may find*
*What was your living mother's mind.*
*Make use of what I leave in love,*
*And God shall bless you from above.*  ~   A. B.

*My dear children,*

I, knowing by experience that the exhortations of parents take most effect when
the speakers leave to speak, and those especially sink deepest which are spoke
latest, and being ignorant whether on my death bed I shall have opportunity to
speak to any of you, much less to all, thought it the best, whilst I was able, to
compose some short matters (for what else to call them I know not) and be-
queath to you, that when I am no more with you, yet I may be daily in your re-
membrance (although that is the least in my aim in what I now do), but that you
may gain some spiritual advantage by my experience. I have not studied in this
you read to show my skill, but to declare the truth, not to set forth myself, but
the glory of God. If I had minded the former, it had been perhaps better pleasing
to you, but seeing the last is the best, let it be best pleasing to you.

The method I will observe shall be this: I will begin with God's dealing with
me from my childhood to this day.

In my young years, about 6 or 7 as I take it, I began to make conscience of
my ways, and what I knew was sinful, as lying, disobedience to parents, etc., I
avoided it. If at any time I was overtaken with the like evils, it was as a great
trouble, and I could not be at rest 'till by prayer I had confessed it unto God. I
was also troubled at the neglect of private duties though too often tardy that
way. I also found much comfort in reading the Scriptures, especially those
places I thought most concerned my condition, and as I grew to have more un-
derstanding, so the more solace I took in them.

In a long fit of sickness which I had on my bed I often communed with my
heart and made my supplication to the most High who set me free from that af-
fliction.

But as I grew up to be about 14 or 15, I found my heart more carnal, and sit-
ting loose from God, vanity and the follies of youth take hold of me.

About 16, the Lord laid His hand sore upon me and smote me with the
smallpox. When I was in my affliction, I besought the Lord and confessed my

pride and vanity, and He was entreated of me and again restored me. But I rendered not to Him according to the benefit received.

After a short time I changed my condition and was married, and came into this country, where I found a new world and new manners, at which my heart rose. But after I was convinced it was the way of God, I submitted to it and joined to the church at Boston.

After some time I fell into a lingering sickness like a consumption together with a lameness, which correction I saw the Lord sent to humble and try me and do me good, and it was not altogether ineffectual.

It pleased God to keep me a long time without a child, which was a great grief to me and cost me many prayers and tears before I obtained one, and after him gave me many more of whom I now take the care, that as I have brought you into the world, and with great pains, weakness, cares, and fears brought you to this, I now travail in birth again of you till Christ be formed in you.

Among all my experiences of God's gracious dealings with me, I have constantly observed this, that He hath never suffered me long to sit loose from Him, but by one affliction or other hath made me look home, and search what was amiss; so usually thus it hath been with me that I have no sooner felt my heart out of order, but I have expected correction for it, which most commonly hath been upon my own person in sickness, weakness, pains, sometimes on my soul, in doubts and fears of God's displeasure and my sincerity towards Him; sometimes He hath smote a child with a sickness, sometimes chastened by losses in estate, and these times (through His great mercy) have been the times of my greatest getting and advantage; yea, I have found them the times when the Lord hath manifested the most love to me. Then have I gone to searching and have said with David, "Lord, search me and try me, see what ways of wickedness are in me, and lead me in the way everlasting," and seldom or never but I have found either some sin I lay under which God would have reformed, or some duty neglected which He would have performed, and by His help I have laid vows and bonds upon my soul to perform His righteous commands.

If at any time you are chastened of God, take it as thankfully and joyfully as in greatest mercies, for if ye be His, ye shall reap the greatest benefit by it. It hath been no small support to me in times of darkness when the Almighty hath hid His face from me that yet I have had abundance of sweetness and refreshment after affliction and more circumspection in my walking after I have been afflicted. I have been with God like an untoward child, that no longer than the rod has been on my back (or at least in sight) but I have been apt to forget Him and myself, too. Before I was afflicted, I went astray, but now I keep Thy statutes.

I have had great experience of God's hearing my prayers and returning comfortable answers to me, either in granting the thing I prayed for, or else in satisfying my mind without it, and I have been confident it hath been from Him, because I have found my heart through His goodness enlarged in thankfulness to Him.

I have often been perplexed that I have not found that constant joy in my pilgrimage and refreshing which I supposed most of the servants of God have, although He hath not left me altogether without the witness of His holy spirit, who hath oft given me His word and set to His seal that it shall be well with me.

I have sometimes tasted of that hidden manna that the world knows not, and have set up my Ebenezer, and have resolved with myself that against such a promise, such tastes of sweetness, the gates of hell shall never prevail; yet have I many times sinkings and droopings, and not enjoyed that felicity that sometimes I have done. But when I have been in darkness and seen no light, yet have I desired to stay myself upon the Lord, and when I have been in sickness and pain, I have thought if the Lord would but lift up the light of His countenance upon me, although He ground me to powder, it would be but light to me; yea, oft have I thought were I in hell itself and could there find the love of God toward me, it would be a heaven. And could I have been in heaven without the love of God, it would have been a hell to me, for in truth it is the absence and presence of God that makes heaven or hell.

Many times hath Satan troubled me concerning the verity of the Scriptures, many times by atheism how I could know whether there was a God; I never saw any miracles to confirm me, and those which I read of, how did I know but they were feigned? That there is a God my reason would soon tell me by the wondrous works that I see, the vast frame of the heaven and the earth, the order of all things, night and day, summer and winter, spring and autumn, the daily providing for this great household upon the earth, the preserving and directing of all to its proper end. The consideration of these things would with amazement certainly resolve me that there is an Eternal Being. But how should I know He is such a God as I worship in Trinity, and such a Saviour as I rely upon? Though this hath thousands of times been suggested to me, yet God hath helped me over. I have argued thus with myself. That there is a God, I see. If ever this God hath revealed himself, it must be in His word, and this must be it or none. Have I not found that operation by it that no human invention can work upon the soul, hath not judgments befallen divers who have scorned and contemned it, hath it not been preserved through all ages maugre all the heathen tyrants and all of the enemies who have opposed it? Is there any story but that which shows the beginnings of times, and how the world came to be as we see? Do we not know the prophecies in it fulfilled which could not have been so long foretold by any but God Himself?

When I have got over this block, then have I another put in my way, that admit this be the true God whom we worship, and that be his word, yet why may not the Popish religion be the right? They have the same God, the same Christ, the same word. They only enterpret it one way, we another.

This hath sometimes stuck with me, and more it would, but the vain fooleries that are in their religion together with their lying miracles and cruel persecutions of the saints, which admit were they as they term them, yet not so to be dealt withal.

The consideration of these things and many the like would soon turn me to my own religion again.

But some new troubles I have had since the world has been filled with blasphemy and sectaries, and some who have been accounted sincere Christians have been carried away with them, that sometimes I have said, "Is there faith upon the earth?" and I have not known what to think; but then I have remembered the works of Christ that so it must be, and if it were possible, the very elect should be deceived. "Behold," saith our Saviour, "I have told you before." That hath stayed

my heart, and I can now say, "Return, O my Soul, to thy rest, upon this rock Christ Jesus will I build my faith, and if I perish, I perish"; but I know all the Powers of Hell shall never prevail against it. I know whom I have trusted, and whom I have believed, and that He is able to keep that I have committed to His charge.

Now to the King, immortal, eternal and invisible, the only wise God, be honour, and glory for ever and ever, Amen.

This was written in much sickness and weakness, and is very weakly and imperfectly done, but if you can pick any benefit out of it, it is the mark which I aimed at.

# To My Dear and Loving Husband

If ever two were one, then surely we.
If ever man were loved by wife, then thee;
If ever wife was happy in a man,
Compare with me, ye women, if you can.
I prize thy love more than whole mines of gold
Or all the riches that the East doth hold.
My love is such that rivers cannot quench,
Nor ought but love from thee, give recompense.
Thy love is such I can no way repay,
The heavens reward thee manifold, I pray.
Then while we live, in love let's so persevere
That when we live no more, we may live ever.

# SAMUEL SEWALL

Samuel Sewall (1652–1730) came to Massachusetts from England at the age of seven. As a grown man, he became a prominent merchant and judge, serving on the court that heard the witchcraft accusations in Salem in 1691–92. He strongly opposed the slave trade in New England and spoke out against it, although his efforts to stop it failed. Most important for our purposes is Sewall's remarkable diary, which he kept from 1674 to 1729 (except the period 1677–84). Beyond documenting the daily life and affairs of a prominent Puritan during a significant period, the diary also reveals the emotional complexity of New England Puritanism and depicts for us better than sermons or other official documents how religion was actually lived at that time.

# Diary

January 13 [1677]. Giving my chickens meat, it came to my mind that I gave them nothing save Indian corn and water, and yet they ate it and thrived very well; and that that food was necessary for them, how mean soever: which much affected me, and convinced [me] what need I stood in of spiritual food, and that I should not nauseate daily duties of prayer, etc.

November 6 [1692]. Joseph threw a knob of brass and hit his sister Betty on the forehead, so as to make it bleed and swell; for which, and his playing at prayer time and eating when return thanks, I whipped him pretty smartly. When I first went in (called by his grandmother), he sought to shadow and hide himself from me behind the head of the cradle: which gave me the sorrowful re-membrance of Adam's carriage.

January 13 [1696]. When I came in, past 7 at night, my wife met me in the entry and told me Betty had surprised them. I was surprised with the abrupt-ness of the relation. It seems Betty Sewall had given some signs of dejection and sorrow, but a little after dinner she burst out into an amazing cry, which caused all the family to cry too. Her mother asked the reason. She gave none; at last said she was afraid she should go to hell, her sins were not pardoned. She was first wounded by my reading a sermon of Mr. Norton's, about the 5th of January (text, John 7. 34): "Ye shall seek me and shall not find me." And those words in the sermon (John 8. 21): "Ye shall seek me and shall die in your sins," ran in her mind and terrified her greatly. . . . Her mother asked her whether she prayed. She answered yes, but feared her prayers were not heard, because her sins not pardoned. Mr. Willard, though sent for timelier, yet not being told of the message, . . . he came not till after I came home. He discoursed with Betty, who could not give a distinct account but was confused, as his phrase was, and as [he] had experienced in himself. Mr. Willard prayed excellently. The Lord bring light and comfort out of this dark and dreadful cloud, and grant that Christ's being formed in my dear child may be the issue of these painful pangs!

December 26 [1696]. We bury our little daughter. . . .

Note: 'twas wholly dry, and I went at noon to see in what order things were set, and there I was entertained with a view of, and converse with, the coffins of my dear father Hull, mother Hull, cousin Quinsey, and my six children; for the little posthumous was now took up and set in upon that that stands on John's, so are three, one upon another twice, on the bench at the end. My mother's lies on a lower bench, at the end, with her head to her husband's head; and I ordered little Sarah to be set on her grandmother's feet. 'Twas an awful yet pleasing treat; hav-ing said, "The Lord knows who shall be brought hither next," I came away.

January 14 [1697]. Copy of the bill I put up on the fast day, giving it to Mr. Willard as he passed by, and standing up at the reading of it and bowing when finished, in the afternoon:

"Samuel Sewall, sensible of the reiterated strokes of God upon himself and family, and being sensible that as to the guilt contracted upon the opening of the

late Commission of Oyer and Terminer at Salem (to which the order for this day relates), he is upon many accounts more concerned than any that he knows of, desires to take the blame and shame of it; asking pardon of men, and especially desiring prayers that God, who has an unlimited authority, would pardon that sin and all other his sins, personal and relative: and according to His infinite benignity and sovereignty, not visit the sin of him or of any other upon himself or any of his, nor upon the land: but that He would powerfully defend him against all temptations to sin, for the future, and vouchsafe him the efficacious, saving conduct of His word and spirit."

October 1 [1697]. Jeremiah Belcher's sons came for us to go to the island. My wife, through indisposition, could not go, but I carried Samuel, Hannah, Elisa, Joseph, Mary and Jane Tappan. I prevailed with Mr. Willard to go; he carried Simon, Elizabeth, William, Margaret, and Elisa Tyng. Had a very comfortable passage thither and home again, though against tide. Had first, butter, honey, curds and cream. For dinner, very good roast lamb, turkey, fowls, apple pie. After dinner, sung the 121st Psalm. Note: a glass of spirits my wife sent stood upon a joint-stool which, Simon Willard jogging, it fell down and broke all to shivers; I said 'twas a lively emblem of our fragility and mortality.

January 14 [1701]. Having been certified last night, about 10 o'clock, of the death of my dear mother at Newbury, Samuel and I set out with John Sewall, the messenger, for that place. . . . Nathaniel Bricket taking in hand to fill the grave, I said:

"Forbear a little, and suffer me to say that amidst our bereaving sorrows we have the comfort of beholding this saint put into the rightful possession of that happiness of living desired, and dying lamented. She lived commendably four and fifty years with her dear husband, and my dear father; and she could not well brook the being divided from him at her death, which is the cause of our taking leave of her in this place. She was a true and constant lover of God's word, worship, and saints; and she always, with a patient cheerfulness, submitted to the divine decree of providing bread for herself and others in the sweat of her brows. And now her infinitely gracious and bountiful master has promoted her to the honor of higher employments, fully and absolutely discharged from all manner of toil and sweat. My honored and beloved friends and neighbors! My dear mother never thought much of doing the most frequent and homely offices of love for me, and lavished away many thousands of words upon me before I could return one word in answer. And therefore I ask and hope that none will be offended that I have now ventured to speak one word in her behalf, when she herself is become speechless."

Made a motion with my hand for the filling of the grave. Note: I could hardly speak for passion and tears.

January 24 [1704]. Took 24ˢ in my pocket, and gave my wife the rest of my cash, £4/3/8, and tell her she shall now keep the cash; if I want, I will borrow of her. She has a better faculty than I at managing affairs. I will assist her, and will endeavor to live upon my salary; will see what it will do. The Lord give His blessing.

April 11 [1712]. I saw six swallows together, flying and chippering very rapturously.

December 23 [1714]. Dr. Cotton Mather preaches excellently from Psalms 37, "Trust in the Lord," only spake of the sun being in the center of our system. I think it inconvenient to assert such problems.

[Sewall's first wife died in 1717; after an unsuccessful courtship of the widow Denison, he married Abigail Tilley in 1719, who, however, died in the night of May 26, 1720, as Sewall says, "to our great astonishment, especially mine."]

September 30 [1720]. Mr. Colman's lecture. Daughter Sewall acquaints Madam Winthrop that if she pleased to be within at 3 P.M., I would wait on her. She answered she would be at home.

October 1. Saturday. I dine at Mr. Stoddard's; from thence I went to Madam Winthrop's just at 3. Spake to her, saying my loving wife died so soon and suddenly, 'twas hardly convenient for me to think of marrying again; however, I came to this resolution, that I would not make my court to any person without first consulting with her. Had a pleasant discourse about 7 (seven) single persons sitting in the fore-seat September 29, viz. Madam Rebecca Dudley, Katherine Winthrop, Bridget Usher, Deliverance Legg, Rebecca Lloyd, Lydia Colman, Elizabeth Bellingham. She propounded one and another for me; but none would do; said Mrs. Lloyd was about her age.

October 3. 2. Waited on Madam Winthrop again; 'twas a little while before she came in. Her daughter Noyes being there alone with me, I said I hoped my waiting on her mother would not be disagreeable to her. She answered she should not be against that that might be for her comfort. I saluted her, and told her I perceived I must shortly wish her a good time (her mother had told me she was with child and within a month or two of her time). By and by in came Mr. Airs, chaplain of the Castle, and hanged up his hat, which I was a little startled at, it seeming as if he was to lodge there. At last Madam Winthrop came too. After a considerable time I went up to her and said if it might not be inconvenient, I desired to speak with her. She assented, and spake of going into another room; but Mr. Airs and Mrs. Noyes presently rose up and went out, leaving us there alone. Then I ushered in discourse from the names in the fore-seat; at last I prayed that Katherine [Mrs. Winthrop] might be the person assigned for me. She instantly took it up in the way of denial, as if she had catched at an opportunity to do it, saying she could not do it before she was asked. Said that was her mind unless she should change it, which she believed she should not; could not leave her children. I expressed my sorrow that she should do it so speedily, prayed her consideration, and asked her when I should wait on her again. She setting no time, I mentioned that day sennight. Gave her Mr. Willard's *Fountain*, opened with the little print and verses, saying I hoped if we did well read that book, we should meet together hereafter, if we did not now. She took the book and put it in her pocket. Took leave.

October 5. Midweek. I dined with the Court; from thence went and visited Cousin Jonathan's wife, lying in with her little Betty. Gave the nurse 2$^s$. Although I had appointed to wait upon her, Madam Winthrop, next Monday, yet I went from my cousin Sewall's thither about 3 P.M. The nurse told me Madam dined abroad at her daughter Noyes's, they were to go out together. I asked for the maid, who was not within. Gave Katee a penny and a kiss, and came away. Accompanied my son and daughter Cooper in their remove to their new house. Went to tell Joseph, and Mr. Belcher saw me by the South Meeting-house though 'twas duskish, and said I had been at housewarming (he had been at our house). Invited me to drink a glass of wine at his house at 7, and eat part

of the pasty provided for the commissioners' voyage to Casco Bay. His Excellency, Madam Belcher, Solomon Stoddard, Col. Fitch, Mr. D. Oliver, Mr. Anthony Stoddard, Mr. Welsteed, Mr. White, Mr. Belcher sat down. At coming home gave us of the cake and gingerbread to carry away. 'Twas about ten before we got home; Mr. Oliver and I waited on the governor to his gate; and then Mr. Oliver would wait on me home.

October 6th. Lecture day. Mr. Cutler, president of the Connecticut college, preached in Dr. Cotton Mather's turn. He made an excellent discourse from Heb. 11. 14: "For they that say such things, declare plainly that they seek a country." Brother Odlin, Son Sewall of Brookline, and Mary Hirst dine with me. I asked Mary of Madam Lord, Mr. Oliver and wife, and bid her present my service to them. A little after 6 P.M. I went to Madam Winthrop's. She was not within. I gave Sarah Chickering the maid 2$^s$, Juno, who brought in wood, 1$^s$. Afterward the nurse came in; I gave her 18$^d$, having no other small bill. After a while Dr. Noyes came in with his mother, and quickly after his wife came in; they sat talking, I think, till eight o'clock. I said I feared I might be some interruption to their business; Dr. Noyes replied pleasantly he feared they might be an interruption to me, and went away. Madam seemed to harp upon the same string. Must take care of her children; could not leave that house and neighborhood where she had dwelt so long. I told her she might do her children as much or more good by bestowing what she laid out in housekeeping, upon them. Said her son would be of age the 7th of August. I said it might be inconvenient for her to dwell with her daughter-in-law, who must be mistress of the house. I gave her a piece of Mr. Belcher's cake and gingerbread wrapped up in a clean sheet of paper; told her of her father's kindness to me when treasurer, and I constable. My daughter Judith was gone from me and I was more lonesome—might help to forward one another in our journey to Canaan. Mr. Eyre came within the door; I saluted him, asked how Mr. Clark did, and he went away. I took leave about 9 o'clock. I told [her] I came now to refresh her memory as to Monday night; said she had not forgot it. In discourse with her, I asked leave to speak with her sister; I meant to gain Madam Mico's favor to persuade her sister. She seemed surprised and displeased, and said she was in the same condition.

October 7th. Friday. I gather the quinces. Gave Mr. Jonathan Simson and Mrs. Fifield, each of them, a funeral sermon.

Cousin Abiel Hobart comes to us. Mr. Short, having received his £40, returns home.

Mr. Cooper visits me, thanks me for my cheese.

October 8. Mr. Short returns not till this day.

October 9. Mr. Sewall preaches very well from Acts 2. 24 of the resurrection of Christ. One woman taken into church; one child baptized.

October 10th. Examine Mr. Briggs his account; said they could not find Mr. Whittemore. Mr. Willard offered to answer for him. But I showed the necessity of his being here; and appointed Wednesday, 10 o'clock; and ordered notice to be given to the auditors, to pray their assistance.

In the evening I visited Madam Winthrop, who treated me with a great deal of courtesy; wine, marmalade. I gave her a *News-Letter* about the Thanksgiving proposals, for sake of the verses for David Jeffries. She tells me Dr. Increase Mather visited her this day, in Mr. Hutchinson's coach.

It seems Dr. Cotton Mather's chimney fell afire yesterday, so as to interrupt the Assembly A.M. Mr. Cutler ceased preaching ¼ of an hour.

October 11th. I writ a few lines to Madam Winthrop to this purpose: "Madam, These wait on you with Mr. Mayhew's sermon, and account of the state of the Indians on Martha's Vineyard. I thank you for your unmerited favors of yesterday; and hope to have the happiness of waiting on you tomorrow before eight o'clock after noon. I pray God to keep you, and give you a joyful entrance upon the two hundred and twenty-ninth year of Christopher Columbus his discovery; and take leave, who am, Madam, your humble servant.     S.S."

Sent this by Deacon Green, who delivered it to Sarah Chickering, her mistress not being at home.

October 12. Give Mr. Whittemore and Willard their oath to Dr. Mather's inventory. Visit Mr. Cooper. Go to the meeting at the Widow Emon's; Mr. Manly prayed, I read half Mr. Henry's 12th chapter of *The Lord's Supper*. Sung 1, 2, 3, 4, 5, 10, and 12th verses of the 30th Psalm. Brother Franklin concluded with prayer. At Madam Winthrop's steps I took leave of Capt. Hill, etc.

Mrs. Anne Cotton came to door ('twas before 8), said Madam Winthrop was within, directed me into the little room, where she was full of work behind a stand; Mrs. Cotton came in and stood. Madam Winthrop pointed to her to set me a chair. Madam Winthrop's countenance was much changed from what 'twas on Monday, looked dark and lowering. At last the work (black stuff or silk) was taken away; I got my chair in place, had some converse, but very cold and indifferent to what 'twas before. Asked her to acquit me of rudeness if I drew off her glove. Inquiring the reason, I told her 'twas great odds between handling a dead goat and a living lady. Got it off. I told her I had one petition to ask of her—that was that she would take off the negative she laid on me the third of October; she readily answered she could not, and enlarged upon it; she told me of it so soon as she could; could not leave her house, children, neighbors, business. I told her she might do some good to help and support me. Mentioning Mrs. Gookin (Nath.), the Widow Weld was spoken of; said I had visited Mrs. Denison. I told her, "Yes!" Afterward I said if after a first and second vagary she would accept of me returning, her victorious kindness and good will would be very obliging. She thanked me for my book (Mr. Mayhew's sermon), but said not a word of the letter. When she insisted on the negative, I prayed there might be no more thunder and lightning, I should not sleep all night. I gave her Dr. Preston, *The Church's Marriage and the Church's Carriage*, which cost me 6ˢ at the sale. The door standing open, Mr. Airs came in, hung up his hat, and sat down. After awhile, Madam Winthrop moving, he went out. John Eyre looked in; I said, "How do ye?" or, "Your servant, Mr. Eyre," but heard no word from him. Sarah filled a glass of wine; she drank to me, I to her; she sent Juno home with me with a good lantern; I gave her 6ᵈ and bid her thank her mistress. In some of our discourse, I told her I had rather go to the stone house adjoining to her than to come to her against her mind. Told her the reason why I came every other night was lest I should drink too deep draughts of pleasure. She had talked of canary; her kisses were to me better than the best canary. Explained the expression concerning Columbus.

October 13. I tell my son and daughter Sewall that the weather was not so fair as I apprehended. Mr. Sewall preached very well in Mr. Wadsworth's turn.

Mr. Williams of Weston and Mr. Odlin dine with us. Text was the excellency of the knowledge of Christ.

Friday, October 14. Made a dinner for my son and daughter Cooper. At table in the best room were Sister Stoddard, Sister Cooper, His Excellency, Mrs. Hannah Cooper, Brother Stoddard, Solomon Stoddard, Mr. Joseph Sewall, Mr. Cooper, Mr. Sewall of Brookline, Mrs. Rand, Mrs. Gerrish, daughter of Brookline. Mr. Gerrish, Clark, and Rand sat at a side table.

October 15. I dine on fish and oil at Mr. Stoddard's. Capt. Hill wished me joy of my proceedings, *i.e.*, with M—— Winthrop; Sister Cooper applauded it, spake of visiting her; I said her complaisance of her visit would be obliging to me.

October 16. Lord's Day. I upbraided myself that could be so solicitous about earthly things, and so cold and indifferent as to the love of Christ, who is altogether lovely. Mr. Prince administered. Dined at my son's with Mr. Cutler and Mr. Shurtleff. Mr. Cutler preaches in the afternoon from Ezek. 16. 30: "How weak is thy heart." Son reads the order for the Thanksgiving.

October 17. Monday. Give Mr. Daniel Willard and Mr. Pelatiah Whittemore their oaths to their accounts, and Mr. John Briggs to his, as they are attorneys to Dr. Cotton Mather, administrator to the estate of Nathan Howell, deceased. In the evening I visited Madam Winthrop, who treated me courteously, but not in clean linen as sometimes. She said she did not know whether I would come again or no. I asked her how she could so impute inconstancy to me. (I had not visited her since Wednesday night, being unable to get over the indisposition received by the treatment received that night, and *I must* in it seemed to sound like a made piece of formality.) Gave her this day's *Gazette*. Heard David Jeffries say the Lord's Prayer, and some other portions of the Scriptures. He came to the door and asked me to go into chamber where his grandmother was tending little Katee, to whom she had given physic; but I chose to sit below. Dr. Noyes and his wife came in and sat a considerable time; had been visiting Son and Daughter Cooper. Juno came home with me.

October 18. Visited Madam Mico, who came to me in a splendid dress. I said, "It may be you have heard of my visiting Madam Winthrop," her sister. She answered, her sister had told her of it. I asked her good will in the affair. She answered, if her sister were for it, she should not hinder it. I gave her Mr. Homes's sermon. She gave me a glass of canary, entertained me with good discourse and a respectful remembrance of my first wife. I took leave.

October 19. Midweek. Visited Madam Winthrop; Sarah told me she was at Mr. Walley's, would not come home till late. I gave her Hannah 3 oranges with her duty, not knowing whether I should find her or no. Was ready to go home; but said if I knew she was there, I would go thither. Sarah seemed to speak with pretty good courage she would be there. I went and found her there, with Mr. Walley and his wife in the little room below. At 7 o'clock I mentioned going home; at 8 I put on my coat and quickly waited on her home. She found occasion to speak loud to the servant, as if she had a mind to be known. Was courteous to me, but took occasion to speak pretty earnestly about my keeping a coach. I said 'twould cost £100 per annum; she said 'twould cost but £40. Spake much against John Winthrop, his false-heartedness. Mr. Eyre came in and sat a while; I offered him Dr. Incr. Mather's *Sermons*, whereof Mr. Appleton's ordination sermon was

one; said he had them already. I said I would give him another. Exit. Came away somewhat late.

October 20. Mr. Colman preaches from Luke 15. 10: "Joy among the angels"; made an excellent discourse.

At council, Col. Townsend spake to me of my hood: should get a wig. I said 'twas my chief ornament; I wore it for sake of the day. Brother Odlin, and Sam, Mary, and Jane Hirst dine with us. Promised to wait on the Governor about 7. Madam Winthrop not being at lecture, I went thither first; found her very serene with her daughter Noyes, Mrs. Dering, and the Widow Shipreeve, sitting at a little table, she in her armed chair. She drank to me, and I to Mrs. Noyes. After a while prayed the favor to speak with her. She took one of the candles and went into the best room, closed the shutters, sat down upon the couch. She told me Madam Usher had been there, and said the coach must be set on wheels, and not be rusting. She spake something of my needing a wig. Asked me what her sister said to me. I told her she said if her sister were for it, she would not hinder it. But I told her she did not say she would be glad to have me for her brother. Said, "I shall keep you in the cold"; and asked her if she would be within to-morrow night, for we had had but a running feat. She said she could not tell whether she should or no. I took leave. As were drinking at the governor's, he said in England the ladies minded little more than that they might have money, and coaches to ride in. I said, "And New England brooks its name." At which Mr. Dudley smiled. Governor said they were not quite so bad here.

October 21. Friday. My son the minister came to me P.M. by appointment and we pray one for another in the old chamber, more especially respecting my courtship. About 6 o'clock I go to Madam Winthrop's; Sarah told me her mistress was gone out, but did not tell me whither she went. She presently ordered me a fire; so I went in, having Dr. Sibb's *Bowels* with me to read. I read the two first sermons; still nobody came in. At last about 9 o'clock Mr. John Eyre came in; I took the opportunity to say to him as I had done to Mrs. Noyes before, that I hoped my visiting his mother would not be disagreeable to him; he answered me with much respect. When 'twas after 9 o'clock he of himself said he would go and call her, she was but at one of his brothers'; a while after I heard Madam Winthrop's voice, inquiring something about John. After a good while and clapping the garden door twice or thrice, she came in. I mentioned something of the lateness; she bantered me, and said I was later. She received me courteously. I asked when our proceedings should be made public; she said they were like to be no more public than they were already. Offered me no wine that I remember. I rose up at 11 o'clock to come away, saying I would put on my coat; she offered not to help me. I prayed her that Juno might light me home; she opened the shutter and said 'twas pretty light abroad, Juno was weary and gone to bed. So I came home by star light as well as I could. At my first coming in, I gave Sarah five shillings. I writ Mr. Eyre his name in his book with the date October 21, 1720. It cost me 8ˢ. *Jehovah jireh!* ["The Lord will provide"]. Madam told me she had visited M. Mico, Wendell, and William Clark of the South [Church].

October 22. Daughter Cooper visited me before my going out of town, stayed till about sunset. I brought her, going near as far as the Orange-tree. Coming back, near Leg's Corner, little David Jeffries saw me, and looking upon

me very lovingly, asked me if I was going to see his grandmother. I said, "Not tonight." Gave him a penny and bid him present my service to his grandmother.

October 24. I went in the hackney coach through the Common, stopped at Madam Winthrop's (had told her I would take my departure from thence). Sarah came to the door with Katee in her arms; but I did not think to take notice of the child. Called her mistress. I told her, being encouraged by David Jeffries' loving eyes and sweet words, I was come to inquire whether she could find in her heart to leave that house and neighborhood, and go and dwell with me at the South End; I think she said softly, "Not yet." I told her it did not lie in my lands to keep a coach. If I should, I should be in danger to be brought to keep company with her neighbor Brooker (he was a little before sent to prison for debt). Told her I had an antipathy against those who would pretend to give themselves, but nothing of their estate. I would a proportion of my estate with myself. And I supposed she would do so. As to a periwig, my best and greatest friend, I could not possibly have a greater, began to find me with hair before I was born, and had continued to do so ever since; and I could not find in my heart to go to another. She commended the book I gave her, Dr. Preston, *The Church Marriage;* quoted him saying 'twas inconvenient keeping out of a fashion commonly used. I said the time and tide did circumscribe my visit. She gave me a dram of black-cherry brandy, and gave me a lump of the sugar that was in it. She wished me a good journey. I prayed God to keep her, and came away. Had a very pleasant journey to Salem.

October 25. Sent a letter of it to my son by Wakefield, who delivered it not till Wednesday; so he visited her not till Friday P.M. and then presented my service to her.

October 27. Kept the Thanksgiving at Salem. Mr. Fisk preached very well from Ephes. 5. 20: "Giving thanks always." Dine at Col. Brown's.

October 29. Hold court in the morn. Had a pleasant journey home a little before sunset.

October 30. Mrs. Phillips and her son sit in their pew.

October 31. She proves her husband's will. At night I visited Madam Winthrop about 6 P.M. They told me she was gone to Madam Mico's. I went thither and found she was gone; so returned to her house, read the epistles to the Galatians, Ephesians in Mr. Eyre's Latin Bible. After the clock struck 8, I began to read the 103 Psalm. Mr. Wendell came in from his warehouse. Asked me if I were alone. Spake very kindly to me, offered me to call Madam Winthrop. I told him she would be angry, had been at Mrs. Mico's; he helped me on with my coat, and I came home; left the *Gazette* in the Bible, which told Sarah of, bid her present my service to Mrs. Winthrop, and tell her I had been to wait on her if she had been at home.

November 1. I was so taken up that I could not go if I would.

November 2. Midweek. Went again, and found Mrs. Alden there, who quickly went out. Gave her about ½ pound of sugar almonds, cost 3$^s$ per £. Carried them on Monday. She seemed pleased with them, asked what they cost. Spake of giving her a hundred pounds per annum if I died before her. Asked her what sum she would give me, if she should die first. Said I would give her time to consider of it. She said she heard as if I had given all to my children by deeds

of gift. I told her 'twas a mistake, Point Judith was mine, etc. That in England, I owned, my father's desire was that it should go to my eldest son; 'twas £20 per annum; she thought 'twas forty. I think when I seemed to excuse pressing this, she seemed to think 'twas best to speak of it; a long winter was coming on. Gave me a glass or two of canary.

November 4th. Friday. Went again about 7 o'clock; found there Mr. John Walley and his wife; sat discoursing pleasantly. I showed them Isaac Moses's [an Indian] writing. Madam W. served comfits to us. After a while a table was spread, and supper was set. I urged Mr. Walley to crave a blessing; but he put it upon me. About 9 they went away. I asked Madam what fashioned necklace I should present her with; she said, "None at all." I asked her whereabout we left off last time, mentioned what I had offered to give her, asked her what she would give me; she said she could not change her condition, she had said so from the beginning, could not be so far from her children, the lecture. Quoted the Apostle Paul affirming that a single life was better than a married. I answered that was for the present distress. Said she had not pleasure in things of that nature as formerly. I said, "You are the fitter to make me a wife." If she held in that mind, I must go home and bewail my rashness in making more haste than good speed. However, considering the supper, I desired her to be within next Monday night, if we lived so long. Assented. She charged me with saying that she must put away Juno if she came to me; I utterly denied it, it never came in my heart; yet she insisted upon it, saying it came in upon discourse about the Indian woman that obtained her freedom this court. About 10 I said I would not disturb the good orders of her house, and came away. She not seeming pleased with my coming away. Spake to her about David Jeffries; had not seen him.

Monday, November 7th. My son prayed in the old chamber. Our time had been taken up by Son and Daughter Cooper's visit, so that I only read the 130th and 143rd Psalm. 'Twas on the account of my courtship. I went to Mad. Winthrop; found her rocking her little Katee in the cradle. I excused my coming so late (near eight). She set me an armed chair and cushion; and so the cradle was between her armed chair and mine. Gave her the remnant of my almonds; she did not eat of them as before, but laid them away; I said I came to inquire whether she had altered her mind since Friday, or remained of the same mind still. She said, "Thereabouts." I told her I loved her, and was so fond as to think that she loved me. She said [she] had a great respect for me. I told her I had made her an offer without asking any advice; she had so many to advise with that 'twas a hindrance. The fire was come to one short brand besides the block, which brand was set up in end; at last it fell to pieces, and no recruit was made. She gave me a glass of wine. I think I repeated again that I would go home and bewail my rashness in making more haste than good speed. I would endeavor to contain myself, and not go on to solicit her to do that which she could not consent to. Took leave of her. As came down the steps she bid me have a care. Treated me courteously. Told her she had entered the 4th year of her widowhood. I had given her the *News-Letter* before. I did not bid her draw off her glove as sometime I had done. Her dress was not so clean as sometime it had been. *Jehovah jireh!*

Midweek, November 9th. Dine at Brother Stoddard's; were so kind as to inquire of me if they should invite Madam Winthrop; I answered, "No."

December 17 [1727]. I was surprised to hear Mr. Thacher of Milton, my old friend, prayed for as dangerously sick. Next day, December 18: I am informed by Mr. Gerrish that my dear friend died last night, which I doubt bodes ill to Milton and the Province, his dying at this time, though in the 77th year of his age. *Deus avertat omen!* ["God avert the omen!"]

December 22 [1727]. The day after the fast, was interred. . . . I was inclined before, and having a pair of gloves sent me, I determined to go to the funeral if the weather proved favorable, which it did; and I hired Blake's coach with four horses. My son, Mr. Cooper and Mr. Prince went with me. Refreshed there with meat and drink; got thither about half an hour past one. It was sad to see [death] triumphed over my dear friend! I rode in my coach to the burying place, not being able to get nearer by reason of the many horses. From thence went directly up the hill where the smith's shop, and so home very comfortably and easily, the ground being mollified. But when I came to my own gate, going in, I fell down, a board slipping under my left foot, my right leg raised off the skin and put me to a great deal of pain, especially when 'twas washed with rum. It was good for me that I was thus afflicted, that my spirit might be brought into a frame more suitable to the solemnity, which is apt to be too light. And by the loss of some of my skin and blood, I might be awakened to prepare for my own dissolution. . . . I have now been at the interment of 4 of my classmates. . . . Now I can go to no more funerals of my classmates, nor none be at mine; for the survivors, the Rev. Mr. Samuel Mather at Windsor and the Rev. Mr. Taylor at Westfield, [are] one hundred miles off, and are entirely enfeebled. I humbly pray that Christ may be graciously present with us all three, both in life and in death, and then we shall safely and comfortably walk through the shady valley that leads to glory.

# ANNE HUTCHINSON

Anne Hutchinson (1591–1643) was a Puritan who came to New England in 1634. Having already known and admired John Cotton from his preaching in England, she joined Cotton's church in Boston and soon became well known as a spiritual counsel to other women. She held meetings for women in her home, during which she led discussions of the weekly sermons; soon she was holding meetings for men as well. For a time, at least sixty persons attended these meetings each week, and Hutchinson expressed strong opinions about the legalism of the ministers in those parts (excepting Cotton), meaning that they purportedly preached a "covenant of works" rather than grace. By September 1634, some were questioning her orthodoxy, and by the fall of 1636, Hutchinson was being summoned into meetings with the region's ministers to answer questions about her theological views. The controversy continued to

grow, and she and her followers were scornfully termed "Antinomians" (against the law), until even Cotton denounced her teachings. In November 1637 she was tried for heresy and banished from the colony. This excerpt is from an account of her trial, published by her great-great-grandson from an "ancient manuscript" that is no longer extant.

# The Examination of
# Mrs. Anne Hutchinson

## NOVEMBER 1637.

*The Examination of Mrs. Hutchinson at the court at Newtown.*

MR. WINTHROP, GOVERNOR: Mrs. Hutchinson, you are called here as one of those that have troubled the peace of the commonwealth and the churches here; you are known to be a woman that hath had a great share in the promoting and divulging of those opinions that are causes of this trouble, and to be nearly joined not only in affinity and affection with some of those the court had taken notice of and passed censure upon, but you have spoken divers things as we have been informed very prejudicial to the honour of the churches and ministers thereof, and you have maintained a meeting and an assembly in your house that hath been condemned by the general assembly as a thing not tolerable nor comely in the sight of God nor fitting for your sex, and notwithstanding that was cried down you have continued the same, therefore we have thought good to send for you to understand how things are, that if you be in an erroneous way we may reduce you that so you may become a profitable member here among us, otherwise if you be obstinate in your course that then the court may take such course that you may trouble us no further, therefore I would intreat you to express whether you do not hold and assent in practice to those opinions and factions that have been handled in court already, that is to say, whether you do not justify Mr. Wheelwright's sermon and the petition.

MRS. HUTCHINSON: I am called here to answer before you but I hear no things laid to my charge.

GOV.: I have told you some already and more I can tell you.    (MRS. H.) Name one Sir.

GOV.: Have I not named some already?

MRS. H.: What have I said or done?

GOV.: Why for your doings, this you did harbour and countenance those that are parties in this faction that you have heard of.    (MRS. H.) That's matter of conscience, Sir.

GOV.: Your conscience you must keep or it must be kept for you.

MRS. H.: Must not I then entertain the saints because I must keep my conscience.

GOV.: Say that one brother should commit felony or treason and come to his other brother's house, if he knows him guilty and conceals him he is guilty of the same. It is his conscience to entertain him, but if his conscience comes into act in giving countance and entertainment to him that hath broken the law he is guilty too. So if you do countance those that are transgressors of the law you are in the same fact.

MRS. H.: What law do they transgress?

GOV.: The law of God and of the state.

MRS. H.: In what particular?

GOV.: Why in this among the rest, whereas the Lord doth say honour thy father and thy mother.

MRS. H.: Ey Sir in the Lord.  (GOV.) This honour you have broke in giving countance to them. *support tolerate, approve*

MRS. H.: In entertaining those did I entertain them against any act (for there is the thing) or what God hath appointed?

GOV.: You knew that Mr. Wheelwright did preach this sermon and those that countance him in this do break a law.

MRS. H.: What law have I broken?

GOV.: Why the fifth commandment.  *commandments seen as laws*

MRS. H.: I deny that for he saith in the Lord.

GOV.: You have joined with them in the faction.

MRS. H.: In what faction have I joined with them?

GOV.: In presenting the petition.

MRS. H.: Suppose I had set my hand to the petition what then?  (GOV.) You saw that case tried before.

MRS. H.: But I had not my hand to the petition.

GOV.: You have councelled them.  (MRS. H.) Wherein?

GOV.: Why in entertaining them.

MRS. H.: What breach of law is that Sir?

GOV.: Why dishonouring of parents.

MRS. H.: But put the case Sir that I do fear the Lord and my parents, may not I entertain them that fear the Lord because my parents will not give me leave?

GOV.: If they be the fathers of the commonwealth, and they of another religion, if you entertain them then you dishonour your parents and are justly punishable.

MRS. H.: If I entertain them, as they have dishonoured their parents I do.

GOV.: No but you by countenancing them above others put honor upon them.

MRS. H.: I may put honor upon them as the children of God and as they do honor the Lord.

GOV.: We do not mean to discourse with those of your sex but only this; you do adhere unto them and do endeavour to set forward this faction and so you do dishonour us.

MRS. H.: I do acknowledge no such thing neither do I think that I ever put any dishonour upon you.

GOV.: Why do you keep such a meeting at your house as you do every week upon a set day?

MRS. H.: It is lawful for me so to do, as it is all your practices and can you find a warrant for yourself and condemn me for the same thing? The ground of my taking it up was, when I first came to this land because I did not go to such meetings as those were, it was presently reported that I did not allow of such meetings but held them unlawful and therefore in that regard they said I was proud and did despise all ordinances, upon that a friend came unto me and told me of it and I to prevent such aspersions took it up, but it was in practice before I came therefore I was not the first.

GOV.: For this, that you appeal to our practice you need no confutation. If your meeting had answered to the former it had not been offensive, but I will say that there was no meeting of women alone, but your meeting is of another sort for there are sometimes men among you.

MRS. H.: There was never any man with us.

GOV.: Well, admit there was no man at your meeting and that you was sorry for it, there is no warrant for your doings, and by what warrant do you continue such a course?

MRS. H.: I conceive there lyes a clear rule in Titus, that the elder women should instruct the younger and then I must have a time wherein I must do it.

GOV.: All this I grant you, I grant you a time for it, but what is this to the purpose that you Mrs. Hutchinson must call a company together from their callings to come to be taught of you?

MRS. H.: Will it please you to answer me this and to give me a rule for then I will willingly submit to any truth. If any come to my house to be instructed in the ways of God what rule have I to put them away?

GOV.: But suppose that a hundred men come unto you to be instructed will you forbear to instruct them?

MRS. H.: As far as I conceive I cross a rule in it.

GOV.: Very well and do you not so here?

MRS. H.: No Sir for my ground is they are men.

GOV.: Men and women all is one for that, but suppose that a man should come and say Mrs. Hutchinson I hear that you are a woman that God hath given his grace unto and you have knowledge in the word of God I pray instruct me a little, ought you not to instruct this man?

MRS. H.: I think I may.—Do you think it not lawful for me to teach women and why do you call me to teach the court?

GOV.: We do not call you to teach the court but to lay open yourself.

MRS. H.: I desire you that you would then set me down a rule by which I may put them away that come unto me and so have peace in so doing.

GOV.: You must shew your rule to receive them.

MRS. H.: I have done it.

GOV.: I deny it because I have brought more arguments than you have.

MRS. H.: I say, to me it is a rule.

MR. ENDICOT: You say there are some rules unto you. I think there is a contradiction in your own words. What rule for your practice do you bring, only a custom in Boston.

MRS. H.: No Sir that was no rule to me but if you look upon the rule in Titus it is a rule to me. If you convince me that it is no rule I shall yield.

GOV.: You know that there is no rule that crosses another, but this rule crosses that in the Corinthians. But you must take it in this sense that elder women must instruct the younger about their business, and to love their husbands and not to make them to clash.

MRS. H.: I do not conceive but that it is meant for some publick times.

GOV.: Well, have you no more to say but this?

MRS. H.: I have said sufficient for my practice.

GOV.: Your course is not to be suffered for, besides that we find such a course as this to be greatly prejudicial to the state, besides the occasion that it is to seduce many honest persons that are called to those meetings and your opinions being known to be different from the word of God may seduce many simple souls that resort unto you, besides that the occasion which hath come of late hath come from none but such as have frequented your meetings, so that now they are flown off from magistrates and ministers and this since they have come to you, and besides that it will not well stand with the commonwealth that families should be neglected for so many neighbours and dames and so much time spent, we see no rule of God for this, we see not that any should have authority to set up any other exercises besides what authority hath already set up and so what hurt comes of this you will be guilty of and we for suffering you.

MRS. H.: Sir I do not believe that to be so.

GOV.: Well, we see how it is we must therefore put it away from you, or restrain you from maintaining this course.

MRS. H.: If you have a rule for it from God's word you may.

GOV.: We are your judges, and not you ours and we must compel you to it.

MRS. H.: If it please you by authority to put it down I will freely let you for I am subject to your authority.

MR. BRADSTREET: I would ask this question of Mrs. Hutchinson, whether you do think this is lawful? for then this will follow that all other women that do not are in a sin.

MRS. H.: I conceive this is a free will offering.

BRADST.: If it be a free will offering you ought to forbear it because it gives offence.

MRS. H.: Sir, in regard of myself I could, but for others I do not yet see light but shall further consider of it.

BRADST.: I am not against all women's meetings but do think them to be lawful.

MR. DUDLEY, DEP. GOV.: Here hath been much spoken concerning Mrs. Hutchinson's meetings and among other answers she saith that men come not there, I would ask you this one question then, whether never any man was at your meeting?

GOV.: There are two meetings kept at their house.

DEP. GOV.: How; is there two meetings?

MRS. H.: Ey Sir, I shall not equivocate, there is a meeting of men and women and there is a meeting only for women.

DEP. GOV.: Are they both constant?

MRS. H.: No, but upon occasions they are deferred.

MR. ENDICOT: Who teaches in the men's meetings none but men, do not women sometimes?

MRS. H.: Never as I heard, not one.

DEP. GOV.: I would go a little higher with Mrs. Hutchinson. About three years ago we were all in peace. Mrs. Hutchinson from that time she came hath made a disturbance, and some that came over with her in the ship did inform me what she was as soon as she was landed. I being then in place dealt with the pastor and teacher of Boston and desired them to enquire of her, and then I was satisfied that she held nothing different from us, but within half a year after, she had vented divers of her strange opinions and had made parties in the country, and at length it comes that Mr. Cotton and Mr. Vane were of her judgment, but Mr. Cotton hath cleared himself that he was not of that mind, but now it appears by this woman's meeting that Mrs. Hutchinson hath so forestalled the minds of many by their resort to her meeting that now she hath a potent party in the country. Now if all these things have endangered us as from that foundation and if she in particular hath disparaged all our ministers in the land that they have preached a covenant of works, and only Mr. Cotton a covenant of grace, why this is not to be suffered, and therefore being driven to the foundation and it being found that Mrs. Hutchinson is she that hath depraved all the ministers and hath been the cause of what is fallen out, why we must take away the foundation and the building will fall.

MRS. H.: I pray Sir prove it that I said they preached nothing but a covenant of works.

DEP. GOV.: Nothing but a covenant of works, why a Jesuit may preach truth sometimes.

MRS. H.: Did I ever say they preached a covenant of works then?

DEP. GOV.: If they do not preach a covenant of grace clearly, then they preach a covenant of works.

MRS. H.: No Sir, one may preach a covenant of grace more clearly than another, so I said.

D. GOV.: We are not upon that now but upon position.

MRS. H.: Prove this then Sir that you say I said.

D. GOV.: When they do preach a covenant of works do they preach truth?

MRS. H.: Yes Sir, but when they preach a covenant of works for salvation, that is not truth.

D. GOV.: I do but ask you this, when the ministers do preach a covenant of works do they preach a way of salvation?

MRS. H.: I did not come hither to answer to questions of that sort.

D. GOV.: Because you will deny the thing.

MRS. H.: Ey, but that is to be proved first.

D. GOV.: I will make it plain that you did say that the ministers did preach a covenant of works.

MRS. H.: I deny that.

D. GOV.: And that you said they were not able ministers of the new testament, but Mr. Cotton only.

MRS. H.: If ever I spake that I proved it by God's word.

COURT: Very well, very well.

MRS. H.: If one shall come unto me in private, and desire me seriously to tell them what I thought of such an one. I must either speak false or true in my answer.

D. GOV.: Likewise I will prove this that you said the gospel in the letter and words holds forth nothing but a covenant of works and that all that do not hold as you do are in a covenant of works.

MRS. H.: I deny this for if I should so say I should speak against my own judgment.

MR. ENDICOT: I desire to speak seeing Mrs. Hutchinson seems to lay something against them that are to witness against her.

GOVER.: Only I would add this. It is well discerned to the court that Mrs. Hutchinson can tell when to speak and when to hold her tongue. Upon the answering of a question which we desire her to tell her thoughts of she desires to be pardoned.

MRS. H.: It is one thing for me to come before a public magistracy and there to speak what they would have me to speak and another when a man comes to me in a way of friendship privately there is difference in that.

GOV.: What if the matter be all one.

MR. HUGH PETERS: That which concerns us to speak unto as yet we are sparing in unless the court command us to speak, then we shall answer to Mrs. Hutchinson notwithstanding our brethren are very unwilling to answer.

GOVERN.: This speech was not spoken in a corner but in a public assembly, and though things were spoken in private yet now coming to us, we are to deal with them as public.

MR. PETERS:  We shall give you a fair account of what was said and desire that we may not be thought to come as informers against the gentlewoman, but as it may be serviceable for the country and our posterity to give you a brief account. This gentlewoman went under suspicion not only from her landing, that she was a woman not only difficult in her opinions, but also of an intemperate spirit. What was done at her landing I do not well remember, but assoon as Mr. Vane and ourselves came this controversy began yet it did reflect upon Mrs. Hutchinson and some of our brethren had dealt with her, and it so fell out that some of our ministry doth suffer as if it were not according to the gospel and as if we taught a covenant of works instead of a covenant of grace. Upon these and the like we did address ourselves to the teacher of that church, and the court then assembled being sensible of these things, and this gentlewoman being as we understood a chief agent, our desire to the teacher was to tell us wherein the difference lay between him and us, for the spring did then arise as we did conceive from this gentlewoman, and so we told him. He said that he thought it not according to God to commend this to the magistrates but to take some other course, and so going on in the discourse we thought it good to send for this gentlewoman, and she willingly came, and at the very first we gave her notice that such reports there were that she did conceive our ministry to be different from the ministry of the gospel, and that we taught a covenant of works, &c. and this was her table talk and therefore we desired her to clear herself and deal plainly. She was very tender at the first. Some of our brethren did desire to put this upon proof, and then her words upon that were The fear of man is a snare why should I be afraid. These were her words. I did then take upon me to ask her this question. What difference do you conceive to be between your teacher and us? She did not request us that we should preserve her from danger or that we should be silent. Briefly, she told me there was a wide and a broad difference between our brother Mr. Cotton and our selves. I desired to know the difference. She answered that he preaches the covenant of grace and you the covenant of works, and that you are not able ministers of the new testament and know no more than the apostles did before the resurrection of Christ. I did then put it to her, What do you conceive of such a brother? She answered he had not the seal of the spirit. And other things we asked her but generally the frame of her course was this, that she did conceive that we were not able ministers of the gospel. And that day being past our brother Cotton was sorry that she should lay us under a covenant of works, and could have wished she had not done so. The elders being there present we did charge them with her, and the teacher of the place said they would speak further with her, and after some time she answered that we were gone as far as the apostles were before Christ's ascension. And since that we have gone with tears some of us to her.

MRS. H.:  If our pastor would shew his writings you should see what I said, and that many things are not so as is reported.

MR. WILSON: Sister Hutchinson, for the writings you speak of I have them not, and this I must say I did not write down all that was said and did pass betwixt one and another, yet I say what is written I will avouch.

*all saying the same thing, they heard Mr. Peters*

DEP. GOV.: I desire that the other elders will say what Mr. Peters hath said.

MR. WELD: Being desired by the honoured court, that which our brother Peters had spoken was the truth and things were spoken as he hath related and the occasion of calling this sister and the passages that were there among us. And myself asking why she did cast such aspersions upon the ministers of the country though we were poor sinful men and for ourselves we cared not but for the precious doctrine we held forth we could not but grieve to hear that so blasphemed. She at that time was sparing in her speech. I need not repeat the things they have been truly related. She said the fear of man is a snare and therefore I will speak freely and she spake her judgment and mind freely as was before related, that Mr. Cotton did preach a covenant of grace and we a covenant of works. And this I remember she said we could not preach a covenant of grace because we were not sealed, and we were not able ministers of the new testament no more than were the disciples before the resurrection of Christ.

MR. PHILLIPS: For my own part I have had little to do in these things only at that time I was there and yet not being privy to the ground of that which our brother Peters hath mentioned but they procuring me to go along with them telling me that they were to deal with her; at first she was unwilling to answer but at length she said there was a great deal of difference between Mr. Cotton and we. Upon this Mr. Cotton did say that he could have wished that she had not put that in. Being asked of particulars she did instance in Mr. Shephard that he did not preach a covenant of grace clearly, and she instanced our brother Weld. Then I asked her of myself (being she spake rashly of them all) because she never heard me at all. She likewise said that we were not able ministers of the new testament and her reason was because we were not sealed.

MR. SIMMES: For my own part being called to speak in this case to discharge the relation wherein I stand to the commonwealth and that which I stand in unto God, I shall speak briefly. For my acquaintance with this person I had none in our native country, only I had occasion to be in her company once or twice before I came, where I did perceive that she did slight the ministers of the word of God. But I came along with her in the ship, and it so fell out that we were in the great cabin together and therein did agree with the labours of Mr. Lothrop and myself, only there was a secret opposition to things delivered. The main thing that was then in hand was about the evidencing of a good estate, and among the rest about that place in John concerning the love of the brethren. That which I took notice of was the corruptness and narrowness of her opinions, which I doubt not but I may call them so, but she said, when she came to Boston there would be something more seen than I said, for such speeches were cast about and abused as that of our saviour, I have many things to say but you cannot bear them now. And being come and she desiring to be admitted as a member, I was desired to be there, and then Mr. Cotton did give me full satisfaction in the things then in question. And for things which have been here spoken, as far as I can remember they are the truth, and when I asked her what she thought of me, she said alas you know my mind long ago, yet I do not think myself

disparaged by her testimony and I would not trouble the court, only this one thing I shall put in, that Mr. Dudley and Mr. Haines were not wanting in the cause after I had given notice of her.

MR. WILSON: I desire you would give me leave to speak this word because of what has been said concerning her entrance into the church. There was some difficulty made, but in her answers she gave full satisfaction to our teacher and myself, and for point of evidencing justification by sanctification she did not deny, but only justification must be first. Our teacher told her then that if she was of that mind she would take away the scruple: for we thought that matter, for point of order we did not greatly stand upon, because we hoped she would hold with us in that truth as well as the other.

MR. SHEPHARD: I am loth to speak in this assembly concerning this gentlewoman in question, but I can do no less than speak what my conscience speaks unto me. For personal reproaches I take it a man's wisdom to conceal. Concerning the reproaches of the ministry of our's there hath been many in the country, and this hath been my thoughts of that. Let men speak what they will not only against persons but against ministry, let that pass, but let us strive to speak to the consciences of men, knowing that if we had the truth with us we shall not need to approve our words by our practice and our ministry to the hearts of the people, and they should speak for us and therefore I have satisfied myself and the brethren with that. Now for that which concerns this gentlewoman at this time I do not well remember every particular, only this I do remember that the end of our meeting was to satisfy ourselves in some points. Among the rest Mrs. Hutchinson was desired to speak her thoughts concerning the ministers of the Bay. Now I remember that she said that we were not able ministers of the new testament. I followed her with particulars, she instanced myself as being at the lecture and hearing me preach when as I gave some means whereby a christian might come to the assurance of God's love. She instanced that I was not sealed. I said why did she say so. She said because you put love for an evidence. Now I am sure she was in an error in this speech for if assurance be an holy estate then I am sure there are not graces wanting to evidence it.

MR. ELIOT: I am loth to spend time therefore I shall consent to what hath been said. Our brethren did intreat us to write and a few things I did write the substance of which hath been here spoken and I have it in writing therefore I do avouch it.

MR. SHEPHARD: I desire to speak this word, it may be but a slip of her tongue, and I hope she will be sorry for it, and then we shall be glad of it.

DEP. GOV.: I called these witnesses and you deny them. You see they have proved this and you deny this, but it is clear. You said they preached a covenant of works and that they were not able ministers of the new testament; now there are two other things that you did affirm which were that the scriptures in the letter of them held forth nothing but a covenant of works and likewise that those that were under a covenant of works cannot be saved.

MRS. H.: Prove that I said so.   (GOV.) Did you say so?

MRS. H.: No Sir it is your conclusion.

D. GOV.: What do I do charging of you if you deny what is so fully proved.

GOV.: Here are six undeniable ministers who say it is true and yet you deny that you did say that they did preach a covenant of works and that they were not able ministers of the gospel, and it appears plainly that you have spoken it, and whereas you say that it was drawn from you in a way of friendship, you did profess then that it was out of conscience that you spake and said The fear of man is a snare wherefore should I be afraid, I will speak plainly and freely.

MRS. H.: That I absolutely deny, for the first question was thus answered by me to them. They thought that I did conceive there was a difference between them and Mr. Cotton. At the first I was somewhat reserved, then said Mr. Peters I pray answer the question directly as fully and as plainly as you desire we should tell you our minds. Mrs. Hutchinson we come for plain dealing and telling you our hearts. Then I said I would deal as plainly as I could, and whereas they say I said they were under a covenant of works and in the state of the apostles why these two speeches cross one another. I might say they might preach a covenant of works as did the apostles, but to preach a covenant of works and to be under a covenant of works is another business.

DEP. GOV.: There have been six witnesses to prove this and yet you deny it.

MRS. H.: I deny that these were the first words that were spoken.

GOV.: You make the case worse, for you clearly shew that the ground of your opening your mind was not to satisfy them but to satisfy your own conscience.

MR. PETERS: We do not desire to be so narrow to the court and the gentlewoman about times and seasons, whether first or after, but said it was.

DEP. GOV.: For that other thing I mentioned for the letter of the scripture that it held forth nothing but a covenant of works, and for the latter that we are in a state of damnation, being under a covenant of works, or to that effect, these two things you also deny. Now the case stands thus. About three quarters of a year ago I heard of it, and speaking of it there came one to me who is not here, but will affirm it if need be, as he did to me that he did hear you say in so many words. He set it down under his hand and I can bring it forth when the court pleases. His name is subscribed to both these things, and upon my peril be it if I bring you not in the paper and bring the minister (meaning Mr. Ward) to be deposed.

GOV.: What say you to this, though nothing be directly proved, yet you hear it may be.

MRS. H.: I acknowledge using the words of the apostle to the Corinthians unto him, that they that were ministers of the letter and not the spirit did preach a covenant of works. Upon his saying there was no such scripture, then I fetched the Bible and shewed him this place 2 Cor. iii. 6. He said that was the letter of the law. No said I it is the letter of the gospel.

GOV.: You have spoken this more than once then.

MRS. H.: Then upon further discourse about proving a good estate and holding it out by the manifestation of the spirit he did acknowledge that to be the nearest way, but yet said he, will you not acknowledge that which we hold forth to be a way too wherein we may have hope; no truly if that be a way it is a way to hell.

GOV.: Mrs. Hutchinson, the court you see hath laboured to bring you to ac-knowledge the error of your way that so you might be reduced, the time now grows late, we shall therefore give you a little more time to consider of it and therefore desire that you attend the court again in the morning.
    [*The next morning.*]

GOV.: We proceeded the last night as far as we could in hearing of this cause of Mrs. Hutchinson. There were divers things laid to her charge, her ordinary meetings about religious exercises, her speeches in derogation of the minis-ters among us, and the weakning of the hands and hearts of the people to-wards them. Here was sufficient proof made of that which she was accused of in that point concerning the ministers and their ministry, as that they did preach a covenant of works when others did preach a covenant of grace, and that they were not able ministers of the new testament, and that they had not the seal of the spirit, and this was spoken not as was pretended out of private conference, but out of conscience and warrant from scripture alledged the fear of man is a snare and seeing God had given her a calling to it she would freely speak. Some other speeches she used, as that the letter of the scripture held forth a covenant of works, and this is offered to be proved by probable grounds. If there be anything else that the court hath to say they may speak.

MRS. H.: The ministers come in their own cause. Now the Lord hath said that an oath is the end of all controversy; though there be a sufficient number of witnesses yet they are not according to the word, therefore I desire they may speak upon oath.

GOV.: Well, it is in the liberty of the court whether they will have an oath or no, and it is not in this case as in case of a jury. If they be satisfied they have suf-ficient matter to proceed.

MRS. H.: I have since I went home perused some notes out of what Mr. Wilson did then write and I find things not to be as hath been alledged.

GOV.: Where are the writings?

MRS. H.: I have them not, it may be Mr. Wilson hath.

GOV.: What are the instructions that you can give, Mr. Wilson?

MR. WILSON: I do say that Mr. Vane desired me to write the discourse out and whether it be in his own hands or in some body's else I know not. For my own copy it is somewhat imperfect, but I could make it perfect with a little pains.

GOV.: For that which you alledge as an exception against the elders it is vain and untrue, for they are no prosecutors in this cause but are called to wit-ness in the cause.

MRS. H.: But they are witnesses of their own cause.

GOV.: It is not their cause but the cause of the whole country and they were un-willing that it should come forth, but that it was the glory and honour of God.

MRS. H.: But it being the Lord's ordinance that an oath should be the end of all strife, therefore they are to deliver what they do upon oath.

MR. BRADSTREET: Mrs. Hutchinson, these are but circumstances and adjuncts to the cause, admit they should mistake you in your speeches you would make them to sin if you urge them to swear.

MRS. H.: That is not the thing. If they accuse me I desire it may be upon oath.

GOV.: If the court be not satisfied they may have an oath.

MR. NOWEL: I should think it convenient that the country also should be satisfied because that I do hear it affirmed, that things which were spoken in private are carried abroad to the publick and thereupon they do undervalue the ministers of congregations.

MR. BROWN: I desire to speak. If I mistake not an oath is of a high nature, and it is not to be taken but in a controversy, and for my part I am afraid of an oath and fear that we shall take God's name in vain, for we may take the witness of these men without an oath.

MR. ENDICOT: I think the ministers are so well known unto us, that we need not take an oath of them, but indeed an oath is the end of all strife.

MRS. H.: There are some that will take their oaths to the contrary.

MR. ENDICOT: Then it shall go under the name of a controversy, therefore we desire to see the notes and those also that will swear.

GOV.: Let those that are not satisfied in the court speak.

MANY SAY: —— We are not satisfied.

GOV.: I would speak this to Mrs. Hutchinson. If the ministers shall take an oath will you sit down satisfied?

MRS. H.: I can't be notwithstanding oaths satisfied against my own conscience.

MR. STOUGHTON: I am fully satisfied with this that the ministers do speak the truth but now in regard of censure I dare not hold up my hand to that, because it is a course of justice, and I cannot satisfy myself to proceed so far in a way of justice, and therefore I should desire an oath in this as in all other things. I do but speak to prevent offence if I should not hold up my hand at the censure unless there be an oath given.

MR. PETERS: We are ready to swear if we see a way of God in it.
[Here was a parley between the deputy governor and Mr. Stoughton about the oath.]

MR. ENDICOT: If they will not be satisfied with a testimony an oath will be in vain.

MR. STOUGHTON: I am persuaded that Mrs. Hutchinson and many other godly-minded people will be satisfied without an oath.

MRS. H.: An oath Sir is an end of all strife and it is God's ordinance.

MR. ENDICOT: A sign it is what respect she hath to their words, and further, pray see your argument, you will have the words that were written and yet Mr. Wilson saith he writ not all, and now you will not believe all these godly ministers without an oath.

MRS. H.: Mr. Wilson did affirm that which he gave in to the governor that then was to be true.    [*Some reply*]    But not all the truth.

MR. WILSON: I did say so far as I did take them they were true.

MR. HARLAKENDEN: I would have the spectators take notice that the court doth not suspect the evidence that is given in, though we see that whatever evidence is brought in will not satisfy, for they are resolved upon the thing and therefore I think you will not be unwilling to give your oaths.

GOV.: I see no necessity of an oath in this thing seeing it is true and the substance of the matter confirmed by divers, yet that all may be satisfied, if the elders will take an oath they shall have it given them.

DEP. GOV.: Let us join the things together that Mrs. Hutchinson may see what they have their oaths for.

MRS. H.: I will prove by what Mr. Wilson hath written that they never heard me say such a thing.

MR. SIMS: We desire to have the paper and have it read.

MR. HARLAKENDEN: I am persuaded that is the truth that the elders do say and therefore I do not see it necessary now to call them to oath.

GOV.: We cannot charge any thing of untruth upon them.

MR. HARLAKENDEN: Besides, Mrs. Hutchinson doth say that they are not able ministers of the new testament.

MRS. H.: They need not swear to that.

DEP. GOV.: Will you confess it then.

MRS. H.: I will not deny it nor say it.

DEP. GOV.: You must do one.

MRS. H.: After that they have taken an oath, I will make good what I say.

DEP. GOV.: Let us state the case and then we may know what to do. That which is laid to Mrs. Hutchinson's charge is this, that she hath traduced the magistrates and ministers of this jurisdiction, that she hath said the ministers preached a covenant of works and Mr. Cotton a covenant of grace, and that they were not able ministers of the gospel, and she excuses it that she made it a private conference and with a promise of secrecy, &c. now this is charged upon her, and they therefore sent for her seeing she made it her table talk, and then she said the fear of man was a snare and therefore she would not be affeared of them.

MRS. H.: This that yourself hath spoken, I desire that they may take their oaths upon.

GOV.: That that we should put the reverend elders unto is this that they would deliver upon oath that which they can remember themselves.

MR. SHEPHARD: I know no reason of the oath but the importunity of this gentlewoman.

MR. ENDICOT: You lifted up your eyes as if you took God to witness that you came to entrap none and yet you will have them swear.

MR. HARLAKENDEN: Put any passage unto them and see what they say.

MRS. H.: They say I said the fear of man is a snare, why should I be afraid. When I came unto them, they urging many things unto me and I being backward to answer at first, at length this scripture came into my mind 29th Prov. 15. The fear of man bringeth a snare, but whoso putteth his trust in the Lord shall be safe.

MR. HARLAKENDEN: This is not an essential thing.

GOV.: I remember his testimony was this.

MRS. H.: Ey, that was the thing that I do deny for they were my words and they were not spoken at the first as they do alledge.

MR. PETERS: We cannot tell what was first or last, we suppose that an oath is an end of all strife and we are tender of it, yet this is the main thing against her that she charged us to be unable ministers of the gospel and to preach a covenant of works.

GOVER.: You do understand the thing, that the court is clear for we are all satisfied that it is truth but because we would take away all scruples, we desire that you would satisfy the spectators by your oath.

MR. BISHOP: I desire to know before they be put to oath whether their testimony be of validity.

DEP. GOV.: What do you mean to trouble the court with such questions. Mark what a flourish Mrs. Hutchinson puts upon the business that she had witnesses to disprove what was said and here is no man to bear witness.

MRS. H.: If you will not call them in that is nothing to me.

MR. ELIOT: We desire to know of her and her witnesses what they deny and then we shall speak upon oath. I know nothing we have spoken of but we may swear to.

MR. SIMS: Ey, and more than we have spoken to.

MR. STOUGHTON: I would gladly that an oath should be given that so the person to be condemned should be satisfied in her conscience, and I would say the same for my own conscience if I should join in the censure—[*Two or three lines in the MS. are defaced and not legible.*]

MR. COGGESHALL: I desire to speak a word—It is desired that the elders would confer with Mr. Cotton before they swear.

GOVERN.: Shall we not believe so many godly elders in a cause wherein we know the mind of the party without their testimony?

MR. ENDICOT TO MR. COGGESHALL: I will tell you what I say. I think that this carriage of your's tends to further casting dirt upon the face of the judges.

MR. HARLAKENDEN: Her carriage doth the same for she doth not object any essential thing, but she goes upon circumstances and yet would have them sworn.

MRS. H.: This I would say unto them. Forasmuch as it was affirmed by the deputy that he would bring proof of these things, and the elders they bring proof in their own cause, therefore I desire that particular witnesses be for these things that they do speak.

GOV.: The elders do know what an oath is and as it is an ordinance of God so it should be used.

MRS. H.: That is the thing I desire and because the deputy spake of witnesses I have them here present.

MR. COLBORN: We desire that our teacher may be called to hear what is said.—Upon this Mr. Cotton came and sat down by Mrs. Hutchinson.

MR. ENDICOT: This would cast some blame upon the ministers.—Well, but whatsoever he will or can say we will believe the ministers.

MR. ELIOT:
MR. SHEPARD: } We desire to see light why we should take an oath.

MR. STOUGHTON: Why it is an end of all strife and I think you ought to swear and put an end to the matter.

MR. PETERS: Our oath is not to satisfy Mrs. Hutchinson but the court.

MR. ENDICOT: The assembly will be satisfied by it.

DEP. GOV.: If the country will not be satisfied you must swear.

MR. SHEPARD: I conceive the country doth not require it.

DEP. GOV.: Let her witnesses be called.

GOV.: Who be they?

MRS. H.: Mr. Leveret and our teacher and Mr. Coggeshall.

GOV.: Mr. Coggeshall was not present.

MR. COGGESHALL: Yes but I was, only I desired to be silent till I should be called.

GOV.: Will you Mr. Coggeshall say that she did not say so?

MR. COGGESHALL: Yes I dare say that she did not say all that which they lay against her.

MR. PETERS: How dare you look into the court to say such a word?

MR. COGGESHALL: Mr. Peters takes upon him to forbid me. I shall be silent.

MR. STOUGHTON: Ey, but she intended this that they say.

GOV.: Well, Mr. Leveret, what were the words? I pray speak.

MR. LEVERET: To my best remembrance when the elders did send for her, Mr. Peters did with much vehemency and intreaty urge her to tell what difference there was between Mr. Cotton and them, and upon his urging of her she said. The fear of man is a snare, but they that trust upon the Lord shall be safe. And being asked wherein the difference was, she answered that they did not preach a covenant of grace so clearly as Mr. Cotton did, and she gave this reason of it because that as the apostles were for a time without the spirit so until they had received the witness of the spirit they could not preach a covenant of grace so clearly.

GOV.: Don't you remember that she said they were not able ministers of the new testament?

MRS. H.: Mr. Weld and I had an hour's discourse at the window and then I spake that, if I spake it.

MR. WELD: Will you affirm that in the court? Did not I say unto you, Mrs. Hutchinson, before the elders. When I produced the thing, you then called for proof. Was not my answer to you, leave it there, and if I cannot prove it you shall be blameless?

MRS. H.: This I remember I spake, but do not you remember that I came afterwards to the window when you was writing and there spake unto you?

MR. WELD: No truly.   (MRS. H.) But I do very well.

GOV.: Mr. Cotton, the court desires that you declare what you do remember of the conference which was at that time and is now in question.

MR. COTTON: I did not think I should be called to bear witness in this cause and therefore did not labour to call to remembrance what was done; but the greatest passage that took impression upon me was to this purpose. The elders spake that they had heard that she had spoken some condemning words of their ministry, and among other things they did first pray her to answer wherein she thought their ministry did differ from mine, how the comparison sprang I am ignorant, but sorry I was that any comparison should be between me and my brethren and uncomfortable it was, she told them to this purpose that they did not hold forth a covenant of grace as I did, but wherein did we differ? why she said that they did not hold forth the seal of the spirit as he doth. Where is the difference there? say they, why saith she speaking to one or other of them, I know not to whom. You preach of the seal of the spirit upon a work and he upon free grace without a work or without respect to a work, he preaches the seal of the spirit upon free grace and you upon a work. I told her I was very sorry that she put comparisons between my ministry and their's, for she had said more than I could myself, and rather I had that she had put us in fellowship with them and not have made that discrepancy. She said, she found the difference. Upon that there grew some speeches upon the thing and I do remember I instanced to them the story of Thomas Bilney in the book of martyrs how freely the spirit witnessed unto him without any respect unto a work as himself professes. Now upon this other speeches did grow. If you put me in mind of any thing I shall speak it, but this was the sum of the difference, nor did it seem to be so ill taken as it is and our brethren did say also that they would not so easily believe reports as they had done and withal mentioned that they would speak no more of it, some of them did; and afterwards some of them did say they were less satisfied than before. And I must say that I did not find her saying they were under a covenant of works, nor that she said they did preach a covenant of works.

GOV.: You say you do not remember, but can you say she did not speak so
————[Here two lines again defaced.]

MR. COTTON: I do remember that she looked at them as the apostles before the ascension.

MR. PETERS: I humbly desire to remember our reverend teacher. May it please you to remember how this came in. Whether do you not remember that she said we were not sealed with the spirit of grace, therefore could not preach

a covenant of grace, and she said further you may do it in your judgment but not in experience, but she spake plump that we were not sealed.

MR. COTTON: You do put me in remembrance that it was asked her why cannot we preach a covenant of grace? Why, saith she, because you can preach no more than you know, or to that purpose, she spake. Now that she said you could not preach a covenant of grace I do not remember such a thing. I remember well that she said you were not sealed with the seal of the spirit.

MR. PETERS: There was a double seal found out that day which never was.

MR. COTTON: I know very well that she took the seal of the spirit in that sense for the full assurance of God's favour by the holy ghost, and now that place in the Ephesians doth hold out that seal.

MR. PETERS: So that was the ground of our discourse concerning the great seal and the little seal.

MR. COTTON: To that purpose I remember somebody speaking of the difference of the witness of the spirit and the seal of the spirit, some to put a distinction called it the broad seal and the little seal. Our brother Wheelwright answered if you will have it so be it so.

MRS. H.: Mr. Ward said that.

SOME THREE OR FOUR OF THE MINISTERS: Mr. Wheelwright said it.

MR. COTTON: No, it was not brother Wheelwright's speech but one of your own expressions, and as I remember it was Mr. Ward.

MR. PETERS:  . . . . .

MR. COTTON: Under favour I do not remember that.

MR. PETERS: Therefore her answer clears it in your judgment but not in your experience.

MRS. H.: My name is precious and you do affirm a thing which I utterly deny.

D. GOV.: You should have brought the book with you.

MR. NOWELL: The witnesses do not answer that which you require.

GOV.: I do not see that we need their testimony any further. Mr. Cotton hath expressed what he remembred, and what took impression upon him, and so I think the other elders also did remember that which took impression upon them.

MR. WELD: I then said to Mrs. Hutchinson when it was come to this issue, why did you let us go thus long and never tell us of it?

GOV.: I should wonder why the elders should move the elders of our congregation to have dealt with her if they saw not some cause.

MR. COTTON: Brother Weld and brother Shepard, I did then clear myself unto you that I understood her speech in expressing herself to you that you did hold forth some matter in your preaching that was not pertinent to the seal of the spirit——[*Two lines defaced.*]

DEP. GOV.: They affirm that Mrs. Hutchinson did say they were not able ministers of the new testament.

MR. COTTON: I do not remember it.

MRS. H.: If you please to give me leave I shall give you the ground of what I know to be true. Being much troubled to see the falseness of the constitution of the church of England, I had like to have turned separatist; whereupon I kept a day of solemn humiliation and pondering of the thing; this scripture was brought unto me—he that denies Jesus Christ to be come in the flesh is antichrist—This I considered of and in considering found that the papists did not deny him to be come in the flesh, nor we did not deny him—who then was antichrist? Was the Turk antichrist only? The Lord knows that I could not open scripture; he must by his prophetical office open it unto me. So after that being unsatisfied in the thing, the Lord was pleased to bring this scripture out of the Hebrews. He that denies the testament denies the testator, and in this did open unto me and give me to see that those which did not teach the new covenant had the spirit of antichrist, and upon this he did discover the ministry unto me and ever since. I bless the Lord, he hath let me see which was the clear ministry and which the wrong. Since that time I confess I have been more choice and he hath let me to distinguish between the voice of my beloved and the voice of Moses, the voice of John Baptist and the voice of antichrist, for all those voices are spoken of in scripture. Now if you do condemn me for speaking what in my conscience I know to be truth I must commit myself unto the Lord.

MR. NOWELL: How do you know that that was the spirit?

MRS. H.: How did Abraham know that it was God that bid him offer his son, being a breach of the sixth commandment?

DEP. GOV.: By an immediate voice.

MRS. H.: So to me by an immediate revelation.

DEP. GOV.: How! an immediate revelation.

*direct revelation from God*

MRS. H.: By the voice of his own spirit to my soul. I will give you another scripture, Jer. 46. 27, 28—out of which the Lord shewed me what he would do for me and the rest of his servants.—But after he was pleased to reveal himself to me I did presently like Abraham run to Hagar. And after that he did let me see the atheism of my own heart, for which I begged of the Lord that it might not remain in my heart, and being thus, he did shew me this (a twelvemonth after) which I told you of before. Ever since that time I have been confident of what he hath revealed unto me.

[*Obliterated*]    another place out of Daniel chap. 7. and he and for us all, wherein he shewed me the sitting of the judgment and the standing of all high and low before the Lord and how thrones and kingdoms were cast down before him. When our teacher came to New-England it was a great trouble unto me, my brother Wheelwright being put by also. I was then much troubled concerning the ministry under which I lived, and then that place in the 30th of Isaiah was brought to my mind. Though the Lord give thee bread of adversity and water of affliction yet shall not thy teachers be removed into corners any more, but thine eyes shall see thy teachers. The Lord giving me this promise and they being gone there was none then left that I was able to hear, and I could not be at rest but I must come hither. Yet that place of Isaiah did much follow me, though the Lord give thee the

bread of adversity and water of affliction. This place lying I say upon me then this place in Daniel was brought unto me and did shew me that . though I should meet with affliction yet I am the same God that delivered Daniel out of the lion's den, I will also deliver thee.——Therefore I desire you to look to it, for you see this scripture fulfilled this day and therefore I desire you that as you tender the Lord and the church and commonwealth to consider and look what you do. You have power over my body but the Lord Jesus hath power over my body and soul, and assure yourselves thus much, you do as much as in you lies to put the Lord Jesus Christ from you, and if you go on in this course you begin you will bring a curse upon you and your posterity, and the mouth of the Lord hath spoken it.

DEP. GOV.: What is the scripture she brings?

MR. STOUGHTON: Behold I turn away from you.

MRS. H.: But now having seen him which is invisible I fear not what man can do unto me.

GOV.: Daniel was delivered by miracle do you think to be deliver'd so too?

MRS. H.: I do here speak it before the court. I look that the Lord should deliver me by his providence.

MR. HARLAKENDEN: I may read scripture and the most glorious hypocrite may read them and yet go down to hell.

MRS. H.: It may be so.

MR. BARTHOLOMEW: I would remember one word to Mrs. Hutchinson among many others. She knowing that I did know her opinions, being she was at my house at London, she was afraid I conceive or loth to impart herself unto me, but when she came within sight of Boston and looking upon the meanness of the place, I conceive, she uttered these words, if she had not a sure word that England should be destroyed her heart would shake. Now it seemed to me at that time very strange that she should say so.

MRS. H.: I do not remember that I looked upon the meanness of the place nor did it discourage me, because I knew the bounds of my habitation were determined, &c.

MR. BARTHOLOMEW: I speak as a member of the court. I fear that her revelations will deceive.

GOV.: Have you heard of any of her revelations?

MR. BARTHOL.: For my own part I am sorry to see her now here and I have nothing against her but what I said was to discover what manner of spirit Mrs. Hutchinson is of; only I remember as we were once going through Paul's church yard she then was very inquisitive after revelations and said that she had never had any great thing done about her but it was revealed to her beforehand.   (MRS. H.) I say the same thing again.

MR. BARTHOLOMEW: And also that she said that she was come to New-England but for Mr. Cotton's sake. As for Mr. Hooker (as I remember) she

said she liked not his spirit, only she spake of a sermon of his in the low countries wherein he said thus—it was revealed to me yesterday that England should be destroyed. She took notice of that passage and it was very acceptable with her.

MR. COTTON: One thing let me intreat you to remember, Mr. Bartholomew, that you never spake any thing to me.

MR. BARTH.: No Sir, I never spake of it to you and therefore I desire to clear Mr. Cotton.

GOV.: There needs no more of that.

MR. BARTH.: Only I remember her eldest daughter said in the ship that she had a revelation that a young man in the ship should be saved, but he must walk in the ways of her mother.

MR. SIMS: I could say something to that purpose, for she said—then what would you say if we should be at New-England within these three weeks, and I reproved her vehemently for it.

MR. ELIOT: That speech of Mr. Hooker's which they alledge is against his mind and judgment.

MR. SIMS: I would intreat Mrs. Hutchinson to remember, that the humble he will teach—I have spoken before of it and therefore I will leave the place with her and do desire her to consider of many expressions that she hath spoken to her husband, but will not enlarge myself.

MR. ENDICOT: I would have a word or two with leave of that which hath thus far been revealed to the court. I have heard of many revelations of Mr. Hutchinson's, but they were reports, but Mrs. Hutchinson I see doth maintain some by this discourse, and I think it is a special providence of God to hear what she hath said. Now there is a revelation you see which she doth expect as a miracle. She saith she now suffers and let us do what we will she shall be delivered by a miracle. I hope the court takes notice of the vanity of it and heat of her spirit. Now because her reverend teacher is here I should desire that he would please to speak freely whether he doth condescend to such speeches or revelations as have been here spoken of, and he will give a great deal of content.

MR. COTTON: May it please you Sir. There are two sorts of revelations, there are [defaced] or against the word besides scripture both which [defaced] tastical and tending to danger more ways than one——there is another sort which the apostle prays the believing Ephesians may be made partakers of, and those are such as are breathed by the spirit of God and are never dispensed but in a word of God and according to a word of God, and though the word revelation be rare in common speech and we make it uncouth in our ordinary expressions, yet notwithstanding, being understood in the scripture sense I think they are not only lawful but such as christians may receive and God bear witness to it in his word, and usually he doth express it in the ministry of the word and doth accompany it by his spirit, or else it is in the reading of the word in some chapter or verse and whenever it comes it comes flying upon the wings of the spirit.

MR. ENDICOT: You give me satisfaction in the thing and therefore I desire you to give your judgment of Mrs. Hutchinson; what she hath said you hear and all the circumstances thereof.

MR. COTTON: I would demand whether by a miracle she doth mean a work above nature or by some wonderful providence for that is called a miracle often in the psalms.

MRS. H.: I desire to speak to our teacher. You know Sir what he doth declare though he doth not know himself    [*something wanting.*]    now either of these ways or at this present time it shall be done, yet I would not have the court so to understand me that he will deliver me now even at this present time.

DEP. GOV.: I desire Mr. Cotton to tell us whether you do approve of Mrs. Hutchinson's revelations as she hath laid them down.

MR. COTTON: I know not whether I do understand her, but this I say, if she doth expect a deliverance in a way of providence—then I cannot deny it.

DEP. GOV.: No Sir we did not speak of that.

MR. COTTON: If it be by way of miracle then I would suspect it.

DEP. GOV.: Do you believe that her revelations are true?

MR. COTTON: That she may have some special providence of God to help her is a thing that I cannot bear witness against.

DEP. GOV.: Good Sir I do ask whether this revelation be of God or no?

MR. COTTON: I should desire to know whether the sentence of the court will bring her to any calamity, and then I would know of her whether she expects to be delivered from that calamity by a miracle or a providence of God.

MRS. H.: By a providence of God I say I expect to be delivered from some calamity that shall come to me.

GOVER.: The case is altered and will not stand with us now, but I see a marvellous providence of God to bring things to this pass that they are. We have been hearkening about the trial of this thing and now the mercy of God by a providence hath answered our desires and made her to lay open her self and the ground of all these disturbances to be by revelations, for we receive no such    made out of the ministry of the word    and so one scripture after another, but all this while there is no use of the ministry of the word nor of any clear call of God by his word, but the ground work of her revelations is the immediate revelation of the spirit and not by the ministry of the word, and that is the means by which she hath very much abused the country that they shall look for revelations and are not bound to the ministry of the word, but God will teach them by immediate revelations and this hath been the ground of all these tumults and troubles, and I would that those were all cut off from us that trouble us, for this is the thing that hath been the root of all the mischief.

COURT: We all consent with you.

GOV.: Ey it is the most desperate enthusiasm in the world, for nothing but a word comes to her mind and then an application is made which is nothing

to the purpose, and this is her revelations when it is impossible but that the word and spirit should speak the same thing.

MR. ENDICOT: I speak in reference to Mr. Cotton. I am tender of you Sir and there lies much upon you in this particular, for the answer of Mr. Cotton doth not free him from that way which his last answer did bring upon him, therefore I beseech you that you'd be pleased to speak a word to that which Mrs. Hutchinson hath spoken of her revelations as you have heard the manner of it. Whether do you witness for her or against her.

MR. COTTON: This is that I said Sir, and my answer is plain that if she doth look for deliverance from the hand of God by his providence, and the revelation be in a word or according to a word, that I cannot deny.

MR. ENDICOT: You give me satisfaction.

DEP. GOV.: No, no, he gives me none at all.

MR. COTTON: But if it be in a way of miracle or a revelation without the word that I do not assent to, but look at it as a delusion, and I think so doth she too as I understand her.

DEP. GOV.: Sir, you weary me and do not satisfy me.

MR. COTTON: I pray Sir give me leave to express my self. In that sense that she speaks I dare not bear witness against it.

MR. NOWELL: I think it is a devilish delusion.

GOVER.: Of all the revelations that ever I read of I never read the like ground laid as is for this. The Enthusiasts and Anabaptists had never the like.

MR. COTTON: You know Sir, that their revelations broach new matters of faith and doctrine.

GOVER.: So do these and what may they breed more if they be let alone. I do acknowledge that there are such revelations as do concur with the word but there hath not been any of this nature.

DEP. GOV.: I never saw such revelations as these among the Anabaptists, therefore am sorry that Mr. Cotton should stand to justify her.

MR. PETERS: I can say the same and this runs to enthusiasm, and I think that is very disputable which our brother Cotton hath spoken    [*wanting*]    an immediate promise that he will deliver them    [*wanting*]    in a day of trouble.

GOVER.: It overthrows all.

DEP. GOV.: These disturbances that have come among the Germans have been all grounded upon revelations, and so they that have vented them have stirred up their hearers to take up arms against their prince and to cut the throats one of another, and these have been the fruits of them, and whether the devil may inspire the same into their hearts here I know not, for I am fully persuaded that Mrs. Hutchinson is deluded by the devil, because the spirit of God speaks truth in all his servants.

GOV.: I am persuaded that the revelation she brings forth is delusion.

[*All the court but some two or three ministers cry out, we all believe it—we all believe it.*]

MR. ENDICOT: I suppose all the world may see where the foundation of all these troubles among us lies.

MR. ELIOT: I say there is an expectation of things promised, but to have a particular revelation of things that shall fall out, there is no such thing in the scripture.

GOV.: We will not limit the word of God.

MR. COLLICUT: It is a great burden to us that we differ from Mr. Cotton and that he should justify these revelations. I would intreat him to answer concerning that about the destruction of England.

GOV.: Mr. Cotton is not called to answer to any thing but we are to deal with the party here standing before us.

MR. BARTHOLOMEW: My wife hath said that Mr. Wheelwright was not acquainted with this way until that she imparted it unto him.

MR. BROWN: Inasmuch as I am called to speak, I would therefore speak the mind of our brethren. Though we had sufficient ground for the censure before, yet now she having vented herself and I find such flat contradiction to the scripture in what she saith, as to that in the first to the Hebrews—God at sundry times spake to our fathers—For my part I understand that scripture and other scriptures of the Lord Jesus Christ, and the apostle writing to Timothy saith that the scripture is able to make one perfect—therefore I say the mind of the brethren—I think she deserves no less a censure than hath been already past but rather something more, for this is the foundation of all mischief and of all those bastardly things which have been overthrowing by that great meeting. They have all come out from this cursed fountain.

GOV.: Seeing the court hath thus declared itself and hearing what hath been laid to the charge of Mrs. Hutchinson and especially what she by the providence of God hath declared freely without being asked, if therefore it be the mind of the court, looking at her as the principal cause of all our trouble, that they would now consider what is to be done to her.——

MR. CODDINGTON: I do think that you are going to censure therefore I desire to speak a word.

GOV.: I pray you speak.

MR. CODDINGTON: There is one thing objected against the meetings. What if she designed to edify her own family in her own meetings may none else be present?

GOV.: If you have nothing else to say but that, it is pity Mr. Coddington that you should interrupt us in proceeding to censure.

MR. CODDINGTON: I would say more Sir, another thing you lay to her Charge is her speech to the elders. Now I do not see any clear witness against her, and you know it is a rule of the court that no man may be a judge and an accuser too. I do not speak to disparage our elders and their callings, but I do not see any thing that they accuse her of witnessed against her, and therefore I do not see how she should be censured for that. And for the other thing which hath fallen from her occasionally by the spirit of God, you know the spirit of God witnesses with our spirits, and there is no truth in

scripture but God bears witness to it by his spirit, therefore I would entreat you to consider whether those things you have alledged against her deserve such censure as you are about to pass, be it to banishment or imprisonment. And again here is nothing proved about the elders, only that she said they did not teach a covenant of grace so clearly as Mr. Cotton did, and that they were in the state of the apostles before the ascension. Why I hope this may not be offensive nor any wrong to them.

GOV.: Pass by all that hath been said formerly and her own speeches have been ground enough for us to proceed upon.

MR. CODDINGTON: I beseech you do not speak so to force things along, for I do not for my own part see any equity in the court in all your proceedings. Here is no law of God that she hath broken nor any law of the country that she hath broke, and therefore deserves no censure, and if she say that the elders preach as the apostles did, why they preached a covenant of grace and what wrong is that to them, for it is without question that the apostles did preach a covenant of grace, though not with that power, till they received the manifestation of the spirit, therefore I pray consider what you do, for here is no law of God or man broken.

MR. HARLAKENDEN: Things thus spoken will stick. I would therefore that the assembly take notice that here is none that condemns the meeting of christian women; but in such a way and for such an end that it is to be detested. And then tho' the matter of the elders be taken away yet there is enow besides to condemn her, but I shall speak no further.

DEP. GOV.: We shall be all sick with fasting.

MR. COLBURN: I dissent from censure of banishment.

MR. STOUGHTON: The censure which the court is about to pass in my conscience is as much as she deserves, but because she desires witness and there is none in way of witness therefore I shall desire that no offence be taken if I do not formally condemn her because she hath not been formally convicted as others are by witnesses upon oath.

MR. CODDINGTON: That is a scruple to me also, because Solomon saith, every man is partial in his own cause, and here is none that accuses her but the elders, and she spake nothing to them but in private, and I do not know what rule they had to make the thing publick, secret things ought to be spoken in secret and publick things in publick, therefore I think they have broken the rules of God's word.

GOV.: What was spoken in the presence of many is not to be made secret.

MR. CODDINGTON: But that was spoken but to a few and in private.

GOV.: In regard Mr. Stoughton is not satisfied to the end all scruples may be removed we shall desire the elders to take their oaths.

[*Here now was a great whispering among the ministers, some drew back others were animated on.*]

MR. ELIOT: If the court calls us out to swear we will swear.

GOV.: Any two of you will serve.

MR. STOUGHTON: There are two things that I would look to discharge my conscience of, 1st to hear what they testify upon oath and 2dly to——

GOV.: It is required of you Mr. Weld and Mr. Eliot.

MR. WELD: ⎫
            ⎬ We shall be willing.
MR. ELIOT: ⎭

GOV.: We'll give them their oaths.    [*Mr. Peters held up his hand also.*]    You shall swear to the truth and nothing but the truth as far as you know. So help you God. What you do remember of her speak, pray speak.

MR. ELIOT: I do remember and I have it written, that which she spake first was, the fear of man is a snare, why should she be afraid but would speak freely. The question being asked whether there was a difference between Mr. Cotton and us, she said there was a broad difference. I would not stick upon words—the thing she said—and that Mr. Cotton did preach a covenant of grace and we of works and she gave this reason—to put a work in point of evidence is a revealing upon a work. We did labour then to convince her that our doctrine was the same with Mr. Cotton's: She said no, for we were not sealed. That is all I shall say.

GOV.: What say you Mr. Weld?

MR. WELD: I will speak to the things themselves—these two things I am fully clear in—she did make a difference in three things, the first I was not so clear in, but that she said this I am fully sure of, that we were not able ministers of the new testament and that we were not clear in our experience because we were not sealed.

MR. ELIOT: I do further remember this also, that she said we were not able ministers of the gospel because we were but like the apostles before the ascension.

MR. CODDINGTON: This was I hope no disparagement to you.

GOV.: Well, we see in the court that she doth continually say and unsay things.

MR. PETERS: I was much grieved that she should say that our ministry was legal. Upon which we had a meeting as you know and this was the same she told us that there was a broad difference between Mr. Cotton and us. Now if Mr. Cotton do hold forth things more clearly than we, it was our grief we did not hold it so clearly as he did, and upon those grounds that you have heard.

MR. CODDINGTON: What wrong was that to say that you were not able ministers of the new testament or that you were like the apostles—methinks the comparison is very good.

GOV.: Well, you remember that she said but now that she should be delivered from this calamity.

MR. COTTON: I remember she said she should be delivered by God's providence, whether now or at another time she knew not.

MR. PETERS: I profess I thought Mr. Cotton would never have took her part.

MR. STOUGHTON: I say now this testimony doth convince me in the thing, and I am fully satisfied the words were pernicious, and the frame of her spirit doth hold forth the same.

GOV.: The court hath already declared themselves satisfied concerning the things you hear, and concerning the troublesomeness of her spirit and the danger of her course amongst us, which is not to be suffered. Therefore if it be the mind of the court that Mrs. Hutchinson for these things that appear before us is unfit for our society, and if it be the mind of the court that she shall be banished out of our liberties and imprisoned till she be sent away, let them hold up their hands.

[*All but three.*]

Those that are contrary minded hold up yours,

[*Mr. Coddington and Mr. Colborn, only.*]

MR. JENNISON: I cannot hold up my hand one way or the other, and I shall give my reason if the court require it.

GOV.: Mrs. Hutchinson, the sentence of the court you hear is that you are banished from out of our jurisdiction as being a woman not fit for our society, and are to be imprisoned till the court shall send you away.

MRS. H.: I desire to know wherefore I am banished?

GOV.: Say no more, the court knows wherefore and is satisfied.

# MARY ROWLANDSON

Mary Rowlandson (c. 1637/38–1710) came to New England in infancy, when her parents journeyed across the Atlantic in 1639. Her family was well off, and she married a man who would become a prominent Puritan minister. Her life might have remained unknown to us had not her hometown, Lancaster, been raided in 1676 as part of King Philip's War. Along with some other settlers, Rowlandson and her three children were captured by Narragansett Indians and held for ransom. Historians guess that she journeyed about 150 miles during her nearly twelve weeks in Indian custody. The older two children were released some weeks after Rowlandson, but her youngest daughter died during the ordeal. The events received wide attention, and from it Rowlandson wrote *The Sovereignty and Goodness of God* in 1682, the first full-length Indian captivity narrative. The portions excerpted here highlight the ways in which Rowlandson mined her Puritan faith to make sense of her suffering and to bring honor to God. They suggest many other important themes as well, including the association of Native Americans with Satan and the message that Puritans in an age of declining piety must return to the intense piety of the first generation.

# A Narrative of the Captivity and Restoration of Mrs. Mary Rowlandson

On the tenth of February 1675, came the Indians with great numbers upon Lancaster: Their first coming was about sun-rising; hearing the noise of some guns, we looked out; several houses were burning, and the smoke ascending to heaven. There were five persons taken in one house, the father, and the mother and a sucking child, they knocked on the head; the other two they took and carried away alive. There were two others, who being out of their garrison upon some occasion were set upon; one was knocked on the head, the other escaped: another there was who running along was shot and wounded, and fell down; he begged of them his life, promising them money (as they told me) but they would not hearken to him but knocked him in the head, and stripped him naked, and split open his bowels. Another seeing many of the Indians about his barn, ventured and went out, but was quickly shot down. There were three others belonging to the same garrison who were killed; the Indians getting up upon the roof of the barn, had advantage to shoot down upon them over their fortification. Thus these murderous wretches went on, burning, and destroying before them.

At length they came and beset our own house, and quickly it was the dolefullest day that ever mine eyes saw. The house stood upon the edge of a hill; some of the Indians got behind the hill, others into the barn, and others behind any thing that could shelter them; from all which places they shot against the house, so that the bullets seemed to fly like hail; and quickly they wounded one man among us, then another, and then a third. About two hours (according to my observation, in that amazing time) they had been about the house before they prevailed to fire it (which they did with flax and hemp, which they brought out of the barn, and there being no defense about the house, only two flankers at two opposite corners and one of them not finished) they fired it once and one ventured out and quenched it, but they quickly fired again, and that took. Now is the dreadful hour come, that I have often heard of (in time of war, as it was the case of others) but now mine eyes see it. Some in our house were fighting for their lives, others wallowing in their blood, the house on fire over our heads, and the bloody heathen ready to knock us on the head, if we stirred out. Now might we hear mothers and children crying out for themselves, and one another, Lord, What shall we do? Then I took my children (and one of my sisters, hers) to go forth and leave the house: but as soon as we came to the door and appeared, the Indians shot so thick that the bullets rattled against the house, as if one had taken an handful of stones and threw them, so that we were fain to give back. We had six stout dogs belonging to our garrison, but none of them would stir, though another time, if any Indian had come to the door, they were ready to fly upon him and tear him down. The Lord hereby would make us the more to

acknowledge his hand, and to see that our help is always in him. But out we must go, the fire increasing, and coming along behind us, roaring, and the Indians gaping before us with their guns, spears and hatchets to devour us. No sooner were we out of the house, but my brother-in-law (being before wounded, in defending the house, in or near the throat) fell down dead whereat the Indians scornfully shouted, and holloed, and were presently upon him, stripping off his clothes, the bullets flying thick, one went through my side, and the same (as would seem) through the bowels and hand of my dear child in my arms. One of my elder sister's children, named William, had then his leg broken, which the Indians perceiving, they knocked him on the head. Thus were we butchered by those merciless heathen, standing amazed, with the blood running down to our heels. My eldest sister being yet in the house, and seeing those woeful sights, the infidels haling mothers one way, and children another, and some wallowing in their blood: and her elder son telling her that her son William was dead, and myself was wounded, she said, And, Lord, let me die with them; which was no sooner said, but she was struck with a bullet, and fell down dead over the threshold. I hope she is reaping the fruit of her good labors, being faithful to the service of God in her place. In her younger years she lay under much trouble upon spiritual accounts, till it pleased God to make that precious scripture take hold of her heart, 2 Corinthians 12. 9. *And he said unto me, my grace is sufficient for thee.* More than twenty years after I have heard her tell how sweet and comfortable that place was to her. But to return: the Indians laid hold of us, pulling me one way, and the Children another, and said, Come go along with us; I told them they would kill me: they answered, If I were willing to go along with them, they would not hurt me.

Oh the doleful sight that now was to behold at this house! *Come, behold the works of the Lord, what desolations he has made in the earth.* Of thirty-seven persons who were in this one house, none escaped either present death, or a bitter captivity, save only one, who might say as he, Job 1. 15, *And I only am escaped alone to tell the news.* There were twelve killed, some shot, some stabbed with their spears, some knocked down with their hatchets. When we are in prosperity, oh the little that we think of such dreadful sights, and to see our dear friends, and relations lie bleeding out their heart's blood upon the ground. There was one who was chopped into the head with a hatchet, and stripped naked, and yet was crawling up and down. It is a solemn sight to see so many Christians lying in their blood, some here, and some there, like a company of sheep torn by wolves. All of them stripped naked by a company of hell-hounds, roaring, singing, ranting and insulting, as if they would have torn our very hearts out; yet the Lord by his almighty power preserved a number of us from death, for there were twenty-four of us taken alive and carried captive.

I had often before this said, that if the Indians should come, I should choose rather to be killed by them than be taken alive but when it came to the trial my mind changed; their glittering weapons so daunted my spirit, that I chose rather to go along with those (as I may say) ravenous beasts, than that moment to end my days; and that I may the better declare what happened to me during that grievous captivity, I shall particularly speak of the several removes we had up and down the wilderness.

## THE FIRST REMOVE

Now away we must go with those barbarous creatures, with our bodies wounded and bleeding, and our hearts no less than our bodies. About a mile we went that night, up upon a hill within sight of the town, where they intended to lodge. There was hard by a vacant house (deserted by the English before, for fear of the Indians). I asked them whether I might not lodge in the house that night to which they answered, What will you love English men still? This was the dolefullest night that ever my eyes saw. Oh the roaring, and singing and dancing, and yelling of those black creatures in the night, which made the place a lively resemblance of hell. And as miserable was the waste that was there made, of horses, cattle, sheep, swine, calves, lambs, roasting pigs, and fowl (which they had plundered in the town) some roasting, some lying and burning, and some boiling to feed our merciless enemies; who were joyful enough though we were disconsolate. To add to the dolefulness of the former day, and the dismalness of the present night: my thoughts ran upon my losses and sad bereaved condition. All was gone, my husband gone (at least separated from me, he being in the Bay; and to add to my grief, the Indians told me they would kill him as he came homeward) my children gone, my relations and friends gone, our house and home and all our comforts within doors, and without, all was gone (except my life) and I knew not but the next moment that might go too. There remained nothing to me but one poor wounded babe, and it seemed at present worse than death that it was in such a pitiful condition, bespeaking compassion, and I had no refreshing for it, nor suitable things to revive it. Little do many think what is the savageness and brutishness of this barbarous enemy, aye even those that seem to profess more than others among them, when the English have fallen into their hands.

Those seven that were killed at Lancaster the summer before upon a Sabbath day, and the one that was afterward killed upon a week day, were slain and mangled in a barbarous manner, by One-eyed John, and Marlborough's praying Indians, which Captain Mosely brought to Boston, as the Indians told me.

## THE SECOND REMOVE

But now, the next morning, I must turn my back upon the town, and travel with them into the vast and desolate wilderness, I knew not whither. It is not my tongue, or pen can express the sorrows of my heart, and bitterness of my spirit, that I had at this departure: but God was with me, in a wonderful manner, carrying me along, and bearing up my spirit, that it did not quite fail. One of the Indians carried my poor wounded babe upon a horse, it went moaning all along, I shall die, I shall die. I went on foot after it, with sorrow that cannot be expressed. At length I took it off the horse, and carried it in my arms till my strength failed, and I fell down with it: Then they set me upon a horse with my wounded child in my lap, and there being no furniture upon the horse's back, as we were going down a steep hill, we both fell over the horse's head, at which they like inhuman creatures laughed, and rejoiced to see it, though I thought we should there have ended our days, as overcome with so many difficulties. But

the Lord renewed my strength still, and carried me along, that I might see more of his power; yea, so much that I could never have thought of, had I not experienced it.

After this it quickly began to snow, and when night came on, they stopped: and now down I must sit in the snow, by a little fire, and a few boughs behind me, with my sick child in my lap; and calling much for water, being now (through the wound) fallen into a violent fever. My own wound also growing so stiff, that I could scarce sit down or rise up; yet so it must be, that I must sit all this cold winter night upon the cold snowy ground, with my sick child in my arms, looking that every hour would be the last of its life; and having no Christian friend near me, either to comfort or help me. Oh, I may see the wonderful power of God, that my spirit did not utterly sink under my affliction: still the Lord upheld me with his gracious and merciful spirit, and we were both alive to see the light of the next morning.

## THE THIRD REMOVE

The morning being come, they prepared to go on their way. One of the Indians got up upon a horse, and they set me up behind him, with my poor sick babe in my lap. A very wearisome and tedious day I had of it; what with my own wound, and my child's being so exceeding sick, and in a lamentable condition with her wound. It may be easily judged what a poor feeble condition we were in, there being not the least crumb of refreshing that came within either of our mouths, from Wednesday night to Saturday night, except only a little cold water. This day in the afternoon, about an hour by sun, we came to the place where they intended, *viz.* an Indian town called Wenimesset, northward of Quabaug. When we were come, Oh the number of pagans (now merciless enemies) that there came about me, that I may say as David, Psalms 27. 13, *I had fainted, unless I had believed*, etc. The next day was the Sabbath: I then remembered how careless I had been of God's holy time, how many Sabbaths I had lost and misspent, and how evilly I had walked in God's sight; which lay so close unto my spirit, that it was easy for me to see how righteous it was with God to cut off the thread of my life, and cast me out of his presence forever. Yet the Lord still showed mercy to me, and upheld me; and as he wounded me with one hand, so he healed me with the other. This day there came to me one Robert Pepper (a man belonging to Roxbury) who was taken in Captain Beers his fight, and had been now a considerable time with the Indians; and up with them almost as far as Albany, to see King Philip, as he told me, and was now very lately come into these parts. Hearing, I say, that I was in this Indian town, he obtained leave to come and see me. He told me, he himself was wounded in the leg at Captain Beers his fight; and was not able some time to go, but as they carried him, and as he took oaken leaves and laid to his wound, and through the blessing of God he was able to travel again. Then I took oaken leaves and laid to my side, and with the blessing of God it cured me also; yet before the cure was wrought, I may say, as it is in Psalms 38. 5–6. *My wounds stink and are corrupt, I am bowed down greatly, I go mourning all the day long*. I sat much alone with a poor wounded child in my lap, which moaned night and day, having nothing to revive the body, or cheer

the spirits of her, but instead of that, sometimes one Indian would come and tell me in one hour, that your master will knock your child in the head, and then a second, and then a third, your master will quickly knock your child in the head. This was the comfort I had from them, miserable comforters are ye all, as he said. Thus nine days I sat upon my knees, with my babe in my lap, till my flesh was raw again; my child being even ready to depart this sorrowful world, they bade me carry it out to another wigwam (I suppose because they would not be troubled with such spectacles) whither I went with a very heavy heart, and down I sat with the picture of death in my lap. About two hours in the night, my sweet babe like a lamb departed this life, on Feb. 18, 1675, it being about six years, and five months old. It was nine days from the first wounding, in this miserable condition, without any refreshing of one nature or other, except a little cold water. I cannot, but take notice, how at another time I could not bear to be in the room where any dead person was, but now the case is changed; I must and could lie down by my dead babe, side by side all the night after. I have thought since of the wonderful goodness of God to me, in preserving me in the use of my reason and senses, in that distressed time, that I did not use wicked and violent means to end my own miserable life. In the morning, when they understood that my child was dead they sent for me home to my master's wigwam: (by my master in this writing, must be understood Quinnapin, who was a sagamore, and married King Philip's wife's sister; not that he first took me, but I was sold to him by another Narragansett Indian, who took me when first I came out of the garrison). I went to take up my dead child in my arms to carry it with me, but they bid me let it alone: there was no resisting, but go I must and leave it. When I had been at my master's wigwam, I took the first opportunity I could get, to go look after my dead child: when I came I asked them what they had done with it? Then they told me it was upon the hill: then they went and showed me where it was, where I saw the ground was newly digged, and there they told me they had buried it: there I left that child in the wilderness, and must commit it, and myself also in this wilderness condition, to Him who is above all. God having taken away this dear child, I went to see my daughter Mary, who was at this same Indian town, at a wigwam not very far off, though we had little liberty or opportunity to see one another. She was about ten years old, and taken from the door at first by a Praying Indian and afterward sold for a gun. When I came in sight, she would fall a-weeping; at which they were provoked, and would not let me come near her, but bade me begone; which was a heart-cutting word to me. I had one child dead, another in the wilderness, I knew not where, the third they would not let me come near to: *Me* (as he said) *have ye bereaved of my children, Joseph is not, and Simeon is not, and ye will take Benjamin also, all these things are against me*. I could not sit still in this condition, but kept walking from place to another. And as I was going along, my heart was even overwhelmed with the thoughts of my condition, and that I should have children, and a nation which I knew not ruled over them. Whereupon I earnestly entreated the Lord, that He would consider my low estate, and show me a token for good, and if it were His blessed will, some sign and hope of some relief. And indeed quickly the Lord answered, in some measure, my poor prayers: for as I was going up and down mourning and lamenting my condition, my son came to me, and asked me how I did; I had not seen him before, since the destruction of the town, and I knew not where he was, till I was informed by himself, that he

was amongst a smaller parcel of Indians, whose place was about six miles off; with tears in his eyes, he asked me whether his sister Sarah was dead; and told me he had seen his sister Mary; and prayed me, that I would not be troubled in reference to himself. The occasion of his coming to see me at this time, was this: there was, as I said, about six miles from us, a small plantation of Indians, where it seems he had been during his captivity: and at this time, there were some forces of the Indians gathered out of our company, and some also from them (among whom was my son's master) to go to assault and burn Medfield: In this time of the absence of his master, his dame brought him to see me. I took this to be some gracious answer to my earnest and unfeigned desire. The next day, *viz.* to this, the Indians returned from Medfield, all the company, for those that belonged to the other small company, came through the town that now we were at. But before they came to us, Oh! the outrageous roaring and whooping that there was: They began their din about a mile before they came to us. By their noise and whooping they signified how many they had destroyed (which was at that time twenty-three). Those that were with us at home, were gathered together as soon as they heard the whooping, and every time that the other went over their number, these at home gave a shout, that the very earth rung again: and thus they continued till those that had been upon the expedition were come up to the Sagamore's wigwam; and then, Oh, the hideous insulting and triumphing that there was over some Englishmen's scalps that they had taken (as their manner is) and brought with them. I cannot but take notice of the wonderful mercy of God to me in those afflictions, in sending me a Bible. One of the Indians that came from Medfield fight, had brought some plunder, came to me, and asked me, if I would have a Bible, he had got one in his basket. I was glad of it, and asked him, whether he thought the Indians would let me read? He answered, Yes: So I took the Bible, and in that melancholy time, it came into my mind to read first the 28th Chapter of Deuteronomy, which I did, and when I had read it, my dark heart wrought on this manner, That there was no mercy for me, that the blessings were gone, and the curses come in their room, and that I had lost my opportunity. But the Lord helped me still to go on reading till I came to Chapter 30 the seven first verses, where I found, there was mercy promised again, if we would return to him by repentance; and though we were scattered from one end of the earth to the other, yet the Lord would gather us together, and turn all those curses upon our enemies. I do not desire to live to forget this scripture, and what comfort it was to me.

Now the Indians began to talk of removing from this place, some one way, and some another. There were now besides myself nine English captives in this place (all of them children, except one woman). I got an opportunity to go and take my leave of them; they being to go one way, and I another, I asked them whether they were earnest with God for deliverance, they told me, they did as they were able, and it was some comfort to me, that the Lord stirred up children to look to Him. The woman *viz.* Goodwife Joslin told me, she should never see me again, and that she could find in her heart to run away; I wished her not to run away by any means, for we were near thirty miles from any English town, and she very big with child, and had but one week to reckon; and another child in her arms, two years old, and bad rivers there were to go over, and we were feeble, with our poor and coarse entertainment. I had my Bible with me, I pulled it out, and asked her whether she would read; we opened the Bible and lighted

on Psalm 27, in which Psalm we especially took notice of that, *ver. ult.*, *Wait on the Lord, Be of good courage, and he shall strengthen thine heart, wait I say on the Lord.*

## THE FOURTH REMOVE

And now I must part with that little company I had. Here I parted from my daughter Mary (whom I never saw again till I saw her in Dorchester, returned from captivity), and from four little cousins and neighbors, some of which I never saw afterward: the Lord only knows the end of them. Amongst them also was that poor woman before mentioned, who came to a sad end, as some of the company told me in my travel: she having much grief upon her spirit, about her miserable condition, being so near her time, she would be often asking the Indians to let her go home; they not being willing to that, and yet vexed with her importunity, gathered a great company together about her, and stripped her naked, and set her in the midst of them; and when they had sung and danced about her (in their hellish manner) as long as they pleased, they knocked her on head, and the child in her arms with her: when they had done that, they made a fire and put them both into it, and told the other children that were with them, that if they attempted to go home, they would serve them in like manner: the children said, she did not shed one tear, but prayed all the while. But to return to my own journey; we travelled about half a day or little more, and came to a desolate place in the wilderness, where there were no wigwams or inhabitants before; we came about the middle of the afternoon to this place, cold and wet, and snowy, and hungry, and weary, and no refreshing, for man, but the cold ground to sit on, and our poor Indian cheer.

Heart-aching thoughts here I had about my poor children, who were scattered up and down among the wild beasts of the forest: my head was light and dizzy (either through hunger or hard lodging, or trouble or all together) my knees feeble, my body raw by sitting double night and day, that I cannot express to man the affliction that lay upon my spirit, but the Lord helped me at that time to express it to himself. I opened my Bible to read, and the Lord brought that precious scripture to me, Jeremiah 31. 16. *Thus saith the Lord, refrain thy voice from weeping, and thine eyes from tears, for thy work shall be rewarded, and they shall come again from the land of the enemy.* This was a sweet cordial to me, when I was ready to faint, many and many a time have I sat down, and wept sweetly over this scripture. At this place we continued about four days. . . .

But before I go any further, I would take leave to mention a few remarkable passages of providence, which I took special notice of in my afflicted time.

1. Of the fair opportunity lost in the long march, a little after the fort fight, when our English army was so numerous, and in pursuit of the enemy, and so near as to take several and destroy them: and the enemy in such distress for food, that our men might track them by their rooting in the earth for ground nuts, whilst they were flying for their lives. I say, that then our army should want provision, and be forced to leave their pursuit and return homeward: and the very next week the enemy came upon our town, like bears bereft of their whelps, or so many ravenous wolves, rending us and our lambs to death. But what shall I say? God seemed to leave His people to themselves, and order all things for His own holy ends. *Shall there be evil in the city and the Lord hath not*

*done it? They are not grieved for the affliction of Joseph, therefore shall they go captive, with the first that go captive.* It is the Lord's doing, and it should be marvelous in our eyes.

2. I cannot but remember how the Indians derided the slowness, and dullness of the English army, in its setting out. For after the desolations at Lancaster and Medfield, as I went along with them, they asked me when I thought the English army would come after them? I told them I could not tell: It may be they will come in May, said they. Thus did they scoff at us, as if the English would be a quarter of a year getting ready.

3. Which also I have hinted before, when the English army with new supplies were sent forth to pursue after the enemy, and they understanding it, fled before them till they came to Baquag river, where they forthwith went over safely: that that river should be impassable to the English. I can but admire to see the wonderful providence of God in preserving the heathen for further affliction to our poor country. They could go in great numbers over, but the English must stop: God had an overruling hand in all those things.

4. It was thought, if their corn were cut down, they would starve and die with hunger: and all their corn that could be found, was destroyed, and they driven from that little they had in store, into the woods in the midst of winter; and yet how to admiration did the Lord preserve them for his Holy ends, and the destruction of many still amongst the English! Strangely did the Lord provide for them; that I did not see (all the time I was among them) one man, woman, or child, die with hunger.

Though many times they would eat that, that a hog or a dog would hardly touch; yet by that God strengthened them to be a scourge to His people.

The chief and commonest food was ground nuts: they ate also nuts and acorns, artichokes, lily roots, ground beans, and several other weeds and roots, that I know not.

They would pick up old bones, and cut them to pieces at the joints, and if they were full of worms and maggots, they would scald them over the fire to make the vermin come out, and then boil them, and drink up the liquor, and then beat the great ends of them in a mortar, and so eat them. They would eat horse's guts, and ears, and all sorts of wild birds which they could catch: also bear, venison, beaver, tortoise, frogs, squirrels, dogs, skunks, rattlesnakes; yea, the very bark of trees; besides all sorts of creatures, and provision which they plundered from the English. I can but stand in admiration to see the wonderful power of God, in providing for such a vast number of our enemies in the wilderness, where there was nothing to be seen, but from hand to mouth. Many times in a morning, the generality of them would eat up all they had, and yet have some further supply against what they wanted. It is said, Psalm 81. 13–14. *Oh, that my people had hearkened to me, and Israel had walked in my ways, I should soon have subdued their enemies, and turned my hand against their adversaries.* But now our perverse and evil carriages in the sight of the Lord, have so offended Him, that instead of turning His hand against them, the Lord feeds and nourishes them up to be a scourge to the whole land.

5. Another thing that I would observe is, the strange providence of God, in turning things about when the Indians were at the highest, and the English at the lowest. I was with the enemy eleven weeks and five days, and not one week passed without the fury of the enemy, and some desolation by fire and sword

upon one place or other. They mourned (with their black faces) for their own losses, yet triumphed and rejoiced in their inhuman, and many times devilish cruelty to the English. They would boast much of their victories; saying, that in two hours time they had destroyed such a captain, and his company at such a place; and such a captain and his company, in such a place; and such a captain and his company in such a place: and boast how many towns they had destroyed, and then scoff, and say, They had done them a good turn, to send them to heaven so soon. Again, they would say, This summer that they would knock all the rogues in the head, or drive them into the sea, or make them fly the country: thinking surely, Agag-like, *The bitterness of death is past*. Now the heathen begin to think all is their own, and the poor Christians' hopes to fail (as to man) and now their eyes are more to God, and their hearts sigh heavenward: and to say in good earnest, *Help Lord, or we perish:* When the Lord had brought His people to this, that they saw no help in anything but Himself: then He takes the quarrel into His own hand: and though they had made a pit, in their own imaginations, as deep as hell for the Christians that summer, yet the Lord hurled themselves into it. And the Lord had not so many ways before to preserve them, but now He hath as many to destroy them. . . .

I can remember the time, when I used to sleep quietly without workings in my thoughts, whole nights together, but now it is other ways with me. When all are fast about me, and no eye open, but His who ever waketh, my thoughts are upon things past, upon the awful dispensation of the Lord towards us; upon His wonderful power and might, in carrying of us through so many difficulties, in returning us in safety, and suffering none to hurt us. I remember in the night season, how the other day I was in the midst of thousands of enemies, and nothing but death before me: it is then hard work to persuade myself, that ever I should be satisfied with bread again. But now we are fed with the finest of the wheat, and, as I may say, with honey out of the rock: instead of the husk, we have the fatted calf: the thoughts of these things in the particulars of them, and of the love and goodness of God towards us, make it true of me, what David said of himself, Psalms 6. 6. *I watered my couch with my tears*. Oh! the wonderful power of God that mine eyes have seen, affording matter enough for my thoughts to run in, that when others are sleeping mine are weeping.

I have seen the extreme vanity of this world: one hour I have been in health, and wealth, wanting nothing: but the next hour in sickness and wounds, and death, having nothing but sorrow and affliction.

Before I knew what affliction meant, I was ready sometimes to wish for it. When I lived in prosperity, having the comforts of the world about me, my relations by me, my heart cheerful, and taking little care for anything; and yet seeing many, whom I preferred before myself, under many trials and afflictions, in sickness, weakness, poverty, losses, crosses, and cares of the world, I should be sometimes jealous lest I should not have my portion in this life, and that scripture would come to my mind, Hebrews 12. 6. *For whom the Lord loveth he chasteneth, and scourgeth every son whom he receiveth*. But now I see the Lord had his time to scourge and chasten me. The portion of some is to have their afflictions by drops, now one drop and then another; but the dregs of the cup, the wine of astonishment, like a sweeping rain that leaveth no food, did the Lord prepare to be my portion. Affliction I wanted, and affliction I had, full measure (I thought),

pressed down and running over; yet I see, when God calls a person to anything, and through never so many difficulties, yet He is fully able to carry them through and make them see, and say they have been gainers thereby. And I hope I can say in some measure, as David did, *It is good for me that I have been afflicted.* The Lord hath showed me the vanity of these outward things. That they are the vanity of vanities, and vexation of spirit; that they are but a shadow, a blast, a bubble, and our whole dependence must be upon Him. If trouble from smaller matters begin to arise in me, I have something at hand to check myself with, and say, why am I troubled? It was but the other day that if I had had the world, I would have given it for my freedom, or to have been a servant to a Christian. I have learned to look beyond present and smaller troubles, and to be quieted under them, as Moses said, Exodus 14. 13. *Stand still and see the salvation of the Lord.*

# WILLIAM PENN

William Penn (1644–1718), was the first English Quaker to arrive in America and the founder of Pennsylvania, which he conceived as a colony that would establish freedom of conscience to all who believed in God. He was well aware of the conflicts between English settlers and Indians before he set sail, and he hoped to handle these conflicts more deftly than his predecessors. Unlike many, such as Rowlandson, Penn believed that the Indians would be peaceful toward him as long as they were fairly treated, which he strove to do through trade and the exchange of goods and land. He wrote this letter to the Indians a few months after he received his charter for Pennsylvania.

## Letter to the Indians

*"London, the 18th of the 8th month, 1681.*

*"My Friends,*
"There is a great God and power that hath made the world, and all things therein, to whom you and I, and all people owe their being and well-being, and to whom you and I must one day give an account for all that we do in the world. This great God hath written his law in our hearts, by which we are taught and commanded to love, and help, and do good to one another. Now this great God hath been pleased to make me concerned in your part of the world, and the king

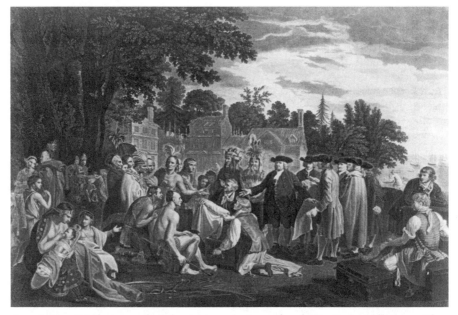

American artists have produced numerous images of early Puritan encounters with Native Americans. This one, from the late nineteenth century, depicts William Penn and the colonists trading with the Indians. *Courtesy of the Library of Congress, Prints & Photographs Division.*

of the country, where I live, hath given me a great province therein; but I desire to enjoy it *with your love and consent*, that we may always live together as neighbours and friends; else what would the great God do to us, who hath made us, not to devour and destroy one another, but to live soberly and kindly together in the world? Now, I would have you well observe, that I am very sensible of the unkindness and injustice that have been too much exercised towards you by the people of these parts of the world, who have sought themselves, and to make great advantages by you, rather than to be examples of goodness and patience unto you, which I hear hath been a matter of trouble to you, and caused great grudgings and animosities, sometimes to the shedding of blood, which hath made the great God angry. But I am not such a man, as is well known in my own country. I have great love and regard towards you, and desire to win and gain your love and friendship by a kind, just, and peaceable life; and the people I send are of the same mind, and shall, in all things, behave themselves accordingly; and, if in anything any shall offend you or your people, you shall have a full and speedy satisfaction for the same, by an equal number of just men on both sides; that, by no means you may have just occasion of being offended against them.

"I shall shortly come to you myself, at which time we may more largely and freely confer and discourse of these matters, in the mean time I have sent my commissioners to treat with you about land, and a firm league of peace. Let me desire you to be kind to them, and the people, and receive these *presents* and *to-*

*kens*, which I have sent you, as a testimony of my *good will* to you, and my resolution to live justly, peaceably, and friendly with you.

*"I am, your loving Friend,*
*"William Penn."*

# ROGER WILLIAMS

Roger Williams (c. 1603–83) was a Puritan minister in England who came to the Massachusetts Bay colony in 1631. He became increasingly vocal as a separatist whom other Puritan clerics found nettlesome, and the General Court voted to banish him from the colony in 1635. Williams settled on the Narragansett Bay and named his new home Providence, in honor of the mercy shown to him by God; the colony itself was named Rhode Island. He was a staunch believer in religious liberty and in the thoroughgoing separation of church and state, and Rhode Island became a sort of refuge for other religious dissenters who were seeking to escape from the Puritan authorities. Williams became a Baptist and founded the first Baptist church in the colonies before he left organized religion behind altogether in his quest for pure liberty of conscience. In this letter, Williams attempted to clarify the relationship between religious liberty and civil responsibility.

## Letter to the Town of Providence on the Limits of Religious Liberty

[*PROVIDENCE, January, 1654–5.*]

That ever I should speak or write a tittle, that tends to such an infinite liberty of conscience, is a mistake, and which I have ever disclaimed and abhorred. To prevent such mistakes, I shall at present only propose this case: There goes many a ship to sea, with many hundred souls in one ship, whose weal and woe is common, and is a true picture of a commonwealth, or a human combination or society. It hath fallen out sometimes, that both papists and protestants, Jews and Turks, may be embarked in one ship; upon which supposal I affirm, that all the liberty of conscience, that ever I pleaded for, turns upon these two hinges—that none of the papists, protestants, Jews, or Turks, be forced to come to the

ship's prayers or worship, nor compelled from their own particular prayers or worship, if they practice any. I further add, that I never denied, that notwithstanding this liberty, the commander of this ship ought to command the ship's course, yea, and also command that justice, peace and sobriety, be kept and practiced, both among the seamen and all the passengers. If any of the seamen refuse to perform their services, or passengers to pay their freight; if any refuse to help, in person or purse, towards the common charges or defence; if any refuse to obey the common laws and orders of the ship, concerning their common peace or preservation; if any shall mutiny and rise up against their commanders and officers; if any should preach or write that there ought to be no commanders or officers, because all are equal in Christ, therefore no masters nor officers, no laws nor orders, nor corrections nor punishments;—I say, I never denied, but in such cases, whatever is pretended, the commander or commanders may judge, resist, compel and punish such transgressors, according to their deserts and merits. This is seriously and honestly minded, may, if it so please the Father of lights, let in some light to such as willingly shut not their eyes.

I remain studious of your common peace and liberty.

# WILLIAM PENN

William Penn wrote this document against religious coercion in 1686, three years before the Act of Toleration was passed in England. Only where liberty of conscience was upheld, Penn believed, would true religion thrive.

## A Persuasive to Moderation to *Church Dissenters*, in Prudence and Conscience

Moderation, the Subject of this Discourse, is in plainer *English, Liberty of Conscience to* Church *Dissenters*: A Cause I have, with all Humility, undertaken to plead, against the Prejudices of the Times.

That there is such a Thing as *Conscience*, and the *Liberty* of it, in Reference to *Faith* and *Worship* towards God, must not be denied, even by those, that are most scandal'd at the *Ill* Use some seem to have made of such Pretences. But to settle the Terms: By *Conscience*, I understand *the Apprehension and Perswasion a Man has of his Duty to God:* By *Liberty of Conscience*, I mean, *A Free and Open Profession and Exercise of that Duty;* especially in *Worship:* But I always premise this *Conscience* to keep within the Bounds of *Morality*, and that it be neither

*Frantick* nor *Mischievous*, but a *Good Subject*, a *Good Child*, a *Good Servant*, in all the Affairs of Life: As exact to yield to *Caesar* the Things that are *Caesar's*, as jealous of withholding from *God* the Thing that is *God's*.

In brief, he that acknowledges the civil *Government* under which he lives, and that maintains no Principle hurtful to his Neighbour in his Civil Property.

For he that in any Thing violates his Duty to these Relations, cannot be said to observe it to God, who ought to have his Tribute out of it. Such do not reject their *Prince, Parent, Master* or *Neighbour*, but God who enjoyns that Duty to them. Those Pathetick Words of Christ will naturally enough reach the Case, *In that ye did it not to them, ye did it not to me*; for Duty to such Relations hath a Divine Stamp: And Divine Right runs through more Things of the World, and Acts of our Lives, than we are aware of: And Sacrilege may be committed against more than the Church. Nor will a Dedication to God, of the Robbery from Man, expiate the Guilt of Disobedience: For though Zeal could turn *Gossip* to Theft, his Altars would renounce the Sacrifice.

The *Conscience* then that I state, and the *Liberty* I pray, carrying so great a *Salvo* and Deference to publick and private Relations, no ill Design can, with any Justice, be fix'd upon the Author, or Reflection upon the Subject, which by this Time, I think, I may venture to call a *Toleration*.

But to this so much craved, as well as needed, *Toleration*, I meet with two Objections of weight, the solving of which will make Way for it in this Kingdom. And the first is a Disbelief of the Possibility of the Thing. *Toleration of Dissenting Worships from that establish'd, is not practicable* (say some) *without Danger to the State, with which it is interwoven.* This is Political. The other Objection is, *That admitting Dissenters to be in the Wrong, (which is always premised by the National Church) such Latitude were the Way to keep up the Dis-union, and instead of compelling them into a better Way, leave them in the Possession and Pursuit of their old Errors,* This is *Religious.* I think I have given the Objections fairly, 'twill be my next Business to answer them as fully.

The Strength of the first Objection against this Liberty, is the *Danger* suggested to the *State;* the Reason is, the National Form being *interwoven* with the Frame of the Government. But this seems to me only said, and not only (with Submission) not prov'd, but not true: For the Establish'd Religion and Worship are no other Ways interwoven with the Government, than that the Government makes Profession of them, and by divers Laws has made them the *Currant Religion,* and required all the Members of the State to conform to it.

This is nothing but what may as well be done by the Government, for any other Perswasion, as that. 'Tis true, 'tis not easy to change an Established Religion, nor is that the Question we are upon; but *State Religions* have been chang'd without the Change of the *States.* We see this in the Governments of *Germany* and *Denmark* upon the *Reformation:* But more clearly and near our selves, in the Case of *Henry the Eighth, Edward the Sixth, Queen Mary* and *Elizabeth;* for the Monarchy, *stood,* the Family *remained* and *succeeded* under all the Revolutions of State-Religion, which could not have been, had the Proposition been generally true.

The Change of Religion then, does not *necessarily* change the Government, or alter the State; and if so, *a fortiori,* Indulgence of Church-Dissenters, does not *necessarily* hazard a Change of the State, where the present State-Religion or Church remains the same; for That I premise.

Some may say, *That it were more facile to change from one National Religion to another, than to maintain: be Monarchy and Church, against the Ambition and Faction of divers Dissenting Parties*. But this is improbable at least. For it were to say, That it is an easier Thing to change a whole Kingdom, than with the Sovereign Power, followed with *Armies, Navies, Judges, Clergy*, and all the *Consormists* of the Kingdom, to secure the Government from the Ambition and Faction of *Dissenters*, as differing in their Interests within themselves, as in their Perswasions; and were they united, have neither Power to awe, nor Rewards to allure to their Party. They can only be formidable, when headed by the Sovereign. They may stop a *Gap*, or make, by his *Accession*, a Ballance: Otherwise, 'till 'tis harder to fight broken and divided Troops, than an entire Body of an Army, it will be always *easier* to maintain the Government under a Toleration of Dissenters, than in a total Change of Religion, and even then it self has not fail'd to have been preserved. But whether it be more or less easy, is not our Point; if they are many, the Danger is of Exasperating, not of making them easy; for the Force of our Question is, Whether such Indulgence be safe to the State? And here we have the first and last, the best and greatest Evidence for us, which is *Fact* and *Experience*, the Journal and Resolves of Time, and Treasure of the Sage.

For, *First*, The *Jews*, that had most to say for their Religion, and whose Religion, was *Twin* to their State, (both being joined, and sent with Wonders from Heaven) *Indulged* Strangers in their Religious Dissents. They required but the Belief of the *Noachical* Principles, which were common to the World: No *Idolater*, and but a *Moral Man*, and he had his *Liberty*, ay, and some *Privileges* too, for he had an Apartment in the Temple, and this without Danger to the Government. Thus *Maimonides*, and others of their own Rabbies, and *Grotius* out of them.

The *Wisdom* of the *Gentiles* was very admirable in this, that though they had many Sects of Philosophers among them, each dissenting from the other in their Principles, as well as Discipline, and that not only in Physical Things, but Points, *Metaphysical*, in which some of the Fathers were not *free*, the School-men *deeply engaged*, and our present Academies but too much *perplexed;* yet they *indulged* them and the best Livers with singular Kindness: The greatest Statesmen and Captains often becoming *Patrons* of the Sects they best affected, honouring their *Readings* with their Presence and Applause. So far were those Ages, which we have made as the Original of Wisdom and Politeness, from thinking *Toleration* an Error of State, or dangerous to the Government. Thus *Plutarch, Strabo, Laertius*, and others.

To these Instances I may add the Latitude of Old *Rome*, that had almost as many Deities as Houses: For *Varro* tells us of no less than *Thirty Thousand* several *Sacra*, or Religious Rites among her People, and yet without a Quarrel: Unhappy Fate of *Christianity!* the best of Religions, and yet her Professors maintain less Charity than Idolaters, while it should be peculiar to them. I fear, it shews us to have but little of it at Heart.

But nearer Home, and in our own Time, we see the Effects of a discreet *Indulgence*, even to Emulation. *Holland*, that *Bog* of the World, neither Sea nor dry Land, now the *Rival* of tallest Monarchs; not by *Conquests, Marriages*, or Accession of *Royal Blood*, the usual Ways to Empire, but by her own superlative *Clemency* and *Industry;* for the one was the Effect of the other: She cherished her

People, whatsoever were their *Opinions,* as the reasonable Stock of the Country, the Heads and Hands of her Trade and Wealth; and making them easy in the main Point, their *Conscience,* she became Great by them; This made her fill with *People,* and they filled her with *Riches* and *Strength.* . . .

That the *Church of England* ought *in Conscience and Prudence* to consent to the Ease desired.

I pray, first, that it be considered, how great a Reflection it will be upon her Honour, that from a *Persecuted,* she should be accounted a *Persecuting Church:* An Overthrow none of her *Enemies* have been able to give to her many *excellent Apologies.* Nor will it be excused, by her saying, *She is in the Right,* which her Persecutors were not; since this is a Confidence not wanting in any of them, or her *Dissenters:* And the Truth is, it is but the Begging of a Question, that will by no Means be granted.

No body ought to know more than *Churchmen,* that *Conscience cannot be forced.* That Offerings against *Conscience,* are as *odious* to God, as *uneasie* to them that make them. That God loves a *free Sacrifice.* That Christ *forbad Fire,* though from Heaven (it self) to punish *Dissenters;* and commanded that the *Tares should grow with the Wheat till the Harvest.* In fine, that we should *love Enemies* themselves: And to exclude worldly Strife for Religion; *That his Kingdom is not of this World.* This was the Doctrine of the *Blessed Saviour* of the *World.*

Saint *Paul* pursues the same Course: Is glad Christ is Preached, be it of *Envy;* the worst Ground for *Dissent* that can be. It was he that ask't that hard, but just Question, *Who art thou that judgest another Man's Servant? To his own Lord he standeth or falleth.* He allows the Church a Warfare, and Weapons to perform it, but they are not *Carnal,* but *Spiritual.* Therefore it was so advised, that every Man in Matters of Religion, should be *fully perswaded in his own Mind,* and if any were short or mistaken, God would, in his Time, Inform them better.

He tells us of *Schismaticks* and *Hereticks* too, and their Punishment, which is to the Point in Hand: He directs to a *first* and *second Admonition,* and if that prevail not, *reject them:* That is, *refuse* them Church Fellowship, *disown* their Relation, and *deny them Communion.* But in all this there is not a Word of *Fines* or *Imprisonments,* nor is it an excuse to any Church, that the *Civil Magistrate* executes the Severity, while they are *Members of her Communion, that make or execute the Laws.*

But if the Church could gain her Point, I mean *Conformity,* unless she could gain *Consent* too, 'twere but *Constraint* at last. A Rape upon the Mind, which may encrease her Number, *not her Devotion.* On the contrary, the rest of her Sons are in danger by their Hypocrisie. The most close, but watchful and Revengeful Thing in the World. Besides, the Scandal can hardly be removed: To *over value Coin,* and *Rate Brass to Silver,* Beggars any Country; and to own them for *Sons* she *never begat,* debases and destroys any Church. 'Twere better to *indulge* foreign coin of *intrinsick Value,* and let it pass for it's Weight. 'Tis not Number, but *Quality:* Two or three sincere Christians, that *form* an Evangelical Church: And though the Church were *less, more Charity* on the one Hand, and *Piety* the other, with exact Church-Censure, and less *civil Coercion,* would give her Credit with Conscience in all Sects; without which, their Accession it self would be no Benefit, but disgrace, and hazard to her Constitution.

And to speak prudently in this Affair, 'tis the *Interest* of the *Church of England,* not to suffer the Extinction of *Dissenters,* that she may have a *Counter-Ballance* to

the *Roman Catholicks*, who, though few in Number, are great in *Quality*, and greater in their foreign Friendships and Assistance. On the other Hand, it is her Interest to Indulge the *Roman Catholick*, that by his Accession, she may at all Times have the *Ballance* in her own Hand, against the *Protestant Dissenter*, leaning to either, as she finds her *Doctrine* undermined by the one, or her *Discipline* by the other; or lastly, her *Civil Interest* endangered from either of them.

And it is certainly the *Interest* of both those *Extremes* of *Dissent*, that *She*, rather than either of them should hold the *Scale*. For as the *Protestant Dissenter* cannot hope for any Tenderness, exclusive of *Roman Catholicks*, but almost the *same Reasons* may be advanced against him. So on the other Hand, it would look imprudent, as well as unjust, in the *Roman Catholicks*, to solicite any Indulgence *exclusive of Protestant Dissenters*. For besides that, it keeps up the Animosity, which it is their Interest to bury; the Consequence will be, to take the Advantage of Time, to snatch it from one another, when an united *Request* for *Liberty*, once granted, will oblige both Parties, in all Times, for Example-sake, to have it Equally preserved. Thus are all Church Interests of *Conformists* and *Dissenters* rendered consistent and safe in their Civil Interest one with the other.

But it will last of all, doubtless, be objected, *That tho' a Toleration were never so desirable in it self, and in it's Consequence beneficial to the Publick, yet the Government cannot allow it, without Ruin to the Church of* England, *which it is obliged to maintain.*

But I think this will not affect the Question at all, unless by maintaining the *Church of England*, it is understood that he should force whole Parties to be of her Communion, or knock them on the Head: Let us call to mind, that the Religion that is true, allows no Man to do Wrong, that Right may come of it. And that nothing has lessen'd the Credit of any Religion more, than declining to support, it self by it's *own Charity* and *Piety*, and taking Sanctuary in the Arms, *rather than the Understandings of Men. Violences* are ill Pillars for Truth to rest upon.

It is a severe Dilemma, that a Man must either renounce *That* of which he makes Conscience in the Sight of God, or be *Civilly* and *Ecclesiastically Reprobated.* There was a Time, when the *Church of England* her self stood in need of Indulgence, and made up a great Part of the *Non-Conformists* of this Kingdom, and what she then wanted, she pleaded for, I mean a *Toleration*. . . .

*Let your Moderation be known to all Men*, was the saying of a great Doctor of the Christian Faith, and his Reason for that Command *Cogent, For the Lord is at Hand.* As if he had said, Have a care what you do, be not *bitter* nor *violent*, for the *Judge is at the Door:* Do as you would be done to, lest what you deny to others, God should *refuse to you.*

# COTTON MATHER

Cotton Mather (1663–1728), son of Increase Mather and co-minister with him of Boston's Second Church, was a dedicated minister who took an active role in the lives of his congregants, as well as one of the most prolific

writers of Puritan texts. His life spanned a crucial period of transition in New England life, one that included the notorious Salem affair in which hundreds were accused of witchcraft and twenty persons were executed. Mather was deeply troubled by the events at Salem, convinced that witches who were in league with the devil were disrupting the holy community, yet distressed that the methods being used to ferret them out would result in false convictions. Nonetheless, he justified the trials in his book *Wonders of the Invisible World*, which came into print even as public opinion grew increasingly divided toward the court authorities and witnesses who had caused so many deaths. These excerpts summarize three of the trials that Mather described, and they reveal much about Puritan fears and assumptions about the potential evil in their midst.

# From Wonders of the Invisible World

## II. THE TRIAL OF BRIDGET BISHOP: ALIAS, OLIVER, AT THE COURT OF OYER AND TERMINER HELD AT SALEM, JUNE 2, 1692.

I. She was indicted for bewitching of several persons in the neighborhood, the indictment being drawn up, according to the form in such cases usual. And pleading, not guilty, there were brought in several persons, who had long undergone many kinds of miseries, which were preternaturally inflicted, and generally ascribed unto a horrible witchcraft. There was little occasion to prove the witchcraft; it being evident and notorious to all beholders. Now to fix the witchcraft on the prisoner at the bar, the first thing used was, the testimony of the bewitched; whereof, several testified, that the shape of the prisoner did oftentimes very grievously pinch them, choke them, bite them, and afflict them; urging them to write their names in a book, which the said specter called, ours. One of them did further testify, that it was the shape of this prisoner, with another, which one day took her from her wheel, and carrying her to the riverside, threatened there to drown her, if she did not sign to the book mentioned: which yet she refused. Others of them did also testify, that the said shape, did in her threats, brag to them, that she had been the death of sundry persons, then by her named; that she had ridden a man, then likewise named. Another testified, the apparition of ghosts unto the specter of Bishop, crying out, you murdered us! About the truth whereof, there was in the matter of fact, but too much suspicion.

II. It was testified, that at the examination of the prisoner, before the magistrates, the bewitched were extremely tortured. If she did but cast her eyes on them, they were presently struck down; and this in such a manner as there could be no collusion in the business. But upon the touch of her hand upon

them, when they lay in their swoons, they would immediately revive; and not upon the touch of anyone's else. Moreover, upon some special actions of her body, as the shaking of her head, or the turning of her eyes, they presently and painfully fell into the like postures. And many of the like accidents now fell out, while she was at the bar. One at the same time testifying, that she said, she could not be troubled to see the afflicted thus tormented.

III. There was testimony likewise brought in, that a man striking once at the place, where a bewitched person said, the shape of this Bishop stood, the be-witched cried out, that he had tore her coat, in the place then particularly speci-fied; and the woman's coat, was found to be torn in that very place.

IV. One Deliverance Hobbs, who had confessed her being a witch, was now tormented by the specters, for her confession. And she now testified, that this Bishop, tempted her to sign the book again, and to deny what she had con-fessed. She affirmed, that it was the shape of this prisoner, which whipped her with iron rods, to compel her thereunto. And she affirmed, that this Bishop was at a general meeting of the witches, in a field at Salem Village and there partook of a diabolical sacrament, in bread and wine then administered!

V. To render it further unquestionable, that the prisoner at the bar, was the person truly charged in *this* witchcraft, there were produced many evidences of *other* witchcrafts, by her perpetrated. For instance, John Cook testified, that about five or six years ago, one morning, about sunrise, he was in his chamber, assaulted by the shape of this prisoner: which looked on him, grinned at him, and very much hurt him, with a blow on the side of the head: and that on the same day, about noon, the same shape walked in the room where he was, and an apple strangely flew out of his hand, into the lap of his mother, six or eight foot from him.

VI. Samuel Gray, testified, that about fourteen years ago, he waked on a night, and saw the room where he lay, full of light; and that he then saw plainly a woman between the cradle, and the bedside, which looked upon him. He rose, and it vanished; though he found the doors all fast. Looking out at the entry door, he saw the same woman, in the same garb again; and said, *In God's name, what do you come for*? He went to bed, and had the same woman again assaulting him. The child in the cradle gave a great screech, and the woman disappeared. It was long before the child could be quieted; and though it were a very likely thriving child, yet from this time it pined away, and after divers months died in a sad condition. He knew not Bishop, nor her name; but when he saw her after this, he knew by her countenance, and apparel, and all circumstances, that it was the apparition of this Bishop, which had thus troubled him.

VII. John Bly and his wife, testified, that he bought a sow of Edward Bishop, the husband of the prisoner; and was to pay the price agreed, unto an-other person. This prisoner being angry that she was thus hindered from finger-ing the money, quarrelled with Bly. Soon after which the sow, was taken with strange fits; jumping, leaping, and knocking her head against the fence, she seemed blind and deaf, and would neither eat nor be sucked. Whereupon a neighbor said, she believed the creature was over-looked; and sundry other cir-cumstances concurred, which made the deponents believe that Bishop had be-witched it.

VIII. Richard Coman testified, that eight years ago, as he lay awake in his bed, with a light burning in the room, he was annoyed with the apparition of

this Bishop, and of two more that were strangers to him; who came and oppressed him so that he could neither stir himself, nor wake anyone else: and that he was the night after, molested again in the like manner; the said Bishop taking him by the throat, and pulling him almost out of the bed. His kinsman offered for this cause to lodge with him; and that night, as they were awake discoursing together: this Coman was once more visited, by the guests which had formerly been so troublesome; his kinsman being at the same time struck speechless and unable to move hand or foot. He had laid his sword by him; which these unhappy specters, did strive much to wrest from him; only he held too fast for them. He then grew able to call the people of his house; but although they heard him, yet they had not power to speak or stir, until at last, one of the people crying out, *what's the matter!* the specters all vanished.

IX. Samuel Shattuck testified, that in the year 1680, this Bridget Bishop, often came to his house upon such frivolous and foolish errands, that they suspected she came indeed with a purpose of mischief. Presently whereupon his eldest child, which was of as promising health and sense, as any child of its age, began to droop exceedingly; and the oftener that Bishop came to the house, the worse grew the child. As the child would be standing at the door, he would be thrown and bruised against the stones, by an invisible hand, and in like sort knock his face against the sides of the house, and bruise it after a miserable manner. Afterwards this Bishop would bring him things to dye, whereof he could not imagine any use; and when she paid him a piece of money, the purse and money were unaccountably conveyed out of a locked box, and never seen more. The child was immediately hereupon taken with terrible fits, whereof his friends thought he would have died: indeed he did almost nothing but cry and sleep for several months together: and at length his understanding was utterly taken away. Among other symptoms of an enchantment upon him, one was, that there was a board in the garden, whereon he would walk; and all the invitations in the world could never fetch him off. About seventeen or eighteen years after, there came a stranger to Shattuck's house, who seeing the child, said, *This poor child is bewitched; and you have a neighbor living not far off, who is a witch.* He added, *Your neighbor has had a falling out with your wife; and she said in her heart, your wife is a proud woman, and she would bring down her pride in this child:* He then remembered, that Bishop had parted from his wife in muttering and menacing terms, a little before the child was taken ill. The abovesaid stranger would needs carry the bewitched boy with him, to Bishop's house, on pretence of buying a pot of cider. The woman entertained him in furious manner; and flew also upon the boy, scratching his face till the blood came, and saying, *Thou rogue, what? dost thou bring this fellow here to plague me?* Now it seems the man had said before he went, that he would fetch blood of her. Ever after the boy was followed with grievous fits, which the doctors themselves generally ascribed unto witchcraft; and wherein he would be thrown still into the fire or the water, if he were not constantly looked after; and it was verily believed that Bishop was the cause of it.

X. John Louder testified, that upon some little controversy with Bishop about her fowls, going well to bed, he did awake in the night by moonlight, and did see clearly the likeness of this woman grievously oppressing him; in which miserable condition she held him unable to help himself, till near day.

He told Bishop of this; but she denied it, and threatened him, very much. Quickly after this, being at home on a Lord's day, with the doors shut about him, he saw a black pig approach him; at which he going to kick, it vanished away. Immediately after, sitting down, he saw a black thing jump in at the window, and come and stand before him. The body, was like that of a monkey, the feet like a cock's, but the face much like a man's. He being so extremely affrighted, that he could not speak; this monster spoke to him and said, *I am a messenger sent unto you, for I understand that you are in some trouble of mind, and if you will be ruled by me, you shall want for nothing in this world.* Whereupon he endeavored to clap his hands upon it; but he could feel no substance, and it jumped out of the window again; but immediately came in by the porch, though the doors were shut, and said, *You had better take my counsel!* He then struck at it with a stick, but struck only the groundsel, and broke the stick. The arm with which he struck was presently disenabled, and it vanished away. He presently went out at the back door, and spied, this Bishop, in her orchard, going toward her house; but he had not power to set one foot forward unto her. Whereupon returning into the house, he was immediately accosted by the monster he had seen before; which goblin was now going to fly at him: whereat he cried out, *The whole armor of God, be between me and you!* So it sprang back, and flew over the apple tree; shaking many apples off the tree, in its flying over. At its leap, it flung dirt with its feet, against the stomach of the man; whereon he was then struck dumb, and so continued for three days together. Upon the producing of this testimony, Bishop denied that she knew this deponent: yet their two orchards joined, and they had often had their little quarrels for some years together.

XI. William Stacy testified, that receiving money of this Bishop, for work done by him, he was gone but a matter of three rods from her, and looking for his money, found it unaccountably gone from him. Some time after, Bishop asked him whether his father would grind her grist for her? He demanded why? She replied, *Because folks count me a witch.* He answered, *No question, but he will grind it for you.* Being then gone about six rods from her, with a small load in his cart, suddenly the off-wheel slumped and sunk down into a hole upon plain ground, so that the deponent, was forced to get help for the recovering of the wheel. But stepping back to look for the hole which might give him this disaster, there was none at all to be found. Some time after, he was waked in the night; but it seemed as light as day, and he perfectly saw the shape of this Bishop, in the room, troubling of him; but upon her going out, all was dark again. He charged Bishop afterwards with it: and she denied it not; but was very angry. Quickly after, this deponent having been threatened by Bishop, as he was in a dark night going to the barn, he was very suddenly taken or lifted from the ground, and thrown against a stone wall; after that, he was again hoisted up and thrown down a bank, at the end of his house. After this again, passing by this Bishop, his horse with a small load, striving to draw, all his gears flew to pieces, and the cart fell down; and this deponent going then to lift a bag of corn, of about two bushels; could not budge it, with all his might.

Many other pranks, of this Bishop's, this deponent was ready to testify. He also testified, that he verily believed, the said Bishop, was the instrument of his daughter, Priscilla's death; of which suspicion, pregnant reasons were assigned.

XII. To crown all, John Bly, and William Bly, testified, that being employed by Bridget Bishop, to help take down the cellar wall, of the old house, wherein she formerly lived, they did in holes of the said old wall, find several poppets, made up of rags, and hog's bristles, with headless pins in them, the points being outward. Whereof she could now give no account unto the court, that was reasonable or tolerable.

XIII. One thing that made against the prisoner was, her being evidently convicted of gross lying, in the court, several times, while she was making her plea. But besides this, a jury of women, found a preternatural teat upon her body; but upon a second search, within three or four hours, there was no such thing to be seen. There was also an account of other people whom this woman had afflicted. And there might have been many more, if they had been, inquired for. But there was no need of them.

XIV. There was one very strange thing more, with which the court was newly entertained. As this woman was under a guard, passing by the great and spacious meetinghouse of Salem, she gave a look towards the house. And immediately a demon invisibly entering the meetinghouse, tore down a part of it; so that though there were no person to be seen there, yet the people at the noise running in, found a board, which was strongly fastened with several nails, transported unto another quarter of the house.

## III. THE TRIAL OF SUSANNA MARTIN, AT THE COURT OF OYER AND TERMINER: HELD BY ADJOURNMENT AT SALEM, JUNE 29, 1692.

I. Susanna Martin, pleading, not guilty to the indictment of witchcrafts brought in against her, there were produced the evidences of many persons very sensibly and grievously bewitched; who all complained of the prisoner at the bar, as the person whom they believed the cause of their miseries. And now, as well as in the other trials, there was an extraordinary endeavor by witchcrafts, with cruel and frequent fits, to hinder the poor sufferers, from giving in their complaints; which the court was forced with much patience to obtain, by much waiting and watching for it.

II. There was now also an account given, of what passed at her first examination before the magistrates. The cast of her eye, then striking the afflicted people to the ground, whether they saw that cast or no; there were these among other passages, between the magistrates, and the examinate.

MAGISTRATE: Pray, what ails these people?

MARTIN: I don't know.

MAGISTRATE: But, what do you think ails them?

MARTIN: I don't desire to spend my judgment upon it.

MAGISTRATE: Don't you think they are bewitched?

MARTIN: No, I do not think they are.

MAGISTRATE: Tell us your thoughts about them then.

MARTIN: No, my thoughts are my own when they are in, but when they are out, they are another's. Their master—

MAGISTRATE: Their master? who do you think, is their master?

MARTIN: If they be dealing in the black art, you may know as well as I.

MAGISTRATE: Well, what have you done towards this?

MARTIN: Nothing at all.

MAGISTRATE: Why, 'tis you or your appearance.

MARTIN: I cannot help it.

MAGISTRATE: Is it not *your master?* How comes your appearance to hurt these?

MARTIN: How do I know? He that appeared in the shape of Samuel, a glorified saint, may appear in anyone's shape.

It was then also noted in her, as in others like her, that if the afflicted went to approach her, they were flung down to the ground. And, when she was asked the reason of it, she said, *I cannot tell; it may be, the devil bears me more malice than another.*

III. The court accounted themselves alarmed by these things, to inquire further into the conversation of the prisoner; and see what there might occur, to render these accusations further credible. Whereupon, John Allen, of Salisbury, testified, that he refusing, because of the weakness of his oxen, to cart some staves, at the request of this Martin, she was displeased at it, and said, *It had been as good that he had; for his oxen should never do him much more service.* Whereupon, this deponent said, *Dost thou threaten me, thou old witch? I'll throw thee into the brook:* Which to avoid, she flew over the bridge, and escaped. But, as he was going home one of his oxen tired, so that he was forced to unyoke him, that he might get him home. He then put his oxen, with many more, upon Salisbury Beach, where cattle did use to get flesh. In a few days, all the oxen upon the beach were found by their tracks, to have run unto the mouth of Merrimack River, and not returned; but the next day they were found come ashore upon Plum Island. They that sought them, used all imaginable gentleness, but they would still run away with a violence that seemed wholly diabolical, till they came near the mouth of Merrimack River; when they ran right into the sea, swimming as far as they could be seen. One of them then swam back again, with a swiftness, amazing to the beholders, who stood ready to receive him, and help up his tired carcass: but the beast ran furiously up into the island, and from thence, through the marshes, up into Newbury Town, and so up into the woods; and there after a while found near Amesbury. So that, of fourteen good oxen, there was only this saved: the rest were all cast up, some in one place, and some in another, drowned.

IV. John Atkinson testified, that he exchanged a cow, with a son of Susanna Martin's, whereat she muttered, and was unwilling he should have it. Going to receive this cow, though he hamstringed her, and haltered her, she of a tame creature grew so mad, that they could scarce get her along. She broke all the ropes that were fastened unto her, and though she were tied fast unto a tree, yet she made her escape, and gave them such further trouble, as they could ascribe to no cause but witchcraft.

V. Bernard Peach testified, that being in bed, on a Lord's-day night, he heard a scrabbling at the window, whereat he then saw, Susanna Martin come in, and jump down upon the floor. She took hold of this deponent's feet, and drawing his body up into a heap, she lay upon him, near two hours; in all which time he could neither speak nor stir. At length, when he could begin to move, he laid hold on her hand, and pulling it up to his mouth, he bit three of her fingers, as he judged, unto the bone. Whereupon she went from the chamber, down the stairs, out at the door. This deponent thereupon called unto the people of the house, to advise them, of what passed; and he himself did follow her. The people saw her not; but there being a bucket at the left hand of the door, there was a drop of blood found on it; and several more drops of blood upon the snow newly fallen abroad. There was likewise the print of her two feet just without the threshold; but no more sign of any footing further off.

At another time this deponent was desired by the prisoner, to come unto a husking of corn, at her house; and she said, *If he did not come, it were better that he did!* He went not; but the night following, Susanna Martin, as he judged, and another came towards him. One of them said, *Here he is!* but he having a quarter-staff, made a blow at them. The roof of the barn, broke his blow; but following them to the window, he made another blow at them, and struck them down; yet they got up, and got out, and he saw no more of them.

About this time, there was a rumor about the town, that Martin had a broken head; but the deponent could say nothing to that.

The said Peach also testified, the bewitching of cattle to death, upon Martin's discontents.

VI. Robert Downer testified, that this prisoner being some years ago prosecuted at court for a witch, he then said unto her, *He believed she was a witch.* Whereat she being dissatisfied, said, *That some she-devil would shortly fetch him away!* Which words were heard by others, as well as himself. The night following, as he lay in his bed, there came in at the window, the likeness of a cat, which flew upon him, took fast hold of his throat, lay on him a considerable while, and almost killed him. At length he remembered, what Susanna Martin, had threatened the day before; and with much striving he cried out, *Avoid, thou she-devil! In the name of God the Father; the Son, and the Holy Ghost, avoid!* whereupon it left him, leaped on the floor, and flew out at the window.

And there also came in several testimonies, that before ever Downer spoke a word of this accident, Susanna Martin and her family, had related, how this Downer had been handled!

VII. John Kimball, testified, that Susanna Martin, upon a causeless disgust, had threatened him, about a certain cow of his, that *She should never do him any more good:* and it came to pass accordingly. For soon after the cow was found stark dead on the dry ground; without any distemper to be discerned upon her. Upon which he was followed with a strange death upon more of his cattle, whereof he lost in one spring to the value of thirty pounds. But the said John Kimball had a further testimony to give in against the prisoner which was truly admirable.

Being desirous to furnish himself with a dog, he applied himself to buy one of this Martin, who had a bitch with whelps in her house. But she not letting

him have his choice, he said, he would supply himself then at one Blaisdell's. Having marked a puppy, which he liked at Blaisdell's, he met George Martin, the husband of the prisoner, going by, who asked him, *Whether he would not have one of his wife's puppies;* and he answered, *No.* The same day, one Edmund Eliot, being at Martin's house, heard George Martin relate, where this Kimball had been, and what he had said. Whereupon Susanna Martin replied, *If I live, I'll give him puppies enough!* Within a few days after, this Kimball coming out of the woods, there arose a little black cloud, in the N.W. and Kimball immediately felt a force upon him, which made him not able to avoid running upon the stumps of trees, that were before him, albeit, he had a broad, plain cart way, before him; but though he had his axe also on his shoulder to endanger him in his falls, he could not forbear going out of his way to tumble over them. When he came below the meetinghouse, there appeared unto him, a little thing like a puppy, of a darkish color; and it shot backwards and forwards between his legs. He had the courage to use all possible endeavors of cutting it, with his axe; but he could not hit it; the puppy gave a jump from him, and went, as to him, it seemed, into the ground. Going a little further, there appeared unto him a black puppy, somewhat bigger than the first; but as black as a coal. Its motions were quicker than those of his axe; it flew at his belly and away; then at his throat; so, over his shoulder one way, and then over his shoulder another way. His heart now began to fail him, and he thought the dog would have tore his throat out. But he recovered himself, and called upon God in his distress; and naming the name of Jesus Christ, it vanished away at once. The deponent spoke not one word of these accidents, for fear of affrighting his wife. But the next morning, Edmond Eliot, going into Martin's house, this woman asked him where Kimball was? He replied, *At home, a bed, for ought he knew.* She returned, *They say, he was frighted last night.* Eliot asked *With what?* She answered, *With puppies.* Eliot asked, *Where she heard of it, for he had heard nothing of it!* She rejoined, *About the town.* Although, Kimball had mentioned the matter to no creature living.

VIII. William Brown testified, that heaven having blessed him with a most pious and prudent wife, this wife of his, one day met with Susanna Martin; but when she approached just unto her Martin, vanished out of sight, and left her extremely affrighted. After which time, the said Martin often appeared unto her, giving her no little trouble; and when she did come, she was visited with birds that sorely pecked and pricked her; and sometimes, a bunch, like a pullet's egg would rise in her throat, ready to choke her, till she cried out, *Witch, you shan't choke me!* While this good woman was in this extremity, the church appointed a day of prayer, on her behalf; whereupon her trouble ceased; she saw not Martin as formerly; and the church, instead of their fast, gave thanks for her deliverance. But a considerable while after, she being summoned to give in some evidence at the court, against this Martin, quickly thereupon, this Martin came behind her, while she was milking her cow, and said unto her, *For thy defaming me at court, I'll make thee the miserablest creature in the world.* Soon after which, she fell into a strange kind of distemper, and became horribly frantic, and uncapable of any reasonable action; the physicians declaring, that her distemper was preternatural, and that some devil had certainly bewitched her; and in that condition she now remained.

IX. Sarah Atkinson testified, that Susanna Martin came from Amesbury, to their house at Newbury, in an extraordinary season, when it was not fit for anyone to travel. She came (as she said, unto Atkinson) all that long way on foot. She bragged, and showed how dry she was; nor could it be perceived that so much as the soles of her shoes were wet. Atkinson was amazed at it; and professed, that she should herself have been wet up to the knees, if she had then came so far; but Martin replied, *She scorned to be drabbled!* It was noted, that this testimony upon her trial, cast her into a very singular confusion.

X.  John Pressey testified, that being one evening very unaccountably bewildered, near a field of Martin's, and several times, as one under an enchantment, returning to the place he had left, at length he saw a marvellous light, about the bigness of a half bushel, near two rod, out of the way. He went, and struck at it with a stick, and laid it on with all his might. He gave it near forty blows; and felt it a palpable substance. But going from it, his heels were struck up, and he was laid with his back on the ground: sliding, as he thought, into a pit; from whence he recovered, by taking hold on the bush; although afterwards he could find no such pit in the place. Having after his recovery, gone five or six rod, he saw Susanna Martin standing on his left hand, as the light had done before; but they changed no words with one another. He could scarce find his house in his return; but at length he got home, extremely affrighted. The next day, it was upon inquiry understood, that Martin was in a miserable condition by pains and hurts that were upon her.

It was further testified by this deponent, that after he had given in some evidence against Susanna Martin, many years ago, she gave him foul words about it; and said, *He should never prosper more;* particularly, *That he should never have more than two cows; that though he were never so likely to have more, yet he should never have them.* And that from that very day to this; namely for twenty years together, he could never exceed that number; but some strange thing or other still prevented his having of any more.

XI.  Jarvis Ring, testified, that about seven years ago, he was oftentimes and grievously oppressed in the night; but saw not who troubled him, until at last he lying perfectly awake, plainly saw Susanna Martin approach him. She came to him, and forcibly bit him by the finger; so that the print of the bite is now so long after to be seen upon him.

XII.  But besides all of these evidences, there was a most wonderful account of one Joseph Ring, produced on this occasion.

This man has been strangely carried about by demons, from one witch-meeting to another, for near two years together; and for one quarter of this time, they have made him, and kept him dumb, though he is now again able to speak. There was one T. H. who having as 'tis judged, a design of engaging this Joseph Ring, in a snare of devilism, contrived a wile, to bring this Ring two shillings in debt unto him.

Afterwards, this poor man would be visited with unknown shapes, and this T. H. sometimes among them; which would force him away with them, unto unknown places, where he saw meetings, feastings, dancings; and after his return, wherein they hurried him along through the air, he gave demonstrations to the neighbors, that he had indeed been so transported. When he was brought unto these hellish meetings, one of the first things they still did unto him, was to give

him a knock on the back, whereupon he was ever as if bound with chains, unca-
pable of stirring out of the place, till they should release him. He related, that
there often came to him a man, who presented him a book, whereto he would
have him set his hand; promising to him, that he should then have even what he
would; and presenting him with all the delectable things, persons, and places,
that he could imagine. But he refusing to subscribe, the business would end
with dreadful shapes, noises and screeches, which almost scared him out of his
wits. Once with the book, there was a pen offered him, and an inkhorn, with
liquor in it, that seemed like blood: but he never touched it.

This man did now affirm, that he saw the prisoner, at several of those hell-
ish rendezvous.

Note, this woman was one of the most impudent, scurrilous, wicked crea-
tures in the world; and she did now throughout her whole trial, discover herself
to be such a one. Yet when she was asked what she had to say for her self, her
chief plea was, that she had led a most virtuous and holy life!

# Revival, Revolution, and the Enlightenment, 1740–1800

In the first half of the eighteenth century, England and America witnessed a series of religious revivals, events in which dynamic evangelists preached to large groups. Many were converted and experienced what they termed "spiritual rebirth," feeling their lives to have been forever transformed. Multiple factors helped to generate these revivals, significantly the widespread laments in the period that American religion had declined from its Puritan glory days. Such laments, or "jeremiads," had occurred since the second generation of Puritans had come of age in New England. But the tendency to chastise the present in light of the past became acute once again in this later stage as ministers wrung their hands over low church membership and lamented the supposed legalism and lifelessness of their congregations.

The event tagged the "Great Awakening" began in the 1730s in Northampton, Massachusetts, where Jonathan Edwards was the minister. George Whitefield, the "Grand Itinerant," traveled here and elsewhere preaching the evangelical doctrine of the new birth. Edwards celebrated the revitalization of piety in his town and elsewhere, but not all were so delighted. Some religious leaders, Charles Chauncy among them, criticized the excesses of the revivals. This debate would remain a divisive one in American Protestantism for centuries to come.

Besides being the era of the evangelical tradition's emergence, the eighteenth century was also the period of Enlightenment rationalism and political revolution and a century of slavery. The documents in this selection begin to illuminate the ways in which these distinct currents flowed together in the religion of eighteenth-century America.

# JONATHAN EDWARDS

Jonathan Edwards (1703–58) was a theologian and Congregationalist minister in Northampton, Massachusetts, when a series of revivals swept through Calvinist New England. The consternation caused by the Great Awakening, as it came to be called, was great enough to prompt sustained reflection upon the emotionality that was unleashed by religious revivals and the constitution of religious affections more generally. Edwards wrote *Some Thoughts Concerning the Present Revival of Religion in New-England* in strong support of the revival, even proposing that it could augur the long-awaited Millennium, and he addressed the excesses of the emotional outpouring—"enthusiasm," a term of contempt—as easily lending themselves to correction. He famously included the spiritual account of his own wife, Sarah Pierpont Edwards, as a model (left unnamed) whose spiritual affections had not in any way compromised her righteousness. Three years later, Edwards would gather his mature thoughts on the religious affections into the *Treatise Concerning Religious Affections*.

# *From* Some Thoughts Concerning the Present Revival of Religion in New-England

## PART I

*Shewing that the extraordinary work that has of late been going on in this land, is a glorious work of God*

The error of those who have ill thoughts of the great religious operation on the minds of men, that has been carried on of late in New England (so far as the ground of such an error has been in the understanding, and not in the disposition), seems fundamentally to lie in three things: *first*, in judging of this work a priori; *secondly*, in not taking the Holy Scriptures as an whole rule whereby to judge of such operations; *thirdly*, in not justly separating and distinguishing the good from the bad.

## [The Revival Not To Be Judged A Priori]

They have greatly erred in the way in which they have gone about to try this work, whether it be a work of the Spirit of God or no, viz. in judging of it a priori; from the way that it began, the instruments that have been employed, the means that have been made use of, and the methods that have been taken and succeeded in carrying it on. Whereas, if we duly consider the matter, it will evidently appear that such a work is not to be judged of a priori, but a posteriori: we are to observe the effect wrought; and if, upon examination of that, it be found to be agreeable to the Word of God, we are bound without more ado to rest in it as God's work; and shall be like to be rebuked for our arrogance, if we refuse so to do till God shall explain to us how he has brought this effect to pass, or why he has made use of such and such means in doing of it. Those texts are enough to cause us with trembling to forbear such a way of proceeding in judging of a work of God's Spirit, Isa. 40:13–14, "Who hath directed the Spirit of the Lord, or being his counselor hath taught him? With whom took he counsel, and who instructed him; and who taught him in the path of judgment, and taught him knowledge, and shewed to him the way of understanding?" John 3:8, "The wind bloweth where it listeth; and thou hearest the sound thereof; but canst not tell whence it cometh, and whither it goeth." We hear the sound, we perceive the effect, and from thence we judge that the wind does indeed blow; without waiting, before we pass this judgment, first to be satisfied what should be the cause of the wind's blowing from such a part of the heavens, and how it should come to pass that it should blow in such a manner, at such a time. To judge a priori is a wrong way of judging of any of the works of God. We are not to resolve that we will first be satisfied how God brought this or the other effect to pass, and why he hath made it thus, or why it has pleased him to take such a course, and to use such and such means, before we will acknowledge his work, and give him the glory of it. This is too much for the clay to take upon it with respect to the potter [cf. Jer. 18:6; Rom. 9:20–21]. "God gives not account of his matters: his judgments are a great deep: he hath his way in the sea, and his path in the great waters, and his footsteps are not known; and who shall teach God knowledge, or enjoin him his way, or say unto him, What doest thou? We know not what is the way of the Spirit, nor how the bones do grow in the womb of her that is with child; even so we know not the works of God who maketh all." No wonder therefore if those that go this forbidden way to work, in judging of the present wonderful operation, are perplexed and confounded. We ought to take heed that we don't expose ourselves to the calamity of those who pried into the ark of God, when God mercifully returned it to Israel, after it had departed from them [I Sam. 6:19].

Indeed God has not taken that course, nor made use of those means, to begin and carry on this great work, which men in their wisdom would have thought most advisable, if he had asked their counsel; but quite the contrary. But it appears to me that the great God has wrought like himself, in the manner of his carrying on this work; so as very much to show his own glory, and exalt his own sovereignty, power and all-sufficiency, and pour contempt on all that human strength, wisdom, prudence and sufficiency, that men have been wont to

trust, and to glory in; and so as greatly to cross, rebuke and chastise the pride and other corruptions of men; in a fulfilment of that [verse,] Isa. 2:17, "And the loftiness of man shall be bowed down, and the haughtiness of men shall be made low, and the Lord alone shall be exalted in that day." God doth thus, in intermingling in his providence so many stumbling blocks with this work; in suffering so much of human weakness and infirmity to appear; and in ordering so many things that are mysterious to men's wisdom: in pouring out his Spirit chiefly on the common people, and bestowing his greatest and highest favors upon them, admitting them nearer to himself than the great, the honorable, the rich and the learned, agreeable to that prophecy, Zech. 12:7, "The Lord also shall save the tents of Judah first, that the glory of the house of David, and the glory of the inhabitants of Jerusalem, do not magnify themselves against Judah." Those that dwelt in the tents of Judah were the common people, that dwelt in the country, and were of inferior rank. The inhabitants of Jerusalem were their citizens, their men of wealth and figure: and Jerusalem also was the chief place of the habitation or resort of their priests and Levites, and their officers and judges; there sat the great Sanhedrin. The house of David were the highest rank of all, the royal family, and the great men that were round about the king. 'Tis evident by the context that this prophecy has respect to something further than the saving the people out of the Babylonish Captivity.

God in this work has begun at the lower end, and he has made use of the weak and foolish things of the world to carry on his work. . . .

Another foundation error of those that don't acknowledge the divinity of this work, is not taking the Holy Scriptures as an whole, and in itself a sufficient rule to judge of such things by. They that have one certain consistent rule to judge by, are like to come to some clear determination; but they that have half a dozen different rules to make the thing they would judge of agree to, no wonder that instead of justly and clearly determining, they do but perplex and darken themselves and others. They that would learn the true measure of anything, and will have many different measures to try it by, and find in it a conformity to, have a task that they will not accomplish.

Those that I am speaking of, will indeed make some use of Scripture, so far as they think it serves their turn; but don't make use of it alone, as a rule sufficient by itself, but make as much, and a great deal more use of other things, diverse and wide from it, to judge of this work by. As particularly:

1. Some make philosophy instead of the Holy Scriptures their rule of judging of this work; particularly the philosophical notions they entertain of the nature of the soul, its faculties and affections. Some are ready to say, "There is but little sober, solid religion in this work; it is little else but flash and noise. Religion nowadays all runs out into transports and high flights of the passions and affections." In their philosophy, the affections of the soul are something diverse from the will, and not appertaining to the noblest part of the soul, but the meanest principles that it has, that belong to men as partaking of animal nature, and what he has in common with the brute creation, rather than anything whereby he is conformed to angels and pure spirits. And though they acknowledge that there is a good use may be made of the affections in religion, yet they suppose that the substantial part of religion don't consist in them, but that they are rather to be looked upon as something adventitious and accidental in Christianity.

But I can't but think that these gentlemen labor under great mistakes, both in their philosophy and divinity. 'Tis true distinction must be made in the affections or passions. There's a great deal of difference in high and raised affections, which must be distinguished by the skill of the observer. Some are much more solid than others. There are many exercises of the affections that are very flashy, and little to be depended on; and oftentimes there is a great deal that appertains to them, or rather that is the effect of them, that has its seat in animal nature, and is very much owing to the constitution and frame of the body; and that which sometimes more especially obtains the name of passion, is nothing solid or substantial. But it is false philosophy to suppose this to be the case with all exercises of affection in the soul, or with all great and high affections; and false divinity to suppose that religious affections don't appertain to the substance and essence of Christianity: on the contrary, it seems to me that the very life and soul of all true religion consists in them.

I humbly conceive that the affections of the soul are not properly distinguished from the will, as though they were two faculties in the soul. All acts of the affections of the soul are in some sense acts of the will, and all acts of the will are acts of the affections. All exercises of the will are in some degree or other, exercises of the soul's appetition or aversion; or which is the same thing, of its love or hatred. The soul wills one thing rather than another, or chooses one thing rather than another, no otherwise than as it loves one thing more than another; but love and hatred are affections of the soul: and therefore all acts of the will are truly acts of the affections; though the exercises of the will don't obtain the name of passions, unless the will, either in its aversion or opposition, be exercised in a high degree, or in a vigorous and lively manner.

All will allow that true virtue or holiness has its seat chiefly in the heart, rather than in the head: it therefore follows from what has been said already, that it consists chiefly in holy affections. The things of religion take place in men's hearts, no further than they are affected with them. The informing of the understanding is all vain, any farther than it affects the heart; or, which is the same thing, has influence on the affections.

Those gentlemen that make light of these raised affections in religion, will doubtless allow that true religion and holiness, as it has its seat in the heart, is capable of very high degrees, and high exercises in the soul. As for instance: they will doubtless allow that the holiness of the heart or will, is capable of being raised to an hundred times as great a degree of strength as it is in the most eminent saint on earth, or to be exerted in an hundred times so strong and vigorous exercises of the heart; and yet be true religion or holiness still, but only in an high degree. Now therefore I would ask them, by what name they will call these high and vigorous exercises of the will or heart? Ben't they high affections? What can they consist in, but in high acts of love; strong and vigorous exercises of benevolence and complacence; high, exalting and admiring thoughts of God and his perfections; strong desires after God, etc.? And now what are we come to but high and raised affections? Yea, those very same high and raised affections that before they objected against, or made light of, as worthy of little regard?

I suppose furthermore that all will allow that there is nothing but solid religion in heaven; but that there, religion and holiness of heart is raised to an

exceeding great height, to strong, high, exalted exercises of heart. Now what other kinds of such exceeding strong and high exercises of the heart, or of holiness as it has its seat in their hearts, can we devise for them, but only holy affections, high degrees of actings of love to God, rejoicing in God, admiring of God, etc.? Therefore these things in the saints and angels in heaven, are not to be despised and cashiered by the name of great heats and transports of the passions.

And it will doubtless be yet further allowed, that the more eminent the saints are on earth, and the stronger their grace is, and the higher its exercises are, the more they are like the saints in heaven—i.e. (by what has been just now observed) the more they have of high or raised affections in religion.

Though there are false affections in religion, and affections that in some respects are raised high, that are flashy, yet undoubtedly there are also true, holy and solid affections; and the higher these are raised, the better: and if they are raised to an exceeding great height, they are not to be thought meanly of or suspected, merely because of their great degree, but on the contrary to be esteemed and rejoiced in. Charity, or divine love, is in Scripture represented as the sum of all the religion of the heart; but this is nothing but an holy affection: and therefore in proportion as this is firmly fixed in the soul, and raised to a great height, the more eminent a person is in holiness. Divine love, or charity, is represented as the sum of all the religion of heaven, and that wherein mainly the religion of the church in its more perfect state on earth shall consist, when knowledge, and tongues, and prophesyings shall cease [I Cor. 13:8]; and therefore the higher this

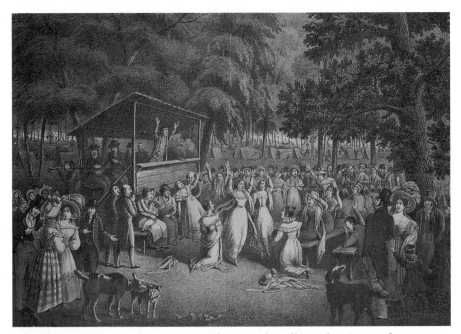

Camp meetings were important venues for revivals well into the nineteenth century. Artists like the one who produced this 1829 lithograph often depicted the high emotional fervor of these events. *Courtesy of the Library of Congress, Prints & Photographs Division.*

holy affection is raised in the church of God, or in a gracious soul, the more excellent and perfect is the state of the church, or a particular soul.

If we take the Scriptures for our rule, then the greater and higher are the exercises of love to God, delight and complacence in God, desires and longings after God, delight in the children of God, love to mankind, brokenness of heart, abhorrence of sin, and self-abhorrence for sin; and the "peace of God which passeth all understanding" [Phil. 4:7], and "joy in the Holy Ghost" [Rom. 14:17], "joy unspeakable and full of glory" [I Pet. 1:8]; admiring thoughts of God, exulting and glorying in God; so much the higher is Christ's religion, or that virtue which he and his apostles taught, raised in the soul.

It is a stumbling to some that religious affections should seem to be so powerful, so that they should be so violent (as they express it) in some persons: they are therefore ready to doubt whether it can be the Spirit of God, or whether this vehemence ben't rather a sign of the operation of an evil spirit. But why should such a doubt arise from no other ground than this? What is represented in Scripture as more powerful in its effects than the Spirit of God, which is therefore called "the power of the highest," Luke 1:35? And its saving effect in the soul [is] called "the power of godliness." So we read of the "demonstration of the Spirit and of power," I Cor. 2:4. And it is said to operate in the minds of men with "the exceeding greatness of divine power," and "according to the working of God's mighty power," Eph. 1:19. So we read of "the effectual working of his power," Eph. 3:7; and of "the power that worketh in" Christians, vs. 20; and of the "glorious power" of God in the operations of the Spirit, Col. 1:11; and of "the work of faith," its being wrought "with power," II Thess. 1:11; and in II Tim. 1:7 the Spirit of God is called the Spirit of "power, and [of] love, and of a sound mind." So [also] the Spirit is represented by a mighty wind, and by fire [Acts 2:2–3], things most powerful in their operation.

## PART III

*Shewing in many instances wherein the subjects or zealous promoters of this work have been injuriously blamed*

This work that has lately been carried on in the land is the work of God, and not the work of man. Its beginning has not been of man's power or device, and its being carried on depends not on our strength or wisdom; but yet God expects of all that they should use their utmost endeavors to promote it, and that the hearts of all should be greatly engaged in this affair, and that we should improve strength in it, however vain human strength is without the power of God; and so he no less requires that we should improve our utmost care, wisdom and prudence, though human wisdom of itself be as vain as human strength. Though God is wont to carry on such a work in such a manner, as many ways, to shew the weakness and vanity of means and human endeavors in themselves; yet at the same time, he carries it on in such a manner as to encourage diligence and vigilance in the use of proper means and endeavors, and to punish the neglect of them. Therefore in our endeavors to promote this great work, we ought to use the utmost caution, vigilance and skill, in the measures we take

in order to it. A great affair should be managed with great prudence: this is the most important affair that ever New England was called to be concerned in. When a people are engaged in war with a powerful and crafty nation, it concerns them to manage an affair of such consequence with the utmost discretion. Of what vast importance then must it be, that we should be vigilant and prudent in the management of this great war that New England now has, with so great a host of such subtle and cruel enemies, wherein we must either conquer or be conquered; and the consequence of the victory, on one side, will be our eternal destruction in both soul and body in hell; and on the other side, our obtaining the kingdom of heaven and reigning in it in eternal glory? We had need always to stand on our watch [Hab. 2:1], and to be well versed in the art of war, and not to be ignorant of the devices of our enemies, and to take heed lest by any means we be beguiled through their subtlety.

Though the Devil be strong, yet in such a war as this, he depends more on his craft than his strength. And the course he has chiefly taken from time to time, to clog, hinder and overthrow revivals of religion in the church of God, has been by his subtle, deceitful management, to beguile and mislead those that have been engaged therein; and in such a course God has been pleased, in his holy and sovereign providence, to suffer him to succeed, oftentimes in a great measure, to overthrow that, which in its beginning appeared most hopeful and glorious. The work that is now begun in New England is, as I have shown, eminently glorious; and if it should go on and prevail, would make New England a kind of heaven upon earth. Is it not therefore a thousand pities that it should be overthrown, through wrong and improper management, that we are led into by our subtle adversary, in our endeavors to promote it?

In treating of the methods that ought to be taken to promote this work, I would, I. Take notice, in some instances, wherein fault has been found with the conduct of those that have appeared to be the subjects of it, or have been zealous to promote it (as I apprehend), beyond just cause. II. I would shew what things ought to be corrected or avoided. III. I would shew positively, what ought to be done to promote this glorious work of God.

## [Ten Criticisms Answered]

I would take notice of some things at which offense has been taken without, or beyond, just cause.

[1] One thing that has been complained of, is ministers addressing themselves rather to the affections of their hearers than to their understandings, and striving to raise their passions to the utmost height, rather by a very affectionate manner of speaking and a great appearance of earnestness in voice and gesture, than by clear reasoning and informing their judgment: by which means, it is objected, that the affections are moved without a proportionable enlightening of the understanding. . . .

I think an exceeding affectionate way of preaching about the great things of religion, has in itself no tendency to beget false apprehensions of them; but on the contrary a much greater tendency to beget true apprehensions of them, than a moderate, dull, indifferent way of speaking of 'em. An appearance of affection and earnestness in the manner of delivery, if it be very great indeed, yet if it be

agreeable to the nature of the subject, and ben't beyond a proportion to its importance and worthiness of affection, and there be no appearance of its being feigned or forced, has so much the greater tendency to beget true ideas or apprehensions in the minds of the hearers, of the subject spoken of, and so to enlighten the understanding: and that for this reason, that such a way or manner of speaking of these things does in fact more truly represent them, than a more cold and indifferent way of speaking of them. If the subject be in its own nature worthy of very great affection, then a speaking of it with very great affection is most agreeable to the nature of that subject, or is the truest representation of it, and therefore has most of a tendency to beget true ideas of it in the minds of those to whom the representation is made. And I don't think ministers are to be blamed for raising the affections of their hearers too high, if that which they are affected with be only that which is worthy of affection, and their affections are not raised beyond a proportion to their importance, or worthiness of affection. I should think myself in the way of my duty to raise the affections of my hearers as high as possibly I can, provided that they are affected with nothing but truth, and with affections that are not disagreeable to the nature of what they are affected with. I know it has long been fashionable to despise a very earnest and pathetical way of preaching; and they, and they only have been valued as preachers, that have shown the greatest extent of learning, and strength of reason, and correctness of method and language: but I humbly conceive it has been for want of understanding, or duly considering human nature, that such preaching has been thought to have the greatest tendency to answer the ends of preaching; and the experience of the present and past ages abundantly confirms the same. . . .

[2] Another thing that some ministers have been greatly blamed for, and I think unjustly, is speaking terror to them that are already under great terrors, instead of comforting them. Indeed, if ministers in such a case go about to terrify persons with that which is not true, or to affright 'em by representing their case worse than it is, or in any respect otherwise than it is, they are to be condemned; but if they terrify 'em only by still holding forth more light to them, and giving them to understand more of the truth of their case, they are altogether to be justified. When sinners' consciences are greatly awakened by the Spirit of God, it is by light imparted to the conscience, enabling them to see their case to be, in some measure, as it is; and if more light be let in, it will terrify 'em still more: but ministers are not therefore to be blamed that they endeavor to hold forth more light to the conscience, and don't rather alleviate the pain they are under, by intercepting and obstructing that light that shines already. To say anything to those who have never believed in the Lord Jesus Christ, to represent their case any otherwise than exceeding terrible, is not to preach the Word of God to 'em; for the Word of God reveals nothing but truth; but this is to delude them. Why should we be afraid to let persons that are in an infinitely miserable condition, know the truth, or bring 'em into the light, for fear it should terrify them? 'Tis light that must convert them, if ever they are converted. The more we bring sinners into the light, while they are miserable, and the light is terrible to them, the more likely it is that by and by the light will be joyful to them. The ease, peace and comfort, that natural men enjoy, have their foundation in darkness and blindness; therefore as that darkness vanishes, and light comes in, their peace

vanishes and they are terrified: but that is no good argument why we should endeavor to hold their darkness, that we may uphold their comfort. The truth is, that as long as men reject Christ, and don't savingly believe in him, however they may be awakened, and however strict, and conscientious, and laborious they may be in religion, they have the wrath of God abiding on them; they are his enemies, and the children of the Devil (as the Scripture calls all that ben't savingly converted, Matt. 13:38; I John 3:10), and 'tis uncertain whether they shall ever obtain mercy: God is under no obligation to shew 'em mercy, nor will he be, if they fast and pray and cry never so much; and they are then especially provoking God, under those terrors, that they stand it out against Christ, and won't accept of an offered Saviour, though they see so much need of him: and seeing this is the truth, they should be told so, that they may be sensible what their case indeed is.

To blame a minister for thus declaring the truth to those who are under awakenings, and not immediately administering comfort to them, is like blaming a surgeon because when he has begun to thrust in his lance, whereby he has already put his patient to great pain, and he shrinks and cries out with anguish, he is so cruel that he won't stay his hand, but goes on to thrust it in further, till he comes to the core of the wound. Such a compassionate physician, who as soon as his patient began to flinch, should withdraw his hand, and go about immediately to apply a plaster, to skin over the wound, and leave the core untouched, would be one that would heal the hurt slightly, crying, "Peace, peace, when there is no peace" [Jer. 6:14; 8:11]. . . .

[3] What has more especially given offense to many, and raised a loud cry against some preachers, as though their conduct were intolerable, is their frighting poor innocent children with talk of hell fire and eternal damnation. But if those that complain so loudly of this really believe what is the general profession of the country, viz. that all are by nature the children of wrath and heirs of hell; and that every one that has not been born again, whether he be young or old, is exposed every moment to eternal destruction, under the wrath of Almighty God; I say, if they really believe this, then such a complaint and cry as this bewrays a great deal of weakness and inconsideration. . . .

[4] Another thing that a great deal has been said against, is having so frequent religious meetings, and spending so much time in religion. And indeed, there are none of the externals of religion but what are capable of excess: and I believe it is true, that there has not been a due proportion observed in religion of late. We have placed religion too much in the external duties of the First Table; we have abounded in religious meetings and in praying, reading, hearing, singing, and religious conference; and there has not been a proportionable increase of zeal for deeds of charity and other duties of the Second Table (though it must be acknowledged that they are also much increased). But yet it appears to me that this objection of persons' spending too much time in religion, has been in the general groundless. Though worldly business must be done, and persons ought not to neglect the business of their particular callings, yet 'tis to the honor of God that a people should be so much in outward acts of religion, as to carry in it a visible, public appearance of a great engagedness of mind in it, as the main business of life. And especially is it fit, that at such an extraordinary time, when God appears unusually present with a people, in wonderful works

of power and mercy, that they should spend more time than usual in religious exercises, to put honor upon that God that is then extraordinarily present, and to seek his face. . . .

[5] The frequent preaching that has lately been, has in a particular manner been objected against as unprofitable and prejudicial. 'Tis objected that when sermons are heard so very often, one sermon tends to thrust out another; so that persons lose the benefit of all: they say two or three sermons in a week is as much as they can remember and digest. Such objections against frequent preaching, if they ben't from an enmity against religion, are for want of duly considering the way that sermons usually profit an auditory. . . .

[6] Another thing wherein I think some ministers have been injured, is in being very much blamed for making so much of outcries, faintings, and other bodily effects; speaking of them as tokens of the presence of God, and arguments of the success of preaching; seeming to strive to their utmost to bring a congregation to that pass, and seeming to rejoice in it, yea, even blessing God for it, when they see these effects.

Concerning this I would observe, in the first place, that there are many things with respect to cryings out, falling down, etc., that are charged on ministers, that they are not guilty of. Some would have it, that they speak of these things as certain evidences of a work of the Spirit of God on the hearts of their hearers, or that they esteem these bodily effects themselves to be the work of God, as though the Spirit of God took hold of, and agitated the bodies of men; and some are charged with making these things essential, and supposing that persons can't be converted without them; whereas I never yet could see the person that held either of these things.

But for speaking of such effects as probable tokens of God's presence, and arguments of the success of preaching, it seems to me they are not to be blamed; because I think they are so indeed: and therefore when I see them excited by preaching the important truths of God's Word, urged and enforced by proper arguments and motives, or are consequent on other means that are good, I don't scruple to speak of them, and to rejoice in them, and bless God for them as such; and that for this (as I think) good reason, viz. that from time to time, upon proper inquiry and examination, and observation of the consequence and fruits, I have found that there are all evidences that the persons in whom these effects appear, are under the influences of God's Spirit, in such cases. Cryings out, in such a manner and with such circumstances, as I have seen them from time to time, is as much an evidence to me, of the general cause it proceeds from, as language: I have learned the meaning of it the same way that persons learn the meaning of language, viz. by use and experience. I confess that when I see a great crying out in a congregation, in the manner that I have seen it, when those things are held forth to 'em that are worthy of their being greatly affected by, I rejoice in it, much more than merely in an appearance of solemn attention, and a shew of affection by weeping; and that because there have been those outcries, I have found from time to time a much greater and more excellent effect. To rejoice that the work of God is carried on calmly, without much ado, is in effect to rejoice that 'tis carried on with less power, or that there is not so much of the influence of God's Spirit: for though the degree of the influence of the Spirit of God on particular persons, is by no means to be judged of by the degree of

external appearances, because of the different constitution, tempers, and circumstances of men; yet if there be a very powerful influence of the Spirit of God on a mixed multitude, it will cause, some way or other, a great visible commotion.

And as to ministers aiming at such effects, and striving by all means to bring a congregation to that pass, that there should be such an uproar among them; I suppose none aim at it any otherwise than as they strive to raise the affections of their hearers to such an height, as very often appears in these effects; and if it be so, that those affections are commonly good, and it be found by experience that such a degree of them commonly has a good effect, I think they are to be justified in so doing. . . .

Thus I have (I hope, by the help of God) finished what I proposed. I have taken the more pains in it because it appears to me that now God is giving us the most happy season to attempt an universal reformation, that ever was given in New England. And 'tis a thousand pities that we should fail of that which would be so glorious, for want of being sensible of our opportunity, or being aware of those things that tend to hinder it, or our taking improper courses to obtain it, or not being sensible in what way God expects we should seek it. If it should please God to bless any means for the convincing the country of his hand in this work, and bringing them fully and freely to acknowledge his glorious power and grace in it, and engage with one heart and soul, and by due methods, to endeavor to promote it, it would be a dispensation of divine providence that would have a most glorious aspect, happily signifying the approach of great and glorious things to the church of God, and justly causing us to hope that Christ would speedily come to set up his kingdom of light, holiness, peace and joy on earth, as is foretold in his Word. "Amen: even so, come, Lord Jesus!" [Rev. 22:20].

# CHARLES CHAUNCY

Charles Chauncy (1705–87), a Congregationalist minister, was a staunch opponent of the New England revivals and of the evangelical style endorsed by Edwards. He traveled widely to gather firsthand accounts of the revival's emotional excesses for his book *Seasonable Thoughts on the State of Religion in New-England*, which was published shortly after Edwards's *Some Thoughts Concerning the Present Revival of Religion* appeared. While never as widely read as Edwards's piece, Chauncy's *Seasonable Thoughts* remains important as an early and thoroughgoing critique of revivalist impulses from a rationalist perspective, one that would share much with later historical manifestations of religious liberalism.

# *From* Seasonable Thoughts on the State of Religion in New-England

. . . The true Account to be given of the *many* and *great* Mistakes of the present Day, about the *SPIRIT's* Influence, is not the *Newness* of the Thing, the not having *felt it before*; but a *notorious* Error generally prevailing, as to the *Way* and *Manner* of judging in this Matter. People, in order to know, whether the Influences they are under, are from the SPIRIT, don't carefully examine them by the *Word of GOD*, and view the *Change* they produce in the *moral State* of their *Minds* and of their *Lives*, but hastily conclude such and such *internal Motions* to be *divine Impressions*, meerly from the *Perception* they have of them. They are ready, at once, if this is *unusual*, or *strong*, to take it for some Influence from above, to speak of it as such, and to act accordingly. This is the Error of the present Day; and 'tis indeed the *proton Pseudos*, the first and grand Delusion: And where this prevails, we need not be at a loss to know the *true Spring* of other Errors.—As to the *Multitudes* who are bro't into such *new*, and (to them) *unheard of Circumstances*, 'tis true, they are *illiterate*, and *young* People; but this notwithstanding, if the *Newness* of their Circumstances is such as is proper to *new Creatures*, they will, in their *general Behaviour*, discover the *true Spirit* and *Genius* of this Sort of Persons. 'Tis a great Mistake to think, that the *new Nature*, or those *Influences* that produce it, however extraordinary, are apt to put Men upon making *wrong* and *strange* Judgments, either of *Persons* or *Things:* They have a contrary Tendency: and 'tis a Reproach to them both, to suppose otherwise. A meer *passionate* Religion, 'tis true, has always led to this, and always will; but not that, which enlightens the Understanding, renews the Will, and makes the Heart good and honest.—How far 'tis a Truth, that *this People* have *scarce* heard of such a Thing as the *Outpouring* of the SPIRIT of GOD, or had *no Notion* of it, may admit of Dispute; but that the *Outpouring* of the SPIRIT should introduce *such a State of Things*, as that those *upon whom* he has been *poured out*, should *not know how to behave*, will, I think, admit of no good Plea in its Defence. 'Tis a plain Case, one of the *main Ends* of the *Out-pouring* of the SPIRIT, is to dispose and enable People to behave as *Christians*, in their various *Stations*, *Relations* and *Conditions* of Life; and if instead of this, they are thrown into such a *strange State*, as that they can't behave as they ought to do, not in here and there a perplext Case, but in some of the most *obvious* and *essential* Points of Practice; let who will call this an *Outpouring* of the SPIRIT, 'tis not such an one as the *Bible* knows any Thing of. And 'tis nothing short of a gross Reflection on the *blessed SPIRIT,* to speak of *him* as *wonderfully* poured out upon a People, and, at the same Time, to suppose such a State of Things arising therefrom, as that People may run into *very ill Conduct*, and it not be thought *strange*, if they do so.—What is observ'd of People's *Readings* to hearken to those, who have been the *Instruments* of bringing them into their present Circumstances, I own, is no other than might be expected: Nor

have I any Doubt, upon my Mind, whether the *Disorders*, so *general* in this Land, had their *Rise* from these Persons. But *Schism*, and *Confusion*, and other *evil Works*, won't change their Nature, be their *Origin* in *People* themselves, or their *Leaders*.

It is still urged, "That when Persons are *extraordinarily* affected with a recent Discovery of the Greatness and Excellency of the divine Being, the Certainty and infinite Importance of eternal Things, the Preciousness of Souls, and the dreadful Danger and Madness of Mankind, together with a great Sense of GOD's distinguishing Kindness and Love to them; no Wonder that now they think they must exert themselves, and do something extraordinary, for the Honour of God, and the Good of Souls, and know not how to forbear speaking and acting with uncommon Earnestness and Vigour. And in these circumstances, if they ben't Persons of uncommon Steadiness and Discretion, or han't some Persons of Wisdom to direct them, 'tis a Wonder, if they don't proceed without due Caution, and do Things that are irregular, and will, in the Issue, do more Hurt than Good." 'Tis readily granted, Persons under a just and strong Sense of divine Things, will exert themselves with an awaken'd Activity in the Business of Religion. 'Twould be no Wonder, if those who had *extraordinary* Discoveries of GOD, were, to an *extraordinary* Degree, filled with Lowliness and Humility, and such an Awe and Reverence of the divine Majesty, as would make them *eminently* circumspect in their whole Deportment towards him; if from the *uncommon* View they had of his Perfections, they were, in an *uncommon* Manner, transformed into his Likeness, appearing in the World *lively Images* of that Goodness, Righteousness, Faithfulness, Kindness, Mercy, Patience and Long-suffering, which are the *moral Glory* of the infinitely perfect Being. 'Twould be no Wonder, if those, who had upon their Minds an *extraordinary* Sense of the *Preciousness of Souls*, discovered extraordinary Care and Pains in working out the Salvation of their *own Souls*; if they were observably *diligent* in *adding to their Faith, Virtue; to Virtue, Knowledge; to Knowledge, Temperance; to Temperance, Patience; to Patience, Godliness; to Godliness, Brotherly-Kindness; and to Brotherly-Kindness, Charity: For they that lack these Things are blind* to the Worth of their *own Souls*; whereas, they *that do them* make it evident that they regard their Souls: *For so an Entrance shall be ministred to them abundantly, into the everlasting Kingdom of our* LORD *and* SAVIOUR JESUS CHRIST. In like Manner, 'twould be no Wonder, if those who had an *extraordinary* View of the *Danger* and *Madness* of those who neglect their Souls, were *proportionably* active, within their *proper Sphere*, in Endeavours to do them all the Service they could; if they were ready with their Advice, their Counsel, their Prayers, their Intreaties, to beget in them a just Concern about Salvation: Nor would they be "worthy of *Indignation*, and be beyond *Compassion*," if, through an *indiscreet Zeal* they should, now and then, be betray'd into Weaknesses and Excesses. These are Things, not to be wondered at; they are no other than might reasonably be expected. But the Wonder is, how an *extraordinary* Discovery of the Greatness and Excellency of GOD, the Importance of eternal Things, and the Preciousness of Souls, and the Danger of their perishing, should make Men vain and conceited, full of themselves, and apt to throw Contempt on others; how it should loosen Men's Tongues to utter such Language as would not be seemly, even in those who profess no Sense of GOD, or divine Things; how it should lead them into wrong Sentiments in

Religion, blind their Eyes as to some of the most plain Points of Doctrine; and in a Word, dispose them to such Things as are called in Scripture, the *Works of the Flesh.*

These don't look like the Fruit of *extraordinary* Discoveries of GOD; but they are the very Things which may be expected, where Men's *Passions* are rais'd to an *extraordinary* Height, without a proportionable Degree of Light in their Understandings.

Such *high Affections,* I know, are freely spoken of as owing to the Influence of the SPIRIT of GOD; and this, when there is not given *"Strength of Understanding in Proportion; and by Means hereof, the Subjects of these Affections may be driven, through Error, into an irregular and sinful Conduct."* But it may justly be question'd, whether *extraordinary Warmth* in the *Passions,* when there is not *answerable Light* in the *Mind,* is so much owing to the SPIRIT of GOD, as some may be ready to imagine. For is it reasonable to think, that the *Divine SPIRIT,* in dealing with Men in a Way of Grace, and in Order to make them good Christians, would give their *Passions* the *chief* Sway over them? Would not this be to invert their Frame? To place the Dominion in those Powers, which were made to be kept in Subjection? And would the alwise GOD introduce such a State of Things in the human Mind? Can this be the Effect of the *Out-pouring* of his SPIRIT? It ought not to be supposed. One of the most *essential* Things necessary in the *new-forming* Men, is the Reduction of their *Passions* to a proper Regimen, i.e. The Government of a *sanctified Understanding:* And 'till this is effected, they may be called *New-Creatures,* but they are far from deserving this Character. *Reasonable* Beings are not to be guided by *Passion* or *Affection,* though the Object of it should be GOD, and the Things of another World: They need, even in this Case, to be under the Government of a *well instructed Judgment:* Nay, when Men's *Passions* are raised to an *extraordinary* Height, if they have not, at the same Time, a due Ballance of *Light* and *Knowledge* in their Minds, they are so far from being in a more desirable State on this Account, that they are in Circumstances of extreme Hazard. There is no Wildness, but they are liable to be hurried into it; there is no Temptation, but they are expos'd to be drawn aside by it: Nor has the Devil ever greater Advantage against them, to make a Prey of them, and lead them captive at his Will. And this has often been verified by sad Experience. Who can boast of greater Transports of Affection, than the wildest Enthusiasts? Who have had their Passions excited to a higher Pitch, than those of the ROMISH Communion? Who have been more artful in their Addresses to the *Passions,* than *Popish Priests*? And who more successful, by *heating* the *Affections* of People, to establish Error and Delusion? Nay, what Engine has the *Devil* himself ever made Use of, to more fatal Purposes, in all Ages, than the *Passions* of the *Vulgar* heightened to such a Degree, as to put them upon acting without Thought and Understanding? The plain Truth is, an *enlightened Mind,* and not *raised Affections,* ought always to be the Guide of those who call themselves Men; and this, in the Affairs of Religion, as well as other Things: And it will be so, where GOD really works on their Hearts, by his SPIRIT. 'Tis true, "the End of the Influence of the SPIRIT of GOD is not to increase Men's natural Capacities:" But 'tis to fit their Powers for religious Exercise, and preserve them in a State of due Subordination. 'Tis as much intended to *open the Understanding,* as to *warm the Affections;* and not only so, but to keep the *Passions* within their proper Bounds,

restraining them from usurping Dominion over the *reasonable* Nature. 'Tis true likewise, "GOD has not oblig'd himself immediately to increase *civil Prudence*, in Proportion to the Degrees of *spiritual Light*." But if it shall please GOD to visit Men with the Influences of his SPIRIT, it may justly be expected, that he should increase their *moral* or *religious* Prudence; that, if he should give them *spiritual Light*, it should be for their Instruction in the Knowledge of what is *Sin*, and what is *Duty*. . . .

I have hitherto considered *Ministers* as the Persons, more especially obliged to discountenance the bad Things, prevailing in the Land; and now go on to observe.

That this is the Duty of *all in general*. Not that I would put any upon acting out of their *proper Sphere*. This would tend rather to Confusion than Reformation.—Good Order is the Strength and Beauty of the World.—The Prosperity both of *Church* and *State* depends very much upon it. And can there be Order, where Men transgress the Limits of their Station, and intermeddle in the Business of others? So far from it, that the only effectual Method, under GOD, for the Redress of *general Evils,* is, for *every one* to be faithful, in doing what is *proper* for him in his *own Place:* And even *all* may *properly* bear a Part, in *rectifying the Disorders* of this Kind, at this Day.

*Civil Rulers* may do a great deal, not only by their *good Example*, but a wise Use of their *Authority*, in their various Places, for the Suppression of every Thing hurtful to Society, and the Encouragement of whatever has a Tendency to make Men happy in the Enjoyment of their Rights, whether *natural* or *Christian*. And herein chiefly lies, (as I humbly conceive) the Duty of Rulers, at this Day. 'Tis true, as *private Men*, they are under the same Obligations with others, to make their Acknowledgments to CHRIST; and doubtless, if HE was *visibly* and *externally* (according to the Custom among *Kings* and *Governors*) to make his solemn Entry into the Land, as their SAVIOUR and LORD, "it would be expected they should, as *public Officers*, make their Appearance, and attend him as their *Sovereign* with sutable Congratulations, and Manifestations of Respect and Loyalty; and if they should stand at a Distance, it would be much more taken Notice of, and awaken his Displeasure much more, than such a Behaviour in the common People." But the Case is widely different, where his supposed Entry is in a *spiritual Sense only, and after such a Manner* even in this Sense, as that there is a *great Variety of Sentiments* about it, among the *best Sort* of Men, of all Ranks and Conditions: Nor does it appear to me, when the Case is thus circumstanc'd, that it is either the *Duty* of *Rulers*, or would be Wisdom in them, by any *authoritative Acts* to determine, whose Sentiments were the most agreable to Truth. And as to their Appointment of Days of *Thanksgiving*, or *fasting*, on this Account, there must be an Impropriety in it, so long as that Complaint of GOD against the *Jews* is to be seen in the *Bible, Behold ye fast for Strife and Debate!* Their *Duty* rather lies in keeping Peace between those, who unhappily differ in their Thoughts about the State of our religious Affairs: And their Care in this Matter ought to be *impartial*. Each Party, without Favour or Affection, should be equally restrain'd from Outrage and Insult. Those, who may think themselves Friends to a *Work of GOD*, should be protected in the Exercise of all their *just Rights*, whether as *Men*, or *Christians:* So on the other Hand, those who may be Enemies to *Error* and *Confusion*, have the same Claim to be protected.

And if, on either Side, they invade the Rights of others, or throw out Slander, at Random, to the Hurt of their Neighbour's Reputation and

Usefulness, and the bringing forward a State of Tumult and Disorder; I see not but the *civil Arm* may justly be stretched forth for the Chastisement of such Persons; and this, though their Abuses should be offered in the Name of the LORD, or under the Pretext of the most flaming Zeal for the REDEEMER'S *Honour*, and serving the Interest of *his Kingdom:* For it ought always to be accounted an Aggravation of the Sin of *Slander*, rather than an Excuse for it, its being committed under the *Cloak of Religion*, and Pretence for the *Glory of GOD;* as it will, under these Circumstances, be of more pernicious Tendency. I am far from thinking, that any Man ought to suffer, either for his *religious Principles*, or *Conduct* arising from them, while he is no Disturber of the *civil Peace;* but when Men, under the Notion of appearing zealous for GOD and *his Truths*, insult their Betters, vilify their Neighbours, and spirit People to Strife and Faction, I know of no Persons more sutable to be taken in Hand by *Authority:* And if they suffer 'tis for their own Follies; nor can they reasonably blame any Body but themselves: Nor am I asham'd, or afraid, to profess it as my Opinion, that it would probably have been of good Service, if those, in these Times, who have been publickly and out-ragiously reviled, had, by their Complaints, put it properly in the *Magistrates* Power, to restrain some Men's *Tongues* with *Bit* and *Bridle*.

    *Private Christians* also, of all Ranks and Conditions, may do something towards the Suppression of these *Errors*, by mourning before the LORD the Dishonour which has hereby been reflected on the Name of CHRIST, and Injury done to Souls; by being much in Prayer to GOD for the Out-pouring of his SPIRIT, in all desirable Influences of Light, and Love, and Peace; by taking good Heed that they ben't themselves drawn aside, avoiding to this End, the Company and familiar Converse of those, who, by *good Words* and *fair Speeches*, might be apt to deceive their Hearts, but especially an Attendance on religious Exercises, where the *Churches* and *Ministry* are freely declaimed against by those who have gone out from them, under the vain Pretence of being more holy than they; and in fine, by a faithful Performance of those Duties, which arise from the various Relations they sustain towards each other: As thus, if they are *Children*, by hearkening to the Advice of their *Parents*, and obeying and honouring them in the LORD; and if they are *Parents*, by counseling, reproving, warning, restraining, and commanding their *Children*, as there may be Occasion: If they are *Servants*, by pleasing their *Masters* well in all Things, not defrauding them of their Time or Labour, but accounting them worthy of all Honour, that the Name of GOD be not blasphemed; and, if they are *Masters*, not only by providing for their *Servants* Things honest and good, but by keeping them within the Rules of Order and Decorum, not suffering them to neglect the Religion of the Family at home, under Pretence of carrying it on elsewhere; especially, when they continue abroad 'till late in the Night, and so as to unfit themselves for the Services of the following Day.

    In these, and such like Ways, *all* may exert themselves in making a Stand against the Progress of Error: And *all* are oblig'd to do so; and for this Reason, among others I han't Room to mention, because the *last Days* are particularly mark'd out in the *Prophecies* of *Scripture*, as the Times wherein may be expected, the Rise of SEDUCERS. . . .

    'Tis true, we read of the coming on of a *glorious State* of Things in the LAST DAYS: Nor will the *Vision fail*.—We may rely upon it, the Prophesies, foretelling the Glory of the REDEEMER'S *Kingdom*, will have their Accomplishment to the

making this Earth of *Paradise*, in Compare with what it now is. But for the *particular Time* when this will be, it *is not for us to know it, the Father having put it in his own Power:* And whoever pretend to such Knowledge, they are wise above what is written; and tho' they may think they know much, they really know nothing as to this Matter.

It may be suggested, that "the *Work of* GOD'S SPIRIT that is so extraordinary and wonderful, is the *dawning*, or at lest, a *Prelude* of that *glorious Work of GOD*, so often foretold in Scripture, which, in the Progress and Issue of it, shall renew the whole World." But what are such Suggestions, but the Fruit of Imagination? Or at best, uncertain Conjecture? And can any good End be answered in endeavouring, upon Evidence absolutely precarious, to instill into the Minds of People a Notion of the *millenium* State, as what is NOW going to be introduced; yea, and of AMERICA, as that Part of the World, which is pointed out in the *Revelations* of GOD for the Place, where this glorious Scene of Things, "will, probably, first begin?" How often, at other Times, and in other Places, has the Conceit been propagated among People, as if the Prophecies touching the Kingdom of CHRIST, in the *latter Days*, were NOW to receive their Accomplishment? And what has been the Effect, but their running wild? So it was in GERMANY, in the Beginning of the Reformation. The *extraordinary* and *wonderful* Things in that Day, were look'd upon by the Men then thought to be most under the *SPIRIT's immediate* Direction, as "the Dawning of that glorious Work of GOD, which should renew the whole World;" and the Imagination of the Multitude being fired with this Notion, they were soon perswaded, that the Saints were now to reign on Earth, and the Dominion to be given into their Hands: And it was under the Influence of this vain Conceit, (in which they were strengthened by *Visions, Raptures* and *Revelations*) that they took up *Arms* against the lawful *Authority*, and were destroy'd, at one Time and another, to the Number of an HUNDRED THOUSAND. . . .

And 'tis well known, that this same Pretence of the near Approach of the MILLENIUM, the *promised Kingdom of the* MESSIAH, was the *Foundation-Error of* the *French Prophets*, and those in their Way, no longer ago than the Beginning of this Century: And so infatuated were they at last, as to publish it to the World, that the glorious Times they spake of, *would be manifest over the whole Earth, within the Term of* THREE YEARS. And what Set of Men have ever yet appear'd in the Christian World, whose Imaginations have been thorowly warmed, but they have, at length, wrought themselves up to a *full Assurance*, that NOW was the Time for the Accomplishment of the Scriptures, and the Creation of the *new Heavens*, and the *new Earth*? No one Thing have they more unitedly concurred in, to their own shameful Disappointment, and the doing unspeakable Damage to the Interest of Religion.—A sufficient Warning, one would think, to keep Men modest; and restrain them from Endeavours to lead People into a Belief of that, of which they have no sufficient *Evidence;* and in which, they may be deceived by their *vain Imaginations*, as Hundreds and Thousands have been before them.

There are unquestionably many Prophecies concerning CHRIST, and the *Glory of his Kingdom*, still to be fulfilled; and it may be of good Service to labour to beget in People a Faith in these Things; or, if they have Faith, to quicken and strengthen it: But it can answer no good End to lead People into the Belief of any *particular* Time, as the Time *appointed* of GOD for the Accomplishment of these Purposes of his Mercy; because this is one of those Matters, his Wisdom has

thought fit to keep conceal'd from the Knowledge of Man. Our own Faith there-
fore upon this Head can be founded only on *Conjecture;* and as 'tis only the like
*blind Faith* we can convey to others, we should be cautious, lest their Conduct
should be agreeable to their Faith. When they have imbib'd from us the
Thought, as if the *glorious Things,* spoken of in Scripture, were to come forward
in their Day, they will be apt (as has often been the Case) to be impatient, and
from their *Officiousness* in tendring their Help where it is not needed, to disserve
the Interest of the Redeemer.

# Charles Woodmason

Charles Woodmason (c. 1720–76) was an Anglican minister who left
wealthy Charleston, South Carolina, for religious work in the rough
Carolina backcountry. There he stayed for six years, traveling thousands of
miles and organizing more than thirty congregations across a wide span of
land. From his journal and sermons, we know that Woodmason found his
formal style of worship frequently scorned and undermined by residents
whom he deemed primitive and uncivilized, hailing from diverse ethnic
and religious backgrounds. Evangelical groups especially predominated,
and it was hard to say whether they or the unchurched did more to inter-
rupt his services and attempt to drive out Anglicanism from their midst
(one group even laid a pile of human excrement upon the communion al-
tar in Woodmason's church). Woodmason was, in turn, horrified by what
he perceived to be the excesses and blasphemies of sectarian religion and
feral irreligion and worked assiduously to restore holy order to religious
life in the region. He aimed his 1770 sermon, "I Cor. 14 v. 40 Let all Things
be done decently & in order," at congregations that were not yet accus-
tomed to ordered worship.

# I Cor. 14 v. 40 Let All Things Be Done Decently and in Order

You have now, my Brethren, the Happiness of a place of Worship to assemble in,
under Sanction of the Laws, and our Church establishment. Wherefore I hope to
see all of you from time to time behave with that Gravity, Reverence, and

"BV Woodmason, Charles" courtesy of The New-York Historical Society.
Copied from the original at the NY Historical Society, RMG.

Devotion as becomes a Christian Congregation—that you may be a Pattern to your Neighbours, and your name smell as a sweet Savour to all afar off. Provoking others to an Imitation of you in Welldoing and in the Decent, Religious Performance of the Public Service of God.

By frequenting Divine Service and your Demeanour in it, you give a sample of yourselves, and Strangers may estimate therefrom your Knowledge in, and Practise of Religion how you are affected in your minds and behave in your Private Retirements—for they who will be rude at Church cannot be polite elsewhere.

We find in the Gospel that Christ promised his blessings to public services, where 2 or 3 are gathered together in his Name; and therefore the public devotion must be preferred before private—and public Communion hath always been accounted necessary in order to our letting our light shine before Men, and making known to the world what opinion we are of. Now the public articles and Confession of Faith of the Church of England is fully known to all the world, therefore by your assembling here your Faith and Belief as to Religion is hereby declared and known to all.

If then you are true members of this our Church, you will religiously abstain from going to any schismatical congregations, who hold opinions contrary to any of the Great Articles of Christianity, or who separate from the public worship legally established lest you be reckoned of their Party or persuasion. For all such separate meetings are breaches of charity, and lead to the propagation of new heresies, or revival of old ones. Besides, it is countenancing of them in their errors, and argues a vanity of mind. For God will give his blessing to us especially, who worship him in the way of his Ordinances; where he himself hath regularly placed us—He being the God of order, not of confusion.

When therefore you visit this House of Prayer, come with a proper disposition of mind and heart—Think that you are going to appear before God in an especial manner—to pay the homage due to your God and Creator and Benefactor—to magnify and extol him for his infinite Perfection—to thank and honour Him for his mercies vouchsafed to mankind. By humble prayer, and supplication, to beg a continuance of all good things we enjoy and a supply of those we want. By your example, managing as much as you can, the practice of religion and piety in the province. . . .

Always continue to come before Service begins—which you may do, as we begin so late. Tis but putting and getting things in order over night—whereas many will hardly set about it till Sunday morning. Contrive too, to go as early as possible to rest on Saturday night so that you may rise early and refresh'ed on the Lords day and not be hurry'd in dressing, and ordering matters. The coming late to sermons discourages people, for lack of company—and coming in after Service is begun is very troublesome—Disturbs both me and ev'ry one and should be avoided as much as possible—But if it is unavoidable, pray enter leisurely—tread softly—nor disturb any who are on their knees or are intent on their devotions. Bring no dogs with you—they are very troublesome—and I shall inform the Magistrate of those who do it, for it is an affront to the Divine Presence which we invoke, to be in the midst of us, and to hear our prayers, to mix unclean things with our Services.

When you are seated—do not whisper, talk, gaze about—shew light Airs, or behaviour—for this argues a wandering mind and irreverence toward God; is

unbecoming religion, and may give scandal and offense to weak Christians—Neither sneeze or cough, if you can avoid it—and to not practice that unseemly, rude, indecent custom of chewing or of spitting, which is very ridiculous and absurd in public, especially in women and in God's House. If you are thirsty—pray drink before you enter or before Service begins, not to go out in midst of prayer, nor be running too and fro like Jews in their Synagogues—except your necessary occasions should oblige you—Do you see anything like it in Charles Town or among well bred people. Keep your children as quiet as possible. If they will be fractious, carry them out at once for I will not have Divine Worship now consider'd by you, as if I was officiating in a private house. But remember, that you are now under authority—and that those who will not behave properly will be made and that the penalty for disturbing any minister while he is at Service, is one hundred pounds Sterling, and 3 years imprisonment. Wherefore I entreat you to behave with all respect toward your maker with silence and inoffensiveness towards each other—so that it may be said of you that not a Congregation in C.T. or the Province observes better order and good manners than this. When you are come to your bench in the first place kneel, and thank God for all his mercies, and particularly for this one on one opportunity of appearing before Him—beseeching Him to bless me and this congregation—to assist us in what we are about to do—to accept what we shall do—to pardon our infirmities and to do abundantly more for us, than we are either about to ask or think, for J.C. his Sake.

While the *Exhortation* is reading, stand gravely, and seriously mind what is there said resolving by the help of God, to keep your thoughts so fix'd on ev'ry part of the Service, as the Worship of the Great, the Dreadful, the Almighty God, and the salvation of your souls, require.

At the Confession, all of you are reverently to kneel—and repeat each sentence with the seriousness of heart and sincerity of mind, as this so solemn and religious act requires. And when I rise to pronounce the absolution, you are still to remain kneeling, and attend to it and receive it with all gladness and humility of mind: begging that this pardon which God hath given his minister power to pronounce in general, may be apply'd to yr selves in particular and that these'd mercifully pardon all your offences.

When the Lord's Prayer is read, you are to join in it and repeat it—and regard and mind the full and comprehensive sense of each petition. . . .

As You are not to omit any Opportunity of coming to Church (and I beg You would come on every Festival, as well as Sunday—'Tis but once in a Month) so are You not to neglect that Holy Sacrament whenever administer'd. . . .

When the Psalms are sung, all of you join with one heart and with one voice. Those among you who have tolerable voice, and a good ear, and who have not yet learn'd the tunes I beg, I earnestly entreat, would learn them. . . . And let me also entreat that you would stand while the Psalms or Hymns are singing—Hereby shewing Reverence to your Maker and doing honour to yourselves. This will make you well spoke of, and to be esteem'd by all well wishers to religion, of ev'ry denomination. Let us be a match for any dissenting congregation in this particular—for what can be more pleasant, a more delightful

task—and if in your families, you would sing an Hymn, ev'ry morning and evening, or after meals, how pleasing, how Christian would this be! . . .

Sermons are, of ordinary means, which God hath appointed for your instruction—and therefore you are to be very attentive to the explication of the Word of God. . . . Many among you possibly prefer extempore sermons, to those which are premeditated, and may call my mode of delivery, rather *reading* than *preaching*—'Tis true, extempore discourses have their peculiar merit—but there is hardly one man in the world, but will speak better and more useful sense, premediately, than extempore. Those who speak extempore, may deliver what they say with more heart, and so affect the passions; but he that writes down what he says, speaks with more consistency, and will more convince your judgment. And if we look on a sermon to be any way in reference to God, surely it ought to be as sensible, and consistent as we can frame it. We are not to offer the lame and blind to the most Holy—But to Him who hath given the Speech of language, utterance, and expression, we ought to honour by the most elegant and choicest diction—the most refin'd sentiments we can possibly devise. . . .

When Children are baptiz'd, join solemnly in all the Service—and pay due attention—Do not quit the Chapel, and move off, but decently attend. Because you are to be witnesses of this solemnity, and yr prayers are desired and requr'd on behalf of the child. And when Baptism is administer'd, let it put you in mind of your duty as Christians, and examine yourselves, how you have kept your baptismal vow—and heartily and devoutly pray, that the child, or children may have Grace to live some way agreeable to our Holy Religion into which he is admitted and become a useful and valuable member of society.

Ev'ry Sunday afternoon, I purpose catechizing as many of you, young and old, as can possibly attend—And you who live at a distance, may sometimes stay—[I daresay here are those who would entertain You for a night]—and I would have as many of you elderly people attend as can conveniently—For don't think of any time lost to hear of fundamentals of Christianity enforc'd and explain'd. For it is by them that you as well as the Children can be saved. It will put several things into your mind, which either you did not mind before, or had forgot. Thus you will benefit yourselves as well as countenance religion and the public service; and it will encourage the children, and do them good.

Where Banns are publish'd—Don't make it a matter of sport: but let it stir you up to put up a petition to heav'n for a blessing of God upon the parties—and you that are married, let it put you in mind of your own vows and promises made as marriage, and how you have perform'd them: for marriage is the most solemn engagement among men—and most sacred—as being a vow made before God, as witness'd to before men, in a fase of the greatest moment in this life, and therefore in all respects a proper occasion for seriousness and devotion.

When the sick are mentioned by me, to be pray'd for, pray for them heartily, as you that others should do for you. If you were in like care and if God would give them patience and thankfulness and make both their sickness and death itself, who ever it shall happen, a real blessing to them.

I desire to be sent for when any of you are sick, if you may enquire into the state of your souls and fit them for another state, should God please to call you from hence—And let me exhort you to visit one another when sick, and to ren-

der all kind of neighbourly offices each for others in these cases. Do all you can to comfort and relieve them—Give them good advice—and exhort them to repentance and amendment of life, should it please God they recover.

I desire that you would endeavor to send for me when any corpse must be interred, bring all corpses to be decently interr'd in this public burial ground. I shall be always ready to come over for due notice and attend on such occasions—and possibly give you discourses suitable to the serious solemnity for I think any time only properly employ'd when engaged in religious offices.

I shall give you a sermon on ev'ry festival and therein explain to you their use, and reason of their institution—and I hope (as I said before) that you will not be backward in attending divine service on those days—hereby you will by degrees discover the beauty, harmony, and structure of the Church of England—How near she come to the primitive Church—and how correspondent all her precepts and institutions are, to the simplicity of the Gospel and spirit of Christianity. She keeps the mean between the 2 Ephesans—Popery and bigotry, on the one Hand—and Presbytery, schism, enthusiasm and hypocrisy, on the other: The more you are engaged in, and are us'd to her Publick Liturgy the more pleas'd and edify'd will You by it—Her study has been to fulfil the Command of my Text, to do all Things with Decency and in order—Not Super?? As the Papists—nor Slovenly as the Presbyterians. For from the apostle days, there were always rules and form both for ministers, and People to guide themselves by, when they assembled to serve God—as may be seen by the ancient Liturgies still extant. . . . much less so an Extempore Prayer, even he as'd approv'd off—No, nor extempore preaching either—Witness the Homilies of the ancient Fathers, and sermons . . . handed down to us. . . . Besides it is an ease to the mind to know beforehand, what we are to engage in. And I confess, there are very few men, with whose extempore prayers I would willingly join—for it's too oft found, that he who prays will often more express and vent his own private thoughts and passions, than the desires and wants of this congregation and the Church: All which, are things utterly to be avoided in all religious office. . . .

And for the composure of our Liturgy, it is in every thing such, as public devotion ought to be, and exactly after the ancient pattern. . . . I heartily wish that all men, admir'd it, I pity them that do not. Let us pray to God, that they may be otherwise minded—that they may be convinc'd of its utility and conform to the use of it. Blessed be God, that there are those among you, who have a love and veneration for it and I hope by your steadiness and adherence to it that you will in time prevail with others to frequent this place and join with us in the solemn Service of God. But let us forbear judging or condemning any that do not agree exactly with us . . . outward Worship. Rites and ceremonies are in themselves universally confess'd to be things indifferent: But tho' they are not *Fundamentals,* yet they are such things as the flourishing of religion and the peace of the Church do very much depend—the apostle would not else have given as the injunction of the test. But let us likewise consider, that great prejudices may lie on some minds, which in time may be remov'd: They may be in some involuntary mistakes, which may be corrected. But still we must not so attend to other men's temples, as to be by them deterr'd from what is our duty—for our Church teacheth us, that we are to take care of our own practises yet not

rashly to condemn those of other men. We can make more excuses for others, than we can for ourselves.—And for you to be wanting in any part of service, or ceremony, it may be a greater fault in you, than in others who know not of reason and consequence of being strictly regular. To his own Master, ev'ry person is to stand or fall. And if more becomes an humble and private Christian, to look into and after his own actions, than to be sharp in spying out, or severe in censoring the carriage of others, as is to much the practice of our dissenting brethren—Who are always looking after *motes* in the eyes of others—But forget the *Beam* which is in their own.

But my Brethren, hold fast the Profession of yr Faith without wavering— nor be driven about with ev'ry wind of doctrine. . . . As You have been baptiz'd into the national Church, persevere in her Communion to the end. Remember, that it is the Church for which our first Reformers shed their blood and laid down their lives and which is this day the principal Bulwark in Europe against Popery—this the Church which is by lawful authority settled and establish'd in this colony. And therefore if there be any obedience due to any command of the Legislature, Communion with our Church is a duty. Unless a man can shew any express command of God to the Contrary, which a Man will be so far from finding in Scripture, that He will find much there to oblige Him to continue in it: For when our Government in general is establish'd, there respect and obedience ought to be paid.

But we are, not only obliged to communicate with the Church, because it is establish'd, but also from its Constitution being so agreeable to the Scriptures and the practice of the first and purest Churches of antiquity. Its rules are so well fitted to answer the very end and design of a Church and pursues those ends so fully that ev'ry thing it enjoin hath a constant and immemorial prescription among us. . . . For as we were not at first converted from *Rome,* so nor did we at first receive such a Christianity as is now taught and practis'd at *Rome,* but such as in nonestablish'd in our Church. Nay, we can shew that we were a settled Church, long before *Augustine* came among us. Many bad things were afterward introduc'd among Us, by the *Roman* Pontiffs, which We, at last, threw aside and in our Reformation, return'd to the ancient State of our own Church, as it stood before the *Romans* came before us.

So that our Reformation was not a *Schism*—nor doth our Church countenance any *Schismaticks,* or excuse any separation from ourselves. From our separation from the See of *Rome,* can never justify one Dissenting Brethren in their leaving of us, as they can never shew the like Reasons and Grounds for their Separation, or dissenting from us in Doctrine and Discipline, as we can, for our believing and asking otherwise than the Bishop of *Rome* doth. So that if any People born and baptiz'd in any Church under Heaven, have a Duty incumbent on them, and ought to continue in that said Church, we of the Church of England have all that and more.—Either there is no necessity of continuing in any Church in which men are born and baptiz'd or there is a necesity for us to continue in our Church. Indeed our case is somewhat hard in this Country, among so many Sectarians which we have on every side. . . .

But I hope my Brethren, that You have not so learn'd Christ—But are so well grounded in the principles and Doctrines of your Faith, as to give sufficient reasons for the one, and by your holy and godly conversation, and on the other

preserve in the Catholic primitive doctrines taught, and the devotions practis'd in our Church, so will be well pleasing in the Sight of God, and gain Honour before men.

*With God of his infinite mercy—*

<div align="right">

*At the High Hill, July 8, 1770*
*At Rafting Creek, July 15, 1770*

</div>

# JOHN WESLEY

John Wesley (1703–91) and his brother Charles (1707–88) founded the Methodist movement in England and North America. As young Englishmen devoted to the Anglican Church, they initiated a "holy club" at Oxford designed to foster greater Christian discipline, devotion, and concern for the poor. They practiced austerity in their daily lives, frequently fasting and praying and strictly limiting their intake of food and sleep. Fellow students derided them as "Methodists" because of their extremely disciplined spirituality. John Wesley traveled to America on several occasions and became one of the early "circuit riders," ministers who rode on horseback around specific circuits to reach more people for their gospel. Like other itinerants, Wesley criticized the settled ministers, especially in New England, for being complacent in their faith. His intense emphasis on proper Christian behavior found expression in countless sermons and other writings, notably his *Plain Account of Christian Perfection*, which he revised through various editions. The final edition (1777) has been read by Methodists for generations; it is excerpted here.

## *From* A Plain Account of Christian Perfection

17. On Monday, June 25, 1744, our first conference began, six clergymen and all our preachers being present. The next morning we seriously considered the doctrine of sanctification, or perfection. The questions asked concerning it, and the substance of the answers given, were as follows:—

Q: What is it to be *sanctified*?

A: To be renewed in the image of God, *in righteousness and true holiness*.

Q: What is implied in being a *perfect Christian*?

A: The loving God with all our heart, and mind, and soul (Deut. vi. 5).

Q: Does this imply that *all inward sin* is taken away?

A: Undoubtedly: or how can we be said to be *saved from all our uncleanness*? (Ezek. xxxvi. 29).

Our second conference began August 1, 1745. The next morning we spoke of sanctification as follows:—

Q: When does inward sanctification begin?

A: In the moment a man is justified. (Yet sin remains in him; yea, the seed of all sin, till he is *sanctified throughout*.) From that time a believer gradually dies to sin, and grows in grace.

Q: Is this ordinarily given till a little before death?

A: It is not, to those who expect it no sooner.

Q: But may we expect it sooner?

A: Why not? For although we grant—(1) That the generality of believers, whom we have hitherto known, were not so sanctified till near death; (2) that few of those to whom St. Paul wrote his Epistles were so at that time; nor (3) he himself at the time of writing his former Epistles; yet all this does not prove that we may not be so *to-day*.

Q: In what manner should we preach sanctification?

A: Scarce at all to those who are not pressing forward: to those who are, always by way of promise; always *drawing* rather than *driving*.

Our third conference began Tuesday, May 26, 1746.

In this we carefully read over the minutes of the two preceding conferences, to observe whether anything contained therein might be retrenched or altered, on more mature consideration. But we did not see cause to alter in any respect what we had agreed upon before.

Our fourth conference began on Tuesday, June the 16th, 1747. As several persons were present who did not believe the doctrine of perfection, we agreed to examine it from the foundation.

In order to do this, it was asked—

How much is allowed by our brethren who differ from us with regard to entire sanctification?

A: They grant—(1) That every one must be entirely sanctified in the article of death; (2) that, till then, a believer daily grows in grace, comes nearer and nearer to perfection; (3) that we ought to be continually pressing after it, and to exhort all others so to do.

Q: What do we allow them?

A: We grant—(1) That many of those who have died in the faith, yea the greater part of those we have known, were not perfected in love till a little before their death; (2) that the term *sanctified* is continually applied by St. Paul to all that were justified; (3) that by this term alone, he rarely, if ever, means,

saved from all sin; (4) that, consequently, it is not proper to use it in that sense, without adding the word *wholly, entirely,* or the like; (5) that the inspired writers almost continually speak of or to those who were justified, but very rarely of or to those who were wholly sanctified; (6) that, consequently, it behoves us to speak almost continually of the state of justification; but more rarely, at least in full and explicit terms, concerning entire sanctification.

Q: What, then, is the point where we divide?

A: It is this: Should we expect to be saved from *all sin* before the article of death?

Q: Is there any clear Scripture *promise* of this, that God will save us from *all sin?*

A: There is: "He shall redeem Israel from all his sins" (Psalm cxxx. 8).

This is more largely expressed in the prophecy of Ezekiel: "Then will I sprinkle clean water upon you, and ye shall be clean: from all your filthiness and from all your idols, will I cleanse you, I will also save you from all your uncleannesses" (ch. xxxiv. 25, 29). No promise can be more clear. And to this the apostle plainly refers in that exhortation, "Having these promises, let us cleanse ourselves from all filthiness of flesh and spirit, perfecting holiness in the fear of God" (2 Cor. vii. 1). Equally clear and express is that ancient promise, "The Lord thy God will circumcise thy heart, and the heart of thy seed, to love the Lord thy God with all thy heart and with all thy soul" (Deut. xxx. 6).

Q: But does any assertion answerable to this occur in the New Testament?

A: There does: and that laid down in the plainest terms. So, 1 John iii. 8: "For this purpose the Son of God was manifested, that He might destroy the works of the devil"; the works of the devil without any limitation or restriction; but all sin is the work of the devil. Parallel to which is the assertion of St. Paul, Eph. v. 25–27: "Christ loved the church, and gave Himself for it; that He might present it to Himself a glorious church, not having spot, or wrinkle, or any such thing: but that it might be holy and without blemish."

And to the same effect is his assertion in the eighth of the Romans (ver. 3, 4): "God sent His Son,—that the righteousness of the law might be fulfilled in us, who walk not after the flesh, but after the Spirit."

Q: Does the New Testament afford any further ground for expecting to be saved from *all sin?*

A: Undoubtedly it does, both in those *prayers* and *commands,* which are equivalent to the strongest assertions.

Q: What prayers do you mean?

A: Prayers for entire sanctification, which, were there no such thing, would be mere mockery of God. Such, in particular, are—(1) "Deliver us from evil." Now, when this is done, when we are delivered from all evil, there can be no sin remaining. (2) "Neither pray I for these alone, but for them also who shall believe on Me through their word; that they all may be one; as Thou, Father, art in Me, and I in Thee, that they also may be one in Us; I in them, and Thou in Me, that they may be made perfect in one" (John xvii. 20–23). (3) "I bow my knees unto the God and Father of our Lord Jesus Christ, that

He would grant you, that ye, being rooted and grounded in love, may be able to comprehend with all saints what is the breadth, and length, and depth, and height; and to know the love of Christ, which passeth knowledge, that ye might be filled with all the fulness of God" (Eph. iii. 14, etc.). (4) "The very God of peace sanctify you wholly; and I pray God, your whole spirit, soul, and body may be preserved blameless unto the coming of our Lord Jesus Christ" (1 Thess. v. 23).

Q: What command is there to the same effect?

A: 1. "Be ye perfect, as your Father who is in heaven is perfect" (Matt. v. 48). 2. "Thou shalt love the Lord thy God with all thy heart, and with all thy soul, and with all thy mind" (Matt. xxii. 37). But if the love of God fill *all the heart*, there can be no sin therein.

I have been the more large in these extracts, because hence it appears, beyond all possibility of exception, that to this day both my brother and I maintained—(1) That Christian perfection is that love of God and our neighbour which implies deliverance from *all sin*; (2) that this is received merely *by faith*; (3) that it is given *instantaneously*, in one moment; (4) that we are to expect it, not at death, but *every moment*; that *now* is the accepted time, *now* is the day of this salvation.

19. At the conference in the year 1759, perceiving some danger that a diversity of sentiments should insensibly steal in among us, we again largely considered this doctrine. And soon after I published *Thoughts on Christian Perfection*, prefaced with the following advertisement:—

The following tract is by no means designed to gratify the curiosity of any man. It is not intended to prove the doctrine at large, in opposition to those who explode and ridicule it; no, nor to answer the numerous objections against it which may be raised even by serious men. All I intend here is simply to declare what are my sentiments on this head; what Christian perfection does, according to my apprehension, include, and what it does not; and to add a few practical observations and directions relative to the subject.

As these thoughts were at first thrown together by way of question and answer, I let them continue in the same form. They are just the same that I have entertained for above twenty years.

Q: What is Christian Perfection?

A: The loving God with all our heart, mind, soul, and strength. This implies that no wrong temper, none contrary to love, remains in the soul; and that all the thoughts, words, and actions are governed by pure love.

Q: Do you affirm that this perfection excludes all infirmities, ignorance, and mistake?

A: I continually affirm quite the contrary, and always have done so.

Q: But how can every thought, word, and work be governed by pure love, and the man be subject at the same time to ignorance and mistake?

A: I see no contradiction here: "A man may be filled with pure love, and still be liable to mistake." Indeed, I do not expect to be freed from actual mistakes till this mortal puts on immortality. I believe this to be a natural consequence of the soul's dwelling in flesh and blood. For we cannot now *think* at all, but by the mediation of those bodily organs, which have suffered equally with the rest of our frame. And hence we cannot avoid sometimes *thinking wrong*, till this corruptible shall have put on incorruption.

But we may carry this thought farther yet. A mistake in judgment may possibly occasion a mistake in practice. For instance: Mr. De Renty's mistake touching the nature of mortification, arising from prejudice of education, occasioned that practical mistake, his wearing an iron girdle. And a thousand such instances there may be, even in those who are in the highest state of grace. Yet, where every word and action springs from love, such a mistake is not properly *a sin*. However, it cannot bear the rigour of God's justice, but needs the atoning blood.

Q: What was the judgment of all our brethren who met at Bristol, in August 1758, on this head?

A: It was expressed in these words: (1) Every one may mistake as long as he lives. (2) A mistake in *opinion* may occasion a mistake in *practice*. (3) Every such mistake is a transgression of the perfect law. Therefore (4) Every such mistake, were it not for the blood of atonement, would expose to eternal damnation. (5) It follows that the most perfect have continual need of the merits of Christ, even for their actual transgressions, and may say, for themselves, as well as for their brethren, "Forgive us our trespasses."

This easily accounts for what might otherwise seem to be utterly unaccountable, namely, that those who are not offended when we speak of the highest degree of love, yet will not hear of living *without sin*. The reason is, they know, all men are liable to mistake, and that in practice as well as in judgment. But they do not know, or do not observe, that this is not sin, if love is the sole principle of action.

Q: But still if they live without sin, does not this exclude the necessity of a Mediator? At least, is it not plain that they stand no longer in need of Christ in His priestly office?

A: Far from it. None feel their need of Christ like these; none so entirely depend upon Him. For Christ does not give life to the soul separate from, but in and with, Himself. Hence his words are equally true of all men, in whatsoever state of grace they are: "As the branch cannot bear fruit of itself, except it abide in the vine; no more can ye, except ye abide in Me. Without" (or separate from) "Me ye can do nothing."

In every state we need Christ in the following respects:—(1) Whatever grace we receive, it is a free gift from Him. (2) We receive it as His purchase, merely in consideration of the price He paid. (3) We have this grace, not only from Christ, but in Him. For our perfection is not like that of a tree, which flourishes by the sap derived from its own root, but, as was said before, like that of a branch, which, united to the vine, bears fruit; but, severed from it, is dried up and withered. (4) All our blessings, temporal, spiritual, and eternal, depend on His intercession for us, which is one branch of His

priestly office, whereof therefore we have always equal need. (5) The best of men still need Christ, in His priestly office, to atone for their omissions, their shortcomings (as some not improperly speak), their mistakes in judgment and practice, and their defects of various kinds, for these are all deviations from the perfect law, and consequently need an atonement. Yet that they are not properly sins, we apprehend, may appear from the words of St. Paul: "He that loveth hath fulfilled the law; for love is the fulfilling of the law" (Rom. xiii. 10). Now, mistakes and whatever infirmities necessarily flow from the corruptible state of the body are no way contrary to love; nor therefore, in the Scripture sense, sin.

To explain myself a little farther on this head—(1) Not only sin, properly so called (that is, a voluntary transgression of a known law), but sin, improperly so called (that is, an involuntary transgression of a divine law, known or unknown), needs the atoning blood. (2) I believe there is no such perfection in this life as excludes these involuntary transgressions, which I apprehend to be naturally consequent on the ignorance and mistakes inseparable from mortality. (3) Therefore, *sinless perfection* is a phrase I never use, lest I should seem to contradict myself. (4) I believe, a person filled with the love of God is still liable to these involuntary transgressions. (5) Such transgressions you may call sins, if you please: I do not, for the reasons above mentioned.

Q: What advice would you give to those that do, and those that do not, call them so?

A: Let those that do not call them sins never think that themselves or any other persons are in such a state as that they can stand before infinite justice without a Mediator. This must argue either the deepest ignorance, or the highest arrogance and presumption.

Let those who do call them so, beware how they confound these defects with sins, properly so called.

But how will they avoid it? how will these be distinguished from those, if they are all promiscuously called sins? I am much afraid, if we should allow any sin to be consistent with perfection, few would confine the idea to those defects concerning which only the assertion could be true.

Q: But how can a liableness to mistake consist with perfect love? Is not a person who is perfected in love every moment under its influence? And can any mistake flow from pure love?

A: I answer—(1) Many mistakes may consist with pure love. (2) Some may accidentally flow from it: I mean, love itself may incline us to mistake. The pure love of our neighbour, springing from the love of God, thinketh no evil, believeth and hopeth all things. Now, this very temper, unsuspicious, ready to believe and hope the best of all men, may occasion our thinking some men better than they really are. Here, then, is a manifest mistake, accidentally flowing from pure love.

※

28. Now, let this perfection appear in its native form, and who can speak one word against it? Will any dare to speak against loving the Lord our God

with all our heart, and our neighbour as ourselves? against a renewal of heart, not only in part, but in the whole image of God? Who is he that will open his mouth against being cleansed from all pollution both of flesh and spirit; or against having all the mind that was in Christ, and walking in all things as Christ walked? What man, who calls himself a Christian, has the hardiness to object to the devoting, not a part, but all our soul, body, and substance to God? What serious man would oppose the giving to God all our heart, and the having one design ruling all our tempers? I say again, let this perfection appear in its own shape, and who will fight against it? It must be disguised before it can be opposed. It must be covered with a bear-skin first, or even the wild beasts of the people will scarce be induced to worry it. But whatever these do, let not the children of God any longer fight against the image of God. Let not the members of Christ say anything against having the whole mind that was in Christ. Let not those who are alive to God oppose the dedicating all our life to Him. Why should you who have His love shed abroad in your heart withstand the giving Him all your heart? Does not all that is within you cry out, 'Oh, who that loves can love enough?' What pity that those who desire and design to please Him should have any other design or desire! much more, that they should dread, as a fatal delusion, yea abhor, as an abomination to God, the having this one desire and design ruling every temper! Why should devout men be afraid of devoting all their soul, body, and substance to God? Why should those who love Christ count it a damnable error to think we may have all the mind that was in Him? We allow, we contend, that we are justified freely through the righteousness and the blood of Christ. And why are you so hot against us, because we expect likewise to be sanctified wholly through His Spirit? We look for no favour either from the open servants of sin, or from those who have only the form of religion. But how long will you who worship God in spirit, who are 'circumcised with the circumcision not made with hands,' set your battle in array against those who seek an entire circumcision of heart, who thirst to be cleansed 'from all filthiness of flesh and spirit,' and to 'perfect holiness in the fear of God'? Are we your enemies because we look for a full deliverance from that 'carnal mind which is enmity against God'? Nay, we are your brethren, your fellow-labourers in the vineyard of our Lord, your companions in the kingdom and patience of Jesus. Although this we confess (if we are fools therein, yet as fools bear with us), we do expect to love God with all our heart, and our neighbour as ourselves. Yea, we do believe that He will in this world so 'cleanse the thoughts of our hearts by the inspiration of His Holy Spirit, that we shall perfectly love Him, and worthily magnify His holy name.'

# PHILLIS WHEATLEY

Phillis Wheatley (c. 1753–84) was a young African girl when she was made a slave and sent to Boston. The Wheatley family, who purchased her and named her after the slave ship *Phillis* that brought her overseas,

helped her to learn to read and write, focusing especially on the King James Bible. Wheatley began writing poetry and published her first poem when she was approximately twelve years old, in the *Newport Mercury*. A few years later, she came to the attention of an international audience when she published an elegy upon the death in 1770 of transatlantic evangelist George Whitefield, whom she had likely heard preach in Boston only the week before. That piece was frequently reprinted and helped Wheatley publish a book, making her the first African American person to do so. Her collected poems were published by a London press in 1773 as *Poems on Various Subjects, Religious and Moral*. She was freed from slavery shortly thereafter. Her short poem, "On Being Brought from Africa to America," is reprinted here, along with the Whitefield elegy and "Thoughts on the Works of Providence."

## On Being Brought from Africa to America

'Twas mercy brought me from my *Pagan* land,
Taught my benighted soul to understand
That there's a God, that there's a *Saviour* too:
Once I redemption neither sought nor knew.
Some view our sable race with scornful eye,
"Their colour is a diabolic die."
Remember, *Christians, Negros*, black as *Cain*,
May be refin'd, and join th' angelic train.

## On the Death of the Rev. Mr. George Whitefield, 1770

Hail, happy saint, on thine immortal throne,
Possest of glory, life, and bliss unknown;
We hear no more the music of thy tongue,
Thy wonted auditories cease to throng.
Thy sermons in unequall'd accents flow'd,
And ev'ry bosom with devotion glow'd;
Thou didst in strains of eloquence refin'd
Inflame the heart, and captivate the mind.

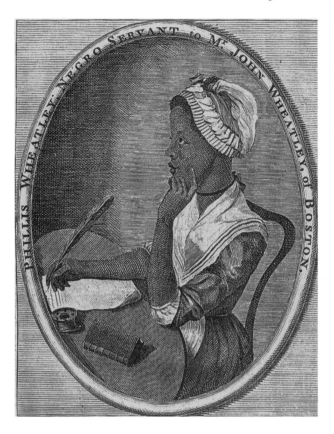

Portrait of Phillis Wheatley, the frontispiece of *Poems on Various Subjects, Religious and Moral* (1773). *Courtesy of the Library of Congress, Prints & Photographs Division.*

Unhappy we the setting sun deplore,
So glorious once, but ah! it shines no more.

Behold the prophet in his tow'ring flight!
He leaves the earth for heav'n's unmeasur'd height,
And worlds unknown receive him from our sight.
There *Whitefield* wings with rapid course his way,
And sails to *Zion* through vast seas of day.
Thy pray'rs, great saint, and thine incessant cries
Have pierc'd the bosom of thy native skies.
Thou moon hast seen, and all the stars of light,
How he has wrestled with his God by night.
He pray'd that grace in ev'ry heart might dwell,
He long'd to see *America* excel;
He charg'd its youth that ev'ry grace divine
Should with full lustre in their conduct shine;
That Saviour, which his soul did first receive,
The greatest gift that ev'n a God can give,
He freely offer'd to the num'rous throng,
That on his lips with list'ning pleasure hung.

"Take him, ye wretched, for your only good,
Take him ye starving sinners, for your food;
Ye thirsty, come to this life-giving stream,
Ye preachers, take him for your joyful theme;
Take him my dear *Americans*, he said,
Be your complaints on his kind bosom laid:
Take him, ye *Africans*, he longs for you,
*Impartial Saviour* is his title due:
Wash'd in the fountain of redeeming blood,
You shall be sons, and kings, and priests to God."

Great *Countess*,\* we *Americans* revere
Thy name, and mingle in thy grief sincere;
*New England* deeply feels, the *Orphans* mourn,
Their more than father will no more return.

But, though arrested by the hand of death,
*Whitefield* no more exerts his lab'ring breath,
Yet let us view him in th' eternal skies,
Let ev'ry heart to this bright vision rise;
While the tomb safe retains its sacred trust,
Till life divine re-animates his dust.

## Thoughts on the Works of Providence

Arise, my soul, on wings enraptur'd, rise
To praise the monarch of the earth and skies,
Whose goodness and beneficence appear
As round its centre moves the rolling year,
Or when the morning glows with rosy charms,
Or the sun slumbers in the ocean's arms:
Of light divine be a rich portion lent
To guide my soul, and favour my intent.
Celestial muse, my arduous flight sustain,
And raise my mind to a seraphic strain!

Ador'd for ever be the God unseen,
Which round the sun revolves this vast machine,
Though to his eye its mass a point appears:
Ador'd the God that whirls surrounding spheres,
Which first ordain'd that mighty *Sol* should reign
The peerless monarch of th' ethereal train:
Of miles twice forty millions is his height,

And yet his radiance dazzles mortal sight
So far beneath—from him th' extended earth
Vigour derives, and ev'ry flow'ry birth:
Vast through her orb she moves with easy grace
Around her *Phoebus* in unbounded space;
True to her course th' impetuous storm derides,
Triumphant o'er the winds, and surging tides.

Almighty, in these wond'rous works of thine,
What *Pow'r*, what *Wisdom*, and what *Goodness* shine?
And are thy wonders, Lord, by men explor'd,
And yet creating glory unador'd!

Creation smiles in various beauty gay,
While day to night, and night succeeds to day:
That *Wisdom*, which attends *Jehovah's* ways,
Shines most conspicuous in the solar rays:
Without them, destitute of heat and light,
This world would be the reign of endless night:
In their excess how would our race complain,
Abhorring life! how hate its length'ned chain!
From air adust what num'rous ills would rise?
What dire contagion taint the burning skies?
What pestilential vapours, fraught with death,
Would rise, and overspread the lands beneath?

Hail, smiling morn, that from the orient main
Ascending dost adorn the heav'nly plain!
So rich, so various are thy beauteous dies,
That spread through all the circuit of the skies,
That, full of thee, my soul in rapture soars,
And thy great God, the cause of all adores.
O'er beings infinite his love extends,
His *Wisdom* rules them, and his *Pow'r* defends.
When tasks diurnal tire the human frame,
The spirits faint, and dim the vital flame,
Then too that ever active bounty shines,
Which not infinity of space confines.
The sable veil, that *Night* in silence draws,
Conceals effects, but shews th' *Almighty Cause*;
Night seals in sleep the wide creation fair,
And all is peaceful but the brow of care.
Again, gay *Phoebus*, as the day before,
Wakes ev'ry eye, but what shall wake no more;
Again the face of nature is renew'd,
Which still appears harmonious, fair, and good.
May grateful strains salute the smiling morn,
Before its beams the eastern hills adorn!

Shall day to day, and night to night conspire
To show the goodness of the Almighty Sire?
This mental voice shall man regardless hear,
And never, never raise the filial pray'r?
To-day, O hearken, nor your folly mourn
For time mispent, that never will return.

But see the sons of vegetation rise,
And spread their leafy banners to the skies.
All-wise Almighty providence we trace
In trees, and plants, and all the flow'ry race;
As clear as in the nobler frame of man,
All lovely copies of the Maker's plan.
The pow'r the same that forms a ray of light,
That call'd creation from eternal night.
"Let there be light," he said: from his profound
Old *Chaos* heard, and trembled at the sound:
Swift as the word, inspir'd by pow'r divine,
Behold the light around its maker shine,
The first fair product of th' omnific God,
And now through all his works diffus'd abroad.

As reason's pow'rs by day our God disclose,
So we may trace him in the night's repose:
Say what is sleep? and dreams how passing strange!
When action ceases, and ideas range
Licentious and unbounded o'er the plains,
Where *Fancy's*, queen in giddy triumph reigns.
Hear in soft strains the dreaming lover sigh
To a kind fair, or rave in jealousy;
On pleasure now, and now on vengeance bent,
The lab'ring passions struggle for a vent.
What pow'r, O man! thy *reason* then restores,
So long suspended in nocturnal hours?
What secret hand returns the mental train,
And gives improv'd thine active pow'rs again?
From thee, O man, what gratitude should rise!
And, when from balmy sleep thou op'st thine eyes,
Let thy first thoughts be praises to the skies.
How merciful our God who thus imparts
O'erflowing tides of joy to human hearts,
When wants and woes might be our righteous lot,
Our God forgetting, by our God forgot!

Among the mental pow'rs a question rose,
"What most the image of th' Eternal shows?"
When thus to *Reason* (so let *Fancy* rove)
Her great companion spoke immortal *Love*.

"Say, mighty pow'r, how long shall strife prevail,
And with its murmurs load the whisp'ring gale?
Refer the cause to *Recollection's* shrine,
Who loud proclaims my origin divine,
The cause whence heav'n and earth began to be,
And is not man immortaliz'd by me?
*Reason* let this most causeless strife subside."
Thus *Love* pronounc'd, and *Reason* thus reply'd.

"Thy birth, celestial queen! 'tis mine to own,
In thee resplendent is the Godhead shown;
Thy words persuade, my soul enraptur'd feels
Resistless beauty which thy smile reveals."
Ardent she spoke, and, kindling at her charms,
She clasp'd the blooming goddess in her arms.

Infinite *Love* wher'er we turn our eyes
Appears: this ev'ry creature's wants supplies;
This most is heard in *Nature's* constant voice,
This makes the morn, and this the eve rejoice;
This bids the fost'ring rains and dews descend
To nourish all, to serve one gen'ral end,
The good of man: yet man ungrateful pays
But little homage, and but little praise.
To him, whose works array'd with mercy shine,
What songs should rise, how constant, how divine!

# JOHN WOOLMAN

John Woolman (1720–72) was a Quaker leader from New Jersey, a pacifist, and an active critic of slavery. He wrote *Some Considerations on the Keeping of Negroes*, which was published in 1754 and helped convince Philadelphia Quakers to advocate for emancipation. Woolman was certain that Christian love entailed the desire to attend to the distresses and afflictions of the poor, particularly slaves and Indians, whom he observed being exploited by traders and colonial administrators. His *Journal*, first published in 1774 and excerpted here, has been influential to later generations of Quakers, abolitionists, and spiritual seekers in America and beyond. It illuminates the simple message of Woolman's eighteenth-century Quaker culture, summarized by Frederick B. Tolles as "the power of the Spirit to shape a life in harmony with the absolute demands of the Sermon on the Mount."

## *From* The Journal of John Woolman

### CHAPTER I.  1720–1742

*His Birth and Parentage.—Some Account of the Operations of Divine Grace on his Mind in his Youth.— His first Appearance in the Ministry.—And his Considerations, while Young, on the Keeping of Slaves.*

I have often felt a motion of love to leave some hints in writing of my experience of the goodness of God, and now, in the thirty-sixth year of my age, I begin this work.

I was born in Northampton, in Burlington County, West Jersey, in the year 1720. Before I was seven years old I began to be acquainted with the operations of Divine love. Through the care of my parents, I was taught to read nearly as soon as I was capable of it; and as I went from school one day, I remember that while my companions were playing by the way, I went forward out of sight, and, sitting down, I read the twenty-second chapter of Revelation: "He showed me a pure river of water of life, clear as crystal, proceeding out of the throne of God and of the Lamb, &c." In reading it, my mind was drawn to seek after that pure habitation which I then believed God had prepared for his servants. The place where I sat, and the sweetness that attended my mind, remain fresh in my memory. This, and the like gracious visitations, had such an effect upon me that when boys used ill language it troubled me; and, through the continued mercies of God, I was preserved from that evil.

The pious instructions of my parents were often fresh in my mind, when I happened to be among wicked children, and were of use to me. Having a large family of children, they used frequently, on first-days, after meeting, to set us one after another to read the Holy Scriptures, or some religious books, the rest sitting by without much conversation; I have since often thought it was a good practice. From what I had read and heard, I believed there had been, in past ages, people who walked in uprightness before God in a degree exceeding any that I knew or heard of now living: and the apprehension of there being less steadiness and firmness amongst people in the present age often troubled me while I was a child.

I may here mention a remarkable circumstance that occurred in my childhood. On going to a neighbor's house, I saw on the way a robin sitting on her nest, and as I came near she went off; but having young ones, she flew about, and with many cries expressed her concern for them. I stood and threw stones at her, and one striking her she fell down dead. At first I was pleased with the exploit, but after a few minutes was seized with horror, at having, in a sportive way, killed an innocent creature while she was careful for her young. I beheld her lying dead, and thought those young ones, for which she was so careful, must now perish for want of their dam to nourish them. After some painful considerations on the subject, I climbed up the tree, took all the young birds, and killed them, supposing that better than to leave them to pine away and die mis-

erably. In this case I believed that Scripture proverb was fulfilled, "The tender mercies of the wicked are cruel." I then went on my errand, and for some hours could think of little else but the cruelties I had committed, and was much troubled. Thus He whose tender mercies are over all his works hath placed a principle in the human mind, which incites to exercise goodness towards every living creature; and this being singly attended to, people become tender-hearted and sympathizing; but when frequently and totally rejected, the mind becomes shut up in a contrary disposition.

About the twelfth year of my age, my father being abroad, my mother reproved me for some misconduct, to which I made an undutiful reply. The next first-day, as I was with my father returning from meeting, he told me that he understood I had behaved amiss to my mother, and advised me to be more careful in future. I knew myself blamable, and in shame and confusion remained silent. Being thus awakened to a sense of my wickedness, I felt remorse in my mind, and on getting home I retired and prayed to the Lord to forgive me, and I do not remember that I ever afterwards spoke unhandsomely to either of my parents, however foolish in some other things.

Having attained the age of sixteen years, I began to love wanton company; and though I was preserved from profane language or scandalous conduct, yet I perceived a plant in me which produced much wild grapes; my merciful Father did not, however, forsake me utterly, but at times, through his grace, I was brought seriously to consider my ways; and the sight of my backslidings affected me with sorrow, yet for want of rightly attending to the reproofs of instruction, vanity was added to vanity, and repentance to repentance. Upon the whole, my mind became more and more alienated from the truth, and I hastened toward destruction. While I meditate on the gulf towards which I travelled, and reflect on my youthful disobedience, for these things I weep, mine eye runneth down with water.

Advancing in age, the number of my acquaintance increased, and thereby my way grew more difficult. Though I had found comfort in reading the Holy Scriptures and thinking on heavenly things, I was now estranged therefrom. I knew I was going from the flock of Christ and had no resolution to return, hence serious reflections were uneasy to me, and youthful vanities and diversions were my greatest pleasure. In this road I found many like myself, and we associated in that which is adverse to true friendship.

In this swift race it pleased God to visit me with sickness, so that I doubted of recovery; then did darkness, horror, and amazement with full force seize me, even when my pain and distress of body were very great. I thought it would have been better for me never to have had being, than to see the day which I now saw. I was filled with confusion, and in great affliction, both of mind and body, I lay and bewailed myself. I had not confidence to lift up my cries to God, whom I had thus offended; but in a deep sense of my great folly I was humbled before him. At length that word which is as a fire and a hammer broke and dissolved my rebellious heart; my cries were put up in contrition; and in the multitude of his mercies I found inward relief, and a close engagement that if he was pleased to restore my health I might walk humbly before him.

After my recovery this exercise remained with me a considerable time, but by degrees giving way to youthful vanities, and associating with wanton young

people, I lost ground. The Lord had been very gracious, and spoke peace to me in the time of my distress, and I now most ungratefully turned again to folly; at times I felt sharp reproof, but I did not get low enough to cry for help. I was not so hardy as to commit things scandalous, but to exceed in vanity and to promote mirth was my chief study. Still I retained a love and esteem for pious people, and their company brought an awe upon me. My dear parents several times admonished me in the fear of the Lord, and their admonition entered into my heart and had a good effect for a season; but not getting deep enough to pray rightly, the tempter, when he came, found entrance. Once having spent a part of the day in wantonness, when I went to bed at night there lay in a window near my bed a Bible, which I opened, and first cast my eye on the text "We lie down in our shame, and our confusion covereth us." This I knew to be my case, and meeting with so unexpected a reproof I was somewhat affected with it, and went to bed under remorse of conscience, which I soon cast off again.

Thus time passed on; my heart was replenished with mirth and wantonness, while pleasing scenes of vanity were presented to my imagination, till I attained the age of eighteen years, near which time I felt the judgments of God in my soul, like a consuming fire, and looking over my past life the prospect was moving. I was often sad, and longed to be delivered from those vanities; then again my heart was strongly inclined to them, and there was in me a sore conflict. At times I turned to folly, and then again sorrow and confusion took hold of me. In a while I resolved totally to leave off some of my vanities, but there was a secret reserve in my heart of the more refined part of them, and I was not low enough to find true peace. Thus for some months I had great troubles; my will was unsubjected, which rendered my labors fruitless. At length, through the merciful continuance of heavenly visitations, I was made to bow down in spirit before the Lord. One evening I had spent some time in reading a pious author, and walking out alone I humbly prayed to the Lord for his help, that I might be delivered from all those vanities which so ensnared me. Thus being brought low, he helped me, and as I learned to bear the cross I felt refreshment to come from his presence, but not keeping in that strength which gave victory I lost ground again, the sense of which greatly affected me. I sought deserts and lonely places, and there with tears did confess my sins to God and humbly craved his help. And I may say with reverence, he was near to me in my troubles, and in those times of humiliation opened my ear to discipline. I was now led to look seriously at the means by which I was drawn from the pure truth, and learned that if I would live such a life as the faithful servants of God lived, I must not go into company as heretofore in my own will, but all the cravings of sense must be governed by a Divine principle. In times of sorrow and abasement these instructions were sealed upon me, and I felt the power of Christ prevail over selfish desires, so that I was preserved in a good degree of steadiness, and being young, and believing at that time that a single life was best for me, I was strengthened to keep from such company as had often been a snare to me.

I kept steadily to meetings; spent first-day afternoons chiefly in reading the Scriptures and other good books, and was early convinced in my mind that true religion consisted in an inward life, wherein the heart doth love and reverence God the Creator, and learns to exercise true justice and goodness, not only toward all men, but also toward the brute creatures; that, as the mind was moved

by an inward principle to love God as an invisible, incomprehensible Being, so, by the same principle, it was moved to love him in all his manifestations in the visible world; that, as by his breath the flame of life was kindled in all animal sensible creatures, to say we love God as unseen, and at the same time exercise cruelty toward the least creature moving by his life, or by life derived from him, was a contradiction in itself. I found no narrowness respecting sects and opinions, but believed that sincere, upright-hearted people, in every society, who truly love God, were accepted of him.

As I lived under the cross, and simply followed the opening of truth, my mind, from day to day, was more enlightened, my former acquaintance were left to judge of me as they would, for I found it safest for me to live in private, and keep these things sealed up in my own breast. While I silently ponder on that change wrought in me, I find no language equal to convey to another a clear idea of it. I looked upon the works of God in this visible creation, and an awfulness covered me. My heart was tender and often contrite, and universal love to my fellow-creatures increased in me. This will be understood by such as have trodden in the same path. Some glances of real beauty may be seen in their faces who dwell in true meekness. There is a harmony in the sound of that voice to which Divine love gives utterance, and some appearance of right order in their temper and conduct whose passions are regulated; yet these do not fully show forth that inward life to those who have not felt it; this white stone and new name is only known rightly by such as receive it.

Now, though I had been thus strengthened to bear the cross, I still found myself in great danger, having many weaknesses attending me, and strong temptations to wrestle with; in the feeling whereof I frequently withdrew into private places, and often with tears besought the Lord to help me, and his gracious ear was open to my cry.

All this time I lived with my parents, and wrought on the plantation; and having had schooling pretty well for a planter, I used to improve myself in winter evenings, and other leisure times. Being now in the twenty-first year of my age, with my father's consent I engaged with a man, in much business as a shop-keeper and baker, to tend shop and keep books. At home I had lived retired; and now having a prospect of being much in the way of company, I felt frequent and fervent cries in my heart to God, the Father of Mercies, that he would preserve me from all taint and corruption; that, in this more public employment, I might serve him, my gracious Redeemer, in that humility and self-denial which I had in a small degree exercised in a more private life.

The man who employed me furnished a shop in Mount Holly, about five miles from my father's house, and six from his own, and there I lived alone and tended his shop. Shortly after my settlement here I was visited by several young people, my former acquaintance, who supposed that vanities would be as agreeable to me now as ever. At these times I cried to the Lord in secret for wisdom and strength; for I felt myself encompassed with difficulties, and had fresh occasion to bewail the follies of times past, in contracting a familiarity with libertine people; and as I had now left my father's house outwardly, I found my Heavenly Father to be merciful to me beyond what I can express.

By day I was much amongst people, and had many trials to go through; but in the evenings I was mostly alone, and I may with thankfulness acknowledge,

that in those times the spirit of supplication was often poured upon me; under which I was frequently exercised, and felt my strength renewed.

After a while, my former acquaintance gave over expecting me as one of their company, and I began to be known to some whose conversation was helpful to me. And now, as I had experienced the love of God, through Jesus Christ, to redeem me from many pollutions, and to be a succor to me through a sea of conflicts, with which no person was fully acquainted, and as my heart was often enlarged in this heavenly principle, I felt a tender compassion for the youth who remained entangled in snares like those which had entangled me. This love and tenderness increased, and my mind was strongly engaged for the good of my fellow-creatures. I went to meetings in an awful frame of mind, and endeavored to be inwardly acquainted with the language of the true Shepherd. One day, being under a strong exercise of spirit, I stood up and said some words in a meeting; but not keeping close to the Divine opening, I said more than was required of me. Being soon sensible of my error, I was afflicted in mind some weeks, without any light or comfort, even to that degree that I could not take satisfaction in anything. I remembered God, and was troubled, and in the depth of my distress he had pity upon me, and sent the Comforter. I then felt forgiveness for my offence; my mind became calm and quiet, and I was truly thankful to my gracious Redeemer for his mercies. About six weeks after this, feeling the spring of Divine love opened, and a concern to speak, I said a few words in a meeting, in which I found peace. Being thus humbled and disciplined under the cross, my understanding became more strengthened to distinguish the pure spirit which inwardly moves upon the heart, and which taught me to wait in silence sometimes many weeks together, until I felt that rise which prepares the creature to stand like a trumpet, through which the Lord speaks to his flock.

From an inward purifying, and steadfast abiding under it springs a lively operative desire for the good of others. All the faithful are not called to the public ministry; but whoever are, are called to minister of that which they have tasted and handled spiritually. The outward modes of worship are various; but whenever any are true ministers of Jesus Christ, it is from the operation of his Spirit upon their hearts, first purifying them, and thus giving them a just sense of the conditions of others. This truth was early fixed in my mind, and I was taught to watch the pure opening, and to take heed lest, while I was standing to speak, my own will should get uppermost, and cause me to utter words from worldly wisdom, and depart from the channel of the true gospel ministry.

In the management of my outward affairs, I may say with thankfulness, I found truth to be my support; and I was respected in my master's family, who came to live in Mount Holly within two years after my going there.

In a few months after I came here, my master bought several Scotchmen servants, from on board a vessel, and brought them to Mount Holly to sell, one of whom was taken sick and died. In the latter part of his sickness, being delirious, he used to curse and swear most sorrowfully; and the next night after his burial I was left to sleep alone in the chamber where he died. I perceived in me a timorousness; I knew, however, I had not injured the man, but assisted in taking care of him according to my capacity. I was not free to ask any one on that occasion to sleep with me. Nature was feeble; but every trial was a fresh incitement to

give myself up wholly to the service of God, for I found no helper like him in times of trouble.

About the twenty-third year of my age, I had many fresh and heavenly openings, in respect to the care and providence of the Almighty over his creatures in general, and over man as the most noble amongst those which are visible. And being clearly convinced in my judgment that to place my whole trust in God was best for me, I felt renewed engagements that in all things I might act on an inward principle of virtue, and pursue worldly business no further than as truth opened my way.

About the time called Christmas I observed many people, both in town and from the country, resorting to public-houses, and spending their time in drinking and vain sports, tending to corrupt one another; on which account I was much troubled. At one house in particular there was much disorder; and I believed it was a duty incumbent on me to speak to the master of that house. I considered I was young, and that several elderly friends in town had opportunity to see these things; but though I would gladly have been excused, yet I could not feel my mind clear.

The exercise was heavy; and as I was reading what the Almighty said to Ezekiel, respecting his duty as a watchman, the matter was set home more clearly. With prayers and tears I besought the Lord for his assistance, and He, in loving-kindness, gave me a resigned heart. At a suitable opportunity I went to the public-house; and seeing the man amongst much company, I called him aside, and in the fear and dread of the Almighty expressed to him what rested on my mind. He took it kindly, and afterwards showed more regard to me than before. In a few years afterwards he died, middle-aged; and I often thought that had I neglected my duty in that case it would have given me great trouble; and I was humbly thankful to my gracious Father, who had supported me herein.

My employer, having a negro woman, sold her, and desired me to write a bill of sale, the man being waiting who bought her. The thing was sudden; and though I felt uneasy at the thoughts of writing an instrument of slavery for one of my fellow-creatures, yet I remembered that I was hired by the year, that it was my master who directed me to do it, and that it was an elderly man, a member of our Society, who bought her; so through weakness I gave way, and wrote it; but at the executing of it I was so afflicted in my mind, that I said before my master and the Friend that I believed slave-keeping to be a practice inconsistent with the Christian religion. This, in some degree, abated my uneasiness; yet as often as I reflected seriously upon it I thought I should have been clearer if I had desired to be excused from it, as a thing against my conscience; for such it was. Some time after this a young man of our Society spoke to me to write a conveyance of a slave to him, he having lately taken a negro into his house. I told him I was not easy to write it; for, though many of our meeting and in other places kept slaves, I still believed the practice was not right, and desired to be excused from the writing. I spoke to him in good-will; and he told me that keeping slaves was not altogether agreeable to his mind; but that the slave being a gift made to his wife he had accepted her. . . .

Scrupling to do writings relative to keeping slaves has been a means of sundry small trials to me, in which I have so evidently felt my own will set aside that I think it good to mention a few of them. Tradesmen and retailers of goods,

who depend on their business for a living, are naturally inclined to keep the good-will of their customers; nor is it a pleasant thing for young men to be under any necessity to question the judgment or honesty of elderly men, and more especially of such as have a fair reputation. Deep-rooted customs, though wrong, are not easily altered; but it is the duty of all to be firm in that which they certainly know is right for them. A charitable, benevolent man, well acquainted with a negro, may, I believe, under some circumstances keep him in his family as a servant, on no other motives than the negro's good; but man, as man, knows not what shall be after him, nor hath he any assurance that his children will attain to that perfection in wisdom and goodness necessary rightly to exercise such power; hence it is clear to me, that I ought not to be the scribe where wills are drawn in which some children are made ales masters over others during life.

About this time an ancient man of good esteem in the neighborhood came to my house to get his will written. He had young negroes, and I asked him privately how he purposed to dispose of them. He told me; I then said, "I cannot write thy will without breaking my own peace," and respectfully gave him my reasons for it. He signified that he had a choice that I should have written it, but as I could not, consistently with my conscience, he did not desire it, and so he got it written by some other person. A few years after, there being great alterations in his family, he came again to get me to write his will. His negroes were yet young, and his son, to whom he intended to give them, was, since he first spoke to me, from a libertine become a sober young man, and he supposed that I would have been free on that account to write it. We had much friendly talk on the subject, and then deferred it. A few days after he came again and directed their freedom, and I then wrote his will.

Near the time that the last-mentioned Friend first spoke to me, a neighbor received a bad bruise in his body and sent for me to bleed him, which having done, he desired me to write his will. I took notes, and amongst other things he told me to which of his children he gave his young negro. I considered the pain and distress he was in, and knew not how it would end, so I wrote his will, save only that part concerning his slave, and carrying it to his bedside read it to him. I then told him in a friendly way that I could not write any instruments by which my fellow-creatures were made slaves, without bringing trouble on my own mind. I let him know that I charged nothing for what I had done, and desired to be excused from doing the other part in the way he proposed. We then had a serious conference on the subject; at length, he agreeing to set her free, I finished his will.

Having found drawings in my mind to visit Friends on Long Island, after obtaining a certificate from our Monthly Meeting, I set off 12th of fifth month, 1756. When I reached the island, I lodged the first night at the house of my dear friend, Richard Hallett. The next day being the first of the week, I was at the meeting in New Town, in which we experienced the renewed manifestations of the love of Jesus Christ to the comfort of the honest-hearted. I went that night to Flushing, and the next day I and my beloved friend, Matthew Franklin, crossed the ferry at White Stone; were at three meetings on the main, and then returned to the island, where I spent the remainder of the week in visiting meetings. The Lord, I believe, hath a people in those parts who are honestly inclined to serve him; but many I fear, are too much clogged with the things of this life, and do not come forward bearing the cross in such faithfulness as he calls for.

My mind was deeply engaged in this visit, both in public and private, and at several places where I was, on observing that they had slaves, I found myself under a necessity, in a friendly way, to labor with them on that subject; expressing, as way opened, the inconsistency of that practice with the purity of the Christian religion, and the ill effects of it manifested amongst us. . . .

Until this year, 1756, I continued to retail goods, besides following my trade as a tailor; about which time I grew uneasy on account of my business growing too cumbersome. I had begun with selling trimmings for garments, and from thence proceeded to sell cloths and linens; and at length, having got a considerable shop of goods, my trade increased every year, and the way to large business appeared open, but I felt a stop in my mind.

Through the mercies of the Almighty, I had, in a good degree, learned to be content with a plain way of living. I had but a small family; and, on serious consideration, believed truth did not require me to engage much in cumbering affairs. It had been my general practice to buy and sell things really useful. Things that served chiefly to please the vain mind in people, I was not easy to trade in; seldom did it; and whenever I did I found it weaken me as a Christian.

The increase of business became my burden; for though my natural inclination was toward merchandise, yet I believed truth required me to live more free from outward cumbers; and there was now a strife in my mind between the two. In this exercise my prayers were put up to the Lord, who graciously heard me, and gave me a heart resigned to his holy will. Then I lessened my outward business, and, as I had opportunity, told my customers of my intentions, that they might consider what shop to turn to; and in a while I wholly laid down merchandise, and followed my trade as a tailor by myself, having no apprentice. I also had a nursery of apple-trees, in which I employed some of my time in hoeing, grafting, trimming, and inoculating. In merchandise it is the custom where I lived to sell chiefly on credit, and poor people often get in debt; when payment is expected, not having wherewith to pay, their creditors often sue for it at law. Having frequently observed occurrences of this kind, I found it good for me to advise poor people to take such goods as were most useful, and not costly.

In the time of trading I had an opportunity of seeing that the too liberal use of spirituous liquors and the custom of wearing too costly apparel led some people into great inconveniences; and that these two things appear to be often connected with each other. By not attending to that use of things which is consistent with universal righteousness, there is an increase of labor which extends beyond what our Heavenly Father intends for us. And by great labor, and often by much sweating, there is even among such as are not drunkards a craving of liquors to revive the spirits; that partly by the luxurious drinking of some, and partly by the drinking of others (led to it through immoderate labor), very great quantities of rum are every year expended in our colonies; the greater part of which we should have no need of, did we steadily attend to pure wisdom.

When men take pleasure in feeling their minds elevated with strong drink, and so indulge their appetite as to disorder their understandings, neglect their duty as members of a family or civil society, and cast off all regard to religion, their case is much to be pitied. And where those whose lives are for the most part regular, and whose examples have a strong influence on the minds of others,

adhere to some customs which powerfully draw to the use of more strong liquor than pure wisdom allows, it hinders the spreading of the spirit of meekness, and strengthens the hands of the more excessive drinkers. This is a case to be lamented.

Every degree of luxury hath some connection with evil; and if those who profess to be disciples of Christ, and are looked upon as leaders of the people, have that mind in them which was also in Christ, and so stand separate from every wrong way, it is a means of help to the weaker. As I have sometimes been much spent in the heat and have taken spirits to revive me, I have found by experience, that in such circumstances the mind is not so calm, nor so fitly disposed for Divine meditation, as when all such extremes are avoided. I have felt an increasing care to attend to that Holy Spirit which sets right bounds to our desires, and leads those who faithfully follow it to apply all the gifts of Divine Providence to the purposes for which they were intended. Did those who have the care of great estates attend with singleness of heart to this heavenly Instructor, which so opens and enlarges the mind as to cause men to love their neighbors as themselves, they would have wisdom given them to manage their concerns, without employing some people in providing the luxuries of life, or others in laboring too hard; but for want of steadily regarding this principle of Divine love, a selfish spirit takes place in the minds of people, which is attended with darkness and manifold confusions in the world.

Though trading in things useful is an honest employ, yet through the great number of superfluities which are bought and sold, and through the corruption of the times, they who apply to merchandise for a living have great need to be well experienced in that precept which the Prophet Jeremiah laid down for his scribe: "Seekest thou great things for thyself? seek them not."

In the winter this year I was engaged with friends in visiting families, and through the goodness of the Lord we oftentimes experienced his heart-tendering presence amongst us.

## A COPY OF A LETTER WRITTEN TO A FRIEND

"In this, thy late affliction, I have found a deep fellow-feeling with thee, and have had a secret hope throughout that it might please the Father of Mercies to raise thee up and sanctify thy troubles to thee; that thou being more fully acquainted with that way which the world esteems foolish, mayst feel the clothing of Divine fortitude, and be strengthened to resist that spirit which leads from the simplicity of the everlasting truth.

"We may see ourselves crippled and halting, and from a strong bias to things pleasant and easy find an impossibility to advance forward; but things impossible with men are possible with God; and our wills being made subject to his, all temptations are surmountable.

"This work of subjecting the will is compared to the mineral in the furnace, which, through fervent heat, is reduced from its first principle: 'He refines them as silver is refined; he shall sit as a refiner and purifier of silver.' By these comparisons we are instructed in the necessity of the melting operation of the hand of God upon us, to prepare our hearts truly to adore him, and manifest that adoration by inwardly turning away from that spirit, in all its workings, which is

not of him. To forward this work the all-wise God is sometimes pleased, through outward distress, to bring us near the gates of death; that life being painful and afflicting, and the prospect of eternity opened before us, all earthly bonds may be loosened, and the mind prepared for that deep and sacred instruction which otherwise would not be received. If kind parents love their children and delight in their happiness, then he who is perfect goodness in sending abroad mortal contagions doth assuredly direct their use. Are the righteous removed by it? their change is happy. Are the wicked taken away in their wickedness? the Almighty is clear. Do we pass through with anguish and great bitterness, and yet recover? He intends that we should be purged from dross, and our ear opened to discipline.

"And now, as thou art again restored, after thy sore affliction and doubts of recovery, forget not Him who hath helped thee, but in humble gratitude hold fast his instructions, and thereby shun those by-paths which lead from the firm foundation. I am sensible of that variety of company to which one in thy business must be exposed; I have painfully felt the force of conversation proceeding from men deeply rooted in an earthly mind, and can sympathize with others in such conflicts, because much weakness still attends me.

"I find that to be a fool as to worldly wisdom, and to commit my cause to God, not fearing to offend men, who take offence at the simplicity of truth, is the only way to remain unmoved at the sentiments of others.

"The fear of man brings a snare. By halting in our duty, and giving back in the time of trial, our hands grow weaker, our spirits get mingled with the people, our ears grow dull as to hearing the language of the true Shepherd, so that when we look at the way of the righteous, it seems as though it was not for us to follow them.

"A love clothes my mind while I write, which is superior to all expression; and I find my heart open to encourage to a holy emulation, to advance forward in Christian firmness. Deep humility is a strong bulwark, and as we enter into it we find safety and true exaltation. The foolishness of God is wiser than man, and the weakness of God is stronger than man. Being unclothed of our own wisdom, and knowing the abasement of the creature, we find that power to arise which gives health and vigor to us."

## On Silent Worship

Worship in Silence hath often been refreshing to my Mind, and a Care attends me that a young Generation may feel the Nature of this Worship.

Great Expence ariseth in Relation to that which is called Divine Worship.

A considerable Part of this Expence is applied toward outward Greatness, and many poor People in raising of Tithe, labour in supporting Customs contrary to the Simplicity that there is in Christ, toward whom my Mind hath often been moved with Pity.

In pure silent Worship, we dwell under the Holy Anointing, and feel Christ to be our Shepherd.

Here the best of Teachers ministers to the several Conditions of his Flock, and the Soul receives immediately from the Divine Fountain, that with which it is nourished.

As I have travelled at Times where those of other Societies have attended our Meetings, and have perceiv'd how little some of them knew of the Nature of silent Worship; I have felt tender Desires in my Heart that we who often sit silent in our Meetings, may live answerable to the Nature of an inward Fellowship with God, that no Stumbling-block through us, may be laid in their Way.

Such is the Load of unnecessary Expence which is called Divine Service in many Places, and so much are the Minds of many People employed in outward Forms and Ceremonies, that the opening of an inward silent Worship in this Nation to me hath appear'd to be a precious Opening.

Within the last four Hundred Years, many pious People have been deeply exercised in Soul on Account of the Superstition which prevailed amongst the professed Followers of Christ, and in support of their Testimony against Oppressive Idolatry, some in several Ages have finished their Course in the Flames.

It appears by the History of the Reformation, that through the Faithfulness of the Martyrs, the Understandings of many have been opened, and the Minds of People, from Age to Age, been more and more prepared for a real Spiritual Worship.

My Mind is often affected with a Sense of the Condition of those People, who in Different Ages have been meek and patient, following Christ through great Afflictions: And while I behold the several Steps of Reformation, and that Clearness, to which through Divine Goodness, it hath been brought by our Ancestors; I feel tender Desires that we who sometimes meet in Silence, may never by our Conduct lay Stumbling-blocks in the way of others, and hinder the Progress of the Reformation in the World.

It was a Complaint against some who were called the Lord's People, that they brought polluted Bread to his Altar, and said the Table of the Lord was contemptible.

In real silent Worship the Soul feeds on that which is Divine; but we cannot partake of the Table of the Lord, and that Table which is prepared by the God of this World.

If Christ is our Shepherd, and feedeth us, and we are faithful in following him, our Lives will have an inviting Language, and the Table of the Lord will not be polluted.

# DAVID BRAINERD

David Brainerd (1718–47) became a missionary to groups of Indians in New York, Pennsylvania, and New Jersey after being expelled from Yale for denouncing the supposed irreligiousness of some faculty members.

The diary that he began keeping in 1740 is the source for what we know about his life, but this document was "corrected" by Jonathan Edwards a few years later to depict Brainerd as a pious example of true religion (as opposed, again, to "enthusiasm"). Whatever the dressing up of events, Brainerd's diary remains useful for its historical idealization of encounters between missionaries and Indians in America, at least from one missionary's view.

## *From* Journal

August 6. In the morning I discoursed to the Indians at the house where we lodged. Many of them were then much affected and appeared surprisingly tender, so that a few words about their souls' concerns would cause the tears to flow freely, and produce many sobs and groans.

In the afternoon, they being returned to the place where I had usually preached among them, I again discoursed to them there. There were about fifty-five persons in all, about forty that were capable of attending divine service with understanding. I insisted upon I John 4:10, "Herein is love." They seemed eager of hearing; but there appeared nothing very remarkable, except their attention, till near the close of my discourse. Then divine truths were attended with a surprising influence, and produced a great concern among them. There were scarce three in forty that could refrain from tears and bitter cries.

They all, as one, seemed in an agony of soul to obtain an interest in Christ; and the more I discoursed of the love and compassion of God in sending His Son to suffer for the sins of men; and the more I invited them to come and partake of His love, the more their distress was aggravated, because they felt themselves unable to come. It was surprising to see how their hearts seemed to be pierced with the tender and melting invitations of the gospel, when there was not a word of terror spoken to them.

There were this day two persons that obtained relief and comfort, which (when I came to discourse with them particularly) appeared solid, rational, and scriptural. After I had inquired into the grounds of their comfort and said many things I thought proper to them, I asked them what they wanted God to do further for them. They replied, "They wanted Christ should wipe their hearts, quite clean." Surprising were now the doings of the Lord, that I can say no less of this day (and I need say no more of it) than that the arm of the Lord was powerfully and marvelously revealed in it.

August 7. Preached to the Indians from Isaiah 53:3–10. There was a remarkable influence attending the Word, and great concern in the assembly; but scarce equal to what appeared the day before, that is, not quite so universal. However, most were much affected, and many in great distress for their souls; and some few could neither go nor stand, but lay flat on the ground, as if pierced at heart,

crying incessantly for mercy. Several were newly awakened, and it was remarkable that as fast as they came from remote places round about the Spirit of God seemed to seize them with concern for their souls.

After public service was concluded, I found two persons more that had newly met with comfort, of whom I had good hopes; and a third that I could not but entertain some hopes of, whose case did not appear so clear as the others; so that there were now six in all that had got some relief from their spiritual distresses, and five whose experience appeared very clear and satisfactory. And it is worthy of remark, that those who obtained comfort first were in general deeply affected with concern for their souls when I preached to them in June last.

August 8. In the afternoon I preached to the Indians; their number was now about sixty-five persons, men, women, and children. I discoursed from Luke 14:16–23 and was favored with uncommon freedom in my discourse. There was much visible concern among them while I was discoursing publicly; but afterwards when I spoke to one and another more particularly, whom I perceived under much concern, the power of God seemed to descend upon the assembly "like a rushing mighty wind," and with an astonishing energy bore down all before it.

I stood amazed at the influence that seized the audience almost universally, and could compare it to nothing more aptly than the irresistible force of a mighty torrent, or swelling deluge, that with its insupportable weight and pressure bears down and sweeps before it whatever is in its way. Almost all persons of all ages were bowed down with concern together, and scarce one was able to withstand the shock of this surprising operation. Old men and women, who had been drunken wretches for many years, and some little children, not more than six or seven years of age, appeared in distress for their souls, as well as persons of middle age. And it was apparent these children (some of them at least) were not merely frightened with seeing the general concern; but were made sensible of their danger, the badness of their hearts, and their misery without Christ, as some of them expressed it.

The most stubborn hearts were now obliged to bow. A principal man among the Indians, who before was most secure and self-righteous and thought his state good because he knew more than the generality of the Indians had formerly done, and who with a great degree of confidence the day before, told me, "he had been a Christian more than ten years," was now brought under solemn concern for his soul, and wept bitterly. Another man advanced in years, who had been a murderer, a powwow (or conjurer) and a notorious drunkard, was likewise brought now to cry for mercy with many tears, and to complain much that he could be no more concerned when he saw his danger so very great.

They were almost universally praying and crying for mercy, in every part of the house, and many out of doors, and numbers could neither go nor stand. Their concern was so great, each one for himself, that none seemed to take any notice of those about them, but each prayed freely for himself. And, I am to think, they were to their own apprehension as much retired as if they had been, individually, by themselves in the thickest desert; or, I believe rather, that they thought nothing about any but themselves, and their own states, and so were everyone praying apart, although all together.

It seemed to me there was now an exact fulfillment of that prophecy, Zechariah 12: 10, 11, 12; for there was now "a great mourning, like the mourning

of Hadadrimmon"; and each seemed to "mourn apart." Methought this had a near resemblance to the day of God's power, mentioned in Joshua 10:14. I must say I never saw any day like it in all respects. It was a day wherein I am persuaded the Lord did much to destroy the kingdom of darkness among this people today.

This concern in general was most rational and just. Those who had been awakened any considerable time complained more especially of the badness of their hearts. Those newly awakened, of the badness of their lives and actions past; all were afraid of the anger of God and of everlasting misery as the desert of their sins. Some of the white people who came out of curiosity to "hear what this babbler would say" to the poor ignorant Indians were much awakened, and some appeared to be wounded with a view of their perishing state.

Those who had lately obtained relief were filled with comfort at this season. They appeared calm and composed, and seemed to rejoice in Christ Jesus. Some of them took their distressed friends by the hand, telling them of the goodness of Christ and the comfort that is to be enjoyed in Him, and thence invited them to come and give up their hearts to Him. I could observe some of them, in the most honest and unaffected manner (without any design of being taken notice of) lifting up their eyes to heaven as if crying for mercy, while they saw the distress of the poor souls around them.

There was one remarkable instance of awakening this day that I cannot but take particular notice of here. A young Indian woman, who, I believe, never knew before she had a soul nor ever thought of any such thing, hearing that there was something strange among the Indians, came to see what was the matter. In her way to the Indians she called at my lodgings, and when I told her I designed presently to preach to the Indians, laughed, and seemed to mock; but went however to them.

I had not proceeded far in my public discourse, before she felt effectually that she had a soul. Before I had concluded my discourse, she was so convinced of her sin and misery and so distressed with concern for her soul's salvation that she seemed like one pierced through with a dart, and cried out incessantly. She could neither go nor stand, nor sit on her seat without being held up. After public service was over, she lay flat on the ground praying earnestly, and would take no notice of, nor give any answer to any that spoke to her. I hearkened to know what she said, and perceived the burden of her prayer to be, *Guttummaukalummeh wechaumeh kmeleh Ndah,* that is, "Have mercy on me, and help me to give You my heart." Thus she continued praying incessantly for many hours together. This was indeed a surprising day of God's power and seemed enough to convince an atheist of the truth, importance and power of God's Word.

August 9. Spent almost the whole day with the Indians, the former part of it in discoursing to many of them privately, especially to some who had lately received comfort, endeavoring to inquire into the grounds of it, as well as to give them some proper instructions, cautions, and directions.

In the afternoon discoursed to them publicly. There were now present about seventy persons, old and young. I opened and applied the Parable of the Sower, Matthew 13. Was enabled to discourse with much plainness, and found afterwards that this discourse was very instructive to them. There were many tears

among them while I was discoursing publicly, but no considerable cry. Yet some were much affected with a few words spoken from Matthew 11:28, "Come unto me, all ye that labor," with which I concluded my discourse. But while I was discoursing near night to two or three of the awakened persons, a divine influence seemed to attend what was spoken to them in a powerful manner, causing the persons to cry out in anguish of soul, although I spoke not a word of terror. On the contrary, I set before them the fullness and all-sufficiency of Christ's merits and His willingness to save all that came to Him, and thereupon pressed them to come without delay.

The cry of these was soon heard by others, who, though scattered before, immediately gathered round. I then proceeded in the same strain of gospel invitation, till they all, except two or three, melted into tears and cries and seemed in the greatest distress to find and secure an interest in the great Redeemer. Some who had but little more than a ruffle made in their passions the day before, seemed now to be deeply affected and wounded at heart. The concern in general appeared near as prevalent as it was the day before. There was indeed a very great mourning among them, and yet everyone seemed to mourn apart. For so great was their concern, that almost everyone was praying and crying for himself, as if none had been near. *Guttummaukalummeh, guttummaukalummeh,* that is, "Have mercy upon me, have mercy upon me," was the common cry.

It was very affecting to see the poor Indians, who the other day were hallooing and yelling in their idolatrous feasts and drunken frolics, now crying to God with such importunity for an interest in His dear Son! Found two or three persons, who, I had reason to hope, had taken comfort upon good grounds since the evening before. These, with others that had obtained comfort, were together and seemed to rejoice much that God was carrying on His work with such power upon others.

August 10. Rode to the Indians and began to discourse more privately to those who had obtained comfort and satisfaction, endeavoring to instruct, direct, caution and comfort them. But others being eager of hearing every word that related to spiritual concerns, soon came together one after another. When I had discoursed to the young converts more than half an hour, they seemed much melted with divine things and earnestly desirous to be with Christ. I told them of the godly soul's perfect purity and full enjoyment of Christ immediately upon its separation from the body, and that it would be forever inconceivably more happy than they had ever been for any short space of time when Christ seemed near to them, in prayer or other duties.

That I might make way for speaking of the resurrection of the body, and thence of the complete blessedness of the man, I said, "But perhaps some of you will say, I love my body as well as my soul, and I cannot bear to think that my body should lie dead, if my soul is happy." To which they all cheerfully replied, *Muttoh, muttoh* (before I had opportunity to prosecute what I designed respecting the resurrection), "No, no." They did not regard their bodies, if their souls might be but with Christ. Then they appeared willing to be absent from the body, that they might be present with the Lord.

When I had spent some time with these, I turned to the other Indians and spoke to them from Luke 19:10, "For the Son of man is come to seek . . ." I had not discoursed long before their concern rose to a great degree, and the house

was filled with cries and groans. When I insisted on the compassion and care of the Lord Jesus Christ for those that were lost, who thought themselves undone and could find no way of escape, this melted them down the more and aggravated their distress that they could not find and come to so kind a Saviour.

Sundry persons, who before had been but slightly awakened, were now deeply wounded with a sense of their sin and misery. One man in particular, who was never before awakened, was now made to feel that "the word of the Lord was quick and powerful, sharper than any two-edged sword." He seemed to be pierced at heart with distress, and his concern appeared most rational and scriptural; for he said that all the wickedness of his past life was brought fresh to his remembrance, and he saw all the vile actions he had done formerly as if done but yesterday.

Found one that had newly received comfort, after pressing distress from day to day. Could not but rejoice and admire divine goodness in what appeared this day. There seems to be some good done by every discourse; some newly awakened every day, and some comforted. It was refreshing to observe the conduct of those that had obtained comfort, while others were distressed with fear and concern; that is, lifting up their hearts to God for them.

Lord's Day, August 11. Discoursed in the forenoon from the Parable of the Prodigal Son, Luke 15. Observed no such remarkable effect of the Word upon the assembly as in days past. There were numbers of careless spectators of the white people, some Quakers, and others. In the afternoon I discoursed upon a part of Peter's sermon, Acts 2, and at the close of my discourse to the Indians made an address to the white people. Divine truths seemed then to be attended with power both to English and Indians. Several of the white heathen were awakened and could not longer be idle spectators, but found they had souls to save or lose as well as the Indians; a great concern spread through the whole assembly. This also appeared to be a day of God's power, especially towards the conclusion of it, although the influence attending the Word seemed scarce so powerful now as in some days past.

The number of the Indians, old and young, was now upwards of seventy. One or two were newly awakened this day, who never had appeared to be moved with concern for their souls before. Those who had obtained relief and comfort, and had given hopeful evidences of having passed a saving change, appeared humble and devout and behaved in an agreeable and Christian-like manner. I was refreshed to see the tenderness of conscience manifest in some of them, one instance of which I cannot but notice. Perceiving one of them very sorrowful in the morning, I inquired into the cause of her sorrow. I found the difficulty was that she had been angry with her child the evening before and was now exercised with fears lest her anger had been inordinate and sinful. This so grieved her that she waked and began to sob before daylight, and continued weeping for several hours together.

August 14. Spent the day with the Indians. There was one of them who had some time since put away his wife (as is common among them) and taken another woman. Now he has been brought under some serious impressions and is much concerned about that affair in particular. He seemed fully convinced of the wickedness of that practice and earnestly desirous to know what God would have him do in his present circumstances. When the law of God respecting

marriage had been opened to them, and the cause of his leaving his wife inquired into, and when it appeared she had given him no just occasion by unchastity to desert her, and that she was willing to forgive his past misconduct and to live peaceably with him for the future, and that she moreover insisted on it as her right to enjoy him; he was then told that it was his indispensable duty to renounce the woman he had last taken and receive the other who was his proper wife, and live peaceably with her during life. With this he readily and cheerfully complied and thereupon publicly renounced the woman he had last taken and publicly promised to live with and be kind to his wife during life, she also promising the same to him. Here appeared a clear demonstration of the power of God's Word upon their hearts. I suppose a few weeks before, the whole world could not have persuaded this man to a compliance with Christian rules in this affair.

I was not without fears, lest this proceeding might be like putting "new wine into old bottles," and that some might be prejudiced against Christianity when they saw the demands made by it. But the man being much concerned about the matter, the determination of it could be deferred no longer and it seemed to have a good rather than an ill effect among the Indians, who generally owned that the laws of Christ were good and right respecting the affairs of marriage. In the afternoon I preached to them from the apostle's discourse to Cornelius, Acts 10:34. There appeared some affectionate concern among them, though not equal to what appeared in several of the former days. They still attended and heard as for their lives, and the Lord's work seemed still to be promoted and propagated among them. . . .

September 13. After having lodged out three nights, arrived at the Indian town I aimed at on Susquehannah, called Shaumoking (one of the places, and the largest of them, that I visited in May last), and was kindly received and entertained by the Indians. But had little satisfaction by reason of the heathenish dance and revel they then held in the house where I was obliged to lodge, which I could not suppress, though I often intreated them to desist, for the sake of one of their own friends who was then sick in the house and whose disorder was much aggravated by the noise. Alas! how destitute of natural affection are these poor uncultivated pagans, although they seem somewhat kind in their own way. Of a truth, "the dark corners of the earth are full of the habitations of cruelty." . . .

September 19. Visited an Indian town called Juneauta, situate on an island in Susquehannah. Was much discouraged with the temper and behavior of the Indians here, although they appeared friendly when I was with them the last spring, and then gave me encouragement to come and see them again. But they now seemed resolved to retain their pagan notions and persist in their idolatrous practices.

September 20. Visited the Indians again at Juneauta island, and found them almost universally very busy in making preparations for a great sacrifice and dance. Had no opportunity to get them together in order to discourse with them about Christianity, by reason of their being so much engaged about their sacrifice. My spirits were much sunk with a prospect so very discouraging, and especially seeing I had now no interpreter but a pagan, who was as much attached to idolatry as any of them (my own interpreter having left me the day before, being obliged to attend upon some important business elsewhere, and knowing

that he could neither speak nor understand the language of these Indians). I was under the greatest disadvantages imaginable. However, I attempted to discourse privately with some of them, but without any appearance of success. Notwithstanding, I still tarried with them.

In the evening they met together, near a hundred of them, and danced around a large fire, having prepared ten fat deer for the sacrifice. The fat of the inwards they burnt in the fire while they were dancing, and sometimes raised the flame to a prodigious height, at the same time yelling and shouting in such a manner that they might easily have been heard two miles or more. They continued their sacred dance all night, or near the matter; after which they ate the flesh of the sacrifice, and so retired each one to his lodging.

I enjoyed little satisfaction this night, being entirely alone on the island (as to any Christian company), and in the midst of this idolatrous revel. Having walked to and fro till body and mind were pained and much oppressed, I at length crept into a little crib made for corn, and there slept on the poles.

Lord's Day, September 22. Spent the day with the Indians on the island. As soon as they were well up in the morning, I attempted to instruct them, and labored for that purpose to get them together, but quickly found they had something else to do. Near noon they gathered together all their powwows (or conjurers), and set about half a dozen of them to playing their juggling tricks, and acting their frantic distracted postures, in order to find out why they were then so sickly upon the island, numbers of them being at that time disordered with a fever, and bloody flux.

In this exercise they were engaged for several hours, making all the wild, ridiculous, and distracted motions imaginable; sometimes singing; sometimes howling; sometimes extending their hands to the utmost stretch, spreading all their fingers; and they seemed to push with them, as if they designed to fright something away, or at least keep it off at arm's-end; sometimes stroking their faces with their hands, then spurting water as fine as mist; sometimes sitting flat on the earth, then bowing down their faces to the ground; wringing their sides, as if in pain and anguish; twisting their faces, turning up their eyes, grunting, and puffing.

Their monstrous actions tended to excite ideas of horror, and seemed to have something in them, as I thought, peculiarly suited to raise the Devil, if he could be raised by anything odd, ridiculous, and frightful. Some of them, I could observe, were much more fervent and devout in the business than others, and seemed to chant, peep, and mutter with a great degree of warmth and vigor, as if determined to awaken and engage the powers below. I sat at a small distance, not more than thirty feet from them (though undiscovered), with my Bible in my hand, resolving, if possible, to spoil their sport, and prevent their receiving any answers from the infernal world, and there viewed the whole scene. They continued their hideous charms and incantations for more than three hours, until they had all wearied themselves out, although they had in that space of time taken sundry intervals of rest; and at length broke up, I apprehended, without receiving any answer at all.

After they had done powwowing, I attempted to discourse with them about Christianity. But they soon scattered, and gave me no opportunity for anything of that nature. A view of these things, while I was entirely alone in the wilderness, destitute of the society of anyone that so much as "named the name of

Christ," greatly sunk my spirits, gave me the most gloomy turn of mind imaginable, almost stripped me of all resolution and hope respecting further attempts for propagating the gospel, and converting the pagans, and rendered this the most burdensome and disagreeable Sabbath that ever I saw.

But nothing, I can truly say, sunk and distressed me like the loss of my hope respecting their conversion. This concern appeared so great, and seemed to be so much my own that I seemed to have nothing to do on earth, if this failed. A prospect of the greatest success in the saving conversion of souls under gospel light, would have done little or nothing towards compensating for the loss of my hope in this respect; and my spirits now were so damped and depressed that I had no heart nor power to make any further attempts among them for that purpose, and could not possibly recover my hope, resolution, and courage, by the utmost of my endeavors.

The Indians of this island can many of them understand the English language considerably well, having formerly lived in some part of Maryland among or near the white people, but are very vicious, drunken, and profane, although not so savage as those who have less acquaintance with the English. Their customs in divers respects differ from those of other Indians upon this river. They do not bury their dead in a common form, but let their flesh consume above ground in close cribs made for that purpose; and at the end of a year, or sometimes a longer space of time, they take the bones, when the flesh is all consumed, and wash and scrape them, and afterwards bury them with some ceremony.

Their method of charming or conjuring over the sick seems somewhat different from that of other Indians, though for substance the same. The whole of it, among these and others, perhaps is an imitation of what seems, by Naaman's expression, II Kings 5:11, to have been the custom of the ancient heathens. For it seems chiefly to consist in their "striking their hands over the diseased," repeatedly stroking them, "and calling upon their gods," excepting the spurting of water like a mist, and some other frantic ceremonies, common to the other conjurations I have already mentioned.

When I was in these parts in May last, I had an opportunity of learning many of the notions and customs of the Indians, as well as of observing many of their practices. I then traveled more than an hundred and thirty miles upon the river above the English settlements. Had in that journey a view of some persons of seven or eight distinct tribes, speaking so many different languages.

But of all the sights I ever saw among them, or indeed anywhere else, none appeared so frightful, or so near akin to what is usually imagined of infernal powers—none ever excited such images of terror in my mind—as the appearance of one who was a devout and zealous reformer, or rather restorer of what he supposed was the ancient religion of the Indians. He made his appearance in his pontifical garb, which was a coat of bears' skins, dressed with the hair on, and hanging down to his toes, a pair of bearskin stockings, and a great wooden face, painted the one half black, and the other tawny, about the color of an Indian's skin, with an extravagant mouth, cut very much awry. The face was fastened to a bearskin cap, which was drawn over his head. He advanced toward me with the instrument in his hand that he used for music in his idolatrous worship, which was a dry tortoise shell, with some corn in it, and the neck of it drawn on to a piece of wood, which made a very convenient handle.

As he came forward, he beat his tune with the rattle, and danced with all his might, but did not suffer any part of his body, not so much as his fingers, to be seen; and no man would have guessed by his appearance and actions, that he could have been a human creature, if they had not had some intimation of it otherwise. When he came near me, I could not but shrink away from him, although it was then noonday, and I knew who it was, his appearance and gestures were so prodigiously frightful. He had a house consecrated to religious uses, with divers images cut out upon the several parts of it; I went in and found the ground beaten almost as hard as a rock with their frequent dancing in it.

I discoursed with him about Christianity, and some of my discourse he seemed to like, but some of it he disliked entirely. He told me that God had taught him his religion, and that he never would turn from it, but wanted to find some that would join heartily with him in it; for the Indians, he said, were grown very degenerate and corrupt. He had thoughts, he said, of leaving all his friends, and traveling abroad, in order to find some that would join with him; for he believed God had some good people somewhere that felt as he did. He had not always, he said, felt as he now did, but had formerly been like the rest of the Indians, until about four or five years before that time: then, he said, his heart was very much distressed, so that he could not live among the Indians, but got away into the woods, and lived alone for some months.

At length, he says, God comforted his heart, and showed him what he should do. Since that time he had known God and tried to serve Him; he loved all men, be they who they would, so as he never did before. He treated me with uncommon courtesy, and seemed to be hearty in it. I was told by the Indians that he opposed their drinking strong liquor with all his power; and if at any time he could not dissuade them from it, by all he could say, he would leave them, and go crying into the woods. It was manifest he had a set of religious notions that he had looked into for himself, and not taken for granted upon bare tradition; and he relished or disrelished whatever was spoken of a religious nature, according as it either agreed or disagreed with his standard. And while I was discoursing he would sometimes say, "Now that I like; so God has taught me," and so on. And some of his sentiments seemed very just. Yet he utterly denied the being of a Devil, and declared there was no such creature known among the Indians of old times, whose religion he supposed he was attempting to revive.

He likewise told me that departed souls all went southward, and that the difference between the good and bad was this, that the former were admitted into a beautiful town with spiritual walls, or walls agreeable to the nature of souls; and that the latter would forever hover round those walls, and in vain attempt to get in. He seemed to be sincere, honest, and conscientious in his own way, and according to his own religious notions, which was more than I ever saw in any other pagan. I perceived he was looked upon and derided among most of the Indians as a precise zealot, that made a needless noise about religious matters; but I must say, there was something in his temper and disposition that looked more like true religion than anything I ever observed amongst other heathens.

But, alas! how deplorable is the state of the Indians upon this river! The brief representation I have here given of their notions and manners is sufficient to show that they are "led captive by Satan at his will," in the most eminent manner. Methinks they might likewise be sufficient to excite the compassion,

and engage the prayers of pious souls for these their fellow men, who sit in "the regions of the shadow of death."

September 23. Made some further attempts to instruct and Christianize the Indians on this island, but all to no purpose. They live so near the white people that they are always in the way of strong liquor, as well as the ill examples of nominal Christians; which renders it so unspeakably difficult to treat with them about Christianity.

# THE PHILADELPHIA SYNAGOGUE

The Petition of the Philadelphia Synagogue to Council of Censors of Pennsylvania marks an important dispute in the early attempts of state and federal governments to delineate the relationship between church and state. In it, a group of prominent Jewish leaders strongly criticized a clause mandating that General Assembly members in the state of Pennsylvania declare their conviction that the scriptures of both the Old and New Testament were divinely inspired as true. The group made their petition in 1783 to the Council of Censors, a body established by the Pennsylvania Constitution to review the constitution's application every seven years, determining whether any body of government had abused its powers and seeking to uphold and preserve the integrity of the constitution. The petition had a significant influence in the creation of the United States Constitution, which would not incorporate any religious oaths for governmental officials.

## The Petition of the Philadelphia Synagogue to Council of Censors of Pennsylvania

*23 Dec. 1783*

To the honourable the COUNCIL of CENSORS, assembled agreeable to the Constitution of the State of Pennsylvania. The Memorial of Rabbi Ger. Seixas of the Synagogue of the Jews at Philadelphia, Simon Nathan their Parnass or President, Asher Myers, Bernard Gratz and Haym Salomon the Mahamad, or Associates of their council in behalf of themselves and their brethren Jews, residing in Pennsylvania,

Most respectfully showeth,

That by the tenth section of the Frame of Government of this Commonwealth, it is ordered that each member of the general assembly of representatives of the freemen of Pennsylvania, before he takes his seat, shall make and

subscribe a declaration, which ends in these words, "I do acknowledge the Scriptures of the old and new Testament to be given by divine inspiration," to which is added an assurance, that "no further or other religious test shall ever hereafter be required of any civil officer or magistrate in this state."

Your memorialists beg leave to observe, that this clause seems to limit the civil rights of your citizens to one very special article of the creed; whereas by the second paragraph of the declaration of the rights of the inhabitants, it is asserted without any other limitation than the professing the existence of God, in plain words, "that no man who acknowledges the being of a God can be justly deprived or abridged of any civil rights as a citizen on account of his religious sentiments." But certainly this religious test deprives the Jews of the most eminent rights of freemen, solemnly ascertained to all men who are not professed Atheists.

May it please your Honors,

Although the Jews in Pennsylvania are but few in number, yet liberty of the people in one country, and the declaration of the government thereof, that these liberties are the rights of the people, may prove a powerful attractive to men, who live under restraints in another country. Holland and England have made valuable acquisitions of men, who for their religious sentiments, were distressed in their own countries.—And if Jews in Europe or elsewhere, should incline to transport themselves to America, and would, for reason of some certain advantage of the soil, climate, or the trade of Pennsylvania, rather become inhabitants thereof, than of any other State; yet the disability of Jews to take seat among the representatives of the people, as worded by the said religious test, might determine their free choice to go to New York, or to any other of the United States of America, where there is no such like restraint laid upon the nation and religion of the Jews, as in Pennsylvania.—Your memorialists cannot say that the Jews are particularly fond of being representatives of the people in assembly or civil officers and magistrates in the State; but with great submission they apprehend that a clause in the constitution, which disables them to be elected by their fellow citizens to represent them in assembly, is a stigma upon their nation and religion, and it is inconsonant with the second paragraph of the said bill of rights; otherwise Jews are as fond of liberty as their religious societies can be, and it must create in them a displeasure, when they perceive that for their professed dissent to doctrine, which is inconsistent with their religious sentiments, they should be excluded from the most important and honourable part of the rights of a free citizen.

Your memorialists beg further leave to represent, that in the religious books of the Jews, which are or may be in every man's hands, there are no such doctrines or principles established as are inconsistent with the safety and happiness of the people of Pennsylvania, and that the conduct and behaviour of the Jews in this and the neighbouring States, has always tallied with the great design of the Revolution; that the Jews of Charlestown, New York, New-Port and other posts, occupied by the British troops, have distinguishedly suffered for their attachment to the Revolution principles; and their brethren at St. Eustatius, for the same cause, experienced the most severe resentments of the British commanders. The Jews of Pennsylvania in proportion to the number of their members, can count with any religious society whatsoever, the Whigs among either of them; they have served some of them in the Continental army; some went out in the militia to fight the common enemy; all of them have cheerfully contributed to the support of

the militia, and of the government of this State; they have no inconsiderable property in lands and tenements, but particularly in the way of trade, some more, some less, for which they pay taxes; they have, upon every plan formed for public utility, been forward to contribute as much as their circumstances would admit of; and as a nation or a religious society, they stand unimpeached of any matter whatsoever, against the safety and happiness of the people.

And your memorialists humbly pray, that if your honours, from any consideration than the subject of this address, should think proper to call a convention for revising the constitution, you would be pleased to recommend this to the notice of that convention.

# THOMAS JEFFERSON

Thomas Jefferson's *A Bill for Establishing Religious Freedom*, drafted in 1779, marks the first attempt in the new nation toward thoroughgoing religious freedom and disestablishment. Having written this document three years after authoring the Declaration of Independence, Jefferson (1743–1826) aimed here to rid the state of all remnants of an established church. It was a dramatic gesture, since Virginia's history was deeply tied to the Anglican church, and the swell of support from Baptists, Presbyterians, and other dissenters hardly eased the fears of those conservative legislative members who were concerned about preserving the old social order. Patrick Henry sought a sort of compromise that would make Christianity "the established Religion of this Commonwealth" without overtly favoring Anglicanism, but that effort eventually failed. The Virginia Assembly passed Jefferson's bill, in a slightly modified form, in 1786 as the Statute for Religious Freedom, making Virginia a model for religious liberty for other parts of the country. The full text of Jefferson's bill is reprinted here (words in italics were deleted from the version that became law).

## A Bill for Establishing
## Religious Freedom

*Well aware that the opinions and belief of men depend not on their own will, but follow involuntarily the evidence proposed to their minds; that* Almighty God hath created the mind free, *and manifested his supreme will that free it shall remain by making it*

free will

*altogether insusceptible of restraint;* that all attempts to influence it by temporal punishments, or burthens, or by civil incapacitations, tend only to beget habits of hypocrisy and meanness, and are a departure from the plan of the holy author of our religion, who being lord both of body and mind, yet chose not to propagate it by coercions on either, as was in his Almighty power to do, *but to extend it by its influence on reason alone;* that the impious presumption of legislators and rulers, civil as well as ecclesiastical, who, being themselves but fallible and uninspired men, have assumed dominion over the faith of others, setting up their own opinions and modes of thinking as the only true and infallible, and as such endeavoring to impose them on others, hath established and maintained false religions over the greatest part of the world and through all time: That to compel a man to furnish contributions of money for the propagation of opinions which he disbelieves *and abhors,* is sinful and tyrannical; that even the forcing him to support this or that teacher of his own religious persuasion, is depriving him of the comfortable liberty of giving his contributions to the particular pastor whose morals he would make his pattern, and whose powers he feels most persuasive to righteousness; and is withdrawing from the ministry those temporary rewards, which proceeding from an approbation of their personal conduct, are an additional incitement to earnest and unremitting labours for the instruction of mankind; that our civil rights have no dependance on our religious opinions, any more than our opinions in physics or geometry; that therefore the proscribing any citizen as unworthy the public confidence by laying upon him an incapacity of being called to offices of trust and emolument, unless he profess or renounce this or that religious opinion, is depriving him injuriously of those privileges and advantages to which, in common with his fellow citizens, he has a natural right; that it tends also to corrupt the principles of that *very* religion it is meant to encourage, by bribing, with a monopoly of worldly honours and emoluments, those who will externally profess and conform to it; that though indeed these are criminal who do not withstand such temptation, yet neither are those innocent who lay the bait in their way; *that the opinions of men are not the object of civil government, nor under its jurisdiction;* that to suffer the civil magistrate to intrude his powers into the field of opinion and to restrain the profession or propagation of principles on supposition of their ill tendency is a dangerous falacy, which at once destroys all religious liberty, because he being of course judge of that tendency will make his opinions the rule of judgment, and approve or condemn the sentiments of others only as they shall square with or differ from his own; that it is time enough for the rightful purposes of civil government for its officers to interfere when principles break out into overt acts against peace and good order; and finally, that truth is great and will prevail if left to herself; that she is the proper and sufficient antagonist to error, and has nothing to fear from the conflict unless by human interposition disarmed of her natural weapons, free argument and debate; errors ceasing to be dangerous when it is permitted freely to contradict them.

  *We the General Assembly of Virginia do enact* that no man shall be compelled to frequent or support any religious worship, place, or ministry whatsoever, nor shall be enforced, restrained, molested, or burthened in his body or goods, nor shall otherwise suffer, on account of his religious opinions or belief; but that all men shall be free to profess, and by argument to maintain, their opinions in

matters of religion, and that the same shall in no wise diminish, enlarge, or affect their civil capacities.

And though we well know that this Assembly, elected by the people for the ordinary purposes of legislation only, have no power to restrain the acts of succeeding Assemblies, constituted with powers equal to our own, and that therefore to declare this act irrevocable would be of no effect in law; yet we are free to declare, and do declare, that the rights hereby asserted are of the natural rights of mankind, and that if any act shall be hereafter passed to repeal the present or to narrow its operation, such act will be an infringement of natural right.

# JAMES MADISON

James Madison's *Memorial and Remonstrance Against Religious Assessments* is a vital part of the same story, since Madison wrote the document against Patrick Henry's compromise bill and in favor of Jefferson's. Madison made a strenuous argument against the state's right to determine matters of religion, including establishing Christianity as the state religion. Such a step would only return the nation to tyrannical rulers, Madison proclaimed. Matters of religion should be left between oneself and God.

## Memorial and Remonstrance
## Against Religious Assessments

TO THE HONORABLE THE GENERAL ASSEMBLY
OF THE COMMONWEALTH OF VIRGINIA
A MEMORIAL AND REMONSTRANCE

We the subscribers, citizens of the said Commonwealth, having taken into serious consideration, a Bill printed by order of the last Session of General Assembly, entitled "A Bill establishing a provision for Teachers of the Christian Religion," and conceiving that the same if finally armed with the sanctions of a law, will be a dangerous abuse of power, are bound as faithful members of a free State to remonstrate against it, and to declare the reasons by which we are determined. We remonstrate against the said Bill,

1. Because we hold it for a fundamental and undeniable truth, "that Religion or the duty which we owe to our Creator and the manner of discharging it, can be directed only by reason and conviction, not by force or violence." The Religion then of every man must be left to the conviction and conscience of

every man; and it is the right of every man to exercise it as these may dictate. This right is in its nature an unalienable right. It is unalienable, because the opinions of men, depending only on the evidence contemplated by their own minds cannot follow the dictates of other men: It is unalienable also, because what is here a right towards men, is a duty towards the Creator. It is the duty of every man to render to the Creator such homage and such only as he believes to be acceptable to him. This duty is precedent, both in order of time and in degree of obligation, to the claims of Civil Society. Before any man can be considered as a member of Civil Society, he must be considered as a subject of the Governour of the Universe: And if a member of Civil Society, who enters into any subordinate Association, must always do it with a reservation of his duty to the General Authority; much more must every man who becomes a member of any particular Civil Society, do it with a saving of his allegiance to the Universal Sovereign. We maintain therefore that in matters of Religion, no mans right is abridged by the institution of Civil Society and that Religion is wholly exempt from its cognizance. True it is, that no other rule exists, by which any question which may divide a Society, can be ultimately determined, but the will of the majority; but it is also true that the majority may trespass on the rights of the minority.

2. Because if Religion be exempt from the authority of the Society at large, still less can it be subject to that of the Legislative Body. The latter are but the creatures and vicegerents of the former. Their jurisdiction is both derivative and limited: it is limited with regard to the co-ordinate departments, more necessarily is it limited with regard to the constituents. The preservation of a free Government requires not merely, that the metes and bounds which separate each department of power be invariably maintained; but more especially that neither of them be suffered to overleap the great Barrier which defends the rights of the people. The Rulers who are guilty of such an encroachment, exceed the commission from which they derive their authority, and are Tyrants. The People who submit to it are governed by laws made neither by themselves nor by an authority derived from them, and are slaves.

3. Because it is proper to take alarm at the first experiment on our liberties. We hold this prudent jealousy to be the first duty of Citizens, and one of the noblest characteristics of the late Revolution. The free men of America did not wait till usurped power had strengthened itself by exercise, and entangled the question in precedents. They saw all the consequences in the principle, and they avoided the consequences by denying the principle. We revere this lesson too much soon to forget it. Who does not see that the same authority which can establish Christianity, in exclusion of all other Religions, may establish with the same ease any particular sect of Christians, in exclusion of all other Sects? that the same authority which can force a citizen to contribute three pence only of his property for the support of any one establishment, may force him to conform to any other establishment in all cases whatsoever?

4. Because the Bill violates that equality which ought to be the basis of every law, and which is more indispensible, in proportion as the validity or expediency of any law is more liable to be impeached. If "all men are by nature equally free and independent," all men are to be considered as entering into Society on equal conditions; as relinquishing no more, and therefore retaining no less, one than another, of their natural rights. Above all are they to be considered as

retaining an *"equal* title to the free exercise of Religion according to the dictates of Conscience." Whilst we assert for ourselves a freedom to embrace, to profess and to observe the Religion which we believe to be of divine origin, we cannot deny an equal freedom to those whose minds have not yet yielded to the evidence which has convinced us. If this freedom be abused, it is an offence against God, not against man: To God, therefore, not to man, must an account of it be rendered. As the Bill violates equality by subjecting some to peculiar burdens, so it violates the same principle, by granting to others peculiar exemptions. Are the Quakers and Menonists the only sects who think a compulsive support of their Religions unnecessary and unwarrantable? Can their piety alone be entrusted with the care of public worship? Ought their Religions to be endowed above all others with extraordinary privileges by which proselytes may be enticed from all others? We think too favorably of the justice and good sense of these denominations to believe that they either covet pre-eminences over their fellow citizens or that they will be seduced by them from the common opposition to the measure.

5. Because the Bill implies either that the Civil Magistrate is a competent Judge of Religious Truth; or that he may employ Religion as an engine of Civil policy. The first is an arrogant pretension falsified by the contradictory opinions of Rulers in all ages, and throughout the world: the second an unhallowed perversion of the means of salvation.

6. Because the establishment proposed by the Bill is not requisite for the support of the Christian Religion. To say that it is, is a contradiction to the Christian Religion itself, for every page of it disavows a dependence on the powers of this world: it is a contradiction to fact; for it is known that this Religion both existed and flourished, not only without the support of human laws, but in spite of every opposition from them, and not only during the period of miraculous aid, but long after it had been left to its own evidence and the ordinary care of Providence. Nay, it is a contradiction in terms; for a Religion not invented by human policy, must have pre-existed and been supported, before it was established by human policy. It is moreover to weaken in those who profess this Religion a pious confidence in its innate excellence and the patronage of its Author; and to foster in those who still reject it, a suspicion that its friends are too conscious of its fallacies to trust it to its own merits.

7. Because experience witnesseth that ecclesiastical establishments, instead of maintaining the purity and efficacy of Religion, have had a contrary operation. During almost fifteen centuries has the legal establishment of Christianity been on trial. What have been its fruits? More or less in all places, pride and indolence in the Clergy, ignorance and servility in the laity, in both, superstition, bigotry and persecution. Enquire of the Teachers of Christianity for the ages in which it appeared in its greatest lustre; those of every sect, point to the ages prior to its incorporation with Civil policy. Propose a restoration of this primitive State in which its Teachers depended on the voluntary rewards of their flocks, many of them predict its downfall. On which Side ought their testimony to have greatest weight, when for or when against their interest?

8. Because the establishment in question is not necessary for the support of Civil Government. If it be urged as necessary for the support of Civil Government only as it is a means of supporting Religion, and it be not necessary for the latter purpose, it cannot be necessary for the former. If Religion be not

within the cognizance of Civil Government how can its legal establishment be necessary to Civil Government? What influence in fact have ecclesiastical establishments had on Civil Society? In some instances they have been seen to erect a spiritual tyranny on the ruins of the Civil authority; in many instances they have been seen upholding the thrones of political tyranny: in no instance have they been seen the guardians of the liberties of the people. Rulers who wished to subvert the public liberty, may have found an established Clergy convenient auxiliaries. A just Government instituted to secure & perpetuate it needs them not. Such a Government will be best supported by protecting every Citizen in the enjoyment of his Religion with the same equal hand which protects his person and his property; by neither invading the equal rights of any Sect, nor suffering any Sect to invade those of another.

9. Because the proposed establishment is a departure from that generous policy, which, offering an Asylum to the persecuted and oppressed of every Nation and Religion, promised a lustre to our country, and an accession to the number of its citizens. What a melancholy mark is the Bill of sudden degeneracy? Instead of holding forth an Asylum to the persecuted, it is itself a signal of persecution. It degrades from the equal rank of Citizens all those whose opinions in Religion do not bend to those of the Legislative authority. Distant as it may be in its present form from the Inquisition, it differs from it only in degree. The one is the first step, the other the last in the career of intolerance. The magnanimous sufferer under this cruel scourge in foreign Regions, must view the Bill as a Beacon on our Coast, warning him to seek some other haven, where liberty and philanthrophy in their due extent, may offer a more certain repose from his Troubles.

10. Because it will have a like tendency to banish our Citizens. The allurements presented by other situations are every day thinning their number. To superadd a fresh motive to emigration by revoking the liberty which they now enjoy, would be the same species of folly which has dishonoured and depopulated flourishing kingdoms.

11. Because it will destroy that moderation and harmony which the forbearance of our laws to intermeddle with Religion has produced among its several sects. Torrents of blood have been spilt in the old world, by vain attempts of the secular arm, to extinguish Religious discord, by proscribing all difference in Religious opinion. Time has at length revealed the true remedy. Every relaxation of narrow and rigorous policy, wherever it has been tried, has been found to assuage the disease. The American Theatre has exhibited proofs that equal and compleat liberty, if it does not wholly eradicate it, sufficiently destroys its malignant influence on the health and prosperity of the State. If with the salutary effects of this system under our own eyes, we begin to contract the bounds of Religious freedom, we know no name that will too severely reproach our folly. At least let warning be taken at the first fruits of the threatened innovation. The very appearance of the Bill has transformed "that Christian forbearance, love and charity," which of late mutually prevailed, into animosities and jealousies, which may not soon be appeased. What mischiefs may not be dreaded, should this enemy to the public quiet be armed with the force of a law?

12. Because the policy of the Bill is adverse to the diffusion of the light of Christianity. The first wish of those who enjoy this precious gift ought to be that it may be imparted to the whole race of mankind. Compare the number of those

who have as yet received it with the number still remaining under the dominion of false Religions; and how small is the former! Does the policy of the Bill tend to lessen the disproportion? No; it at once discourages those who are strangers to the light of revelation from coming into the Region of it; and countenances by example the nations who continue in darkness, in shutting out those who might convey it to them. Instead of Levelling as far as possible, every obstacle to the victorious progress of Truth, the Bill with an ignoble and unchristian timidity would circumscribe it with a wall of defence against the encroachments of error.

13. Because attempts to enforce by legal sanctions, acts obnoxious to so great a proportion of Citizens, tend to enervate the laws in general, and to slacken the bands of Society. If it be difficult to execute any law which is not generally deemed necessary or salutary, what must be the case, where it is deemed invalid and dangerous? And what may be the effect of so striking an example of impotency in the Government, on its general authority?

14. Because a measure of such singular magnitude and delicacy ought not to be imposed, without the clearest evidence that it is called for by a majority of citizens, and no satisfactory method is yet proposed by which the voice of the majority in this case may be determined, or its influence secured. "The people of the respective counties are indeed requested to signify their opinion respecting the adoption of the Bill to the next Session of Assembly." But the representation must be made equal, before the voice either of the Representatives or of the Counties will be that of the people. Our hope is that neither of the former will, after due consideration, espouse the dangerous principle of the Bill. Should the event disappoint us, it will still leave us in full confidence, that a fair appeal to the latter will reverse the sentence against our liberties.

15. Because finally, "the equal right of every citizen to the free exercise of his Religion according to the dictates of conscience" is held by the same tenure with all our other rights. If we recur to its origin, it is equally the gift of nature; if we weigh its importance, it cannot be less dear to us; if we consult the "Declaration of those rights which pertain to the good people of Virginia, as the basis and foundation of Government," it is enumerated with equal solemnity, or rather studied emphasis. Either then, we must say, that the Will of the Legislature is the only measure of their authority; and that in the plenitude of this authority, they may sweep away all our fundamental rights; or, that they are bound to leave this particular right untouched and sacred: Either we must say, that they may controul the freedom of the press, may abolish the Trial by Jury, may swallow up the Executive and Judiciary Powers of the State; nay that they may despoil us of our very right of suffrage, and erect themselves into an independent and hereditary Assembly or, we must say, that they have no authority to enact into law the Bill under consideration. We the Subscribers say, that the General Assembly of this Commonwealth have no such authority: And that no effort may be omitted on our part against so dangerous an usurpation, we oppose to it, this remonstrance; earnestly praying, as we are in duty bound, that the Supreme Lawgiver of the Universe, by illuminating those to whom it is addressed, may on the one hand, turn their Councils from every act which would affront his holy prerogative, or violate the trust committed to them: and on the other, guide them into every measure which may be worthy of his [blessing, may re]dound to their own praise, and may establish more firmly the liberties, the prosperity and the happiness of the Commonwealth.

# HANNAH ADAMS

Hannah Adams (1755–1831) was a self-educated New Englander who read Thomas Broughton's *Dictionary of Religions* in childhood and spent much of the rest of her life researching and writing about the world's diverse religions. She published her *Alphabetical Compendium* in Boston in 1784, a book that was unusually liberal in its attempt, as she put it, "to avoid giving the least preference of one denomination above another . . . consequently the making use of any such appellations as Hereticks, Schismaticks, Enthusiasts, Fanaticks, &c. is carefully avoided" (front matter, n.p.). Adams significantly revised and added to the work in three subsequent editions, retitled in two editions the *View of Religious Opinions* (1784, 1801) and in the fourth and final edition, *A Dictionary of All Religions and Religious Denominations* (1817). Her work was well regarded and widely read by her contemporaries, particularly those who shared her liberal Unitarian bent toward tolerance and understanding. The following excerpt, from the first edition in 1784, is useful as a contemporary description of religion in the United States in the early days of the new republic, replete with its vast diversity of opinion, doctrine, and practice.

# *From* An Alphabetical Compendium of the Various Sects Which Have Appeared in the World from the Beginning of the Christian Era to the Present Day

## APPENDIX 4TH. RELIGIONS OF AMERICA. UNITED STATES. NEW-ENGLAND.

Previous to an account of the present denominations in this part of America, a short sketch of the Aborigines will not, perhaps, be unentertaining to some readers.

The natives of New-England believed not only a plurality of Gods, who made and govern the several nations of the world, but they made Deities of every thing they imagined to be great, powerful, beneficial, or hurtful to mankind: yet, they conceived one Almighty Being, who dwells in the southwest

---

Transcribed by RMG, pp. lv–xiii; lxxxiii; I have made silent corrections to avoid frequent (*sic*) notations, and I have deleted Hannah Adams's frequent italicizations.

region of the Heavens, to be superior to all the rest: this Almighty Being they called Kichtan, who at first, according to their tradition, made a man and woman out of a stone, but upon some dislike destroyed them again; and then made another couple out of a tree, from whom descended all the nations of the earth; but how they came to be scattered and dispersed into countries so remote from one another they cannot tell. They believed their supreme God to be a good Being, and paid a sort of acknowledgement to him for plenty, victory, and other benefits.

But there is another power which they called Hobbamocko, in English the Devil, of whom they stood in greater awe, and worshipped merely from a principle of terror.

The immortality of the soul was universally believed among them; when good men die they said their souls went to Kichtan, where they meet their friends, and enjoy all manner of pleasures; when wicked men die, they went to Kichtan also, but are commanded to walk away; and so wander about in restless discontent and darkness forever.

At present the Indians in New-England are almost wholly extinct.

## Massachusetts

There are various denominations in this state, but the Congregationalists predominate. Those of New-England, generally regulate themselves according to the Congregational Platform. This Platform leaves the scriptures to be the sole rule of faith, ordinances and discipline, as to what relates to authority and polity. It leaves each church with plenary unceded power; making the Councils and Synods advisory only. It was passed and received as the plan of public confederacy, which united the Presbyterians and Independents under the one common title of Congregationalists.

It was a fundamental principle of this union, that every voluntary assembly of Christians had power to form, organize and govern themselves; and in imitation of the apostolic churches, to gather and incorporate themselves by a public covenant, and to elect and ordain all their public officers.

There are also in this state a number of Episcopalians, Presbyterians, Baptists, Quakers, Hopkinsians, Universalists, Shakers, Deists, &c.

## New-Hampshire

The prevailing religion of this state is similar with that of the Massachusetts. And the other denominations are nearly the same; only it is said, there is a larger proportion of Quakers.

## Rhode Island

This state was settled by some of the Antinomian exiles, on a plan of entire religious liberty: men of every denomination being equally protected and countenanced, enjoying all the honours and offices of government.

Many of the Quakers and Baptists flocked to this new settlement; and there never was an instance of persecution for conscience sake countenanced by the Governors of this state.

There are at present in this state, a large number of Quakers and Baptists of different denominations; a few Congregationalists, Moravians, Universalists, Hopkinsians, &c.

The Jews have a synagogue in this state.

There are also a few in Rhode-Island who adhere to Jemima Wilkinson, who was born in Cumberland. It is said by those who are intimately acquainted with her, that she asserts, that in October 1776, she was taken sick and actually died, and her soul went to Heaven, where it still continues. Soon after, her body was re-animated with the spirit and power of Christ, upon which she set up as a public teacher, and declares she has an immediate revelation for all she delivers; and is arrived to a state of absolute perfection. It is also said she pretends to foretell future events, to discern the secrets of the heart, and to have the power of healing diseases: and if any person who makes application to her is not healed, she attributes it to their want of faith. She asserts, that those who refuse to believe these exalted things concerning her, will be in the state of the unbelieving Jews, who rejected the counsel of God against themselves; and she tells her hearers, this is the eleventh hour, and this is the last call of mercy that ever shall be granted them: for she heard an enquiry in Heaven, saying, "Who will go and preach to a dying world?" or words to that import: and she says she answered, "Here am I, send me"; and that she left the realms of light and glory, and the company of the heavenly host, who are continually praising and worshipping God, in order to descend upon earth, and pass through many sufferings and trials for the happiness of mankind. She assumes the title of the Universal Friend of Mankind; hence her followers distinguish themselves by the name of Friends.

## Connecticut

Congregationalism is the predominant religion of this state; but a number of the Connecticut churches have formed themselves on the Presbyterian model according to Scotland.

There is also a number of Episcopalians, Baptists, Quakers, Hopkinsians, Universalists, Sandemanians, Deists, &c.

## New-York

The inhabitants of this state are generally Protestants of different persuasions, as Lutherans, Quakers, Baptists, Episcopalians, Dutch, Gallic and German Calvinists, Moravians, Methodists, &c. who have all their respective houses of worship.

The Jews have a synagogue in this state.

It is ordained in the constitution of New-York, that the free exercise of religious worship, without discrimination or preference, shall forever be allowed to all mankind.

There is also a number of Shakers at Nisquiunia in this state.

A gentleman of New-York, who lately visited a society of Shakers in Acquakanoch, whose congregation consisted of about ninety persons, was astonished at the facility with which they performed almost incredible actions: one woman, in particular, had acquired such an understanding in the principle of balance as to be able to turn round on her heel a full half hour, so swiftly, that

it was difficult to discriminate the object. They are extremely reluctant to enter into conversation upon the principles of their worship, but content themselves with declaring, that they have all been very great sinners, and therefore it is that they mortify themselves by painful exercises.

## New-Jersey

After the coming of the white people, the Indians in New-Jersey, who once held a plurality of Deities, supposed there were only three, because they saw people of three kinds of complexions, viz.-English, Negroes, and themselves.

It is a notion pretty generally prevailing among them, that it was not the same God made them who made us; but that they were created after the white people: and it is probably they suppose their God gained some special skill by seeing the white people made, and so made them better: for it is certain they look upon themselves, and their methods of living, which they say their God expressly prescribed for them, vastly preferable to the white people, and their methods.

With regard to a future state of existence, many of them imagine that the chichung, i.e. the shadow, or what survives the body, will, at death, go southward, and in an unknown but curious place-will enjoy some kind of happiness, such as hunting, feasting, dancing, and the like. And what they suppose will contribute much to their happiness in the next state is, that they shall never be weary of those entertainments.

Those who have any notion about rewards and punishments in a future state, seem to imagine that most will be happy, and that those who are not so, will be punished only with privation, being only excluded from the walls of the good world where happy spirits reside.

These rewards and punishments, they suppose to depend entirely upon their behaviour towards mankind; and have no reference to any thing which relates to the worship of the supreme Being.

According to the present constitution of this state, all persons are allowed to worship God in the manner which is most agreeable to their own consciences. There is no establishment of any one religious sect, in preference to another; and no Protestant inhabitants are to be denied the enjoyment of any civil rights, merely on account of their religious sentiments.

There are Dutch, Gallic, and German Calvinists in this state. There is also a number of Episcopalians, Presbyterians, Baptists, Quakers, &c.

## Pennsylvania

The inhabitants of this state are of different religious denominations, especially Quakers; it was from William Penn, a celebrated Quaker, that this place received its name. Civil and religious liberty in their utmost latitude, was laid down by this great man, as the only foundation of all his institutions. Christians of all denominations might not only live unmolested, but have a share in the government of this colony.

At present the Quakers have at least four places of worship in the city of Philadelphia. A number departed from the rest on account of political principles, maintaining defensive war, and have built an elegant plain meeting-house

in Arch-street. They call themselves free Quakers; but it is thought since the peace, they will reunite with the other Friends.

There are also in this city, three Episcopal churches, two Roman-Catholic chapels; several German and Dutch churches, some of which are Lutheran, others Calvinistical; one Moravian chapel; one Methodist meeting; three Presbyterian or Congregational; one Baptist church, Calvinists; part of this church who separated from the other, call themselves Universalists.

There is also a number of Jews in this state.

## Maryland

The first European settlers of this state were chiefly, if not wholly, Roman-Catholics, and like the settlers of New-England, their settlement was founded upon a strong desire of the unmolested practice of their own religion.

Lord Baltimore, one of the most eminent of the settlers, established a perfect toleration in all religious matters, so that Dissenters of all denominations flocked to this colony.

At present there is here a larger proportion of Roman Catholics than in any of the other states. Among the Protestants, Episcopacy is the predominant religion; but there are various other denominations.

## Virginia

The predominant religion in this state, is that of the Church of England; but all other denominations are tolerated.

Virginia contains fifty-four parishes and churches, thirty of forty of which have ministers, with chapels of ease in those of larger extent.

## North and South Carolina

The predominant religion in these states, is Episcopacy; but there are various other persuasions; liberty of conscience being universally allowed.

## Georgia

According to the best account, the Indian natives of Georgia had some notion of an omnipotent Being, who formed man, and inhabited the sun, the clouds, and the clear sky. They likewise had some idea of his providence and power over the human race. It is even said, that they believed somewhat of a future state; and that the souls of bad men walk up and down the place where they died; but, that God, or, as they call him, the Beloved, chooses some from children, whom he takes care of, and resides in and teaches.

At present Episcopacy is the predominant religion of this state.

There is a considerable number of Dutch, Gallic, and German Calvinistical churches, at Ebenezer, in Georgia.

There is also a number of Methodists. Here the Rev. Mr. George Whitefield founded an orphan-house, which is now converted into a college for the education of young men designed chiefly for the ministry; and through his zeal and pious care, this favourite seminary is at present in a thriving condition.

From the foregoing view of the various religions of the different countries of the world, it appears, that the Christian Religion is of very small extent, compared with those many and vast countries overspread with Paganism or Mohammedism. This great and sad truth may be further evinced by the following calculation, ingeniously made by some, who, dividing the inhabited world into thirty parts, find, that

| XIX | Of them are possessed by | Pagans, |
| VI | | Jews and Mohammedans, |
| II | | Christians of the Greek Church, |
| | | Church of Rome, |
| III | | Those of the Protestant Communion. |

If this calculation be true, Christianity, taken in its largest latitude, bears no greater proportion to the other religions than five to twenty-five.

THE END.

# PART III

# From New Republic to Divided Nation, 1800–65

The period after the American Revolution was one of tremendous creativity, ferment, and contention. New sects arose that would grow into religions, Mormonism notable among them. Jews and Catholics grew in number, while Eastern Orthodox Christians sent missionaries to the New World. Evangelicalism witnessed more revivals, in a time described as the Second Great Awakening. Unitarianism gained ground in northeastern intellectual circles, dramatically altering the appearance of Christianity in New England. Observers such as Alexis de Tocqueville, a Frenchman who visited the young nation, were able to pinpoint both the high optimism and the anxiety that seemed to characterize the country as a whole at this time, including its diverse religious manifestations.

A vast array of Protestant reform movements arose during this antebellum ("before the war") period to address some of the problems faced by the young nation. No problem vexed the nation or the churches more thoroughly than slavery, for which the Bible proved to be a flexible text. In the North, evangelicalism was pivotal in producing the complex movement known as abolitionism; and many, black and white, invoked the scriptural themes of freedom and justice, reading God's tangible deliverance of the slaves from their slave masters in the exodus of Israelites from the hands of the Egyptians. Many southern Christians, however, perceived in the Bible a divine mandate for the slave system. Religious persons stood on all sides of the slavery issue, in other words, putting the Bible and Christian history to their own uses.

The selections presented here emphasize some of this rich religious variety and conflict.

# JOSEPH SMITH

Joseph Smith (1805–44) founded the Church of Jesus Christ of Latter-day Saints, whose adherents are called Mormons. While many derided him in his own time (and continue to do so) as a demagogue, his followers have seen him as a prophet who received revelations on the order of the Bible. The church that he founded (including numerous split-off groups) has grown exponentially since his violent death at the hands of an angry mob in Carthage, Illinois. In some of his autobiographical writings, Smith recounts receiving the revelations that would inaugurate the Latter-day Saint movement. These personal writings are useful to students of American religious history for describing the many evangelical movements that were inhabiting upstate New York at the time.

The first excerpt, "The Articles of Faith of the Church of Jesus Christ of Latter-day Saints," summarizes in creedal form some of the key church teachings as recorded by Smith. They were first given to the public in a letter that Smith wrote to John Wentworth in 1842 and would later appear in *The Pearl of Great Price*. The second is a revelation received in 1843 pertaining to plural marriage, which would prove to be one of the most controversial dimensions of Mormonism within American society.

# The Articles of Faith

## OF THE CHURCH OF JESUS CHRIST
## OF LATTER-DAY SAINTS

1 We believe in God, the Eternal Father, and in His Son, Jesus Christ, and in the Holy Ghost.

2 We believe that men will be punished for their own sins, and not for Adam's transgression.

3 We believe that through the Atonement of Christ, all mankind may be saved, by obedience to the laws and ordinances of the Gospel.

4 We believe that the first principles and ordinances of the Gospel are: first, Faith in the Lord Jesus Christ; second, Repentance; third, Baptism by immersion for the remission of sins; fourth, Laying on of hands for the gift of the Holy Ghost.

5  We believe that a man must be called of God, by prophecy, and by the laying on of hands, by those who are in authority, to preach the Gospel and administer in the ordinances thereof.

6  We believe in the same organization that existed in the Primitive Church, namely, apostles, prophets, pastors, teachers, evangelists, etc.

7  We believe in the gift of tongues, prophecy, revelation, visions, healing, interpretation of tongues, etc.

8  We believe the Bible to be the word of God as far as it is translated correctly; we also believe the Book of Mormon to be the word of God.

9  We believe all that God has revealed, all that He does now reveal, and we believe that He will yet reveal many great and important things pertaining to the Kingdom of God.

10  We believe in the literal gathering of Israel and in the restoration of the Ten Tribes; that Zion (the New Jerusalem) will be built upon the American continent; that Christ will reign personally upon the earth; and, that the earth will be renewed and receive its paradisiacal glory.

11  We claim the privilege of worshiping Almighty God according to the dictates of our own conscience, and allow all men the same privilege, let them worship how, where, or what they may.

12  We believe in being subject to kings, presidents, rulers, and magistrates, in obeying, honoring, and sustaining the law.

13  We believe in being honest, true, chaste, benevolent, virtuous; and in doing good to all men; indeed, we may say that we follow the admonition of Paul—We believe all things, we hope all things, we have endured many things, and hope to be able to endure all things. If there is anything virtuous, lovely, or of good report or praiseworthy, we seek after these things.

## SECTION 132.

REVELATION *given through Joseph Smith the Prophet, at Nauvoo, Illinois, recorded July 12, 1843, relating to the new and everlasting covenant, including the eternity of the marriage covenant, as also plurality of wives. ——The Prophet's inquiry of the Lord—He is told to prepare himself to receive the new and everlasting covenant— Conditions of this law—The power of the Holy Priesthood instituted by the Lord must be operative in ordinances to be in effect beyond the grave—Marriage by secular authority is of effect during mortality only—Though the form of marriage should make it appear to be for time and eternity, the ordinance is not valid beyond the grave unless solemnized by the authority of the Holy Priesthood as the Lord directs—Marriage duly authorized for time and eternity to be attended by surpassing blessings—Essentials for the attainment of the status of godhood—The meaning of eternal lives—Plurality of wives acceptable only when commanded by the Lord—The sin of adultery—Commandment to Emma Smith, wife of the Prophet.*

Depiction of Joseph Smith
receiving the plates of the
Book of Mormon from
the angel Moroni (1886).
*Courtesy of the Library
of Congress, Prints &
Photographs Division.*

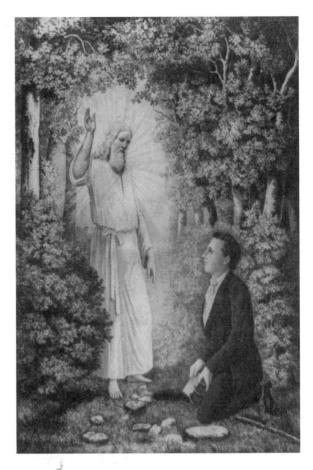

1. Verily, thus saith the Lord unto you my servant Joseph, that inasmuch as you have inquired of my hand to know and understand wherein I, the Lord, justified my servants Abraham, Isaac, and Jacob, as also Moses, David and Solomon, my servants, as touching the principle and doctrine of their having many wives and concubines—

2. Behold, and lo, I am the Lord thy God, and will answer thee as touching this matter.

3. Therefore, prepare thy heart to receive and obey the instructions which I am about to give unto you; for all those who have this law revealed unto them must obey the same.

4. For behold, I reveal unto you a new and an everlasting covenant; and if ye abide not that covenant, then are ye damned; for no one can reject this covenant and be permitted to enter into my glory.

5. For all who will have a blessing at my hands shall abide the law which was appointed for that blessing, and the conditions thereof, as were instituted from before the foundation of the world.

6. And as pertaining to the new and everlasting covenant, it was instituted for the fulness of my glory; and he that receiveth a fulness thereof must and shall abide the law, or he shall be damned, saith the Lord God.

7. And verily I say unto you, that the conditions of this law are these: All covenants, contracts, bonds, obligations, oaths, vows, performances, connections, associations, or expectations, that are not made and entered into and sealed by the Holy Spirit of promise, of him who is anointed, both as well for time and for all eternity, and that too most holy, by revelation and commandment through the medium of mine anointed, whom I have appointed on the earth to hold this power (and I have appointed unto my servant Joseph to hold this power in the last days, and there is never but one on the earth at a time on whom this power and the keys of this priesthood are conferred), are of no efficacy, virtue, or force in and after the resurrection from the dead; for all contracts that are not made unto this end have an end when men are dead.

8. Behold, mine house is a house of order, saith the Lord God, and not a house of confusion.

9. Will I accept of an offering, saith the Lord, that is not made in my name?

10. Or will I receive at your hands that which I have not appointed?

11. And will I appoint unto you, saith the Lord, except it be by law, even as I and my Father ordained unto you, before the world was?

12. I am the Lord thy God; and I give unto you this commandment—that no man shall come unto the Father but by me or by my word, which is my law, saith the Lord.

13. And everything that is in the world, whether it be ordained of men, by thrones, or principalities, or powers, or things of name, whatsoever they may be, that are not by me or by my word, saith the Lord, shall be thrown down, and shall not remain after men are dead, neither in nor after the resurrection, saith the Lord your God.

14. For whatsoever things remain are by me; and whatsoever things are not by me shall be shaken and destroyed.

15. Therefore, if a man marry him a wife in the world, and he marry her not by me nor by my word, and he covenant with her so long as he is in the world and she with him, their covenant and marriage are not of force when they are dead, and when they are out of the world; therefore, they are not bound by any law when they are out of the world.

16. Therefore, when they are out of the world they neither marry nor are given in marriage; but are appointed angels in heaven; which angels are ministering servants, to minister for those who are worthy of a far more, and an exceeding, and an eternal weight of glory.

17. For these angels did not abide my law; therefore, they cannot be enlarged, but remain separately and singly, without exaltation, in their saved condition, to all eternity; and from henceforth are not gods, but are angels of God forever and ever.

18. And again, verily I say unto you, if a man marry a wife, and make a covenant with her for time and for all eternity, if that covenant is not by me or by my word, which is my law, and is not sealed by the Holy Spirit of promise, through him whom I have anointed and appointed unto this power, then it is not valid neither of force when they are out of the world, because they are not

joined by me, saith the Lord, neither by my word, when they are out of the world it cannot be received there, because the angels and the gods are appointed there, by whom they cannot pass; they cannot, therefore, inherit my glory; for my house is a house of order, saith the Lord God.

19.  And again, verily I say unto you, if a man marry a wife by my word, which is my law, and by the new and everlasting covenant, and it is sealed unto them by the Holy Spirit of promise, by him who is anointed, unto whom I have appointed this power and the keys of this priesthood; and it shall be said unto them—Ye shall come forth in the first resurrection; and if it be after the first resurrection, in the next resurrection; and shall inherit thrones, kingdoms, principalities, and powers, dominions, all heights and depths—then shall it be written in the Lamb's Book of Life, that he shall commit no murder whereby to shed innocent blood, and if ye abide in my covenant, and commit no murder whereby to shed innocent blood, it shall be done unto them in all things whatsoever my servant hath put upon them, in time, and through all eternity; and shall be of full force when they are out of the world; and they shall pass by the angels, and the gods, which are set there, to their exaltation and glory in all things, as hath been sealed upon their heads, which glory shall be a fulness and a continuation of the seeds forever and ever.

20.  Then shall they be gods, because they have no end; therefore shall they be from everlasting to everlasting, because they continue; then shall they be above all, because all things are subject unto them. Then shall they be gods, because they have all power, and the angels are subject unto them.

21.  Verily, verily, I say unto you, except ye abide my law ye cannot attain to this glory.

22.  For strait is the gate, and narrow the way that leadeth unto the exaltation and continuation of the lives, and few there be that find it, because ye receive me not in the world neither do ye know me.

23.  But if ye receive me in the world, then shall ye know me, and shall receive your exaltation; that where I am ye shall be also.

24.  This is eternal lives—to know the only wise and true God, and Jesus Christ, whom he hath sent. I am he. Receive ye, therefore, my law.

25.  Broad is the gate, and wide the way that leadeth to the deaths; and many there are that go in thereat, because they receive me not, neither do they abide in my law.

26.  Verily, verily, I say unto you, if a man marry a wife according to my word, and they are sealed by the Holy Spirit of promise, according to mine appointment, and he or she shall commit any sin or transgression of the new and everlasting covenant whatever, and all manner of blasphemies, and if they commit no murder wherein they shed innocent blood, yet they shall come forth in the first resurrection, and enter into their exaltation; but they shall be destroyed in the flesh, and shall be delivered unto the buffetings of Satan unto the day of redemption, saith the Lord God.

27.  The blasphemy against the Holy Ghost, which shall not be forgiven in the world nor out of the world, is in that ye commit murder wherein ye shed innocent blood, and assent unto my death, after ye have received my new and everlasting covenant, saith the Lord God; and he that abideth not this law can in nowise enter into my glory, but shall be damned, saith the Lord.

28. I am the Lord thy God, and will give unto thee the law of my Holy Priesthood, as was ordained by me and my Father before the world was.

29. Abraham received all things, whatsoever he received, by revelation and commandment, by my word, saith the Lord, and hath entered into his exaltation and sitteth upon his throne.

30. Abraham received promises concerning his seed, and of the fruit of his loins—from whose loins ye are, namely, my servant Joseph—which were to continue so long as they were in the world; and as touching Abraham and his seed, out of the world they should continue; both in the world and out of the world should they continue as innumerable as the stars; or, if ye were to count the sand upon the seashore ye could not number them.

31. This promise is yours also, because ye are of Abraham, and the promise was made unto Abraham; and by this law is the continuation of the works of my Father, wherein he glorifieth himself.

32. Go ye, therefore, and do the works of Abraham; enter ye into my law and ye shall be saved.

33. But if ye enter not into my law ye cannot receive the promise of my Father, which he made unto Abraham.

34. God commanded Abraham, and Sarah gave Hagar to Abraham to wife. And why did she do it? Because this was the law; and from Hagar sprang many people. This, therefore, was fulfilling, among other things, the promises.

35. Was Abraham, therefore, under condemnation? Verily I say unto you, Nay; for I, the Lord, commanded it.

36. Abraham was commanded to offer his son Isaac; nevertheless, it was written: Thou shalt not kill. Abraham, however, did not refuse, and it was accounted unto him for righteousness.

37. Abraham received concubines, and they bore him children; and it was accounted unto him for righteousness, because they were given unto him, and he abode in my law; as Isaac also and Jacob did none other things than that which they were commanded; and because they did none other things than that which they were commanded, they have entered into their exaltation, according to the promises, and sit upon thrones, and are not angels but are gods.

38. David also received many wives and concubines, and also Solomon and Moses my servants, as also many others of my servants, from the beginning of creation until this time; and in nothing did they sin save in those things which they received not of me.

39. David's wives and concubines were given unto him of me, by the hand of Nathan, my servant, and others of the prophets who had the keys of this power; and in none of these things did he sin against me save in the case of Uriah and his wife; and, therefore he hath fallen from his exaltation, and received his portion; and he shall not inherit them out of the world, for I gave them unto another, saith the Lord.

40. I am the Lord thy God, and I gave unto thee, my servant Joseph, an appointment, and restore all things. Ask what ye will, and it shall be given unto you according to my word.

41. And as ye have asked concerning adultery, verily, verily, I say unto you, if a man receiveth a wife in the new and everlasting covenant, and if she be

with another man, and I have not appointed unto her by the holy anointing, she hath committed adultery and shall be destroyed.

42. If she be not in the new and everlasting covenant, and she be with another man, she has committed adultery.

43. And if her husband be with another woman, and he was under a vow, he hath broken his vow and hath committed adultery.

44. And if she hath not committed adultery, but is innocent and hath not broken her vow, and she knoweth it, and I reveal it unto you, my servant Joseph, then shall you have power, by the power of my Holy Priesthood, to take her and give her unto him that hath not committed adultery but hath been faithful; for he shall be made ruler over many.

45. For I have conferred upon you the keys and power of the priesthood, wherein I restore all things, and make known unto you all things in due time.

46. And verily, verily, I say unto you, that whatsoever you seal on earth shall be sealed in heaven; and whatsoever you bind on earth, in my name and by my word, saith the Lord, it shall be eternally bound in the heavens; and whosesoever sins you remit on earth shall be remitted eternally in the heavens; and whosesoever sins you retain on earth shall be retained in heaven.

47. And again, verily I say, whomsoever you bless I will bless, and whomsoever you curse I will curse, saith the Lord; for I, the Lord, am thy God.

48. And again, verily I say unto you, my servant Joseph, that whatsoever you give on earth, and to whomsoever you give any one on earth, by my word and according to my law, it shall be visited with blessings and not cursings, and with my power, saith the Lord, and shall be without condemnation on earth and in heaven.

49. For I am the Lord thy God, and will be with thee even unto the end of the world, and through all eternity; for verily I seal upon you your exaltation, and prepare a throne for you in the kingdom of my Father, with Abraham your father.

50. Behold, I have seen your sacrifices, and will forgive all your sins; I have seen your sacrifices in obedience to that which I have told you. Go, therefore, and I make a way for your escape, as I accepted the offering of Abraham of his son Isaac.

51. Verily, I say unto you: A commandment I give unto mine handmaid, Emma Smith, your wife, whom I have given unto you, that she stay herself and partake not of that which I commanded you to offer unto her; for I did it, saith the Lord, to prove you all, as I did Abraham, and that I might require an offering at your hand, by covenant and sacrifice.

52. And let mine handmaid, Emma Smith, receive all those that have been given unto my servant Joseph, and who are virtuous and pure before me; and those who are not pure, and have said they were pure, shall be destroyed, saith the Lord God.

53. For I am the Lord thy God, and ye shall obey my voice; and I give unto my servant Joseph that he shall be made ruler over many things; for he hath been faithful over a few things, and from henceforth I will strengthen him.

54. And I command mine handmaid, Emma Smith, to abide and cleave unto my servant Joseph, and to none else. But if she will not abide this commandment she shall be destroyed, saith the Lord; for I am the Lord thy God, and will destroy her if she abide not in my law.

55. But if she will not abide this commandment, then shall my servant Joseph do all things for her, even as he hath said; and I will bless him and multiply him and give unto him an hundred-fold in this world, of fathers and mothers, brothers and sisters, houses and lands, wives and children, and crowns of eternal lives in the eternal worlds.

56. And again, verily I say, let mine handmaid forgive my servant Joseph his trespasses; and then shall she be forgiven her trespasses, wherein she has trespassed against me; and I, the Lord thy God, will bless her, and multiply her, and make her heart to rejoice.

57. And again, I say, let not my servant Joseph put his property out of his hands, lest an enemy come and destroy him; for Satan seeketh to destroy; for I am the Lord thy God, and he is my servant; and behold, and lo, I am with him, as I was with Abraham, thy father, even unto his exaltation and glory.

58. Now, as touching the law of the priesthood, there are many things pertaining thereunto.

59. Verily, if a man be called of my Father, as was Aaron, by mine own voice, and by the voice of him that sent me, and I have endowed him with the keys of the power of this priesthood, if he do anything in my name, and according to my law and by my word, he will not commit sin, and I will justify him.

60. Let no one, therefore, set on my servant Joseph; for I will justify him; for he shall do the sacrifice which I require at his hands for his transgressions, saith the Lord your God.

61. And again, as pertaining to the law of the priesthood—if any man espouse a virgin, and desire to espouse another, and the first give her consent, and if he espouse the second, and they are virgins, and have vowed to no other man, then is he justified; he cannot commit adultery for they are given unto him; for he cannot commit adultery with that that belongeth unto him and to no one else.

62. And if he have ten virgins given unto him by this law, he cannot commit adultery, for they belong to him, and they are given unto him; therefore is he justified.

63. But if one or either of the ten virgins, after she is espoused, shall be with another man, she has committed adultery, and shall be destroyed; for they are given unto him to multiply and replenish the earth, according to my commandment, and to fulfil the promise which was given by my Father before the foundation of the world, and for their exaltation in the eternal worlds, that they may bear the souls of men; for herein is the work of my Father continued, that he may be glorified.

64. And again, verily, verily, I say unto you, if any man have a wife, who holds the keys of this power, and he teaches unto her the law of my priesthood, as pertaining to these things, then shall she believe and administer unto him, or she shall be destroyed, saith the Lord your God; for I will destroy her; for I will magnify my name upon all those who receive and abide in my law.

65. Therefore, it shall be lawful in me, if she receive not this law, for him to receive all things whatsoever I, the Lord his God, will give unto him, because she did not believe and administer unto him according to my word; and she then becomes the transgressor; and he is exempt from the law of Sarah, who administered unto Abraham according to the law when I commanded Abraham to take Hagar to wife.

66. And now, as pertaining to this law, verily, verily, I say unto you, I will reveal more unto you, hereafter; therefore, let this suffice for the present. Behold, I am Alpha and Omega. Amen.

# RALPH WALDO EMERSON

Ralph Waldo Emerson (1803–82) began his career as a Unitarian minister in Boston's Second Church but left the institution in 1832 on a quest toward what would become Transcendentalism. The works of Emerson, a well-known lecturer and author, touched on many themes: individual self-reliance over slavish conformity, intuition over rationalism, idealism over materialism, and more. Above all, Emerson argued against the cold intellectualism and scholasticism of the Unitarians no less than the Calvinists, and his paeans to the wisdom of the human soul would inspire generations to come.

The Harvard Divinity School Address, delivered in 1838, marks a dramatic occasion in which Emerson openly challenged the doctrine that Christ constituted a special revelation (a doctrine to which Unitarians of the period still adhered) and set forth his own independent spiritual vision. The address created a tremendous stir, and Harvard professors, outraged, quickly distanced themselves from Emerson's views. Thereafter viewed as a heretic in institutional circles, Emerson continued to "unsettle all things," as he put it, and to lend his considerable talents to new literary and spiritual explorations.

## Harvard Divinity School Address

In this refulgent summer, it has been a luxury to draw the breath of life. The grass grows, the buds burst, the meadow is spotted with fire and gold in the tint of flowers. The air is full of birds, and sweet with the breath of the pine, the balm-of-Gilead, and the new hay. Night brings no gloom to the heart with its welcome shade. Through the transparent darkness the stars pour their almost spiritual rays. Man under them seems a young child, and his huge globe a toy. The cool night bathes the world as with a river, and prepares his eyes again for the crimson dawn. The mystery of nature was never displayed more happily. The corn and the wine have been freely dealt to all creatures, and the never-broken silence with which the old bounty goes forward has not yielded yet one

word of explanation. One is constrained to respect the perfection of this world in which our senses converse. How wide; how rich; what invitation from every property it gives to every faculty of man! In its fruitful soils; in its navigable sea; in its mountains of metal and stone; in its forests of all woods; in its animals; in its chemical ingredients; in the powers and path of light, heat, attraction and life, it is well worth the pith and heart of great men to subdue and enjoy it. The planters, the mechanics, the inventors, the astronomers, the builders of cities, and the captains, history delights to honor.

But when the mind opens and reveals the laws which traverse the universe and make things what they are, then shrinks the great world at once into a mere illustration and fable of this mind. What am I? and What is? asks the human spirit with a curiosity new-kindled, but never to be quenched. Behold these out-running laws, which our imperfect apprehension can see tend this way and that, but not come full circle. Behold these infinite relations, so like, so unlike; many, yet one. I would study, I would know, I would admire forever. These works of thought have been the entertainments of the human spirit in all ages.

A more secret, sweet, and overpowering beauty appears to man when his heart and mind open to the sentiment of virtue. Then he is instructed in what is above him. He learns that his being is without bound; that to the good, to the perfect, he is born, low as he now lies in evil and weakness. That which he venerates is still his own, though he has not realized it yet. *He ought.* He knows the sense of that grand word, though his analysis fails to render account of it. When in innocency or when by intellectual perception he attains to say,—"I love the Right; Truth is beautiful within and without for evermore. Virtue, I am thine; save me; use me; thee will I serve, day and night, in great, in small, that I may be not virtuous, but virtue";— then is the end of the creation answered, and God is well pleased.

The sentiment of virtue is a reverence and delight in the presence of certain divine laws. It perceives that this homely game of life we play, covers, under what seem foolish details, principles that astonish. The child amidst his baubles is learning the action of light, motion, gravity, muscular force; and in the game of human life, love, fear, justice, appetite, man, and God, interact. These laws refuse to be adequately stated. They will not be written out on paper, or spoken by the tongue. They elude our persevering thought; yet we read them hourly in each other's faces, in each other's actions, in our own remorse. The moral traits which are all globed into every virtuous act and thought,—in speech we must sever, and describe or suggest by painful enumeration of many particulars. Yet, as this sentiment is the essence of all religion, let me guide your eye to the precise objects of the sentiment, by an enumeration of some of those classes of facts in which this element is conspicuous.

The intuition of the moral sentiment is an insight of the perfection of the laws of the soul. These laws execute themselves. They are out of time, out of space, and not subject to circumstance. Thus in the soul of man there is a justice whose retributions are instant and entire. He who does a good deed is instantly ennobled. He who does a mean deed is by the action itself contracted. He who puts off impurity, thereby puts on purity. If a man is at heart just, then in so far is he God; the safety of God, the immortality of God, the majesty of God do enter into that man with justice. If a man dissemble, deceive, he deceives himself,

and goes out of acquaintance with his own being. A man in the view of absolute goodness, adores, with total humility. Every step so downward, is a step upward. The man who renounces himself, comes to himself.

See how this rapid intrinsic energy worketh everywhere, righting wrongs, correcting appearances, and bringing up facts to a harmony with thoughts. Its operation in life, though slow to the senses, is at last as sure as in the soul. By it a man is made the Providence to himself, dispensing good to his goodness, and evil to his sin. Character is always known. Thefts never enrich; alms never impoverish; murder will speak out of stone walls. The least admixture of a lie,— for example, the taint of vanity, any attempt to make a good impression, a favorable appearance,—will instantly vitiate the effect. But speak the truth, and all nature and all spirits help you with unexpected furtherance. Speak the truth, and all things alive or brute are vouchers, and the very roots of the grass underground there do seem to stir and move to bear you witness. See again the perfection of the Law as it applies itself to the affections, and becomes the law of society. As we are, so we associate. The good, by affinity, seek the good; the vile, by affinity, the vile. Thus of their own volition, souls proceed into heaven, into hell.

These facts have always suggested to man the sublime creed that the world is not the product of manifold power, but of one will, of one mind; and that one mind is everywhere active, in each ray of the star, in each wavelet of the pool; and whatever opposes that will is everywhere balked and baffled, because things are made so, and not otherwise. Good is positive. Evil is merely privative, not absolute: it is like cold, which is the privation of heat. All evil is so much death or nonentity. Benevolence is absolute and real. So much benevolence as a man hath, so much life hath he. For all things proceed out of this same spirit, which is differently named love, justice, temperance, in its different applications, just as the ocean receives different names on the several shores which it washes. All things proceed out of the same spirit, and all things conspire with it. Whilst a man seeks good ends, he is strong by the whole strength of nature. In so far as he roves from these ends, he bereaves himself of power, or auxiliaries; his being shrinks out of all remote channels, he becomes less and less, a mote a point, until absolute badness is absolute death.

The perception of this law of laws awakens in the mind a sentiment which we call the religious sentiment, and which makes our highest happiness. Wonderful is its power to charm and to command. It is a mountain air. It is the embalmer of the world. It is myrrh and storax, and chlorine and rosemary. It makes the sky and the hills sublime, and the silent song of the stars is it. By it is the universe made safe and habitable, not by science or power. Thought may work cold and intransitive in things, and find no end or unity; but the dawn of the sentiment of virtue on the heart, gives and is the assurance that Law is sovereign over all natures; and the worlds, time, space, eternity, do seem to break out into joy.

This sentiment is divine and deifying. It is the beatitude of man. It makes him illimitable. Through it, the soul first knows itself. It corrects the capital mistake of the infant man, who seeks to be great by following the great, and hopes to derive advantages *from another,*—by showing the fountain of all good to be in himself, and that he, equally with every man, is an inlet into the deeps of Reason. When he says, "I ought"; when love warms him; when he chooses,

warned from on high, the good and great deed; then, deep melodies wander through his soul from Supreme Wisdom.—Then he can worship, and be enlarged by his worship; for he can never go behind this sentiment. In the sublimest flights of the soul, rectitude is never surmounted, love is never outgrown.

This sentiment lies at the foundation of society, and successively creates all forms of worship. The principle of veneration never dies out. Man fallen into superstition, into sensuality, is never quite without the visions of the moral sentiment. In like manner, all the expressions of this sentiment are sacred and permanent in proportion to their purity. The expressions of this sentiment affect us more than all other compositions. The sentences of the oldest time, which ejaculate this piety, are still fresh and fragrant. This thought dwelled always deepest in the minds of men in the devout and contemplative East; not alone in Palestine, where it reached its purest expression, but in Egypt, in Persia, in India, in China. Europe has always owed to oriental genius its divine impulses. What these holy bards said, all sane men found agreeable and true. And the unique impression of Jesus upon mankind, whose name is not so much written as ploughed into the history of this world, is proof of the subtle virtue of this infusion.

Meantime, whilst the doors of the temple stand open, night and day, before every man, and the oracles of this truth cease never, it is guarded by one stern condition; this, namely; it is an intuition. It cannot be received at second hand. Truly speaking, it is not instruction, but provocation, that I can receive from another soul. What he announces, I must find true in me, or reject; and on his word, or as his second, be he who he may, I can accept nothing. On the contrary, the absence of this primary faith is the presence of degradation. As is the flood, so is the ebb. Let this faith depart, and the very words it spake and the things it made become false and hurtful. Then falls the church, the state, art, letters, life. The doctrine of the divine nature being forgotten, a sickness infects and dwarfs the constitution. Once man was all; now he is an appendage, a nuisance. And because the indwelling Supreme Spirit cannot wholly be got rid of, the doctrine of it suffers this perversion, that the divine nature is attributed to one or two persons, and denied to all the rest, and denied with fury. The doctrine of inspiration is lost; the base doctrine of the majority of voices usurps the place of the doctrine of the soul. Miracles, prophecy, poetry, the ideal life, the holy life, exist as ancient history merely; they are not in the belief, nor in the aspiration of society; but, when suggested, seem ridiculous. Life is comic or pitiful as soon as the high ends of being fade out of sight, and man becomes near-sighted, and can only attend to what addresses the senses.

These general views, which, whilst they are general, none will contest, find abundant illustration in the history of religion, and especially in the history of the Christian church. In that, all of us have had our birth and nurture. The truth contained in that, you, my young friends, are now setting forth to teach. As the Cultus, or established worship of the civilized world, it has great historical interest for us. Of its blessed words, which have been the consolation of humanity, you need not that I should speak. I shall endeavor to discharge my duty to you on this occasion, by pointing out two errors in its administration, which daily appear more gross from the point of view we have just now taken.

Jesus Christ belonged to the true race of prophets. He saw with open eye the mystery of the soul. Drawn by its severe harmony, ravished with its beauty,

he lived in it, and had his being there. Alone in all history he estimated the greatness of man. One man was true to what is in you and me. He saw that God incarnates himself in man, and evermore goes forth anew to take possession of his World. He said, in this jubilee of sublime emotion, "I am divine. Through me, God acts; through me, speaks. Would you see God, see me; or see thee, when thou also thinkest as I now think." But what a distortion did his doctrine and memory suffer in the same, in the next, and the following ages! There is no doctrine of the Reason which will bear to be taught by the Understanding. The understanding caught this high chant from the poet's lips, and said, in the next age, "This was Jehovah come down out of heaven. I will kill you, if you say he was a man." The idioms of his language and the figures of his rhetoric have usurped the place of his truth; and churches are not built on his principles, but on his tropes. Christianity became a Mythus, as the poetic teaching of Greece and of Egypt, before. He spoke of miracles; for he felt that man's life was a mir- acle, and all that man doth, and he knew that this daily miracle shines as the character ascends. But the word Miracle, as pronounced by Christian churches, gives a false impression; it is Monster. It is not one with the blowing clover and the falling rain.

He felt respect for Moses and the prophets, but no unfit tenderness at post- poning their initial revelations to the hour and the man that now is; to the eter- nal revelation in the heart. Thus was he a true man. Having seen that the law in us is commanding, he would not suffer it to be commanded. Boldly, with hand, and heart, and life, he declared it was God. Thus is he, as I think, the only soul in history who has appreciated the worth of man.

1. In this point of view we become sensible of the first defect of historical Christianity. Historical Christianity has fallen into the error that corrupts all at- tempts to communicate religion. As it appears to us, and as it has appeared for ages, it is not the doctrine of the soul, but an exaggeration of the personal, the positive, the ritual. It has dwelt, it dwells, with noxious exaggeration about the *person* of Jesus. The soul knows no persons. It invites every man to expand to the full circle of the universe, and will have no preferences but those of sponta- neous love. But by this eastern monarchy of a Christianity, which indolence and fear have built, the friend of man is made the injurer of man. The manner in which his name is surrounded with expressions which were once sallies of ad- miration and love, but are now petrified into official titles, kills all generous sympathy and liking. All who hear me, feel that the language that describes Christ to Europe and America is not the style of friendship and enthusiasm to a good and noble heart, but is appropriated and formal,—paints a demigod, as the Orientals or the Greeks would describe Osiris or Apollo. Accept the injuri- ous impositions of our early catechetical instruction, and even honesty and self- denial were but splendid sins, if they did not wear the Christian name. One would rather be

"A pagan, suckled in a creed outworn,"

than to be defrauded of his manly right in coming into nature and finding not names and places, not land and professions, but even virtue and truth fore- closed and monopolized. You shall not be a man even. You shall not own the world; you shall not dare and live after the infinite Law that is in you, and in

company with the infinite Beauty which heaven and earth reflect to you in all lovely forms; but you must subordinate your nature to Christ's nature; you must accept our interpretations, and take his portrait as the vulgar draw it.

That is always best which gives me to myself. The sublime is excited in me by the great stoical doctrine, Obey thyself. That which shows God in me, fortifies me. That which shows God out of me, makes me a wart and a wen. There is no longer a necessary reason for my being. Already the long shadows of untimely oblivion creep over me, and I shall decease forever.

The divine bards are the friends of my virtue, of my intellect, of my strength. They admonish me that the gleams which flash across my mind are not mine, but God's; that they had the like, and were not disobedient to the heavenly vision. So I love them. Noble provocations go out from them, inviting me to resist evil; to subdue the world; and to Be. And thus, by his holy thoughts, Jesus serves us, and thus only. To aim to convert a man by miracles is a profanation of the soul. A true conversion, a true Christ, is now, as always, to be made by the reception of beautiful sentiments. It is true that a great and rich soul, like his, falling among the simple, does so preponderate, that, as his did, it names the world. The world seems to them to exist for him, and they have not yet drunk so deeply of his sense as to see that only by coming again to themselves, or to God in themselves, can they grow forevermore. It is a low benefit to give me something; it is a high benefit to enable me to do somewhat of myself. The time is coming when all men will see that the gift of God to the soul is not a vaunting, overpowering, excluding sanctity, but a sweet, natural goodness, a goodness like thine and mine, and that so invites thine and mine to be and to grow.

The injustice of the vulgar tone of preaching is not less flagrant to Jesus than to the souls which it profanes. The preachers do not see that they make his gospel not glad, and shear him of the locks of beauty and the attributes of heaven. When I see a majestic Epaminondas, or Washington; when I see among my contemporaries a true orator, an upright judge, a dear friend; when I vibrate to the melody and fancy of a poem; I see beauty that is to be desired. And so lovely, and with yet more entire consent of my human being, sounds in my ear the severe music of the bards that have sung of the true God in all ages. Now do not degrade the life and dialogues of Christ out of the circle of this charm, by insulation and peculiarity. Let them lie as they befell, alive and warm, part of human life and of the landscape and of the cheerful day.

2. The second defect of the traditionary and limited way of using the mind of Christ is a consequence of the first; this, namely; that the Moral Nature, that Law of laws whose revelations introduce greatness—yea, God himself—into the open soul, is not explored as the fountain of the established teaching in society. Men have come to speak of the revelation as somewhat long ago given and done, as if God were dead. The injury to faith throttles the preacher; and the goodliest of institutions becomes an uncertain and inarticulate voice.

It is very certain that it is the effect of conversation with the beauty of the soul, to beget a desire and need to impart to others the same knowledge and love. If utterance is denied, the thought lies like a burden on the man. Always the seer is a sayer. Somehow his dream is told; somehow he publishes it with solemn joy: sometimes with pencil on canvas, sometimes with chisel on stone,

sometimes in towers and aisles of granite, his soul's worship is builded; sometimes in anthems of indefinite music; but clearest and most permanent, in words.

The man enamored of this excellency becomes its priest or poet. The office is coeval with the world. But observe the condition, the spiritual limitation of the office. The spirit only can teach. Not any profane man, not any sensual, not any liar, not any slave can teach, but only he can give, who has; he only can create, who is. The man on whom the soul descends, through whom the soul speaks, alone can teach. Courage, piety, love, wisdom, can teach; and every man can open his door to these angels, and they shall bring him the gift of tongues. But the man who aims to speak as books enable, as synods use, as the fashion guides, and as interest commands, babbles. Let him hush.

To this holy office you propose to devote yourselves. I wish you may feel your call in throbs of desire and hope. The office is the first in the world. It is of that reality that it cannot suffer the deduction of any falsehood. And it is my duty to say to you that the need was never greater of new revelation than now. From the views I have already expressed, you will infer the sad conviction, which I share, I believe, with numbers, of the universal decay and now almost death of faith in society. The soul is not preached. The Church seems to totter to its fall, almost all life extinct. On this occasion, any complaisance would be criminal which told you, whose hope and commission it is to preach the faith of Christ, that the faith of Christ is preached.

It is time that this ill-suppressed murmur of all thoughtful men against the famine of our churches;—this moaning of the heart because it is bereaved of the consolation, the hope, the grandeur that come alone out of the culture of the moral nature,—should be heard through the sleep of indolence, and over the din of routine. This great and perpetual office of the preacher is not discharged. Preaching is the expression of the moral sentiment in application to the duties of life. In how many churches, by how many prophets, tell me, is man made sensible that he is an infinite Soul; that the earth and heavens are passing into his mind; that he is drinking forever the soul of God? Where now sounds the persuasion, that by its very melody imparadises my heart, and so affirms its own origin in heaven? Where shall I hear words such as in elder ages drew men to leave all and follow,—father and mother, house and land, wife and child? Where shall I hear these august laws of moral being so pronounced as to fill my ear, and I feel ennobled by the offer of my uttermost action and passion? The test of the true faith, certainly, should be its power to charm and command the soul, as the laws of nature control the activity of the hands,—so commanding that we find pleasure and honor in obeying. The faith should blend with the light of rising and of setting suns, with the flying cloud, the singing bird, and the breath of flowers. But now the priest's Sabbath has lost the splendor of nature; it is unlovely; we are glad when it is done; we can make, we do make, even sitting in our pews, a far better, holier, sweeter, for ourselves.

Whenever the pulpit is usurped by a formalist, then is the worshipper defrauded and disconsolate. We shrink as soon as the prayers begin, which do not uplift, but smite and offend us. We are fain to wrap our cloaks about us, and secure, as best we can, a solitude that hears not. I once heard a preacher who sorely tempted me to say I would go to church no more. Men go, thought I,

where they are wont to go, else had no soul entered the temple in the afternoon. A snow-storm was falling around us. The snow-storm was real, the preacher merely spectral, and the eye felt the sad contrast in looking at him, and then out of the window behind him into the beautiful meteor of the snow. He had lived in vain. He had no one word intimating that he had laughed or wept, was married or in love, had been commended, or cheated, or chagrined. If he had ever lived and acted, we were none the wiser for it. The capital secret of his profession, namely, to convert life into truth, he had not learned. Not one fact in all his experience had he yet imported into his doctrine. This man had ploughed and planted and talked and bought and sold; he had read books; he had eaten and drunken; his head aches, his heart throbs; he smiles and suffers; yet was there not a surmise, a hint, in all the discourse, that he had ever lived at all. Not a line did he draw out of real history. The true preacher can be known by this, that he deals out to the people his life;—life passed through the fire of thought. But of the bad preacher, it could not be told from his sermon what age of the world he fell in; whether he had a father or a child; whether he was a freeholder or a pauper; whether he was a citizen or a countryman; or any other fact of his biography. It seemed strange that the people should come to church. It seemed as if their houses were very unentertaining, that they should prefer this thoughtless clamor. It shows that there is a commanding attraction in the moral sentiment, that can lend a faint tint of light to dulness and ignorance coming in its name and place. The good hearer is sure he has been touched sometimes; is sure there is somewhat to be reached, and some word that can reach it. When he listens to these vain words, he comforts himself by their relation to his remembrance of better hours, and so they clatter and echo unchallenged.

I am not ignorant that when we preach unworthily, it is not always quite in vain. There is a good ear, in some men, that draws supplies to virtue out of very indifferent nutriment. There is poetic truth concealed in all the commonplaces of prayer and of sermons, and though foolishly spoken, they may be wisely heard; for each is some select expression that broke out in a moment of piety from some stricken or jubilant soul, and its excellency made it remembered. The prayers and even the dogmas of our church are like the zodiac of Denderah and the astronomical monuments of the Hindus, wholly insulated from anything now extant in the life and business of the people. They mark the height to which the waters once rose. But this docility is a check upon the mischief from the good and devout. In a large portion of the community, the religious service gives rise to quite other thoughts and emotions. We need not chide the negligent servant. We are struck with pity, rather, at the swift retribution of his sloth. Alas for the unhappy man that is called to stand in the pulpit, and not give bread of life. Everything that befalls, accuses him. Would he ask contributions for the missions, foreign or domestic? Instantly his face is suffused with shame, to propose to his parish that they should send money a hundred or a thousand miles, to furnish such poor fare as they have at home and would do well to go the hundred or the thousand miles to escape. Would he urge people to a godly way of living;—and can he ask a fellow-creature to come to Sabbath meetings, when he and they all know what is the poor uttermost they can hope for therein? Will he invite them privately to the Lord's Supper? He dares not. If no heart warm this rite, the hollow, dry, creaking formality is too plain, than that he can face a

man of wit and energy and put the invitation without terror. In the street, what has he to say to the bold village blasphemer? The village blasphemer sees fear in the face, form, and gait of the minister.

Let me not taint the sincerity of this plea by any oversight of the claims of good men. I know and honor the purity and strict conscience of numbers of the clergy. What life the public worship retains, it owes to the scattered company of pious men, who minister here and there in the churches, and who, sometimes accepting with too great tenderness the tenet of the elders, have not accepted from others, but from their own heart, the genuine impulses of virtue, and so still command our love and awe, to the sanctity of character. Moreover, the exceptions are not so much to be found in a few eminent preachers, as in the better hours, the truer inspirations of all,—nay, in the sincere moments of every man. But, with whatever exception, it is still true that tradition characterizes the preaching of this country; that it comes out of the memory, and not out of the soul; that it aims at what is usual, and not at what is necessary and eternal; that thus historical Christianity destroys the power of preaching, by withdrawing it from the exploration of the moral nature of man; where the sublime is, where are the resources of astonishment and power. What a cruel injustice it is to that Law, the joy of the whole earth, which alone can make thought dear and rich; that Law whose fatal sureness the astronomical orbits poorly emulate;—that it is travestied and depreciated, that it is behooted and behowled, and not a trait, not a word of it articulated. The pulpit in losing sight of this Law, loses its reason, and gropes after it knows not what. And for want of this culture the soul of the community is sick and faithless. It wants nothing so much as a stern, high, stoical, Christian discipline, to make it know itself and the divinity that speaks through it. Now man is ashamed of himself; he skulks and sneaks through the world, to be tolerated, to be pitied, and scarcely in a thousand years does any man dare to be wise and good, and so draw after him the tears and blessings of his kind.

Certainly there have been periods when, from the inactivity of the intellect on certain truths, a greater faith was possible in names and persons. The Puritans in England and America found in the Christ of the Catholic Church and in the dogmas inherited from Rome, scope for their austere piety and their longings for civil freedom. But their creed is passing away, and none arises in its room. I think no man can go with his thoughts about him into one of our churches, without feeling that what hold the public worship had on men is gone, or going. It has lost its grasp on the affection of the good and the fear of the bad. In the country, neighborhoods, half parishes are *signing off*, to use the local term. It is already beginning to indicate character and religion to withdraw from the religious meetings. I have heard a devout person, who prized the Sabbath, say in bitterness of heart, "On Sundays, it seems wicked to go to church." And the motive that holds the best there is now only a hope and a waiting. What was once a mere circumstance, that the best and the worst men in the parish, the poor and the rich, the learned and the ignorant, young and old, should meet one day as fellows in one house, in sign of an equal right in the soul, has come to be a paramount motive for going thither.

My friends, in these two errors, I think, I find the causes of a decaying church and a wasting unbelief. And what greater calamity can fall upon a nation

than the loss of worship? Then all things go to decay. Genius leaves the temple to haunt the senate or the market. Literature becomes frivolous. Science is cold. The eye of youth is not lighted by the hope of other worlds, and age is without honor. Society lives to trifles, and when men die we do not mention them.

And now, my brothers, you will ask, What in these desponding days can be done by us? The remedy is already declared in the ground of our complaint of the Church. We have contrasted the Church with the Soul. In the soul then let the redemption be sought. Wherever a man comes, there comes revolution. The old is for slaves. When a man comes, all books are legible, all things transparent, all religions are forms. He is religious. Man is the wonderworker. He is seen amid miracles. All men bless and curse. He saith yea and nay, only. The stationariness of religion; the assumption that the age of inspiration is past, that the Bible is closed; the fear of degrading the character of Jesus by representing him as a man;—indicate with sufficient clearness the falsehood of our theology. It is the office of a true teacher to show us that God is, not was; that He speaketh, not spake. The true Christianity,—a faith like Christ's in the infinitude of man,—is lost. None believeth in the soul of man, but only in some man or person old and departed. Ah me! no man goeth alone. All men go in flocks to this saint or that poet, avoiding the God who seeth in secret. They cannot see in secret; they love to be blind in public. They think society wiser than their soul, and know not that one soul, and their soul, is wiser than the whole world. See how nations and races flit by on the sea of time and leave no ripple to tell where they floated or sunk, and one good soul shall make the name of Moses, or of Zeno, or of Zoroaster, reverend forever. None assayeth the stern ambition to be the Self of the nation and of nature, but each would be an easy secondary to some Christian scheme, or sectarian connection, or some eminent man. Once leave your own knowledge of God, your own sentiment, and take secondary knowledge, as St. Paul's, or George Fox's, or Swedenborg's, and you get wide from God with every year this secondary form lasts, and if, as now, for centuries,—the chasm yawns to that breadth, that men can scarcely be convinced there is in them anything divine.

Let me admonish you, first of all, to go alone; to refuse the good models, even those which are sacred in the imagination of men, and dare to love God without mediator or veil. Friends enough you shall find who will hold up to your emulation Wesleys and Oberlins, Saints and Prophets. Thank God for these good men, but say, "I also am a man." Imitation cannot go above its model. The imitator dooms himself to hopeless mediocrity. The inventor did it because it was natural to him, and so in him it has a charm. In the imitator something else is natural, and he bereaves himself of his own beauty, to come short of another man's.

Yourself a newborn bard of the Holy Ghost, cast behind you all conformity, and acquaint men at first hand with Deity. Look to it first and only, that fashion, custom, authority, pleasure, and money, are nothing to you,—are not bandages over your eyes, that you cannot see,—but live with the privilege of the immeasurable mind. Not too anxious to visit periodically all families and each family in your parish connection,—when you meet one of these men or women, be to them a divine man; be to them thought and virtue; let their timid aspirations find in you a friend; let their trampled instincts be genially tempted out in

your atmosphere; let their doubts know that you have doubted, and their wonder feel that you have wondered. By trusting your own heart, you shall gain more confidence in other men. For all our penny-wisdom, for all our soul-destroying slavery to habit, it is not to be doubted that all men have sublime thoughts; that all men value the few real hours of life; they love to be heard; they love to be caught up into the vision of principles. We mark with light in the memory the few interviews we have had, in the dreary years of routine and of sin, with souls that made our souls wiser; that spoke what we thought; that told us what we knew; that gave us leave to be what we inly were. Discharge to men the priestly office, and, present or absent, you shall be followed with their love as by an angel.

And, to this end, let us not aim at common degrees of merit. Can we not leave, to such as love it, the virtue that glitters for the commendation of society, and ourselves pierce the deep solitudes of absolute ability and worth? We easily come up to the standard of goodness in society. Society's praise can be cheaply secured, and almost all men are content with those easy merits; but the instant effect of conversing with God will be to put them away. There are persons who are not actors, not speakers, but influences; persons too great for fame, for display; who disdain eloquence; to whom all we call art and artist, seems too nearly allied to show and by-ends, to the exaggeration of the finite and selfish, and loss of the universal. The orators, the poets, the commanders encroach on us only as fair women do, by our allowance and homage. Slight them by preoccupation of mind, slight them, as you can well afford to do, by high and universal aims, and they instantly feel that you have right, and that it is in lower places that they must shine. They also feel your right; for they with you are open to the influx of the all-knowing Spirit, which annihilates before its broad noon the little shades and gradations of intelligence in the compositions we call wiser and wisest.

In such high communion let us study the grand strokes of rectitude: a bold benevolence, an independence of friends, so that not the unjust wishes of those who love us shall impair our freedom, but we shall resist for truth's sake the freest flow of kindness, and appeal to sympathies far in advance; and,—what is the highest form in which we know this beautiful element,—a certain solidity of merit, that has nothing to do with opinion, and which is so essentially and manifestly virtue, that it is taken for granted that the right, the brave, the generous step will be taken by it, and nobody thinks of commending it. You would compliment a coxcomb doing a good act, but you would not praise an angel. The silence that accepts merit as the most natural thing in the world, is the highest applause. Such souls, when they appear, are the Imperial Guard of Virtue, the perpetual reserve, the dictators of fortune. One needs not praise their courage,—they are the heart and soul of nature. O my friends, there are resources in us on which we have not drawn. There are men who rise refreshed on hearing a threat; men to whom a crisis which intimidates and paralyzes the majority,—demanding not the faculties of prudence and thrift, but comprehension, immovableness, the readiness of sacrifice,—comes graceful and beloved as a bride. Napoleon said of Massena, that he was not himself until the battle began to go against him; then, when the dead began to fall in ranks around him, awoke his powers of combination, and he put on terror and victory as a robe. So it is in

rugged crises, in unweariable endurance, and in aims which put sympathy out of question, that the angel is shown. But these are heights that we can scarce remember and look up to without contrition and shame. Let us thank God that such things exist.

And now let us do what we can to rekindle the smouldering, nigh quenched fire on the altar. The evils of the church that now is are manifest. The question returns, What shall we do? I confess, all attempts to project and establish a Cultus with new rites and forms, seem to me vain. Faith makes us, and not we it, and faith makes its own forms. All attempts to contrive a system are as cold as the new worship introduced by the French to the goddess of Reason,— today, pasteboard and filigree, and ending tomorrow in madness and murder. Rather let the breath of new life be breathed by you through the forms already existing. For if once you are alive, you shall find they shall become plastic and new. The remedy to their deformity is first, soul, and second, soul, and evermore, soul. A whole popedom of forms one pulsation of virtue can uplift and vivify. Two inestimable advantages Christianity has given us; first the Sabbath, the jubilee of the whole world, whose light dawns welcome alike into the closet of the philosopher, into the garret of toil, and into prison-cells, and everywhere suggests, even to the vile, the dignity of spiritual being. Let it stand forevermore, a temple, which new love, new faith, new sight shall restore to more than its first splendor to mankind. And secondly, the institution of preaching,—the speech of man to men,—essentially the most flexible of all organs, of all forms. What hinders that now, everywhere, in pulpits, in lecture-rooms, in houses, in fields, wherever the invitation of men or your own occasions lead you, you speak the very truth, as your life and conscience teach it, and cheer the waiting, fainting hearts of men with new hope and new revelation?

I look for the hour when that supreme Beauty which ravished the souls of those Eastern men, and chiefly of those Hebrews, and through their lips spoke oracles to all time, shall speak in the West also. The Hebrew and Greek Scriptures contain immortal sentences, that have been bread of life to millions. But they have no epical integrity; are fragmentary; are not shown in their order to the intellect. I look for the new Teacher that shall follow so far those shining laws that he shall see them come full circle; shall see their rounding complete grace; shall see the world to be the mirror of the soul; shall see the identity of the law of gravitation with purity of heart; and shall show that the Ought, that Duty, is one thing with Science, with Beauty, and with Joy.

# ELIZABETH ANN BAYLEY SETON

Elizabeth Ann Bayley Seton (1774–1821) grew up a Protestant in New York City, where she helped to organize the Society for the Relief of Poor Widows and Small Children. In 1803, she traveled to Italy with her ailing husband and the oldest of their children. After her husband's death soon

thereafter, she came under the tutelage of two brothers, Antonio and Filippo Filicchi, and soon determined to convert to Roman Catholicism. She returned to the United States, where her family was greatly displeased by her decision, and joined the church in 1805. Seton moved to Baltimore with her children and founded a new sisterhood that came to be called the American Sisters of Charity and, later, the Sisters of Charity of St. Joseph. She was beatified by the Roman Catholic Church in 1963, by which point six religious orders in the United States claimed her as their founder.

These letters, published by her grandson (the author of the second and third paragraphs below), speak to the difficulties that Seton faced as a Catholic convert in the United States during a time of deep anti-Catholic sentiments. They also demonstrate her passion for the Catholic faith.

## Letters

The Catholic religion so fully satisfied my heart and soul in Italy, that had not my duty towards my children deterred me, I would have retired into a convent after my husband's death. In losing him, my father, and my sister Rebecca, all seems ended here on earth; for although my children are indeed a treasure, I dare not rest a hope of happiness on such frail young beings whose lives are so uncertain. When I arrived here from Leghorn, the clergy had much to say to me on the score of religion, and spoke of Antichrist, idolatry, and urged any number of objections, all of which, without altering the opinions I had formed, were quite enough to frighten me into irresolution as to what step I should take; and here now I am in God's hands, praying day and night for His heavenly direction, which alone can guide me straight. I instruct my children in the religion of Catholics as well as I can, without, however, taking any decided course, although my greatest comfort is found in imagining myself a member of their church. Pray, dear friend, for me who love you tenderly.

*In the above and in other letters, Mrs. Seton has given an idea of the trials of her mind, and the anxiety she felt on the subject of religion. The Rev. Mr. Hobart felt provoked at the change in his friend's religious sentiments, and his pride was wounded that a woman should dare dispute with him. He overwhelmed her with books and letters. Writing to some one in September, she says: "Mr. Hobart was here for the first time yesterday since your absence, and was so entirely out of all patience, that it was in vain to show the letter. . . . . . His visit was short and painful on both sides." And a little later she writes to the same friend: "Mr. Hobart and all the other Reverends have left me to my comtemplations, or to my 'best judgment,' I suppose; but I hope rather to God."*

*Towards the close of the year Mrs. Seton became more fully aware than before, that she must for the future rely upon her own exertions to maintain herself and children. Her friends and relatives were mostly alienated by what they considered an unnatural tendency to be a Catholic. In their eyes it was already bad enough to be poor, although loss of fortune might possibly be repaired; but to become "Papist" was to incur moral and social degradation. Writing to Mrs. Scott, on the 28th of November, she says; "There is nothing new in my prospects since your departure, except a suggestion of Mr. Wilkes's, that in order to avoid the boarding-school plan, I might receive boarders from the curate of St. Mark's, who has ten or twelve scholars, and lives in the vicinity of the city. This would produce a part, at least, of the necessary means to make the ends of the year meet with my manner of living."*

# BISHOP CARROLL TO ANTHONY FILICCHI

*Baltimore, Jan. 13th, 1805*

*Dear and Much Respected Sir,*

Your last favor was from Boston, Oct. 4th. I did not answer it because you were not to remain there long, and my answer might therefore be left in the post-office. Expecting to hear of your return to New York, it appeared to me more advisable to defer writing till that time. But no intelligence concerning you, or the very interesting subject of our correspondence having been received since your letter, already referred to, I could not defer any longer the expression of my acknowledgments for your favor, and at the same time to remind you of your promise to visit Washington this winter, and, of course, to give me the pleasure of a personal acquaintance. Though, as is mentioned already, I have heard no more than is contained in your last concerning the most estimable lady for whose situation and happiness you are so much interested; yet I have the fullest confidence, that after being put to the severe and most distressing trials of interior darkness, doubts, and terrors of making a wrong step, our merciful Father in heaven will soon send her relief, and diffuse light and consolation in her heart. Among the religious books in her possession, I doubt not of her having that most excellent one generally ascribed to Thomas à Kempis, *Of the following of Christ.* Recommend to her, when her soul is weighed down with trouble and anxiety, to read the ninth chapter of the second book, entitled, *Of the wants or absence of every comfort.* As far as it is in my power to judge of her state of mind, from the account of it contained in your letters, I do not think it advisable for her, at present, to perplex herself with reading any more controversy. She has seen enough on that subject to assure herself of the true principles for settling her faith. Her great business now should be to beseech our Divine Redeemer to revive in her heart the grace of her baptism, and to fortify her soul in the resolution of following unreservedly the voice of God speaking to her heart, however difficult and painful the sacrifice may be which it requires. Having confirmed herself in this resolution, it must be to her a matter of the first importance to inspect the state of her conscience, and to judge herself impartially and with the

utmost sincerity, divesting herself as much as she can, with the aid of Divine Grace, not only of every sinful attachment, but of every affection that has not God for its source, its motive, and its object. She ought to consider whether the tears she sheds and the prayers she offers to Heaven, are purely for God's sake, and arise solely from compunction for sin; and are unmixed with any alloy of worldly respects, or inordinate solicitude for the attainment of some worldly purpose. Indeed, when I read the words you copied from her letters, and her letters themselves, I remain convinced of the sincerity of her endeavors to make herself conformable in all things to the Divine will; but afterwards a fear arises in my mind that God discovers in her some lurking imperfection, and defers the final grace of her conversion, till her soul be entirely purified of its irregular attachments. The ordinary course of Providence with respect to those who are to be tried by interior darkness and tribulations, is to subject them to it after their conversion is completed; and it often happens that those trials become highly useful, and dispose those who are subjected to them to disclose, with the utmost sincerity, the entire state of their conscience, all their weaknesses, and even those imperfections of which formerly they made no account. Perhaps in the case of your most esteemed and respected friend, it pleases God to suffer her to experience now, before her open union with His church, those agitations of conscience which will induce her to perform with the greatest care and attention all previous duties necessary for her adoption into it.

You will be good enough to ascribe this long letter to the solicitude with which you have inspired me for the object of yours, and to my desire of adding my feeble cooperation to your charitable and earnest labors for her happiness.

I am, with the highest respect and esteem, dear sir, your most obedient and humble servant,

*J., Bishop of Baltimore*

## MRS. SETON TO MR. PHILIP FILICCHI

*New York, January, 1805*

*My Dear Mr. Filicchi,*

I find, from your brother's letters, that you expect to hear from me, though from your not answering my first letter, I concluded that I had entirely forfeited your friendship. This would not be the case if you knew the pitiable situation to which my poor soul has been reduced; finding no satisfaction in any thing, or any consolation but in tears and prayers. But after being left entirely to myself and little children, my friends dispersed in the country for the summer season, the clergy, tired of my stupid comprehension, and Mr. Anthony, wearied with my scruples and doubts, took his departure to Boston, I gave myself up to prayer, encouraging myself with the hope that my unrighteousness would be no more remembered at the foot of the cross, and that sincere and unremitted asking would be answered in God's own time. This author and that author on the *Prophecies* was read again and again; the texts they referred to were read on my knees with constant tears, but not with much conviction. They had told me from the beginning that my strong tendency to believe your doctrine must be a

*temptation,* and as I knew the old enemy would naturally trouble a heart so eagerly seeking to know the will of God, I resolved to redouble the only weapons against him—prayer, fasting, and humility, and found my mind settle gradually in confidence in Christ and the infinite treasures of His mercy. For some months I have stood between the two ways, looking steadily upwards, but fearing to proceed, never crossing the street that led to *your* church without lifting up my heart for mercy, and often in the Protestant Church finding my soul at mass in Leghorn. This was my exact situation when the New Year commenced, and without any other intention than that of enjoying a good sermon on the season, I took down a volume of *Bourdaloue,* who, speaking of the wise men's inquiry: "Where is he who is born king of the Jews?" draws the inference that when we no longer discern the star of faith, we must seek it where only it is to be found, with the depositories of His word. Therefore, once more I resolved, after heartily committing my cause to God, again to read those books on the Catholic faith which had first won me towards it, and in consequence would, I hoped, with a helping hand from above, lead me to it. I have endeavored to see Mr. O'Brien, but been disappointed; have written to Bishop Carroll, but his silence to Mr. Anthony's letter makes me hesitate to send mine. Yet even under these strong impressions, I could not make any decision in my own soul without asking some questions for its relief and comfort. If your brother return here I will try to do so from him; if not, I am sure that God will help me by some other means. It would be wicked, you know, to doubt (though I am so utterly unworthy) that through Jesus I shall receive this dearest and greatest favor, having already received so many.

## TO AMABILIA FILICCHI

*January, 1805*

It is many a long day since I wrote you, dear friend, for this perpetual routine of life with my sweet darlings is the same thing every day, except that our old servant has had a long sickness, and I have had the comfort of nursing her night and day. . . . . . . . You would not say we are unhappy, for the mutual love with which it is all seasoned, can only be enjoyed by those who have experienced our reverse, but we never give it a sigh. I play the piano in the evening for my children, and after they have danced themselves tired, we gather round the fire, and I go over with them the scenes of David, Daniel, Judith, or other great characters of the Bible, until we entirely forget the present. The neighbors' children, too, sometimes come in to hear our stories, sing our hymns, and say prayers with us. Dear, dearest Amabilia, God will at last deliver. How I read with an agonizing heart the Epiphany sermon of Bourdaloue. Alas! where is my star? I have tried so many ways to see Dr. O'Brien, who they say is the only Catholic priest in New York, where they say, too, Catholics are the offscouring of the people; indeed, somebody even said their congregation was "a public nuisance;" but that troubles me not. The congregation of a city may be very shabby, yet very pleasing to God; or there may be very bad people among it, yet that can not hurt the *faith,* as I take it, and should the priest himself deserve no more respect than is here allowed him, his ministry of the sacraments would be the

same to me if, dearest friend, I shall ever receive them. I seek but God and His church, and expect to find my peace in *them*, not in the people.

Would you believe, Amabilia? In desperation of heart I went last Sunday to St. George's church; the wants and necessities of my soul were so pressing, that I looked straight up to God, and I told Him since I can not see the way to please You, whom alone I wish to please, every thing is indifferent to me, and until You do show me the way You mean me to go, I will walk on in the path You suffered me to be placed on at my birth, and even go to the very sacrament where I once used to find you. So away I went, but if I left the house a Protestant, I returned to it a Catholic I think, since I determined to go no more to the Protestants, being much more troubled than ever I thought I could be. But so it was that at the bowing of my head before the bishop to receive his absolution, which is given publicly and universally to all in the church, I had not the least faith in his prayer, and looked for an apostolic loosing from my sins—which, by the book Mr. Hobart had given me to read, I find they do not claim or admit. Then, trembling, I went to communion, half dead with the inward struggles, when they said: "The body and blood of Christ." Oh! Amabilia, no words for my trial. And I remember that in my old prayer-book of a former edition, which I used when I was a child, it was not as now said to be *spiritually* taken and received. However, to get thoughts away, I took the "Daily Exercise" of good Abbé Plunket, to read the prayers after communion, but finding every word addressed to our dear Saviour as really present and conversing with the soul. I became half crazy, and for the first time could not bear the sweet caresses of my darlings or bless their little dinner. O my God! that day. But it finished calmly at last, abandoning all to God with a renewed confidence in the Blessed Virgin, whose mild and peaceful look reproached my bold excesses, and reminded me to fix my heart above with better hopes.

Now, my friends tell me to take care, that I am a mother, and must answer for my children at the judgment-seat, whatever faith I lead them to. That being so, I will go peaceably and firmly to the Catholic Church. For if faith is so important to our salvation, I will seek it where true faith first began, will seek it among those who received it from God Himself. The controversies on it I am quite incapable of deciding, and as the strictest Protestant allows salvation to a good Catholic, to the Catholics will I go, and try to be a good one. May God accept my good intention and pity me. As to supposing the word of our Lord has failed, and that He suffered His first foundation to be built on by Antichrist, I can not stop on that without stopping on every other word of our Lord, and being tempted to be no Christian at all. For if the chief church became Antichrist's, and the second holds her rights from it, then I should be afraid both might be antichristian, and I be lost by following either.

*March 14th, 1805*

A day of days for me, Amabilia. I have been—where? To the church of St. Peter, which has a cross on the top instead of a weathercock—to what is called here among so many churches the CATHOLIC CHURCH.

When I turned the corner of the street it is in—"Here, my God, I go," said I, "my heart all to You." Entering it, how that heart died away, as it were, in silence before that little tabernacle and the great crucifixion above it. "Ah! my God, here

let me rest," I said, as I went down on my knees, and my head sunk on my bosom. If I could have thought of any thing but of God there was enough, I suppose, to have astonished a stranger in the hurry and bustle of this congregation; but as I came to visit His Majesty only, I knew not what it meant until afterwards. It was a day they receive ashes—the beginning of Lent—and the most venerable Irish priest, who seems just come there, talked of death so familiarly that he delighted and revived me.

After all had departed, I was called to the little room next to the sanctuary, and made my profession of faith as the Catholic Church prescribes, and then came away light of heart, and with a clearer head than I have had these many long months, but not without begging our Lord to bury deep my heart, in that wounded side so well depicted in the beautiful crucifixion, or lock it up in His little tabernacle where I shall now rest forever.

Oh! Amabilia, the endearments of this day with the children, and the play of the heart with God while trying to keep up their little amusements with them. Anna suspects, I anticipate, her delight when I take her next Sunday.

So happy I am now to prepare for this good confession which, bad as I am, I would be ready to make on the house-top to insure the good *absolution* I hope for after it, and then to begin a new life, a new existence itself. It is no great difficulty for me to prepare for this confession, for truly my life has been well called over in bitterness of soul these past months of sorrow. It is done—easy enough, too; the kindest and most respectable confessor is this Mr. O'Brien—with the compassion and yet firmness in this work of mercy which I would have expected from our Lord himself. Our Lord himself I saw alone in him in this venerable sacrament. How awful those words of unloosing after a thirty years' bondage! I felt as if my chains fell, as those of St. Peter's, at the touch of the Divine Messenger. My God! what new scenes for my soul.

On the annunciation I shall be made one with Him who said, "Unless ye eat the flesh of the Son of Man, and drink his blood, ye shall not have life in you." I count the days and hours; yet a few more of hope and expectation, and then! How bright is the sun these morning walks to the church for preparation—deep snow or smooth ice, all is to me the same; I see nothing but the bright little cross on St. Peter's steeple.

# CHARLES GRANDISON FINNEY

Charles Grandison Finney (1792–1875) was one of the most important evangelists in American history. His preaching was plainspoken and direct, urging listeners to make an immediate decision for Christ and experience the new birth, and he presided over numerous revivals at which countless numbers converted. He was particularly notable for developing various revival techniques, known as the "new measures," that intensified the pressure upon unconverted listeners to convert. Influenced by

Protestant reformers such as Theodore Dwight Weld, Finney preached against slavery and advocated temperance while preaching a doctrine of holiness and Christian perfection. From 1851 to 1865, he served as president of Oberlin College. Finney wrote about his own conversion experience in his *Memoirs*, written in his seventy-fifth year.

## *From* Memoirs

North of the village, and over a hill, lay a piece of woods, in which I was in the almost daily habit of walking, more or less, when it was pleasant weather. It was now October, and the time was past for my frequent walks there. Nevertheless, instead of going to the office, I turned and bent my course toward the woods, feeling that I must be alone, and away from all human eyes and ears, so that I could pour out my prayer to God.

But still my pride must show itself. As I went over the hill, it occurred to me that some one might see me and suppose that I was going away to pray. Yet probably there was not a person on earth that would have suspected such a thing, had he seen me going. But so great was my pride, and so much was I possessed with the fear of man, that I recollect that I skulked along under the fence, till I got so far out of sight that no one from the village could see me. I then penetrated into the woods, I should think, a quarter of a mile, went over on the other side of the hill, and found a place where some large trees had fallen across each other, leaving an open place between. There I saw I could make a kind of closet. I crept into this place and knelt down for prayer. As I turned to go up into the woods, I recollect to have said, "I will give my heart to God, or I never will come down from there." I recollect repeating this as I went up—"I will give my heart to God before I ever come down again."

But when I attempted to pray I found that my heart would not pray. I had supposed that if I could only be where I could speak aloud, without being overheard, I could pray freely. But lo! when I came to try, I was dumb; that is, I had nothing to say to God; or at least I could say but a few words, and those without heart. In attempting to pray I would hear a rustling in the leaves, as I thought, and would stop and look up to see if somebody were not coming. This I did several times.

Finally I found myself verging fast to despair. I said to myself, "I cannot pray. My heart is dead to God, and will not pray." I then reproached myself for having promised to give my heart to God before I left the woods. When I came to try, I found I could not give my heart to God. My inward soul hung back, and there was no going out of my heart to God. I began to feel deeply that it was too late; that it must be that I was given up of God and was past hope.

The thought was pressing me of the rashness of my promise, that I would give my heart to God that day or die in the attempt. It seemed to me as if that was binding upon my soul; and yet I was going to break my vow. A great sink-

ing and discouragement came over me, and I felt almost too weak to stand upon my knees.

Just at this moment I again thought I heard some one approach me, and I opened my eyes to see whether it were so. But right there the revelation of my pride of heart, as the great difficulty that stood in the way, was distinctly shown to me. An overwhelming sense of my wickedness in being ashamed to have a human being see me on my knees before God, took such powerful possession of me, that I cried at the top of my voice, and exclaimed that I would not leave that place if all the men on earth and all the devils in hell surrounded me. "What!" I said, "such a degraded sinner as I am, on my knees confessing my sins to the great and holy God; and ashamed to have any human being, and a sinner like myself, find me on my knees endeavoring to make my peace with my offended God!" The sin appeared awful, infinite. It broke me down before the Lord.

Just at that point this passage of Scripture seemed to drop into my mind with a flood of light: "Then shall ye go and pray unto me, and I will hearken unto you. Then shall ye seek me and find me, when ye shall search for me with all your heart." I instantly seized hold of this with my heart. I had intellectually believed the Bible before; but never had the truth been in my mind that faith was a voluntary trust instead of an intellectual state. I was as conscious as I was of my existence, of trusting at that moment in God's veracity. Somehow I knew that that was a passage of Scripture, though I do not think I had ever read it. I knew that it was God's word, and God's voice, as it were, that spoke to me. I cried to Him, "Lord, I take thee at thy word. Now thou knowest that I do search for thee with all my heart, and that I have come here to pray to thee; and thou hast promised to hear me."

That seemed to settle the question that I could then, that day, perform my vow. The Spirit seemed to lay stress upon that idea in the text, "When you search for me with all your heart." The question of when, that is of the present time, seemed to fall heavily into my heart. I told the Lord that I should take him at his word; that he could not lie; and that therefore I was sure that he heard my prayer, and that he would be found of me.

He then gave me many other promises, both from the Old and the New Testament, especially some most precious promises respecting our Lord Jesus Christ. I never can, in words, make any human being understand how precious and true those promises appeared to me. I took them one after the other as infallible truth, the assertions of God who could not lie. They did not seem so much to fall into my intellect as into my heart, to be put within the grasp of the voluntary powers of my mind; and I seized hold of them, appropriated them, and fastened upon them with the grasp of a drowning man.

I continued thus to pray, and to receive and appropriate promises for a long time, I know not how long. I prayed till my mind became so full that, before I was aware of it, I was on my feet and tripping up the ascent toward the road. The question of my being converted, had not so much as arisen to my thought; but as I went up, brushing through the leaves and bushes, I recollect saying with great emphasis, "If I am ever converted, I will preach the Gospel."

I soon reached the road that led to the village, and began to reflect upon what had passed; and I found that my mind had become most wonderfully quiet and peaceful. I said to myself. "What is this? I must have grieved the Holy

Ghost entirely away. I have lost all my conviction. I have not a particle of concern about my soul; and it must be that the Spirit has left me." "Why!" thought I, "I never was so far from being concerned about my own salvation in my life."

Then I remembered what I had said to God while I was on my knees—that I had said I would take him at his word; and indeed I recollected a good many things that I had said, and concluded that it was no wonder that the Spirit had left me; that for such a sinner as I was to take hold of God's word in that way, was presumption if not blasphemy. I concluded that in my excitement I had grieved the Holy Spirit, and perhaps committed the unpardonable sin.

I walked quietly toward the village; and so perfectly quiet was my mind that it seemed as if all nature listened. It was on the 10th of October, and a very pleasant day. I had gone into the woods immediately after an early breakfast; and when I returned to the village I found it was dinner time. Yet I had been wholly unconscious of the time that had passed; it appeared to me that I had been gone from the village but a short time.

But how was I to account for the quiet of my mind? I tried to recall my convictions, to get back again the load of sin under which I had been laboring. But all sense of sin, all consciousness of present sin or guilt, had departed from me. I said to myself, "What is this, that I cannot arouse any sense of guilt in my soul, as great a sinner as I am?" I tried in vain to make myself anxious about my present state. I was so quiet and peaceful that I tried to feel concerned about that, lest it should be a result of my having grieved the Spirit away. But take any view of it I would, I could not be anxious at all about my soul, and about my spiritual state. The repose of my mind was unspeakably great. I never can describe it in words. The thought of God was sweet to my mind, and the most profound spiritual tranquillity had taken full possession of me. This was a great mystery; but it did not distress or perplex me.

I went to my dinner, and found I had no appetite to eat. I then went to the office, and found that Squire W—— had gone to dinner. I took down my bass-viol, and, as I was accustomed to do, began to play and sing some pieces of sacred music. But as soon as I began to sing those sacred words, I began to weep. It seemed as if my heart was all liquid; and my feelings were in such a state that I could not hear my own voice in singing without causing my sensibility to overflow. I wondered at this, and tried to suppress my tears, but could not. After trying in vain to suppress my tears, I put up my instrument and stopped singing.

After dinner we were engaged in removing our books and furniture to another office. We were very busy in this, and had but little conversation all the afternoon. My mind, however, remained in that profoundly tranquil state. There was a great sweetness and tenderness in my thoughts and feelings. Everything appeared to be going right, and nothing seemed to ruffle or disturb me in the least.

Just before evening the thought took possession of my mind, that as soon as I was left alone in the new office, I would try to pray again—that I was not going to abandon the subject of religion and give it up, at any rate; and therefore, although I no longer had any concern about my soul, still I would continue to pray.

By evening we got the books and furniture adjusted; and I made up, in an open fire-place, a good fire, hoping to spend the evening alone. Just at dark

Squire W——, seeing that everything was adjusted, bade me good-night and went to his home. I had accompanied him to the door; and as I closed the door and turned around, my heart seemed to be liquid within me. All my feelings seemed to rise and flow out; and the utterance of my heart was, "I want to pour my whole soul out to God." The rising of my soul was so great that I rushed into the room back of the front office, to pray.

There was no fire, and no light, in the room; nevertheless it appeared to me as if it were perfectly light. As I went in and shut the door after me, it seemed as if I met the Lord Jesus Christ face to face. It did not occur to me then, nor did it for some time afterward, that it was wholly a mental state. On the contrary it seemed to me that I saw him as I would see any other man. He said nothing, but looked at me in such a manner as to break me right down at his feet. I have always since regarded this as a most remarkable state of mind; for it seemed to me a reality, that he stood before me, and I fell down at his feet and poured out my soul to him. I wept aloud like a child, and made such confessions as I could with my choked utterance. It seemed to me that I bathed his feet with my tears; and yet I had no distinct impression that I touched him, that I recollect.

I must have continued in this state for a good while; but my mind was too much absorbed with the interview to recollect anything that I said. But I know, as soon as my mind became calm enough to break off from the interview, I returned to the front office, and found that the fire that I had made of large wood was nearly burned out. But as I turned and was about to take a seat by the fire, I received a mighty baptism of the Holy Ghost. Without any expectation of it, without ever having the thought in my mind that there was any such thing for me, without any recollection that I had ever heard the thing mentioned by any person in the world, the Holy Spirit descended upon me in a manner that seemed to go through me, body and soul. I could feel the impression, like a wave of electricity, going through and through me. Indeed it seemed to come in waves and waves of liquid love; for I could not express it in any other way. It seemed like the very breath of God. I can recollect distinctly that it seemed to fan me, like immense wings.

No words can express the wonderful love that was shed abroad in my heart. I wept aloud with joy and love; and I do not know but I should say, I literally bellowed out the unutterable gushings of my heart. These waves came over me, and over me, and over me, one after the other, until I recollect I cried out, "I shall die if these waves continue to pass over me." I said, "Lord, I cannot bear any more;" yet I had no fear of death.

How long I continued in this state, with this baptism continuing to roll over me and go through me, I do not know. But I know it was late in the evening when a member of my choir—for I was the leader of the choir—came into the office to see me. He was a member of the church. He found me in this state of loud weeping, and said to me, "Mr. Finney, what ails you?" I could make him no answer for some time. He then said, "Are you in pain?" I gathered myself up as best I could, and replied, "No, but so happy that I cannot live."

He turned and left the office, and in a few minutes returned with one of the elders of the church, whose shop was nearly across the way from our office. This elder was a very serious man; and in my presence had been very watchful, and I had scarcely ever seen him laugh. When he came in, I was very much in the

state in which I was when the young man went out to call him. He asked me how I felt, and I began to tell him. Instead of saying anything, he fell into a most spasmodic laughter. It seemed as if it was impossible for him to keep from laughing from the very bottom of his heart.

There was a young man in the neighborhood who was preparing for college, with whom I had been very intimate. Our minister, as I afterward learned, had repeatedly talked with him on the subject of religion, and warned him against being misled by me. He informed him that I was a very careless young man about religion; and he thought that if he associated much with me his mind would be diverted, and he would not be converted.

After I was converted, and this young man was converted, he told me that he had said to Mr. Gale several times, when he had admonished him about associating so much with me, that my conversations had often affected him more, religiously, than his preaching. I had, indeed, let out my feelings a good deal to this young man.

But just at the time when I was giving an account of my feelings to this elder of the church, and to the other member who was with him, this young man came into the office. I was sitting with my back toward the door, and barely observed that he came in. He listened with astonishment to what I was saying, and the first I knew he partly fell upon the floor, and cried out in the greatest agony of mind, "Do pray for me!" The elder of the church and the other member knelt down and began to pray for him; and when they had prayed, I prayed for him myself. Soon after this they all retired and left me alone.

The question then arose in my mind, "Why did Elder B—— laugh so? Did he not think that I was under a delusion, or crazy?" This suggestion brought a kind of darkness over my mind; and I began to query with myself whether it was proper for me—such a sinner as I had been—to pray for that young man. A cloud seemed to shut in over me; I had no hold upon anything in which I could rest; and after a little while I retired to bed, not distressed in mind, but still at a loss to know what to make of my present state. Notwithstanding the baptism I had received, this temptation so obscured my view that I went to bed without feeling sure that my peace was made with God.

I soon fell asleep, but almost as soon awoke again on account of the great flow of the love of God that was in my heart. I was so filled with love that I could not sleep. Soon I fell asleep again, and awoke in the same manner. When I awoke, this temptation would return upon me, and the love that seemed to be in my heart would abate; but as soon as I was asleep, it was so warm within me that I would immediately awake. Thus I continued till, late at night, I obtained some sound repose.

When I awoke in the morning the sun had risen, and was pouring a clear light into my room. Words cannot express the impression that this sunlight made upon me. Instantly the baptism that I had received the night before, returned upon me in the same manner. I arose upon my knees in the bed and wept aloud with joy, and remained for some time too much overwhelmed with the baptism of the Spirit to do anything but pour out my soul to God. It seemed as if this morning's baptism was accompanied with a gentle reproof, and the Spirit seemed to say to me, "Will you doubt?" "Will you doubt?" I cried, "No! I will

not doubt; I cannot doubt." He then cleared the subject up so much to my mind that it was in fact impossible for me to doubt that the Spirit of God had taken possession of my soul.

In this state I was taught the doctrine of justification by faith, as a present experience. That doctrine had never taken any such possession of my mind, that I had ever viewed it distinctly as a fundamental doctrine of the Gospel. Indeed, I did not know at all what it meant in the proper sense. But I could now see and understand what was meant by the passage, "Being justified by faith, we have peace with God through our Lord Jesus Christ." I could see that the moment I believed, while up in the woods all sense of condemnation had entirely dropped out of my mind; and that from that moment I could not feel a sense of guilt or condemnation by any effort that I could make. My sense of guilt was gone; my sins were gone; and I do not think I felt any more sense of guilt than if I never had sinned.

This was just the revelation that I needed. I felt myself justified by faith; and, so far as I could see, I was in a state in which I did not sin. Instead of feeling that I was sinning all the time, my heart was so full of love that it overflowed. My cup ran over with blessing and with love; and I could not feel that I was sinning against God. Nor could I recover the least sense of guilt for my past sins. Of this experience I said nothing that I recollect, at the time, to anybody; that is, of this experience of justification.

❋

This morning, of which I have just spoken, I went down into the office, and there I was having the renewal of these mighty waves of love and salvation flowing over me, when Squire W—— came into the office. I said a few words to him on the subject of his salvation. He looked at me with astonishment, but made no reply whatever, that I recollect. He dropped his head, and after standing a few minutes left the office. I thought no more of it then, but afterward found that the remark I made pierced him like a sword; and he did not recover from it till he was converted.

Soon after Mr. W—— had left the office, Deacon B—— came into the office and said to me, "Mr. Finney, do you recollect that my cause is to be tried at ten o'clock this morning? I suppose you are ready?" I had been retained to attend this suit as his attorney. I replied to him, "Deacon B——, I have a retainer from the Lord Jesus Christ to plead his cause, and I cannot plead yours." He looked at me with astonishment, and said, "What do you mean?" I told him, in a few words, that I had enlisted in the cause of Christ; and then repeated that I had a retainer from the Lord Jesus Christ to plead his cause, and that he must go and get somebody else to attend his law-suit; I could not do it. He dropped his head, and without making any reply, went out. A few moments later, in passing the window, I observed that Deacon B—— was standing in the road, seemingly lost in deep meditation. He went away, as I afterward learned, and immediately settled his suit. He then betook himself to prayer, and soon got into a much higher religious state than he had ever been in before.

I soon sallied forth from the office to converse with those whom I should meet about their souls. I had the impression, which has never left my mind, that God wanted me to preach the Gospel, and that I must begin immediately. I somehow seemed to know it. If you ask me how I knew it, I cannot tell how I knew it, any more than I can tell how I knew that that was the love of God and the baptism of the Holy Ghost which I had received. I did somehow know it with a certainty that was past all possibility of doubt. And so I seemed to know that the Lord commissioned me to preach the Gospel.

# BISHOP INNOCENT VENIAMINOV

Bishop Innocent Veniaminov (1797–1879) was a Russian Orthodox priest (later bishop and then archbishop) who traveled to North America as a missionary among the Aleutian people. He embarked at the island of Unalaska in 1824 and ten years later moved to Sitka, the capital of Russian America. Throughout his mission work, he learned native dialects and translated parts of the Bible and Divine Liturgy into native languages (Aleut and later Tlingit). In the 1840s and 1850s, he led a massive expansion of mission work into the Alaskan interior, as well as northern coastal regions; some of his buildings still stand today as the oldest standing structures in Alaska. Bishop Innocent founded the Orthodox Missionary Society in 1870, which supported mission work in Alaska until the Communist Revolution in Russia in 1917. He was also the first Orthodox bishop in America. This excerpt from his "Instructions to the Priest-Monk Theophan" in 1853 highlights Bishop Innocent's approach to the native people among whom he and other missionaries worked.

## Instructions to the Priest-Monk Theophan

- On arriving at some settlement of savages, thou shalt on no account say that thou art sent by any government, or give thyself out for some kind of official functionary, but appear in the guise of a poor wanderer, a sincere well-wisher to his fellow-men, who has come for the single purpose of showing them the means to attain prosperity and, as far as possible, guiding them in their quest.
- From the moment when thou first enterest on thy duties, do thou strive, by conduct and by virtues becoming thy dignity, to win the

good opinion and respect not alone of the natives, but of the civilized residents as well. Good opinion breeds respect, and one who is not respected will not be listened to.

- On no account show open contempt for their manner of living, customs, etc., however these may appear deserving of it, for nothing insults and irritates savages so much as showing them open contempt and making fun of them and anything belonging to them.

- From thy first interview with natives, do thy best to win their confidence and friendly regard, not by gifts or flattery, but by wise kindliness, by constant readiness to help in every way, by good and sensible advice and sincerity. For who will open his heart to thee, unless he trust thee?

- In giving instruction and talking with natives generally, be gentle, pleasant, simple, and in no way assume an overbearing, didactic manner, for by so doing thou canst seriously jeopardize the success of thy labors.

- When a native speaks to thee, hear him out attentively, courteously and patiently, and answer questions convincingly, carefully and kindly; for any question asked by a native on spiritual subjects is a matter of great importance to the preacher, since it may be an indication both of the state of the questioner's soul and of his capacity, as well as of his desire, to learn. But by not answering him even only once, or answering in a way at which he can take offense, he may be silenced forever.

- Those who show no wish to receive holy baptism, even after repeated persuasion, should not in any way be vexed, nor, especially, coerced. And although justice demands that converts and such as are ready to become converts should be treated with greater kindness and consideration, still thou, as preacher of the Gospel, shouldst not be insulting in thy treatment of such as show no disposition to listen to instruction, but shouldst be friendly in thy intercourse with them. This will be to them the best proof that thou dost really and truly wish them well.

# JARENA LEE

Jarena Lee (1783–unknown) was an African American evangelist who was the first woman ordained to preach in the African Methodist Episcopal (AME) Church. Having experienced conversion under the preaching of the Reverend Richard Allen, she was baptized as a Methodist in 1807. Shortly thereafter, she felt a call to preach, but because she was a woman during a time when Methodists (and other groups) sharply delimited female opportunities for public speech, her request was denied for a time. Lee persisted,

however, and eventually succeeded in the goal that she felt the Lord had impressed upon her. She would later recount these events in her self-published spiritual autobiography, from which the following excerpt is taken.

## *From* The Life and Religious Experience of Jarena Lee

*And it shall come to pass . . . that I will pour out my Spirit upon all flesh;*
*and your sons, and your* daughters *shall prophecy.*   ~   JOEL ii. 28

I was born February 11th, 1783, at Cape May, state of New Jersey. At the age of seven years I was parted from my parents, and went to live as a servant maid, with a Mr. Sharp, at the distance of about sixty miles from the place of my birth.

My parents being wholly ignorant of the knowledge of God, had not therefore instructed me in any degree in this great matter. Not long after the commencement of my attendance on this lady, she had bid me do something respecting my work, which in a little while after, she asked me if I had done, when I replied, Yes—but this was not true.

At this awful point, in my early history, the spirit of God moved in power through my conscience, and told me I was a wretched sinner. On this account so great was the impression, and so strong were the feelings of guilt, that I promised in my heart that I would not tell another lie.

But notwithstanding this promise my heart grew harder, after a while, yet the spirit of the Lord never entirely forsook me, but continued mercifully striving with me, until his gracious power converted my soul.

The manner of this great accomplishment was as follows: In the year 1804, it so happened that I went with others to hear a missionary of the Presbyterian order preach. It was an afternoon meeting, but few were there, the place was a school room; but the preacher was solemn, and in his countenance the earnestness of his master's business appeared equally strong, as though he were about to speak to a multitude.

At the reading of the Psalms, a ray of renewed conviction darted into my soul. These were the words, composing the first verse of the Psalms for the service:

> Lord, I am vile, conceived in sin,
> Born unholy and unclean.
> Sprung from man, whose guilty fall
> Corrupts the race, and taints us all.

This description of my condition struck me to the heart, and made me to feel in some measure, the weight of my sins, and sinful nature. But not knowing how to run immediately to the Lord for help, I was driven of Satan, in the course of a few days, and tempted to destroy myself.

There was a brook about a quarter of a mile from the house, in which there was a deep hole, where the water whirled about among the rocks; to this place it was suggested, I must go and drown myself.

At the time I had a book in my hand; it was on a Sabbath morning, about ten o'clock; to this place I resorted, where on coming to the water I sat down on the bank, and on my looking into it; it was suggested, that drowning would be an easy death. It seemed as if some one was speaking to me, saying put your head under, it will not distress you. But by some means, of which I can give no account, my thoughts were taken entirely from this purpose, when I went from the place to the house again. It was the unseen arm of God which saved me from self murder.

But notwithstanding this escape from death, my mind was not at rest—but so great was the labour of my spirit and the fearful oppressions of a judgment to come, that I was reduced as one extremely ill. On which account a physician was called to attend me, from which illness I recovered in about three months.

But as yet I had not found him of whom Moses and the prophets did write, being extremely ignorant: there being no one to instruct me in the way of life and salvation as yet. After my recovery, I left the lady, who during my sickness, was exceedingly kind, and went to Philadelphia. From this place I soon went a few miles into the country, where I resided in the family of a Roman Catholic. But my anxiety still continued respecting my poor soul, on which account I used to watch my opportunity to read in the Bible; and this lady observing this, took the Bible from me and hid it, giving me a novel in its stead—which when I perceived, I refused to read.

Soon after this I again went to the city of Philadelphia; and commenced going to the English Church, the pastor of which was an Englishman, by the name of Pilmore, one of the number, who at first preached Methodism in America, in the city of New York.

But while sitting under the ministration of this man, which was about three months, and at the last time, it appeared that there was a wall between me and a communion with that people, which was higher than I could possibly see over, and seemed to make this impression upon my mind, *this is not the people for you.*

But on returning home at noon I inquired of the head cook of the house respecting the rules of the Methodists, as I knew she belonged to that society, who told me what they were; on which account I replied, that I should not be able to abide by such strict rules not even one year;—however, I told her that I would go with her and hear what they had to say.

The man who was to speak in the afternoon of that day, was the Rev. Richard Allen, since bishop of the African Episcopal Methodists in America. During the labors of this man that afternoon, I had come to the conclusion, that this is the people to which my heart unites, and it so happened, that as soon as the service closed he invited such as felt a desire to flee the wrath to come, to unite on trial with them—I embraced the opportunity. Three weeks from that day, my soul was gloriously converted to God, under preaching, at the very outset of the sermon. The text was barely pronounced, which was: "I perceive thy heart is not right in the sight of God" [Acts 8:21], when there appeared to *my* view, in the centre of the heart *one* sin; and this was *malice*, against one particular individual, who had strove deeply to injure me, which I resented. At this

discovery I said, *Lord* I forgive *every* creature. That instant, it appeared to me, as if a garment, which had entirely enveloped my whole person, even to my fingers ends, split at the crown of my head, and was stripped away from me, passing like a shadow, from my sight—when the glory of God seemed to cover me in its stead.

That moment, though hundreds were present, I did leap to my feet, and declare that God, for Christ's sake, had pardoned the sins of my soul. Great was the ecstasy of my mind, for I felt that not only the sin of *malice* was pardoned, but all other sins were swept away together. That day was the first when my heart had believed, and my tongue had made confession unto salvation—the first words uttered, a part of that song, which shall fill eternity with its sound, was *glory to God.* For a few moments I had power to exhort sinners, and to tell of the wonders and of the goodness of him who had clothed me with *his* salvation. During this, the minister was silent, until my soul felt its duty had been performed, when he declared another witness of the power of Christ to forgive sins on earth, was manifest in my conversion.

From the day on which I first went to the Methodist church, until the hour of my deliverance, I was strangely buffetted by that enemy of all righteousness—the devil.

I was naturally of a lively turn of disposition; and during the space of time from my first awakening until I knew my peace was made with God, I rejoiced in the vanities of this life, and then again sunk back into sorrow.

For four years I had continued in this way, frequently labouring under the awful apprehension, that I could never be happy in this life. This persuasion was greatly strengthened, during the three weeks, which was the last of Satan's power over me, in this peculiar manner: on which account, I had come to the conclusion that I had better be dead than alive. Here I was again tempted to destroy my life by drowning; but suddenly this mode was changed, and while in the dusk of the evening, as I was walking to and fro in the yard of the house, I was beset to hang myself, with a cord suspended from the wall enclosing the secluded spot.

But no sooner was the intention resolved on in my mind, than an awful dread came over me, when I ran into the house; still the tempter pursued me. There was standing a vessel of water—into this I was strongly impressed to plunge my head, so as to extinguish the life which God had given me. Had I have done this, I have been always of the opinion that I should have been unable to have released myself; although the vessel was scarcely large enough to hold a gallon of water. Of me may it not be said, as written by Isaiah, (chap. 65, verses 1,2.) "I am sought of them that asked not for me; I am found of them that sought me not." Glory be to God for his redeeming power, which saved me from the violence of my own hands, from the malice of Satan, and from eternal death; for had I have killed myself, a great ransom could not have delivered me; for it is written—"No murderer hath eternal life abiding in him" [1 John 3:15]. How appropriately can I sing—

> "Jesus sought me, when a stranger,
> Wandering from the fold of God;
> He to rescue me from danger,
> Interposed his precious blood."

*[handwritten margin note: 2nd suicide attempt]*

But notwithstanding the terror which seized upon me, when about to end my life, I had no view of the precipice on the edge of which I was tottering, until it was over, and my eyes were opened. Then the awful gulf of hell seemed to be open beneath me, covered only, as it were, by a spider's web, on which I stood. I seemed to hear the howling of the damned, to see the smoke of the bottomless pit, and to hear the rattling of those chains, which hold the impenitent under clouds of darkness to the judgment of the great day.

I trembled like Belshazzar, and cried out in the horror of my spirit, "God be merciful to me a sinner." That night I formed a resolution to pray; which, when resolved upon, there appeared, sitting in one corner of the room, Satan, in the form of a monstrous dog, and in a rage, as if in pursuit, his tongue protruding from his mouth to a great length, and his eyes looked like two balls of fire; it soon, however, vanished out of my sight. From this state of terror and dismay, I was happily delivered under the preaching of the Gospel as before related.

This view, which I was permitted to have of Satan, in the form of a dog, is evidence, which corroborates in my estimation, the Bible account of a hell of fire, which burneth with brimstone, called in Scripture the bottomless pit; the place where all liars, who repent not, shall have their portion; as also the Sabbath breaker, the adulterer, the fornicator, with the fearful, the abominable, and the unbelieving, this shall be the portion of their cup.

This language is too strong and expressive to be applied to any state of suffering in *time*. Were it to be thus applied, the reality could no where be found in human life; the consequence would be, that *this* scripture would be found a false testimony. But when made to apply to an endless state of perdition, in eternity, beyond the bounds of human life, then this language is found not to exceed our views of a state of eternal damnation.

During the latter part of my state of conviction, I can now apply to my case, as it then was, the beautiful words of the poet:

> "The more I strove against its power,
> I felt its weight and guilt the more;
> 'Till late I hear'd my Saviour say,
> Come hither soul, I am the way."

This I found to be true, to the joy of my disconsolate and despairing heart, in the hour of my conversion to God.

During this state of mind, while sitting near the fire one evening, after I had heard Rev. Richard Allen, as before related, a view of my distressed condition so affected my heart, that I could not refrain from weeping and crying aloud; which caused the lady with whom I then lived, to inquire, with surprise, what ailed me; to which I answered, that I knew not what ailed me. She replied that I ought to pray. I arose from where I was sitting, being in an agony, and weeping convulsively, requested her to pray for me; but at the very moment when she would have done so, some person rapped heavily at the door for admittance; it was but a person of the house, but this occurrence was sufficient to interrupt us in our intentions; and I believe to this day, I should then have found salvation to my soul. This interruption was, doubtless, also the work of Satan. *active in the world*

Although at this time, when my conviction was so great, yet I knew not that Jesus Christ was the Son of God, the second person in the adorable trinity. I

knew him not in the pardon of my sins, yet I felt a consciousness that if I died without pardon, that my lot must inevitably be damnation. If I would pray—I knew not how. I could form no connexion of ideas into words; but I knew the Lord's prayer; this I uttered with a loud voice, and with all my might and strength. I was the most ignorant creature in the world; I did not even know that Christ had died for the sins of the world, and to save sinners. Every circumstance, however, was so directed as still to continue and increase the sorrows of my heart, which I now know to have been a godly sorrow which wrought repentance, which is not to be repented of. Even the falling of the dead leaves from the forests, and the dried spires of the mown grass, showed me that I too must die, in like manner. But my case was awfully different from that of the grass of the field, or the wide spread decay of a thousand forests, as I felt within me a living principle, an immortal spirit, which cannot die, and must forever either enjoy the smiles of its Creator, or feel the pangs of ceaseless damnation.

But the Lord led me on; being gracious, he took pity on my ignorance; he heard my wailings, which had entered into the ear of the Lord of Sabaoth. Circumstances so transpired that I soon came to a knowledge of the being and character of the Son of God, of whom I knew nothing.

My strength had left me. I had become feverish and sickly through the violence of my feelings, on which account I left my place of service to spend a week with a coloured physician, who was a member of the Methodist society, and also to spend this week in going to places where prayer and supplication was statedly made for such as me.

Through this means I had learned much, so as to be able in some degree to comprehend the spiritual meaning of the text, which the minister took on the Sabbath morning, as before related, which was, "I perceive thy heart is not right in the sight of God." Acts, chap. 8, verse 21.

This text, as already related, became the power of God unto salvation to me, because I believed. I was baptized according to the direction of our Lord, who said, as he was about to ascend from the mount, to his disciples, "Go ye into all the world and preach my gospel to every creature, he that believeth and is baptized shall be saved" [Mark 16:15–16].

I have now passed through the account of my conviction, and also of my conversion to God; and shall next speak of the blessing of sanctification.

A time after I had received forgiveness flowed sweetly on; day and night my joy was full, no temptation was permitted to molest me. I could say continually with the psalmist, that "God had separated my sins from me, as far as the east is from the west" [Ps. 103:12]. I was ready continually to cry,

"Come all the world, come sinner thou,
All things in Christ are ready now."

I continued in this happy state of mind for almost three months, when a certain coloured man, by name William Scott, came to pay me a religious visit. He had been for many years a faithful follower of the Lamb; and he had also taken much time in visiting the sick and distressed of our colour, and understood well the great things belonging to a man of full stature in Christ Jesus.

In the course of our conversation, he inquired if the Lord had justified my soul. I answered, yes. He then asked me if he had sanctified me. I answered, no;

and that I did not know what that was. He then undertook to instruct me further in the knowledge of the Lord respecting this blessing.

He told me the progress of the soul from a state of darkness, or of nature, was threefold; or consisted in three degrees, as follows:—First, conviction for sin. Second, justification from sin. Third, the entire sanctification of the soul to God. I thought this description was beautiful, and immediately believed in it. He then inquired if I would promise to pray for this in my secret devotions. I told him, yes. Very soon I began to call upon the Lord to show me all that was in my heart, which was not according to his will. Now there appeared to be a new struggle commencing in my soul, not accompanied with fear, guilt, and bitter distress, as while under my first conviction for sin; but a labouring of the mind to know more of the right way of the Lord. I began now to feel that my heart was not clean in his sight; that there yet remained the roots of bitterness, which if not destroyed, would ere long sprout up from these roots, and overwhelm me in a new growth of the brambles and brushwood of sin.

By the increasing light of the Spirit, I had found there yet remained the root of pride, anger, self-will, with many evils, the result of fallen nature. I now became alarmed at this discovery, and began to fear that I had been deceived in my experience. I was now greatly alarmed, lest I should fall away from what I knew I had enjoyed; and to guard against this I prayed almost incessantly, without acting faith on the power and promises of God to keep me from falling. I had not yet learned how to war against temptation of this kind. Satan well knew that if he could succeed in making me disbelieve my conversion, that he would catch me either on the ground of complete despair, or on the ground of infidelity. For if all I had passed through was to go for nothing, and was but a fiction, the mere ravings of a disordered mind, then I would naturally be led to believe that there is nothing in religion at all.

From this snare I was mercifully preserved, and led to believe that there was yet a greater work than that of pardon to be wrought in me. I retired to a secret place (after having sought this blessing, as well as I could, for nearly three months, from the time brother Scott had instructed me respecting it) for prayer, about four o'clock in the afternoon. I had struggled long and hard, but found not the desire of my heart. When I rose from my knees, there seemed a voice speaking to me, as I yet stood in a leaning posture—"Ask for sanctification." When to my surprise, I recollected that I had not even thought of it in my whole prayer. It would seem Satan had hidden the very object from my mind, for which I had purposely kneeled to pray. But when this voice whispered in my heart, saying, "Pray for sanctification," I again bowed in the same place, at the same time, and said, "Lord *sanctify* my soul for Christ's sake?" That very instant, as if lightning had darted through me, I sprang to my feet, and cried, "The Lord has sanctified my soul!" There was none to hear this but the angels who stood around to witness my joy—and Satan, whose malice raged the more. That Satan was there, I knew; for no sooner had I cried out, "The Lord has sanctified my soul," than there seemed another voice behind me, saying, "No, it is too great a work to be done." But another spirit said, "Bow down for the witness—I received it—*thou art sanctified!*" The first I knew of myself after that, I was standing in the yard with my hands spread out, and looking with my face toward heaven.

I now ran into the house and told them what had happened to me, when, as it were, a new rush of the same ecstasy came upon me, and caused me to feel as if I were in an ocean of light and bliss.

During this, I stood perfectly still, the tears rolling in a flood from my eyes. So great was the joy, that it is past description. There is no language that can describe it, except that which was heard by St. Paul, when he was caught up to the third heaven, and heard words which it was not lawful to utter.

## MY CALL TO PREACH THE GOSPEL

Between four and five years after my sanctification, on a certain time, an impressive silence fell upon me, and I stood as if some one was about to speak to me, yet I had no such thought in my heart. But to my utter surprise there seemed to sound a voice which I thought I distinctly heard, and most certainly understood, which said to me, "Go preach the Gospel!" I immediately replied aloud, "No one will believe me." Again I listened, and again the same voice seemed to say, "Preach the Gospel; I will put words in your mouth, and will turn your enemies to become your friends."

At first I supposed that Satan had spoken to me, for I had read that he could transform himself into an angel of light, for the purpose of deception. Immediately I went into a secret place, and called upon the Lord to know if he had called me to preach, and whether I was deceived or not; when there appeared to my view the form and figure of a pulpit, with a Bible lying thereon, the back of which was presented to me as plainly as if it had been a literal fact.

In consequence of this, my mind became so exercised that during the night following, I took a text, and preached in my sleep. I thought there stood before me a great multitude, while I expounded to them the things of religion. So violent were my exertions, and so loud were my exclamations, that I awoke from the sound of my own voice, which also awoke the family of the house where I resided. Two days after, I went to see the preacher in charge of the African Society, who was the Rev. Richard Allen, the same before named in these pages, to tell him that I felt it my duty to preach the gospel. But as I drew near the street in which his house was, which was in the city of Philadelphia, my courage began to fail me; so terrible did the cross appear, it seemed that I should not be able to bear it. Previous to my setting out to go to see him, so agitated was my mind, that my appetite for my daily food failed me entirely. Several times on my way there, I turned back again; but as often I felt my strength again renewed, and I soon found that the nearer I approached to the house of the minister, the less was my fear. Accordingly, as soon as I came to the door, my fears subsided, the cross was removed, all things appeared pleasant—I was tranquil.

I now told him, that the Lord had revealed it to me, that I must preach the gospel. He replied by asking, in what sphere I wished to move in? I said, among the Methodists. He then replied, that a Mrs. Cook, a Methodist lady, had also some time before requested the same privilege; who it was believed, had done much good in the way of exhortation, and holding prayer meetings; and who

had been permitted to do so by the verbal license of the preacher in charge at the time. But as to women preaching, he said that our Discipline knew nothing at all about it—that it did not call for women preachers. This I was glad to hear, because it removed the fear of the cross—but not no sooner did this feeling cross my mind, than I found that a love of souls had in a measure departed from me; that holy energy which burned within me, as a fire, began to be smothered. This I soon perceived.

O how careful ought we to be, lest through our by-laws of church government and discipline, we bring into disrepute even the word of life. For as unseemly as it may appear now-a-days for a woman to preach, it should be remembered that nothing is impossible with God. And why should it be thought impossible, heterodox, or improper, for a woman to preach? seeing the Saviour died for the woman as well as the man.

If a man may preach, because the Saviour died for him, why not the woman? seeing he died for her also. Is he not a whole Saviour, instead of a half one? as those who hold it wrong for a woman to preach, would seem to make it appear.

Did not Mary *first* preach the risen Saviour, and is not the doctrine of the resurrection the very climax of Christianity—hangs not all our hope on this, as argued by St. Paul? Then did not Mary, a woman, preach the gospel? for she preached the resurrection of the crucified Son of God.

But some will say, that Mary did not expound the Scripture, therefore, she did not preach, in the proper sense of the term. To this I reply, it may be that the term *preach,* in those primitive times, did not mean exactly what it is now *made* to mean; perhaps it was a great deal more simple then, than it is now:—if it were not, the unlearned fishermen could not have preached the gospel at all, as they had no learning.

To this it may be replied, by those who are determined not to believe that it is right for a woman to preach, that the disciples, though they were fishermen, and ignorant of letters too, were inspired so to do. To which I would reply, that though they were inspired, yet that inspiration did not save them from showing their ignorance of letters, and of man's wisdom; this the multitude soon found out, by listening to the remarks of the envious Jewish priests. If then, to preach the gospel, by the gift of heaven, comes by inspiration solely, is God straitened; must he take the man exclusively? May he not, did he not, and can he not inspire a female to preach the simple story of the birth, life, death, and resurrection of our Lord, and accompany it too, with power to the sinner's heart. As for me, I am fully persuaded that the Lord called me to labour according to what I have received, in his vineyard. If he has not, how could he consistently bear testimony in favour of my poor labours, in awakening and converting sinners?

In my wanderings up and down among men, preaching according to my ability, I have frequently found families who told me that they had not for several years been to a meeting, and yet, while listening to hear what God would say by his poor coloured female instrument, have believed with trembling—tears rolling down their cheeks, the signs of contrition and repentance towards God. I firmly believe that I have sown seed, in the name of the Lord, which shall appear with its increase at the great day of accounts, when Christ shall come to make up his jewels.

At a certain time, I was beset with the idea, that soon or late I should fall from grace, and lose my soul at last. I was frequently called to the throne of grace about this matter, but found no relief; the temptation pursued me still. Being more and more afflicted with it, till at a certain time when the spirit strongly impressed it on my mind to enter into my closet, and carry my case once more to the Lord; the Lord enabled me to draw nigh to him, and to his mercy seat, at this time, in an extraordinary manner; for while I wrestled with him for the victory over this disposition to doubt whether I should persevere, there appeared a form of fire, about the size of a man's hand, as I was on my knees; at the same moment, there appeared to the eye of faith a man robed in a white garment, from the shoulders down to the feet; from him a voice proceeded, saying: "Thou shalt never return from the cross." Since that time I have never doubted, but believe that god will keep me until the day of redemption. Now I could adopt the very language of St. Paul, and say that nothing could have separated my soul from the love of god, which is in Christ Jesus [Rom. 8:35–39]. From that time, 1807, until the present, 1833, I have not yet doubted the power and goodness of God to keep me from falling, through sanctification of the spirit and belief of the truth.

## MY MARRIAGE

In the year 1811, I changed my situation in life, having married Mr. Joseph Lee, Pastor of a Coloured Society at Snow Hill, about six miles from the city of Philadelphia. It became necessary therefore for me to remove. This was a great trial at first, as I knew no person at Snow Hill, except my husband; and to leave my associates in the society, and especially those who composed the *band* of which I was one. Not but those who have been in sweet fellowship with such as really love God, and have together drank bliss and happiness from the same fountain, can tell how dear such company is, and how hard it is to part from them.

At Snow Hill, as was feared, I never found that agreement and closeness in communion and fellowship, that I had in Philadelphia, among my young companions, nor ought I to have expected it. The manners and customs at this place were somewhat different, on which account I became discontented in the course of a year, and began to importune my husband to remove to the city. But this plan did not suit him, as he was the Pastor of the Society; he could not bring his mind to leave them. This afflicted me a little. But the Lord soon showed me in a dream what his will was concerning this matter.

I dreamed that as I was walking on the summit of a beautiful hill, that I saw near me a flock of sheep, fair and white, as if but newly washed; when there came walking toward me, a man of a grave and dignified countenance, dressed entirely in white, as it were in a robe, and looking at me, said emphatically, "Joseph Lee must take care of these sheep, or the wolf will come and devour them." When I awoke, I was convinced of my error, and immediately, with a glad heart, yielded to the right way of the Lord. This also greatly strengthened my husband in his care over them, for fear the wolf should by some means take

any of them away. The following verse was beautifully suited to our condition, as well as to all the little flocks of God scattered up and down this land:

"Us into Thy protection take,
And gather with Thine arm;
Unless the fold we first forsake,
The wolf can never harm."

After this, I fell into a state of general debility, and in an ill state of health, so much so, that I could not sit up; but a desire to warn sinners to flee the wrath to come, burned vehemently in my heart, when the Lord would send sinners into the house to see me. Such opportunities I embraced to press home on their consciences the things of eternity, and so effectual was the word of exhortation made through the Spirit, that I have seen them fall to the floor crying aloud for mercy.

From this sickness I did not expect to recover, and there was but one thing which bound me to earth, and this was, that I had not as yet preached the gospel to the fallen sons and daughters of Adam's race, to the satisfaction of my mind. I wished to go from one end of the earth to the other, crying, Behold, behold the Lamb! To this end I earnestly prayed the Lord to raise me up, if consistent with his will. He condescended to hear my prayer, and to give me a token in a dream, that in due time I should recover my health. The dream was as follows: I thought I saw the sun rise in the morning, and ascend to an altitude of about half an hour high, and then become obscured by a dense black cloud, which continued to hide its rays for about one third part of the day, and then it burst forth again with renewed splendour.

This dream I interpreted to signify my early life, my conversion to God, and this sickness, which was a great affliction, as it hindered me, and I feared would forever hinder me from preaching the gospel, was signified by the cloud; and the bursting forth of the sun, again, was the recovery of my health, and being permitted to preach.

I went to the throne of grace on this subject, where the Lord made this impressive reply in my heart, while on my knees: "Ye shall be restored to thy health again, and worship God in full purpose of heart."

This manifestation was so impressive, that I could but hide my face, as if someone was gazing upon me, to think of the great goodness of the Almighty God to my poor soul and body. From that very time I began to gain strength of body and mind, glory to God in the highest, until my health was fully recovered.

For six years from this time I continued to receive from above, such baptisms of the Spirit as mortality could scarcely bear. About that time I was called to suffer in my family, by death—five, in the course of about six years, fell by his hand; my husband being one of the number, which was the greatest affliction of all.

I was now left alone in the world, with two infant children, one of the age of about two years, the other six months, with no other dependance than the promise of Him who hath said—"I will be the widow's God, and a father to the fatherless" [Ps. 68:5]. Accordingly, he raised me up friends, whose liberality

comforted and solaced me in my state of widowhood and sorrows. I could sing with the greatest propriety the words of the poet.

> "He helps the stranger in distress,
> The widow and the fatherless,
> And grants the prisoner sweet release."

I can say even now, with the Psalmist, "Once I was young, but now I am old, yet I have never seen the righteous forsaken, nor his seed begging bread" [Ps. 37:25]. I have ever been fed by his bounty, clothed by his mercy, comforted and healed when sick, succoured when tempted, and every where upheld by his hand.

## THE SUBJECT OF MY CALL TO PREACH RENEWED

It was now eight years since I had made application to be permitted to preach the gospel, during which time I had only been allowed to exhort, and even this privilege but seldom. This subject now was renewed afresh in my mind; it was as a fire shut up in my bones. About thirteen months passed on, while under this renewed impression. During this time, I had solicited of the Rev. Bishop Richard Allen, who at this time had become Bishop of the African Episcopal Methodists in America, to be permitted the liberty of holding prayer meetings in my own hired house, and of exhorting as I found liberty, which was granted me. By this means, my mind was relieved, as the house was soon filled when the hour appointed for prayer had arrived.

I cannot but relate in this place, before I proceed further with the above subject, the singular conversion of a very wicked young man. He was a coloured man, who had generally attended our meetings, but not for any good purpose; but rather to disturb and to ridicule our denomination. He openly and uniformly declared that he neither believed in religion, nor wanted anything to do with it. He was of a Gallio disposition, and took the lead among the young people of colour. But after a while he fell sick, and lay about three months in a state of ill health; his disease was consumption. Toward the close of his days, his sister who was a member of the society, came and desired me to go and see her brother, as she had no hopes of his recovery; perhaps the Lord might break into his mind. I went alone, and found him very low. I soon commenced to inquire respecting his state of feeling, and how he found his mind. His answer was, "O tolerable well," with an air of great indifference. I asked him if I should pray for him. He answered in a sluggish and careless manner, "O yes, if you have time." I then sung a hymn, kneeled down and prayed for him, and then went my way.

Three days after this, I went again to visit the young man. At this time there went with me two of the sisters in Christ. We found the Rev. Mr. Cornish, of our denomination, labouring with him. But he said he received but little satisfaction from him. Pretty soon, however, brother Cornish took his leave; when myself, with the other two sisters, one of which was an elderly woman named Jane Hutt, the other was younger, both coloured, commenced conversing with him, respecting his eternal interest, and of his hopes of a happy eternity, if any he had. He said but little; we then kneeled down together and besought the Lord in

his behalf, praying that if mercy were not clear gone forever, to shed a ray of softening grace upon the hardness of his heart. He appeared now to be somewhat more tender, and we thought we could perceive some tokens of conviction, as he wished us to visit him again, in a tone of voice not quite as indifferent as he had hitherto manifested.

But two days had elapsed after this visit, when his sister came for me in haste, saying, that she believed her brother was then dying, and that he had *sent* for me. I immediately called on Jane Hutt, who was still among us as a mother in Israel, to go with me. When we arrived there, we found him sitting up in his bed, very restless and uneasy, but he soon laid down again. He now wished me to come to him, by the side of his bed. I asked him how he was. He said, "Very ill;" and added, "Pray for me, quick?" We now perceived his time in this world to be short. I took up the hymn-book and opened to a hymn suitable to his case, and commenced to sing. But there seemed to be a *horror* in the room—a darkness of a mental kind, which was felt by us all; there being five persons, except the sick young man and his nurse. We had sung but one verse, when they all gave over singing, on account of this unearthly sensation, but myself. I continued to sing on alone, but in a dull and heavy manner, though looking up to God all the while for help. Suddenly, I felt a spring of energy awake in my heart, when darkness gave way in some degree. It was but a glimmer from above. When the hymn was finished, we all kneeled down to pray for him. While calling on the name of the Lord, to have mercy on his soul, and to grant him repentance unto life, it came suddenly into my mind never to rise from my knees until God should hear prayer in his behalf, until he should convert and save his soul.

Now, while I thus continued importuning heaven, as I felt I was led, a ray of light, more abundant, broke forth among us. There appeared to my view, though my eyes were closed, the Saviour in full stature, nailed to the cross, just over the head of the young man, against the ceiling of the room. I cried out, brother look up, the Saviour is come, he will pardon you, your sins he will forgive. My sorrow for the soul of the young man was gone; I could no longer pray—joy and rapture made it impossible. We rose up from our knees, when lo, his eyes were gazing with ecstasy upward; over his face there was an expression of joy; his lips were clothed in a sweet and holy smile; but no sound came from his tongue; it was heard in its stillness of bliss, full of hope and immortality. Thus, as I held him by the hand his happy and purified soul soared away, without a sign or a groan, to its eternal rest.

I now closed his eyes, straightened out his limbs, and left him to be dressed for the grave. But as for me, I was filled with the power of the Holy Ghost—the very room seemed filled with glory. His sister and all that were in the room rejoiced, nothing doubting but he had entered into Paradise; and I believe I shall see him at the last and great day, safe on the shores of salvation.

But to return to the subject of my call to preach. Soon after this, as above related, the Rev. Richard Williams was to preach at Bethel Church, where I with others were assembled. He entered the pulpit, gave out the hymn, which was sung, and then addressed the throne of grace; took his text, passed through the exordium, and commenced to expound it. The text he took is in Jonah, 2d chap. 9th verse,—"Salvation is of the Lord." But as he proceeded to explain, he

seemed to have lost the spirit; when in the same instant, I sprang, as by an alto-gether supernatural impulse, to my feet, when I was aided from above to give an exhortation on the very text which my brother Williams had taken.

I told them that I was like Jonah; for it had been then nearly eight years since the Lord had called me to preach his gospel to the fallen sons and daugh-ters of Adam's race, but that I had lingered like him, and delayed to go at the bidding of the Lord, and warn those who are as deeply guilty as were the peo-ple of Ninevah.

During the exhortation, God made manifest his power in a manner suffi-cient to show the world that I was called to labour according to my ability, and the grace given unto me, in the vineyard of the good husbandman.

I now sat down, scarcely knowing what I had done, being frightened. I imagined, that for this indecorum, as I feared it might be called, I should be ex-pelled from the church. But instead of this, the Bishop rose up in the assembly, and related that I had called upon him eight years before, asking to be permitted to preach, and that he had put me off; but that he now as much believed that I was called to that work, as any of the preachers present. These remarks greatly strengthened me, so that my fears of having given an offence, and made myself liable as an offender, subsided, giving place to a sweet serenity, a holy job of a peculiar kind, untasted in my bosom until then.

The next Sabbath day, while sitting under the word of the gospel, I felt moved to attempt to speak to the people in a public manner, but I could not bring my mind to attempt it in the church. I said, Lord, anywhere but here. Accordingly, there was a house not far off which was pointed out to me, to this I went. It was the house of a sister belonging to the same society with myself. Her name was Anderson. I told her I had come to hold a meeting in her house, if she would call in her neighbours. With this request she immediately complied. My congregation consisted of but five persons. I commenced by reading and singing a hymn, when I dropped to my knees by the side of a table to pray. When I arose I found my hand resting on the Bible, which I had not noticed till that moment. It now occurred to me to take a text. I opened the Scripture, as it happened, at the 141st Psalm, fixing my eye on the 3d verse, which reads: "Set a watch, O Lord, before my mouth, keep the door of my lips." My sermon, such as it was, I applied wholly to myself, and added an exhortation. Two of my con-gregation wept much, as the fruit of my labour this time. In closing I said to the few, that if any one would open a door, I would hold a meeting the next sixth-day evening; when one answered that her house was at my service. Accordingly I went, and God made manifest his power among the people. Some wept, while others shouted for joy. One whole seat of females, by the power of God, as the rushing of a wind, were all bowed to the floor at once, and screamed out. Also a sick man and woman in one house, the Lord convicted them both; one lived, and the other died. God wrought a judgment—some were well at night, and died in the morning. At this place I continued to hold meetings about six months. During that time I kept house with my little son, who was very sickly. About this time I had a call to preach at a place about thirty miles distant, among the Methodists, with whom I remained one week, and during the whole time, not a thought of my little son came into my mind; it was hid from me, lest I should have been diverted from the work I had to, to look after my son. Here by the instrumentality of a poor coloured woman, the Lord poured forth his

spirit among the people. Though, as I was told, there were lawyers, doctors, and magistrates present, to hear me speak, yet there was mourning and crying among sinners, for the Lord scattered fire among them of his own kindling. The Lord gave his handmaiden power to speak for his great name, for he arrested the hearts of the people, and caused a shaking amongst the multitude, for God was in the midst.

I now returned home, found all well; no harm had come to my child, although I left it very sick. Friends had taken care of it which was of the Lord. I now began to think seriously of breaking up housekeeping, and forsaking all to preach the everlasting Gospel. I felt a strong desire to return to the place of my nativity, at Cape May, after an absence of about fourteen years. To this place, where the heaviest cross was to be met with, the Lord sent me, as Saul of Tarsus was sent to Jerusalem, to preach the same gospel which he had neglected and despised before his conversion. I went by water, and on my passage was much distressed by sea sickness, so much so that I expected to have died, but such was not the will of the Lord respecting me. After I had disembarked, I proceeded on as opportunities offered, toward where my mother lived. When within ten miles of that place, I appointed an evening meeting. There were a goodly number came out to hear. The Lord was pleased to give me light and liberty among the people. After meeting, there came an elderly lady to me and said, she believed the Lord had sent me among them; she then appointed me another meeting there two weeks from that night. The next day I hastened forward to the place of my mother, who was happy to see me, and the happiness was mutual between us. With her I left my poor sickly boy, while I departed to do my Master's will. In this neighborhood I had an uncle, who was a Methodist, and who gladly threw open his door for meetings to be held there. At the first meeting which I held at my uncle's house, there was, with others who had come from curiosity to hear the coloured woman preacher, an old man, who was a deist, and who said he did not believe the coloured people had any souls—he was sure they had none. He took a seat very near where I was standing, and boldly tried to look me out of countenance. But as I laboured on in the best manner I was able, looking to God all the while, though it seemed to me I had but little liberty, yet there went an arrow from the bent bow of the gospel, and fastened in his till then obdurate heart. After I had done speaking, he went out, and called the people around him, said that my preaching might seem a small thing, yet he believed I had the worth of souls at heart. This language was different from what it was a little time before, as he now seemed to admit that coloured people had souls, whose good I had in view, his remark must have been without meaning. He now came into the house, and in the most friendly manner shook hands with me, saying, he hoped God had spared him to some good purpose. This man was a great slave holder, and had been very cruel; thinking nothing of knocking down a slave with a fence stake, or whatever might come to hand. From this time it was said of him that he became greatly altered in his ways for the better. At that time he was about seventy years old, his head as white as snow; but whether he became a converted man or not, I never heard.

The week following, I had an invitation to hold a meeting at the Court House of the County, when I spoke from the 53d chap. of Isaiah, 3d verse. It was a solemn time, and the Lord attended the word; I had life and liberty, though there were people there of various denominations. Here again I saw the aged

slaveholder, who notwithstanding his age, walked about three miles to hear me. This day I spoke twice, and walked six miles to the place appointed. There was a magistrate present, who showed his friendship, by saying in a friendly manner, that he had heard of me: he handed me a hymn-book, pointing to a hymn which he had selected. When the meeting was over, he invited me to preach in a schoolhouse in his neighbourhood, about three miles distant from where I then was. During this meeting one backslider was reclaimed. This day I walked six miles, and preached twice to large congregations, both in the morning and evening. The Lord was with me, glory be to his holy name. I next went six miles and held a meeting in a coloured friend's house, at eleven o'clock in the morning, and preached to a well behaved congregation of both coloured and white. After service I again walked back, which was in all twelve miles in the same day. This was on Sabbath, or as I sometimes call it, seventh-day; for after my conversion I preferred the plain language of the quakers: On fourth-day, after this, in compliance with an invitation received by note, from the same magistrate who had heard me at the above place, I preached to a large congregation, where we had a precious time: much weeping was heard among the people. The same gentleman, now at the close of the meeting, gave out another appointment at the same place, that day week. Here again I had liberty, there was a move among the people. Ten years from that time, in the neighbourhood of Cape May, I held a prayer meeting in a school house, which was then the regular place of preaching for the Episcopal Methodists; after service, there came a white lady of the first distinction, a member of the Methodist Society, and told me that at the same school house, ten years before under my preaching, the Lord first awakened her. She rejoiced much to see me, and invited me home with her, where I staid till the next day. This was bread cast on the waters, seen after many days.

From this place I next went to Dennis Creek meeting house, where at the invitation of an elder, I spoke to a large congregation of various and conflicting sentiments, when a wonderful shock of God's power was felt, shown everywhere by groans, by sighs, and loud and happy amens. I felt as if aided from above. My tongue was cut loose, the stammerer spoke freely; the love of God, and of his service, burned with a vehement flame within me—his name was glorified among the people.

But here I feel myself constrained to give over, as from the smallness of this pamphlet I cannot go through with the whole of my journal, as it would probably make a volume of two hundred pages; which, if the Lord be willing, may at some future day be published. But for the satisfaction of such as may follow after me, when I am no more, I have recorded how the Lord called me to his work, and how he has kept me from falling from grace, as I feared I should. In all things he has proved himself a God of truth to me; and in his service I am now as much determined to spend and be spent, as at the very first. My ardour for the progress of his cause abates not a whit, so far as I am able to judge, though I am now something more than fifty years of age.

As to the nature of uncommon impressions, which the reader cannot but have noticed, and possibly sneered at in the course of these pages, they may be accounted for in this way: It is known that the blind have the sense of hearing in a manner much more acute than those who can see: also their sense of feeling is exceedingly fine, and is found to detect any roughness on the smoothest surface, where those who can see can find none. So it may be with such as I am, who has

never had more than three months schooling; and wishing to know much of the way and law of God, have therefore watched the more closely the operations of the Spirit, and have in consequence been led thereby. But let it be remarked that I have never found that Spirit to lead me contrary to the Scriptures of truth, as I understand them. "For as many as are led by the Spirit of God are the sons of God."—Rom. viii. 14.

I have now only to say, May the blessing of the Father, and of the Son, and of the Holy Ghost, accompany the reading of this poor effort to speak well of his name, wherever it may be read. AMEN.

# FREDERICK DOUGLASS

Frederick Douglass (1818–95) grew up as a slave in Maryland, the son of a slave mother and a white man. He taught himself to read and write and educated himself about the growing sentiment against slavery in the United States, organizing a number of secret schools for fellow slaves before escaping from slavery altogether in 1838. Settling in New Bedford, Massachusetts, Douglass joined the African Methodist Episcopal Zion church and, gifted with excellent oratorical skills, shortly became a hired lecturer for the Massachusetts Anti-Slavery Society. In 1844–45, he wrote his autobiographical narrative from which this excerpt is taken. The *Narrative* made him famous at home and abroad, selling 30,000 copies in the United States and Britain within the first five years, and was translated into numerous languages. This excerpt addresses the disparity between the religion of the slaveholders and that of religious slaves, such as Douglass, even when they read the same Bible and prayed to the same God.

## *From* Narrative of the Life of an American Slave

In August, 1832, my master attended a Methodist camp-meeting held in the Bay-side, Talbot county, and there experienced religion. I indulged a faint hope that his conversion would lead him to emancipate his slaves, and that, if he did

Reprinted by permission of the publisher from *The Narrative of the Life of Frederick Douglass: An American Slave, Written by Himself*, edited by Benjamin Quarles, 84–86, 109–112, 155–163, Cambridge, Mass.: The Belknap Press of Harvard University Press, Copyright © 1960, 1988 by the President and Fellows of Harvard College.

not do this, it would, at any rate, make him more kind and humane. I was disappointed in both these respects. It neither made him to be humane to his slaves, nor to emancipate them. If it had any effect on his character, it made him more cruel and hateful in all his ways; for I believe him to have been a much worse man after his conversion that before. Prior to his conversion, he relied upon his own depravity to shield and sustain him in his savage barbarity; but after his conversion, he found religious sanction and support for his slaveholding cruelty. He made the greatest pretensions to piety. His house was the house of prayer. He prayed morning, noon, and night. He very soon distinguished himself among his brethren, and was soon made a class-leader and exhorter. His activity in revivals was great, and he proved himself an instrument in the hands of the church in converting many souls. His house was the preachers' home. They used to take great pleasure in coming there to put up; for while he starved us, he stuffed them. We have had three or four preachers there at a time. The names of those who used to come most frequently while I lived there, were Mr. Storks, Mr. Ewery, Mr. Humphry, and Mr. Hickey. I have also seen Mr. George Cookman at our house. We slaves loved Mr. Cookman. We believed him to be a good man. We thought him instrumental in getting Mr. Samuel Harrison, a very rich slaveholder, to emancipate his slaves; and by some means got the impression that he was laboring to effect the emancipation of all the slaves. When he was at our house, we were sure to be called in to prayers. When the others were there, we were sometimes called in and sometimes not. Mr. Cookman took more notice of us than either of the other ministers. He could not come among us without betraying his sympathy for us, and, stupid as we were, we had the sagacity to see it.

While I lived with my master in St. Michael's, there was a white young man, a Mr. Wilson, who proposed to keep a Sabbath school for the instruction of such slaves as might be disposed to learn to read the New Testament. We met but three times, when Mr. West and Mr. Fairbanks, both class-leaders, with many others, came upon us with sticks and other missiles, drove us off, and forbade us to meet again. Thus ended our little Sabbath school in the pious town of St. Michael's.

I have said my master found religious sanction for his cruelty. As an example, I will state one of many facts going to prove the charge. I have seen him tie up a lame young woman, and whip her with a heavy cowskin upon her naked shoulders, causing the warm red blood to drip; and, in justification of the bloody deed, he would quote this passage of Scripture—"He that knoweth his master's will, and doeth it not, shall be beaten with many stripes."

Master would keep this lacerated young woman tied up in this horrid situation four or five hours at a time. I have known him to tie her up early in the morning, and whip her before breakfast; leave her, go to his store, return at dinner, and whip her again, cutting her in the places already made raw with his cruel lash. The secret of master's cruelty toward "Henny" is found in the fact of her being almost helpless. When quite a child, she fell into the fire, and burned herself horribly. Her hands were so burnt that she never got the use of them. She could do very little but bear heavy burdens. She was to master a bill of expense; and as he was a mean man, she was a constant offence to him. He seemed desirous of getting the poor girl out of existence. He gave her away once to his

sister; but, being a poor gift, she was not disposed to keep her. Finally, my benevolent master, to use his own words, "set her adrift to take care of herself." Here was a recently-converted man, holding on upon the mother, and at the same time turning out her helpless child to starve and die! Master Thomas was one of the many pious slaveholders who hold slaves for the very charitable purpose of taking care of them.

*

On the first of January, 1834, I left Mr. Covey, and went to live with Mr. William Freeland, who lived about three miles from St. Michael's. I soon found Mr. Freeland a very different man from Mr. Covey. Though not rich, he was what would be called an educated southern gentleman. Mr. Covey, as I have shown, was a well-trained negro-breaker and slavedriver. The former (slaveholder though he was) seemed to possess some regard for honor, some reverence for justice, and some respect for humanity. The latter seemed totally insensible to all such sentiments. Mr. Freeland had many of the faults peculiar to slaveholders, such as being very passionate and fretful; but I must do him the justice to say, that he was exceedingly free from those degrading vices to which Mr. Covey was constantly addicted. The one was open and frank, and we always knew where to find him. The other was a most artful deceiver, and could be understood only by such as were skilful enough to detect his cunningly-devised frauds. Another advantage I gained in my new master was, he made no pretensions to, or profession of, religion; and this, in my opinion, was truly a great advantage. I assert most unhesitatingly, that the religion of the south is a mere covering for the most horrid crimes,—a justifier of the most appalling barbarity,—a sanctifier of the most hateful frauds,—and a dark shelter under, which the darkest, foulest, grossest, and most infernal deeds of slaveholders find the strongest protection. Were I to be again reduced to the chains of slavery, next to that enslavement, I should regard being the slave of a religious master the greatest calamity that could befall me. For of all slaveholders with whom I have ever met, religious slaveholders are the worst. I have ever found them the meanest and basest, the most cruel and cowardly, of all others. It was my unhappy lot not only to belong to a religious slaveholder, but to live in a community of such religionists. Very near Mr. Freeland lived the Rev. Daniel Weeden, and in the same neighborhood lived the Rev. Rigby Hopkins. These were members and ministers in the Reformed Methodist Church. Mr. Weeden owned, among others, a woman slave, whose name I have forgotten. This woman's back, for weeks, was kept literally raw, made so by the lash of this merciless, *religious* wretch. He used to hire hands. His maxim was, Behave well or behave ill, it is the duty of a master occasionally to whip a slave, to remind him of his master's authority. Such was his theory, and such his practice.

Mr. Hopkins was even worse than Mr. Weeden. His chief boast was his ability to manage slaves. The peculiar feature of his government was that of whipping slaves in advance of deserving it. He always managed to have one or more of his slaves to whip every Monday morning. He did this to alarm their fears, and strike terror into those who escaped. His plan was to whip for the smallest offences, to prevent the commission of large ones. Mr. Hopkins could always

find some excuse for whipping a slave. It would astonish one, unaccustomed to a slaveholding life, to see with what wonderful ease a slaveholder can find things, of which to make occasion to whip a slave. A mere look, word, or motion,—a mistake, accident, or want of power,—are all matters for which a slave may be whipped at any time. Does a slave look dissatisfied? It is said, he has the devil in him, and it must be whipped out. Does he speak loudly when spoken to by his master? Then he is getting high-minded, and should be taken down a button-hole lower. Does he forget to pull off his hat at the approach of a white person? Then he is wanting in reverence, and should be whipped for it. Does he ever venture to vindicate his conduct, when censured for it? Then he is guilty of impudence,—one of the greatest crimes of which a slave can be guilty. Does he ever venture to suggest a different mode of doing things from that pointed out by his master? He is indeed presumptuous, and getting above himself; and nothing less than a flogging will do for him. Does he, while ploughing, break a plough,—or, while hoeing, break a hoe? It is owing to his carelessness, and for it a slave must always be whipped. Mr. Hopkins could always find something of this sort to justify the use of the lash, and he seldom failed to embrace such opportunities. There was not a man in the whole county, with whom the slaves who had the getting their own home, would not prefer to live, rather than with this Rev. Mr. Hopkins. And yet there was not a man any where round, who made higher professions of religion, or was more active in revivals,—more attentive to the class, love-feast, prayer and preaching meetings, or more devotional in his family,—that prayed earlier, later, louder, and longer,—than this same reverend slave-driver, Rigby Hopkins.

✳

## APPENDIX

I find, since reading over the foregoing Narrative that I have, in several instances, spoken in such a tone and manner, respecting religion, as may possibly lead those unacquainted with my religious views to suppose me an opponent of all religion. To remove the liability of such misapprehension, I deem it proper to append the following brief explanation. What I have said respecting and against religion, I mean strictly to apply to the *slaveholding religion* of this land, and with no possible reference to Christianity proper; for, between the Christianity of this land, and the Christianity of Christ, I recognize the widest possible difference—so wide, that to receive the one as good, pure, and holy, is of necessity to reject the other as bad, corrupt, and wicked. To be the friend of the one, is of necessity to be the enemy of the other. I love the pure, peaceable, and impartial Christianity of Christ: I therefore hate the corrupt, slaveholding, women-whipping, cradle-plundering, partial and hypocritical Christianity of this land. Indeed, I can see no reason, but the most deceitful one, for calling the religion of this land Christianity. I look upon it as the climax of all misnomers, the boldest of all frauds, and the grossest of all libels. Never was there a clearer case of "stealing the livery of the court of heaven to serve the devil in." I am filled with unutterable loathing when I contemplate the religious pomp and show, together with the horrible inconsistencies, which every

where surround me. We have men-stealers for ministers, women-whippers for missionaries, and cradle-plunderers for church members. The man who wields the blood-clotted cowskin during the week fills the pulpit on Sunday, and claims to be a minister of the meek and lowly Jesus. The man who robs me of my earnings at the end of each week meets me as a class-leader on Sunday morning, to show me the way of life, and the path of salvation. He who sells my sister, for purposes of prostitution, stands forth as the pious advocate of purity. He who proclaims it a religious duty to read the Bible denies me the right of learning to read the name of the God who made me. He who is the religious advocate of marriage robs whole millions of its sacred influence, and leaves them to the ravages of wholesale pollution. The warm defender of the sacredness of the family relation is the same that scatters whole families,—sundering husbands and wives, parents and children, sisters and brothers,—leaving the hut vacant, and the hearth desolate. We see the thief preaching against theft, and the adulterer against adultery. We have men sold to build churches, women sold to support the gospel, and babes sold to purchase Bibles for the *poor heathen! all for the glory of God and the good of souls!* The slave auctioneer's bell and the church-going bell chime in with each other, and the bitter cries of the heart-broken slave are drowned in the religious shouts of his pious master. Revivals of religion and revivals in the slave-trade go hand in hand together. The slave prison and the church stand near each other. The clanking of fetters and the rattling of chains in the prison, and the pious psalm and solemn prayer in the church, may be heard at the same time. The dealers in the bodies and souls of men erect their stand in the presence of the pulpit, and they mutually help each other. The dealer gives his blood-stained gold to support the pulpit, and the pulpit, in return, covers his infernal business with the garb of Christianity. Here we have religion and robbery the allies of each other—devils dressed in angels' robes, and hell presenting the semblance of paradise.

> "Just God! and these are they,
> Who minister at thine altar, God of right!
> Men who their hands, with prayer and blessing, lay
> On Israel's ark of light.

> "What! preach, and kidnap men?
> Give thanks, and rob thy own afflicted poor?
> Talk of thy glorious liberty, and then
> Bolt hard the captive's door?

> "What! servants of thy own
> Merciful Son, who came to seek and save
> The homeless and the outcast, fettering down
> The tasked and plundered slave!

> "Pilate and Herod friends!
> Chief priests and rulers, as of old, combine!
> Just God and holy! is that church which lends
> Strength to the spoiler thine?"

The Christianity of America is a Christianity, of whose votaries it may be as truly said, as it was of the ancient scribes and Pharisees, "They bind heavy

burdens, and grievous to be borne, and lay them on men's shoulders, but they themselves will not move them with one of their fingers. All their works they do for to be seen of men.——They love the uppermost rooms at feasts, and the chief seats in the synagogues, . . . . . . and to be called of men, Rabbi, Rabbi.——But woe unto you, scribes and Pharisees, hypocrites! for ye shut up the kingdom of heaven against men; for ye neither go in yourselves, neither suffer ye them that are entering to go in. Ye devour widows' houses, and for a pretence make long prayers; therefore ye shall receive the greater damnation. Ye compass sea and land to make one proselyte, and when he is made, ye make him twofold more the child of hell than yourselves.——Woe unto you, scribes and Pharisees, hypocrites! for ye pay tithe of mint, and anise, and cumin, and have omitted the weightier matters of the law, judgment, mercy, and faith; these ought ye to have done, and not to leave the other undone. Ye blind guides! which strain at a gnat, and swallow a camel. Woe unto you, scribes and Pharisees, hypocrites! for ye make clean the outside of the cup and of the platter; but within, they are full of extortion and excess.——Woe unto you, scribes and Pharisees, hypocrites! for ye are like unto whited sepulchres, which indeed appear beautiful outward, but are within full of dead men's bones, and of all uncleanness. Even so ye also outwardly appear righteous unto men, but within ye are full of hypocrisy and iniquity."

Dark and terrible as is this picture, I hold it to be strictly true of the overwhelming mass of professed Christians in America. They strain at a gnat, and swallow a camel. Could any thing be more true of our churches? They would be shocked at the proposition of fellowshipping a *sheep*-stealer; and at the same time they hug to their communion a *man*-stealer, and brand me with being an infidel, if I find fault with them for it. They attend with Pharisaical strictness to the outward forms of religion, and at the same time neglect the weightier matters of the law, judgment, mercy, and faith. They are always ready to sacrifice, but seldom to show mercy. They are they who are represented as professing to love God whom they have not seen, whilst they hate their brother whom they have seen. They love the heathen on the other side of the globe. They can pray for him, pay money to have the Bible put into his hand, and missionaries to instruct him; while they despise and totally neglect the heathen at their own doors.

Such is, very briefly, my view of the religion of this land; and to avoid any misunderstanding, growing out of the use of general terms, I mean, by the religion of this land, that which is revealed in the words, deeds, and actions, of those bodies, north and south, calling themselves Christian churches, and yet in union with slaveholders. It is against religion, as presented by these bodies, that I have felt it my duty to testify.

I conclude these remarks by copying the following portrait of the religion of the south, (which is, by communion and fellowship, the religion of the north,) which I soberly affirm is "true to the life," and without caricature or the slightest exaggeration. It is said to have been drawn, several years before the present anti-slavery agitation began, by a northern Methodist preacher, who, while residing at the south, had an opportunity to see slaveholding morals, manners, and piety, with his own eyes. "Shall I not visit for these things? saith the Lord. Shall not my soul be avenged on such a nation as this?"

## "A PARODY.

"Come, saints and sinners, hear me tell
How pious priests whip Jack and Nell,
And women buy and children sell,
And preach all sinners down to hell,
And sing of heavenly union.

"They'll bleat and baa, [go on] like goats,
Gorge down black sheep, and strain at motes,
Array their backs in fine black coats,
Then seize their negroes by their throats,
And choke, for heavenly union.

"They'll church you if you sip a dram,
And damn you if you steal a lamb;
Yet rob old Tony, Doll, and Sam,
Of human rights, and bread and ham;
Kidnapper's heavenly union.

"They'll loudly talk of Christ's reward,
And bind his image with a cord,
And scold, and swing the lash abhorred,
And sell their brother in the Lord
To handcuffed heavenly union.

"They'll read and sing a sacred song,
And make a prayer both loud and long,
And teach the right and do the wrong,
Hailing the brother, sister throng,
With words of heavenly union.

"We wonder how such saints can sing,
Or praise the Lord upon the wing,
Who roar, and scold, and whip, and sting,
And to their slaves and mammon cling,
In guilty conscience union.

"They'll raise tobacco, corn, and rye,
And drive, and thieve, and cheat, and lie,
And lay up treasures in the sky,
By making switch and cowskin fly,
In hope of heavenly union.

"They'll crack old Tony on the skull,
And preach and roar like Bashan bull,
Or braying ass, of mischief full,
Then seize old Jacob by the wool,
And pull for heavenly union.

"A roaring, ranting, sleek man-thief,
Who lived on mutton, veal, and beef,

Yet never would afford relief
To needy, sable sons of grief,
Was big with heavenly union.

"'Love not the world,' the preacher said,
And winked his eye, and shook his head;
He seized on Tom, and Dick, and Ned,
Cut short their meat, and clothes, and bread,
Yet still loved heavenly union.

"Another preacher whining spoke
Of One whose heart for sinners broke:
He tied old Nanny to an oak,
And drew the blood at every stroke,
And prayed for heavenly union.

"Two others oped their iron jaws,
And waved their children-stealing paws;
There sat their children in gewgaws;
By stinting negroes' backs and maws,
They kept up heavenly union.

"All good from Jack another takes,
And entertains their flirts and rakes,
Who dress as sleek as glossy snakes,
And cram their mouths with sweetened cakes;
And this goes down for union."

Sincerely and earnestly hoping that this little book may do something toward throwing light on the American slave system, and hastening the glad day of deliverance to the millions of my brethren in bonds—faithfully relying upon the power of truth, love, and justice, for success in my humble efforts—and solemnly pledging myself anew to the sacred cause,—I subscribe myself,
*FREDERICK DOUGLASS.*

*LYNN, Mass., April 28, 1845.*

# ANGELINA EMILY GRIMKÉ

Angelina Emily Grimké (1805–79) was an abolitionist and a proponent of women's rights. She and her sister, the equally active Sarah Grimké, were the daughters of a Charleston, South Carolina, planter who owned slaves. They grew so dismayed by slavery that they left the South for Philadelphia, where they became Quakers (although they became alienated by the Quaker Friends' rejection of radical abolitionism in favor of a

more gradual approach). In 1838, Angelina Grimké married the well-known abolitionist Theodore Dwight Weld.

When the American Anti-Slavery Society invited her to meet with New York women about the degradations of southern slavery, Grimké decided instead to make her appeal directly to Southern women in the hope that they would rise together to fight against the injustice and inhumanity of the slave system. The resulting document, reprinted here, was celebrated among abolitionists, but it was burned in the Grimké sisters' hometown. It remains significant as a biblically based refutation of slavery in the U.S. South.

# Appeal to the Christian Women of the South

We have seen that the code of laws framed by Moses with regard to servants was designed to *protect them* as *men and women,* to secure to them their *rights* as *human beings,* to guard them from oppression and defend them from violence of every kind. Let us now turn to the Slave laws of the South and West and examine them too. I will give you the substance only, because I fear I shall trespass too much on your time, were I to quote them at length.

1. *Slavery* is hereditary and perpetual, to the last moment of the slave's earthly existence, and to all his descendants to the latest posterity.

2. The labor of the slave is compulsory and uncompensated; while the kind of labor, the amount of toil, the time allowed for rest, are dictated solely by the master. No bargain is made, no wages given. A pure despotism governs the human brute; and even his covering and provender, both as to quantity and quality, depend entirely on the master's discretion.

3. The slave being considered a personal chattel may be sold or pledged, or leased at the will of his master. He may be exchanged for marketable commodities, or taken in execution for the debts or taxes either of a living or dead master. Sold at auction, either individually, or in lots to suit the purchaser, he may remain with his family, or be separated from them for ever.

4. Slaves can make no contracts and have no *legal* right to any property, real or personal. Their own honest earnings and the legacies of friends belong in point of law to their masters.

5. Neither a slave nor a free colored person can be a witness against any *white,* or free person, in a court of justice, however atrocious may have been the crimes they have seen him commit, if such testimony would be for the benefit of a *slave;* but they may give testimony *against a fellow slave,* or free colored man, even in cases affecting life, if the *master* is to reap the advantage of it.

6. The slave may be punished at his master's discretion—without trial—without any means of legal redress; whether his offence be real or imaginary;

An updated wood carv-
ing of Angelina Grimké.
*Courtesy of the Library
of Congress, Prints &
Photographs Division.*

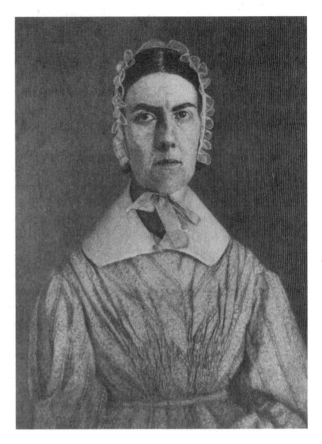

and the master can transfer the same despotic power to any person or persons,
he may choose to appoint.

7.  The slave is not allowed to resist any free man under *any* circumstances,
*his* only safety consists in the fact that his *owner* may bring suit and recover the
price of his body, in case his life is taken, or his limbs rendered unfit for labor.

8.  Slaves cannot redeem themselves, or obtain a change of masters, though
cruel treatment may have rendered such a change necessary for their personal
safety.

9.  The slave is entirely unprotected in his domestic relations.

10. The laws greatly obstruct the manumission of slaves, even where the
master is willing to enfranchise them.

11. The operation of the laws tends to deprive slaves of religious instruc-
tion and consolation.

12. The whole power of the laws is exerted to keep slaves in a state of the
lowest ignorance.

13. There is in this country a monstrous inequality of law and right. What is
a trifling fault in the *white* man, is considered highly criminal in the *slave*; the
same offences which cost a white man a few dollars only, are punished in the ne-
gro with death.

14. The laws operate most oppressively upon free people of color.

Shall I ask you now my friends, to draw the *parallel* between Jewish *servitude* and American *slavery?* No! For there is *no likeness* in the two systems; I ask you rather to mark the contrast. The laws of Moses *protected servants* in their *rights* as *men and women,* guarded them from oppression and defended them from wrong. The Code Noir of the South *robs the slave of all his rights* as a *man,* reduces him to a chattel personal, and defends the *master* in the exercise of the most unnatural and unwarantable power over his slave. They each bear the impress of the hand which formed them. The attributers of justice and mercy are shadowed out in the Hebrew code; those of injustice and cruelty, in the Code Noir of America. Truly it was wise in the slaveholders of the South to declare their slaves to be "chattels personal"; for before they could be robbed of wages, wives, children, and friends, it was absolutely necessary to deny they were human beings. It is wise in them, to keep them in abject ignorance, for the strong man armed must be bound before we can spoil his house—the powerful intellect of man must be bound down with the iron chains of nescience before we can rob him of his rights as a man; we must reduce him to a *thing* before we can claim the right to set our feet upon his neck, because it was only *all things* which were originally *put under the feet of man* by the Almighty and Beneficent Father of all, who has declared himself to be *no respecter* of persons, whether red, white or black.

But some have even said that Jesus Christ did not condemn slavery. To this I reply that our Holy Redeemer lived and preached among the Jews only. The laws which Moses had enacted fifteen hundred years previous to his appearance among them, had never been annulled, and these laws protected every servant in Palestine. If then He did not condemn Jewish servitude this does not prove that he would not have condemned such a monstrous system as that of American *slavery,* if that had existed among them. But did not Jesus condemn slavery? Let us examine some of his precepts. "*Whatsoever* ye would that men should do to you, do ye *even so to them*[.]" Let every slaveholder apply these queries to his own heart; Am *I* willing to be a slave—Am *I* willing to see *my* wife the slave of another—Am *I* willing to see my mother a slave, or my father, my sister or my brother? If *not,* then in holding others as slaves, I am doing what I would *not* wish to be done to me or any relative I have; and thus have I broken this golden rule which was given *me* to walk by.

But some slaveholders have said, "we were never in bondage to any man," and therefore the yoke of bondage would be insufferable to us, but slaves are accustomed to it, their backs are fitted to the burden. Well, I am willing to admit that you who have lived in freedom would find slavery even more oppressive than the poor slave does, but then you may try this question in another form— Am I willing to reduce *my little child* to slavery? You know that *if it is brought up a slave* it will never know any contrast, between freedom and bondage, its back will become fitted to the burden just as the negro child's does—*not by nature*— but by daily, violent pressure, in the same way that the head of the Indian child becomes flattened by the boards in which it is bound. It has been justly remarked that "*God never made a slave,*" he made man upright; his back was *not* made to carry burdens, nor his neck to wear a yoke, and the *man* must be crushed within him, before *his* back can be *fitted* to the burden of perpetual

golden rule

slavery; and that his back is *not* fitted to it, is manifested by the insurrections that so often disturb the peace and security of slaveholding countries. Who ever heard of a rebellion of the beasts of the field; and why not? simply because *they* were all placed *under the feet of man,* into whose hand they were delivered; it was originally designed that they should serve him, therefore their necks have been formed for the yoke, and their backs for the burden; but *not so with man,* intellectual, immortal man! I appeal to you, my friends, as mothers; Are you willing to enslave *your* children? You start back with horror and indignation at such a question. But why, if slavery is *no wrong* to those upon whom it is imposed? why, if as has often been said, slaves are happier than their masters, free from the cares and perplexities of providing for themselves and their families: why not place *your children* in the way of being supported without your having the trouble to provide for them, or they for themselves? Do you not perceive that as soon as this golden rule of action is applied to *yourselves* that you involuntarily shrink from the test; as soon as *your* actions are weighed in *this* balance of the sanctuary that *you are found wanting?* Try yourselves by another of the Divine precepts, "Thou shalt love thy neighbor as thyself." Can we love a man *as* we love *ourselves*[;] if we do, and continue to do unto him, what we would not wish any one to do to us? Look too, at Christ's example, what does he say of himself, "I came *not* to be ministered unto, but to minister." Can you for a moment imagine the meek, and lowly, and compassionate Saviour, *a Slaveholder?* do you not shudder at this thought as much as at that of his being *a warrior?* But why, if slavery is not sinful?

Again, it has been said, the Apostle Paul did not condemn Slavery, for he sent Onesimus back to Philemon. I do not think it can be said he sent him back, for no coercion was made use of. Onesimus was not thrown into prison and then sent back in chains to his master, as your runaway slaves often are—this could not possibly have been the case, because you know Paul as a Jew, was *bound to protect* the runaway, *he had no right* to send any fugitive back to his master. The state of the case then seems to have been this. Onesimus had been an unprofitable servant to Philemon and left him—he afterwards became converted under the Apostle's preaching, and seeing that he had been to blame in his conduct, and desiring by future fidelity to atone for past error, he wished to return, and the Apostle gave him the letter we now have as a recommendation to Philemon, informing him of the conversion of Onesimus, and entreating him as "Paul the aged" "to receive him, *not* now as a *servant,* but *above* a servant, a brother beloved, especially to me, but how much more unto thee, both in the flesh and in the Lord. If thou count *me* therefore as a partner, *receive him as myself.*" This then surely cannot be forced into a justification of the practice of returning runaway slaves back to their masters, to be punished with cruel beatings and scourgings as they often are. Besides the word ζουλος here translated servant, is the same that is made use of in Matt. xvii, 27. Now it appears that this servant owed his lord ten thousands talents; he possessed property to a vast amount. Onesimus could not then have been a *slave,* for slaves do not own their wives, or children; no, not even their own bodies, much less property. But again, the servitude which the apostle was accustomed to, must have been very different from American slavery, for he says, "the heir (or son), as long as he is a child, differeth *nothing from a servant,* though he be lord of all. But is under *tutors* and

governors until the time appointed of the father." From this it appears, that the means of *instruction* were provided for *servants* as well as children; and indeed we know it must have been so among the Jews, because their servants were not permitted to remain in perpetual bondage, and therefore it was absolutely necessary they should be prepared to occupy higher stations in society than those of servants. Is it so at the South, my friends? Is the daily bread of instruction provided for *your slaves?* are their minds enlightened, and they gradually prepared to rise from the grade of menials into that of *free,* independent members of the state? Let your own statute book, and your own daily experience, answer these questions.

If this apostle sanctioned *slavery,* why did he exhort masters thus in his epistle to the Ephesians, "and ye, masters, do the same things unto them (i.e. perform your duties to your servants as unto Christ, not unto me) *forbearing threatening;* knowing that your master also is in heaven, neither is *there respect of persons with him."* And in Colossians, "Masters give unto your servants that which is *just and equal,* knowing that ye also have a master in heaven." Let slaveholders only obey these injunctions of Paul, and I am satisfied slavery would soon be abolished. If he thought it sinful even to *threaten* servants, surely he must have thought it sinful to flog and to beat them with sticks and paddles; indeed, when delineating the character of a bishop, he expressly names this as one feature of it, *"no striker."* Let masters give unto their servants that which is *just* and *equal,* and all that vast system of unrequited labor would crumble into ruin. Yes, and if they once felt they had no right to the *labor* of their servants without pay, surely they could not think they had a right to their wives, their children, and their own bodies. Again, how can it be said Paul sanctioned slavery, when, as though to put this matter beyond all doubt, in that black catalogue of sins enumerated in his first epistle to Timothy, he mentions *"menstealers,"* which word may be translated *"slavedealers."* But you may say, we all despise slavedealers as much as any one can; they are never admitted into genteel or respectable society. And why not? Is it not because even you shrink back from the idea of associating with those who make their fortunes by trading in the bodies and souls of men, women, and children? whose daily work it is to break human hearts, by tearing wives from their husbands, and children from their parents? But why hold slavedealers as despicable, if their trade is lawful and virtuous? and why despise them more than the *gentlemen of fortune and standing* who employ them as *their* agents? Why more than the *professors of religion* who barter their fellow-professors to them for gold and silver? We do not despise the land agent, or the physician, or the merchant, and why? Simply because their professions are virtuous and honorable; and if the trade of men-jobbers were honorable, you would not despise them either. There is no difference in *principle,* in *Christian ethics,* between the despised slavedealer and the *Christian* who buys slaves from, or sells slaves to him; indeed, if slaves were not wanted by the respectable, the wealthy, and the religious in that community, there would be no slaves in that community, and of course no *slavedealers.* It is then the *Christians* and the *honorable men* and *women* of the South, who are the *main pillars* of this grand temple built to Mammon and to Moloch. It is the *most enlightened* in every country who are *most* to blame when any public sin is supported by public opinion, hence Isaiah says, *"When* the Lord hath performed his whole work upon

mount *Zion* and on *Jerusalem,* (then) I will punish the fruit of the stout heart of the king of Assyria, and the glory of his high looks." And was it not so? Open the historical records of that age, was not Israel carried into captivity B.C. 606, Judah B.C. 588, and the stout heart of the heathen monarchy not punished until B.C. 536, fifty-two years *after* Judah's, and seventy years *after* Israel's captivity, when it was overthrown by Cyrus, king of Persia? Hence, too, the apostle Peter says, "judgment must *begin at the house of God."* Surely this would not be the case, if the *professors of religion* were not *most worthy* of blame.

But it may be asked, why are *they* most culpable? I will tell you, my friends. It is because sin is imputed to us just in proportion to the spiritual light we receive. Thus the prophet Amos says, in the name of Jehovah, "*You only* have I known of all the families of the earth: *therefore* I will punish *you* for all your iniquities." Hear too the doctrine of our Lord on this important subject; "The servant who *knew* his Lord's will and *prepared not* himself, neither did according to his will, shall be beaten with *many* stripes": and why? "For unto whomsoever *much* is given, of *him* shall *much* be required; and to whom men have committed *much,* of *him* they will ask the *more."* Oh! then that the *Christians* of the south would ponder these things in their hearts, and awake to the vast responsibilities which rest *upon them* at this important crisis.

I have thus, I think, clearly proved to you seven propositions, viz.: First, that slavery is contrary to the declaration of our independence. Second, that it is contrary to the first charter of human rights given to Adam, and renewed to Noah. Third, that the fact of slavery having been the subject of prophecy, furnishes *no* excuse whatever to slavedealers. Fourth, that no such system existed under the patriarchal dispensation. Fifth, that *slavery never* existed under the Jewish dispensation; but so far otherwise, that every servant was placed under the *protection of law,* and care taken not only to prevent all *involuntary* servitude, but all *voluntary perpetual* bondage. Sixth, that slavery in America reduces a *man* to a *thing,* a "chattel personal," *robs him* of *all* his rights as a *human being,* fetters both his mind and body, and protects the *master* in the most unnatural and unreasonable power, whilst it *throws him out* of the protection of law. Seventh, that slavery is contrary to the example and precepts of our holy and merciful Redeemer, and of his apostles.

But perhaps you will be ready to query, why appeal to *women* on this subject? *We* do not make the laws which perpetuate slavery. *No* legislative power is vested in *us; we* can do nothing to overthrow the system, even if we wished to do so. To this I reply, I know you do not make the laws, but I also know that *you are the wives and mothers, the sisters and daughters of those who do;* and if you really suppose *you* can do nothing to overthrow slavery, you are greatly mistaken. You can do much in every way: four things I will name. 1st. You can read on this subject. 2d. You can pray over this subject. 3d. You can speak on this subject. 4th. You can *act* on this subject. I have not placed reading before praying because I regard it more important, but because, in order to pray aright, we must understand what we are praying for; it is only then we can "pray with the understanding and the spirit also."

1. Read then on the subject of slavery. Search the Scriptures daily, whether the things I have told you are true. Other books and papers might be a great help to you in this investigation, but they are not necessary, and it is hardly probable that your Committees of Vigilance will allow you to have any other.

The *Bible* then is the book I want you to read in the spirit of inquiry, and the spirit of prayer. Even the enemies of Abolitionists, acknowledge that their doctrines are drawn from it. In the great mob in Boston last autumn, when the books and papers of the Anti-Slavery Society were thrown out of the windows of their office, an individual laid hold of the Bible and was about tossing it out to the ground, when another reminded him that it was the Bible he had in his hand. "*O! 'tis all one*," he replied, and out went the sacred volume along with the rest. We thank him for the acknowledgment. Yes, "*it is all one*," for our books and papers are mostly commentaries on the Bible, and the Declaration. Read the *Bible* then, it contains the words of Jesus, and they are spirit and life. Judge for yourselves whether *he sanctioned* such a system of oppression and crime.

2. Pray over this subject. When you have entered into your closets, and shut to the doors, then pray to your father, who seeth in secret, that he would open your eyes to see whether slavery is *sinful*, and if it is, that he would enable you to bear a faithful, open and unshrinking testimony against it, and to do whatsoever your hands find to do, leaving the consequences entirely to him, who still says to us whenever we try to reason away duty from the fear of consequences, "*What is that to thee, follow thou me.*" Pray also for that poor slave, that he may be kept patient and submissive under his hard lot, until God is pleased to open the door of freedom to him without violence or bloodshed. Pray too for the master that his heart may be softened, and he made willing to acknowledge, as Joseph's brethren did, "Verily we are guilty concerning our brother," before he will be compelled to add in consequence of Divine judgment, "therefore is all this evil come upon us." Pray also for all your brethren and sisters who are laboring in the righteous cause of Emancipation in the Northern States, England and the world. There is great encouragement for prayer in these words of our Lord. "Whatsoever ye shall ask the Father *in my name, he will give* it to you"— Pray then without ceasing, in the closet and the social circle.

3. Speak on this subject. It is through the tongue, the pen, and the press, that truth is principally propagated. Speak then to your relatives, your friends, your acquaintances on the subject of slavery; be not afraid if you are conscientiously convinced it is *sinful*, to say so openly, but calmly, and to let your sentiments be known. If you are served by the slaves of others, try to ameliorate their condition as much as possible; never aggravate their faults, and thus add fuel to the fire of anger already kindled in a master and mistress's bosom; remember their extreme ignorance, and consider them as your Heavenly Father does the *less* culpable on this account, even when they do wrong things. Discountenance *all* cruelty to them, all starvation, all corporal chastisement; these may brutalize and *break* their spirits, but will never bond them to willing, cheerful obedience. If possible, see that they are comfortably and *seasonably* fed, whether in the house or the field; it is unreasonable and cruel to expect slaves to wait for their breakfast until eleven o'clock, when they rise at five or six. Do all you can, to induce their owners to clothe them well, and to allow them many little indulgences which would contribute to their comfort. Above all, try to persuade your husband, father, brothers and sons, that *slavery is a crime against God and man*, and that it is a great sin to keep *human beings* in such abject ignorance; to deny them the privilege of learning to read and write. The Catholics are universally condemned, for denying the Bible to the common people, but, *slaveholders must*

*not* blame them, for *they* are doing the *very same thing*, and for the very same reason, neither of these systems can bear the light which bursts from the pages of that Holy Book. And lastly, endeavour to inculcate submission on the part of the slaves, but whilst doing this be faithful in pleading the cause of the oppressed.

> Will *you* behold unheeding,
> Life's holiest feelings crushed,
> Where *woman's* heart is bleeding,
> Shall *woman's* heart be hushed?

4. Act on this subject. Some of you own slaves yourselves. If you believe slavery is *Sinful,* set them at liberty, "undo the heavy burdens and let the oppressed go free." If they wish to remain with you, pay them wages, if not let them leave you. Should they remain teach them, and have them taught the common branches of an English education; they have minds and those minds, *ought to be improved.* So precious a talent as intellect, never was given to be wrapt in a napkin and buried in the earth. It is the *duty* of all, as far as they can, to improve their own mental faculties, because we are commanded to love God with *all our minds,* as well as with all our hearts, and we commit a great sin, if we *forbid or prevent* that cultivation of the mind in others, which would enable them to perform this duty. Teach your servants then to read &c, and encourage them to believe it is their *duty* to learn, if it were only that they might read the Bible.

But some of you will say, we can neither free our slaves nor teach them to read, for the laws of our state forbid it. Be not surprised when I say such wicked laws *ought to be no barrier* in the way of your duty, and I appeal to the Bible to prove this position. What was the conduct of Shiphrah and Puah, when the king of Egypt issued his cruel mandate, with regard to the Hebrew children? "*They* feared *God,* and did *not* as the King of Egypt commanded them, but saved the men children alive." Did these *women* do right in disobeying that monarch? "*Therefore* (says the sacred text,) *God dealt well* with them, and made them houses." Ex. i. What was the conduct of Shadrach, Meshach, and Abednego, when Nebuchadnezzar set up a golden image in the plain of Dura, and commanded all people, nations, and languages to fall down and worship it? "Be it known, unto thee, (said these faithful *Jews*) O king, that *we will not* serve thy gods, nor worship the image which thou hast set up." Did these men *do right in disobeying the law* of their sovereign: Let their miraculous deliverance from the burning fiery furnace, answer; Dan. iii. What was the conduct of Daniel, when Darius made a firm decree that no one should ask a petition of any man or God for thirty days? Did the prophet cease to pray? No! "When Daniel *knew that the writing was signed,* he went into his house, and his windows being *open* towards Jerusalem, he kneeled upon his knees three times a day, and prayed and gave thanks before his God, as he did aforetime." Did Daniel do right thus to *break* the law of his king? Let his wonderful deliverance out of the mouths of the lions answer; Dan. vii. Look, too, at the Apostles Peter and John. When the rulers of the Jews, "*commanded them not* to speak at all, nor teach in the name of Jesus," what did they say? "Whether it be right in the sight of God, to hearken unto you more than unto God, judge ye." And what did they do? "They spake the word of God with boldness, and with great power gave the Apostles witness of the *resurrection* of the Lord Jesus"; although *this* was the very doctrine, for the preaching of

which, they had just been cast into prison, and further threatened. Did these men do right? I leave *you* to answer, who now enjoy the benefits of their labors and sufferings, in that Gospel they dared to preach when positively commanded *not to teach any more* in the name of Jesus; Acts iv.

But some of you may say, if we do free our slaves, they will be taken up and sold, therefore there will be no use in doing it. Peter and John might just as well have said, we will not preach the gospel, for if we do, we shall be taken up and put in prison, therefore there will be no use in our preaching. *Consequences,* my friends, belong no more to *you,* than they did to these apostles. Duty is ours and events are God's. If you think slavery is sinful, all *you* have to do is to set your slaves at liberty, do all you can to protect them, and in humble faith and fervent prayer, commend them to your common Father. He can take care of them; but if for wise purposes he sees fit to allow them to be sold, this will afford you an opportunity of testifying openly, wherever you go, against the crime of *mansteal-ing.* Such an act will be *clear robbery,* and if exposed, might, under the Divine direction, do the cause of Emancipation more good, than any thing that could happen, for "He makes even the wrath of man to praise him, and the remainder of wrath he will restrain."

I know that this doctrine of obeying *God,* rather than man, will be considered as dangerous and heretical by many, but I am not afraid openly to avow it, because it is the doctrine of the Bible; but I would not be understood to advocate resistance to any law however oppressive, if, in obeying it, I was not obliged to commit *sin.* If for instance, there was a law, which imposed imprisonment or a fine upon me if I manumitted a slave, I would on no account resist that law, I would set the slave free, and then go to prison or pay the fine. If a law commands me to *sin I will break it;* if it calls me to *suffer,* I will let it take its course *unresistingly.* The doctrine of blind obedience and unqualified submission to *any human* power, whether civil or ecclesiastical, is the doctrine of despotism, and ought to have no place among Republicans and Christians.

But you will perhaps say, such a course of conduct would inevitably expose us to great suffering. Yes! my christian friends, I believe it would, but this will *not* excuse you or any one else for the neglect of *duty.* If Prophets and Apostles, Martyrs, and Reformers had not been willing to suffer for the truth's sake, where would the world have been now? If they had said, we cannot speak the truth, we cannot do what we believe is right, because the *laws of our country or public opinion are against us,* where would our holy religion have been now? The Prophets were stoned, imprisoned, and killed by the Jews. And why? Because they exposed and openly rebuked public sins; they opposed public opinion; had they held their peace, they all might have lived in ease and died in favor with a wicked generation. Why were the Apostles persecuted from city to city, stoned, incarcerated, beaten, and crucified? Because they dared to *speak the truth;* to tell the Jews, boldly and fearlessly, that *they* were the *murderers* of the Lord of Glory, and that, however great a stumbling-block the Cross might be to them, there was no other name given under heaven by which men could be saved, but the name of Jesus. Because they declared, even at Athens, the seat of learning and refinement, the self-evident truth, that "they be no gods that are made with men's hands," and exposed to the Grecians the foolishness of worldy wisdom, and the impossibility of salvation but through Christ, whom they despised on

account of the ignominious death he died. Because at Rome, the proud mistress of the world, they thundered out the terrors of the law upon that idolatrous, war-making, and slaveholding community. Why were the martyrs stretched upon the rack, gibbeted and burnt, the scorn and diversion of a Nero, whilst their tarred and burning bodies sent up a light which illuminated the Roman capital? Why were the Waldenses hunted like wild beasts upon the mountains of Piedmont, and slain with the sword of the Duke of Savoy and the proud monarch of France [Philip II]? Why were the Presbyterians chased like the partridge over the highlands of Scotland—the Methodists pumped, and stoned, and pelted with rotten eggs—the Quakers incarcerated in filthy prisons, beaten, whipped at the cart's tail, banished and hung? Because they dared to *speak* the *truth*, to *break* the unrighteous *laws* of their country, and chose rather to suffer affliction with the people of God, "not accepting deliverance," even under the gallows. Why were Luther and Calvin persecuted and excommunicated, Cranmer, Ridley, and Latimer burnt? Because they fearlessly proclaimed the truth, though that truth was contrary to public opinion, and the authority of Ecclesiastical councils and conventions. Now all this vast amount of human suffering might have been saved. All these Prophets and Apostles, Martyrs, and Reformers, might have lived and died in peace with all men, but following the example of their great pattern, "they despised the shame, endured the cross, and are now set down on the right hand of the throne of God," having received the glorious welcome of "well *done* good and faithful servants, enter ye into the joy of your Lord."

But you may say we are *women*, how can *our* hearts endure persecution? And why not? Have not *women* stood up in all the dignity and strength of moral courage to be the leaders of the people, and to bear a faithful testimony for the truth whenever the providence of God has called them to do so? Are there no *women* in that noble army of martyrs who are now singing the song of Moses and the Lamb? Who led out the women of Israel from the house of bondage, striking the timbrel, and singing the song of deliverance on the banks of that sea whose waters stood up like walls of crystal to open a passage for their escape? It was a *woman;* Miriam, the prophetess, the sister of Moses and Aaron. Who went up with Barak to Kadesh to fight against Jabin, King of Canaan, into whose hand Israel had been sold because of their iniquities? It was a *woman!* Deborah the wife of Lapidoth, the judge, as well as the prophetess of that backsliding people; Judges iv, 9. Into whose hands was Sisera, the captain of Jabin's host delivered? Into the hand of a *woman.* Jael the wife of Heber! Judges vi, 21. Who dared to *speak the truth* concerning those judgments which were coming upon Judea, when Josiah, alarmed at finding that his people "had not kept the word of the Lord to do after all that was written in the book of the Law," sent to enquire of the Lord concerning these things? It was a *woman.* Huldah the prophetess, the wife of Shallum; 2, Chron. xxxiv, 22. Who was chosen to deliver the whole Jewish nation from that murderous decree of Persia's King, which wicked Haman had obtained by calumny and fraud? It was a *woman;* Esther the Queen; yes, weak and trembling *woman* was the instrument appointed by God, to reverse the bloody mandate of the eastern monarch, and save the *whole visible church* from destruction. What human voice first proclaimed to Mary that she should be the mother of our Lord? It was a *woman!* Elizabeth, the wife of

Zacharias; Luke i, 42, 43. Who united with the good old Simeon in giving thanks publicly in the temple, when the child, Jesus, was presented there by his parents, "and spake of him to all them that looked for redemption in Jerusalem"? It was a *woman!* Anna the prophetess. Who first proclaimed Christ as the true Messiah in the streets of Samaria, once the capital of the ten tribes? It was a *woman!* Who ministered to the Son of God whilst on earth a despised and persecuted Reformer, in the humble garb of a carpenter? They were *women!* Who followed the rejected King of Israel, as his fainting footsteps trod the road to Calvary? "A great company of people and of *women"*: and it is remarkable that to *them alone,* he turned and addressed the pathetic language, "Daughters of Jerusalem, weep not for me, but weep for yourselves and your children." Ah! who sent unto the Roman Governor when he was set down on the judgment seat, saying unto him, "Have thou nothing to do with that just man, for I have suffered many things this day in a dream because of him"? It was a *woman!* the wife of Pilate. Although *"he knew* that for envy the Jews had delivered Christ," yet *he* consented to surrender the Son of God into the hands of a brutal soldiery, after having himself scourged his naked body. Had the *wife* of Pilate sat upon that judgment seat, what would have been the result of the trial of this "just person"?

And who last hung around the cross of Jesus on the mountain of Golgotha? Who first visited the sepulchre early in the morning on the first day of the week, carrying sweet spices to embalm his precious body, not knowing that it was incorruptible and could not be holden by the bands of death? These were *women!* To whom did he *first* appear after his resurrection? It was to a *woman!* Mary Magdalene; Mark xvi, 9. Who gathered with the apostles to wait at Jerusalem, in prayer and supplication, for "the promise of the Father"; the spiritual blessing of the Great High Priest of his Church, who had entered, *not* into the splendid temple of Solomon, there to offer the blood of bulls, and of goats, and the smoking censer upon the golden altar, but into Heaven itself, there to present his intercessions, after having "given himself for us, an offering and a sacrifice to God for a sweet smelling savor"? *Women* were among that holy company; Acts, i, 14. And did *women* wait in vain? Did those who had ministered to his necessities, followed in his train, and wept at his crucifixion, wait in vain? No! No! Did the cloven tongues of fire descend upon the heads of *women* as well as men? Yes, my friends, "it sat upon *each of them"*; Acts ii, 3. *Women* as well as men were to be living stones in the temple of grace, and therefore *their* heads were consecrated by the descent of the Holy Ghost as well as those of men. Were *women* recognized as fellow laborers in the gospel field? They were! Paul says in his epistle to the Philippians, "help those *women* who labored with men, in the gospel"; Phil. iv, 3.

But this is not all. Roman *women* were burnt at the stake, *their* delicate limbs were torn joint from joint by the ferocious beasts of the Amphitheatre, and tossed by the wild bull in his fury, for the diversion of that idolatrous, warlike, and slaveholding people. Yes, *women* suffered under the ten persecutions of heathen Rome, with the most unshrinking constancy and fortitude; not all the entreaties of friends, nor the claims of new born infancy, nor the cruel threats of enemies could make *them* sprinkle one grain of incense upon the altars of Roman idols. Come now with me to the beautiful valleys of Piedmont. Whose blood stains the green sward, and decks the wild flowers with colors not their

own, and smokes on the sword of persecuting France? It is *woman's*, as well as man's? Yes, *women* were accounted as sheep for the slaughter, and were cut down as the tender saplings of the wood.

But time would fail me, to tell of all those hundreds and thousands of *women*, who perished in the Low countries of Holland, when Alva's sword of vengeance was unsheathed against the Protestants, when the Catholic Inquisitions of Europe became the merciless executioners of vindictive wrath, upon those who dared to worship God, instead of bowing down in unholy adoration before "my Lord God the *Pope*," and when England, too, burnt her Ann Ascoes at the stake of martyrdom. Suffice it to say, that the Church, after having been driven from Judea to Rome, and from Rome to Piedmont, and from Piedmont to England, and from England to Holland, at last stretched her fainting wings over the dark bosom of the Atlantic, and found on the shores of a great wilderness, a refuge from tyranny and oppression—as she thought, but *even here,* (the warm blush of shame mantles my cheeks as I write it,) *even there,* woman was beaten and banished, imprisoned, and hung upon the gallows, a trophy to the Cross.

And what, I would ask in conclusion, have *women* done for the great and glorious cause of Emancipation? Who wrote that pamphlet which moved the heart of Wilberforce to pray over the wrongs, and his tongue to plead the cause of the oppressed African? It was a *woman*, Elizabeth Heyrick. Who labored assiduously to keep the sufferings of the slave continually before the British public? They were *women*. And how did they do it? By their needles, paint brushes and pens, by speaking the truth, and petitioning Parliament for the abolition of slavery. And what was the effect of their labors? Read it in the Emancipation bill of Great Britain. Read it, in the present state of her West India Colonies. Read it, in the impulse which has been given to the cause of freedom in the United States of America. Have English women then done so much for the negro, and shall American women do nothing? Oh no! Already are there sixty female Anti-Slavery Societies in operation. These are doing just what the English women did, telling the story of the colored man's wrongs, praying for his deliverance, and presenting his kneeling image constantly before the public eye on bags and needle-books, card-racks, pen-wipers, pin-cushions, &c. Even the children of the north are inscribing on their handy work, "May the points of our needles prick the slaveholder's conscience." Some of the reports of these Societies exhibit not only considerable talent, but a deep sense of religious duty, and a determination to persevere through evil as well as good report, until every scourge, and every shackle, is buried under the feet of the manumitted slave.

The Ladies' Anti-Slavery Society of Boston was called last fall, to a severe trial of their faith and constancy. They were mobbed by "the gentlemen of property and standing," in that city at their anniversary meeting, and their lives were jeoparded by an infuriated crowd; but their conduct on that occasion did credit to our sex, and affords a full assurance that they will *never* abandon the cause of the slave. The pamphlet, Right and Wrong in Boston, issued by them in which a particular account is given of that "mob of broad cloth in broad day," does equal credit to the head and the heart of her who wrote it. I wish my Southern sisters could read it; they would then understand that the women of the North have engaged in this work from a sense of *religious duty,* and that nothing will ever in-

duce them to take their hands from it until it is fully accomplished. They feel no hostility to you, no bitterness or wrath; they rather sympathize in your trials and difficulties; but they well know that the first thing to be done to help you, is to pour in the light of truth on your minds, to urge you to reflect on, and pray over the subject. This is all *they* can do for you, *you* must work out your own deliverance with fear and trembling, and with the direction and blessing of God, *you can do it.* Northern women may labor to produce a correct public opinion at the North, but if Southern women sit down in listless indifference and criminal idleness, public opinion cannot be rectified and purified at the South. It is manifest to every reflecting mind, that slavery must be abolished: the era in which we live, and the light which is overspreading the whole world on this subject, clearly show that the time cannot be distant when it will be done. Now there are only two ways in which it can be effected, by moral power or physical force, and it is for *you* to choose which of these you prefer. Slavery always has, and always will produce insurrections wherever it exists, because it is a violation of the natural order of things, and no human power can much longer perpetuate it. The opposers of abolitionists fully believe this; one of them remarked to me not long since, there is no doubt there will be a most terrible overturning at the South in a few years, such cruelty and wrong, must be visited with Divine vengeance soon. Abolitionists believe, too, that this must inevitably be the case if you do not repent, and they are not willing to leave you to perish without entreating you, to save yourselves from destruction; well may they say with the apostle, "am I then your enemy because I tell you the truth," and warn you to flee from impending judgments.

But why, my dear friends, have I thus been endeavoring to lead you through the history of more than three thousand years, and to point you to that great cloud of witnesses who have gone before, "from works to rewards"? Have I been seeking to magnify the sufferings, and exalt the character of woman, that she "might have praise of men"? No! no! my object has been to arouse *you*, as the wives and mothers, the daughters and sisters, of the South, to a sense of your duty as *women*, and as Christian women, on that great subject, which has already shaken our country, from the St. Lawrence and the lakes, to the Gulf of Mexico, and from the Mississippi to the shores of the Atlantic; *and will continue mightily to shake it,* until the polluted temple of slavery fall and crumble into ruin. I would say unto each one of you, "what meanest thou, O sleeper! arise and call upon thy God, if so be that God will think upon us that we perish not." Perceive you not that dark cloud of vengeance which hangs over our boasting Republic? Saw you not the lightnings of Heaven's wrath, in the flame which leaped from the Indian's torch to the roof of yonder dwelling, and lighted with its horrid glare the darkness of midnight? Heard you not the thunders of Divine anger, as the distant roar of the cannon came rolling onward, from the Texian country, where Protestant American Rebels are fighting with Mexican Republicans—for what? For the reestablishment of *slavery;* yes! of American slavery in the bosom of a Catholic Republic, where that system of robbery, violence, and wrong, had been legally abolished for twelve years. Yes! citizens of the United States, after plundering Mexico of her land, are now engaged in deadly conflict for the privilege of fastening chains, and collars, and manacles—upon whom? upon the subjects of some foreign prince? No! upon native born

American Republican citizens, although the fathers of these very men declared to the whole world, while struggling to free themselves from the three penny taxes of an English king, that they believed it to be a *self-evident* truth that *all men* were created equal, and had an *unalienable right to liberty.*

Well may the poet exclaim in bitter sarcasm,

> The fustian flag that proudly waves
> In solemn mockery o'er *a land of slaves.*

Can you not, my friends, understand the signs of the time; do you not see the sword of retributive justice hanging over the South, or are you still slumbering at your posts?—Are there no Shiphrahs, no Puahs among you, who will dare in Christian firmness and Christian meekness, to refuse to obey the *wicked laws* which require *woman to enslave, to degrade and to brutalize woman?* Are there no Miriams, who would rejoice to lead out the captive daughters of the Southern States to liberty and light? Are there no Huldahs there who will dare to *speak the truth* concerning the sins of the people and those judgments, which it requires no prophet's eye to see must follow if repentance is not speedily sought? Is there no Esther among you who will plead for the poor devoted slave? Read the history of this Persian queen, it is full of instruction; she at first refused to plead for the Jews: but hear the words of Mordecai, "Think not within thyself, that *thou shalt escape in the king's house more than all the Jews, for if thou altogether hold-est thy peace at this time,* then shall there enlargement and deliverance arise to the Jews from another place: but *thou and thy father's house shall be destroyed.*" Listen, too, to her magnanimous reply to this powerful appeal; "*I will* go in unto the king, which is *not* according to law, and if I perish, I perish." Yes! if there were but *one* Esther at the South, she *might* save her country from ruin; but let the Christian women there arise, as the Christian women of Great Britain did, in the majesty of moral power, and that salvation is certain. Let them embody themselves in societies, and send petitions up to their different legislatures, entreating their husbands, fathers, brothers, and sons, to abolish the institution of slavery; no longer to subject *woman* to the scourge and the chain, to mental darkness and moral degradation; no longer to tear husbands from their wives, and children from their parents; no longer to make men, women, and children, work *without wages;* no longer to make their lives bitter in hard bondage; no longer to reduce *American citizens* to the abject condition of *slaves,* of "chattels personal"; no longer to barter the *image of God* in human shambles for corruptible things such as silver and gold.

The *women of the South can overthrow* this horrible system of oppression and cruelty, licentiousness and wrong. Such appeals to your legislatures would be irresistible, for there is something in the heart of man which will bend under moral suasion. There is a swift witness for truth in his bosom, which *will respond to truth* when it is uttered with calmness and dignity. If you could obtain but six signatures to such a petition in only one state, I would say, send up that petition, and be not in the least discouraged by the scoffs and jeers of the heartless, or the resolution of the house to lay it on the table. It will be a great thing if the subject can be introduced into your legislatures in any way, even by *women,* and *they* will be the most likely to introduce it there in the best possible manner, as a matter of *morals* and *religion,* not of expediency or politics. You may petition, too, the dif-

ferent ecclesiastical bodies of the slave states. Slavery must be attacked with the whole power of truth and the sword of the spirit. You must take it up on *Christian* ground, and fight against it with Christian weapons, whilst your feet are shod with the preparation of the gospel of peace. And *you are now* loudly called upon by the cries of the widow and the orphan, to arise and gird yourselves for this great moral conflict, with the whole armour of righteousness upon the right hand and on the left. . . .

Sisters in Christ, I have done. As a Southerner, I have felt it was my duty to address you. I have endeavored to set before you the exceeding sinfulness of slavery, and to point you to the example of those noble women who have been raised up in the church to effect great revolutions, and to suffer for the truth's sake. I have appealed to your sympathies as women, to your sense of duty as *Christian women.* I have attempted to vindicate the Abolitionists, to prove the entire safety of immediate Emancipation, and to plead the cause of the poor and oppressed. I have done—I have sowed the seeds of truth, but I well know, that even if an Apollos were to follow in my steps to water them, *"God only* can give the increase." To Him then who is able to prosper the work of his servant's hand, I commend this Appeal in fervent prayer, that as he "hath *chosen the weak things of the world,* to confound the things which are mighty," so He may cause His blessing, to descend and carry conviction to the hearts of many Lydias through these speaking pages. Farewell—Count me not your "enemy because I have told you the truth," but believe me in unfeigned affection,

*Your sympathizing Friend,*
*Angelina E. Grimké.*

# CATHARINE E. BEECHER

Catharine E. Beecher (1800–78), the daughter of the well-known reformer and evangelical Protestant minister Lyman Beecher and the sister of Henry Ward Beecher and Harriet Beecher Stowe, was one of the best-known women of her time. A vocal advocate for women's education, she founded three important schools for young women and wrote prolifically on a multitude of subjects, including homemaking, health, and religion. She advocated what would come to be termed "domestic feminism," a program of encouraging women to value their feminine domestic roles and expanding their moral influence within the home while protecting them from the world beyond. Creating a moral middle-class home would have the effect of inculcating democratic values in children and thus ensure stability and progress in the nation.

Opposed to woman's suffrage, Beecher also opposed the radical abolitionist position of Angelina Grimké. She wrote her *Essay on Slavery and Abolitionism* as a response to Angelina Grimké's *Appeal to the Christian Women of the South.*

## Essay on Slavery and Abolitionism

*My Dear Friend,*

Your public address to Christian females at the South has reached me, and I have been urged to aid in circulating it at the North. I have also been informed, that you contemplate a tour, during the ensuing year, for the purpose of exerting your influence to form Abolition Societies among ladies of the non-slave-holding States.

Our acquaintance and friendship give me a claim to your private ear; but there are reasons why it seems more desirable to address you, who now stand before the public as an advocate of Abolition measures, in a more public manner.

The object I have in view, is to present some reasons why it seems unwise and inexpedient for ladies of the non-slave-holding States to unite themselves in Abolition Societies; and thus, at the same time, to exhibit the inexpediency of the course you propose to adopt. . . .

The distinctive peculiarity of the Abolition Society is this: it is a voluntary association in one section of the country, designed to awaken public sentiment against a moral evil existing in another section of the country. . . .

The best way to make a person like a thing which is disagreeable, is to try in some way to make it agreeable. . . . If the friends of the blacks had quietly set themselves to work to increase their intelligence, their usefulness, their respectability, their meekness, gentleness, and benevolence, and then had appealed to the pity, generosity, and christian feelings of their fellow citizens, a very different result would have appeared. Instead of this, reproaches, rebukes, and sneers, were employed to convince the whites that their prejudices were sinful, and without any just cause. . . . This tended to irritate the whites, and to increase their prejudice against the blacks. . . . Then, on the other hand, the blacks extensively received the Liberator, and learned to imbibe the spirit of its conductor.

They were taught to feel that they were injured and abused, the objects of a guilty and unreasonable prejudice—that they occupied a lower place in society than was right—that they ought to be treated as if they were whites; and in repeated instances, attempts were made by their friends to mingle them with whites, so as to break down the existing distinctions of society. Now, the question is not, whether these things, that were urged by Abolitionists, were true. The thing maintained is, that the method taken by them to remove this prejudice was neither peaceful nor christian in its tendency, but, on the contrary, was

calculated . . . to generate anger, pride, and recrimination, on one side, and envy, discontent, and revengeful feelings, on the other. . . .

Take another example. If a prudent and benevolent female had selected almost any village in New England, and commenced a school for coloured females, in a quiet, appropriate, and unostentatious way, the world would never have heard of the case, except to applaud her benevolence. . . . But instead of this, there appeared public advertisements . . . stating that a seminary for the education of young ladies of colour was to be opened in Canterbury, in the state of Connecticut. . . . It was an entire disregard of the prejudices and the proprieties of society, and calculated to stimulate pride, anger, ill-will, contention. . . .

The assertion that Christianity itself has led to strife and contention, is not a safe method of evading this argument. Christianity is a system of *persuasion*, tending, by kind and gentle influences, to make men *willing* to leave off their sins. . . .

The preceding are some of the reasons which, on the general view, I would present as opposed to the proposal of forming Abolition Societies; and they apply equally to either sex. There are some others which seem to oppose peculiar objections to the action of females in the way you would urge. . . .

It is Christianity that has given to woman her true place in society. And it is the peculiar trait of Christianity alone that can sustain her therein. "Peace on earth and good will to men" is the character of all the rights and privileges, the influence, and the power of woman. A man may act on society by the collision of intellect, in public debate; he may urge his measures by a sense of shame, by fear and by personal interest; he may coerce by the combination of public sentiment; he may drive by physical force, and he does not outstep the boundaries of his sphere. But all the power, and all the conquests that are lawful to woman, are those only which appeal to the kindly, generous, peaceful and benevolent principles.

Woman is to win every thing by peace and love; by making herself so much respected, esteemed and loved, that to yield to her opinions and to gratify her wishes, will be the free-will offering of the heart. But this is to be all accomplished in the domestic and social circle. There let every woman become so cultivated and refined in intellect . . . so unassuming and unambitious . . . so "gentle and easy to be entreated," as that every heart will repose in her presence; then, the fathers, the husbands, and the sons, will find an influence thrown around them, to which they will yield not only willingly but proudly. . . . But the moment woman begins to feel the promptings of ambition, or the thirst for power, her aegis of defence is gone. All the sacred protection of religion, all the generous promptings of chivalry, all the poetry of romantic gallantry, depend upon woman's retaining her place as dependent and defenceless, and making no claims, and maintaining no right but what are the gifts of honour, rectitude and love.

. . . If these general principles are correct, they are entirely opposed to the plan of arraying females in any Abolition movement; because . . . it brings them forward as partisans in a conflict that has been begun and carried forward by measures that are any thing rather than peaceful in their tendencies; because it draws them forth from their appropriate retirement, to expose themselves to

the ungoverned violence of mobs, and to sneers and ridicule in public places; because it leads them into the arena of political collision, not as peaceful mediators to hush the opposing elements, but as combatants to cheer up and carry forward the measures of strife.

If it is asked, "May not woman appropriately come forward as a suppliant for a portion of her sex who are bound in cruel bondage?" It is replied, that, the rectitude and propriety of any such measure, depend entirely on its probable results. If petitions from females will operate to exasperate; if they will be deemed obtrusive, indecorous, and unwise, by those to whom they are addressed; . . . if they will be the opening wedge, that will tend eventually to bring females as petitioners and partisans into every political measure that may tend to injure and oppress their sex . . . then it is neither appropriate nor wise, nor right, for a woman to petition for the relief of oppressed females. . . .

In this country, petitions to congress, in reference to the official duties of legislators, seem, IN ALL CASES, to fall entirely without the sphere of female duty. Men are the proper persons to make appeals to the rulers whom they appoint, and if their female friends, by arguments and persuasions, can induce them to petition, all the good that can be done by such measures will be secured. But if females cannot influence their nearest friends, to urge forward a public measure in this way, they surely are out of their place, in attempting to do it themselves.

There are some other considerations, which should make the American females peculiarly sensitive in reference to any measure, which should even *seem* to draw them from their appropriate relations in society.

It is allowed by all reflecting minds, that the safety and happiness of this nation depends upon having the *children* educated, and not only intellectually, but morally and religiously. There are now nearly two millions of children and adults in this country who cannot read, and who have no schools of any kind. To give only a small supply of teachers to these destitute children, who are generally where the population is sparse, will demand *thirty thousand teachers*. . . . Where is this army of teachers to be found? Is it at all probable that the other sex will afford even a moderate portion of this supply? . . . Men will be educators in the college, in the high school, in some of the most honourable and lucrative common schools, but the *children*, the *little children* of this nation must, to a wide extent, be taught by females, or remain untaught. . . . And as the value of education rises in the public mind . . . women will more and more be furnished with those intellectual advantages which they need to fit them for such duties.

The result will be, that America will be distinguished above all other nations, for well-educated females. . . . But if females, as they approach the other sex, in intellectual elevation, begin to claim, or to exercise in any manner, the peculiar prerogatives of that sex, education will prove a doubtful and dangerous blessing. But this will never be the result. For the more intelligent a woman becomes, the more she can appreciate the wisdom of that ordinance that appointed her subordinate station, and the more her taste will conform to the graceful and dignified retirement and submission it involves.

But it may be asked, is there nothing to be done to bring this national sin of slavery to an end? . . .

To this it may be replied, that Christian females may, and can say and do much to bring these evils to an end; and the present is a time and an occasion when it seems most desirable that they should know, and appreciate, and *exercise* the power which they do possess for so desirable an end. . . .

And is there not a peculiar propriety in such an emergency, in looking for the especial agency and assistance of females, who are shut out from the many temptations that assail the other sex,—who are the appointed ministers of all the gentler charities of life,—who are mingled throughout the whole mass of the community,—who dwell in those retirements where only peace and love ought ever to enter,—whose comfort, influence, and dearest blessings, all depend on preserving peace and good will among men?

In the present aspect of affairs among us, when everything seems to be tending to disunion and distraction, it surely has become the duty of every female instantly to relinquish the attitude of a partisan, in every matter of clashing interests, and to assume the office of a mediator, and an advocate of peace. . . .

# GEORGE D. ARMSTRONG

George D. Armstrong (1813–99) was a Presbyterian minister from New Jersey who spent his career in Virginia, where he became an outspoken advocate for the southern cause of slavery. A prolific writer of more than twenty books and many published sermons, Armstrong's *The Christian Doctrine of Slavery* (1857) contested the antislavery writings of Philadelphia clergyman Albert Barnes, using scriptural exegesis far removed from that of Christians on the other side of the issue. The ensuing controversy would lead to the split of the Old School Presbyterian Church in 1857. This excerpt from that book summarizes the Christian pro-slavery position of the time.

## *From* The Christian Doctrine of Slavery

Where God has appointed a *work* for his Church, he has generally appointed the *way* also in which that work is to be done. And where this is the case, the Church is as much bound to respect the one appointment as the other. Both the *work* of the Church and the *way* are often more distinctly set forth in the life and ministry of Christ and his Apostles than in any positive precept. But in whatever manner the will of God is made known, that will is law to his Church.

In the case of a race of men in slavery, the *work* which God has appointed his Church—as we learn it, both from the example and the precepts of inspired men—is to labor to secure in them a Christian life on earth and meetness for his heavenly kingdom. The African slave, in our Southern States, may be deeply degraded; the debasing effects of generations of sin may, at first sight, seem to have almost obliterated his humanity, yet is he an immortal creature; one for whom God the Son died; one whom God the Spirit can re-fashion, so as to make him a worthy worshipper among God's people on earth, and a welcome worshipper among the ransomed in heaven; one whom God the Father waiteth to receive as a returning prodigal to his heart and to his home. And the commission of the Church, "go ye into *all the world* and preach the Gospel *to every creature*," sends her a messenger of glad tidings to him as truly as to men far above him in the scale of civilization. On this point there can be no difference of opinion among God's people, North or South, who intelligently take the word of God as their "only rule of faith and obedience." This is *the work* of God, assigned by him to his Church, in so far as the slave race among us is concerned.

In what *way* is this work to be done? We answer, By preaching the same Gospel of God's grace alike to the master and the slave; and when there is credible evidence given that this Gospel has been received in faith, to admit them, master and slave, into the same Church—the Church of the Lord Jesus Christ, in which "there is neither bond nor free"—and to seat them at the same table of the Lord, that drinking of the same cup, and eating of the same loaf, they may witness to the world their communion in the body and blood of the same Saviour. And having received them into the same Church, to teach them the duties belonging to their several "callings" out of the same Bible, and subject them to the discipline prescribed by the same law, the law of Christ. And this, the teaching of the Church, is to be addressed not to her members only, but to the world at large; and her discipline of her members is to be exercised not in secret, but before the world, that the light which God has given her may appear unto all men. This is just *the way* in which Christ and his Apostles dealt with slavery. The instructions they have given us in their life and in their writings prohibit any other.

In this way must the Church labor to make "good masters and good slaves," just as she labors to make "good husbands, good wives, good parents, good children, good rulers, good subjects. With the ultimate effect of this upon the civil and political condition of the slave the Church has nothing directly to do. If the ultimate effect of it be the emancipation of the slave—we say—in God's name, "let it come." "If it be of God, we *cannot*"—and we *would not* if we could—"overthrow it, lest haply we be found even to fight against God." If the ultimate effect be the perpetuation of slavery divested of its incidental evils—a slavery in which the master shall be required, by the laws of man as well as that of God, "to give unto the slave that which is just and equal," and the slave to render to the master a cheerful obedience and hearty service—we say, let slavery continue. It may be, that such a slavery, regulating the relations of capital and labor, though implying some deprivation of personal liberty, will prove a better defense of the poor against the oppression of the rich, than the too great freedom in which capital is placed in many of the free States of Europe at the present day. Something of this kind is what the masses of free laborers in France

are clamoring for under the name of *"the right to labor."* Something of this kind would have protected the ejected tenantry of the Duke of Sutherland against the tyranny which drove them forth from the home of their childhood, and quenched the fire upon many a hearth-stone, and converted once cultivated fields into sheep-walks. It may be, that *Christian slavery* is God's solution of the problem about which the wisest statesmen of Europe confess themselves "at fault." "Bonds make free, be they but righteous bonds. Freedom enslaves, if it be an unrighteous freedom."

To this way of dealing with slavery, thus clearly pointed out in God's word, does God in his providence "shut us up," for years to come. None but the sciolist in political philosophy can regard the problem of emancipation—even granting that this were the aim which the Christian citizen should have immediately in view—as a problem of easy solution. And thoughtful Christian men at the North, it has seemed to us, often lose sight of the greatest difficulties in the case. It is comparatively an easy matter to devise a scheme of emancipation in which all the just rights and the well-being of the master shall be provided for. But how shall we, as God-fearing men, provide for the just rights and well-being of the emancipated slave? To leave the partially civilized slave race, in a state of freedom, in contact with a much more highly civilized race, as all history testifies, is inevitable destruction to the former. Their writ of enfranchisement is their death-warrant. To remove one hundredth part of the annual increase of the slave race to Liberia, year by year, would soon quench for ever that light of Christian civilization which a wise philanthropy has kindled upon the dark coast of Africa. How shall we provide for the well-being of the enfranchised slave? Here is the real difficulty in the problem of emancipation.

We mean to express no opinion respecting the feasibility of the future emancipation of the slave race among us. As we stated in the outset, our purpose is to introduce no question on which the Bible does not give us specific instruction. And we have referred to the question of emancipation—a question which it belongs to the State, and not the Church, to settle—simply that the reader may see how completely God's word and God's providence are "at one," in so far as the present duty of the Church is concerned. Is slavery to continue? We want the best of Christian masters and the best of Christian slaves, that it may prove a blessing to both the one and the other. Is ultimate emancipation before us? We want the best of Christian masters to devise and carry out the scheme by which it shall be effected, and the best of Christian slaves, that their emancipation may be an enfranchisement indeed. And this is just what the Bible plan of dealing with slavery aims at. The *future* may be hidden from view in "the clouds and darkness" with which God oft veils his purposes; but there is light—heaven's light—upon the *present*. And it is with the *present alone* we have immediately to do.

This is *one way* of dealing with slavery, and so firmly convinced are we that it is *God's way* for his Church that we cannot abandon it.

*Another way* proposed is—confounding the distinction between slavery itself and the incidental evils which attach to it in our country, and at the present day, under the guise of dealing with "AMERICAN SLAVERY;" in *the teaching* of the Church to denounce slave-holding as a SIN, as "evil, always evil, and only evil," (*Barnes' Notes, 1 Cor. VII.* 21); and in *the discipline* of the Church to treat it as an *"offence,"* and "detach the Church from it, as it is detached from piracy,

intemperance, theft, licentiousness, and duelling," (*Church and State*, p. 193), and so labor directly to put an end to slavery throughout the world.

To all this we object—

FIRST.—There is a radical fallacy involved in the use which is made of the expression, "AMERICAN SLAVERY."

By American Slavery, Dr. Barnes means—and the same is true of all anti-slavery writers whose works we have seen—the aggregate of, 1. Slavery itself; and, 2. The incidental evils which attach to it in this country and at this day, considered as inseparable—an indivisible unit. This treatment of the subject is—

1. *Unphilosophical.* Nothing is more real than the distinction, as set forth in the writings of Paul. (See § 15.) The fact that Dr. B. can write about Jewish slavery, and Roman slavery, and American slavery, as different the one from the others, shows that there must be something common to them all, to which we give the common name, Slavery; and something peculiar to each, which we designate by the adjuncts Jewish, Roman, American. Dr. B. admits that Roman slavery, as encountered by the Apostles in their day, was far more cruel and oppressive than American slavery now is—that is, that much of the incidental evil which once attached to slavery has disappeared. If much has already disappeared, why may not all that remains disappear in like manner? The change that has taken place, has been effected under the benign influence of Christianity. And just as certainly as we believe that Christianity is from God, and is destined to a final triumph in the world, just so certainly do we believe that slavery—if it is to continue to exist—must continue to be modified by it, until all its incidental evils disappear.

2. It is *unscriptural.* By this we mean, 1. It is an essentially different way of approaching the subject of slavery from that adopted by the Apostles. Paul never wrote a line respecting *Jewish* slavery—meaning thereby, slavery itself and the incidental evils which attached to it in his day and among the Jews—or *Roman* slavery; nor does he give the Churches any directions couched in any such language as this. He writes about *slavery*, which he treats as neither a sin nor an offence; and about *certain evils* attaching to slavery as he encountered it, which he treats as sinful, and requires the Church, in her own proper sphere, to labor to correct. 2. It ignores the very ground upon which the whole method of dealing with slavery prescribed in the Word of God, is predicated.

In his introduction to his "Scriptural Views of Slavery," Dr. Barnes justifies his dealing, as he does, with what he calls "American Slavery," upon the ground—

1. That slavery, as it exists in the United States, is slavery divested of all the incidental evils of which it is reasonable to suppose Christianity will ever divest it; and hence, that all which now belongs to it, ought to be considered as, for all practical purposes, essential to the system.

This is certainly "American glorification"—"with a witness." For ourselves, we love our country; and we feel an honest, patriotic pride in her standing among the nations. But God forbid, that we should entertain the thought that her social institutions, either in law or in fact, shall never be brought more fully under the control of God's truth than they now are; that the wife shall never be better protected against the wrong often inflicted by the profligate husband; and the child against the cruelty of the drunken father; and all this, without destroy-

ing the essential character of the marital and parental relations as set forth in the Word of God; that our heart and our home relations shall never be more thoroughly Christian than they now are. And so, too, with respect to slavery. Had we heard such sentiments as those just quoted from Dr. B., as part of a Fourth-of-July oration of some beardless Sophomore, we could have comforted ourselves with the reflection—increasing years may give the young man wisdom. That we should read them from the pen of one who must have "gray hairs here and there upon him," we can account for only by calling to mind what Paul tells us of the effects of feeding on "unwholesome words."—1 *Tim. VI.* 3.

2. That what we have designated as God's way of dealing with slavery, is dealing with slavery *in the abstract*, and not as a *practical* matter."

What Dr. B.'s idea of dealing with an institution *in the abstract* is, we know not. We have always supposed that such dealing implied the abstraction—i.e., the taking away or neglecting for the time being—something, either essential or incidental, belonging to such institution. But, surely, we are not dealing with American slavery—slavery as it exists among us, in the abstract—in any such sense as this.

We take slavery, and the whole of slavery, just as it exists among us, and, after Paul's example, we separate it into—1. That which is *essential*, i.e., that which must continue if slavery continues; and, 2. That which is *incidental*, i.e., that which may disappear and slavery yet remain. Having done this, we then, *in discussion, deal with both parts.* We prove from the Word of God, that the *first* is not in violation of his law; and show, just as clearly, that much of the *second* is in violation of that law. And *in our practical dealing with it, as a Church, we deal with both parts.* The *first* we treat as not sinful, and require both the parties to conform to its obligations; much of the *second*—and just so much of it as is in violation of God's law—we prohibit, with all the authority given by Christ to his Church over her members, and in every proper way, we seek to remove from the world at large. If this is not dealing with slavery in its entirety, we ask, What is? If this is dealing with slavery *in the abstract*, we ask, What have we abstracted?

We remarked that there was "a radical fallacy involved in the use which is made of the expression, *American slavery,*" as used by Dr. B. and other writers of the same school. The reader will now see just what was meant by that remark.

The only meaning which can properly attach to the expression *American slavery*, is that of slavery as it exists in these United States of America. In this sense of the expression, we are dealing with American slavery, just as truly, and just as fully, and with far more of *practical* wisdom, we think, than Dr. B. is. The real difference between us is, that we distinguish between that which is essential and that which is incidental, as Paul did, and we deal with each as it deserves, as Paul did. Whilst Dr. B., neglecting this distinction, and thus, practically, treating all as essential, deals with it as an indivisible unit; and he does this under the guise of dealing with "American slavery," foisting upon that phrase, in addition to its proper meaning, the idea of the indivisible unity of the mass. To take such a course as this, when the issues in question are such as they are, is nothing more nor less than "a begging of the question."

SECOND.—We object to the course proposed by Dr. B. and others, for dealing with slavery, because it requires the Church to obtrude herself into the province of the State, and this, in direct violation of the ordinance of God. A course which

has never been taken in times past, without disastrous consequences to the Church which did the wrong, as well as to the State which permitted the wrong to be done. Many a thing which it is right and proper, and even the duty of the Christian citizen, in this our free country, to do, the Church, as such, has no right to intermeddle with. It is, doubtless, the duty of the Christian citizen, for example, to use all proper means to inform himself respecting the qualifications of candidates for office, and having thus informed himself, to vote for the one whom he believes will best discharge the duties of the office. But will any Christian man, hence contend that it is right for the preacher, in the pulpit and on the Sabbath, to discuss the claims of rival candidates, and the Church, in her councils to direct her members how to vote? The Church and State has each its own appropriate sphere of operation assigned it of God, and neither can innocently intrude herself into the province of the other.

THIRD.—It leads to tampering with God's truth, and "wresting the Scripture," as Dr. B. has done in his Notes, by the application to them of principles and methods of interpretation, which destroy all certainty in human language. In order to make the Bible declare that slave-holding is a sin, when it plainly teaches just the contrary; and to teach in the Church doctrines which we are forbidden to teach under the most solemn sanctions. (See § 12.) This course has led not a few, once fair and promising members of the Church, and even ministers, into open "blasphemy;" and Paul teaches us, that such is its natural tendency, (1 Tim. VI. 4.) We have no desire to walk in their way, or to meet their doom.

FOURTH.—It requires us to quit a method of dealing with slavery which has worked well in time past—all of real advantage to the slave that has ever been done by the Church has been done in this way—and to substitute for it a method which, to say the least of it, is a mere experiment, and an experiment which has wrought nothing but harm to the slave thus far—and we say this, after watching its operation during a ministry of twenty years, all of it, in God's providence, spent in a slave-holding state.

For all these reasons, we can never adopt this second *way* proposed. GOD'S WORK IN GOD'S WAY, the Church at the South, in common with some portions of the Church at the North also, have inscribed upon their banner; and under that banner do we mean to fight the "Lord's battles," grace assisting us, until he who bid us gird on our armor shall give us leave to put it off. Churches of God may cut us off from their communion. They cannot break our union with Christ, "the Head." Ministers of the Gospel, from whom we have a right to expect better things, may revile us—we "fear God rather than man." "A conscience void of offence before God," is above all price. With this whole subject of slavery, we mean to deal just as Christ and his Apostles dealt—to preach what they preached—to labor as they labored—to govern the Church of God as they governed it—in Christian fellowship and brotherhood with God's people at the North, and in other lands, *if we* MAY:—in faithfulness to Christ, though in opposition to all the world, *if we* MUST.

# ALEXIS DE TOCQUEVILLE

Alexis de Tocqueville (1805–59) was a French statesman who traveled across America for nine months on behalf of the French government. The trip resulted in a book on the American penal system, the reason for Tocqueville's commission, and his magisterial two-volume study, *Democracy in America*. In *Democracy in America*, Tocqueville analyzed the paradoxical American emphases on individualism and conformity in an influential examination of the promise and perils of democracy. His thinking on religion, represented in this excerpt, addresses the peculiar nature of religious voluntarism in the United States.

## *From* Democracy in America

### RELIGION CONSIDERED AS A POLITICAL INSTITUTION AND HOW IT POWERFULLY CONTRIBUTES TO THE MAINTENANCE OF A DEMOCRATIC REPUBLIC AMONG THE AMERICANS

*North America is peopled by men professing a democratic and republican Christianity. Arrival of the Catholics. Why the Catholics nowadays form the most democratic and republican class.*

Every religion has some political opinion linked to it by affinity.

The spirit of man, left to follow its bent, will regulate political society and the City of God in uniform fashion; it will, if I dare put it so, seek to *harmonize* earth with heaven.

Most of English America was peopled by men who, having shaken off the pope's authority, acknowledged no other religious supremacy; they therefore brought to the New World a Christianity which I can only describe as democratic and republican; this fact singularly favored the establishment of a temporal republic and democracy. From the start politics and religion agreed, and they have not since ceased to do so.

About fifty years ago Ireland began to pour a Catholic population into the United States. Also American Catholicism made converts. There are now in the United States more than a million Christians professing the truths of the Roman Church.

Edited by J.P. Mayer and Max Lerner. Translated by George Lawrence. English translation copyright © 1965 by Harper & Row, Publishers, Inc. Reprinted by permission of HarperCollins Publishers.

These Catholics are very loyal in the practice of their worship and full of zeal and ardor for their beliefs. Nevertheless, they form the most republican and democratic of all classes in the United States. At first glance this is astonishing, but reflection easily indicates the hidden causes therefore.

I think one is wrong in regarding the Catholic religion as a natural enemy of democracy. Rather, among the various Christian doctrines Catholicism seems one of those most favorable to equality of conditions. For Catholics religious society is composed of two elements: priest and people. The priest is raised above the faithful; all below him are equal.

In matters of dogma the Catholic faith places all intellects on the same level; the learned man and the ignorant, the genius and the common herd, must all subscribe to the same details of belief; rich and poor must follow the same observances, and it imposes the same austerities upon the strong and the weak; it makes no compromise with any mortal, but applying the same standard to every human being, it mingles all classes of society at the foot of the same altar, just as they are mingled in the sight of God.

Catholicism may dispose the faithful to obedience, but it does not prepare them for inequality. However, I would say that Protestantism in general orients men much less toward equality than toward independence.

Catholicism is like an absolute monarchy. The prince apart, conditions are more equal there than in republics.

It has often happened that a Catholic priest has left his sanctuary to become a power in society, taking his place in the social hierarchy; he has then sometimes used his religious influence to assure the duration of a political order of which he is part; then, too, one has found Catholic partisans of the aristocracy from religious motives.

But once priests are excluded or exclude themselves from the government, as happens in the United States, no men are more led by their beliefs than are Catholics to carry the idea of equality of conditions over into the political sphere.

So while the nature of their beliefs may not give the Catholics of the United States any strong impulsion toward democratic and republican opinions, they at least are not naturally contrary thereto, whereas their social position and small numbers constrain them to adopt them

Most of the Catholics are poor, and unless all citizens govern, they will never attain to the government themselves. The Catholics are in a minority, and it is important for them that all rights should be respected so that they can be sure to enjoy their own in freedom. For these two reasons they are led, perhaps in spite of themselves, toward political doctrines which, maybe, they would adopt with less zeal were they rich and predominant.

The Catholic clergy in the United States has made no effort to strive against this political tendency but rather seeks to justify it. American Catholic priests have divided the world of the mind into two parts; in one are revealed dogmas to which they submit without discussion; political truth finds its place in the other half, which they think God has left to man's free investigation. Thus American Catholics are both the most obedient of the faithful and the most independent citizens.

Therefore one can say that there is not a single religious doctrine in the United States hostile to democratic and republican institutions. All the clergy there speak the same language; opinions are in harmony with the laws, and there is, so to say, only one mental current.

While I was temporarily living in one of America's great cities, I was invited to attend a political meeting designed to aid the Poles by helping them to get arms and money.

I found two or three thousand people in a vast hall prepared for their reception. Soon a priest dressed in his ecclesiastical habit came forward onto the platform. The audience took off their hats and stood in silence while he spoke as follows:

"Almighty God! Lord of Hosts! Thou who didst strengthen the hearts and guide the arms of our fathers when they fought for the sacred rights of their national independence! Thou who didst make them triumph over a hateful oppression and didst grant to our people the blessings of peace and of liberty, look with favor, Lord, upon the other hemisphere; have pity upon a heroic people fighting now as we fought before for the defense of these same rights! Lord, who hast created all men in the same image, do not allow despotism to deform Thy work and maintain inequality upon the earth. Almighty God! Watch over the destinies of the Poles and make them worthy to be free; may Thy wisdom prevail in their councils and Thy strength in their arms; spread terror among their enemies; divide the powers that contrive their ruin; and do not allow that injustice which the world has witnessed for fifty years to be consummated in our time. Lord, who holdest in Thy strong hand the hearts of peoples and of men, raise up allies to the sacred cause of true right; arouse at last the French nation, that, forgetting the apathy in which its leaders lull, it may fight once more for the freedom of the world.

"O Lord! Turn not Thou Thy face from us, and grant that we may always be the most religious and the most free nation upon earth.

"God Almighty, hear our supplications this day, and save the Poles. We beseech Thee in the name of Thy beloved son, our Lord Jesus Christ, who died upon the cross for the salvation of all men. Amen."

The whole assembly answered reverently, "Amen."

## INDIRECT INFLUENCE OF RELIGIOUS BELIEFS UPON POLITICAL SOCIETY IN THE UNITED STATES

*Christian morality common to all sects. Influence of religion on American mores. Respect for the marriage tie. How religion keeps the imagination of the Americans within certain limits and moderates their passion for innovation. Opinion of the Americans concerning the political value of religion. Their efforts to extend and assure its sway.*

I have just pointed out the direct action of religion on politics in the United States. Its indirect action seems to me much greater still, and it is just when it is not speaking of freedom at all that it best teaches the Americans the art of being free.

There is an innumerable multitude of sects in the United States. They are all different in the worship they offer to the Creator, but all agree concerning the duties of men to one another. Each sect worships God in its own fashion, but all preach the same morality in the name of God. Though it is very important for man as an individual that his religion should be true, that is not the case for society. Society has nothing to fear or hope from another life; what is most important for it is not that all citizens should profess the true religion but that they should profess religion. Moreover, all the sects in the United States belong to the great unity of Christendom, and Christian morality is everywhere the same.

One may suppose that a certain number of Americans, in the worship they offer to God, are following their habits rather than their convictions. Besides, in the United States the sovereign authority is religious, and consequently hypocrisy should be common. Nonetheless, America is still the place where the Christian religion has kept the greatest real power over men's souls; and nothing better demonstrates how useful and natural it is to man, since the country where it now has widest sway is both the most enlightened and the freest.

I have said that American priests proclaim themselves in general terms in favor of civil liberties without excepting even those who do not admit religious freedom; but none of them lend their support to any particular political system. They are at pains to keep out of affairs and not mix in the combinations of parties. One cannot therefore say that in the United States religion influences the laws or political opinions in detail, but it does direct mores, and by regulating domestic life it helps to regulate the state.

I do not doubt for an instant that the great severity of mores which one notices in the United States has its primary origin in beliefs. There religion is often powerless to restrain men in the midst of innumerable temptations which fortune offers. It cannot moderate their eagerness to enrich themselves, which everything contributes to arouse, but it reigns supreme in the souls of the women, and it is women who shape mores. Certainly of all countries in the world America is the one in which the marriage tie is most respected and where the highest and truest conception of conjugal happiness has been conceived.

In Europe almost all the disorders of society are born around the domestic hearth and not far from the nuptial bed. It is there that men come to feel scorn for natural ties and legitimate pleasures and develop a taste for disorder, restlessness of spirit, and instability of desires. Shaken by the tumultuous passions which have often troubled his own house, the European finds it hard to submit to the authority of the state's legislators. When the American returns from the turmoil of politics to the bosom of the family, he immediately finds a perfect picture of order and peace. There all his pleasures are simple and natural and his joys innocent and quiet, and as the regularity of life brings him happiness, he easily forms the habit of regulating his opinions as well as his tastes.

Whereas the European tries to escape his sorrows at home by troubling society, the American derives from his home that love of order which he carries over into affairs of state.

In the United States it is not only mores that are controlled by religion, but its sway extends even over reason.

Among the Anglo-Americans there are some who profess Christian dogmas because they believe them and others who do so because they are afraid to look as though they did not believe in them. So Christianity reigns without obstacles, by universal consent; consequently, as I have said elsewhere, everything in the moral field is certain and fixed, although the world of politics seems given over to argument and experiment. So the human spirit never sees an unlimited field before itself; however bold it is, from time to time it feels that it must halt before insurmountable barriers. Before innovating, it is forced to accept certain primary assumptions and to submit its boldest conceptions to certain formalities which retard and check it.

The imagination of the Americans, therefore, even in its greatest aberrations, is circumspect and hesitant; it is embarrassed from the start and leaves its work unfinished. These habits of restraint are found again in political society and singularly favor the tranquillity of the people as well as the durability of the institutions they have adopted. Nature and circumstances have made the inhabitant of the United States a bold man, as is sufficiently attested by the enterprising spirit with which he seeks his fortune. If the spirit of the Americans were free of all impediment, one would soon find among them the boldest innovators and the most implacable logicians in the world. But American revolutionaries are obliged ostensibly to profess a certain respect for Christian morality and equity, and that does not allow them easily to break the laws when those are opposed to the executions of their designs; nor would they find it easy to surmount the scruples of their partisans even if they were able to get over their own. Up till now no one in the United States has dared to profess the maxim that everything is allowed in the interests of society, an impious maxim apparently invented in an age of freedom in order to legitimatize every future tyrant.

Thus, while the law allows the American people to do everything, there are things which religion prevents them from imagining and forbids them to dare.

Religion, which never intervenes directly in the government of American society, should therefore be considered as the first of their political institutions, for although it did not give them the taste for liberty, it singularly facilitates their use thereof.

The inhabitants of the United States themselves consider religious beliefs from this angle. I do not know if all Americans have faith in their religion—for who can read the secrets of the heart?—but I am sure that they think it necessary to the maintenance of republican institutions. That is not the view of one class or party among the citizens, but of the whole nation; it is found in all ranks.

In the United States, if a politician attacks a sect that is no reason why the supporters of that very sect should not support him, if he attacks all sects together, everyone shuns him, and he remains alone.

While I was in America, a witness called at assizes of the county of Chester (state of New York) declared that he did not believe in the existence of God and the immortality of the soul. The judge refused to allow him to be sworn in, on the ground that the witness had destroyed beforehand all possible confidence in his testimony. Newspapers reported the fact without comment.

For the Americans the ideas of Christianity and liberty are so completely mingled that it is almost impossible to get them to conceive of the one without the other; it is not a question with them of sterile beliefs bequeathed by the past and vegetating rather than living in the depths of the soul.

I have known Americans to form associations to send priests out into the new states of the West and establish schools and churches there; they fear that religion might be lost in the depths of the forest and that the people growing up there might be less fitted for freedom than those from whom they sprang. I have met rich New Englanders who left their native land in order to establish the fundamentals of Christianity and of liberty by the banks of the Missouri or on the prairies of Illinois. In this way, in the United States, patriotism continually adds fuel to the fires of religious zeal. You will be mistaken if you think that such men are guided only by thoughts of the future life; eternity is only one of the things that concern them. If you talk to these missionaries of Christian civilization you will be surprised to hear them so often speaking of the goods of this world and to meet a politician where you expected to find a priest. "There is a solidarity between all the American republics," they will tell you; "if the republics of the West were to fall into anarchy or to be mastered by a despot, the republican institutions now flourishing on the Atlantic coast would be in great danger; we therefore have an interest in seeing that the new states are religious so that they may allow us to remain free."

That is what the Americans think, but our pedants find it an obvious mistake; constantly they prove to me that all is fine in America except just that religious spirit which I admire; I am informed that on the other side of the ocean freedom and human happiness lack nothing but Spinoza's belief in the eternity of the world and Cabanis' contention that thought is a secretion of the brain. To that I have really no answer to give, except that those who talk like that have never been in America and have never seen either religious peoples or free ones. So I shall wait till they come back from a visit to America.

There are people in France who look on republican institutions as a temporary expedient for their own aggrandizement. They mentally measure the immense gap separating their vices and their poverty from power and wealth, and they would like to fill this abyss with ruins in an attempt to bridge it. Such people stand toward liberty much as the medieval *condottieri* stood toward the kings; they make war on their own account, no matter whose colors they wear: the republic, they calculate, will at least last long enough to lift them from their present degradation. It is not to such as they that I speak, but there are others who look forward to a republican form of government as a permanent and tranquil state and as the required aim to which ideas and mores are constantly steering modern societies. Such men sincerely wish to prepare mankind for liberty. When such as these attack religious beliefs, they obey the dictates of their passions, not their interests. Despotism may be able to do without faith, but freedom cannot. Religion is much more needed in the republic they advocate than in the monarchy they attack, and in democratic republics most of all. How could society escape destruction if, when political ties are relaxed, moral ties are not tightened? And what can be done with a people master of itself if it is not subject to God?

# THE MAIN CAUSES THAT MAKE RELIGION
# POWERFUL IN AMERICA

*Care with which the Americans have separated church and state. The laws, public opinion, and the clergy's own endeavors all work toward this end. Religion's power over the souls of men in the United States is due to this. Why? What is the natural state of contemporary man in regard to religion? What peculiar and accidental causes in some countries prevent men from achieving this state?*

Eighteenth-century philosophers had a very simple explanation for the gradual weakening of beliefs. Religious zeal, they said, was bound to die down as enlightenment and freedom spread. It is tiresome that the facts do not fit this theory at all.

There are sections of the population in Europe where unbelief goes hand in hand with brutishness and ignorance, whereas in America the most free and enlightened people in the world zealously perform all the external duties of religion.

The religious atmosphere of the country was the first thing that struck me on arrival in the United States. The longer I stayed in the country, the more conscious I became of the important political consequences resulting from this novel situation.

In France I had seen the spirits of religion and of freedom almost always marching in opposite directions. In America I found them intimately linked together in joint reign over the same land.

My longing to understand the reason for this phenomenon increased daily.

To find this out, I questioned the faithful of all communions; I particularly sought the society of clergymen, who are the depositaries of the various creeds and have a personal interest in their survival. As a practicing Catholic I was particularly close to the Catholic priests, with some of whom I soon established a certain intimacy. I expressed my astonishment and revealed my doubts to each of them; I found that they all agreed with each other except about details; all thought that the main reason for the quiet sway of religion over their country was the complete separation of church and state. I have no hesitation in stating that throughout my stay in America I met nobody, lay or cleric, who did not agree about that.

This led me to examine more closely than before the position of American priests in political society. I was surprised to discover that they held no public appointments. There was not a single one in the administration, and I found that they were not even represented in the assemblies.

In several states the law, and in all the rest public opinion, excludes them from a career in politics.

When I finally came to inquire into the attitudes of the clergy themselves, I found that most of them seemed voluntarily to steer clear of power and to take a sort of professional pride in claiming that it was no concern of theirs.

I heard them pronouncing anathemas against ambition and bad faith, under whatsoever political opinions those were at pains to hide. But I learned from their discourses that men are not guilty in the sight of God because of these very opinions, provided they are sincere, and that it is no more a sin to make a

mistake in some question of government than it is a sin to go wrong in building one's house or plowing one's field.

I saw that they were careful to keep clear of all parties, shunning contact with them with all the anxiety attendant upon personal interest.

These facts convinced me that I had been told the truth. I then wished to trace the facts down to their causes. I wondered how it could come about that by diminishing the apparent power of religion one increased its real strength, and I thought it not impossible to discover the reason.

The short space of sixty years can never shut in the whole of man's imagination; the incomplete joys of this world will never satisfy his heart. Alone among all created beings, man shows a natural disgust for existence and an immense longing to exist; he scorns life and fears annihilation. These different instincts constantly drive his soul toward contemplation of the next world, and it is religion that leads him thither. Religion, therefore, is only one particular form of hope, and it is as natural to the human heart as hope itself. It is by a sort of intellectual aberration, and in a way, by doing moral violence to their own nature, that men detach themselves from religious beliefs; an invincible inclination draws them back. Incredulity is an accident; faith is the only permanent state of mankind.

Considering religions from a purely human point of view, one can then say that all religions derive an element of strength which will never fail from man himself, because it is attached to one of the constituent principles of human nature.

I know that, apart from influence proper to itself, religion can at times rely on the artificial strength of laws and the support of the material powers that direct society. There have been religions intimately linked to earthly governments, dominating men's souls both by terror and by faith; but when a religion makes such an alliance, I am not afraid to say that it makes the same mistake as any man might; it sacrifices the future for the present, and by gaining a power to which it has no claim, it risks its legitimate authority.

When a religion seeks to found its sway only on the longing for immortality equally tormenting every human heart, it can aspire to universality; but when it comes to uniting itself with a government, it must adopt maxims which apply only to certain nations. Therefore, by allying itself with any political power, religion increases its strength over some but forfeits the hope of reigning over all.

As long as a religion relies only upon the sentiments which are the consolation of every affliction, it can draw the heart of mankind to itself. When it is mingled with the bitter passions of this world, it is sometimes constrained to defend allies who are such from interest rather than from love; and it has to repulse as adversaries men who still love religion, although they are fighting against religion's allies. Hence religion cannot share the material strength of the rulers without being burdened with some of the animosity roused against them.

Even those political powers that seem best established have no other guarantee of their permanence beyond the opinions of a generation, the interests of a century, or often the life of one man. A law can modify that social state which seems most fixed and assured, and everything changes with it.

Like our years upon earth, the powers of society are all more or less transitory; they follow one another quickly, like the various cares of life; and there has

never been a government supported by some invariable disposition of the human heart or one founded upon some interest that is immortal.

So long as a religion derives its strength from sentiments, instincts, and passions, which are reborn in like fashion in all periods of history, it can brave the assaults of time, or at least it can only be destroyed by another religion. But when a religion chooses to rely on the interests of this world, it becomes almost as fragile as all earthly powers. Alone, it may hope for immortality; linked to ephemeral powers, it follows their fortunes and often falls together with the passions of a day sustaining them.

Hence any alliance with any political power whatsoever is bound to be burdensome for religion. It does not need their support in order to live, and in serving them it may die.

The danger I have just pointed out exists at all times but is not always equally obvious.

There are centuries when governments appear immortal and others when society's existence seems frailer than that of a man.

Some constitutions keep the citizens in a sort of lethargic slumber, while others force them into feverish agitation.

When governments seem so strong and laws so stable, men do not see the danger that religion may run by allying itself with power.

When governments are clearly feeble and laws changeable, the danger is obvious to all, but often then there is no longer time to avoid it. One must therefore learn to perceive it from afar.

When a nation adopts a democratic social state and communities show republican inclinations, it becomes increasingly dangerous for religion to ally itself with authority. For the time is coming when power will pass from hand to hand, political theories follow one another, and men, laws, and even constitutions vanish or alter daily, and that not for a limited time but continually. Agitation and instability are natural elements in democratic republics, just as immobility and somnolence are the rule in absolute monarchies.

If the Americans, who change the head of state every four years, elect new legislators every two years and replace provincial administrators every year, and if the Americans, who have handed over the world of politics to the experiments of innovators, had not placed religion beyond their reach, what could it hold on to in the ebb and flow of human opinions? Amid the struggle of parties, where would the respect due to it be? What would become of its immortality when everything around it was perishing?

The American clergy were the first to perceive this truth and to act in conformity with it. They saw that they would have to give up religious influence if they wanted to acquire political power, and they preferred to lose the support of authority rather than to share its vicissitudes.

In America religion is perhaps less powerful than it has been at certain times and among certain peoples, but its influence is more lasting. It restricts itself to its own resources, of which no one can deprive it; it functions in one sphere only, but it pervades it and dominates there without effort.

On every side in Europe we hear voices deploring the absence of beliefs and asking how religion can be given back some remnant of its former power.

I think we should first consider attentively what ought to be the *natural state* of man with regard to religion at the present day; then, knowing what we can hope and what we must fear, we can clearly see the aim to which our efforts should be directed.

Two great dangers threaten the existence of religion: schism and indifference.

In ages of fervor it sometimes happens that men abandon their religion, but they only escape from its yoke in order to submit to that of another. Faith changes its allegiance but does not die. Then the former religion rouses in all hearts ardent love or implacable hatred; some leave it in anger, others cling to it with renewed ardor: beliefs differ, but irreligion is unknown.

But this is not the case when a religious belief is silently undermined by doctrines which I shall call negative because they assert the falseness of one religion but do not establish the truth of any other.

Then vast revolutions take place in the human mind without the apparent cooperation of the passions of man and almost without his knowledge. One sees some men lose, as from forgetfulness, the object of their dearest hopes. Carried away by an imperceptible current against which they have not the courage to struggle but to which they yield with regret, they abandon the faith they love to follow the doubt that leads them to despair.

In such ages beliefs are forsaken through indifference rather than from hate; without being rejected, they fall away. The unbeliever, no longer thinking religion true, still considers it useful. Paying attention to the human side of religious beliefs, he recognizes their sway over mores and their influence over laws. He understands their power to lead men to live in peace and gently to prepare them for death. Therefore he regrets his faith after losing it, and deprived of a blessing whose value he fully appreciates, he fears to take it away from those who still have it.

On the other hand, he who still believes is not afraid openly to avow his faith. He looks on those who do not share his hopes as unfortunate rather than as hostile; he knows he can win their esteem without following their example; hence he is at war with no man; for him society is not an arena where religion has to fight a relentless battle against a thousand enemies, and he loves his contemporaries, while condemning their weaknesses and sorrowing over their mistakes.

With unbelievers hiding their incredulity and believers avowing their faith, a public opinion favorable to religion takes shape; religion is loved, supported, and honored, and only by looking into the depths of men's souls will one see what wounds it has suffered.

The mass of mankind, never left without religious feeling, sees no impediments to established beliefs. The instinctive sense of another life without difficulty leads them to the foot of the altar and opens their hearts to the precepts and consolations of faith.

Why does this picture not apply to us?

There are some among us who have ceased to believe in Christianity without adopting any other religion.

There are others in a permanent state of doubt who already pretend no longer to believe.

Yet others are still believing Christians but do not dare to say so.

Amid these tepid friends and ardent adversaries there are finally a very few faithful ready to brave all obstacles and scorn all dangers for their beliefs. These have triumphed over human weakness to rise above common opinion. Carried away by the very force of this effort, they no longer know precisely where to stop. Since they have seen in their country that the first use made of independence has been to attack religion, they dread their contemporaries and recoil in alarm from the freedom which they seek. Imagining unbelief to be something new, they comprise all that is new in one indiscriminate animosity. They are at war with their age and country and see each opinion professed as a necessary enemy of faith.

That should not now be the natural state of men with regard to religion.

Therefore with us there must be some accidental and particular cause preventing the human spirit from following its inclination and driving it beyond those limits within which it should naturally remain.

I am profoundly convinced that this accidental and particular cause is the close union of politics and religion.

Unbelievers in Europe attack Christians more as political than as religious enemies; they hate the faith as the opinion of a party much more than as a mistaken belief, and they reject the clergy less because they are the representatives of God than because they are the friends of authority.

European Christianity has allowed itself to be intimately united with the powers of this world. Now that these powers are falling, it is as if it were buried under their ruins. A living being has been tied to the dead; cut the bonds holding it and it will arise.

I do not know what is to be done to give back to European Christianity the energy of youth. God alone could do that, but at least it depends on men to leave faith the use of all the strength it still retains.

## HOW RELIGION IN THE UNITED STATES
## MAKES USE OF DEMOCRATIC INSTINCTS

An earlier chapter has shown that men cannot do without dogmatic beliefs, and even that it is most desirable that they should have them. I would add here that religious dogmas seem to me the most desirable of all. That can clearly be deduced, even if one only considers the interests of this world.

There is hardly any human action, however private it may be, which does not result from some very general conception men have of God, of His relations with the human race, of the nature of their soul, and of their duties to their fellows. Nothing can prevent such ideas from being the common spring from which all else originates.

It is therefore of immense importance to men to have fixed ideas about God, their souls, and their duties toward their Creator and their fellows, for doubt about these first principles would leave all their actions to chance and condemn them, more or less, to anarchy and impotence.

That is therefore the most important question about which all of us need fixed ideas, and unfortunately it is the subject on which it is most difficult for each of us, left to his own unaided reason, to settle his ideas.

Only minds singularly free from the ordinary preoccupations of life, penetrating, subtle, and trained to think, can at the cost of much time and trouble sound the depths of these truths that are so necessary.

Indeed we see that philosophers themselves are almost always surrounded by uncertainties, that at each pace the natural light which guides them grows dimmer and threatens to go out, and that for all their efforts they have done no more than discover a small number of contradictory ideas on which the mind of man has been ceaselessly tossed for thousands of years without ever firmly grasping the truth or even finding mistakes that are new. Studies of this sort are far above the average capacities of men, and even if most men were capable of such inquiries, they clearly would not have time for them.

Fixed ideas about God and human nature are indispensable to men for the conduct of daily life, and it is daily life that prevents them from acquiring them.

The difficulty seems unparalleled. Among the sciences some that are useful to the crowd are also within its capacities; others can be mastered only by the few and are not cultivated by the majority, who need nothing beyond their more remote applications. But the sciences in question are essential to the daily life of all, though their study is out of reach of most.

General ideas respecting God and human nature are therefore the ideas above all others which ought to be withdrawn from the habitual action of private judgment and in which there is most to gain and least to lose by recognizing an authority.

The chief object and one of the principal advantages of religion is to provide answers to each of these primordial questions; these answers must be clear, precise, intelligible to the crowd, and very durable.

Some religions are very false and very ridiculous. Nevertheless, one can say that all those religions which remain within the circle of influence which I have just defined and do not claim to go beyond it (as many religions have tried to do, restraining the free flight of the human mind on every side) impose a salutary control on the intellect, and one must recognize, whether or not they save men's souls in the next world, that they greatly contribute to their happiness and dignity in this.

This is especially true of men living in free countries.

When a people's religion is destroyed, doubt invades the highest faculties of the mind and half paralyzes all the rest. Each man gets into the way of having nothing but confused and changing notions about the matters of greatest importance to himself and his fellows. Opinions are ill-defended or abandoned, and in despair of solving unaided the greatest problems of human destiny, men ignobly give up thinking about them.

Such a state inevitably enervates the soul, and relaxing the springs of the will, prepares a people for bondage.

Then not only will they let their freedom be taken from them, but often they actually hand it over themselves.

When there is no authority in religion or in politics, men are soon frightened by the limitless independence with which they are faced. They are worried and worn out by the constant restlessness of everything. With everything on the move in the realm of the mind, they want the material order at least to be firm and stable, and as they cannot accept their ancient beliefs again, they hand themselves over to a master.

For my part, I doubt whether man can support complete religious independence and entire political liberty at the same time. I am led to think that if he has no faith he must obey, and if he is free he must believe.

The great usefulness of religions is even more apparent among egalitarian peoples than elsewhere.

One must admit that equality, while it brings great benefits to mankind, opens the door, as I hope to show later, to very dangerous instincts. It tends to isolate men from each other so that each thinks only of himself.

It lays the soul open to an inordinate love of material pleasure.

The greatest advantage of religions is to inspire diametrically contrary urges. Every religion places the object of man's desires outside and beyond worldly goods and naturally lifts the soul into regions far above the realm of the senses. Every religion also imposes on each man some obligations toward mankind, to be performed in common with the rest of mankind, and so draws him away, from time to time, from thinking about himself. That is true even of the most false and dangerous religions.

Thus religious peoples are naturally strong just at the point where democratic peoples are weak. And that shows how important it is for people to keep their religion when they become equal.

I have neither the right nor the intention to examine the means by which God inspires a sense of religious belief into the heart of man. At the moment I am only looking at religions from a purely human point of view. I seek to discover how they can most easily preserve their power in the democratic centuries which lie before us.

I have pointed out how in times of enlightenment and democracy the human spirit is loath to accept dogmatic beliefs and has no lively sense of the need for them except in the matter of religion. This shows that, at such times above all, religions should be most careful to confine themselves to their proper sphere, for if they wish to extend their power beyond spiritual matters they run the risk of not being believed at all. They should therefore be at pains to define the sphere in which they claim to control the human spirit, and outside that sphere it should be left completely free to follow its own devices.

Muhammad brought down from heaven and put into the Koran not religious doctrines only, but political maxims, criminal and civil laws, and scientific theories. The Gospels, on the other hand, deal only with the general relations between man and God and between man and man. Beyond that, they teach nothing and do not oblige people to believe anything. That alone, among a thousand reasons, is enough to show that Islam will not be able to hold its power long in ages of enlightenment and democracy, while Christianity is destined to reign in such ages, as in all others.

Continuing this line of argument further, I find that, humanly speaking, if religions are to be capable of maintaining themselves in democratic ages, it is not enough that they should simply remain within the spiritual sphere. Their power also depends a great deal on the nature of the beliefs they profess, the external forms they adopt, and the duties they impose.

The preceding observation, that equality leads men to very general and very vast ideas, is especially applicable to religion. Men who are alike and on the same level in this world easily conceive the idea of a single God who imposes the same laws on each man and grants him future happiness at the same

price. The conception of the unity of mankind ever brings them back to the idea of the unity of the Creator, whereas when men are isolated from one another by great differences, they easily discover as many divinities as there are nations, castes, classes, and families, and they find a thousand private roads to go to heaven.

One cannot deny that Christianity itself has in some degree been affected by the influence of social and political conditions on religious beliefs.

At the time when Christianity appeared on earth, Providence, which no doubt was preparing the world for its reception, had united a great part of mankind, like an immense flock, under the scepter of the Caesars. The men composing this multitude were of many different sorts, but they all had this in common, that they obeyed the same laws, and each of them was so small and weak compared to the greatness of the emperor that they all seemed equal in comparison to him.

One must recognize that this new and singular condition of humanity disposed men to receive the general truths preached by Christianity, and this serves to explain the quick and easy way in which it then penetrated the human spirit.

The counterpart of this state of things was evident after the destruction of the empire.

The Roman world being then broken up into a thousand fragments, each nation reverted to its former individuality. There soon developed within these nations an infinite hierarchy of ranks. Racial differences became marked, and castes divided each nation into several peoples. In the midst of this communal effort, which seemed bent on subdividing humanity into as many fragments as it is possible to conceive, Christianity did not lose sight of the principal general ideas which it had brought to light, but seemed nonetheless to lend itself, as far as it could, to the new tendencies which came into existence as humanity was broken up. Men continued to worship one sole God, creator and preserver of all things, but each people, each city, and, one may almost say, each man thought he could obtain some particular privilege and win the favor of private protectors before the throne of grace. Unable to subdivide the Deity, they could at least multiply and aggrandize His agents beyond measure. For most Christians the worship of angels and saints became an almost idolatrous cult, and for a time there was room to fear that the Christian religion might relapse into the religions it had conquered.

It seems clear that the more the barriers separating the nations within the bosom of humanity and those separating citizen from citizen within each people tended to disappear, by so much the more did the spirit of humanity, as if of its own accord, turn toward the idea of a unique and all-powerful Being who dispensed the same laws equally and in the same way to all men. In democratic ages, therefore, it is particularly important not to confuse the honor due to secondary agents with the worship belonging to the Creator alone.

Another truth seems very clear to me, that religions should pay less attention to external practices in democratic times than in any others.

In speaking of the philosophical method of the Americans I have made clear that in a time of equality nothing is more repugnant to the human spirit than the idea of submitting to formalities. Men living at such times are impatient of fig-

ures of speech; symbols appear to them as childish artifices used to hide or dress up truths which could more naturally be shown to them naked and in broad daylight. Ceremonies leave them cold, and their natural tendency is to attach but secondary importance to the details of worship.

In democratic ages those whose duty is to regulate the external forms of worship should pay special attention to these natural propensities of the human mind in order not to run counter to them unnecessarily.

I believe firmly in the need for external ceremonies. I know that they fix the human spirit in the contemplation of abstract truths and help it to grasp them firmly and believe ardently in them. I do not imagine that it is possible to maintain a religion without external observances. Nevertheless, I think that in the coming centuries it would be particularly dangerous to multiply them beyond measure, indeed that they should be limited to such as are absolutely necessary to perpetuate dogma itself, which is the essence of religions, whereas ritual is only the form. A religion which became more detailed, more inflexible, and more burdened with petty observances at a time when people were becoming more equal would soon find itself reduced to a band of fanatic zealots in the midst of a skeptical multitude.

I anticipate the objection that religions with general and eternal truths for their subject cannot thus trim their sails to the changing urges of each century without losing their reputation for certainty in men's eyes. My answer is that one must make a very careful distinction between the chief opinions which form a belief, and are what the theologians call articles of faith, and those secondary notions which are connected with it. Religions are bound to hold firmly to the first, whatever may be the spirit of the time. But they should be very careful not to bind themselves like that to the secondary ones at a time when everything is in flux and the mind, accustomed to the moving pageant of human affairs, is reluctant to be held fixed. Things external and secondary, it would seem, have a chance of enduring only when society itself is static. In any other circumstances I am disposed to regard rigidity as dangerous.

A passion for well-being is, as we shall see, the most lively of all the emotions aroused or inflamed by equality, and it is a passion shared by all. So this taste for well-being is the most striking and unalterable characteristic of democratic ages.

It may be that, should any religion attempt to destroy this mother of all desires, it would itself be destroyed thereby. If it attempted to wean men entirely from thinking of the good things of this world in order to concentrate all their faculties on the contemplation of the next, sooner or later one may be sure that men's souls would slip through its fingers to plunge headlong into the delights of purely material and immediate satisfactions.

The main business of religions is to purify, control, and restrain that excessive and exclusive taste for well-being which men acquire in times of equality, but I think it would be a mistake for them to attempt to conquer it entirely and abolish it. They will never succeed in preventing men from loving wealth, but they may be able to induce them to use only honest means to enrich themselves.

This leads me to raise a final point, which in some degree includes all the others. The more people are assimilated to one another and brought to an equality, the more important it becomes that religions, while remaining studiously

aloof from the daily turmoil of worldly business, should not needlessly run counter to prevailing ideas or the permanent interests of the mass of the people. For as public opinion becomes ever increasingly the first and more irresistible of powers, there is no force outside it to support a prolonged resistance. The same holds good of a democratic people either in a republic or subject to a despot. In times of equality kings may often command obedience, but it is always the majority that establishes belief. So in all matters not contrary to faith one must defer to the majority.

I have shown in the first part of this book how the American clergy stands aloof from public business. That is the most striking, but not the only, example of their self-restraint. Religion in America is a world apart in which the clergyman is supreme, but one which he is careful never to leave; within its limits he guides men's minds, while outside them he leaves men to themselves, to the freedom and instability natural to themselves and the times they live in. I have seen no country in which Christianity is less clothed in forms, symbols, and observances than it is in the United States, or where the mind is fed with clearer, simpler, or more comprehensive conceptions. Though American Christians are divided into very many sects, they all see their religion in the same light. This is true of Roman Catholics as well as of other beliefs. Nowhere else do Catholic priests show so little taste for petty individual observances, for extraordinary and peculiar ways to salvation, and nowhere else do they care so much for the spirit and so little for the letter of the law. Nowhere else is that doctrine of the church which forbids offering to saints the worship due to God alone more clearly taught or more generally obeyed. Yet the Roman Catholics of America are very submissive and very sincere.

Another observation can be made which applies to the clergy of every communion. American priests do not try to divert and concentrate all of people's attention on the future life; they freely allow them to give some of their hearts' care to the needs of the present, apparently considering the good things of this world as objects of some, albeit secondary, importance. While they themselves do no productive work, they take an interest in the progress of industry and praise its achievements; while they are ever pointing to the other world as the great object of the hopes and fears of the faithful, they do not forbid the honest pursuit of prosperity in this. Far from trying to show that these two worlds are distinct and opposed to each other, they seek to discover the points of connection and alliance.

All the clergy of America are aware of the intellectual domination of the majority, and they treat it with respect. They never struggle against it unless the struggle is necessary. They keep aloof from party squabbles, but they freely adopt the general views of their time and country and let themselves go unresistingly with the tide of feeling and opinion which carries everything around them along with it. They try to improve their contemporaries but do not quit fellowship with them. Public opinion is therefore never hostile to them but rather supports and protects them. Faith thus derives its authority partly from its inherent strength and partly from the borrowed support of public opinion.

Thus, by respecting all democratic instincts which are not against it and making use of many favorable ones, religion succeeds in struggling successfully with that spirit of individual independence which is its most dangerous enemy.

# HOW THE AMERICANS APPLY THE DOCTRINE OF SELF-INTEREST PROPERLY UNDERSTOOD TO RELIGION

If the doctrine of self-interest properly understood were concerned with this world only, that would not be nearly enough. For there are a great many sacrifices which can only be rewarded in the next. However hard one may try to prove that virtue is useful, it will always be difficult to make a man live well if he will not face death.

One therefore wants to know whether this doctrine can easily be reconciled with religious beliefs.

The philosophers who teach this doctrine tell men that to be happy in life they must watch their passions and be careful to restrain their excesses, that lasting happiness cannot be won except at the cost of a thousand ephemeral pleasures, and finally, that one must continually master oneself in order to serve oneself better.

The founders of almost all religions have used very much the same language. The way they point out to man is the same; only the goal is farther off; instead of putting in this world the reward for the sacrifices demanded, they transpose it to the next.

Nevertheless, I refuse to believe that all who practice virtue from religious motives do so only in hope of reward.

I have known zealous Christians who constantly forgot themselves to labor more ardently for the happiness of others, and I have heard them claim that they did this only for the sake of rewards in the next world. But I cannot get it out of my head that they were deceiving themselves. I respect them too much to believe them.

Christianity does, it is true, teach that we must prefer others to ourselves in order to gain heaven. But Christianity also teaches that we must do good to our fellows for love of God. That is a sublime utterance; man's mind filled with understanding of God's thought; he sees that order is God's plan, in freedom labors for this great design, ever sacrificing his private interests for this wondrous ordering of all that is, and expecting no other reward than the joy of contemplating it.

Hence I do not think that interest is the only driving force behind men of religion. But I do think that interest is the chief means used by religions themselves to guide men, and I have no doubt that that is how they work on the crowd and become popular.

I do not therefore see any plain reason why the doctrine of self-interest properly understood should drive men away from religious beliefs, but rather do I see how to unravel the ways in which it brings them close thereto.

Let us start from the assumption that in order to gain happiness in this world a man resists all his instinctive impulses and deliberately calculates every action of his life, that instead of yielding blindly to the first onrush of his passions he has learned the art of fighting them, and that he habitually and effortlessly sacrifices the pleasure of the moment for the lasting interests of his whole life.

If such a man believes in the religion that he professes, it will hardly cost him anything to submit to such restrictions as it imposes. Reason itself advises him to do so, and habits already formed make it easy.

Even if he does feel some doubt about the object of his hopes, he will not easily let that hold him back, and he will think it wise to risk some of the good things of this world to save his claims to the immense inheritance promised in the next.

"If we make a mistake by thinking the Christian religion true," Pascal has said, "we have no great thing to lose. But if we make a mistake by thinking it false, how dreadful is our case."

The Americans affect no vulgar indifference to a future state, nor do they affect a childish pride in despising perils from which they hope to escape.

They practice their religion therefore without shame and without weakness. But in the very midst of their zeal one generally sees something so quiet, so methodical, so calculated that it would seem that the head rather than the heart leads them to the foot of the altar.

Not only do the Americans practice their religion out of self-interest, but they often even place in this world the interest which they have in practicing it. Priests in the Middle Ages spoke of nothing but the other life; they hardly took any trouble to prove that a sincere Christian might be happy here below.

But preachers in America are continually coming down to earth. Indeed they find it difficult to take their eyes off it. The better to touch their hearers, they are forever pointing out how religious beliefs favor freedom and public order, and it is often difficult to be sure when listening to them whether the main object of religion is to procure eternal felicity in the next world or prosperity in this.

# PHILIP SCHAFF

Philip Schaff (1819–93) was born in Switzerland and was confirmed in the Lutheran Church as a young man. He studied theology and church history at the Universities of Tübingen, Halle, and Berlin, where he found himself drawn to the view of "evangelical catholicism," which blended the Protestant focus on the gospel with the Catholic emphasis on history and tradition. In 1843, he accepted a faculty position at the German Reformed seminary in Mercersburg, Pennsylvania. Ten years later, he returned to Europe, where he lectured to European audiences about America and what Schaff saw as its hopeful potential for ecumenicity and progress. Those lectures were published in 1855 as *America: A Sketch of the Political, Social and Religious Character of the United States of America*, a book that celebrated the voluntary character of organized religion in the United States while denouncing those whom Schaff perceived as outliers, notably Mormons.

# *From* America

## RELIGION AND THE CHURCH

I come now to the point most important in my own view, and, doubtless, most interesting to this assembly. But want of time obliges me to confine myself to some general remarks, which may, at least, help to pilot you through the mazes of American church history.

It is a vast advantage to that country itself, and one may say to the whole world, that the United States were first settled in great part from religious motives; that the first emigrants left the homes of their fathers for faith and conscience' sake, and thus at the outset stamped upon their new home the impress of positive Christianity, which now exerts a wholesome influence even on those later emigrants, who have no religion at all.

The ecclesiastical character of America, however, is certainly very different from that of the Old World. Two points in particular require notice.

The first is this. While in Europe ecclesiastical institutions appear in historical connection with Catholicism, and even in evangelical countries, most of the city and village churches, the universities, and religious foundations, point to a mediaeval origin; in North America, on the contrary, every thing had a Protestant beginning, and the Catholic Church has come in afterwards as one sect among the others, and has always remained subordinate. In Europe, Protestantism has, so to speak, fallen heir to Catholicism; in America, Catholicism under the wing of Protestant toleration and freedom of conscience, has found an adopted home, and is everywhere surrounded by purely Protestant institutions. True, the colony of Maryland, planted by the Catholic Lord Baltimore, was one of the earliest settlements of North America. But, in the first place, even this was by no means specifically Roman. It was founded expressly on the thoroughly anti-Roman, and essentially Protestant, principles of religious toleration. And then, again, it never had any specific influence on the character of the country; for even the prominent position of the city of Baltimore, as the American metropolis of the Roman Church, is of much later date. Far more important and influential were the settlements of the Puritans in New England, the Episcopalians in Virginia, the Quakers in Pennsylvania, the Dutch in New York, in the course of the seventeenth century, the Presbyterians from Scotland and North Ireland, and the German Lutherans and Reformed from the Palatinate, in the first half of the eighteenth. These have given the country its spirit and character. Its past course and present condition are unquestionably due mainly to the influence of Protestant principles. The Roman Church has attained social and political importance in the eastern and western States only within the last twenty years, chiefly in consequence of the vast Irish emigration; but it will never be able to control the doctrines of the New World, though it should increase a hundred fold.

Another peculiarity in the ecclesiastical condition of North America, connected with the Protestant origin and character of the country, is the separation of church and state. The infidel reproach, that had it not been for the power of the state, Christianity would have long ago died out; and the argument of Roman controversialists, that Protestantism could not stand without the support of princes and civil governments, both are practically refuted and utterly annihilated in the United States. The president and governors, the congress at Washington, and the state legislatures, have, as such, nothing to do with the church, and are by the Constitution expressly forbidden to interfere in its affairs. State officers have no other rights in the church, than their personal rights as members of particular denominations. The church, indeed, everywhere enjoys the protection of the laws for its property, and the exercise of its functions; but it manages its own affairs independently, and has also to depend for its resources entirely on voluntary contributions. As the state commits itself to no particular form of Christianity, there is of course also no civil requisition of baptism, confirmation, and communion. Religion is left to the free will of each individual, and the church has none but moral means of influencing the world.

This separation was by no means a sudden, abrupt event, occasioned, say, by the Revolution. The first settlers, indeed, had certainly no idea of such a thing; they proceeded rather on Old Testament theocratic principles, like Calvin, John Knox, the Scottish Presbyterians, and the English Puritans of the seventeenth century; regarding state and church as the two arms of one and the same divine will. In the colony of Massachusetts, the Puritans, in fact, founded a rigid Calvinistic state-church system. They made the civil franchise depend on membership in the church; and punished not only blasphemy and open infidelity, but even every departure from the publicly acknowledged code of Christian faith and practice as a political offense. In Boston, in the seventeenth century, even the Quakers, who certainly acted there in a very fanatical and grossly indecent way, were formally persecuted, publicly scourged, imprisoned, and banished; and, in Salem, of the same State, witches were burnt as accomplices of the devil. The last traces of this state-church system in New England were not obliterated till long after the American Revolution, and even to this day most of the States have laws for the observance of the Sabbath, monogamy, and other specifically Christian institutions. Thus the separation of the temporal and spiritual powers is by no means absolute. While New England had Congregationalism for its established religion, New York also had at first the Dutch Reformed, and afterwards the English Episcopal church, and Virginia, and some other Southern States, also the English Episcopal, for their establishments. With these the other forms of Christianity were tolerated either not at all, or under serious restrictions, as formerly the Dissenters were in England.

But on the other hand, there prevailed in other North American colonies from their foundation, therefore long before the Revolution of 1776, entire freedom of faith and conscience; as in Rhode Island, founded by the Baptist, Roger Williams, who was banished from Massachusetts for heresy, and thus set by bitter experience against religious intolerance; in Pennsylvania, which the quaker, William Penn, originally designed as an asylum for his brethren in faith, but to which he soon invited also German Reformed and Lutherans from the Palatinate, guaranteeing equal rights to all, and leaving each to the guidance of

the "inward light;" and, finally, in Maryland, founded by Lord Baltimore on the same basis of universal religious toleration.

After the American Revolution this posture of the State gradually became general. First, the legislature of Virginia, after the colony had separated from the mother-country, annulled the rights and privileges of the Episcopal establishment, and placed all the dissenting bodies on a perfectly equal footing with it in the eye of the law. Her example was followed by the other colonies, which had established churches. When Congress was organized at the close of the war, an article was placed in the Constitution, forbidding the enactment of laws about religion; and similar prohibitions are found in the constitutions of the several States.

We would by no means vindicate this separation of church and state as the perfect and final relation between the two. The kingdom of Christ is to penetrate and transform like leaven, all the relations of individual and national life. We much prefer this separation, however, to the territorial system and a police guardianship of the church, the Bride of the God-man, the free-born daughter of heaven; and we regard it as adapted to the present wants of America, and favorable to her religious interests. For it is by no means to be thought, that the separation of church and state there is a renunciation of Christianity by the nation; like the separation of the state and the school from the church, and the civil equality of Atheism with Christianity, which some members of the abortive Frankfurt Parliament were for introducing in Germany. It is not an annihilation of one factor, but only an amicable separation of the two in their spheres of outward operation; and thus equally the church's declaration of independence towards the state, and an emancipation of the state from bondage to a particular confession. The nation, therefore, is still Christian, though it refuses to be governed in this deepest concern of the mind and heart by the temporal power. In fact, under such circumstances, Christianity, as the free expression of personal conviction and of the national character, has even greater power over the mind, than when enjoined by civil laws and upheld by police regulations.

This appears practically in the strict observance of the Sabbath, the countless churches and religious schools, the zealous support of Bible and Tract societies, of domestic and foreign missions, the numerous revivals, the general attendance on divine worship, and the custom of family devotion—all expressions of the general Christian character of the people, in which the Americans are already in advance of most of the old Christian nations of Europe.

In fact, even the state, as such, to some extent officially recognizes Christianity. Congress appoints chaplains (mostly from the Episcopal, sometimes from the Presbyterian and the Methodist clergy) for itself, the army, and the navy. It opens every day's session with prayer, and holds public worship on the Sabbath in the Senate Chamber at Washington. The laws of the several States also contain strict prohibitions of blasphemy, atheism, Sabbath-breaking, polygamy, and other gross violations of general Christian morality.

Thus the separation is not fully carried out in practice, on account of the influence of Christianity on the popular mind. It is even quite possible that the two powers may still come into collision. The tolerance of the Americans has its limits and counterpoise in that religious fanaticism, to which they are much inclined. This may be seen in the expulsion of the Mormons, who so grossly offended the religious and moral sense of the people. Great political difficulties

may arise, especially from the growth of the Roman church, which has been latterly aiming everywhere at political influence, and thus rousing the jealousy and opposition of the great Protestant majority. The Puritanic Americans see in Catholicism an ecclesiastical despotism, from which they fear also political despotism, so that its sway in the United States must be the death of Republican freedom. Thus the Catholic question has already come to be regarded by many as at the same time a political question, involving the existence of the Republic; and a religious war between Catholics and Protestants, though in the highest degree improbable, is still by no means an absolute impossibility; as, in fact, slight skirmishes have already occurred in the street fight between the two parties in Philadelphia in 1844, and the violent demolition of a Roman convent at Charlestown, Mass. The secret political party of the "Know-Nothings," which is just sweeping over the States with the rapidity of the whirlwind, but which, for this very reason, cannot last long in this particular form, is mainly directed against the influence of Romanism.

If, however, the great question of the relation of church and state be not by any means fully solved even in the United States, still the two powers are there at all events much more distant than in any other country.

The natural result of this arrangement is a general prevalence of freedom of conscience and religious faith, and of the voluntary principle, as it is called: that is, the promotion of every religious work by the free-will offerings of the people. The state, except in the few cases mentioned above, does nothing towards building churches, supporting ministers, founding theological seminaries, or aiding indigent students in preparation for the ministry. No taxes are laid for these objects; no one is compelled to contribute a farthing to them. What is done for them is far, indeed, from being always done from the purest motives—love to God and to religion—often from a certain sense of honor, and for all sorts of selfish by-ends; yet always from free impulses, without any outward coercion.

This duly considered, it is truly wonderful, what a multitude of churches, ministers, colleges, theological seminaries, and benevolent institutions are there founded and maintained entirely by free-will offerings. In Berlin there are hardly forty churches for a population of four hundred and fifty thousand, of whom, in spite of all the union of church and state, only some thirty thousand attend public worship. In New York, to a population of six hundred thousand, there are over two hundred and fifty well-attended churches, some of them quite costly and splendid, especially in Broadway and Fifth Avenue. In the city of Brooklyn, across the East River, the number of churches is still larger in proportion to the population, and in the country towns and villages, especially in New England, the houses of worship average one to every thousand, or frequently even five hundred, souls. If these are not Gothic cathedrals, they are yet mostly decent, comfortable buildings, answering all the purposes of the congregation often even far better than the most imposing works of architecture. In every new city district, in every new settlement, one of the first things thought of is the building of a temple to the Lord, where the neighboring population may be regularly fed with the bread of life and encouraged to labor, order, obedience, and every good work. Suppose the state, in Germany, should suddenly withdraw its support from church and university, how many preachers and professors would be breadless, and how many auditories closed!

The voluntary system unquestionably has its great blemishes. It is connected with all sorts of petty drudgery, vexations, and troubles, unknown in well endowed Established Churches. Ministers and teachers, especially among the recent German emigrants in America, who have been accustomed to State provision for religion and education, have very much to suffer from the free system. They very often have to make begging tours for the erection of a church, and submit to innumerable other inconveniences for the good cause, till a congregation is brought into a proper course, and its members become practised in free giving.

But, on the other hand, the voluntary system calls forth a mass of individual activity and interest among the laity in ecclesiastical affairs, in the founding of new churches and congregations, colleges and seminaries, in home and foreign missions, and in the promotion of all forms of Christian philanthropy. We may here apply in a good sense our Lord's word: "Where the treasure is, there the heart will be also." The man, who, without coercion, brings his regular offering for the maintenance of the church and the minister, has commonly much more interest in both, and in their prosperity he sees with pleasure the fruit of his own labor. The same is true of seminaries. All the congregations and synods are interested in the theological teacher, whom they support, and who trains ministers of the Word for them; while in Europe the people give themselves little or no trouble about the theological faculties.

It is commonly thought that this state of things necessarily involves an unworthy dependence of the minister on his congregation. But this is not usually the case. The Americans expect a minister to do his duty, and they most esteem that one who fearlessly and impartially declares the whole counsel of God, and presents the depravity of man and the threatenings of the Divine Word as faithfully as he does the comforting promises. Cases of ministers employed for a certain time, as hired servants, occur indeed occasionally in independent German rationalistic congregations, and perhaps among the Universalists, but not in a regular synod. A pious congregation well knows that by such a degradation of the holy office, which preaches reconciliation, and binds and looses in the name of Christ, it would degrade itself; and a minister, in any respectable church connection, would not be allowed to accept a call on such terms, even were he willing.

Favored by the general freedom of faith, all Christian denominations and sects, except the Oriental, have settled in the United States, on equal footing in the eye of the law; here attracting each other, there repelling; rivalling in both the good and the bad sense; and mutually contending through innumerable religious publications. They thus present a motley sampler of all church history, and the results it has thus far attained. A detailed description of these at present is forbidden, both by want of time and by the proportion of the discourse. Suffice it to say, in general, that the whole present distracted condition of the church in America, pleasing and promising as it may be, in one view, must yet be regarded on the whole as unsatisfactory, and as only a state of transition to something higher and better.

America seems destined to be the Phenix grave not only of all European nationalities, as we have said above, but also of all European churches and sects, of Protestantism and Romanism. I cannot think, that any one of the present

confessions and sects, the Roman, or the Episcopal, or the Congregational, or the Presbyterian, or the Lutheran, or the German or Dutch Reformed, or the Methodist, or the Baptist communion, will ever become exclusively dominant there; but rather, that out of the mutual conflict of all something wholly new will gradually arise.

At all events, whatever may become of the American denominations and sects of the present day, the kingdom of Jesus Christ must at last triumph in the New World, as elsewhere, over all foes, old and new. Of this we have the pledge in the mass of individual Christianity in America; but above all, in the promise of the Lord, who is with his people always to the end of the world, and who has founded his church upon a rock, against which the gates of hell shall never prevail. And his words are yea and amen.

With this prospect we finish this outline miniature of life in the United States. You see from it, that all the powers of Europe, good and bad, are there fermenting together under new and peculiar conditions. All is yet in a chaotic transition state; but organizing energies are already present, and the spirit of God broods over them, to speak in time the almighty word: "Let there be light!" and to call forth from the chaos a beautiful creation.

Perhaps, in the view of many of my respected hearers, I have drawn too favorable a picture. But I beg to remind them, first, that the dark side, which, indeed, I have not concealed, has been only too often presented in disproportion and caricature by European tourists or distant observers; and, secondly, that it would be very ungrateful and dishonorable for me to disparage my new fatherland behind its back, to uncover its nakedness with unsparing hand, and neglect its virtues and its glorious prospects.

In general, however, notwithstanding all differences on particular points, few intelligent and unprejudiced Germans certainly will think me wrong in designating America as a world of the future. I do so, not in disparagement of old and venerable Europe. She, indeed, unquestionably trembled to her foundations in 1848, and seemed on the verge of a fearful anarchy and barbarism; but she has since already shown, that in Christianity and civilization she has the power and the pledge of regeneration. I do not believe, that Europe, which we Americans revere and love as our bodily and spiritual mother, must become a second Asia, in order that America may become a higher Europe. In fact, this critical moment itself gives promise of regeneration of the East and of the venerable birth-place of Christianity. This we may hope, in the providence of God, will be the final result of the present contest between Russia and the Western Powers for Constantinople and the key of the holy sepulchre. The partition walls between nations and countries are gradually being removed by the facilities of communication, which must serve in a higher hand as instruments for spiritual and eternal ends. Europe, Asia, Africa, America, and Australia, all belong to the Lord, who died for them all. They come nearer together every year, and must at last, without distinction of old and new, whether called into the vineyard early or late, exchange the hand of brotherhood, submit in free obedience to the common Lord, glorify his name, and fulfill the promise of one fold under one shepherd.

# GENERAL ECCLESIASTICAL CONDITION
# OF THE UNITED STATES

As the present can be duly understood only in its connection with the past, allow me to premise a few historical remarks.

North America, as already observed, follows strictly in the train of the ecclesiastical revolution of the sixteenth century, and is in its prevailing religious character primarily a continuation of European Protestantism. The American historian, Bancroft, throughout his extensive work, proceeds on the presumption, that even the entire civil constitution and social life of North America, is a product of the English Puritanism, which is itself a modification of the Genevan Calvinism. This is an exaggerated view. Bancroft, in his "History of the United States," writes in general as a propagandist of Republicanism—and of Republicanism, too, as conceived by the Democratic party—and hence sees some things in an entirely false light. Yet his view has somewhat of truth. It certainly cannot be denied, that the American system of general political freedom and equality (which, however, has a restriction and counterpart in the slavery of the Southern States), with its kindred doctrine—not by any means fully applied, yet aiming to be—of the rights and duties of self government and active coöperation of the people in all the affairs of the Commonwealth, is, in some sense, a transferring to the civil sphere the idea of the universal priesthood of Christians, which was first clearly and emphatically brought forward by the Reformers. With the universal priesthood comes also a corresponding universal kingship; though, of course, this no more excludes a special kingship, or a rank of rulers, than the other, a particular ministry. This universal kingship is what the American Republic aims at. Whether it will ever realize it is a very different question. Certainly not by the unfolding of any powers of mere nature. The Bible idea of a general priesthood and kingship can be realized only by supernatural grace, and will not appear in its full reality before the consummation of all things at the glorious coming of Christ.

The Germanic and Protestant character of the United States reveals itself particularly in their uncommon mobility and restless activity, contrasting with the mournful stagnation of the Romanic and Roman Catholic countries of Central and South America. The people are truly a nation of progress, both in the good sense and in the bad; of the boldest, often foolhardy, enterprise; a restless people, finding no satisfaction, save in constant striving, running, and chasing after a boundless future. I state here an actual fact, palpable to every one, who sets foot in the New World, and observes, for instance, the bustle and headway of such a city as New York. This spirit of enterprise is shared also by the religious bodies, even by the Roman Church, which promises itself a glorious future in America.

The connecting link between European and American church history is England,—poorer in ideas, than Germany, but exhibiting Protestantism more as an institution, and in far greater political and social importance, than any country of the continent; as, in fact, she is to this day the mightiest bulwark of Protestantism against Rome. The six Northeastern States, collectively called New England, have thus far exerted the leading religious influence in the

Union. Through these especially the ecclesiastical life of North America strikes its deepest roots in those mighty religious and civil contests, which shook England in the seventeenth century; in that Puritanic movement, which may be called a second Reformation, a more consistent, though an extreme, carrying out of the Protestant principle against the semi-Catholicism of the Episcopal Establishment.

Apart from what was merely preparatory, the church history of the United States properly begins with the emigration of the Puritan "Pilgrim Fathers." These pious, bible-reading, earnest, and energetic Puritans, persecuted in England for their faith, and sacrificing to religious conviction their father-land, and all associated with that sweet word, first sought refuge in Holland in the year 1611; thence in 1620 crossed the Atlantic; landed, after a long, stormy voyage, on the lonely rock of Plymouth, and here first of all kneeled in tears, to thank their Lord and God for their happy deliverance from the perils of death and from all bondage of conscience. Soon reinforced by larger emigrations of their brethren in faith, especially in 1630, they founded in Massachusetts, according to the principles of the strictest Calvinism, a theocratic state, and became the fathers of a republic, of whose power and importance they did not dream;—a striking proof, that the greatest results may flow from small beginnings.

True, the settlement of Virginia, with the planting of the English Episcopal Church there, was of earlier date (1607); but this proceeded mainly from commercial interests, and has accordingly had no such influence in forming the religious character of the Americans. The same may be said of the founding of the New Netherland colony by the Hollanders, who established a trading port on Manhattan island as early as 1614, thus laying the foundation for the town of New Amsterdam, as New York was originally called, and some years afterwards transplanted the Reformed Dutch Church with the Heidelberg Cathechism, and the Decrees of Dort to the banks of the Hudson and the Delaware.

Pennsylvania, on the contrary, had a decidedly religious origin. The renowned William Penn, designed it (1680) primarily as an asylum for his persecuted brethren in faith, and stamped it from the first with the main features of the Quaker sect, which may be plainly discerned to this day, especially in Philadelphia, the "city of brotherly-love." At the same date Maryland (so called after Henrietta Maria, daughter of Henry IV., and wife of Charles I.) became a refuge of persecuted Catholics under Lord Baltimore. After the infamous revocation of the Edict of Nantes by the grandson of Henry the Fourth, many Huguenots betook themselves to North and South Carolina, New York, and New Jersey, and there gradually merged themselves in the Presbyterian and Episcopal churches. In the beginning of the last century began the emigration of the German Lutherans and Reformed from the provinces on the Rhine. This emigration passed chiefly to Pennsylvania, and was occasioned in part by the devastation of the Palatinate, and the oppression of the Protestants by the army of Louis the Fourteenth. Somewhat later the Salzburgers sought and found in Georgia a home of peace, and freedom for their Lutheran faith. About the middle of the eighteenth century Zinzendorf and Spangenburg planted in the same State, but more especially in Pennsylvania (at Bethlehem and Nazareth), several communities of Moravian Brethren; while Mühlenberg, as commissioner of the Halle Orphan House, organized the Lutheran Church, and the Swiss Schlatter

the German Reformed, in Pennsylvania. In the same period John Wesley and Whitefield several times appeared on the soil of the New World, as mighty evangelists and revival preachers; and the great movement of Methodism, in connection with the awakening influence from New England, mainly from the metaphysical divine and powerful preacher, Jonathan Edwards, stirred and fructified the whole land.

Thus was North America from the first, like Geneva in the time of the Reformation, only on a much larger scale, an asylum for all the persecuted of the Old World. And so it has remained to this day; though the later emigration has rather lost the religious character, and is mostly ruled by secular interests. It is an incalculable advantage for that land, that its first settlements sprang in great part from earnest religious movements. Modern infidelity and indifferentism, which are likewise imported, cannot do it near so much harm, as if they had laid the foundation of its institutions.

From this history of the rise of the United States, we can understand, in the first place, how the principle of religious toleration should be so deeply rooted in the people. They must give up their own tradition and their holiest associations, before they can ever bow to ecclesiastical despotism and exclusiveness. The persecuted man has always been an advocate of toleration for his own interest, and, to be consistent, must also sympathize with all the persecuted. In America universal freedom of faith and conscience came by necessity, and with this a separation of Church and State, even in those colonies where they were originally united.

But this is only one side of the matter. From the above allusions to American church history it is at the same time clear, that the principle of religious freedom rests there on a *religious* basis, as the result of many sufferings and persecutions for the sake of faith and conscience; and thus differs very materially from some modern theories of toleration, which run out into sheer religious indifference and unbelief. The American is as intolerant as he is tolerant; and, to appreciate his character, we must keep this paradoxical fact always in view. In many things he is even decidedly fanatical. Think only of the Puritanic origin of New England, and of the enormous influence which the strict Calvinism still exerts on the whole land. In the same Geneva, which so hospitably received all hunted Protestants from France, Italy, Spain, England, and Scotland, there reigned at the same time a rigoristic church discipline, and Servetus was burned as a blasphemer. The American leaves every man at liberty to belong to any church, confession, or sect, or to none, according to his own free conviction. But within the particular confessions the lines are far more sharply and strictly drawn than in Europe. There every church member is required to adhere closely to the doctrines and usages of the particular body, to which he belongs.

Hence in America a preacher or theological professor far more easily than here incurs suspicion of neology and heresy, and, though not indeed imprisoned nor banished, much less burned, as in Papal times, is yet forthwith deposed, and, if necessary, formally excommunicated, if after due investigation it appear, that he teaches and acts contrary to his church, which called him and bound him to a certain confession of faith. A rationalist, like Paulus, Wegscheider, Röhr, Bretschneider, Uhlich, Wislicenus, could not find a place in the pulpit or professorial chair of any respectable communion, not even the Unitarian; while in Germany even the

majority of the theological chairs and superintendencies have for twenty years, in spite of all obligation to symbols, been filled by men of this or some similar school. That even at this day a man like Dr. Baur, who denies the genuineness of all the New Testament books, except four epistles of Paul and the Apocalypse, and treats the Gospel history almost like a heathen mythology, should still hold the first theological chair of the evangelical church of Würtemberg, is absolutely incomprehensible to a Presbyterian, a Puritan, or an Episcopalian. A man, who does not believe in the divinity of Christ, the inspiration and authority of the Bible, the necessity of conversion and regeneration, and who does not at the same time live a strictly moral life, must in America enter any other calling sooner than the ministry. In the pulpit he will appear to the people, who have a very sound discernment in the matter, as a hypocrite, or as an objective lie, in bold contradiction with the nature and spirit of his calling.

From the decidedly Protestant character of the country, however, one can also, much more easily than in Germany, incur the opposite charge of hyperorthodoxy, of Puseyism, and of Romanizing tendencies; as, for example, by objecting to the Puritanic views of Catholicism and of church history, by insisting on the import of the church, its unity, and historical continuity, or on a mystical view of the sacraments, in opposition to the prevailing symbolical theory. I might, if it were proper, give some striking instances of this from my own experience. In this respect the German churches of America are more tolerant, by reason of their connection with the German theology; whereas the English and Anglo-American theology has adhered far more to the lines of the old Protestant, especially the Puritanic, extremely anti-Catholic orthodoxy of the seventeenth century, and has been more directly under the control of the ecclesiastical authorities.

This supervision of theology by the church is a valuable remnant of discipline, and ought, I think, to be preferred to too broad and latitudinarian a freedom of doctrine; though I grant, and that from bitter personal experience, that it is very often associated with shallowness, bigotry, and the spirit of persecution; and thus in many ways hinders the free development of theology.

The religious character of North America, viewed as a whole, is predominantly of the Reformed or Calvinistic stamp, which modifies there even the Lutheran Church, to its gain, indeed, in some respects, but to its loss in others. To obtain a clear view of the enormous influence which Calvin's personality, moral earnestness, and legislative genius, have exerted on history, you must go to Scotland and to the United States. The Reformed Church, where it develops itself freely from its own inward spirit and life, lays special stress on thorough moral reform, individual, personal Christianity, freedom and independence of congregational life, and strict church discipline. It draws a clear line between God and the world, Church and State, regenerate and unregenerate. It is essentially practical, outwardly directed, entering into the relations of the world, organizing itself in every variety of form; aggressive and missionary. It has also a vein of legalism, and here, though from an opposite direction, falls in with the Roman Church, from which in every other respect it departs much further than Lutheranism. It places the Bible above every thing else, and would have its church life ever a fresh, immediate emanation from this, without troubling itself much about tradition and intermediate history. Absolute supremacy of the Holy

Scriptures, absolute sovereignty of Divine grace, and radical moral reform on the basis of both, these are the three most important and fundamental features of the Reformed type of Protestantism.

In the ecclesiastical condition of America, with all the differences among particular branches, these general characteristics are all clearly defined. The religious life of that country is uncommonly practical, energetic, and enterprising. Congregations, synods, and conventions display an unusual amount of oratorical power, and of talent for organization and government; and it is amazing, what a mass of churches, seminaries, benevolent institutions, religious unions and societies, are there founded and supported by mere voluntary contribution. In all these respects, Germany and the whole continent of Europe, where the spirit of church building and general religious progress does not keep pace at all with the rapid increase of population in large cities, could learn very much from America.

With these virtues, however, American Christianity, of course, has also corresponding faults and infirmities. It is more Petrine than Johannean; more like busy Martha than like the pensive Mary, sitting at the feet of Jesus. It expands more in breadth than in depth. It is often carried on like a secular business, and in a mechanical or utilitarian spirit. It lacks the beautiful enamel of deep fervor and heartiness, the true mysticism, an appreciation of history and the church; it wants the substratum of a profound and spiritual theology; and under the mask of orthodoxy it not unfrequently conceals, without intending or knowing it, the tendency to abstract intellectualism and superficial rationalism. This is especially evident in the doctrine of the church and the Sacraments, and in the meagreness of the worship, which lacks not only all such symbols as the cross, the baptismal font, the gown, but even every liturgical element (except in the Episcopal and most of the German churches), so that nothing is left, but preaching, free prayer, and singing, and even the last is very often left merely to the choir, instead of being the united act of the congregation.

Here now is the work of the German church for America; not only of the Lutheran, but also of the German Reformed, which in fact was never strictly Calvinistic, but has always been rather Melanchthonian, moderate, mediating between Lutheranism and Calvinism, between the Germanic and the Romanic Protestantism, and has accordingly in recent times almost everywhere, especially in Prussia, fallen in with the Evangelical Union. The German church, with its hearty enjoyment of Christianty, and direct intercourse with a personal Saviour, its contemplative turn, its depth of inward view, its regard for history, and its spirited theology, might and should enter as a wholesome supplemental element into the development of American Protestantism; and this it has, in fact, within a few years begun in a small way to do, assisted by the increasing number of translation of the standard works of German theology. It is still more plainly the mission duty of the Episcopal church in that country to restrain the unchurchly and centrifugal forces of ultra-Protestantism. By her excellent Prayer Book she supplies to a much greater extent than the German denominations the defects of a purely subjective and jejune worship, and she would recommend herself still more if she would allow greater freedom and variety in the liturgical service. Her theological mission too is to mediate between the extremes of Romanism and Puritanism; but her native American literature so far

does not correspond with her great material resources and social standing, and has not exerted much influence yet to shape the theological thinking of the country; partly on account of her pedantry and exclusiveness.

As to the good and the evil effects of the voluntary principle, which follows unavoidably from the separation of church and state, and underlies the whole American church system, I have already expressed myself in the first lecture, and will not here repeat my remarks.

I must here, however, speak more fully of the Sect system, which I then only briefly touched upon. America is the classic land of sects, where in perfect freedom from civil disqualification, they can develop themselves without restraint. This fact is connected indeed with the above-mentioned predominance of the Reformed type of religion. For in the Reformed church the Protestant features, and with them the subjective, individualizing principle, are most prominent. But in the term *sect-system* we refer at the same time to the whole ecclesiastical condition of the country. For there the distinction of church and sect properly disappears; at least the distinction of established church and dissenting bodies, as it is commonly understood in England and Germany. In America, there is, in fact, no national or established church; therefore no dissenter. There all religious associations, which do not outrage the general Christian sentiment and the public morality (as the Mormons, who, for their conduct, were driven from Ohio and Illinois), enjoy the same protection and the same rights. The distinction between confessions or denominations (as the word is there) and sects is therefore likewise entirely arbitrary, unless perhaps the acknowledgment or rejection of the ecumenical or old Catholic symbols be made the test; though this would not strictly apply even in Germany.

Favored by the general freedom of conscience, the representatives of all the forms of Christianity in the Old World, except the Greek—for we here leave out of view the isolated Russian colony in the Northwest of America—have gradually planted themselves in the vast field of the United States by emigration from all European countries, and are receiving reinforcements every year. There is the Roman with his Tridentinum and pompous mass; the Episcopal Anglican with his Thirty-nine Articles and Book of Common Prayer; the Scotch Presbyterian with his Westminster Confession, and his presbyteries and synods; the Congregationalist, or Puritan in the stricter sense, also with the Westminster Confession, but with his congregational independence; the Baptist, with his immersion and anti-paedobaptism; the Quaker, with his inward light; the Methodist, with his call to repentance and conversion, and his artificial machinery; the Lutheran, now with all his symbols, from the Augustana to the Form of Concord, now with the first only, and now with none of them; the German Reformed and Reformed Dutch, with the Heidelberg Cathechism and the Presbyterian Synodal church polity; the Unionist, either with the consensus of both confessions, or indifferently rejecting all symbols; the Moravian community, with its silent educational and missionary operations; and a multitude of smaller sects besides, mostly of European origin, but some of American. In short, all the English and Scotch churches and sects, and all branches of German and Netherland Protestantism, are there represented. Each one alone is, of course, weaker than its mother church in Europe, except the Puritanic, which has attained its chief historical importance only in New England. But they are

all there, not rarely half a dozen in a single country town, each with its own church or chapel; and, where they have any real vitality at all, they grow there proportionally much faster than in Europe. Some, as the Presbyterian, the Methodist, the German Protestant, and the Roman Catholic, have even almost doubled their numbers within the last ten or twenty years.

This confusion of denominations and sects makes very different impressions on the observer from different theological and religious points of view. If he makes all of individual Christianity, and regards the conversion of men as the whole work of the church, he will readily receive a very favorable impression of the religious state of things in America. It is not to be denied, that by the great number of churches and sects this work is promoted; since they multiply the agencies, spur each other on, vie with each other, striving to outdo one another in zeal and success. We might refer to the separation of Paul and Barnabas, by which one stream of apostolic missionary labor was divided into two, and fructified a greater number of fields with its living waters. There are in America probably more awakened souls, and more individual effort and self-sacrifice for religious purposes, proportionally, than in any other country in the world, Scotland alone perhaps excepted. This is attributable, at least in part, to the unrestricted freedom with which all Christian energies may there put themselves forth; and to the fact, that no sect can rely on the favor of the State, but that each is thrown upon its own resources, and has therefore to apply all its energies to keep pace with its neighbors and prevent itself from being swallowed up.

The charge that the sect system necessarily plays into the hands of infidelity on one side and of Romanism on the other has hitherto at least not proved true, though such a result is very naturally suggested. There is in America far less open unbelief and skepticism, than in Europe; and Romanism is extremely unpopular. Whether things will continue so is a very different question.

But on closer inspection the sect system is seen to have also its weaknesses and its shady side. It brings all sorts of impure motives into play, and encourages the use of unfair, or at least questionable means for the promotion of its ends. It nourishes party spirit and passion, envy, selfishness, and bigotry. It changes the peaceful kingdom of God into a battle-field, where brother fights brother, not, of course, with sword and bayonet, yet with loveless harshness and all manner of detraction, and too often subordinates the interests of the church universal to those of his own party. It tears to pieces the beautiful body of Jesus Christ, and continually throws in among its members the fire-brands of jealousy and discord, instead of making them work together harmoniously for the same high and holy end. It should not be forgotten, that Christianity aims not merely to save individual souls, and then leave them to themselves, but to unite them with God and therefore also with one another. It is essentially love, and tends towards association; and the church is and ought to become more and more the one body of Jesus Christ, the fullness of Him who filleth all in all. If, therefore, the observer start with the conception of the church as an organic communion of saints, making unity and universality its indispensable marks, and duly weighing the many exhortations of Holy Scripture to keep the unity of the Spirit in the bond of peace; he cannot possibly be satisfied with the sect system, but must ever come out against it with the warnings of Paul against the divisions and parties in the Corinthian church. A friend very near to me, and a thoughtful,

deeply earnest theologian, has keenly assailed and exposed the sect system as the proper American Antichrist. The noblest and most pious minds in America most deeply disapprove and deplore at least the sect *spirit*; and fortunately too, this spirit recedes in proportion as the genuine spirit of Christianity, the uniting and cooperative spirit of brotherly love and peace, makes itself felt. In the American Bible and Tract Societies and Sunday School Union, the various evangelical denominations work hand in hand and get along right well together, although their Catholicity is more of a negative character, not reconciling, but concealing the confessional differences, and although their charity is at an end as soon as the Romish church is mentioned, as if she was simply an enemy of Christ. Several of the most prominent churches maintain a friendly inter-delegation; and even in those which do not, or which make it a mere form, all the true children of God, when they see one another face to face, exchange the hand of fellowship in spite of all the jealousy and controversy between their respective communions.

Sectarianism, moreover—and this I might especially commend to the attention of German divines—is by no means a specifically American malady, as often represented; it is deeply seated in Protestantism itself, and is so far a matter of general Protestant interest. Suppose that in Prussia church and state should be suddenly severed; the same state of things would at once arise here. The parties now in conflict within the Established Church, would embody themselves in as many independent churches and sects, and you would have an Old Lutheran Church, a New Lutheran Church, a Reformed Church, a United Church—and that again divided into a union positively resting on the symbols, and a union acknowledging only the Scriptures—perhaps, also, a Schleiermacherian Church, and who knows how many spiritualistic and rationalistic sects and independent single congregations besides. America in fact draws all its life originally from Europe. It is not a land of *new* sects; for those which have originated there, as the Mormons, are the most insignificant, and have done nothing at all to determine the religious character of the people. It is only the rendezvous of all European churches and sects, which existed long before, either as establishments or as dissenting bodies. England and Scotland have almost as many different religious bodies as the United States, with the single difference that in the former countries one (the Episcopal in England, the Presbyterian in Scotland) enjoys the privilege of state patronage, while in America all stand on the same footing.

In forming our judgment of the American sect system, therefore, we are led back to the general question, whether Protestantism constitutionally involves a tendency towards denominationalism and sectarianism, wherever it is not hindered by the secular power. This we cannot so very easily deny. Protestantism is Christianity in the form of free subjectivity; of course not an unregenerate subjectivity, resting on natural reason—for this is the essence of rationalism—but a regenerate subjectivity, based on and submitting to the Word of God. It is thus distinguished from Catholicism, which takes Christianity in an entirely objective sense, as a new law, and as absolute authority, and does not therefore allow national and individual peculiarities at all their full right and free development. In the first, the centrifugal force predominates; in the second, the centripetal—there freedom, here authority. And to harmonize perfectly these two opposite yet correlative principles, is the highest, but also the most difficult, problem of history.

Accordingly it is the great work and the divine mission of Protestantism, to place each individual soul in immediate union with Christ and his Word; to complete in each one the work of redemption, to build in each one a temple of God, a spiritual church; and to unfold and sanctify all the energies of the individual. But, through the sinfulness of human nature, the principle of subjectivity and freedom may run out into selfish isolation, endless division, confusion, and licentiousness; just as the principle of objectivity, disproportionately applied, leads to stagnation and petrifaction; the principle of authority, to despotism in the rulers and slavery in the ruled. In North America, the most radically Protestant land, the constitutional infirmities of Protestantism, in religious and political life, are most fully developed, together with its energy and restless activity; just as the natural diseases of Catholicism appear most distinctly in the exclusively Roman countries of southern Europe.

Now in this unrestrained development and splitting up of Christian interests, most palpable in America, the Roman Catholic sees symptoms of an approaching dissolution of Protestantism and the negative preparation for its return into the bosom of the only saving church. But such a relapse to a position already transcended in church history, such an annulling of the whole history of the last three centuries, is, according to all historical analogy, impossible. How inconceivable, that in this age of the general circulation of literature, the Book of all books can again be taken away from the people, and all the liberties, hard won by the Reformation, obliterated! Catholicism can, indeed, draw over to itself as it has lately done in Germany, England, and America, individuals, tired of the Protestant confusion and uncertainty, having no patience with the present, and no faith in the future, longing for a comfortable pillow of absolute, tangible authority. But Protestantism in the mass can never be swallowed up by it; or if it should be, it would soon break out again with increased violence, and shake the Roman structure still more deeply than it did in the sixteenth century.

We believe, indeed, by all means, that the present divided condition of Protestantism, is only a temporary transition state, but that it will produce something far more grand and glorious, than Catholicism ever presented in its best days. Protestantism after all still contains the most vigorous energies and the greatest activity of the church. It represents the progressive principle of history. It is Christianity in motion. Hence more may be expected from it than from the comparative stagnation of the Roman or Greek Catholicism. Converted regenerate individuals, these subjective Protestant heart-churches, are the living stones for the true Evangelical Catholic Church, which is to combine and perfect in itself all that is true and good and beautiful in the past. But this requires the previous fulfillment of the mission of Protestantism, the transforming of each individual man into a temple of God. Out of the most confused chaos God will bring the most beautiful order; out of the deepest discords, the noblest harmony; out of the most thoroughly developed Protestantism, the most harmonious and at the same time the freest Catholicism. What wild controversy has already raged, what violent passion has been kindled among theologians, about the doctrine of the Eucharist! And yet this sacrament is the feast of the holiest and deepest love, the symbol of the closest fellowship of Christ and the church. The one, holy, universal, apostolic church is an article not only of faith, but also of hope, to be fully accomplished only with the glorious return of Christ.

In America are found, in some degree, as a preparation, for this great end, all the data for the problem of the most comprehensive union. For there, not only the Lutheran and Reformed confessions, but also the English and all the European sections and forms of the church are found in mutual attrition and in ferment. But, of course, Europe likewise, especially Germany and England, must have its part in the work; nay, must make the beginning. For Europe still stands at the head of Christian civilization, and is ever producing from her prolific womb new ideas and movements, which, through the growing facility, and frequency of inter-communication, the swelling emigration, and the exportation of elements of literature and culture of every kind, at once make themselves felt in America, perpetuate themselves there in modified forms, and come into immediate contact and conflict, so as to bury themselves in each other, and rise again as the powers of a new age in the history of the world and the church. Therefore have I called America, even in respect to religion and the church, the Phenix-grave of Europe.

## THE MORMONS

I confess, I would fain pass over this sect in silence. It really lies out of the pale of Christianity and the church; for as to single corrupted elements of Christianity, these may be found even in Manicheism and Mohammedanism. Nor has it exerted the slightest influence on the general character and religious life of the American people, but has rather been repelled by it, even by force, as an element altogether foreign and infernal. Besides, I fear I can say nothing at all satisfactory about this phenomenon, owing to want of accurate knowledge from the proper sources on our own part, and to the general immaturity of the phenomenon itself. But by such silence I should disappoint expectations. For concerning nothing have I been more frequently asked in Germany, than concerning the primeval forests and the Mormons—the oldest and the newest products of America—as if it had nothing of greater interest and importance than these.

Unquestionably a remarkable appearance in the history of the religious vagrancy of the human mind is this Mormonism. And the most remarkable thing about it is perhaps the fact, that this worst product of America should so rapidly spread in old experienced Europe, and seem to elicit, even in cultivated Germany, much more curiosity and interest, than the most important political and ecclesiastical matters in the New World. Something similar is true of table-turning and spirit-rapping. If America is so prolific of all sorts of "humbugs," Europe was the honor of immediately imitating them.

The principal points in the external history of this sect are these:—The Book of Mormon, the last prophet of the Indians, was miraculously discovered, it is pretended, near Palmyra, N. Y., written on golden plates, abounding in Scripture passages and gross grammatical errors, and consisting of a very tedious romance about the ten tribes of Israel driven away to America and converted by Christ in person. The discoverer, Joe Smith, an uneducated but cunning Yankee, was assisted by an angel to translate into English and publish this new bible, the original of which, full of Egyptian hieroglyphics, has since disappeared. He was ordained to the "Melchisedekian priesthood," and made an effort, at first not very

successful, to gather from the corrupt Babel of nominal Christendom, on the basis of this new revelation, a distinct sect, styled:—The Church of Jesus Christ of Latter-Day Saints, and to prepare them for the approaching return of Christ, (A.D., 1830). This sect moved to the states of Ohio and Missouri; and not thriving there, and encountering violent persecution, they went to Illinois, where they built a city and a splendid temple at Nauvoo on the bank of the Mississippi, in 1839. There they were attacked by a violent outbreak of popular indignation against them, as a gang of shameless imposters and robbers; their temple was destroyed, and their prophet Joe Smith, since venerated by his successors as a holy martyr, was killed, (A.D., 1844). The remnant of the Mormons then made a toilsome pilgrimage over the Rocky Mountains to the Great Salt Lake, surrounded by high mountains, in the fertile and mineral territory of Utah, on the overland route to California (A.D., 1846). There they founded the city of the Great Salt Lake, also called the City of the Desert; a second Solomon's Temple, which, when finished, is intended to surpass everything the world has yet seen in this line; and a theocratic community under the direction of the inspired prophet and priest-king, Brigham Young. In this remote high-land of the Far West, almost cut off from all communication, they have made rapid material progress. They have sent missionaries into almost all parts of the world, and have successfully propagated themselves in England (especially in Wales, where they are said to have made thousands of converts), as well as in Denmark and Norway. Thus, almost like a second edition of Mohammedanism, has this sect risen in the extreme West, to the astonishment of the world; and just at the time, too, when the old Mohammedanism in the East is decaying and lying as a carcass, around which the Russian, French, and English eagles are gathering together.

Their crisis, however, is yet to come, when they shall have reached the lawful number of sixty thousand (they now number perhaps half this at Salt Lake), and Utah, one of the territories of the United States, shall come to be erected into an independent state. They may possibly give Congress great trouble, and require its armed interference. For it is very questionable, whether it will admit into its confederacy a state on such a theocratic and despotic basis, and with such moral or rather immoral principles and institutions. American toleration, as we have before remarked, has its limits; the separation of church and state by no means involves a separation of the nation from Christianity and Christian morality. The uncommon regard of the American people for the female sex absolutely requires monogamy; and for this reason alone they can never make terms with the Mormons. Their missionaries in Europe, it is said, indeed, commonly deny polygamy; but in the United States it is universally believed, that they practice it; and it has been recently stated in many journals, that their governor, Young, the successor of Smith, appeared in public with thirty wives, sixteen of whom had children at the breast. This would make the system a much enlarged and improved edition of Mohammedanism, with the best prospect of a numerous posterity. But, though this fact be not credited, we must still believe the American captain and engineer, Stansbury, who in his account of his expedition to the Salt Lake, states that he himself heard Governor Young say in the church, he had a right to take a thousand wives, if he thought good; and he challenged any one to contradict him from the Bible. The professed religious motive for polygamy is chiefly to raise up as fast as possible a "holy generation for the Lord."

Thus much is certain, that the Mormons and the Americans, or the proper people of the United States, do not fit together, but have a deadly hatred of each other. Hence the former, persecuted and driven away by their own countrymen, have tried their fortune in the Old World; and have already enticed hundreds and thousands to travel over sea and land to their New Zion beyond the Rocky Mountains, near the gold country of California; where a Mormon, in 1848, first discovered gold-dust in a brook. Declamations against their actual and supposed corruption of Christianity, and their high claims of new revelations and visions, always find ready access with a certain class. But at the same time the Mormons appeal to the spirit of emigration so widely diffused, and meet it with the most flattering promises. Their emigrant ships are said to be very cleanly, and in general excellently furnished. They have a special emigrant fund, to which every member is bound to contribute, to provide for the removal of indigent converts. They are even seriously thinking of opening an easier passage to the "State of the West," from the isthmus of Panama.

Mormonism, as a system of religion, strikingly resembles Irvingism. The Irvingites, in fact, see in it a diabolical caricature of their own figure; as the Roman Catholic missionaries thought the striking resemblances of some heathen religions of the East to the doctrines and usages of their church could be accounted for only as satanic imitations. Mormonism and Irvinigism are about contemporaneous in origin with each other and with Puseyism. Both look for the speedy return of Christ, and make it a leading object of faith and hope. Both consider all present Christendom, Protestant as well as Catholic, an apostate and hopeless Babel; only Irvingism is much more moderate and cautious on this point, having a high regard for church antiquity, and really seeking to combine the truth of Catholicism and Protestantism. Both believe, that the only remedy is to be found in a direct revelation and a supernatural new creation; nay, in a divine restoration of all the offices and miraculous powers of the apostolic church, Both have a hierarchy modelled on the apostolic constitution, with apostles, prophets, and evangelists. Both lay claim to the gift of tongues, prophecy, and the power of miraculous healing by prayer and laying on of hands; and indeed the Irvingites are inclined, with their rivals, to admit the agency of supernatural powers, but refer them to a satanic origin. Both regard the Jewish tithe-paying as a sacred Christian duty. Both send into all the world, where they are allowed access, apostles and evangelists to collect the "latter-day saints" into the true Zion, and to prepare for receiving the Lord in his glory.

But the Mormons lack the solemn liturgical worship of the Irvingites; and above all the fine culture, the deep moral and religious earnestness, the humility and mildness, the honest effort after holiness, and the Christian loveliness, for which the Irvingites, so far as I personally know, and can gather from the writings of Carlyle, Thiersch, Böhm, Rothe, and others, are highly distinguished, and by which they prove themselves true disciples and followers of Jesus, in spite of all their singular views. Nay, if only the half be true of what is reported in the public prints respecting the horrible "spiritual-wife system," as it is called, and other peculiarities of the Mormons, they are on a decidedly immoral and abominable track; so that the Americans cannot be particularly blamed for wishing to be rid of such a pest. But then the fact remains the more striking, which Captain Stansbury gives from his own observation, that among these

"Latter-day Saints" peace, harmony, and happiness generally prevail. It is remarkable, too, that Mormonism has had far better outward success, than Irvingism, which, though less bold and energetic, is incomparably higher and more pure and earnest in an intellectual and moral point of view. The Irvingites have only two small congregations in America, so far as I know, in the State of New York; and even in England and Germany they seem of late to be rather stationary. Thus, however, the tares often grow much faster than the wheat; and error is not seldom more popular than truth.

But I readily grant, that Mormonism is, to me, still one of the unsolved riddles of the modern history of religion; and I therefore venture no final judgment upon it. I must only beg, in the name of my adopted fatherland, that you will not judge America in any way by this irregular growth. She has inherited from her mother Europe, and preserved, much that is infinitely better, and will undoubtedly produce in future far worthier fruits in the field of religious and ecclesiastical life.

We need no new sects; there are already too many. We need no new revelation; the old is sufficient. America, to fulfill her mission, has only to present in its unity and beauty the old and eternally young church of Christ, according to the word of God and the nearly two thousand years' experience of Christian history, whose results are there embodied in so many denominations and sects, yet united in a common national life. Whatever may be her immediate future, thus much is certain: that there, as everywhere, the Lord rules supreme over the wisdom and folly of men, and that all kingdoms must at last bow to him, "from the rising of the sun even unto the going down of the same."

# Science, Immigration, and Consumer Capitalism, 1865–1920

The decades after the Civil War witnessed further social, political, and economic changes in the United States, not to mention intellectual and practical shifts in religion. Initially, religious responses to Charles Darwin's theories of evolution and natural selection were mostly favorable, if occasionally wary. Soon, however, some church leaders came to equate Darwinism with atheism, in a conflict that has persisted in various forms into our own time.

A second feature of this period that had an effect on religion was the steep rise in immigration. New immigrants numbered some 10 million between 1860 and 1890 and increased to 15 million between 1890 and 1914. Southern and eastern Europeans made up the majority of these immigrants, but Mexicans, Chinese, and Japanese were also part of the pattern. Jews and Catholics who were already in the United States experienced internal tensions as a growing number of their co-religionists arrived, many of whom hailed from different countries and classes and so did not always receive warm welcomes here. Waves of Protestant anti-Catholicism and, to a lesser extent, anti-Semitism, also erupted, signaling the strain felt by many white Protestants toward these foreign-looking newcomers. Religious multiplicity could be celebrated, as in the 1893 World's Parliament of Religions, but it also remained, for many, a persistent source of unease.

Finally, the glitz of the Gilded Age and the shift from an industrial, producer economy toward consumer capitalism that dawned around the turn of the twentieth century became a source of religious dissent. Groups varied in their outlooks on wealth and poverty, and these differences, too, are apparent in the selections included here.

# JAMES WOODROW

James Woodrow (1828–1907) first trained to be a scientist and later became a Presbyterian minister. Having studied under the noted natural scientist Louis Agassiz at Harvard, he then attended Heidelberg University, where he received a Ph.D. in chemistry under the tutelage of Robert Wilhelm Bunsen. Beginning in 1860, Woodrow served as the Perkins Professor at Columbia Theological Seminary in Columbia, South Carolina, in a faculty line intended to emphasize the compatibility of science and religion. He was a central figure in southern Presbyterian debates over evolution. After he vocalized his strong view that the Bible does not teach science and should not be the final authority on scientific knowledge, he was tried for heresy and, although acquitted, fired from his seminary position. This document, *Evolution*, is a lecture that Woodrow gave in 1884, shortly before church leaders declared Woodrow's teaching "repugnant to the word of God."

## Evolution

## ADDRESS

*Gentlemen of the Alumni Association:*
At the same time that you honored me with an invitation to deliver an address before you on this occasion, the Board of Directors of the Theological Seminary, in view of the fact that "Scepticism in the world is using alleged discoveries in science to impugn the word of God," requested me "to give fully my views, as taught in this institution, upon Evolution, as it respects the world, the lower animals, and man." Inasmuch as several members of the Board are also members of this Association, and both Board and Association feel the same interest in the Seminary, I have supposed that I could not select a subject more likely to meet with your approval than the one suggested to me by the Directors.

I am all the more inclined to make this choice, as it will afford me the opportunity of showing you that additional study has, in some respects, to a certain extent modified my views since I expressed them to many of you in the class-room.

As is intimated in the Board's request, I may assume that your chief interest in the topic is not in its scientific aspects, but in relations it may bear to the word

of God; and therefore I will speak mainly of these relations. Not that I regard you as indifferent to science; from my past acquaintance with you, I have too high an appreciation of your intelligence to regard that as possible; for no intelligent person can be indifferent to knowledge, and especially can no intelligent child of God be indifferent to a knowledge of his Father's handiwork, or of the methods by which he controls the course of his universe. Still, on the present occasion it is doubtless the relations between science, or that which claims to be science, and the Bible; and not science itself, that should receive our attention.

Before entering on the discussion of the specific subject of Evolution in itself and in its relations to the Sacred Scriptures, it may be well to consider the relations subsisting between the teachings of the Scriptures and the teachings of natural science generally. We hear much of the harmony of science and Scripture, of their reconciliation, and the like. Now, is it antecedently probable that there is room for either agreement or disagreement? We do not speak of the harmony of mathematics and chemistry, or of zoology and astronomy, or the reconciliation of physics and metaphysics. Why? Because the subject-matter of each of these branches of knowledge is so different from the rest. It is true we may say that some assertion made by astronomy cannot be correct, because it contradicts some known truth of mathematics or of physics. But yet, in such a case, we would not proceed to look for harmony or reconciliation; we would confine ourselves to the task of removing the contradiction by seeking the error which caused it, and which it proved to exist; for we know that, as truth is one, two contradictories cannot both be true.

May it not be that we have here a representation of the probable relations between the Bible and science—that their contents are so entirely different that it is vain and misleading to be searching for harmonies; and that we should confine our efforts to the examination of real or seeming contradictions which may emerge, and rest satisfied, without attempting to go farther, when we have discovered that there is no contradiction, if it was only seeming, or have pointed out the error that caused it, if real?

Let us test this point by examining special cases which have arisen, and with regard to which conclusions satisfactory to all believers in the Bible have now been reached.

In Genesis i. 16, the Bible speaks of the two great lights, the sun and the moon, and of the stars as if these were of comparatively insignificant size and importance. It says further, Joshua x. 13, that "the sun stood still, and the moon stayed"; "the sun stood still in the midst of the heaven, and hasted not to go down about a whole day." In these and other passages the Bible has been thought to teach that the sun and the moon are larger than any of the stars, and that sun, moon, and stars, having been created for the benefit of man, revolve around the earth as a centre. On the scientific side, two forms of astronomy have been presented: the Ptolemaic, teaching that the earth is the centre of the universe; the Copernican, teaching that the sun is the centre of our planetary system. Those who asked for harmony between science and the Bible found wonderful confirmation of the Bible in the Ptolemaic astronomy, and of the Ptolemaic astronomy in the Bible. But gradually it came to be seen and admitted that, whatever might be its teachings on other subjects, the Bible was at least not intended to teach

astronomy; and for centuries general assent has been given to the words of Calvin: "Moses does not speak with philosophical acuteness on occult mysteries, but relates those things which are everywhere observed, even by the uncultivated." . . "He who would learn astronomy, and other recondite arts, let him go elsewhere." Thus it has come to be believed that all we are entitled to ask, as regards the relations between astronomy and the Bible, is that they shall not contradict each other; not that they shall agree with each other. Believers in the Bible as such are indifferent as to what form of astronomy may prevail. Calvin's belief in the geocentric system no more interfered with his confidence in the Bible than does our belief in the heliocentric system interfere with our confidence in the same sure word.

Geography furnishes another illustration of this same kind of harmony between the Bible and science, which is not less instructive. For centuries geographers taught as science that which was claimed to be in perfect accord with the Bible in such passages as these: "They shall gather together his elect from the four winds, from one end of heaven to the other"; "I saw four angels standing on the four corners of the earth, holding the four winds of the earth"; "And shall go out to deceive the nations of the four quarters of the earth." So the Bible and science were thus found further to confirm each other. But, again, in process of time it came to be seen that neither the words of the Bible nor the phenomena of the earth taught what had been supposed; that the Bible taught nothing about the shape or other characteristics of the earth in these or other passages; and that the phenomena of the earth, rightly understood, did not teach that it is a four-cornered immovable plain. Here, again, it is seen that all we should ask for is not harmony, but absence of contradiction. The examination of other cases would lead to the same conclusion.

The Bible does not teach science; and to take its language in a scientific sense is grossly to pervert its meaning.

Yet it is not correct in any of these cases to say that the language of the Bible does not express the exact truth; that it is accommodated to the weakness of the popular mind, to the ignorance of the unlearned. We are often told by some defenders of the Bible that it speaks inaccurately when it says that the sun rises and sets, or that it stood still upon Gibeon. But what is accurate speech? It is speech which conveys exactly the thought intended. Now, if to say that the sun rises conveys exactly the thought intended, wherein can this expression be called inaccurate? There is no intention to explain the cause of the fact of rising. This fact exists equally, whether produced by the sun's absolute motion in space or by the rotation of the earth on its axis. The meaning is, that the relative position of our horizon and the sun has changed in a certain way; and in stating that the change has taken place, there is not the remotest reference to the cause. In passing from Europe to the United States, we say that we go westward. But we are met by the assertion, uttered in a patronising tone of superior wisdom: "Oh no; you speak erroneously; you show that you are not acquainted with the real state of the facts; or if you are, you are speaking inaccurately for the sake of accommodating yourself to your ignorant hearers; you make a false statement because your hearers could not otherwise gain any idea from you on the subject. The truth is, that when you thought you were going westward, you were going eastward at a rapid rate; what you call your going westward was merely stop-

ping a small part of the eastward motion you had in common with the surface of the earth." Now it would probably be hard to discuss this sage utterance in a perfectly respectful manner. But wherein does it differ from the tone of those who apologise for the "gross form" in which the Scriptures convey instruction, for their not speaking with "greater exactness," and the like? A phenomenal truth is as much a truth as is the so-called scientific explanation of it; and words which accurately convey a knowledge of the phenomenon are as exactly true as those which accurately convey a knowledge of the explanation. Science has to do almost exclusively with the explanation; it is interested in phenomenal truths only on account of their relations to each other; while the Bible speaks solely of the phenomenal truths involved in natural science for their own sake, and never for the sake of the explanation of them or their scientific relations to each other.

Admitting these principles, which are so readily admitted in their application to the cases already considered, many difficulties usually regarded as of the gravest character at once disappear. For example, in Leviticus xi. and Deut. xiv. the divinely inspired lawgiver classes the coney and the hare as animals that chew the cud; he places the bat amongst the birds; he speaks of the locust, the beetle, and the grasshopper as flying creeping things that go upon all four. Now if these representations are to be taken as scientific statements, we must without hesitation say there is here a sad batch of blunders: for the coney and the hare do not chew the cud; the bat is not a bird; the locust, the beetle, the grasshopper, and other flying creeping things, do not go upon four, but upon six. But now suppose that the words used conveyed exactly the knowledge that was intended, are they not correctly used? *We* understand by "chewing the cud" bringing back into the mouth, for the purpose of being chewed, food which had been previously swallowed; but if those to whom the words in question were addressed understood by them that motion of the mouth which accompanies chewing, then they would recognise by this motion the hare and the coney as rightly characterised. So with the bat—in a scientific sense it is not a bird; it is a mammal; hence, if we are teaching natural history, we would grievously err in making such a classification. But in describing flying things which do not creep, the bat was rightly placed where it is. Two years ago the Legislature of South Carolina enacted that "it shall not be lawful for any person . . . to destroy any bird whose principal food is insects, . . . comprising all the varieties of birds represented by the several families of *bats*, whip-poor-wills, . . . humming birds, blue birds," etc. Does this law prove that the Legislature did not know that the bat in a natural history sense is not a bird? They were not undertaking to teach zoology: they wished to point out the flying animals whose principal food is insects, and with all propriety and accuracy they did it. So "going on all four," when used in reference to the motion of animals, may fairly be taken as applying to the prone position of the animal which is common to the quadruped and the insect, and not at all to the number of feet. In this sense the phrase with perfect accuracy applies to the horizontal position of the locust and other insects; while the important natural history fact, that the insect has six feet, and not four, is perfectly immaterial.

In all these instances I think it has been made to appear that there is no contradiction; but he would be bold indeed who would claim that there is here

harmony between science and the Bible. On the contrary, is it not most pointedly suggested that any exposition of Scripture which seems to show that natural science is taught, is thereby proved to be incorrect? For this reason, I may say in passing, I am strongly inclined to disbelieve the popular interpretations of the first chapter of Genesis, which find there a compendium of the science of geology.

As in the example above given, so in all other cases of supposed contradiction of the Bible by science, I have found that the fair honest application of such principles has caused the contradiction to disappear. I have found nothing in my study of the Holy Bible and of natural science that shakes my firm belief in the divine inspiration of every word of that Bible, and in the consequent absolute truth, the absolute inerrancy, of every expression which it contains, from beginning to end. While there are not a few things which I confess myself wholly unable to understand, yet I have found nothing which contradicts other known truth. It ought to be observed that this is a very different thing from saying that I have found everything in the Sacred Scriptures to be in harmony with natural science. To reach this result it would be necessary to know the exact meaning of every part of the Scriptures, and the exact amount of truth in each scientific proposition. But to show that in any case there is no contradiction, all that is needed is to show that a reasonable supposition of what the passage in question may mean does not contradict the proved truth in science. We do not need to show that our interpretation *must* be correct, but only that it *may* be correct—that it is not reached by distortion or perversion, but by an honest application of admitted principles of exegesis.

It should be noted that the matters respecting which there are supposed to be inconsistencies between the teachings of science and the Bible are such as cannot possibly directly affect any moral or religious truth; but that they derive their importance to the Christian believer solely from the bearing they may have on the truthfulness of the Scriptures. In the name of Christianity, belief in the existence of people living on the other side of the earth has been denounced as absurd and heretical; but how is any moral duty or any doctrine of religion affected by this belief? unless, indeed, it may be from doubt it may cast upon the truthfulness of the Bible. And with this exception, what difference can it make with regard to any relation between ourselves and our fellow-men, or between ourselves and God and the Lord Jesus Christ, whether the earth came into existence six thousand years or six thousand million years ago; whether the earth is flat or round; whether it is the centre of the universe or on its edge; whether there has been one creation or many; whether the Noachian deluge covered a million or two hundred million square miles; and last of all, I may add, whether the species of organic beings now on the earth were created mediately or immediately?

After these preliminary observations, I proceed to discuss the main subject of this address.

Before answering the question, What do you think of Evolution? I must ask, What do you mean by Evolution?

When thinking of the origin of anything, we may inquire, Did it come into existence just as it is? or did it pass through a series of changes from a previous state in order to reach its present condition? For example, if we think of a tree, we can conceive of it as having come immediately into existence just as we see

it; or, we may conceive of it as having begun its existence as a minute cell in connexion with a similar tree, and as having reached its present condition by passing through a series of changes, continually approaching and at length reaching the form before us. Or thinking of the earth, we can conceive of it as having come into existence with its present complex character; or we may conceive of it as having begun to exist in the simplest possible state, and as having reached its present condition by passing through a long series of stages, each derived from its predecessor. To the second of these modes, we apply the term "Evolution." It is evidently equivalent to "derivation"; or, in the case of organic beings, to "descent."

This definition or description of Evolution does not include any reference to the power by which the origination is effected; it refers to the mode, and to the mode alone. So far as the definition is concerned, the immediate existence might be attributed to God or to chance; the derived existence to inherent uncreated law, or to an almighty personal Creator, acting according to laws of his own framing. It is important to consider this distinction carefully, for it is wholly inconsistent with much that is said and believed by both advocates and opponents of Evolution. It is not unusual to represent Creation and Evolution as mutually exclusive, as contradictory: Creation meaning the immediate calling out of non-existence by divine power; Evolution, derivation from previous forms or states by inherent, self-originated or eternal laws, independent of all connexion with divine personal power. Hence, if this is correct, those who believe in Creation are theists; those who believe in Evolution are atheists. But there is no propriety in thus mingling in the definition two things which are so completely different as the power that produces an effect, and the mode in which the effect is produced.

The definition now given, which seems to me the only one which can be given within the limits of natural science, necessarily excludes the possibility of the questions whether the doctrine is theistic or atheistic, whether it is religious or irreligious, moral or immoral. It would be as plainly absurd to ask these questions as to inquire whether the doctrine is white or black, square or round, light or heavy. In this respect it is like every other hypothesis or theory in science. These are qualities which do not belong to such subjects. The only question that can rationally be put is, Is the doctrine true or false? If this statement is correct,—and it is almost if not quite self-evident—it should at once end all disputes not only between Evolution and religion, but between natural science and religion universally. To prove that the universe, the earth, and the organic beings upon the earth, had once been in a different condition from the present, and had gradually reached the state which we now see, could not disprove or tend to disprove the existence of God or the possession by him of a single attribute ever thought to belong to him. How can our belief in this doctrine tend to weaken or destroy our belief that he is infinite, that he is eternal, that he is unchangeable, in his being, or his wisdom, or his power, or his holiness, or his justice, or his goodness, or his truth? Or how can our rejection of the doctrine either strengthen or weaken our belief in him? Or how can either our acceptance or rejection of Evolution affect our love to God, or our recognition of our obligation to obey and serve him—carefully to keep all his commandments and ordinances?

True, when we go outside the sphere of natural science, and inquire whence this universe, questions involving theism forthwith arise. Whether it came into existence immediately or mediately is not material; but what or who brought it into existence? Did it spring from the fortuitous concurrence of eternally-existing atoms? Are the matter and the forces which act upon it in certain definite ways eternal; and is the universe, as we behold it, the result of their blind unconscious operation? Or, on the other hand, was the universe in all its orderly complexity brought into existence by the will of an eternal personal spiritual God, one who is omniscient, omnipresent, omnipotent? These questions of course involve the very foundations of religion and morality; but they lie wholly outside of natural science; and are, I repeat, not in the least affected by the decision of that other question, Did the universe come into its present condition immediately or mediately; instantly, in a moment, or gradually, through a long series of intermediate stages? They are not affected by, nor do they affect, the truth or falsehood of Evolution.

But, admitting that the truth of Theism is not involved in the question before us, it may fairly be asked, Does not the doctrine of Evolution contradict the teachings of the Bible? This renders it necessary to inquire whether the Bible teaches anything whatever as to the mode in which the world and its inhabitants were brought into their present state; and if so, what that teaching is.

It does not seem to be antecedently probable that there would be any specific teaching there on the subject. We have learned that "the Scriptures principally teach what man is to believe concerning God, and what duty God requires of man"; and that "the whole counsel of God, concerning all things necessary for his own glory, man's salvation, faith, and life, is either expressly set down in Scripture, or by good and necessary consequence may be deduced from Scripture." But this does not include the principles of natural science in any of its branches. We have already seen that it certainly does not include the teaching of astronomy or of geography; it does not include anatomy or physiology, zoology or botany—a scientific statement of the structure, growth, and classification of animals and plants. Is it any more likely that it includes an account of the limits of the variation which the kinds of plants and animals may undergo, or the circumstances and conditions by which such variation may be affected? We would indeed expect to find God's relation to the world and all its inhabitants set forth; but he is equally the Creator and Preserver, however it may have pleased him, through his creating and preserving power, to have brought the universe into its present state. He is as really and truly your Creator, though you are the descendant of hundreds of ancestors, as he was of the first particle of matter which he called into being, or the first plant or animal, or the first angel in heaven.

So much at least seems clear—-that whatever the Bible may say touching the mode of creation, is merely incidental to its main design, and must be interpreted accordingly. Well may we repeat with Calvin, "He who would learn astronomy and other recondite arts, let him go elsewhere."

It is further to be observed, that whatever may be taught is contained in the first part of the oldest book in the world, in a dead language, with a very limited literature; that the record is extremely brief, compressing an account of the most stupendous events into the smallest compass. Now the more remote from the

present is any event recorded in human language, the more completely any language deserves to be called dead, the more limited its contemporaneous literature, the briefer the record itself, the more obscure must that record be—the more difficult it must be to ascertain its exact meaning, and especially that part of its meaning which is merely incidental to its main design. As to the portions which bear on that design, the obscurity will be illuminated by the light cast backwards from the later and fuller and clearer parts of the Bible. But on that with which we are now specially concerned no such light is likely to fall.

To illustrate this point, I may refer to other parts of this early record. In the account of the temptation of Eve, we have a circumstantial and apparently very plain description of the being that tempted her. It was a serpent; and we read that "the serpent was more subtil than any beast of the field." Further, it was a beast which was to go upon its belly, and whose head could be bruised. Surely, it might be said, it is perfectly plain that the record should cause us to believe that it was a mere beast of the field, a mere serpent, that tempted Eve. But to narrate the fall of man is not simply incidental to the design of the Bible; on the contrary, its chief design may be said to be to record that fall and to show how man may recover from it. Hence, from the later parts of the Bible we learn that the tempter was no beast of the field, as seems to be so clearly stated; but it was "the dragon, that old serpent, which is the devil, even Satan," whatever may have been the guise in which he appeared to our first mother.

Then from the sentence pronounced upon the serpent, "I will put enmity between thee and the woman, and between thy seed and her seed; it shall bruise thy head, and thou shalt bruise his heel,"—from this it would seem to be clear that what we are here taught, and all that we are here taught, is that the woman's son was to crush the head of the beast, whilst his own heel would be bruised; whereas we learn from books which come after that this sentence really contains the germ of the entire plan of salvation; and that the woman's son who was to bruise the serpent's head at such cost to himself is Jesus the Saviour, who on Calvary through his death destroyed "him that had the power of death, that is, the devil." Now, since in these cases, where the meaning seems to be so unmistakably clear, and where the subject matter belongs to the main design of the book, and yet where the real meaning is so entirely different, as we learn from the later Scriptures, how cautious we should be not to feel too confident that we have certainly reached the true meaning in cases where the subject-matter is merely incidental, and where no light falls back from the later Scriptures to guide us aright!

The actual examination of the sacred record seems to me to show that the obscurity exists which might have been reasonably anticipated. It is clear that God is there represented as doing whatever is done. But whether in this record the limitless universe to the remotest star or nebula is spoken of, or only some portion of it, and if the latter, what portion, I cannot tell. And if there is an account of the methods according to which God proceeded in his creative work, I cannot perceive it. It is said *that* God created; but, so far as I can see, it is not said *how* he created. We are told nothing that contradicts the supposition, for example, that, in creating our earth and the solar system of which it forms a part, he brought the whole into existence very much in the condition in which we now see the several parts; or, on the other hand, that he proceeded by the steps indicated in what is

called the nebular hypothesis. Just as the contrary beliefs of Calvin and ourselves touching the centre of the solar system fail to contradict a single word in the Bible, so the contrary beliefs of those who accept and those who reject the nebular hypothesis fail to contradict a single word of the Bible.

I regard the same statements as true when made respecting the origin of the almost numberless species of organic beings which now exist and which have existed in the past. In the Bible I find nothing that contradicts the belief that God immediately brought into existence each form independently; or that contradicts the contrary belief that, having originated one or a few forms, he caused all the others to spring from these in accordance with laws which he ordained and makes operative.

If that which is perhaps the most commonly received interpretation of the biblical record of creation is correct, then it is certain that the Bible, implicitly yet distinctly, teaches the doctrine of Evolution. According to this interpretation, the record contains an account of the first and only origination of plants and animals, and all that exist now or that have existed from the beginning are their descendants. If, then, we have the means of ascertaining the characteristics of these ancestors of existing kinds, we can learn whether they were identical with their descendants or not. If the early forms were the same as the present, then the hypothesis of Evolution or descent with modification is not true; but if they were different, then it is true. Now, not indeed the very earliest, but great numbers of the earlier forms of animals and plants have been preserved to the present day, buried in the earth, so that we can see for ourselves what they were. An examination of these remains makes it absolutely certain that none of the species now existing are the same as the earlier, but that these were wholly unlike those now living; and that there have been constant changes in progress from the remote ages of the past, the effect of which has been by degrees to bring the unlike forms of a distant antiquity into likeness with those which are now on the earth. Hence all who believe that the creation described in the Bible was the origination of the ancestors of the organic forms that have since existed, cannot help believing in the hypothesis of Evolution. This is so obvious that it is surprising that it has been so generally overlooked.

There seems to be no way of avoiding this conclusion, except by assuming that the so-called remains of animals and plants buried in the earth are not really remains of beings that were once alive, but that God created them just as we find them. But this assumption must be rejected, because it is inconsistent with a belief in God as a God of truth. It is impossible to believe that a God of truth would create corpses or skeletons or drift-wood or stumps.

If the interpretation which I have spoken of as perhaps most commonly received is rejected, then it may be thought that the Bible speaks only of the first origination of organic beings millions of years ago, but says nothing of the origin of the ancestors of those now on the earth; but that it may be supposed that when one creation became extinct, there were other successive immediate independent creations down to the beginning of the present era. There may be nothing in the Bible contradicting this supposition; but certainly there is nothing there favoring it. And if it is rejected in favor of Evolution, it is not an interpretation of Scripture that is rejected, but something that confessedly lies outside of it.

Or, in the next place, the interpretation may be adopted that the narrative in the Bible relates exclusively to the origination of existing forms, and that it is wholly silent respecting those of which we find the buried remains. It need hardly be said that, on this interpretation, as in the last case, there is nothing in the silence of the Scriptures that either suggests or forbids belief in Evolution as regards all the creations preceding the last. For anything that appears to the contrary, the multitudes of successively different forms belonging to series unmentioned in Scripture may have sprung from a common source in accordance with the doctrine of descent with modification.

When we reach the account of the origin of man, we find it more detailed. In the first narrative there is nothing that suggests the mode of creating any more than in the case of the earth, or the plants and animals. But in the second, we are told that "the Lord God formed man of the dust of the ground, and breathed into his nostrils the breath of life; and man became a living soul." Here seems to be a definite statement utterly inconsistent with the belief that man, either in body or soul, is the descendant of other organised beings. At first sight the statement, that "man was formed of the dust of the ground," seems to point out with unmistakable clearness the exact nature of the material of which man's body was made. But further examination does not strengthen this view. For remembering the principles and facts already stated, and seeking to ascertain the meaning of "dust of the ground" by examining how the same words are employed elsewhere in the narrative, the sharp definiteness which seemed at first to be so plainly visible somewhat disappears. For example, we are told in one place that the waters were commanded to bring forth the moving creature that hath life, and fowl that may fly above the earth; and the command was obeyed. And yet, in another place we are told that out of the ground the Lord God formed every beast of the field, and every fowl of the air. Now as both these statements are true, it is evident that there can be no intention to describe the material employed. There, was some sort of connexion with the water, and some with the ground; but beyond this nothing is clear. Then further, in the sentence which God pronounced upon Adam, he says: "Out of the ground wast thou taken; for dust thou art, and unto dust shalt thou return." And in the curse uttered against the serpent, it was said: "Dust shalt thou eat all the days of thy life." Now Adam, to whom God was speaking, was flesh and blood and bone; and the food of serpents then as now consisted of the same substances, flesh and blood. The only proper conclusion in view of these facts seems to be that the narrative does not intend to distinguish in accordance with chemical notions different kinds of matter, specifying here inorganic in different states, and there organic, but merely to refer in a general incidental way to previously existing matter, without intending or attempting to describe its exact nature. For such reasons it does not seem to me certain that we have a definite statement which necessarily conveys the first meaning mentioned touching the material used in the formation of man's body. If this point is doubtful, there would seem to be no ground for attributing a different origin to man's body from that which should be attributed to animals: if the existing animal species were immediately created, so was man; if they were derived from ancestors unlike themselves, so may man have been. Just so far as doubt rests on the meaning of the narrative, just so far are we forbidden to say that either mode of creation contradicts the

narrative. And as the interpretation suggested may be true, we are not at liberty to say that the Scriptures are contradicted by Evolution.

As regards the soul of man, which bears God's image, and which differs so entirely not merely in degree but in kind from anything in the animals, I believe that it was immediately created, that we are here so taught; and I have not found in science any reason to believe otherwise. Just as there is no scientific basis for the belief that the doctrine of derivation or descent can bridge over the chasms which separate the non-existent from the existent, and the inorganic from the organic, so there is no such basis for the belief that this doctrine can bridge over the chasm which separates the mere animal from the exalted being which is made after the image of God. The mineral differs from the animal in kind, not merely in degree; so the animal differs from man in kind; and while science has traced numberless transitions from degree to degree, it has utterly failed to find any indications of transition from kind to kind in this sense. So in the circumstantial account of the creation of the first woman, there are what seem to me insurmountable obstacles in the way of fully applying the doctrine of descent.

But it is not surprising that, even if Evolution is generally true, it should not be true of man in his whole being. Man, as the image of God, is infinitely above the animals; and in man's entire history God has continually been setting aside the ordinary operation of the laws by which he controls his creation. For man's sake, the course of the sun in the heavens was stayed; the walls of Jericho fell down at the sound of the trumpets; manna ordinarily decayed in one day, but resisted decay for two days when one of these was the day of man's sacred rest; for man's sake the waters of the Red Sea and of the River Jordan stood upright as an heap; iron was made to swim; women received their dead raised to life again; the mouths of lions were stopped; the violence of fire was quenched; water was turned into wine; without medicine the blind saw, the lame walked, the lepers were cleansed, the dead were raised; more than all, and above all, for man's sake God himself took on him our nature as the second Adam by being born of a woman, underwent the miseries of this life, the cursed death of the cross; was buried; he rose again on the third day, ascended into heaven; whence, as both God and man, he shall come to judge the world at the last day. Surely then, I repeat, it is not surprising that, though man in his body so closely resembles the animals, yet as a whole his origin as well as his history should be so different from theirs.

Having now pointed out the probable absence of contradiction between the Scripture account of creation and the doctrine of Evolution, except in the case of man so far as regards his soul, but without having at all considered the probable truth or falsehood of Evolution, I proceed next, as briefly as possible, to state a few of the facts which seem to be sufficient at least to keep us from summarily rejecting the doctrine as certainly false.

First, as to the earth, in connexion with the other members of our solar system.

Some inquirers into the past history of this system have been led to suppose that at one time the whole of the matter now composing the various separate bodies may have existed in a nebulous state, forming a vast sphere with a diameter far exceeding that of the orbit of Neptune, the outermost planet; that this

sphere rotated about its axis, and that it was undergoing gradual contraction. If there ever was such a sphere, it is claimed by some of those who have most carefully studied these subjects, that, in accordance with the laws by which God is now governing his material works, just such a solar system as ours would necessarily have resulted. As the sphere contracted, the nebulous matter would become more dense, and the rate of rotation would increase and would thereby increase the centrifugal force so that at length a belt or ring would be thrown off from the equatorial region of the sphere; which belt might continue to rotate as an unbroken mass, or, if broken, would be collected by the laws of attraction into a spheroidal body, which would rotate upon its own axis and would also continue to revolve in a path around the axis of the whole mass—both these revolutions being in the same direction, the axis of the new spheroid being not far from parallel with the general axis, and the orbit of revolution being not far from parallel with the plane of the general equator. This process would be repeated from time to time, new belts or spheroids with the same characteristics being successively formed. So from each of these spheroids, as it continued to contract, similar secondary spheroids might be successively formed, each assuming a shape determined by the rate of rotation. At a certain stage in the cooling, the nebulous matter would become a liquid molten mass, ultimately solid. As the solid spheroid cooled still more, it would still continue to contract, but unequally in the interior and on the exterior, and thus the surface would be covered with successively formed wrinkles or ridges.

Now, in every particular, with very slight exception, the constitution of our solar system and our earth is exactly such as has just been described. It consists of a number of spheroids, each rotating on its own axis, and revolving around a central mass; and around the several primary spheroids are others which rotate on their axes, and revolve around their primaries as these do around the sun—all having a form determined by the rate of rotation; the primaries or planets all rotate on axes nearly parallel with the axis of the sun; the planes of their orbits of revolution nearly coincide with the equatorial plane of the sun; these revolutions and rotations are all in the same direction; in the case of Saturn, in addition to revolving satellites are revolving belts or rings. Coming to our earth, it exhibits the plainest marks of having once been in a molten state; the great mountain chains, which certainly have been formed during successive periods, are just such as would be formed by the wrinkling of the earth's crust caused by unequal contraction. Hence it would seem not unreasonable to conclude that, if the nebular hypothesis has not been proved to be certainly true, it has at least been shown to be probable. The number and variety of coincidences between the facts which we see and the necessary results of the supposition on which the nebular hypothesis is founded, are so very great that it must go far to produce the conviction that that supposition can hardly be wrong. As before intimated, the correspondence is not perfect; but the exceptions are not such as to disprove the hypothesis—they are merely the residual phenomena, which in the case of even the most firmly established principles await a full explanation.

If it should be objected that, as this scheme rests on a mere supposition, no part of the superstructure can be stronger than the foundation, and that therefore it must be supposition and nothing more throughout, I would say that this objection rests on a misapprehension of the nature of reasoning on such subjects. Let

us examine, by way of illustration, the method by which the truth of the doctrine of gravitation was established. At first it was the gravitation hypothesis merely. Newton formed the supposition that the heavenly bodies are drawn towards each other by the same force which draws bodies towards each other on the earth. He calculated what the motions of the moon and the planets should be if this supposition is correct. After many efforts, he found that many of these motions were nearly what his supposition would require. Even the first observed coincidence was a step towards proving the truth of his hypothesis; and as these coincidences multiplied, his conviction of its truth was increased; until at length he and all who took the trouble to become acquainted with the facts of the case believed with the utmost confidence that it was absolutely true. But even when this conviction was reached, there were still many phenomena which Newton could not explain on his hypothesis; but these residual phenomena, formidable as they were, did not shake his confidence, and should not have done so. Now, if Newton's gravitation hypothesis was entitled to his confidence on account of the number and variety of coincidences, notwithstanding the apparently inconsistent facts, ought not the nebular hypothesis to be entitled to similar confidence, provided there should be similar coincidences in number and variety, even though there remain some apparently inconsistent facts? And as the gravitation hypothesis rests upon a mere supposition in the same sense with the nebular hypothesis, ought the superstructure for that reason to be rejected in the one case any more than in the other?

It deserves to be remarked here that, after Newton had framed his hypothesis, he was led for years to abandon it, inasmuch as with the measurements of the earth on the basis of which he made his first calculations the motions of the heavenly bodies were utterly inconsistent with it.

To conclude, then, as regards the earth, I would say in the terms of one definition of Evolution—terms which have furnished to witlings so much amusement, but yet which so accurately and appropriately express the idea intended—that I think it very probable that our earth and solar system constitute one case in which the homogeneous has been transformed by successive differentiations into the heterogeneous.

In the next place, respecting the origin of the various kinds of animals and organised forms generally, it has been supposed by some naturalists that existing forms, instead of having been independently created, have all been derived by descent, with modification, from a few forms or a single one. It is known that the offspring of a single pair differ slightly from each other and from their parents; it is further known that such differences or variations may be transmitted to subsequent generations; and it is self-evident that under changing conditions the varieties best fitted to the new conditions would be most likely to survive. Now, under the operation of these principles, it is held that all the immense variety of existing forms of plants and animals may have sprung from one or a few initial simple types.

In accordance with this supposition, the earliest inhabitants of the world would be very simple forms. Among the varieties produced in successive generations some would be more complex in their organisation than their parents; such complexity being transmitted would form kinds somewhat higher in rank; these in turn would give rise to others still more complex and higher; until at

length at the present day the most complex and highest would exist. All would not undergo such modifications as to produce the higher forms; hence there would be at all times, along with the highest, every intermediate stage—though the existing low forms would differ in many particulars from their ancestors, unless, indeed, the conditions under which they lived remained unchanged.

Now, in the statement just made we have an outline of the facts made known to us by an examination of the animals and plants which are buried in the earth. The sediment in the waters all over the world sooner or later sinks to the bottom in the form of layers; this sediment contains remains of plants and animals carried down with it, and in various ways permanently preserves them. Of course only a very small part of the plants and animals could be thus preserved; still a few would be. If we could gain access to these layers and examine their contents, we would obtain a knowledge of the successive generations of the past—the lowest layer being the oldest. It happens that a vast number of such layers have been hardened into rock, and have been raised from the waters where they were formed, and so broken and tilted that we have ready access to them. Not less than nine-tenths of the dry land, so far as examined, is composed of sedimentary rocks; and of these a large part contain the remains of plants and animals which were living at the time the rocks were formed. Of course it is not to be supposed that a complete series is known of all that ever were formed; still enough are brought to view to lead to the belief that from an examination of their contents we may obtain a fair knowledge of the history of the succession of animals and plants from an early period down to the present. We cannot go back to the beginning, but we can go a long way. The outline thus obtained shows us that all the earlier organic beings in existence, through an immense period, as proved by an immense thickness of layers resting on each other, were of lower forms, with not one as high or of as complex an organisation as the fish. Then the fish appeared, and remained for a long time the highest being on the earth. Then followed at long intervals the amphibian, or frog-like animal, the reptile, the lowest mammalian, then gradually the higher and higher, until at length appeared man, the head and crown of creation. The plants present a similar history—the first known being simple forms, like the seaweed, followed as we pass upwards through the later layers, by forms of higher and higher type, until we reach the diversity and complexity of existing vegetation. It is seen, too, that when a new type is first found, it does not present the full typical characters afterwards observed, but along with some of these also some of the characters belonging to other types. The earliest reptiles, for example, present many of the characters of the fish, the earliest birds and mammals many of the characters of the reptile; and so throughout the series. It is true there are many gaps, but not more than might be expected from the fact that the series of layers containing the remains is incomplete. When the layers show that the circumstances existing during the period while they were forming remained unchanged, then the kinds of animals underwent little or no change; but if the layers show rapid changes in climate, depth of water, etc., then the species of animals changed rapidly and frequently.

It would further follow, from the supposition under consideration, that, all animals being related to each other by descent, they must resemble each other. In the organic world every one knows that likeness suggests relationship, and

that relationship usually accompanies likeness—the nearer the relationship, the closer generally is the likeness. Now, careful observation makes known to us that the various animals are surprisingly like each other. In the highest class of vertebrate animals, and also in man, for example, the skeleton, the nervous system, the digestive system, the circulatory system, are all constructed on exactly the same plan. If the skull of a man is compared with the skull of a dog, or a horse, each will be seen to be composed of the same bones similarly situated. Where the number differs, the difference will be seen to result from the growing together of several bones in one case which were separate in the others. So the human arm, the leg of the quadruped, the wing of the bird, the paddle of the whale, will be found to be formed on exactly the same plan. When the form of the animal is such as to render unnecessary any part belonging to the general plan, it is not omitted at once, but is reduced in size and so placed as not to be in the way, and then in other similar animals by degrees passes beyond recognition. And so it is with every part. There are also the same kinds of resemblance between the lowest animals; and, further, between any section of the lower animals and those which are just above or just below them in rank. Thus we may arrange all the forms in the entire animal kingdom, from highest to lowest, according to their resemblances; and while the highest is indeed very unlike the lowest—a man very unlike a simple cell—yet at every step as we pass through the entire series we find the resemblances vastly greater than the differences.

We thus have another set of facts which plainly would follow from descent with modification.

The existence of rudimentary organs is still another fact which would follow very naturally from this mode of creation, but which seems not very likely to have occurred if each species was independently created. For example, though a cow has no upper front teeth, a calf has such teeth some time before it is born. The adult whalebone whale has no teeth at all, but the young before birth is well supplied with them. In the blind worm, a snake-like animal, there are rudimentary legs which never appear externally. In the leg of a bird, the bone below the thigh-bone, instead of being double as in the general plan, has the shin-bone, and a rudimentary bone welded into it representing the small outer bone, but not fulfilling any of its uses. The blind fish of the Mammoth Cave have optic nerves and rudimentary eyes. So in the leg of the horse, of the ox, and indeed in many parts of the body of every kind of animal, will be found rudimentary organs, apparently not of the least use to the animal itself, but of great use to those animals which they closely resemble. All these facts are just such as the doctrine of descent with modification would lead us to expect, but which seem hard to understand on the supposition that each species was independently and immediately created.

Again, the changes through which an animal passes in its embryonic state are just such as the doctrine of descent requires. All animals begin life in the lowest form, and all in substantially the same form. Each at first is a simple cell. Beginning with this cell in the case of the higher animals, we find that, in the course of embryonic development, at successive stages the general forms are presented which characterise the several groups in which animals are placed when classified according to their resemblance to each other, ascending from the lowest to the highest. While it cannot be said that the human embryo is at one period

an invertebrate, then a fish, afterwards a reptile, a mammalian quadruped, and at last a human being, yet it is true that it has at one period the invertebrate structure, then successively, in a greater or less number of particulars, the structure of the fish, the reptile, and the mammalian quadruped. And in many of these particulars the likeness is strikingly close.

The last correspondence which I shall point out between the results of the doctrine of descent and actual facts is that which is presented by the geographical distribution of animals. In this wide field I must confine myself to a few points.

By examining the depths of the channels which separate islands from each other or from neighboring continents, the relative length of time during which they must have been without land communication between them may be approximately ascertained. Where the channel is shallow, they may have formed parts of a single body of land recently; but where it is deep, they must ordinarily have been separate for a long time. For example, Great Britain is separated from the continent of Europe by a very shallow channel; Madagascar is cut off from Africa by one that is very deep. In the East Indies, Borneo is separated from Java by a sea not three hundred feet deep; it is separated from Celebes, which is much nearer than Java, by a channel more than five thousand feet deep. Now, if the theory of descent with modification is true, it should be expected that in the regions recently separated, the animals would differ but slightly; in regions separated long ago, the animals would differ more widely; and that, just in proportion to the length of separation. This is exactly what we find in the regions mentioned. The animals of Great Britain differ little from those on the adjacent continent; while the animals of Madagascar differ greatly from those of the neighboring coast of Africa. There are few kinds found in Java which are not also found in Borneo; while on the other hand very few kinds are found in Celebes which exist in Borneo. So it is the world over.

And this is not all. When we examine the kinds of animals which have recently become extinct in each country, we find that they correspond exactly with those which now inhabit that country; they are exactly such as should have preceded the present according to the doctrine of descent. For example, lions, tigers, and other flesh-eating animals of the highest rank, are found scattered over the great Eastern continent. In Australia the kangaroo and other pouched animals like the opossum abound, but none of any higher rank. In South America are found the sloth, the armadillo, and other forms which we meet with no where else on the earth. Now, in the Eastern continent we find buried in caves and the upper layers of the earth extinct kinds of lions, bears, hyenas, and the like, which differ from existing kinds, but yet closely resemble them. But we find nothing like the kangaroo or other pouched animals, or like the sloth or armadillo. Whereas if we examine the extinct buried animals in Australia, we find they are all pouched, with not a single example of anything of as high rank as the lion or the bear; and if we do the same in South America, we see extinct kinds of armadillos and sloths, but nothing at all like the animals of Asia or Australia. It is equally true that wherever regions of the world are separated by barriers which prevent the passage of animals—whether these barriers are seas, or mountain ranges, or climatic zones—the groups of animals inhabiting the separated regions differ more or less widely from each other just in proportion to the length

of time during which the barriers have existed. If the barrier is such that it prevents the passage of one kind of animal and not another, then the groups will resemble each other in the animals whose passage is not prevented, and will differ in the rest. All this is independent of climate, and other conditions of life: two regions may have the same climate, may be equally favorable to the existence of a certain group of animals; but if these regions are separated by impassable barriers, the groups differ just as previously stated.

In view of all the facts now presented—the way in which animals have succeeded each other, beginning as far back as we can go, and coming down to the present; the series of resemblances which connect them from the lowest to the highest, exhibiting such remarkable unity of plan; the existence of rudimentary organs; the geographical distribution of animals, and the close connexion of that distribution now and in the past;—in view of all these facts the doctrine of descent with modification, which so perfectly accords with them all, cannot be lightly and contemptuously dismissed. In the enumeration made, I have been careful to state none but well-ascertained facts, which any one who wishes to take the time can easily verify. Are not the coincidences such as must almost compel belief of the doctrine, unless it can be proved to be contradictory of other known truth? For my part I cannot but so regard them; and the more fully I become acquainted with the facts of which I have given a faint outline, the more I am inclined to believe that it pleased God, the Almighty Creator, to create present and intermediate past organic forms not immediately but mediately, in accordance with the general plan involved in the hypothesis I have been illustrating.

Believing, as I do, that the Scriptures are almost certainly silent on the subject, I find it hard to see how any one could hesitate to prefer the hypothesis of mediate creation to the hypothesis of immediate creation. The latter has nothing to offer in its favor; we have seen a little of what the former may claim.

I cannot take time to discuss at length objections which have been urged against this hypothesis, but may say that they do not seem to me of great weight. It is sometimes said that, if applied to man, it degrades him to regard him as in any respect the descendant of the beast. We have not been consulted on the subject, and possibly our desire for noble origin may not be able to control the matter; but, however that may be, it is hard to see how dirt is nobler than the highest organisation which God had up to that time created on the earth. And further, however it may have been with Adam, we are perfectly certain that each one of us has passed through a state lower than that of the fish, then successively through states not unlike those of the tadpole, the reptile, and the quadruped. Hence, whatever nobility may have been conferred on Adam by being made of dust has been lost to us by our passing through these low animal stages.

It has been objected that it removes God to such a distance from us that it tends to atheism. But the doctrine of descent certainly applies to the succession of men from Adam up to the present. Are we any farther from God than were the earlier generations of the antediluvians? Have we fewer proofs of his existence and power than they had? It must be plain that, if mankind shall continue to exist on the earth so long, millions of years hence the proofs of God's almighty creative power will be as clear as they are to-day.

It has been also objected that this doctrine excludes the idea of design in na-
ture. But if the development of an oak from an acorn in accordance with laws
which God has ordained and executes, does not exclude the idea of design, I ut-
terly fail to see how the development of our complex world, teeming with co-
adaptations of the most striking character, can possibly exclude that idea.

I have now presented briefly, but as fully as possible in an address of this
kind, my views as to the method which should be adopted in considering the re-
lations between the Scriptures and natural science, showing that all that should
be expected is that it shall be made to appear by interpretations which may be
true that they do not contradict each other; that the contents and aims of the
Scriptures and of natural science are so different that it is unreasonable to look
for agreement or harmony; that terms are not and ought not to be used in the
Bible in a scientific sense, and that they are used perfectly truthfully when they
convey the sense intended; that on these principles all alleged contradictions of
natural science by the Bible disappear; that a proper definition of Evolution ex-
cludes all reference to the origin of the forces and laws by which it works, and
therefore that it does not and cannot affect belief in God or in religion; that, ac-
cording to not unreasonable interpretations of the Bible, it does not contradict
anything there taught so far as regards the earth, the lower animals, and proba-
bly man as to his body; that there are many good grounds for believing that
Evolution is true in these respects; and lastly, that the reasons urged against it
are of little or no weight.

I would say in conclusion, that while the doctrine of Evolution in itself, as
before stated, is not and cannot be either Christian or anti-Christian, religious or
irreligious, theistic or atheistic, yet viewing the history of our earth and its in-
habitants, and of the whole universe, as it is unfolded by its help, and then go-
ing outside of it and recognising that it is God's PLAN OF CREATION, instead of be-
ing tempted to put away thoughts of him, as I contemplate this wondrous series
of events, caused and controlled by the power and wisdom of the Lord God
Almighty, I am led with profounder reverence and admiration to give glory and
honor to him that sits on the throne, who liveth for ever and ever; and with
fuller heart and a truer appreciation of what it is to create, to join in saying,
Thou art worthy, O Lord, to receive glory and honor and power; for thou hast
created all things, and for thy pleasure they are and were created.

# RUSSELL HERMAN CONWELL

Russell Herman Conwell (1843–1925) was an attorney-turned-Baptist
minister whose Philadephia church was one of the largest Protestant
churches of the late nineteenth century. A precursor to the later
"megachurch," this church hosted an array of services (including li-
braries, a gymnasium, and an enormous sanctuary) as part of an effort to
meet parishioners' social as well as spiritual needs. Along with this

church, called "The Temple," Conwell also founded Temple University and served for thirty-eight years as its president. Conwell supposedly delivered his best-known sermon, "Acres of Diamonds," more than six thousand times between 1873 and 1924. The talk, a prototypical example of the Gospel of Wealth so ripe for the Gilded Age, emphasized earning wealth as a spiritual duty but also underscored the necessity of generosity and stewardship of one's riches. Although Conwell himself made a fortune, he gave the bulk of his money away and was nicknamed "the penniless millionaire." This excerpt is from his famous sermon.

# From Acres of Diamonds

When going down the Tigris and Euphrates rivers many years ago with a party of English travelers I found myself under the direction of an old Arab guide whom we hired up at Bagdad, and I have often thought how that guide resembled our barbers in certain mental characteristics. He thought that it was not only his duty to guide us down those rivers, and do what he was paid for doing, but also to entertain us with stories curious and weird, ancient and modern, strange and familiar. Many of them I have forgotten, and I am glad I have, but there is one I shall never forget.

The old guide was leading my camel by its halter along the banks of those ancient rivers, and he told me story after story until I grew weary of his story-telling and ceased to listen. I have never been irritated with that guide when he lost his temper as I ceased listening. But I remember that he took off his Turkish cap and swung it in a circle to get my attention. I could see it through the corner of my eye, but I determined not to look straight at him for fear he would tell another story. But although I am not a woman, I did finally look, and as soon as I did he went right into another story.

Said he, "I will tell you a story now which I reserve for my particular friends." When he emphasized the words "particular friends," I listened, and I have ever been glad I did. I really feel devoutly thankful, that there are 1,674 young men who have been carried through college by this lecture who are also glad that I did listen. The old guide told me that there once lived not far from the River Indus an ancient Persian by the name of Ali Hafed. He said that Ali Hafed owned a very large farm, that he had orchards, grain-fields, and gardens; that he had money at interest, and was a wealthy and contented man. He was contented because he was wealthy, and wealthy because he was contented. One day there visited that old Persian farmer one of those ancient Buddhist priests, one of the wise men of the East. He sat down by the fire and told the old farmer how this world of ours was made. He said that this world was once a mere bank of fog, and that the Almighty thrust His finger into this bank of fog, and began slowly to move His finger around, increasing the speed until at last He whirled

Portrait of Russell Herman Conwell, who preached "Acres of Diamonds." *Courtesy of the Library of Congress, Prints & Photographs Division.*

this bank of fog into a solid ball of fire. Then it went rolling through the universe, burning its way through other banks of fog, and condensed the moisture without, until it fell in floods of rain upon its hot surface, and cooled the outward crust. Then the internal fires bursting outward through the crust threw up the mountains and hills, the valleys, the plains and prairies of this wonderful world of ours. If this internal molten mass came bursting out and cooled very quickly it became granite; less quickly copper, less quickly silver, less quickly gold, and, after gold, diamonds were made.

Said the old priest, "A diamond is a congealed drop of sunlight." Now that is literally scientifically true, that a diamond is an actual deposit of carbon from the sun. The old priest told Ali Hafed that if he had one diamond the size of his thumb he could purchase the county, and if he had a mine of diamonds he could place his children upon thrones through the influence of their great wealth.

Ali Hafed heard all about diamonds, how much they were worth, and went to his bed that night a poor man. He had not lost anything, but he was poor because he was discontented, and discontented because he feared he was poor. He said, "I want a mine of diamonds," and he lay awake all night.

Early in the morning he sought out the priest. I know by experience that a priest is very cross when awakened early in the morning, and when he shook that old priest out of his dreams, Ali Hafed said to him:

"Will you tell me where I can find diamonds?"

"Diamonds! What do you want with diamonds?" "Why, I wish to be immensely rich." "Well, then, go along and find them. That is all you have to do; go and find them, and then you have them." "But I don't know where to go." "Well, if you will find a river that runs through white sands, between high mountains, in those white sands you will always find diamonds." "I don't believe there is any such river." "Oh yes, there are plenty of them. All you have to do is to go and find them, and then you have them." Said Ali Hafed, "I will go."

So he sold his farm, collected his money, left his family in charge of a neighbor, and away he went in search of diamonds. He began his search, very properly to my mind, at the Mountains of the Moon. Afterward he came around into Palestine, then wandered on into Europe, and at last when his money was all spent and he was in rags, wretchedness, and poverty, he stood on the shore of that bay at Barcelona, in Spain, when a great tidal wave came rolling in between the pillars of Hercules, and the poor, afflicted, suffering, dying man could not resist the awful temptation to cast himself into that incoming tide, and he sank beneath its foaming crest, never to rise in this life again.

When that old guide had told me that awfully sad story he stopped the camel I was riding on and went back to fix the baggage that was coming off another camel, and I had an opportunity to muse over his story while he was gone. I remember saying to myself, "Why did he reserve that story for his 'particular friends'?" There seemed to be no beginning, no middle, no end, nothing to it. That was the first story I had ever heard told in my life, and would be the first one I ever read, in which the hero was killed in the first chapter. I had but one chapter of that story, and the hero was dead.

When the guide came back and took up the halter of my camel, he went right ahead with the story, into the second chapter, just as though there had been no break. The man who purchased Ali Hafed's farm one day led his camel into the garden to drink, and as that camel put its nose into the shallow water of that garden brook, Ali Hafed's successor noticed a curious flash of light from the white sands of the stream. He pulled out a black stone having an eye of light reflecting all the hues of the rainbow. He took the pebble into the house and put it on the mantel which covers the central fires, and forgot all about it.

A few days later this same old priest came in to visit Ali Hafed's successor, and the moment he opened that drawing-room door he saw that flash of light on the mantel, and he rushed up to it, and shouted: "Here is a diamond! Has Ali Hafed returned?" "Oh no, Ali Hafed has not returned, and that is not a diamond. That is nothing but a stone we found right out here in our own garden." "But," said the priest, "I tell you I know a diamond when I see it. I know positively that is a diamond."

Then together they rushed out into that old garden and stirred up the white sands with their fingers, and lo! there came up other more beautiful and valuable gems than the first. "Thus," said the guide to me, and, friends, it is historically true, "was discovered the diamond-mine of Golconda, the most magnificent diamond-mine in all the history of mankind, excelling the Kimberly itself. The Kohinoor, and the Orloff of the crown jewels of England and Russia, the largest on earth, came from that mine."

When that old Arab guide told me the second chapter of his story, he then took off his Turkish cap and swung it around in the air again to get my attention

to the moral. Those Arab guides have morals to their stories, although they are not always moral. As he swung his hat, he said to me, "Had Ali Hafed remained at home and dug in his own cellar, or underneath his own wheat-fields, or in his own garden, instead of wretchedness, starvation, and death by suicide in a strange land, he would have had 'acres of diamonds.' For every acre of that old farm, yes, every shovelful, afterward revealed gems which since have decorated the crowns of monarchs."

When he had added the moral to his story I saw why he reserved it for "his particular friends." But I did not tell him I could see it. It was that mean old Arab's way of going around a thing like a lawyer, to say indirectly what he did not dare say directly, that "in his private opinion there was a certain young man then traveling down the Tigris River that might better be at home in America." I did not tell him I could see that, but I told him his story reminded me of one, and I told it to him quick, and I think I will tell it to you.

I told him of a man out in California in 1847, who owned a ranch. He heard they had discovered gold in southern California, and so with a passion for gold he sold his ranch to Colonel Sutter, and away he went, never to come back. Colonel Sutter put a mill upon a stream that ran through that ranch, and one day his little girl brought some wet sand from the raceway into their home and sifted it through her fingers before the fire, and in that falling sand a visitor saw the first shining scales of real gold that were ever discovered in California. The man who had owned that ranch wanted gold, and he could have secured it for the mere taking. Indeed, thirty-eight millions of dollars has been taken out of a very few acres since then. About eight years ago I delivered this lecture in a city that stands on that farm, and they told me that a one-third owner for years and years had been getting one hundred and twenty dollars in gold every fifteen minutes, sleeping or waking, without taxation. You and I would enjoy an income like that—if we didn't have to pay an income tax. . . .

Now then, I say again that the opportunity to get rich, to attain unto great wealth, is here in Philadelphia now, within the reach of almost every man and woman who hears me speak tonight, and I mean just what I say. I have not come to this platform even under these circumstances to recite something to you. I have come to tell you what in God's sight I believe to be the truth, and if the years of life have been of any value to me in the attainment of common sense, I know I am right; that the men and women sitting here, who found it difficult perhaps to buy a ticket to this lecture or gathering to-night, have within their reach "acres of diamonds," opportunities to get largely wealthy. There never was a place on earth more adapted than the city of Philadelphia to-day, and never in the history of the world did a poor man without capital have such an opportunity to get rich quickly and honestly as he has now in our city. I say it is the truth, and I want you to accept it as such; for if you think I have come to simply recite something, then I would better not be here. I have no time to waste in any such talk, but to say the things I believe, and unless some of you get richer for what I am saying to-night my time is wasted.

I say that you ought to get rich, and it is your duty to get rich. How many of my pious brethren say to me, "Do you, a Christian minister, spend your time going up and down the country advising young people to get rich, to get money?" "Yes, of course I do." They say, "Isn't that awful! Why don't you preach the

gospel instead of preaching about man's making money?" "Because to make money honestly is to preach the gospel." That is the reason. The men who get rich may be the most honest men you find in the community.

"Oh," but says some young man here to-night, "I have been told all my life that if a person has money he is very dishonest and dishonorable and mean and contemptible." My friend, that is the reason why you have none, because you have that idea of people. The foundation of your faith is altogether false. Let me say here clearly, and say it briefly, though subject to discussion which I have not time for here, ninety-eight out of one hundred of the rich men of America are honest. That is why they are rich. That is why they are trusted with money. That is why they carry on great enterprises and find plenty of people to work with them. It is because they are honest men.

Says another young man, "I hear sometimes of men that get millions of dollars dishonestly." Yes, of course you do, and so do I. But they are so rare a thing in fact that the newspapers talk about them all the time as a matter of news until you get the idea that all the other rich men got rich dishonestly.

My friend, you take and drive me—if you furnish the auto—out into the suburbs of Philadelphia, and introduce me to the people who own their homes around this great city, those beautiful homes with gardens and flowers, those magnificent homes so lovely in their art, and I will introduce you to the very best people in character as well as in enterprise in our city, and you know I will. A man is not really a true man until he owns his own home, and they that own their homes are made more honorable and honest and pure, and true and economical and careful, by owning the home.

For a man to have money, even in large sums, is not an inconsistent thing. We preach against covetousness, and you know we do, in the pulpit, and oftentimes preach against it so long and use the terms about "filthy lucre" so extremely that Christians get the idea that when we stand in the pulpit we believe it is wicked for any man to have money—until the collection-basket goes around, and then we almost swear at the people because they don't give more money. Oh, the inconsistency of such doctrines as that!

Money is power, and you ought to be reasonably ambitious to have it. You ought because you can do more good with it than you could without it. Money printed your Bible, money builds your churches, money sends your missionaries, and money pays your preachers, and you would not have many of them, either, if you did not pay them. I am always willing that my church should raise my salary, because the church that pays the largest salary always raises it the easiest. You never knew an exception to it in your life. The man who gets the largest salary can do the most good with the power that is furnished to him. Of course he can if his spirit be right to use it for what it is given to him.

I say, then, you ought to have money. If you can honestly attain unto riches in Philadelphia, it is your Christian and godly duty to do so. It is an awful mistake of these pious people to think you must be awfully poor in order to be pious.

Some men say, "Don't you sympathize with the poor people?" Of course I do, or else I would not have been lecturing these years. I won't give in but what I sympathize with the poor, but the number of poor who are to be sympathized with is very small. To sympathize with a man whom God has punished for his sins, thus to help him when God would still continue a just punishment, is to do

wrong, no doubt about it, and we do that more than we help those who are deserving. While we should sympathize with God's poor—that is, those who cannot help themselves—let us remember there is not a poor person in the United States who was not made poor by his own shortcomings, or by the shortcomings of some one else. It is all wrong to be poor, anyhow. Let us give in to that argument and pass that to one side.

A gentleman gets up back there, and says, "Don't you think there are some things in this world that are better than money?" Of course I do, but I am talking about money now. Of course there are some things higher than money. Oh yes, I know by the grave that has left me standing alone that there are some things in this world that are higher and sweeter and purer than money. Well do I know there are some things higher and grander than gold. Love is the grandest thing on God's earth, but fortunate the lover who has plenty of money. Money is power, money is force, money will do good as well as harm. In the hands of good men and women it could accomplish, and it has accomplished, good.

I hate to leave that behind me. I heard a man get up in a prayer-meeting in our city and thank the Lord he was "one of God's poor." Well, I wonder what his wife thinks about that? She earns all the money that comes into that house, and he smokes a part of that on the veranda. I don't want to see any more of the Lord's poor of that kind, and I don't believe the Lord does. And yet there are some people who think in order to be pious you must be awfully poor and awfully dirty. That does not follow at all. While we sympathize with the poor, let us not teach a doctrine like that.

Yet the age is prejudiced against advising a Christian man (or, as a Jew would say, a godly man) from attaining unto wealth. The prejudice is so universal and the years are far enough back, I think, for me to safely mention that years ago up at Temple University there was a young man in our theological school who thought he was the only pious student in that department. He came into my office one evening and sat down by my desk, and said to me: "Mr. President, I think it is my duty sir, to come in and labor with you." "What has happened now?" Said he, "I heard you say at the Academy, at the Peirce School commencement," that you thought it was an honorable ambition for a young man to desire to have wealth, and that you thought it made him temperate, made him anxious to have a good name, and made him industrious. You spoke about man's ambition to have money helping to make him a good man. Sir, I have come to tell you the Holy Bible says that 'money is the root of all evil.'"

I told him I had never seen it in the Bible, and advised him to go out into the chapel and get the Bible, and show me the place. So out he went for the Bible, and soon he stalked into my office with the Bible open, with all the bigoted pride of the narrow sectarian, or of one who founds his Christianity on some misinterpretation of Scripture. He flung the Bible down on my desk, and fairly squealed into my ear: "There it is, Mr. President; you can read it for yourself." I said to him: "Well, young man, you will learn when you get a little older that you cannot trust another denomination to read the Bible for you. You belong to another denomination. You are taught in the theological school, however, that emphasis is exegesis. Now, will you take that Bible and read it yourself, and give the proper emphasis to it?"

He took the Bible, and proudly read, "'The love of money is the root of all evil.'"

Then he had it right, and when one does quote aright from that same old Book he quotes the absolute truth. I have lived through fifty years of the mightiest battle that old Book has ever fought, and I have lived to see its banners flying free; for never in the history of this world did the great minds of earth so universally agree that the Bible is true—all true—as they do at this very hour.

So I say that when he quoted right, of course he quoted the absolute truth. "The love of money is the root of all evil." He who tries to attain unto it too quickly, or dishonestly, will fall into many snares, no doubt about that. The love of money. What is that? It is making an idol of money, and idolatry pure and simple everywhere is condemned by the Holy Scriptures and by man's common sense. The man that worships the dollar instead of thinking of the purposes for which it ought to be used, the man who idolizes simply money, the miser that hordes his money in the cellar, or hides it in his stocking, or refuses to invest it where it will do the world good, that man who hugs the dollar until the eagle squeals has in him the root of all evil.

I think I will leave that behind me now and answer the question of nearly all of you who are asking, "Is there opportunity to get rich in Philadelphia?" Well, now, how simple a thing it is to see where it is, and the instant you see where it is it is yours. Some old gentleman gets up back there and says, "Mr. Conwell, have you lived in Philadelphia for thirty-one years and don't know that the time has gone by when you can make anything in this city?" "No, I don't think it is." "Yes, it is; I have tried it." "What business are you in?" "I kept a store here for twenty years, and never made over a thousand dollars in the whole twenty years."

"Well, then, you can measure the good you have been to this city by what this city has paid you, because a man can judge very well what he is worth by what he receives; that is, in what he is to the world at this time. If you have not made over a thousand dollars in twenty years in Philadelphia, it would have been better for Philadelphia if they had kicked you out of the city nineteen years and nine months ago. A man has no right to keep a store in Philadelphia twenty years and not make at least five hundred thousand dollars, even though it be a corner grocery up-town." You say, "You cannot make five thousand dollars in a store now." Oh, my friends, if you will just take only four blocks around you, and find out what the people want and what you ought to supply and set them down with your pencil, and figure up the profits you would make if you did supply them, you would very soon see it. There is wealth right within the sound of your voice.

Some one says: "You don't know anything about business. A preacher never knows a thing about business." Well, then, I will have to prove that I am an expert. I don't like to do this, but I have to do it because my testimony will not be taken if I am not an expert. My father kept a country store, and if there is any place under the stars where a man gets all sorts of experience in every kind of mercantile transactions, it is in the country store. I am not proud of my experience, but sometimes when my father was away he would leave me in charge of the store, though fortunately for him that was not very often. But this did occur many times, friends: A man would come in the store, and say to me, "Do you

keep jack-knives?" "No, we don't keep jack-knives," and I went off whistling a tune. What did I care about that man, anyhow? Then another farmer would come in and say, "Do you keep jack-knives?" "No, we don't keep jack-knives." Then I went away and whistled another tune. Then a third man came right in the same door and said, "Do you keep jack-knives?" "No. Why is every one around here asking for jack-knives? Do you suppose we are keeping this store to supply the whole neighborhood with jack-knives?" Do you carry on your store like that in Philadelphia? The difficulty was I had not then learned that the foundation of godliness and the foundation principle of success in business are both the same precisely. The man who says, "I cannot carry my religion into business" advertises himself either as being an imbecile in business, or on the road to bankruptcy, or a thief, one of the three, sure. He will fail within a very few years. He certainly will if he doesn't carry his religion into business. If I had been carrying on my father's store on a Christian plan, godly plan, I would have had a jack-knife for the third man when he called for it. Then I would have actually done him a kindness, and I would have received a reward myself, which it would have been my duty to take.

There are some over-pious Christian people who think if you take any profit on anything you sell that you are an unrighteous man. On the contrary, you would be a criminal to sell goods for less than they cost. You have no right to do that. You cannot trust a man with your money who cannot take care of his own. You cannot trust a man in your family that is not true to his own wife. You cannot trust a man in the world that does not begin with his own heart, his own character, and his own life. It would have been my duty to have furnished a jack-knife to the third man, or the second, and to have sold it to him and actually profited myself. I have no more right to sell goods without making a profit on them than I have to overcharge him dishonestly beyond what they are worth. But I should so sell each bill of goods that the person to whom I sell shall make as much as I make. . . .

Arise, ye millions of Philadelphians, trust in God and man, and believe in the great opportunities that are right here—not over in New York or Boston, but here—for business, for everything that is worth living for on earth. There was never an opportunity greater.

# WALTER RAUSCHENBUSCH

Walter Rauschenbusch (1861–1918) was a Baptist pastor in the Hell's Kitchen area of New York City, where he became aghast at the deplorable living conditions of many immigrants in this rapidly industrializing city. He became familiar with the effects of low wages and poor living conditions through his own church members, and he developed strong religious and political convictions about the need for more equitable distribution of wealth. His principles fueled his social activism, and in 1892 he

helped form a group of clergy (the Brotherhood of the Kingdom) that committed itself to the social teachings of Jesus. These ideas later found fruition in Rauschenbusch's major books, including *Christianity and the Social Crisis* (1907) and, most notably, *A Theology for the Social Gospel* (1917). His exposition of the Social Gospel has remained influential in American Christian circles, particularly in liberal ones.

# *From* A Theology for the Social Gospel

The argument of this book is built on the conviction that the social gospel is a permanent addition to our spiritual outlook and that its arrival constitutes a stage in the development of the Christian religion.

We need not waste words to prove that the social gospel is being preached. It is no longer a prophetic and occasional note. It is a novelty only in backward social or religious communities. The social gospel has become orthodox.

This new orientation, which is observable in all parts of our religious life, is not simply a prudent adjustment of church methods to changed conditions. There is religious compulsion behind it. Those who are in touch with the student population know what the impulse to social service means to college men and women. It is the most religious element in the life of many of them. Among ministerial students there is an almost impatient demand for a proper social outlet. Some hesitate to enter the regular ministry at all because they doubt whether it will offer them sufficient opportunity and freedom to utter and apply their social convictions. For many ministers who have come under the influence of the social gospel in mature years, it has signified a religious crisis, and where it has been met successfully, it has brought fresh joy and power, and a distinct enlargement of mind. It has taken the place of conventional religion in the lives of many outside the Church. It constitutes the moral power in the propaganda of Socialism.

All those social groups which distinctly face toward the future, clearly show their need and craving for a social interpretation and application of Christianity. Whoever wants to hold audiences of working people must establish some connection between religion and their social feelings and experiences. The religious organizations dealing with college men and women know that any appeal which leaves out the social note is likely to meet a listless audience. The most effective evangelists for these two groups are men who have thoroughly embodied the social gospel in their religious life and thought. When the great evangelistic effort of the "Men and Religion Forward Movement" was first planned, its organizers made room for "Social Service" very hesitatingly. But as soon as the movement was tried out before the public, it became clear that only the meetings which offered the people the social application of religion were striking fire and drawing crowds.

The Great War has dwarfed and submerged all other issues, including our social problems. But in fact the war is the most acute and tremendous social problem of all. All whose Christianity has not been ditched by the catastrophe are demanding a christianizing of international relations. The demand for disarmament and permanent peace, for the rights of the small nations against the imperialistic and colonizing powers, for freedom of the seas and of trade routes, for orderly settlement of grievances,—these are demands for social righteousness and fraternity on the largest scale. Before the War the social gospel dealt with social classes; to-day it is being translated into international terms. The ultimate cause of the war was the same lust for easy and unearned gain which has created the internal social evils under which every nation has suffered. The social problem and the war problem are fundamentally one problem, and the social gospel faces both. After the War the social gospel will "come back" with pent-up energy and clearer knowledge.

The social movement is the most important ethical and spiritual movement in the modern world, and the social gospel is the response of the Christian consciousness to it. Therefore it had to be. The social gospel registers the fact that for the first time in history the spirit of Christianity has had a chance to form a working partnership with real social and psychological science. It is the religious reaction on the historic advent of democracy. It seeks to put the democratic spirit, which the Church inherited from Jesus and the prophets, once more in control of the institutions and teachings of the Church.

The social gospel is the old message of salvation, but enlarged and intensified. The individualistic gospel has taught us to see the sinfulness of every human heart and has inspired us with faith in the willingness and power of God to save every soul that comes to him. But it has not given us an adequate understanding of the sinfulness of the social order and its share in the sins of all individuals within it. It has not evoked faith in the will and power of God to redeem the permanent institutions of human society from their inherited guilt of oppression and extortion. Both our sense of sin and our faith in salvation have fallen short of the realities under its teaching. The social gospel seeks to bring men under repentance for their collective sins and to create a more sensitive and more modern conscience. It calls on us for the faith of the old prophets who believed in the salvation of nations. . . .

<center>❉</center>

What is the function of the Church in the process of salvation? What is it worth to a man to have the support and guidance of the Church in saving his soul?

If we listen to the Church's own estimate of itself it is worth as much as oxygen is to animal life. It is indispensable. "Outside of the Church there is no salvation." Very early in its history the Church began to take a deep interest in itself and to assert high things about itself. Every community is inclined to develop an expanded self-consciousness if the opportunity is at all favorable,

and the Christian Church has certainly not let its opportunity go begging. Some historian has said, it is a wonder that the Church has not been made a person in the Godhead.

It is important to remember that when its high claims were first developed, they were really largely true. Christianity was in sharp opposition not only to the State but to the whole social life surrounding it. It created a Christian duplicate of the social order for its members, as far as it could. Christian influences were not yet diffused in society and literature. The Christian spirit and tradition could really be found nowhere except in the organized Christian groups. If the individual was to be impregnated with the saving power of Christianity, the Church had to do it. There was actually no salvation outside of the Church. But the statements in which men of the first generations expressed their genuine experience of what the Church meant to them, were turned into a theological formula and repeated in later times when the situation had changed, and when, for a time, the Church was not the supreme help but a great hindrance. The claims for the indispensability of the Church and its sacraments and officers became more specific as the hierarchic Church developed. First no man could be saved outside of the Church; next he could not be saved unless he was in right relation to his bishop; and finally he could not be saved unless he submitted to the Roman pontiff.

What are the functions of the Church in salvation, and how indispensable is it? And what has the social gospel to say to the theological valuation of the Church?

The Church is the social factor in salvation. It brings social forces to bear on evil. It offers Christ not only many human bodies and minds to serve as ministers of his salvation, but its own composite personality, with a collective memory stored with great hymns and Bible stories and deeds of heroism, with trained aesthetic and moral feelings, and with a collective will set on righteousness. A super-personal being organized around an evil principle and set on predatory aims is the most potent breeder of sin in individuals and in other communities. What, then, might a super-personal being do which would be organized around Jesus Christ as its impelling power, and would have for its sole or chief object to embody his spirit in its life and to carry him into human thought and the conduct of affairs? . . .

In the following brief propositions I should like to offer a few suggestions, on behalf of the social gospel, for the theological formulation of the doctrine of the Kingdom. Something like this is needed to give us "a theology for the social gospel."

1. The Kingdom of God is divine in its origin, progress and consummation. It was initiated by Jesus Christ, in whom the prophetic spirit came to its consummation, it is sustained by the Holy Spirit, and it will be brought to its fulfilment by the power of God in his own time. The passive and active resistance of the Kingdom of Evil at every stage of its advance is so great, and the human resources of the Kingdom of God so slender, that no explanation can satisfy a religious mind which does not see the power of God in its movements. The Kingdom of God, therefore, is miraculous all the way, and is the continuous revelation of the power, the righteousness, and the love of God. The establishment of a community of righteousness in mankind is just as much a saving act of God

as the salvation of an individual from his natural selfishness and moral inability. The Kingdom of God, therefore, is not merely ethical, but has a rightful place in theology. This doctrine is absolutely necessary to establish that organic union between religion and morality, between theology and ethics, which is one of the characteristics of the Christian religion. When our moral actions are consciously related to the Kingdom of God they gain religious quality. Without this doctrine we shall have expositions of schemes of redemption and we shall have systems of ethics, but we shall not have a true exposition of Christianity. The first step to the reform of the Churches is the restoration of the doctrine of the Kingdom of God.

2. The Kingdom of God contains the teleology of the Christian religion. It translates theology from the static to the dynamic. It sees, not doctrines or rites to be conserved and perpetuated, but resistance to be overcome and great ends to be achieved. Since the Kingdom of God is the supreme purpose of God, we shall understand the Kingdom so far as we understand God, and we shall understand God so far as we understand his Kingdom. As long as organized sin is in the world, the Kingdom of God is characterized by conflict with evil. But if there were no evil, or after evil has been overcome, the Kingdom of God will still be the end to which God is lifting the race. It is realized not only by redemption, but also by the education of mankind and the revelation of his life within it.

3. Since God is in it, the Kingdom of God is always both present and future. Like God it is in all tenses, eternal in the midst of time. It is the energy of God realizing itself in human life. Its future lies among the mysteries of God. It invites and justifies prophecy, but all prophecy is fallible; it is valuable in so far as it grows out of action for the Kingdom and impels action. No theories about the future of the Kingdom of God are likely to be valuable or true which paralyze or postpone redemptive action on our part. To those who postpone, it is a theory and not a reality. It is for us to see the Kingdom of God as always coming, always pressing in on the present, always big with possibility, and always inviting immediate action. We walk by faith. Every human life is so placed that it can share with God in the creation of the Kingdom, or can resist and retard its progress. The Kingdom is for each of us the supreme task and the supreme gift of God. By accepting it as a task, we experience it as a gift. By labouring for it we enter into the joy and peace of the Kingdom as our divine fatherland and habitation.

4. Even before Christ, men of God saw the Kingdom of God as the great end to which all divine leadings were pointing. Every idealistic interpretation of the world, religious or philosophical, needs some such conception. Within the Christian religion the idea of the Kingdom gets its distinctive interpretation from Christ. (a) Jesus emancipated the idea of the Kingdom from previous nationalistic limitations and from the debasement of lower religious tendencies, and made it world-wide and spiritual. (b) He made the purpose of salvation essential in it. (c) He imposed his own mind, his personality, his love and holy will on the idea of the Kingdom. (d) He not only foretold it but initiated it by his life and work. As humanity more and more develops a racial consciousness in modern life, idealistic interpretations of the destiny of humanity will become more influential and important. Unless theology has a solidaristic vision higher and

fuller than any other, it can not maintain the spiritual leadership of mankind, but will be outdistanced. Its business is to infuse the distinctive qualities of Jesus Christ into its teachings about the Kingdom, and this will be a fresh competitive test of his continued headship of humanity.

5. The Kingdom of God is humanity organized according to the will of God. Interpreting it through the consciousness of Jesus we may affirm these convictions about the ethical relations within the Kingdom: (a) Since Christ revealed the divine worth of life and personality, and since his salvation seeks the restoration and fulfilment of even the least, it follows that the Kingdom of God, at every stage of human development, tends toward a social order which will best guarantee to all personalities their freest and highest development. This involves the redemption of social life from the cramping influence of religious bigotry, from the repression of self-assertion in the relation of upper and lower classes, and from all forms of slavery in which human beings are treated as mere means to serve the ends of others. (b) Since love is the supreme law of Christ, the Kingdom of God implies a progressive reign of love in human affairs. We can see its advance wherever the free will of love supersedes the use of force and legal coercion as a regulative of the social order. This involves the redemption of society from political autocracies and economic oligarchies; the substitution of redemptive for vindictive penology; the abolition of constraint through hunger as part of the industrial system; and the abolition of war as the supreme expression of hate and the completest cessation of freedom. (c) The highest expression of love is the free surrender of what is truly our own, life, property, and rights. A much lower but perhaps more decisive expression of love is the surrender of any opportunity to exploit men. No social group or organization can claim to be clearly within the Kingdom of God which drains others for its own ease, and resists the effort to abate this fundamental evil. This involves the redemption of society from private property in the natural resources of the earth, and from any condition in industry which makes monopoly profits possible. (d) The reign of love tends toward the progressive unity of mankind, but with the maintenance of individual liberty and the opportunity of nations to work out their own national peculiarities and ideals.

6. Since the Kingdom is the supreme end of God, it must be the purpose for which the Church exists. The measure in which it fulfils this purpose is also the measure of its spiritual authority and honour. The institutions of the Church, its activities, its worship, and its theology must in the long run be tested by its effectiveness in creating the Kingdom of God. For the Church to see itself apart from the Kingdom, and to find its aims in itself, is the same sin of selfish detachment as when an individual selfishly separates himself from the common good. The Church has the power to save in so far as the Kingdom of God is present in it. If the Church is not living for the Kingdom, its institutions are part of the "world." In that case it is not the power of redemption but its object. It may even become an anti-Christian power. If any form of church organization which formerly aided the Kingdom now impedes it, the reason for its existence is gone.

7. Since the Kingdom is the supreme end, all problems of personal salvation must be reconsidered from the point of view of the Kingdom. It is not sufficient to set the two aims of Christianity side by side. There must be a synthesis, and theology must explain how the two react on each other. (See Chapter X of

this book.) The entire redemptive work of Christ must also be reconsidered under this orientation. Early Greek theology saw salvation chiefly as the redemption from ignorance by the revelation of God and from earthliness by the impartation of immortality. It interpreted the work of Christ accordingly, and laid stress on his incarnation and resurrection. Western theology saw salvation mainly as forgiveness of guilt and freedom from punishment. It interpreted the work of Christ accordingly, and laid stress on the death and atonement. If the Kingdom of God was the guiding idea and chief end of Jesus—as we now know it was—we may be sure that every step in His life, including His death, was related to that aim and its realization, and when the idea of the Kingdom of God takes its due place in theology, the work of Christ will have to be interpreted afresh.

8. The Kingdom of God is not confined within the limits of the Church and its activities. It embraces the whole of human life. It is the Christian transfiguration of the social order. The Church is one social institution alongside of the family, the industrial organization of society, and the State. The Kingdom of God is in all these, and realizes itself through them all. During the Middle Ages all society was ruled and guided by the Church. Few of us would want modern life to return to such a condition. Functions which the Church used to perform, have now far outgrown its capacities. The Church is indispensable to the religious education of humanity and to the conservation of religion, but the greatest future awaits religion in the public life of humanity. . . .

Being historically minded and realistic in its interests, the social gospel is less concerned in the metaphysical problems involved in the trinitarian and christological doctrines. The speculative problem of christological dogma was how the divine and human natures united in the one person of Christ; the problem of the social gospel is how the divine life of Christ can get control of human society. The social gospel is concerned about a progressive social incarnation of God.

The social gospel is believed by trinitarians and unitarians alike, by Catholic Modernists and Kansas Presbyterians of the most cerulean colour. It arouses a fresh and warm loyalty to Christ wherever it goes, though not always a loyalty to the Church. All who believe in it are at one in desiring the spiritual sovereignty of Christ in humanity. Their attitude to the problems of the creeds will usually be determined by other influences.

Yet there are certain qualities in the social gospel which may create a feeling of apathy toward the speculative questions. It is modern and is out for realities. It is ethical and wants ethical results from theology. It is solidaristic and feels homesick in the atomistic desert of individualism.

The social gospel joins with all modern thought in the feeling that the old theology does not give us a Christ who is truly personal. Just as the human race, when it appears in theology, is an amorphous metaphysical conception which could be more briefly designated by an algebraic symbol, in the same way the personality of Jesus is not allowed to be real under theological influence. If it does stand out vital and resolute, it is in spite of theology and not because of it. Some of the greatest theologians, men who wrote epoch-making treatises about Christ, such as Athanasius, give no indication that the personality of Jesus was live and real to them. When those who have been trained under the old religious beliefs come under the influence of historical teaching, the realization that Jesus

was actually a person, and not merely part of a "scheme of redemption," often comes as a great and beneficent shock. He has been made part of a scheme of salvation, the second premise in a great syllogism. The social gospel wants to see a personality able to win hearts, dominate situations, able to bind men in loyalty and make them think like himself, and to set revolutionary social forces in motion.

Every event and saying in the life of Christ has, of course, been scanned intensely and used over and over for edification or theological proof. But in the main the theological significance of the life of Christ has been comprised in the incarnation, the atonement, and the resurrection. The life in general served mainly to connect and lead up to these great events, and to found the Church. The things in which Jesus himself was passionately interested and which he strove to accomplish, do not seem to count for much. The impartation of divine life and immortality to the race was accomplished when he was a babe. The atonement might actually have been frustrated if the life effort of Jesus had been successful, for if the Jews had accepted his spiritual leadership, they would not have killed him.

The social gospel would interpret all the events of his life, including his death, by the dominant purpose which he consistently followed, the establishment of the Kingdom of God. This is the only interpretation which would have appealed to himself. His life was what counted; his death was part of it. The historic current of salvation which went out from him is the prolongation of that life into which he put his conscious energy.

Theology has made the divinity of Christ a question of nature rather than character. His divinity was an inheritance or endowment which he brought with him and which was fixed for him in his pre-existent state. He was divine on account of what took place at one moment in the womb of one Jewish woman rather than on account of all that took place in the inner depths of his spirit when he communed with his Father and fought through the issues of his life. Theology has been on a false trail in seeking the key to his life in the difficult doctrine of the two natures. That doctrine has never been settled. The formula of Chalcedon was a compromise. Any attempt to think precisely about the question results in a caricature; safety lies in vagueness. We shall come closer to the secret of Jesus if we think less of the physical process of conception and more of the spiritual processes of desire, choice, affirmation, and self-surrender within his own will and personality. The mysteries of the spiritual world take place within the will.

To repeat: The social gospel is not primarily interested in metaphysical questions; its christological interest is all for a real personality who could set a great historical process in motion; it wants his work interpreted by the purposes which ruled and directed his active life; it would have more interest in basing the divine quality of his personality on free and ethical acts of his will than in dwelling on the passive inheritance of a divine essence. . . .

Finally we must inquire how the atonement affected men. What did the death of Christ add to his life in the way of reconciling, and redemptive power? The answer to this can not be narrowed down to a single influence. An event like the death of Jesus influences human thought and feeling in many ways. I shall mention three.

First: It was the conclusive demonstration of the power of sin in humanity. I can not contemplate the force and malignancy of the six social and racial sins which converged on Jesus without a deep sense of the enormous power of evil in the world and of the bitter task before those who make up the cutting edge of the Kingdom of God. In various ways this realization comes to all who think of the cross of Christ. But the solidaristic interpretation of the killing power of sin is by far step toward redemption from sin, the cross was an essential part of the redemptive process. The life of Christ never spread such a realization of sin as his death has done.

Second: the death of Christ was the supreme revelation of love.

Love is the social instinct of the race. In all its many forms it binds man to man. Every real improvement of society gives love a freer chance. Every genuine progress must be preceded by a new capitalization of love.

Jesus put love to the front in his teaching. He was ready to accept love for God and man as a valid equivalent for the customary religious and ethical duties. His own character and action are redolent of virile and energetic love.

If Jesus had died a natural death, posterity would still treasure his teaching, coupled with the commentary of his life, as the most beautiful exposition of love. But its effectiveness was greatly increased by his death. Death has a strange power over the human imagination and memory. A pathetic or heroic death wins a place for a weak and cowardly man. If a significant death is added to a brave and self-sacrificing life, the effect is great. A righteous man might well pray for this as the last great blessing of his life, that his death might interpret the higher meaning of his life and weld all his labors into one by the flame of suffering. This crowning grace was given to Jesus. His death underscored all he said on love. It put the red seal of sincerity on his words. "Greater love hath no man than that he give his life for his friends." Unless he gives it for his enemies too.

The human value of his love was translated into higher terms by the belief that Christ revealed and expressed the heart and mind of God. If Christ stood for saving pity and tender mercy and love that seeks the lost, then God must be that kind of a God. It is a question if the teaching of Jesus alone could have made that the common faith of millions. His death effectively made God a God of love to the simplest soul, and that has transformed the meaning of the universe and the whole outlook of the race. Surely the character of the God a man worships reacts on the man. Suppose that our life has mocked our creed of love a thousand times; how many times would our life have mocked at love if love were not in our creed? Suppose the dualism of the first century had written pessimism and ascetic resignation into our creed. Suppose that instead of the Father of Jesus Christ we had a God who embodied the doctrine of the survival of the fit, the rule of the strong, and the suppression of the weak, how would that have affected the spiritual character of Western civilization? How much chance would there have been for democracy? Instead of that, love has been written into the character of God and into the ethical duty of man; not only common love, but self-sacrificing love. And it was the death of Christ which furnished the chief guarantee for the love of God and the chief incentive to self-sacrificing love in men.

It is true that the self-sacrifice generated by Christianity has been misdirected and used up for nothing in ascetic Christianity. But no one can well deny

that the sum total of self-sacrifice evoked by Christianity has been and is enormous, and that its influence on the development of Christian civilization has been very great. Some of the legal conceptions of the atonement have obscured the love of God in the death of Christ. But the fact that the Christian consciousness has reacted against any despotic elements in the character of God, is proof of the fact that the essentially Christian idea had done its work in us and overcome the sinful alloy with which it was mixed.

Since we live in the fellowship of a God of love, we are living in a realm of grace as friends and sons of God. We do not have to earn all we get by producing merit. We live on grace and what we do is slight compared with what is done for us.

This conviction, too, is based on the death of Christ. Belief in the atonement has enabled religious souls first to break away from self-made righteousness and to realize salvation as a gift. With their eye on the cross of Christ they denied the merit system, first of Judaism, later of the Catholic Church. The great religious characters are those who escaped from themselves and learned to depend on God,—Paul, Augustine, Saint Francis, Tauler on whom Luther fed, Luther himself.

Self-earned righteousness and pride in self are the marks of religious individualism. Humility is the capacity to realize that we count for little in ourselves and must take our place in a larger fellowship of life. Therefore humility and dependence on grace are social virtues.

The cross is the monumental fact telling of grace and inviting repentance and humility.

Thus the death of Christ was the conclusive and effective expression of the love of Jesus Christ for God and man, and his complete devotion to the Kingdom of God. The more his personality was understood to be the full and complete expression of the character of God, the more did his death become the assurance and guarantee that God loves us, forgives us, and is willing to do all things to save us.

It is the business of theologians and preachers to make the atonement effective in producing the characteristic of love in Christian men and women. If it does not assimilate them to the mind of Christ it has missed its purpose. We can either be saved by non-ethical sacramental methods, or by absorbing the moral character of Jesus into our own character. Let every man judge which is the salvation he wants.

The social gospel is based on the belief that love is the only true working principle of human society. It teaches that the Kingdom of Evil has thrust love aside and employed force, because love will support only a fraternal distribution of property and power, while force will support exploitation and oppression. If love is the fundamental quality in God, it must be part of the constitution of humanity. Then it can not be impossible to found society on love. The atonement is the symbol and basis of a new social order.

Third: the death of Christ has reinforced prophetic religion.

Historical criticism has performed an inestimable service to true religion by clearing up the historical antagonism between priest and prophet in the Old Testament, and labeling the literary documents of Jewish religion according to the religious interest which produced or reedited them. This antagonism is a

permanent element in the Christian religion, and part of the conflict between the Kingdom of God and the Kingdom of Evil. A comprehension of the difference between prophet and priest is essential to a clear understanding of Jesus and to intelligent discipleship.

The priest is the religious professional. He performs religious functions which others are not allowed to perform. It is therefore to his interest to deny the right of free access to God, and to interpose himself and his ceremonial between the common man and God. He has an interest in representing God as remote, liable to anger, jealous of his rights, and quick to punish, because this gives importance to the ritual methods of placating God which the priest alone can handle. It is essential to the priestly interest to establish a monopoly of rights and functions for his group. He is all for authority, and in some form or other he is always a spokesman of that authority and shares its influence. Doctrine and history as he teaches it, establish a *jure divino* institution of his order, which is transmitted either by physical descent, as in the Aaronic priesthood, or by spiritual descent through some form of exclusive ordination, as in the Catholic priesthood. As history invariably contradicts his claims, he frequently tampers with history by Deuteronomic codes or Pseudo-Isidorian Decretals, in order to secure precedents and the weight of antiquity. He is opposed to free historical investigation because this tears open the protective web of idealized history and doctrine which he has woven about him. He is the middle man of religion, and like other middle-men he is sincerely convinced that he is necessary for the good of humanity and that religion would perish without him. But underneath all is the selfish interest of his class, which exploits religion.

The prophet becomes a prophet by some personal experience of God, which henceforth is the dominant reality of his life. It creates inward convictions which become his message to men. Usually after great inward conflicts and the bursting of priest-made barriers he has discovered the way of access to God, and has found him wonderful,—just, merciful, free. As a result of his own experience he usually becomes the constitutional enemy of priestly religion, the scorner of sacrificial and ritual doings, a voice of doubt about the doctrines and the literature which shelter the priest. He too is a middle-man, but he wants no monopoly. His highest desire is to have all men share what he has experienced. If his own caste or people claim special privileges as a divinely descended caste or a chosen people, he is always for some expansion of religious rights, for a crossing of boundaries and a larger unity. His interest is in freedom, reality, immediateness,—the reverse of the priestly interest. His religious experience often gives a profound quickening to his social consciousness, an unusual sense of the value of life and a strong compassion with the suffering and weak, and therefore a keen feeling for human rights and indignation against injustice. He has a religious conviction that God is against oppression and on the side of the weak.

The religion of the priest and the religion of the prophet grow side by side, on the same national soil and from the same historic convictions, but they are two distinct and antagonistic religions. The usual distinctions which separate religions and denominations are trivial compared with this. This difference cuts across most other lines of cleavage. Since the Reformation, however, the personal qualities which marked the prophet have become to some extent the mark and foundation of continuous religious bodies. Over against Catholicism,

Protestantism has, in its noblest periods, had prophetic quality; over against the Established Churches the Free Churches have a prophetic mission. But the flame of prophetic religion is always dying down for lack of oxygen. It burns only when there is something worth burning for. It kindles wherever the Kingdom of God is clashing with the Kingdom of Evil. You can tell where the conflict is on today when you hear the voice of prophetic religion. In every religious body, even in those that have repudiated priestliness, you have the undeveloped and unconscious priest and prophet side by side; mixed types, like Ezekiel and Savonarola; embryonic prophets; spent prophets; prophets who have given up; prophets whose bodies and minds have been hurt and thrown out of equilibrium. God knows his own.

The prophet is always the predestined advance agent of the Kingdom of God. His religion flings him as a fighter and protester against the Kingdom of Evil. His sense of justice, compassion, and solidarity sends him into tasks which would be too perilous for others. It connects him with oppressed social classes as their leader. He bears their risk and contempt. As he tries to rally the moral and religious forces of society, he encounters derelict and frozen religion, and the selfish and conservative interest of the classes which exploit religion. He tries to arouse institutional religion from the inside, or he pounds it from the outside. This puts him in the position of a heretic, a free thinker, an enemy of religion, an atheist. Probably no prophet escaped without bearing some such name. His opposition to social injustice arouses the same kind of antagonism from those who profit by it. How far these interests will go in their methods of suppressing the prophets depends on their power and their needs. I have been impressed with the fact that though Christianity began in a renascence of prophetism, scarcely any personality who bears the marks of the prophet can be found in Church History between A.D. 100 and A.D. 1200. Two main explanations suggest themselves: that their own capacity for self-sacrifice led the potential prophets into the monasteries and put them under monastic obedience; and that the Catholic Church, which embodies the priestly principles, suffocated the nascent prophets by its spiritual authority and the physical force it could command.

In this way the death of Jesus has taken personal hold on countless religious souls. It has set them free from the fear of pain and the fear of men, and given them a certain finishing quality of strength. It has inspired courage and defiance of evil, and sent men on lost hopes. The cross of Christ put God's approval on the sacrificial impulse in the hearts of the brave, and dignified it by connecting it with one of the central dogmas of our faith. The cross has become the motive and the method of noble personalities.

It has compelled reflection on the value of the prophets for the progress of humanity. What might have been a sporadic and unaccountable religious instinct, has been lifted to the level of a law of history and religion.

By the light of burning heretics Christ's bleeding feet I track,
Toiling up new Calvaries ever with the cross that turns not back.
And these mounts of anguish number how each generation learned
One new word of that grand Credo which in prophet-hearts hath burned
Since the first man stood God-conquered with his face to heaven upturned.

The death of Jesus was the clearest and most conspicuous case of prophetic suffering. It shed its own clarity across all other, less perfect cases, and interpreted their moral dignity and religious significance. His death comforted and supported all who bore prophetic suffering by the consciousness that they were "bearing the marks of the Lord Jesus" and were carrying on what he had borne. The prophet is always more or less cast out by society and profoundly lonely and homeless; consequently he reaches out for companionship, for a tribal solidarity of his own, and a chieftainship of the spirit to which he can give his loyalty and from which he can gather strength. Then it is his rightful comfort to remember that Jesus has suffered before him.

Thus the cross of Christ contributes to strengthen the power of prophetic religion, and therewith the redemptive forces of the Kingdom of God. Before the Reformation the prophet had only a precarious foothold within the Church and no right to live outside of it. The rise of free religion and political democracy has given him a field and a task. The era of prophetic and democratic Christianity has just begun. This concerns the social gospel, for the social gospel is the voice of prophecy in modern life.

# PITTSBURGH PLATFORM

The Pittsburgh Platform was adopted in 1885 by a group of rabbis in the Reform Jewish tradition who were called together by Kaufmann Kohler, the president of Cincinnati's Hebrew Union College. The statement of principles aimed to extract the moral essence from the Torah while purging the perceived excesses of Mosaic and rabbinic law, a way of distinguishing Judaism as a regular religion among other religions in America, such as Protestantism. Of course, this attempt to distill Judaism from a range of purportedly antiquated rituals did not sit well with all Jews, but Reform leaders were a vocal segment of American Judaism. The Pittsburgh Platform, along with related events, such as the notorious "shrimp incident" two years earlier (when Hebrew Union College served the forbidden shellfish to recent rabbinical graduates), helped spur the Conservative movement in American Judaism among those who wanted to retain more of the traditional elements of their tradition.

# Pittsburgh Platform

## DECLARATION OF PRINCIPLES

### 1885 Pittsburgh Conference

1. We recognize in every religion an attempt to grasp the Infinite, and in every mode, source or book of revelation held sacred in any religious system the consciousness of the indwelling of God in man. We hold that Judaism presents the highest conception of the God-idea as taught in our Holy Scriptures and developed and spiritualized by the Jewish teachers, in accordance with the moral and philosophical progress of their respective ages. We maintain that Judaism preserved and defended midst continual struggles and trials and under enforced isolation, this God-idea as the central religious truth for the human race.

2. We recognize in the Bible the record of the consecration of the Jewish people to its mission as the priest of the one God, and value it as the most potent instrument of religious and moral instruction. We hold that the modern discoveries of scientific researches in the domain of nature and history are not antagonistic to the doctrines of Judaism, the Bible reflecting the primitive ideas of its own age, and at times clothing its conception of divine Providence and Justice dealing with men in miraculous narratives.

3. We recognize in the Mosaic legislation a system of training the Jewish people for its mission during its national life in Palestine, and today we accept as binding only its moral laws, and maintain only such ceremonies as elevate and sanctify our lives, but reject all such as are not adapted to the views and habits of modern civilization.

4. We hold that all such Mosaic and rabbinical laws as regulate diet, priestly purity, and dress originated in ages and under the influence of ideas entirely foreign to our present mental and spiritual state. They fail to impress the modern Jew with a spirit of priestly holiness; their observance in our days is apt rather to obstruct than to further modern spiritual elevation.

5. We recognize, in the modern era of universal culture of heart and intellect, the approaching of the realization of Israel's great Messianic hope for the establishment of the kingdom of truth, justice, and peace among all men. We consider ourselves no longer a nation, but a religious community, and therefore expect neither a return to Palestine, nor a sacrificial worship under the sons of Aaron, nor the restoration of any of the laws concerning the Jewish state.

6. We recognize in Judaism a progressive religion, ever striving to be in accord with the postulates of reason. We are convinced of the utmost necessity of preserving the historical identity with our great past. Christianity and Islam, being daughter religions of Judaism, we appreciate their providential mission, to aid in the spreading of monotheistic and moral truth. We acknowledge that the spirit of broad humanity of our age is our ally in the fulfillment of our mission,

and therefore we extend the hand of fellowship to all who cooperate with us in the establishment of the reign of truth and righteousness among men.

7. We reassert the doctrine of Judaism that the soul is immortal, grounding the belief on the divine nature of human spirit, which forever finds bliss in righteousness and misery in wickedness. We reject as ideas not rooted in Judaism, the beliefs both in bodily resurrection and in Gehenna and Eden (Hell and Paradise) as abodes for everlasting punishment and reward.

8. In full accordance with the spirit of the Mosaic legislation, which strives to regulate the relations between rich and poor, we deem it our duty to participate in the great task of modern times, to solve, on the basis of justice and righteousness, the problems presented by the contrasts and evils of the present organization of society.

# RALPH WALDO TRINE

Ralph Waldo Trine (1866–1958) was a prolific writer of popular inspirational texts during the high tide of New Thought, a spiritual movement that emphasized the capacity of the mind to visualize and thereby attain material goods, such as health and wealth. Trine's books sold well in his own lifetime and still more after his death, circulating far beyond institutional New Thought circles to a wide public of self-help readers. His 1897 book, *In Tune with the Infinite*, had broad appeal in a culture that was ripe for the word that individuals could be in charge of their earthly lives, if not their final destinies. Perennially in print since its publication, it remains one of the best-selling New Thought books of all time.

## *From* In Tune with the Infinite

### THE SUPREME FACT OF HUMAN LIFE

From the great central fact of the universe in regard to which we have agreed, namely, this Spirit of Infinite Life that is back of all and from which all comes, we are led to inquire as to what is the great central fact in human life. From what has gone before, the question almost answers itself.

*The great central fact in human life, in your life and in mine, is the coming into a conscious, vital realization of our oneness with this Infinite Life, and the opening of ourselves fully to this divine inflow.* This is the great central fact in human life, for in

this all else is included, all else follows in its train. In just the degree that we come into a conscious realization of our oneness with the Infinite Life, and open ourselves to this divine inflow, do we actualize in ourselves the qualities and powers of the Infinite Life.

And what does this mean? It means simply this: that we are recognizing our true identity, that we are bringing our lives into harmony with the same great laws and forces, and so opening ourselves to the same great inspirations, as have all the prophets, seers, sages, and saviours in the world's history, all men of truly great and mighty power. For in the degree that we come into this realization and connect ourselves with this Infinite Source, do we make it possible for the higher powers to play, to work, to manifest through us.

We can keep closed to this divine inflow, to these higher forces and powers, through ignorance, as most of us do, and thus hinder or even prevent their manifesting through us. Or we can intentionally close ourselves to their operations and thus deprive ourselves of the powers to which, by the very nature of our being, we are rightful heirs. On the other hand, we can come into so vital a realization of the oneness of our real selves with this Infinite Life, and can open ourselves so fully to the incoming of this divine inflow, and so to the operation of these higher forces, inspirations, and powers, that we can indeed and in truth become what we may well term, God-men.

And what is a God-man? One in whom the powers of God are manifesting, though yet a man. No one can set limitations to a man or a woman of this type; for the only limitations he or she can have are those set by the self. Ignorance is the most potent factor in setting limitations to the majority of mankind; and so the great majority of people continue to live their little, dwarfed, and stunted lives simply by virtue of the fact that they do not realize the larger life to which they are heirs. They have never as yet come into a knowledge of the real identity of their true selves.

Mankind has not yet realized that the real self is one with the life of God. Through its ignorance it has never yet opened itself to the divine inflow, and so has never made itself a channel through which the infinite powers and forces can manifest. When we know ourselves merely as men, we live accordingly, and have merely the powers of men. When we come into the realization of the fact that we are God-men, then again we live accordingly, and have the powers of God-men. *In the degree that we open ourselves to this divine inflow are we changed from mere men into God-men. . . .*

I hear it asked, What can be said in a concrete way in regard to the practical application of these truths, so that one can hold himself in the enjoyment of perfect bodily health; and more, that one may heal himself of any existing disease? In reply, let it be said that the chief thing that can be done is to point out the great underlying principle, and that each individual must make his own application; one person cannot well make this for another.

First let it be said, that the very fact of one's holding the thought of perfect health sets into operation vital forces which will in time be more or less productive of the effect,—perfect health. Then speaking more directly in regard to the great principle itself, from its very nature, it is clear that more can be accomplished through the process of realization than through the process of affirmation, though for some affirmation may be a help, an aid to realization.

In the degree, however, that you come into a vital realization of your oneness with the Infinite Spirit of Life, whence all life in individual form has come and is continually coming, and in the degree that through this realization you open yourself to its divine inflow, do you set into operation forces that will sooner or later bring even the physical body into a state of abounding health and strength. For to realize that this Infinite Spirit of Life can from its very nature admit of no disease, and to realize that this, then, is the life in you, by realizing your oneness with it, you can so open yourself to its more abundant entrance that the diseased bodily conditions—effects—will respond to the influences of its all-perfect power, this either quickly or more tardily, depending entirely upon yourself.

There have been those who have been able to open themselves so fully to this realization that the healing has been instantaneous and permanent. The degree of intensity always eliminates in like degree the element of time. *It must, however, be a calm, quiet, and expectant intensity, rather than an intensity that is fearing, disturbed, and non-expectant.* Then there are others who have come to this realization by degrees.

Many will receive great help, and many will be entirely healed by a practice somewhat after the following nature: With a mind at peace, and with a heart going out in love to all, go into the quiet of your own interior self, holding the thought,—I am one with the Infinite Spirit of Life, the life of my life. I then as spirit, I a spiritual being, can in my own real nature admit of no disease. I now open my body, in which disease has gotten a foothold, I open it fully to the inflowing tide of this Infinite Life, and it now, even now, is pouring in and coursing through my body, and the healing process is going on. Realize this so fully that you begin to feel a quickening and a warming glow imparted by the life forces to the body. Believe the healing process is going on. Believe it, and hold continually to it. Many people greatly desire a certain thing, but expect something else. They have greater faith in the power of evil than in the power of good, and hence remain ill.

If one will give himself to this meditation, realization, treatment, or whatever term it may seem best to use, at stated times, as often as he may choose, and then *continually hold himself in the same attitude of mind,* thus allowing the force to work continually, he will be surprised how rapidly the body will be exchanging conditions of disease and inharmony for health and harmony. There is no particular reason, however, for this surprise, for in this way he is simply allowing the Omnipotent Power to do the work, which will have to do it ultimately in any case.

If there is a local difficulty, and one wants to open this particular portion, in addition to the entire body, to this inflowing life, he can hold this particular portion in thought, for to fix the thought in this way upon any particular portion of the body stimulates or increases the flow of the life forces in that portion. It must always be borne in mind, however, that whatever healing may be thus accomplished, effects will not permanently cease until causes have been removed. In other words, *as long as there is the violation of law, so long disease and suffering will result.*

This realization that we are considering will have an influence not only where there is a diseased condition of the body, but even where there is not this condition it will give an increased bodily life, vigor, and power.

We have had many cases, in all times and in all countries, of healing through the operation of the interior forces, entirely independent of external agencies. Various have been the methods, or rather, various have been the names applied to them, but the great law underlying all is one and the same, and the same today. When the Master sent his followers forth, his injunction to them was to heal the sick and the afflicted, as well as to teach the people. The early church fathers had the power of healing, in short, it was a part of their work.

And why should we not have the power today, the same as they had it then? Are the laws at all different? Identically the same. Why, then? Simply because, with a few rare exceptions here and there, we are unable to get beyond the mere letter of the law into its real vital spirit and power. It is the letter that killeth, it is the spirit that giveth life and power. Every soul who becomes so individualized that he breaks through the mere letter and enters into the real vital spirit, *will have the power*, as have all who have gone before, and when he does, he will also be the means of imparting it to others, for he will be one who will move and who will speak with authority.

We are rapidly finding today, and we shall find even more and more, as time passes, that practically all disease, with its consequent suffering, has its origin in perverted mental and emotional states and conditions. *The mental attitude we take toward anything determines to a greater or less extent its effects upon us.* If we fear it, or if we antagonize it, the chances are that it will have detrimental or even disastrous effects upon us. If we come into harmony with it by quietly recognizing and inwardly asserting our superiority over it, in the degree that we are able successfully to do this, in that degree will it carry with it no injury for us.

No disease can enter into or take hold of our bodies unless it find therein something corresponding to itself which makes it possible. And in the same way, no evil or undesirable condition of any kind can come into our lives unless there is already in them that which invites it and so makes it possible for it to come. The sooner we begin to look within ourselves for the cause of whatever comes to us, the better it will be, for so much the sooner will we begin to make conditions within ourselves such that only *good* may enter.

We, who from our very natures should be masters of all conditions, by virtue of our ignorance are mastered by almost numberless conditions of every description.

Do I fear a draft? There is nothing in the draft—a little purifying current of God's pure air—to cause me trouble, to bring on a cold, perhaps an illness. The draft can affect me only in the degree that I *myself* make it possible, only in the degree that I allow it to affect me. We must distinguish between causes and mere occasions. The draft is not cause, nor does it carry cause with it.

Two persons are sitting in the same draft. The one is injuriously affected by it, the other experiences not even an inconvenience, but he rather enjoys it. The one is a creature of circumstances; he fears the draft, cringes before it, continually thinks of the harm it is doing him. In other words, he opens every avenue for it to enter and take hold of him, and so it—harmless and beneficent in itself—brings to him exactly what he has empowered it to bring. The other recognizes himself as the master over and not the creature of circumstances. He is not concerned about the draft. He puts himself into harmony with it, makes himself

positive to it, and instead of experiencing any discomfort, he enjoys it, and in addition to its doing him a service by bringing the pure fresh air from without to him, it does him the additional service of hardening him even more to any future conditions of a like nature. But if the draft was cause, it would bring the same results to both. The fact that it does not, shows that it is not a cause, but a condition, and it brings to each, effects which correspond to the conditions it finds within each.

Poor draft! How many thousands, nay millions of times it is made the scapegoat by those who are too ignorant or too unfair to look their own weaknesses square in the face, and who instead of becoming imperial masters, remain cringing slaves. Think of it, what it means! A man created in the image of the eternal God, sharer of His life and power, born to have dominion, fearing, shaking, cringing before a little draft of pure life-giving air. But scapegoats are convenient things, even if the only thing they do for us is to aid us in our constant efforts at self-delusion.

The best way to disarm a draft of the bad effects it has been accustomed to bring one, is first to bring about a pure and healthy set of conditions within, then, to change one's mental attitude toward it. Recognize the fact that of itself it has no power, it has only the power you invest it with. Thus you will put yourself into harmony with it, and will no longer sit in fear of it. Then sit in a draft a few times and get hardened to it, as every one, by going at it judiciously, can readily do. "But suppose one is in delicate health, or especially subject to drafts?" Then be simply a little judicious at first; don't seek the strongest that can be found, especially if you do not as yet in your own mind feel equal to it, for if you do not, it signifies that you still fear it. That supreme regulator of all life, *good common sense,* must be used here, the same as elsewhere.

If we are born to have dominion, and that we are is demonstrated by the fact that some have attained to it,—and what one *has* done, soon or late all *can* do,—then it is not necessary that we live under the domination of any physical agent. In the degree that we recognize our own interior powers, then are we rulers and able to dictate; in the degree that we fail to recognize them, we are slaves, and are dictated to. We build whatever we find within us; we attract whatever comes to us, and all in accordance with spiritual law, for all natural law is spiritual law.

The whole of human life is cause and effect; there is no such thing in it as chance, nor is there even in all the wide universe. Are we not satisfied with whatever comes into our lives? The thing to do, then, is not to spend time in railing against the imaginary something we create and call fate, but to look to the within, and change the causes at work there, in order that things of a different nature may come, for there will come exactly what we cause to come. This is true not only of the physical body, but of all phases and conditions of life. We invite whatever comes, and did we not invite it, either consciously or unconsciously, it could not and it would not come. This may undoubtedly be hard for some to believe, or even to see, at first. But in the degree that one candidly and open-mindedly looks at it, and then studies into the silent, but subtle and, so to speak, omnipotent workings of the thought forces, and as he traces their effects within him and about him, it becomes clearly evident, and easy to understand.

And then whatever does come to one depends for its effects entirely upon his mental attitude toward it. Does this or that occurrence or condition cause you annoyance? Very well; it causes you annoyance, and so disturbs your peace merely because you allow it to. You are born to have absolute control over your own dominion, but if you voluntarily hand over this power, even if for a little while, to some one or to some thing else, then you of course, become the creature, the one controlled.

To live undisturbed by passing occurrences you must first find your own centre. You must then be firm in your own centre, and so rule the world from within. He who does not himself condition circumstances allows the process to be reversed, and becomes a conditioned circumstance. Find your centre and live in it. Surrender it to no person, to no thing. In the degree that you do this will you find yourself growing stronger and stronger in it. And how can one find his centre? By realizing his oneness with the Infinite Power, and by living continually in this realization.

But if you do not rule from your own centre, if you invest this or that with the power of bringing you annoyance, or evil, or harm, then take what it brings, but cease your railings against the eternal goodness and beneficence of all things.

# W. E. B. Du Bois

W. E. B. Du Bois (1868–1963) was one of the most prominent intellectuals and spokespersons for African Americans in the twentieth century. Having earned a Harvard doctorate in history, he early made a name for himself as a sociological researcher, interviewing thousands of African Americans in their homes and publishing *The Philadelphia Negro* in 1899. He then taught at Atlanta University, during which time he published his most famous book, *The Souls of Black Folk*, a powerful collection of essays that served to counter the arguments then being made by Booker T. Washington's conservative positions on racial accommodation. Du Bois later worked for the National Association for the Advancement of Colored People and edited *Crisis*, the organization's monthly magazine, and he published several more books during his lifetime. He became active in African affairs and spent the latter years of his life in Ghana.

His essay on "The Sorrow Songs" appeared in *The Souls of Black Folk*, and the other documents presented here appeared in *The Independent*. "Credo" became popular among African Americans as a sign of racial pride, often appearing on cards in domestic settings. "A Litany of Atlanta" appeared after race riots killed ten African Americans and wounded hundreds more, destroying numerous black-owned businesses as well.

# The Sorrow Songs

*I walk through the churchyard*
*To lay this body down;*
*I know moon-rise, I know star-rise;*
*I walk in the moonlight, I walk in the starlight;*
*I'll lie in the grave and stretch out my arms,*
*I'll go to judgment in the evening of the day,*
*And my soul and thy soul shall meet that day,*
*When I lay this body down.* ~ NEGRO SONG.

They that walked in darkness sang songs in the olden days—Sorrow Songs—for they were weary at heart. And so before each thought that I have written in this book I have set a phrase, a haunting echo of these weird old songs in which the soul of the black slave spoke to men. Ever since I was a child these songs have stirred me strangely. They came out of the South unknown to me, one by one, and yet at once I knew them as of me and of mine. Then in after years when I came to Nashville I saw the great temple builded of these songs towering over the pale city. To me Jubilee Hall seemed ever made of the songs themselves, and its bricks were red with the blood and dust of toil. Out of them rose for me morning, noon, and night, bursts of wonderful melody, full of the voices of my brothers and sisters, full of the voices of the past.

Little of beauty has America given the world save the rude grandeur God himself stamped on her bosom; the human spirit in this new world has expressed itself in vigor and ingenuity rather than in beauty. And so by fateful chance the Negro folk-song—the rhythmic cry of the slave—stands to-day not simply as the sole American music, but as the most beautiful expression of human experience born this side the seas. It has been neglected, it has been, and is, half despised, and above all it has been persistently mistaken and misunderstood; but notwithstanding, it still remains as the singular spiritual heritage of the nation and the greatest gift of the Negro people.

Away back in the thirties the melody of these slave songs stirred the nation, but the songs were soon half forgotten. Some, like "Near the lake where drooped the willow," passed into current airs and their source was forgotten;

W. E. B. Du Bois.
*Courtesy of the Library
of Congress, Prints &
Photographs Division.*

others were caricatured on the "minstrel" stage and their memory died away. Then in war-time came the singular Port Royal experiment after the capture of Hilton Head, and perhaps for the first time the North met the Southern slave face to face and heart to heart with no third witness. The Sea Islands of the Carolinas, where they met, were filled with a black folk of primitive type, touched and moulded less by the world about them than any others outside the Black Belt. Their appearance was uncouth, their language funny, but their hearts were human and their singing stirred men with a mighty power. Thomas Wentworth Higginson hastened to tell of these songs, and Miss McKim and others urged upon the world their rare beauty. But the world listened only half credulously until the Fisk Jubilee Singers sang the slave songs so deeply into the world's heart that it can never wholly forget them again.

There was once a blacksmith's son born at Cadiz, New York, who in the changes of time taught school in Ohio and helped defend Cincinnati from Kirby Smith. Then he fought at Chancellorsville and Gettysburg and finally served in the Freedman's Bureau at Nashville. Here he formed a Sunday-school class of black children in 1866, and sang with them and taught them to sing. And then they taught him to sing, and when once the glory of the Jubilee songs passed into the soul of George L. White, he knew his life-work was to let those Negroes sing to the world as they had sung to him. So in 1871 the pilgrimage of the Fisk

Jubilee Singers began. North to Cincinnati they rode,—four half-clothed black boys and five girl-women,—led by a man with a cause and a purpose. They stopped at Wilberforce, the oldest of Negro schools, where a black bishop blessed them. Then they went, fighting cold and starvation, shut out of hotels, and cheerfully sneered at, ever northward; and ever the magic of their song kept thrilling hearts, until a burst of applause in the Congregational Council at Oberlin revealed them to the world. They came to New York and Henry Ward Beecher dared to welcome them, even though the metropolitan dailies sneered at his "Nigger Minstrels." So their songs conquered till they sang across the land and across the sea, before Queen and Kaiser, in Scotland and Ireland, Holland and Switzerland. Seven years they sang, and brought back a hundred and fifty thousand dollars to found Fisk University.

Since their day they have been imitated—sometimes well, by the singers of Hampton and Atlanta, sometimes ill, by straggling quartettes. Caricature has sought again to spoil the quaint beauty of the music, and has filled the air with many debased melodies which vulgar ears scarce know from the real. But the true Negro folk-song still lives in the hearts of those who have heard them truly sung and in the hearts of the Negro people.

What are these songs, and what do they mean? I know little of music and can say nothing in technical phrase, but I know something of men, and knowing them, I know that these songs are the articulate message of the slave to the world. They tell us in these eager days that life was joyous to the black slave, careless and happy. I can easily believe this of some, of many. But not all the past South, though it rose from the dead, can gainsay the heart-touching witness of these songs. They are the music of an unhappy people, of the children of disappointment; they tell of death and suffering and unvoiced longing toward a truer world, of misty wanderings and hidden ways.

The songs are indeed the siftings of centuries; the music is far more ancient than the words, and in it we can trace here and there signs of development. My grandfather's grandmother was seized by an evil Dutch trader two centuries ago; and coming to the valleys of the Hudson and Housatonic, black, little, and lithe, she shivered and shrank in the harsh north winds, looked longingly at the hills, and often crooned a heathen melody to the child between her knees, thus:

Do    ba - na  co - ba,  ge - ne    me,    ge - ne  me!

Do    ba - na  co - ba,  ge - ne    me,    ge - ne  me!

Ben d'  nu - li, nu - li, nu - li, nu - li, ben    d'    le.

The child sang it to his children and they to their children's children, and so two hundred years it has travelled down to us and we sing it to our children, knowing as little as our fathers what its words may mean, but knowing well the meaning of its music.

This was primitive African music; it may be seen in larger form in the strange chant which heralds "The Coming of John":

> "You may bury me in the East,
> You may bury me in the West,
> But I'll hear the trumpet sound in that morning,"

—the voice of exile.

Ten master songs, more or less, one may pluck from this forest of melody— songs of undoubted Negro origin and wide popular currency, and songs peculiarly characteristic of the slave. One of these I have just mentioned. Another whose strains begin this book is "Nobody knows the trouble I've seen." When, struck with a sudden poverty, the United States refused to fulfil its promises of land to the freedmen, a brigadier-general went down to the Sea Islands to carry the news. An old woman on the outskirts of the throng began singing this song; all the mass joined with her, swaying. And the soldier wept.

The third song is the cradle-song of death which all men know,—"Swing low, sweet chariot,"—whose bars begin the life story of "Alexander Crummell." Then there is the song of many waters, "Roll, Jordan, roll," a mighty chorus with minor cadences. There were many songs of the fugitive like that which opens "The Wings of Atalanta," and the more familiar "Been a-listening." The seventh is the song of the End and the Beginning— "My Lord, what a mourning! when the stars begin to fall"; a strain of this is placed before "The Dawn of Freedom." The song of groping—"My way's cloudy"—begins "The Meaning of Progress"; the ninth is the song of this chapter—"Wrestlin' Jacob, the day is a-breaking,"— a pæan of hopeful strife. The last master song is the song of songs—"Steal away,"—sprung from "The Faith of the Fathers."

There are many others of the Negro folk-songs as striking and characteristic as these, as, for instance, the three strains in the third, eighth, and ninth chapters; and others I am sure could easily make a selection on more scientific principles. There are, too, songs that seem to me a step removed from the more primitive types: there is the maze-like medley, "Bright sparkles," one phrase of which heads "The Black Belt"; the Easter carol, "Dust, dust and ashes"; the dirge, "My mother's took her flight and gone home"; and that burst of melody hovering over "The Passing of the First-Born"—"I hope my mother will be there in that beautiful world on high."

These represent a third step in the development of the slave song, of which "You may bury me in the East" is the first, and songs like "March on" (chapter six) and "Steal away" are the second. The first is African music, the second Afro-American, while the third is a blending of Negro music with the music heard in the foster land. The result is still distinctively Negro and the method of blending original, but the elements are both Negro and Caucasian. One might go further and find a fourth step in this development, where the songs of white America have been distinctively influenced by the slave songs or have incorporated whole phrases of Negro melody, as "Swanee River" and "Old Black Joe." Side by side, too, with the growth has gone the debasements and imitations—the Negro

"minstrel" songs, many of the "gospel" hymns, and some of the contemporary "coon" songs,—a mass of music in which the novice may easily lose himself and never find the real Negro melodies.

In these songs, I have said, the slave spoke to the world. Such a message is naturally veiled and half articulate. Words and music have lost each other and new and cant phrases of a dimly understood theology have displaced the older sentiment. Once in a while we catch a strange word of an unknown tongue, as the "Mighty Myo," which figures as a river of death; more often slight words or mere doggerel are joined to music of singular sweetness. Purely secular songs are few in number, partly because many of them were turned into hymns by a change of words, partly because the frolics were seldom heard by the stranger, and the music less often caught. Of nearly all the songs, however, the music is distinctly sorrowful. The ten master songs I have mentioned tell in word and music of trouble and exile, of strife and hiding; they grope toward some unseen power and sigh for rest in the End.

The words that are left to us are not without interest, and, cleared of evident dross, they conceal much of real poetry and meaning beneath conventional theology and unmeaning rhapsody. Like all primitive folk, the slave stood near to Nature's heart. Life was a "rough and rolling sea" like the brown Atlantic of the Sea Islands; the "Wilderness" was the home of God, and the "lonesome valley" led to the way of life. "Winter'll soon be over," was the picture of life and death to a tropical imagination. The sudden wild thunder-storms of the South awed and impressed the Negroes,—at times the rumbling seemed to them "mournful," at times imperious:

> "My Lord calls me,
> He calls me by the thunder,
> The trumpet sounds it in my soul."

The monotonous toil and exposure is painted in many words. One sees the ploughmen in the hot, moist furrow, singing:

> "Dere's no rain to wet you,
> Dere's no sun to burn you,
> Oh, push along, believer,
> I want to go home."

The bowed and bent old man cries, with thrice-repeated wail:

> "O Lord, keep me from sinking down,"

and he rebukes the devil of doubt who can whisper:

> "Jesus is dead and God's gone away."

Yet the soul-hunger is there, the restlessness of the savage, the wail of the wanderer, and the plaint is put in one little phrase:

My        soul     wants some thing that's     new,     that's new

Over the inner thoughts of the slaves and their relations one with another the shadow of fear ever hung, so that we get but glimpses here and there, and also with them, eloquent omissions and silences. Mother and child are sung, but seldom father; fugitive and weary wanderer call for pity and affection, but there is little of wooing and wedding; the rocks and the mountains are well known, but home is unknown. Strange blending of love and helplessness sings through the refrain:

> "Yonder's my ole mudder,
> Been waggin' at de hill so long;
> 'Bout time she cross over,
> Git home bime-by."

Elsewhere comes the cry of the "motherless" and the "Farewell, farewell, my only child."

Love-songs are scarce and fall into two categories—the frivolous and light, and the sad. Of deep successful love there is ominous silence, and in one of the oldest of these songs there is a depth of history and meaning:

A black woman said of the song, "It can't be sung without a full heart and a troubled sperrit." The same voice sings here that sings in the German folk-song:

> "Jetz Geh i' an's brunele, trink' aber net."

Of death the Negro showed little fear, but talked of it familiarly and even fondly as simply a crossing of the waters, perhaps—who knows?—back to his ancient forests again. Later days transfigured his fatalism, and amid the dust and dirt the toiler sang:

> "Dust, dust and ashes, fly over my grave,
> But the Lord shall bear my spirit home."

The things evidently borrowed from the surrounding world undergo characteristic change when they enter the mouth of the slave. Especially is this true

of Bible phrases. "Weep, O captive daughter of Zion," is quaintly turned into "Zion, weep-a-low," and the wheels of Ezekiel are turned every way in the mystic dreaming of the slave, till he says:

> "There's a little wheel a-turnin' in-a-my heart."

As in olden time, the words of these hymns were improvised by some leading minstrel of the religious band. The circumstances of the gathering, however, the rhythm of the songs, and the limitations of allowable thought, confined the poetry for the most part to single or double lines, and they seldom were expanded to quatrains or longer tales, although there are some few examples of sustained efforts, chiefly paraphrases of the Bible. Three short series of verses have always attracted me,—the one that heads this chapter, of one line of which Thomas Wentworth Higginson has fittingly said, "Never, it seems to me, since man first lived and suffered was his infinite longing for peace uttered more plaintively." The second and third are descriptions of the Last Judgment,—the one a late improvisation, with some traces of outside influence:

> "Oh, the stars in the elements are falling,
> And the moon drips away into blood,
> And the ransomed of the Lord are returning unto God,
> Blessed be the name of the Lord."

And the other earlier and homelier picture from the low coast lands:

> "Michael, haul the boat ashore,
> Then you'll hear the horn they blow,
> Then you'll hear the trumpet sound,
> Trumpet sound the world around,
> Trumpet sound for rich and poor,
> Trumpet sound the Jubilee,
> Trumpet sound for you and me."

Through all the sorrow of the Sorrow Songs there breathes a hope—a faith in the ultimate justice of things. The minor cadences of despair change often to triumph and calm confidence. Sometimes it is faith in life, sometimes a faith in death, sometimes assurance of boundless justice in some fair world beyond. But whichever it is, the meaning is always clear: that sometime, somewhere, men will judge men by their souls and not by their skins. Is such a hope justified? Do the Sorrow Songs sing true?

The silently growing assumption of this age is that the probation of races is past, and that the backward races of to-day are of proven inefficiency and not worth the saving. Such an assumption is the arrogance of peoples irreverent toward Time and ignorant of the deeds of men. A thousand years ago such an assumption, easily possible, would have made it difficult for the Teuton to prove his right to life. Two thousand years ago such dogmatism, readily welcome, would have scouted the idea of blond races ever leading civilization. So wofully unorganized is sociological knowledge that the meaning of progress, the meaning of "swift" and "slow" in human doing, and the limits of human perfectability, are veiled, unanswered sphinxes on the shores of science. Why should Æschylus have sung two thousand years before Shakespeare was born? Why has civilization

flourished in Europe, and flickered, flamed, and died in Africa? So long as the world stands meekly dumb before such questions, shall this nation proclaim its ignorance and unhallowed prejudices by denying freedom of opportunity to those who brought the Sorrow Songs to the Seats of the Mighty?

Your country? How came it yours? Before the Pilgrims landed we were here. Here we have brought our three gifts and mingled them with yours: a gift of story and song—soft, stirring melody in an ill-harmonized and unmelodious land; the gift of sweat and brawn to beat back the wilderness, conquer the soil, and lay the foundations of this vast economic empire two hundred years earlier than your weak hands could have done it; the third, a gift of the Spirit. Around us the history of the land has centred for thrice a hundred years; out of the nation's heart we have called all that was best to throttle and subdue all that was worst; fire and blood, prayer and sacrifice, have billowed over this people, and they have found peace only in the altars of the God of Right. Nor has our gift of the Spirit been merely passive. Actively we have woven ourselves with the very warp and woof of this nation,—we fought their battles, shared their sorrow, mingled our blood with theirs, and generation after generation have pleaded with a headstrong, careless people to despise not Justice, Mercy, and Truth, lest the nation be smitten with a curse. Our song, our toil, our cheer, and warning have been given to this nation in blood-brotherhood. Are not these gifts worth the giving? Is not this work and striving? Would America have been America without her Negro people?

Even so is the hope that sang in the songs of my fathers well sung. If somewhere in this whirl and chaos of things there dwells Eternal Good, pitiful yet masterful, then anon in His good time America shall rend the Veil and the prisoned shall go free. Free, free as the sunshine trickling down the morning into these high windows of mine, free as yonder fresh young voices welling up to me from the caverns of brick and mortar below—swelling with song, instinct with life, tremulous treble and darkening bass. My children, my little children, are singing to the sunshine, and thus they sing:

cheer    the    wea - ry    trav - el - ler    A -

- long    the    heav - en - ly    way.

And the traveller girds himself, and sets his face toward the Morning, and goes his way.

## THE AFTER-THOUGHT

*Hear my cry, O God the Reader; vouchsafe that this my book fall not still-born into the world-wilderness. Let there spring, Gentle One, from out its leaves vigor of thought and thoughtful deed to reap the harvest wonderful. Let the ears of a guilty people tingle with truth, and seventy millions sigh for the righteousness which exalteth nations, in this drear day when human brotherhood is mockery and a snare. Thus in Thy good time may infinite reason turn the tangle straight, and these crooked marks on a fragile leaf be not indeed.*

## Credo

I believe in God who made of one blood all races that dwell on earth.

I believe that all men, black and brown and white, are brothers, varying, through Time and Opportunity, in form and gift and feature, but differing in no essential particular, and alike in soul and in the possibility of infinite development.

Especially do I believe in the Negro Race; in the beauty of its genius, the sweetness of its soul, and its strength in that meekness which shall yet inherit this turbulent earth.

I believe in pride of race and lineage and self; in pride of self so deep as to scorn injustice to other selves; in pride of lineage so great as to despise no man's father; in pride of race so chivalrous as neither to offer bastardy to the weak nor beg wedlock of the strong, knowing that men may be brothers in Christ, even tho they be not brothers-in-law.

I believe in Service—humble reverent service, from the blackening of boots to the whitening of souls; for Work is Heaven, Idleness Hell, and Wage is the "Well done!" of the Master who summoned all them that labor and are heavy laden, making no distinction between the black sweating cotton-hands of Georgia and the First Families of Virginia, since all distinction not based on deed is devilish and not divine.

I believe in the Devil and his angels, who wantonly work to narrow the opportunity of struggling human beings, especially if they be black; who spit in the faces of the fallen, strike them that cannot strike again, believe the worst and work to prove it, hating the image which their Maker stamped on a brother's soul.

I believe in the Prince of Peace. I believe that War is Murder. I believe that armies and navies are at bottom the tinsel and braggadocio of oppression and wrong; and I believe that the wicked conquest of weaker and darker nations by nations whiter and stronger but foreshadows the death of that strength.

I believe in Liberty for all men; the space to stretch their arms and their souls; the right to breathe and the right to vote, the freedom to choose their friends, enjoy the sunshine and ride on the railroads, uncursed by color; thinking, dreaming, working as they will in a kingdom of God and love.

I believe in the training of children black even as white; the leading out of little souls into the green pastures and beside the still waters, not for pelf or peace, but for Life lit by some large vision of beauty and goodness and truth; lest we forget, and the sons of the fathers, like Esau, for mere meat barter their birthright in a mighty nation.

Finally, I believe in Patience—patience with the weakness of the Weak and the strength of the Strong, the prejudice of the Ignorant and the ignorance of the Blind; patience with the tardy triumph of Joy and the mad chastening of Sorrow—patience with God.

# A Litany of Atlanta

*Done at Atlanta, in the Day of Death, 1906*

O Silent God, Thou whose voice afar in mist and mystery hath left our ears an-hungered in these fearful days—
> *Hear us, good Lord!*

Listen to us, Thy children: our faces dark with doubt are made a mockery in Thy sanctuary. With uplifted hands we front Thy heaven, O God, crying:
> *We beseech Thee to hear us, good Lord!*

We are not better than our fellows, Lord, we are but weak and human men. When our devils do deviltry, curse Thou the doer and the deed: curse them as we curse them, do to them all and more than ever they have done to innocence and weakness, to womanhood and home.

*Have mercy upon us, miserable sinners!*

And yet whose is the deeper guilt? Who made these devils? Who nursed them in crime and fed them on injustice? Who ravished and debauched their mothers and their grandmothers? Who bought and sold their crime, and waxed fat and rich on public iniquity?

*Thou knowest, good God!*

Is this Thy justice, O Father, that guile be easier than innocence, and the innocent crucified for the guilt of the untouched guilty?

*Justice, O judge of men!*

Wherefore do we pray? Is not the God of the fathers dead? Have not seers seen in Heaven's halls Thine hearsed and lifeless form stark amidst the black and rolling smoke of sin; where all along bow bitter forms of endless dead?

*Awake, Thou that sleepest!*

Thou art not dead, but flown afar, up hills of endless light, thru blazing corridors of suns, where worlds do swing of good and gentle men, of women strong and free—far from the cozenage, black hypocrisy and chaste prostitution of this shameful speck of dust!

*Turn again, O Lord, leave us not to perish in our sin!*

From lust of body and lust of blood
*Great God, deliver us!*

From lust of power and lust of gold,
*Great God, deliver us!*

From the leagued lying of despot and of brute,
*Great God, deliver us!*

A city lay in travail, God our Lord, and from her loins sprang twin Murder and Black Hate. Red was the midnight; clang, crack and cry of death and fury filled the air and trembled underneath the stars when church spires pointed silently to Thee. And all this was to sate the greed of greedy men who hide behind the veil of vengeance!

*Bend us Thine ear, O Lord!*

In the pale, still morning we looked upon the deed. We stopped our ears and held our leaping hands, but they—did they not wag their heads and leer and cry with bloody jaws: *Cease from Crime!* The word was mockery, for thus they train a hundred crimes while we do cure one.

*Turn again our captivity, O Lord!*

Behold this maimed and broken thing; dear God, it was an humble black man who toiled and sweat to save a bit from the pittance paid him. They told him: *Work and Rise.* He worked. Did this man sin? Nay, but some one told how

some one said another did—one whom he had never seen nor known. Yet for that man's crime this man lieth maimed and murdered, his wife naked to shame, his children, to poverty and evil.

*Hear us, O Heavenly Father!*

Doth not this justice of hell stink in Thy nostrils, O God? How long shall the mounting flood of innocent blood roar in Thine ears and pound in our hearts for vengeance? Pile the pale frenzy of blood-crazed brutes who do such deeds high on Thine altar, Jehovah Jireh, and burn it in hell forever and forever!

*Forgive us, good Lord; we know not what we say!*

Bewildered we are, and passion-tost, mad with the madness of a mobbed and mocked and murdered people; straining at the armposts of Thy Throne, we raise our shackled hands and charge Thee, God, by the bones of our stolen fathers, by the tears of our dead mothers, by the very blood of Thy crucified Christ: *What meaneth this?* Tell us the Plan; give us the Sign!

*Keep not thou silence, O God!*

Sit no longer blind, Lord God, deaf to our prayer and dumb to our dumb suffering. Surely Thou too art not white, O Lord, a pale, bloodless, heartless thing?

*Ah! Christ of all the Pities!*

Forgive the thought! Forgive these wild, blasphemous words. Thou art still the God of our black fathers, and in Thy soul's soul sit some soft darkenings of the evening, some shadowings of the velvet night.

But whisper—speak—call, great God, for Thy silence is white terror to our hearts! The way, O God, show us the way and point us the path.

Whither? North is greed and South is blood; within, the coward, and without, the liar. Whither? To death?

*Amen! Welcome dark sleep!*

Whither? To life? But not this life, dear God, not this. Let the cup pass from us, tempt us not beyond our strength, for there is that clamoring and clawing within, to whose voice we would not listen, yet shudder lest we must, and it is red, Ah! God! It is a red and awful shape.

*Selah!*

In yonder East trembles a star.

*Vengeance is mine; I will repay, saith the Lord!*

Thy will, O Lord, be done!

*Kyrie Eleison!*

Lord, we have done these pleading, wavering words.

*We beseech Thee to hear us, good Lord!*

We bow our heads and hearken soft to the sobbing of women and little children.

*We beseech Thee to hear us, good Lord!*

Our voices sink in silence and in night.

*Hear us, good Lord!*

In night, O God of a godless land!
  *Amen!*

In silence, O Silent God.
  *Selah!*

# BLACK ELK

Black Elk (1863–1950) was an Oglala Lakota who earned fame among his own people for a vision he received as a youth about his curative gifts. He subsequently became a medicine man. Black Elk worked for a time as a hired performer in Buffalo Bill's Wild West Show while remaining a traditional healer. He lived through the Ghost Dance movement and the massacre at Wounded Knee in 1890 and was shortly thereafter baptized as a Catholic. When John G. Neihardt came to interview the Sioux about their history, he focused on Black Elk and published *Black Elk Speaks* in 1932. While not written in Black Elk's own hand, the book has been widely read as a gripping account of the spiritual world of the Lakota and the horrors of Wounded Knee. While some have criticized Neihardt's account for reinforcing a patronizing view of the American Indian as a tragic, noble savage who is fixed in time, others see in Black Elk's story a welcome depiction of change, continuity, and adaptation in native American cultures.

## *From* Black Elk Speaks: Being the Life Story of a Holy Man of the Oglala Sioux

### THE FIRST CURE

After the Heyoka ceremony, I came to live here where I am now between Wounded Knee Creek and Grass Creek. Others came too, and we made these little gray houses of logs that you see, and they are square. It is a bad way to live, for there can be no power in a square.

You have noticed that everything an Indian does is in a circle, and that is because the Power of the World always works in circles, and everything tries to be

round. In the old days when we were a strong and happy people, all our power came to us from the sacred hoop of the nation, and so long as the hoop was unbroken, the people flourished. The flowering tree was the living center of the hoop, and the circle of the four quarters nourished it. The east gave peace and light, the south gave warmth, the west gave rain, and the north with its cold and mighty wind gave strength and endurance. This knowledge came to us from the outer world with our religion. Everything the Power of the World does is done in a circle. The sky is round, and I have heard that the earth is round like a ball, and so are all the stars. The wind, in its greatest power, whirls. Birds make their nests in circles, for theirs is the same religion as ours. The sun comes forth and goes down again in a circle. The moon does the same, and both are round. Even the seasons form a great circle in their changing, and always come back again to where they were. The life of a man is a circle from childhood to childhood, and so it is in everything where power moves. Our tepees were round like the nests of birds, and these were always set in a circle, the nation's hoop, a nest of many nests, where the Great Spirit meant for us to hatch our children.

But the Wasichus have put us in these square boxes. Our power is gone and we are dying, for the power is not in us any more. You can look at our boys and see how it is with us. When we were living by the power of the circle in the way we should, boys were men at twelve or thirteen years of age. But now it takes them very much longer to mature.

Well, it is as it is. We are prisoners of war while we are waiting here. But there is another world.

It was in the Moon of Shedding Ponies (May) when we had the heyoka ceremony. One day in the Moon of Fatness (June), when everything was blooming, I invited One Side to come over and eat with me. I had been thinking about the four–rayed herb that I had now seen twice—the first time in the great vision when I was nine years old, and the second time when I was lamenting on the hill. I knew that I must have this herb for curing, and I thought I could recognize the place where I had seen it growing that night when I lamented.

After One Side and I had eaten, I told him there was a herb I must find, and I wanted him to help me hunt for it. Of course I did not tell him I had seen it in a vision. He was willing to help, so we got on our horses and rode over to Grass Creek. Nobody was living over there. We came to the top of a high hill above the creek, and there we got off our horses and sat down, for I felt that we were close to where I saw the herb growing in my vision of the dog.

We sat there awhile singing together some heyoka songs. Then I began to sing alone a song I had heard in my first great vision:

"In a sacred manner they are sending voices."

After I had sung this song, I looked down towards the west, and yonder at a certain spot beside the creek were crows and magpies, chicken hawks and spotted eagles circling around and around.

Then I knew, and I said to One Side: "Friend, right there is where the herb is growing." He said: "We will go forth and see." So we got on our horses and rode down Grass Creek until we came to a dry gulch, and this we followed up. As we neared the spot the birds all flew away, and it was a place where four or

five dry gulches came together. There right on the side of the bank the herb was growing, and I knew it, although I had never seen one like it before, except in my vision.

It had a root about as long as to my elbow, and this was a little thicker than my thumb. It was flowering in four colors, blue, white, red, and yellow.

We got off our horses, and after I had offered red willow bark to the Six Powers, I made a prayer to the herb, and said to it: "Now we shall go forth to the two-leggeds, but only to the weakest ones, and there shall be happy days among the weak."

It was easy to dig the herb, because it was growing in the edge of the clay gulch. Then we started back with it. When we came to Grass Creek again, we wrapped it in some good sage that was growing there.

Something must have told me to find the herb just then, for the next evening I needed it and could have done nothing without it.

I was eating supper when a man by the name of Cuts-to-Pieces came in, and he was saying: "Hey, hey, hey!" for he was in trouble. I asked him what was the matter, and he said: "I have a boy of mine, and he is very sick and l am afraid he will die soon. He has been sick a long time. They say you have great power from the horse dance and the heyoka ceremony, so maybe you can save him for me. I think so much of him."

I told Cuts-to-Pieces that if he really wanted help, he should go home and bring me back a pipe with an eagle feather on it. While he was gone, I thought about what I had to do; and I was afraid, because I had never cured anybody yet with my power, and I was very sorry for Cuts-to-Pieces. I prayed hard for help. When Cuts-to-Pieces came back with the pipe, I told him to take it around to the left of me, leave it there, and pass out again to the right of me. When he had done this, I sent for One Side to come and help me. Then I took the pipe and went to where the sick little boy was. My father and my mother went with us, and my friend, Standing Bear, was already there.

I first offered the pipe to the Six Powers, then I passed it, and we all smoked. After that I began making a rumbling thunder sound on the drum. You know, when the power of the west comes to the two-leggeds, it comes with rumbling, and when it has passed, everything lifts up its head and is glad and there is greenness. So I made this rumbling sound. Also, the voice of the drum is an offering to the Spirit of the World. Its sound arouses the mind and makes men feel the mystery and power of things.

The sick little boy was on the northeast side of the tepee, and when we entered at the south, we went around from left to right, stopping on the west side when we had made the circle.

You want to know why we always go from left to right like that. I can tell you something of the reason, but not all. Think of this: Is not the south the source of life, and does not the flowering stick truly come from there? And does not man advance from there toward the setting sun of his life? Then does not he approach the colder north where the white hairs are? And does he not then arrive, if he lives, at the source of light and understanding, which is the east? Then does he not return to where he began, to his second childhood, there to give back his life to all life, and his flesh to the earth whence it came? The more you think about this, the more meaning you will see in it.

As I said, we went into the tepee from left to right, and sat ourselves down on the west side. The sick little boy was on the northeast side, and he looked as though he were only skin and bones. I had the pipe, the drum and the four-rayed herb already, so I asked for a wooden cup, full of water, and an eagle bone whistle, which was for the spotted eagle of my great vision. They placed the cup of water in front of me; and then I had to think awhile, because I had never done this before and I was in doubt.

I understood a little more now, so I gave the eagle bone whistle to One Side and told him now to use it in helping me. Then I filled the pipe with red willow bark, and gave it to the pretty young daughter of Cuts-to-Pieces, telling her to hold it, just as I had seen the virgin of the east holding it in my great vision.

Everything was ready now, so I made low thunder on the drum, keeping time as I sent forth a voice. Four times I cried "Hey-a-a-hey," drumming as I cried to the Spirit of the World, and while I was doing this I could feel the power coming through me from my feet up, and I knew that I could help the sick little boy.

I kept on sending a voice, while I made low thunder on the drum, saying: "My Grandfather, Great Spirit, you are the only one and to no other can any one send voices. You have made everything, they say, and you have made it good and beautiful. The four quarters and the two roads crossing each other, you have made. Also you have set a power where the sun goes down. The two-leggeds on earth are in despair. For them, my Grandfather, I send a voice to you. You have said this to me: The weak shall walk. In vision you have taken me to the center of the world and there you have shown me the power to make over. The water in the cup that you have given me, by its power shall the dying live. The herb that you have shown me, through its power shall the feeble walk upright. From where we are always facing (the south), behold, a virgin shall appear, walking the good red road, offering the pipe as she walks, and hers also is the power of the flowering tree. From where the Giant lives (the north), you have given me a sacred, cleansing wind, and where this wind passes the weak shall have strength. You have said this to me. To you and to all your powers and to Mother Earth I send a voice for help."

You see, I had never done this before, and I know now that only one power would have been enough. But I was so eager to help the sick little boy that I called on every power there is.

I had been facing the west, of course, while sending a voice. Now I walked to the north and to the east and to the south, stopping there where the source of all life is and where the good red road begins. Standing there I sang thus:

> "In a sacred manner I have made them walk.
> A sacred nation lies low.
> In a sacred manner I have made them walk.
> A sacred two-legged, he lies low.
> In a sacred manner, he shall walk."

While I was singing this I could feel something queer all through my body, something that made me want to cry for all unhappy things, and there were tears on my face.

Now I walked to the quarter of the west, where I lit the pipe, offered it to the powers, and, after I had taken a whiff of smoke, I passed it around.

When I looked at the sick little boy again, he smiled at me, and I could feel that the power was getting stronger.

I next took the cup of water, drank a little of it, and went around to where the sick little boy was. Standing before him, I stamped the earth four times. Then, putting my mouth to the pit of his stomach, I drew through him the cleansing wind of the north. I next chewed some of the herb and put it in the water, afterward blowing some of it on the boy and to the four quarters. The cup with the rest of the water I gave to the virgin, who gave it to the sick little boy to drink. Then I told the virgin to help the boy stand up and to walk around the circle with him, beginning at the south, the source of life. He was very poor and weak, but with the virgin's help he did this.

Then I went away.

Next day Cuts-to-Pieces came and told me that his little boy was feeling better and was sitting up and could eat something again. In four days he could walk around. He got well and lived to be thirty years old.

Cuts-to-Pieces gave me a good horse for doing this; but of course I would have done it for nothing.

When the people heard about how the little boy was cured, many came to me for help, and I was busy most of the time.

This was in the summer of my nineteenth year (1882), in the Moon of Making Fat.

## THE MESSIAH

There was hunger among my people before I went away across the big water, because the Wasichus did not give us all the food they promised in the Black Hills treaty. They made that treaty themselves; our people did not want it and did not make it. Yet the Wasichus who made it had given us less than half as much as they promised. So the people were hungry before I went away.

But it was worse when I came back. My people looked pitiful. There was a big drouth, and the rivers and creeks seemed to be dying. Nothing would grow that the people had planted, and the Wasichus had been sending less cattle and other food than ever before. The Wasichus had slaughtered all the bison and shut us up in pens. It looked as though we might all starve to death. We could not eat lies, and there was nothing we could do.

And now the Wasichus had made another treaty to take away from us about half the land we had left. Our people did not want this treaty either, but Three Stars came and made the treaty just the same, because the Wasichus wanted our land between the Smoky Earth and the Good River. So the flood of Wasichus, dirty with bad deeds, gnawed away half of the island that was left to us. When Three Stars came to kill us on the Rosebud, Crazy Horse whipped him and drove him back. But when he came this time without any soldiers, he whipped us and drove us back. We were penned up and could do nothing.

All the time I was away from the home across the big water, my power was gone, and I was like a dead man moving around most of the time. I could hardly remember my vision, and when I did remember, it seemed like a dim dream.

Just after I came back, some people asked me to cure a sick person, and I was afraid the power would not come back to me; but it did. So I went on helping the sick, and there were many, for the measles had come among the people who were already weak because of hunger. There were more sick people that winter when the whooping cough came and killed little children who did not have enough to eat.

So it was. Our people were pitiful and in despair.

But early that summer when I came back from across the big water (1889) strange news had come from the west, and the people had been talking and talking about it. They were talking about it when I came home, and that was the first I had heard of it. This news came to the Ogalalas first of all, and I heard that it came to us from the Shoshones and Blue Clouds (Arapahoes). Some believed it and some did not believe. It was hard to believe; and when I first heard of it, I thought it was only foolish talk that somebody had started somewhere. This news said that out yonder in the west at a place near where the great mountains (The Sierras) stand before you come to the big water, there was a sacred man among Paiutes who had talked to the Great Spirit in a vision, and the Great Spirit had told him how to save the Indian peoples and make the Wasichus disappear and bring back all the bison and the people who were dead and how there would be a new earth. Before I came back, the people had got together to talk about this and they had sent three men, Good Thunder, Brave Bear and Yellow Breast, to see this sacred man with their own eyes and learn if the story about him was true. So these three men had made the long journey west, and in the fall after I came home, they returned to the Ogalalas with wonderful things to tell.

There was a big meeting at the head of White Clay Creek, not far from Pine Ridge, when they came back, but I did not go over there to hear, because I did not yet believe. I thought maybe it was only the despair that made people believe, just as a man who is starving may dream of plenty of everything good to eat.

I did not go over to the meeting, but I heard all they had to tell. These three men all said the same thing, and they were good men. They said that they traveled far until they came to a great flat valley near the last great mountains before the big water, and there they saw the Wanekia, who was the son of the Great Spirit, and they talked to him. Wasichus called him Jack Wilson, but his name was Wovoka. He told them that there was another world coming, just like a cloud. It would come in a whirlwind out of the west and would crush out everything on this world, which was old and dying. In that other world there was plenty of meat, just like old times; and in that world all the dead Indians were alive, and all the bison that had ever been killed were roaming around again.

This sacred man gave some sacred red paint and two eagle feathers to Good Thunder. The people must put this paint on their faces and they must dance a ghost dance that the sacred man taught to Good Thunder, Yellow Breast, and Brave Bear. If they did this, they could get on this other world when it came, and the Wasichus would not be able to get on, and so they would disappear. When he gave the two eagle feathers to Good Thunder, the sacred man said: "Receive these eagle feathers and behold them, for my father will cause these to bring your people back to him."

This was all that was heard the whole winter.

When I heard this about the red paint and the eagle feathers and about bringing the people back to the Great Spirit, it made me think hard. I had had a great vision that was to bring the people back into the nation's hoop, and maybe this sacred man had had the same vision and it was going to come true, so that the people would get back on the red road. Maybe I was not meant to do this myself, but if I helped with the power that was given me, the tree might bloom again and the people prosper. This was in my mind all that winter, but I did not know what vision the sacred man out there had seen, and I wished I could talk to him and find out. This was sitting deeper in my mind every day, and it was a very bad winter, with much hunger and sickness.

My father died in the first part of the winter from the bad sickness that many people had. This made me very sad. Everything good seemed to be going away. My younger brother and sister had died before I came home, and now I was fatherless in this world. But I still had my mother. I was working in a store for the Wasichus so that I could get something for her to eat, and I just kept on working there and thinking about what Good Thunder, Yellow Breast, and Brave Bear had told; but I did not feel sure yet.

During that winter the people wanted to hear some more about this sacred man and the new world coming, so they sent more men out there to learn what they could. Good Thunder and Yellow Breast, with two others, went from Pine Ridge. Some went with them from other agencies, and two of these were Kicking Bear and Short Bull. News came back from these men as they traveled west, and it seemed that everywhere people believed all that we had heard, and more. Letters came back telling us this. I kept on working in the store and helping sick people with my power.

Then it was spring (1890), and I heard that these men had all come back from the west and that they said it was all true. I did not go to this meeting either, but I heard the gossip that was everywhere now, and people said it was really the son of the Great Spirit who was out there; that when he came to the Wasichus a long time ago, they had killed him; but he was coming to the Indians this time, and there would not be any Wasichus in the new world that would come like a cloud in a whirlwind and crush out the old earth that was dying. This they said would happen after one more winter, when the grasses were appearing (1891).

I heard many wonderful things about the Wanekia that these men had seen and heard, and they were good men. He could make animals talk, and once while they were with him he made a spirit vision, and they all saw it. They saw a big water, and beyond it was a beautiful green land where all the Indians that had ever lived and the bison and the other animals were all coming home together. Then the Wanekia, they said, made the vision go out, because it was not yet time for this to happen. After another winter it would happen, when the grasses were appearing.

And once, they said, the Wanekia held out his hat for them to look into; and when they did this, all but one saw there the whole world and all that was wonderful. But that one could see only the inside of the hat, they said.

Good Thunder himself told me that, with the power of the Wanekia, he had gone to a bison skin tepee; and there his son, who had been dead a long time, was living with his wife, and they had a long talk together.

This was not like my great vision, and I just went on working in the store. I was puzzled and did not know what to think.

Afterwhile I heard that north of Pine Ridge at the head of Cheyenne Creek, Kicking Bear had held the first ghost dance, and that people who danced had seen their dead relatives and talked to them. The next thing I heard was that they were dancing on Wounded Knee Creek just below Manderson.

I did not believe yet, but I wanted to find out things, because all this was sitting more and more strongly in my heart since my father died. Something seemed to tell me to go and see. For awhile I kept from going, but at last I could not any more. So I got on my horse and went to this ghost dance on Wounded Knee Creek below Manderson.

I was surprised, and could hardly believe what I saw; because so much of my vision seemed to be in it. The dancers, both women and men, were holding hands in a big circle, and in the center of the circle they had a tree painted red with most of its branches cut off and some dead leaves on it. This was exactly like the part of my vision where the holy tree was dying, and the circle of the men and women holding hands was like the sacred hoop that should have power to make the tree to bloom again. I saw too that the sacred articles the people had offered were scarlet, as in my vision, and all their faces were painted red. Also, they used the pipe and the eagle feathers. I sat there looking on and feeling sad. It all seemed to be from my great vision somehow and I had done nothing yet to make the tree to bloom.

Then all at once great happiness overcame me, and it all took hold of me right there. This was to remind me to get to work at once and help to bring my people back into the sacred hoop, that they might again walk the red road in a sacred manner pleasing to the Powers of the Universe that are One Power. I remembered how the spirits had taken me to the center of the earth and shown me the good things, and how my people should prosper. I remembered how the Six Grandfathers had told me that through their power I should make my people live and the holy tree should bloom. I believed my vision was coming true at last, and happiness overcame me.

When I went to the dance, I went only to see and to learn what the people believed; but now I was going to stay and use the power that had been given me. The dance was over for that day, but they would dance again next day, and I would dance with them.

## VISIONS OF THE OTHER WORLD

So I dressed myself in a sacred manner, and before the dance began next morning I went among the people who were standing around the withered tree. Good Thunder, who was a relative of my father and later married my mother, put his arms around me and took me to the sacred tree that had not bloomed, and there he offered up a prayer for me. He said: "Father, Great Spirit, behold this boy! Your ways he shall see!" Then he began to cry.

I thought of my father and my brother and sister who had left us, and I could not keep the tears from running out of my eyes. I raised my face up to keep them back, but they came out just the same. I cried with my whole heart,

and while I cried I thought of my people in despair. I thought of my vision, and how it was promised me that my people should have a place in this earth where they could be happy every day. I thought of them on the wrong road now, but maybe they could be brought back into the hoop again and to the good road.

Under the tree that never bloomed I stood and cried because it had withered away. With tears on my face I asked the Great Spirit to give it life and leaves and singing birds, as in my vision.

Then there came a strong shivering all over my body, and I knew that the power was in me.

Good Thunder now took one of my arms, Kicking Bear the other, and we began to dance. The song we sang was like this:

> "Who do you think he is that comes?
> It is one who seeks his mother!"

It was what the dead would sing when entering the other world and looking for their relatives who had gone there before them.

As I danced, with Good Thunder and Kicking Bear holding my arms between them, I had the queer feeling that I knew and I seemed to be lifted clear off the ground. I did not have a vision all that first day. That night I thought about the other world and that the Wanekia himself was with my people there and maybe the holy tree of my vision was really blooming yonder right then, and that it was there my vision had already come true. From the center of the earth I had been shown all good and beautiful things in a great circle of peace, and maybe this land of my vision was where all my people were going, and there they would live and prosper where no Wasichus were or could ever be.

Before we started dancing next day, Kicking Bear offered a prayer, saying: "Father, Great Spirit, behold these people! They shall go forth to-day to see their relatives, and yonder they shall be happy, day after day, and their happiness will not end."

Then we began dancing, and most of the people wailed and cried as they danced, holding hands in a circle; but some of them laughed with happiness. Now and then some one would fall down like dead, and others would go staggering around and panting before they would fall. While they were lying there like dead they were having visions, and we kept on dancing and singing, and many were crying for the old way of living and that the old religion might be with them again.

After awhile I began to feel very queer. First, my legs seemed to be full of ants. I was dancing with my eyes closed, as the others did. Suddenly it seemed that I was swinging off the ground and not touching it any longer. The queer feeling came up from my legs and was in my heart now. It seemed I would glide forward like a swing, and then glide back again in longer and longer swoops. There was no fear with this, just a growing happiness.

I must have fallen down, but I felt as though I had fallen off a swing when it was going forward, and I was floating head first through the air. My arms were stretched out, and all I saw at first was a single eagle feather right in front of me. Then the feather was a spotted eagle dancing on ahead of me with his wings fluttering, and he was making the shrill whistle that is his. My body did not move at all, but I looked ahead and floated fast toward where I looked.

There was a ridge right in front of me, and I thought I was going to run into it, but I went right over it. On the other side of the ridge I could see a beautiful land where many, many people were camping in a great circle. I could see that they were happy and had plenty. Everywhere there were drying racks full of meat. The air was clear and beautiful with a living light that was everywhere. All around the circle, feeding on the green, green grass, were fat and happy horses; and animals of all kinds were scattered all over the green hills, and singing hunters were returning with their meat.

I floated over the tepees and began to come down feet first at the center of the hoop where I could see a beautiful tree all green and full of flowers. When I touched the ground, two men were coming toward me, and they wore holy shirts made and painted in a certain way. They came to me and said: "It is not yet time to see your father, who is happy. You have work to do. We will give you something that you shall carry back to your people, and with it they shall come to see their loved ones."

I knew it was the way their holy shirts were made that they wanted me to take back. They told me to return at once, and then I was out in the air again, floating fast as before. When I came right over the dancing place, the people were still dancing, but it seemed they were not making any sound. I had hoped to see the withered tree in bloom, but it was dead.

Then I fell back into my body, and as I did this I heard voices all around and above me, and I was sitting on the ground. Many were crowding around, asking me what vision I had seen. I told them just what I had seen, and what I brought back was the memory of the holy shirts the two men wore.

That evening some of us got together at Big Road's tepee and decided to use the ghost shirts I had seen. So the next day I made ghost shirts all day long and painted them in the sacred manner of my vision. As I made these shirts, I thought how in my vision everything was like old times and the tree was flowering, but when I came back the tree was dead. And I thought that if this world would do as the vision teaches, the tree could bloom here too.

I made the first shirt for Afraid-of-Hawk and the second for the son of Big Road.

In the evening I made a sacred stick like that I had seen in my first vision and painted it red with the sacred paint of the Wanekia. On the top of it I tied one eagle feather, and this I carried in the dance after that, wearing the holy shirt as I had seen it.

Because of my vision and the power they knew I had, I was asked to lead the dance next morning. We all stood in a straight line, facing the west, and I prayed: "Father, Great Spirit, behold me! The nation that I have is in despair. The new earth you promised you have shown me. Let my nation also behold it."

After the prayer we stood with our right hands raised to the west, and we all began to weep, and right there, as they wept, some of them fainted before the dance began.

As we were dancing I had the same queer feeling I had before, as though my feet were off the earth and swinging. Kicking Bear and Good Thunder were holding my arms. Afterwhile it seemed they let go of me, and once more I floated head first, face down, with arms extended, and the spotted eagle was dancing there ahead of me again, and I could hear his shrill whistle and his scream.

I saw the ridge again, and as I neared it there was a deep, rumbling sound, and out of it there leaped a flame. But I glided right over it. There were six villages ahead of me in the beautiful land that was all clear and green in living light. Over these in turn I glided, coming down on the south side of the sixth village. And as I touched the ground, twelve men were coming towards me, and they said: "Our Father, the two-legged chief, you shall see!"

Then they led me to the center of the circle where once more I saw the holy tree all full of leaves and blooming.

But that was not all I saw. Against the tree there was a man standing with arms held wide in front of him. I looked hard at him, and I could not tell what people he came from. He was not a Wasichu and he was not an Indian. His hair was long and hanging loose, and on the left side of his head he wore an eagle feather. His body was strong and good to see, and it was painted red. I tried to recognize him, but I could not make him out. He was a very fine-looking man. While I was staring hard at him, his body began to change and became very beautiful with all colors of light, and around him there was light. He spoke like singing: "My life is such that all earthly beings and growing things belong to me. Your father, the Great Spirit, has said this. You too must say this."

Then he went out like a light in a wind.

The twelve men who were there spoke: "Behold them! Your nation's life shall be such!"

I saw again how beautiful the day was—the sky all blue and full of yellow light above the greening earth. And I saw that all the people were beautiful and young. There were no old ones there, nor children either—just people of about one age, and beautiful.

Then there were twelve women who stood in front of me and spoke: "Behold them! Their way of life you shall take back to earth." When they had spoken, I heard singing in the west, and I learned the song I heard.

Then one of the twelve men took two sticks, one painted white and one red, and, thrusting them in the ground, he said: "Take these! You shall depend upon them. Make haste!"

I started to walk, and it seemed as though a strong wind went under me and picked me up. I was in the air, with outstretched arms, and floating fast. There was a fearful dark river that I had to go over, and I was afraid. It rushed and roared and was full of angry foam. Then I looked down and saw many men and women who were trying to cross the dark and fearful river, but they could not. Weeping, they looked up to me and cried: "Help us!" But I could not stop gliding, for it was as though a great wind were under me.

Then I saw my earthly people again at the dancing place, and fell back into my body lying there. And I was sitting up, and people were crowding around me to ask what vision I had seen.

I told my vision through songs, and the older men explained them to the others. I sang a song, the words of which were those the Wanekia spoke under the flowering tree, and the air of it was that which I heard in the West after the twelve women had spoken. I sang it four times, and the fourth time all the people began to weep together because the Wasichus had taken the beautiful world away from us.

I thought and thought about this vision. The six villages seemed to represent the Six Grandfathers that I had seen long ago in the Flaming Rainbow

Tepee, and I had gone to the sixth village, which was for the Sixth Grandfather, the Spirit of the Earth, because I was to stand for him in the world. I wondered if the Wanekia might be the red man of my great vision, who turned into a bison, and then into the four-rayed herb, the daybreak-star herb of understanding. I thought the twelve men and twelve women were for the moons of the year.

# MARY ANTIN

Mary Antin (1881–1949) immigrated to the United States from Russia in the last years of the nineteenth century, when she was thirteen years old. She cast away the religious Judaism of her childhood as an "Old World" relic that did not belong in the "New World" of America. She later wrote an autobiographical account of her own Americanization, *The Promised Land* (1912), which would come to be viewed as one of the greatest early works of Jewish American literature. The book went through thirty-four editions and sold nearly 85,000 copies while Antin was still living. Her pro-assimilation stance, favoring a universalist ethic over and against Jewish particularism, was not shared by all Jewish immigrants, however, and later readers would see signs of strain in Antin's portrayal of her family. This excerpt hints at some of the religious tensions that Antin and other immigrants experienced in the New World.

## *From* The Promised Land

I was born, I have lived, and I have been made over. Is it not time to write my life's story? I am just as much out of the way as if I were dead, for I am absolutely other than the person whose story I have to tell. Physical continuity with my earlier self is no disadvantage. I could speak in the third person and not feel that I was masquerading. I can analyze my subject, I can reveal everything; for *she,* and not *I,* is my real heroine. My life I have still to live; her life ended when mine began.

A generation is sometimes a more satisfactory unit for the study of humanity than a lifetime; and spiritual generations are as easy to demark as physical ones. Now I am the spiritual offspring of the marriage within my conscious experience of the Past and the Present. My second birth was no less a birth because there was no distinct incarnation. Surely it has happened before that one body

served more than one spiritual organization. Nor am I disowning my father and mother of the flesh, for they were also partners in the generation of my second self; copartners with my entire line of ancestors. They gave me body, so that I have eyes like my father's and hair like my mother's. The spirit also they gave me, so that I reason like my father and endure like my mother. But did they set me down in a sheltered garden, where the sun should warm me, and no winter should hurt, while they fed me from their hands? No; they early let me run in the fields—perhaps because I would not be held—and eat of the wild fruits and drink of the dew. Did they teach me from books, and tell me what to believe? I soon chose my own books, and built me a world of my own. . . .

When I was a little girl, the world was divided into two parts; namely, Polotzk, the place where I lived, and a strange land called Russia. All the little girls I knew lived in Polotzk, with their fathers and mothers and friends. Russia was the place where one's father went on business. It was so far off, and so many bad things happened there, that one's mother and grandmother and grown-up aunts cried at the railroad station, and one was expected to be sad and quiet for the rest of the day, when the father departed for Russia.

After a while there came to my knowledge the existence of another division, a region intermediate between Polotzk and Russia. It seemed there was a place called Vitebsk, and one called Vilna, and Riga, and some others. From those places came photographs of uncles and cousins one had never seen, and letters, and sometimes the uncles themselves. These uncles were just like people in Polotzk; the people in Russia, one understood, were very different. In answer to one's questions, the visiting uncles said all sorts of silly things, to make everybody laugh; and so one never found out why Vitebsk and Vilna, since they were not Polotzk, were not as sad as Russia. Mother hardly cried at all when the uncles went away.

One time, when I was about eight years old, one of my grown-up cousins went to Vitebsk. Everybody went to see her off, but I didn't. I went with her. I was put on the train, with my best dress tied up in a bandana, and I stayed on the train for hours and hours, and came to Vitebsk. I could not tell, as we rushed along, where the end of Polotzk was. There were a great many places on the way, with strange names, but it was very plain when we got to Vitebsk.

The railroad station was a big place, much bigger than the one in Polotzk. Several trains came in at once, instead of only one. There was an immense buffet, with fruits and confections, and a place where books were sold. My cousin never let go my hand, on account of the crowd. Then we rode in a cab for ever so long, and I saw the most beautiful streets and shops and houses, much bigger and finer than any in Polotzk.

We remained in Vitebsk several days, and I saw many wonderful things, but what gave me my one great surprise was something that wasn't new at all. It was the river—the river Dvina. Now the Dvina is in Polotzk. All my life I had seen the Dvina. How, then, could the Dvina be in Vitebsk? My cousin and I had come on the train, but everybody knew that a train could go everywhere, even to Russia. It became clear to me that the Dvina went on and on, like a railroad track, whereas I had always supposed that it stopped where Polotzk stopped. I

had never seen the end of Polotzk; I meant to, when I was bigger. But how could there be an end to Polotzk now? Polotzk was everything on both sides of the Dvina, as all my life I had known; and the Dvina, it now turned out, never broke off at all. It was very curious that the Dvina should remain the same, while Polotzk changed into Vitebsk!

The mystery of this transmutation led to much fruitful thinking. The boundary between Polotzk and the rest of the world was not, as I had supposed, a physical barrier, like the fence which divided our garden from the street. The world went like this now: Polotzk—more Polotzk—more Polotzk—Vitebsk! And Vitebsk was not so different, only bigger and brighter and more crowded. And Vitebsk was not the end. The Dvina, and the railroad, went on beyond Vitebsk,—went on to Russia. Then was Russia more Polotzk? Was here also no dividing fence? How I wanted to see Russia! But very few people went there. When people went to Russia it was a sign of trouble; either they could not make a living at home, or they were drafted for the army, or they had a lawsuit. No, nobody went to Russia for pleasure. Why, in Russia lived the Czar, and a great many cruel people; and in Russia were the dreadful prisons from which people never came back.

Polotzk and Vitebsk were now bound together by the continuity of the earth, but between them and Russia a formidable barrier still interposed. I learned, as I grew older, that much as Polotzk disliked to go to Russia, even more did Russia object to letting Polotzk come. People from Polotzk were sometimes turned back before they had finished their business, and often they were cruelly treated on the way. It seemed there were certain places in Russia— St. Petersburg, and Moscow, and Kiev—where my father or my uncle or my neighbor must never come at all, no matter what important things invited them. The police would seize them and send them back to Polotzk, like wicked criminals, although they had never done any wrong.

It was strange enough that my relatives should be treated like this, but at least there was this excuse for sending them back to Polotzk, that they belonged there. For what reason were people driven out of St. Petersburg and Moscow who had their homes in those cities, and had no other place to go to? Ever so many people, men and women and even children, came to Polotzk, where they had no friends, with stories of cruel treatment in Russia; and although they were nobody's relatives, they were taken in, and helped, and set up in business, like unfortunates after a fire.

It was very strange that the Czar and the police should want all Russia for themselves. It was a very big country; it took many days for a letter to reach one's father in Russia. Why might not everybody be there who wanted to?

I do not know when I became old enough to understand. The truth was borne in on me a dozen times a day, from the time I began to distinguish words from empty noises. My grandmother told me about it, when she put me to bed at night. My parents told me about it, when they gave me presents on holidays. My playmates told me, when they drew me back into a corner of the gateway, to let a policeman pass. Vanka, the little white-haired boy, told me all about it, when he ran out of his mother's laundry on purpose to throw mud after me when I happened to pass. I heard about it during prayers, and when women quarrelled in the market place; and sometimes, waking in the night, I heard my

parents whisper it in the dark. There was no time in my life when I did not hear and see and feel the truth—the reason why Polotzk was cut off from the rest of Russia. It was the first lesson a little girl in Polotzk had to learn. But for a long while I did not understand. Then there came a time when I knew that Polotzk and Vitebsk and Vilna and some other places were grouped together as the "Pale of Settlement," and within this area the Czar commanded me to stay, with my father and mother and friends, and all other people like us. We must not be found outside the Pale, because we were Jews.

So there was a fence around Polotzk, after all. The world was divided into Jews and Gentiles. This knowledge came so gradually that it could not shock me. It trickled into my consciousness drop by drop. By the time I fully understood that I was a prisoner, the shackles had grown familiar to my flesh.

The first time Vanka threw mud at me, I ran home and complained to my mother, who brushed off my dress and said, quite resignedly, "How can I help you, my poor child? Vanka is a Gentile. The Gentiles do as they like with us Jews." The next time Vanka abused me, I did not cry, but ran for shelter, saying to myself, "Vanka is a Gentile." The third time, when Vanka spat on me, I wiped my face and thought nothing at all. I accepted ill-usage from the Gentiles as one accepts the weather. The world was made in a certain way, and I had to live in it.

Not quite all the Gentiles were like Vanka. Next door to us lived a Gentile family which was very friendly. There was a girl as big as I, who never called me names, and gave me flowers from her father's garden. And there were the Parphens, of whom my grandfather rented his store. They treated us as if we were not Jews at all. On our festival days they visited our house and brought us presents, carefully choosing such things as Jewish children might accept; and they liked to have everything explained to them, about the wine and the fruit and the candles, and they even tried to say the appropriate greetings and blessings in Hebrew. My father used to say that if all the Russians were like the Parphens, there would be no trouble between Gentiles and Jews; and Fedora Pavlovna, the landlady, would reply that the Russian *people* were not to blame. It was the priests, she said, who taught the people to hate the Jews. Of course she knew best, as she was a very pious Christian. She never passed a church without crossing herself.

The Gentiles were always crossing themselves; when they went into a church, and when they came out, when they met a priest, or passed an image in the street. The dirty beggars on the church steps never stopped crossing themselves; and even when they stood on the corner of a Jewish street, and received alms from Jewish people, they crossed themselves and mumbled Christian prayers. In every Gentile house there was what they called an "icon," which was an image or picture of the Christian god, hung up in a corner, with a light always burning before it. In front of the icon the Gentiles said their prayers, on their knees, crossing themselves all the time.

I tried not to look in the corner where the icon was, when I came into a Gentile house. I was afraid of the cross. Everybody was, in Polotzk—all the Jews, I mean. For it was the cross that made the priests, and the priests made our troubles, as even some Christians admitted. The Gentiles said that we had killed their God, which was absurd, as they never had a God—nothing but images. Besides, what they accused us of had happened so long ago; the Gentiles them-

selves said it was long ago. Everybody had been dead for ages who could have had anything to do with it. Yet they put up crosses everywhere, and wore them on their necks, on purpose to remind themselves of these false things; and they considered it pious to hate and abuse us, insisting that we had killed their God. To worship the cross and to torment a Jew was the same thing to them. That is why we feared the cross.

Another thing the Gentiles said about us was that we used the blood of murdered Christian children at the Passover festival. Of course that was a wicked lie. It made me sick to think of such a thing. I knew everything that was done for Passover, from the time I was a very little girl. The house was made clean and shining and holy, even in the corners where nobody ever looked. Vessels and dishes that were used all the year round were put away in the garret, and special vessels were brought out for the Passover week. I used to help unpack the new dishes, and find my own blue mug. When the fresh curtains were put up, and the white floors were uncovered, and everybody in the house put on new clothes, and I sat down to the feast in my new dress, I felt clean inside and out. And when I asked the Four Questions, about the unleavened bread and the bitter herbs and the other things, and the family, reading from their books, answered me, did I not know all about Passover, and what was on the table, and why? It was wicked of the Gentiles to tell lies about us. The youngest child in the house knew how Passover was kept.

The Passover season, when we celebrated our deliverance from the land of Egypt, and felt so glad and thankful, as if it had only just happened, was the time our Gentile neighbors chose to remind us that Russia was another Egypt. That is what I heard people say, and it was true. It was not so bad in Polotzk, within the Pale; but in Russian cities, and even more in the country districts, where Jewish families lived scattered, by special permission of the police, who were always changing their minds about letting them stay, the Gentiles made the Passover a time of horror for the Jews. Somebody would start up that lie about murdering Christian children, and the stupid peasants would get mad about it, and fill themselves with vodka, and set out to kill the Jews. They attacked them with knives and clubs and scythes and axes, killed them or tortured them, and burned their houses. This was called a "pogrom." Jews who escaped the pogroms came to Polotzk with wounds on them, and horrible, horrible stories, of little babies torn limb from limb before their mothers' eyes. Only to hear these things made one sob and sob and choke with pain. People who saw such things never smiled any more, no matter how long they lived; and sometimes their hair turned white in a day, and some people became insane on the spot.

Often we heard that the pogrom was led by a priest carrying a cross before the mob. Our enemies always held up the cross as the excuse of their cruelty to us. I never was in an actual pogrom, but there were times when it threatened us, even in Polotzk; and in all my fearful imaginings, as I hid in dark corners, thinking of the horrible things the Gentiles were going to do to me, I saw the cross, the cruel cross.

I remember a time when I thought a pogrom had broken out in our street, and I wonder that I did not die of fear. It was some Christian holiday, and we had been warned by the police to keep indoors. Gates were locked; shutters were barred. If a child cried, the nurse threatened to give it to the priest, who

would soon be passing by. Fearful and yet curious, we looked through the cracks in the shutters. We saw a procession of peasants and townspeople, led by a number of priests, carrying crosses and banners and images. In the place of honor was carried a casket, containing a relic from the monastery in the outskirts of Polotzk. Once a year the Gentiles paraded with this relic, and on that occasion the streets were considered too holy for Jews to be about; and we lived in fear till the end of the day, knowing that the least disturbance might start a riot, and a riot lead to a pogrom.

On the day when I saw the procession through a crack in the shutter, there were soldiers and police in the street. This was as usual, but I did not know it. I asked the nurse, who was pressing to the crack over my head, what the soldiers were for. Thoughtlessly she answered me, "In case of a pogrom." Yes, there were the crosses and the priests and the mob. The church bells were pealing their loudest. Everything was ready. The Gentiles were going to tear me in pieces, with axes and knives and ropes. They were going to burn me alive. The cross—the cross! What would they do to me first?

There was one thing the Gentiles might do to me worse than burning or rending. It was what was done to unprotected Jewish children who fell into the hands of priests or nuns. They might baptize me. That would be worse than death by torture. Rather would I drown in the Dvina than a drop of the baptismal water should touch my forehead. To be forced to kneel before the hideous images, to kiss the cross,—sooner would I rush out to the mob that was passing, and let them tear my vitals out. To forswear the One God, to bow before idols,— rather would I be seized with the plague, and be eaten up by vermin. I was only a little girl, and not very brave; little pains made me ill, and I cried. But there was no pain that I would not bear—no, none—rather than submit to baptism. . . .

❋

As I look back to-day I see, within the wall raised around my birthplace by the vigilance of the police, another wall, higher, thicker, more impenetrable. This is the wall which the Czar with all his minions could not shake, the priests with their instruments of torture could not pierce, the mob with their firebrands could not destroy. This wall within the wall is the religious integrity of the Jews, a fortress erected by the prisoners of the Pale, in defiance of their jailers; a stronghold built of the ruins of their pillaged homes, cemented with the blood of their murdered children.

Harassed on every side, thwarted in every normal effort, pent up within narrow limits, all but dehumanized, the Russian Jew fell back upon the only thing that never failed him,—his hereditary faith in God. In the study of the Torah he found the balm for all his wounds; the minute observance of traditional rites became the expression of his spiritual cravings; and in the dream of a restoration to Palestine he forgot the world.

What did it matter to us, on a Sabbath or festival, when our life was centred in the synagogue, what czar sat on the throne, what evil counsellors whispered in his ear? They were concerned with revenues and policies and ephemeral trifles of all sorts, while we were intent on renewing our ancient covenant with God, to the end that His promise to the world should be fulfilled, and His justice overwhelm the nations.

On a Friday afternoon the stores and markets closed early. The clatter of business ceased, the dust of worry was laid, and the Sabbath peace flooded the quiet streets. No hovel so mean but what its easement sent out its consecrated ray, so that a wayfarer passing in the twilight saw the spirit of God brooding over the lowly roof.

Care and fear and shrewishness dropped like a mask from every face. Eyes dimmed with weeping kindled with inmost joy. Wherever a head bent over a sacred page, there rested the halo of God's presence.

Not on festivals alone, but also on the common days of the week, we lived by the Law that had been given us through our teacher Moses. How to eat, how to bathe, how to work—everything had been written down for us, and we strove to fulfil the Law. The study of the Torah was the most honored of all occupations, and they who engaged in it the most revered of all men.

My memory does not go back to a time when I was too young to know that God had made the world, and had appointed teachers to tell the people how to live in it. First came Moses, and after him the great rabbis, and finally the Rav of Polotzk, who read all day in the sacred books, so that he could tell me and my parents and my friends what to do whenever we were in doubt. If my mother cut up a chicken and found something wrong in it,—some hurt or mark that should not be,—she sent the housemaid with it to the rav, and I ran along, and saw the rav look in his big books; and whatever he decided was right. If he called the chicken "trefah" I must not eat of it; no, not if I had to starve. And the rav knew about everything: about going on a journey, about business, about marrying, about purifying vessels for Passover.

Another great teacher was the dayyan, who heard people's quarrels and settled them according to the Law, so that they should not have to go to the Gentile courts. The Gentiles were false, judges and witnesses and all. They favored the rich man against the poor, the Christian against the Jew. The dayyan always gave true judgments. Nohem Rabinovitch, the richest man in Polotzk, could not win a case against a servant maid, unless he were in the right.

Besides the rav and the dayyan there were other men whose callings were holy,—the shohat, who knew how cattle and fowls should be killed; the hazzan and the other officers of the synagogue; the teachers of Hebrew, and their pupils. It did not matter how poor a man was, he was to be respected and set above other men, if he were learned in the Law.

In the synagogue scores of men sat all day long over the Hebrew books, studying and disputing from early dawn till candles were brought in at night, and then as long as the candles lasted. They could not take time for anything else, if they meant to become great scholars. Most of them were strangers in Polotzk, and had no home except the synagogue. They slept on benches, on tables, on the floor; they picked up their meals wherever they could. They had come from distant cities, so as to be under good teachers in Polotzk; and the townspeople were proud to support them by giving them food and clothing and sometimes money to visit their homes on holidays. But the poor students came in such numbers that there were not enough rich families to provide for all, so that some of them suffered privation. You could pick out a poor student in a crowd, by his pale face and shrunken form.

There was almost always a poor student taking meals at our house. He was assigned a certain day, and on that day my grandmother took care to have something especially good for dinner. It was a very shabby guest who sat down with us at table, but we children watched him with respectful eyes. Grandmother had told us that he was a lamden (scholar), and we saw something holy in the way he ate his cabbage.

Not every man could hope to be a rav, but no Jewish boy was allowed to grow up without at least a rudimentary knowledge of Hebrew. The scantiest income had to be divided so as to provide for the boys' tuition. To leave a boy without a teacher was a disgrace upon the whole family, to the remotest relative. For the children of the destitute there was a free school, supported by the charity of the pious. And so every boy was sent to heder (Hebrew school) almost as soon as he could speak; and usually he continued to study until his confirmation, at thirteen years of age, or as much longer as his talent and ambition carried him. My brother was five years old when he entered on his studies. He was carried to the heder, on the first day, covered over with a praying-shawl, so that nothing unholy should look on him; and he was presented with a bun, on which were traced, in honey, these words: "The Torah left by Moses is the heritage of the children of Jacob."

After a boy entered heder, he was the hero of the family. He was served before the other children at table, and nothing was too good for him. If the family were very poor, all the girls might go barefoot, but the heder boy must have shoes; he must have a plate of hot soup, though the others ate dry bread. When the rebbe (teacher) came on Sabbath afternoon, to examine the boy in the hearing of the family, everybody sat around the table and nodded with satisfaction, if he read his portion well; and he was given a great saucerful of preserves, and was praised, and blessed, and made much of. No wonder he said, in his morning prayer, "I thank Thee, Lord, for not having created me a female." It was not much to be a girl, you see. Girls could not be scholars and rabbonim.

I went to my brother's heder, sometimes, to bring him his dinner, and saw how the boys studied. They sat on benches around the table, with their hats on, of course, and the sacred fringes hanging beneath their jackets. The rebbe sat at an end of the table, rehearsing two or three of the boys who were studying the same part, pointing out the words with his wooden pointer, so as not to lose the place. Everybody read aloud, the smallest boys repeating the alphabet in a singsong, while the advanced boys read their portions in a different sing-song; and everybody raised his voice to its loudest so as to drown the other voices. The good boys never took their eyes off their page, except to ask the rebbe a question; but the naughty boys stared around the room, and kicked each other under the table, till the rebbe caught them at it. He had a ruler for striking the bad boys on the knuckles, and in a corner of the room leaned a long birch wand for pupils who would not learn their lessons.

The boys came to heder before nine in the morning, and remained until eight or nine in the evening. Stupid pupils, who could not remember the lesson, sometimes had to stay till ten. There was an hour for dinner and play at noon. Good little boys played quietly in their places, but most of the boys ran out of the house and jumped and yelled and quarrelled.

There was nothing in what the boys did in heder that I could not have done—if I had not been a girl. For a girl it was enough if she could read her prayers in Hebrew, and follow the meaning by the Yiddish translation at the bottom of the page. It did not take long to learn this much,—a couple of terms with a rebbetzin (female teacher)—and after that she was done with books.

A girl's real schoolroom was her mother's kitchen. There she learned to bake and cook and manage, to knit, sew, and embroider; also to spin and weave, in country places. And while her hands were busy, her mother instructed her in the laws regulating a pious Jewish household and in the conduct proper for a Jewish wife; for, of course, every girl hoped to be a wife. A girl was born for no other purpose.

How soon it came, the pious burden of wifehood! One day the girl is play-ing forfeits with her laughing friends, the next day she is missed from the circle. She has been summoned to a conference with the shadchan (marriage broker), who has been for months past advertising her housewifely talents, her piety, her good looks, and her marriage portion, among families with marriageable sons. Her parents are pleased with the son-in-law proposed by the shadchan, and now, at the last, the girl is brought in, to be examined and appraised by the prospective parents-in-law. If the negotiations go off smoothly, the marriage contract is written, presents are exchanged between the engaged couple, through their respective parents, and all that is left the girl of her maidenhood is a period of busy preparation for the wedding.

If the girl is well-to-do, it is a happy interval, spent in visits to the drapers and tailors, in collecting linens and featherbeds and vessels of copper and brass. The former playmates come to inspect the trousseau, enviously fingering the silks and velvets of the bride-elect. The happy heroine tries on frocks and man-tles before her glass, blushing at references to the wedding day; and to the ques-tion, "How do you like the bridegroom?" she replies, "How should I know? There was such a crowd at the betrothal that I didn't see him."

Marriage was a sacrament with us Jews in the Pale. To rear a family of chil-dren was to serve God. Every Jewish man and woman had a part in the fulfil-ment of the ancient promise given to Jacob that his seed should be abundantly scattered over the earth. Parenthood, therefore, was the great career. But while men, in addition to begetting, might busy themselves with the study of the Laws, woman's only work was motherhood. To be left an old maid became, ac-cordingly, the greatest misfortune that could threaten a girl; and to ward off that calamity the girl and her family, to the most distant relatives, would strain every nerve, whether by contributing to her dowry, or hiding her defects from the marriage broker, or praying and fasting that God might send her a husband.

Not only must all the children of a family be mated, but they must marry in the order of their ages. A younger daughter must on no account marry before an elder. A houseful of daughters might be held up because the eldest failed to find favor in the eyes of prospective mothers-in-law; not one of the others could marry till the eldest was disposed of. . . .

I was fed on dreams, instructed by means of prophecies, trained to hear and see mystical things that callous senses could not perceive. I was taught to call myself a princess, in memory of my forefathers who had ruled a nation. Though I went in the disguise of an outcast, I felt a halo resting on my brow. Sat upon by

brutal enemies, unjustly hated, annihilated a hundred times, I yet arose and held my head high, sure that I should find my kingdom in the end, although I had lost my way in exile; for He who had brought my ancestors safe through a thousand perils was guiding my feet as well. God needed me and I needed Him, for we two together had a work to do, according to an ancient covenant between Him and my forefathers. . . .

❋

It was a little before Passover that the cry of the hunted thrilled the Jewish world with the familiar fear. The wholesale expulsion of Jews from Moscow and its surrounding district at cruelly short notice was the name of this latest disaster. Where would the doom strike next? The Jews who lived illegally without the Pale turned their possessions into cash and slept in their clothes, ready for immediate flight. Those who lived in the comparative security of the Pale trembled for their brothers and sisters without, and opened wide their doors to afford the fugitives refuge. And hundreds of fugitives, preceded by a wail of distress, flocked into the open district, bringing their trouble where trouble was never absent, mingling their tears with the tears that never dried.

The open cities becoming thus suddenly crowded, every man's chance of making a living was diminished in proportion to the number of additional competitors. Hardship, acute distress, ruin for many: thus spread the disaster, ring beyond ring, from the stone thrown by a despotic official into the ever-full river of Jewish persecution.

Passover was celebrated in tears that year. In the story of the Exodus we would have read a chapter of current history, only for us there was no deliverer and no promised land.

But what said some of us at the end of the long service? Not "May we be next year in Jerusalem," but "Next year—in America!" So there was our promised land, and many faces were turned towards the West. And if the waters of the Atlantic did not part for them, the wanderers rode its bitter flood by a miracle as great as any the rod of Moses ever wrought.

My father was carried away by the westward movement, glad of his own deliverance, but sore at heart for us whom he left behind. It was the last chance for all of us. We were so far reduced in circumstances that he had to travel with borrowed money to a German port, whence he was forwarded to Boston, with a host of others, at the expense of an emigrant aid society.

I was about ten years old when my father emigrated. I was used to his going away from home, and "America" did not mean much more to me than "Kherson," or "Odessa," or any other names of distant places. I understood vaguely, from the gravity with which his plans were discussed, and from references to ships, societies, and other unfamiliar things, that this enterprise was different from previous ones; but my excitement and emotion on the morning of my father's departure were mainly vicarious.

I know the day when "America" as a world entirely unlike Polotzk lodged in my brain, to become the centre of all my dreams and speculations. Well I know the day. I was in bed, sharing the measles with some of the other children. Mother brought us a thick letter from father, written just before boarding the

ship. The letter was full of excitement. There was something in it besides the description of travel, something besides the pictures of crowds of people, of foreign cities, of a ship ready to put out to sea. My father was travelling at the expense of a charitable organization, without means of his own, without plans, to a strange world where he had no friends; and yet he wrote with the confidence of a well-equipped soldier going into battle. The rhetoric is mine. Father simply wrote that the emigration committee was taking good care of everybody, that the weather was fine, and the ship comfortable. But I heard something, as we read the letter together in the darkened room, that was more than the words seemed to say. There was an elation, a hint of triumph, such as had never been in my father's letters before. I cannot tell how I knew it. I felt a stirring, a straining in my father's letter. It was there, even though my mother stumbled over strange words, even though she cried, as women will when somebody is going away. My father was inspired by a vision. He saw something—he promised us something. It was this "America." And "America" became my dream. . . .

Our turn came at last. We were conducted through the gate of departure, and after some hours of bewildering manœuvres, desribed in great detail in the report to my uncle, we found ourselves—we five frightened pilgrims from Polotzk—on the deck of a great big steamship afloat on the strange big waters of the ocean. . . .

And so suffering, fearing, brooding, rejoicing, we crept nearer and nearer to the coveted shore, until, on a glorious May morning, six weeks after our departure from Polotzk, our eyes beheld the Promised Land, and my father received us in his arms. . . .

✸

My father, in his ambition to make Americans of us, was rather headlong and strenuous in his methods. To my mother, on the eve of departure for the New World, he wrote boldly that progressive Jews in America did not spend their days in praying; and he urged her to leave her wig in Polotzk, as a first step of progress. My mother, like the majority of women in the Pale, had all her life taken her religion on authority; so she was only fulfilling her duty to her husband when she took his hint, and set out upon her journey in her own hair. Not that it was done without reluctance; the Jewish faith in her was deeply rooted, as in the best of Jews it always is. The law of the Fathers was binding to her, and the outward symbols of obedience inseparable from the spirit. But the breath of revolt against orthodox externals was at this time beginning to reach us in Polotzk from the greater world, notably from America. Sons whose parents had impoverished themselves by paying the fine for non-appearance for military duty, in order to save their darlings from the inevitable sins of violated Judaism while in the service, sent home portraits of themselves with their faces shaved; and the grieved old fathers and mothers, after offering up special prayers for the renegades, and giving charity in their name, exhibited the significant portraits on their parlor tables. My mother's own nephew went no farther than Vilna, ten hours' journey from Polotzk, to learn to cut his beard; and even within our town limits young women of education were beginning to reject the wig after marriage. A notorious example was the beautiful daughter of Lozhe the Rav,

who was not restrained by her father's conspicuous relation to Judaism from exhibiting her lovely black curls like a maiden; and it was a further sign of the times that the rav did not disown his daughter. What wonder, then, that my poor mother, shaken by these foreshadowings of revolution in our midst, and by the express authority of her husband, gave up the emblem of matrimonial chastity with but a passing struggle? Considering how the heavy burdens which she had borne from childhood had never allowed her time to think for herself at all, but had obliged her always to tread blindly in the beaten paths, I think it greatly to her credit that in her puzzling situation she did not lose her poise entirely. Bred to submission, submit she must; and when she perceived a conflict of authorities, she prepared to accept the new order of things under which her children's future was to be formed; wherein she showed her native adaptability, the readiness to fall into line, which is one of the most charming traits of her gentle, self-effacing nature.

My father gave my mother very little time to adjust herself. He was only three years from the Old World with its settled prejudices. Considering his education, he had thought out a good deal for himself, but his line of thinking had not as yet brought him to include woman in the intellectual emancipation for which he himself had been so eager even in Russia. This was still in the day when he was astonished to learn that women had written books—had used their minds, their imaginations, unaided. He still rated the mental capacity of the average woman as only a little above that of the cattle she tended. He held it to be a wife's duty to follow her husband in all things. He could do all the thinking for the family, he believed; and being convinced that to hold to the outward forms of orthodox Judaism was to be hampered in the race for Americanization, he did not hesitate to order our family life on unorthodox lines. There was no conscious despotism in this; it was only making manly haste to realize an ideal the nobility of which there was no one to dispute.

My mother, as we know, had not the initial impulse to depart from ancient usage that my father had in his habitual scepticism. He had always been a nonconformist in his heart; she bore lovingly the yoke of prescribed conduct. Individual freedom, to him, was the only tolerable condition of life; to her it was confusion. My mother, therefore, gradually divested herself, at my father's bidding, of the mantle of orthodox observance; but the process cost her many a pang, because the fabric of that venerable garment was interwoven with the fabric of her soul.

My father did not attempt to touch the fundamentals of her faith. He certainly did not forbid her to honor God by loving her neighbor, which is perhaps not far from being the whole of Judaism. If his loud denials of the existence of God influenced her to reconsider her creed, it was merely an incidental result of the freedom of expression he was so eager to practise, after his life of enforced hypocrisy. As the opinions of a mere woman on matters so abstract as religion did not interest him in the least, he counted it no particular triumph if he observed that my mother weakened in her faith as the years went by. He allowed her to keep a Jewish kitchen as long as she pleased, but he did not want us children to refuse invitations to the table of our Gentile neighbors. He would have no bar to our social intercourse with the world around us, for only by freely sharing the life of our neighbors could we come into our full inheritance of

American freedom and opportunity. On the holy days he bought my mother a ticket for the synagogue, but the children he sent to school. On Sabbath eve my mother might light the consecrated candles, but he kept the store open until Sunday morning. My mother might believe and worship as she pleased, up to the point where her orthodoxy began to interfere with the American progress of the family.

The price that all of us paid for this disorganization of our family life has been levied on every immigrant Jewish household where the first generation clings to the traditions of the Old World, while the second generation leads the lift of the New. Nothing more pitiful could be written in the annals of the Jews; nothing more inevitable; nothing more hopeful. Hopeful, yes; alike for the Jew and for the country that has given him shelter. For Israel is not the only party that has put up a forfeit in this contest. The nations may well sit by and watch the struggle, for humanity has a stake in it. I say this, whose life has borne witness, whose heart is heavy with revelations it has not made. And I speak for thousands; oh, for thousands!

My gray hairs are too few for me to let these pages trespass the limit I have set myself. That part of my life which contains the climax of my personal drama I must leave to my grandchildren to record. My father might speak and tell how, in time, he discovered that in his first violent rejection of everything old and established he cast from him much that he afterwards missed. He might tell to what extent he later retraced his steps, seeking to recover what he had learned to value anew; how it fared with his avowed irreligion when put to the extreme test; to what, in short, his emancipation amounted. And he, like myself, would speak for thousands. My grandchildren, for all I know, may have a graver task than I have set them. Perhaps they may have to testify that the faith of Israel is a heritage that no heir in the direct line has the power to alienate from his successors. Even I, with my limited perspective, think it doubtful if the conversion of the Jew to any alien belief or disbelief is ever thoroughly accomplished. What positive affirmation of the persistence of Judaism in the blood my descendants may have to make, I may not be present to hear.

It would be superfluous to state that none of these hints and prophecies troubled me at the time when I horrified the schoolyard by denying the existence of God, on the authority of my father; and defended my right to my atheism, on the authority of the Constitution. I considered myself absolutely, eternally, delightfully emancipated from the yoke of indefensible superstitions. I was wild with indignation and pity when I remembered how my poor brother had been cruelly tormented because he did not want to sit in heder and learn what was after all false or useless. I knew now why poor Reb' Lebe had been unable to answer my questions; it was because the truth was not whispered outside America. I was very much in love with my enlightenment, and eager for opportunities to give proof of it.

It was Miss Dillingham, she who helped me in so many ways, who unconsciously put me to an early test, the result of which gave me a shock that I did not get over for many a day. She invited me to tea one day, and I came in much trepidation. It was my first entrance into a genuine American household; my first meal at a Gentile—yes, a Christian—board. Would I know how to behave properly? I do not know whether I betrayed my anxiety; I am certain only that I

was all eyes and ears, that nothing should escape me which might serve to guide me. This, after all, was a normal state for me to be in, so I suppose I looked natural, no matter how much I stared. I had been accustomed to consider my table manners irreproachable, but America was not Polotzk, as my father was ever saying; so I proceeded very cautiously with my spoons and forks. I was cunning enough to try to conceal my uncertainty; by being just a little bit slow, I did not get to any given spoon until the others at table had shown me which it was.

All went well, until a platter was passed with a kind of meat that was strange to me. Some mischievous instinct told me that it was ham—forbidden food; and I, the liberal, the free, was afraid to touch it! I had a terrible moment of surprise, mortification, self-contempt; but I helped myself to a slice of ham, nevertheless, and hung my head over my plate to hide my confusion. I was furious with myself for my weakness. I to be afraid of a pink piece of pig's flesh, who had defied at least two religions in defence of free thought! And I began to reduce my ham to indivisible atoms, determined to eat more of it than anybody at the table.

Alas! I learned that to eat in defence of principles was not so easy as to talk. I ate, but only a newly abnegated Jew can understand with what squirming, what protesting of the inner man, what exquisite abhorrence of myself. That Spartan boy who allowed the stolen fox hidden in his bosom to consume his vitals rather than be detected in the theft, showed no such miracle of self-control as did I, sitting there at my friend's tea-table, eating unjewish meat.

And to think that so ridiculous a thing as a scrap of meat should be the symbol and test of things so august! To think that in the mental life of a half-grown child should be reflected the struggles and triumphs of ages! Over and over and over again I discover that I am a wonderful thing, being human; that I am the image of the universe, being myself; that I am the repository of all the wisdom in the world, being alive and sane at the beginning of this twentieth century. The heir of the ages am I, and all that has been is in me, and shall continue to be in my immortal self.

# JOSIAH STRONG

Josiah Strong (1847–1916) was a Congregationalist minister and secretary of the Ohio Home Missionary Society when he published *Our Country: Its Possible Future and Its Present Crisis* in 1885. Strong argued that God had appointed Anglo-Saxon Protestants in the United States to lead the world in the fulfillment of Christ's kingdom on earth. Yet the fulfillment of their mission depended upon successfully battling the eight "perils" of immigration, Romanism (i.e., Roman Catholicism), challenges to public education, Mormonism (Latter-day Saints), intemperance and the liquor traffic, socialism, the love of wealth, and the evils spawned by city living. While

there was little that was original in the book itself—Protestant leaders of the American Home Missionary Society had been making likeminded claims for decades—the book sold well, and individual parts were frequently reprinted and published in pamphlets, newspapers, and magazines. As scholars have long noted, Strong's book precisely reflected the mood and mindset of white Anglo-Saxon Protestants of the time, and it remains a significant historical document for that reason. These excerpts demonstrate the dangers that many Protestants attributed to Roman Catholicism and to the Mormon Church.

## *From* Our Country

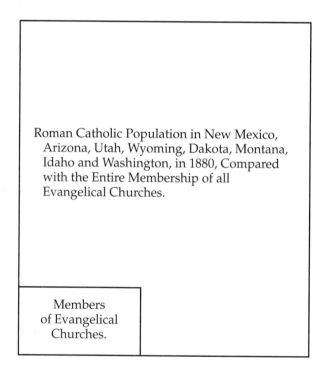

Roman Catholic Population in New Mexico, Arizona, Utah, Wyoming, Dakota, Montana, Idaho and Washington, in 1880, Compared with the Entire Membership of all Evangelical Churches.

Members of Evangelical Churches.

## CHAPTER V
## PERILS—ROMANISM

The perils which threaten the nation and peculiarly menace the West demand, for their adequate presentation, much more space than the narrow limits of this work allow. We can touch only salient points.

# Romanism

There are many who are disposed to attribute any fear of Roman Catholicism in the United States to bigotry or childishness. Such see nothing in the character and attitude of Romanism that is hostile to our free institutions, or find nothing portentous in its growth. Let us, then, first, compare some of the fundamental principles of our free institutions with those of the Roman Catholic church.

I. *The Declaration of Independence teaches Popular Sovereignty. It says that "governments derive their just powers from the consent of the governed."* Roman Catholic doctrine invests the Pope with supreme sovereignty. In *Essays on Religion and Literature,* edited by Archbishop Manning, 1867, we read, p. 416; "Moreover, the right of deposing kings is inherent in the supreme sovereignty which the Popes, as vicegerents of Christ, exercise over all Christian nations."

In Art. VI., Sec. 2 of the Constitution we find: *"This Constitution and the laws of the United States which shall be made in pursuance thereof . . . . shall be the supreme law of the land."* The Canon Law of the Church of Rome is essentially the constitution of that church, binding upon Roman Catholics everywhere. The bull, *Pastoralis Regiminis,* published by Benedict XIV., is a part of the Canon Law and decrees that those who refuse to obey *any* "commands of the Court of Rome, if they be ecclesiastics, are *ipso facto* suspended from their orders and offices; and, if they be laymen, are smitten with excommunication."

The bull *Unam Sanctam* of Boniface VIII., which is also a part of the Canon Law, and acknowledged by Cardinal Manning as an "Article of Faith," says: "It is necessary that one sword should be under another, and that the temporal authority should be subject to the spiritual power. And thus the prophecy of Jeremiah is fulfilled in the church and the ecclesiastical power, 'Behold, I have set thee over the kingdoms, to root out, and to pull down, and to destroy, and to throw down, to build and to plant!' Therefore, if the earthly power go astray, it must be judged by the spiritual power; but if the spiritual power go astray, it must be judged by God alone. Moreover, we declare, say, define, and pronounce it to be altogether necessary to salvation that every human creature should be subject to the Roman Pontiff." Bishop Gilmour, of Cleveland, Ohio, in his Lenten Letter, March, 1873, said: "Nationalities must be subordinate to religion, and we must learn that we are Catholics first and citizens next. God is above man, and the church above the state."

Here is a distinct issue touching the highest allegiance of the Roman Catholic citizens of the United States, whether it is due to the Pope or to the constitution and the laws of the land. In his Syllabus of Errors, Proposition 42, issued December 8, 1864, Pius IX. said: "It is an error to hold that, In the case of conflicting laws between the two powers, the civil law ought to prevail." The reigning pontiff, in an encyclical issued January 10, 1890, says: "It is wrong to break the law of Jesus Christ in order to obey the magistrate, or under pretence of civil rights to transgress the laws of the church." Again Leo XIII. says: "But if the laws of the state are openly at variance with the law of God—if they inflict injury upon the church. . . . or set at naught the authority of Jesus Christ which is vested in the Supreme Pontiff, then indeed it becomes a duty to resist them, a sin to render obedience."

We must not imagine that the two spheres, religious and secular, are so distinct as to prevent all conflict of authorities. Why does Pius IX. say that it is an error to hold that, "In the case of conflicting laws between the two powers, the civil law ought to prevail," unless there is some possibility of conflict? Says Mr. Gladstone: "Even in the United States, where the severance between church and state is supposed to be complete, a long catalogue might be drawn of subjects belonging to the domain and competency of the State, but also undeniably affecting the government of the Church; such as, by way of example, marriage, burial, education, prison discipline, blasphemy, poor-relief, incorporation, mortmain, religious endowments, vows of celibacy, and obedience." The Pope might declare that any or all of these are "things which belong to faith and morals" or "that pertain to the discipline and government of the church," over which matters the Vatican Council decreed him to be possessed of "all the fulness of supreme power."

The word "morals" is quite broad enough to overlap politics. Cardinal Manning says: "Why should the Holy Father touch any matter in politics at all? For this plain reason, because politics are a part of morals. . . . . Politics are morals on the widest scale." Leo XIII. in his encyclical of January 10, 1890, declares that *"politics . . . . are inseparably bound up with the laws of morality and religious duties."* This declaration is *ex cathedra* and, therefore, "infallible," the end of controversy to all good Roman Catholics. It renders every utterance which the Pope may hereafter make concerning politics absolutely binding on the conscience of every Romanist, at the peril of salvation. This is perhaps the most important word that has come from Rome since 1870 when the Vatican Council "put the top-stone to the pyramid of the Roman hierarchy." Not that papal interference in politics is anything new in doctrine or practice, but it has often been denied, and Roman Catholics commonly profess entire loyalty both to the civil power and to the Pope, thus implying that the two spheres, secular and religious, are quite distinct; while moderate Romanists have sometimes expressly said: "We will take our religion but not our politics from Rome." It is, therefore, of the highest importance that we have here a perfectly clear and irreversible declaration, which no good Roman Catholic will dispute, that politics is not *possibly* or *incidentally* but *"inseparably,"* bound up with morality and religion. That is, the connection between the two spheres is necessary, and the Pope has "full and supreme power" over politics as one of the "things which belong to faith and morals;" and he who denies this must rest under the *"anathema sit"* of the Vatican Council. . . .

If it seems to any that I have exaggerated the surrender of reason and conscience required of a good Roman Catholic, weigh these words of Cardinal Bellarmine, one of the most celebrated theologians of the Roman Church: "If the Pope should err by enjoining vices or forbidding virtues, the Church would be obliged to believe vices to be good and virtues bad, unless it would sin against conscience."

The revised Statutes of the United States declare:—*"The alien seeking citizenship must make oath to renounce forever all allegiance and fidelity to any foreign prince, potentate, state or sovereignty, in particular that to which he has been subject."* The Roman Catholic profession of faith, having the sanction of the Council which met at Baltimore in 1884, contains the following oath of allegiance to the Pope:—

"And I pledge and swear true obedience to the Roman Pontiff, vicar of Jesus Christ, and successor of the blessed Peter, prince of the Apostles." We have already seen how broad is the obligation which the oath lays on the Romanists. Here, then, are men who have sworn allegiance to two different powers, each claiming to be supreme, whose spheres of authority are "inseparably" bound together and which, therefore, afford abundant opportunity for the rise of conflicting interests and irreconcilable requirements.

By way of throwing light on such a situation, it is interesting to read in the Canon Law: "No oaths are to be kept if they are against the interests of the Church of Rome." And again: "Oaths which are against the Church of Rome, are not to be called oaths, but perjuries." An American ecclesiastic, Bishop English, of Charleston, S.C., quotes this canon, and defending it says: "These are the principles which I have been taught from Roman Catholic authors, by Roman Catholic professors; they are the principles which I find recognized in all enactments and interpretations of councils in the Roman Catholic church, from the Council at Jerusalem, held by the Apostles, down to the present day." In a work prepared by Rev. F. X. Schouppe for Roman Catholic schools and colleges and bearing the imprimatur of Cardinal Manning, we read (p. 278), "The civil laws are binding on the conscience only so long as they are conformable to the rights of the Catholic Church."

When a man has placed his conscience and will in the keeping of another for life, and on pain of eternal damnation, how can he make unconditional pledges touching anything? Or, having made them, how can they be of any value, if he accepts such doctrine as the above? Is his oath of allegiance to the government worthy of respect? Ought we not to place the same estimate on it that Cardinal Newman did when he said that no pledge from Catholics was of any value to which Rome was not a party?

The two greatest living statesmen, Gladstone and Bismarck, hold that the allegiance demanded by the Pope is inconsistent with good citizenship. Says the former: "—the Pope demands for himself the right to determine the province of his own rights, and has so defined it in formal documents as to warrant any and every invasion of the civil sphere; and that this new version of the principles of the Papal church inexorably binds its members to the admission of these exorbitant claims, without any refuge or reservation on behalf of their duty to the Crown." He also says: "That Rome requires a convert who now joins her to forfeit his moral and mental freedom, and to place his loyalty and civil duty at the mercy of another."

The constitution of the United States guarantees *Liberty of Conscience.* Nothing is dearer or more fundamental. The first amendment to the constitution says: *"Congress shall make no law respecting an establishment of religion or prohibiting the free exercise thereof."* Pius IX. declared it to be an error that, "Every man is free to embrace and profess the religion he shall believe true, guided by the light of reason." And from this dictum no good Roman Catholic can differ. . . .

Another of our principles closely related to that of religious liberty is *Freedom of Speech and of the Press,* which is guaranteed to us by the First Amendment to the Constitution. *"Congress shall make no law . . . . abridging the freedom of speech or of the press."* Leo XIII., in a letter, June 17, 1885, said, "Such a duty (obedience), while incumbent upon all without exception, *is most strictly so*

*on journalists* who, if they were not animated with the *spirit of docility and submission* so necessary to every Catholic, would help to extend and greatly aggravate the evils we deplore." A writer for the *Catholic World* in an article entitled "The Catholic of the Nineteenth Century," shows us what would become of free speech and the freedom of the press in the event of Roman ascendency in the United States. He says: "The supremacy asserted for the Church in matters of education implies the additional and cognate function of the censorship of ideas, and the right to examine and approve or disapprove all books, publications, writings and utterances intended for public instruction, enlightenment, or entertainment, and the supervision of places of amusement. This is the principle upon which the Church has acted in handing over to the civil authorities for punishment *criminals in the world of ideas.*"

Again, none of our fundamental principles is more distinctly American than that of the *Complete Separation of Church and State,* which is required in the First Amendment to the Constitution, already quoted. Pius IX. teaches the exact opposite. He says it is an error to hold that, "The Church ought to be separated from the State, and the State from the Church." He also declares it to be an error that, "The Church has not the power of availing herself of force, or any direct or indirect temporal power."

Another foundation stone of our free institutions is the *Public School,* of which the state has and should have the entire direction without any ecclesiastical interference whatever. Touching this point, Pius IX. says it is an error to hold that, "The entire direction of public schools . . . . may and must appertain to the civil power, and belong to it so far that no other authority whatsoever shall be recognized as having any right to interfere in the discipline of the schools, the arrangement of the studies . . . . or the choice and approval of the teachers." And again the same Pope: It is an error that, "The best theory of civil society requires that popular schools . . . . should be freed from all ecclesiastical authority, government, and interference, and should be fully subject to the civil and political power, in conformity with the will of rulers and the prevalent opinions of the age." Again he says: It is an error, that, "This system of instructing youth, which consists in separating it from the Catholic faith and from the power of the church . . . . may be approved by Catholics." Bishop McQuaid in a lecture at Horticultural Hall, Boston, February 13, 1876, declared: "The state has no right to educate, and when the state undertakes the work of education it is usurping the powers of the church."

If there remains in any mind a lingering doubt as to the irreconcilable hostility of the Roman hierarchy toward our public school system it would be dissipated by reading, *The Judges of Faith vs. Godless Schools,* a little book written by a Roman Catholic priest and "Addressed to Catholic Parents." It bears the indorsements of Cardinals Gibbons and Newman, and of various dignitaries of that church. The prefatory note states that the book contains, "the conciliar or single rulings of no less than three hundred and eighty of the high and highest church dignitaries. There are brought forward, twenty-one plenary and provincial councils; six or seven diocesan synods; two Roman pontiffs; two sacred congregations of some twenty cardinals and pontifical officials; seven single cardinals, who with thirty-three archbishops, make forty primates and metropolitans; finally, nearly eighty single bishops and archbishops, deceased or living, in the United States." All this mass of authority is against our public schools; and

the animus of these ecclesiastics toward this cherished institution is indicated by such epithets and appellations as the following: "mischievous," "baneful to society," "a social plague," "Godless," "pestilential," "scandalous," "filthy," "vicious," "diabolical," places of "unrestrained immorality," where things are done the recital of which would "curdle the blood in your veins."

Rome has never favored popular education. In Protestant countries like Germany and the United States, where there is a strong sentiment in favor of it, she has been compelled in self-defence to open schools of her own. But her real attitude toward the education of the masses should be inferred from her course in those countries where she has, or has had, undisputed sway; and there she has kept the people in besotted ignorance. *The Cyclopedia of Education*, 1877, in its article on "Illiteracy," gives a table containing the statistics of thirty countries. Of these, five are starred as "nearly free from illiteracy," and all of them are Protestant. The highest percentage of illiteracy given for any Protestant country in the world is thirty-three. In all those countries where fifty per cent or more are illiterate the religion is Roman Catholic, Greek or heathen, viz.: Argentine Republic, eighty-three per cent; China, fifty per cent; Greece, eighty-two per cent; Hungary, fifty-one; India, ninety-five; Italy, seventy-three; Mexico, ninety-three; Poland, ninety-one; Russia, ninety-one; Spain, eighty. Here, six Roman Catholic countries, including Italy, the home of the Pope, where until recent years, the church has had undisputed sway, are far more illiterate than heathen China. Touching the education of the masses—except in Protestant countries as explained above—we are forced to infer either the indifference or the incompetence of the Church of Rome.

We have made a brief comparison of some of the fundamental principles of Romanism with those of the Republic. And,

1. We have seen the supreme sovereignty of the Pope opposed to the sovereignty of the people.

2. We have seen that the commands of the Pope, instead of the constitution and laws of the land, demand the highest allegiance of Roman Catholics in the United States.

3. We have seen that the alien Romanist who seeks citizenship swears true obedience to the Pope instead of "renouncing forever all allegiance to any foreign prince, potentate, state or sovereignty," as required by our laws.

4. We have seen that Romanism teaches religious intolerance instead of religious liberty.

5. We have seen that Rome demands the censorship of ideas and of the press, instead of the freedom of the press and of speech.

6. We have seen that she approves the union of church and state instead of their entire separation.

7. We have seen that she is opposed to our public school system.

Manifestly there is an irreconcilable difference between papal principles and the fundamental principles of our free institutions. Popular government is self-government. A nation is capable of self-government only so far as the individuals who compose it are capable of self-government. To place one's conscience, therefore, in the keeping of another, and to disavow all personal responsibility in obeying the dictation of another, is as far as possible from *self*-government, and, therefore, wholly inconsistent with republican institutions, and, if sufficiently common, dangerous to their stability. It is the theory of

absolutism in the state, that man exists for the state. It is the theory of absolutism in the church that man exists for the church. But in republican and Protestant America it is believed that church and state exist for the people and are to be administered by them. Our fundamental ideas of society, therefore, are as radically opposed to Vaticanism as to imperialism, and it is as inconsistent with our liberties for Americans to yield allegiance to the Pope as to the Czar. It is true the Third Plenary Council in Baltimore denied that there is any antagonism between the laws, institutions and spirit of the Roman church and those of our country, and in so doing illustrated the French proverb that "To deny is to confess." No Protestant church makes any such denials. . . .

II. Look now very briefly at the attitude or purpose of Romanism in this country. In an encyclical letter of November 7, 1885, Leo XIII., as reported by cable to the *New York Herald,* said: "We exhort all Catholics to devote careful attention to public matters, and take part in all municipal affairs and elections, and all public services, meetings and gatherings. All Catholics must make themselves felt as active elements in daily political life in countries where they live. All Catholics should exert their power to cause the constitutions of states to be modeled on the principles of the true church." "If Catholics are idle," says the same Pope, "the reins of power will easily be gained by persons whose opinions can surely afford little prospect of welfare. Hence, Catholics have just reason to enter into political life; . . . . having in mind the purpose of introducing the wholesome life-blood of Catholic wisdom and virtue into the whole system of the state. All Catholics who are worthy of the name must . . . . work to the end, that every state be made conformable to the Christian model we have described." That Catholic authority, Dr. Brownson, in his Review for July, 1864, declared: "Undoubtedly it is the intention of the Pope to possess this country. In this intention he is aided by the Jesuits and all the Catholic prelates and priests." And in some cases expectation is as eager as desire. Father Hecker in his last work, published in 1887, says: "The Catholics will out-number, before the close of this century, all other believers in Christianity put together in the republic."

III. Many of our Roman Catholic fellow citizens undoubtedly love the country, and believe that in seeking to Romanize it they are serving its highest interests, but when we remember, as has been shown, that the fundamental principles of Romanism are opposed to those of the Republic, that the difference between them does not admit of adjustment, but is diametric and utter, it becomes evident that it would be *impossible to "make America Catholic,"* (which the archbishop of St. Paul declared at the late Baltimore Congress to be the mission of Roman Catholics in this country) *without bringing the principles of that church into active conflict with those of our government, thus compelling Roman Catholics to choose between them, and in that event, every Romanist who remained obedient to the Pope, that is, who continued to be a Romanist, would necessarily become disloyal to our free institutions.*

IV. It is said, and truly, that there are two types of Roman Catholics in the United States. They may be distinguished as those who are "more Catholic than Roman," and those who are more Roman than Catholic. The former have felt the influence of modern thought, have been liberalized, and come into a large measure of sympathy with American institutions. Many are disposed to think that men of this class will control the Roman church in this country and already talk of an "American Catholic Church." But there is no such thing as an

American or Mexican or Spanish Catholic Church. It is the Roman Catholic Church in America, Mexico and Spain, having one and the same head, whose word is law, as absolute and as unquestioned among Roman Catholics here as in Spain or Mexico. "The archbishops and bishops of the United States, in Third Plenary Council assembled," in their Pastoral Letter "to their clergy and faithful people," declare: "We glory that we are, and, with God's blessing, shall continue to be, not the American Church, nor the Church in the United States, nor a Church in any other sense, exclusive or limited, but an integral part of the one, holy, Catholic and Apostolic Church of Jesus Christ."

The Roman Catholics of the United States have repudiated none of the utterances of Leo XIII. or of Pius IX., nor have they declared their political independence of the Vatican. On the contrary, the most liberal leaders of the church here vehemently affirm their enthusiastic loyalty to the Pope. The Pastoral Letter issued by the Third Plenary Council of Baltimore (December 7, 1884), and signed by Cardinal Gibbons, "In his own name and in the name of all the Fathers," says: "Nor are there in the world more devoted adherents of the Catholic Church, the See of Peter, and the Vicar of Christ, than the Catholics of the United States." Says a writer on the recent Roman Catholic Congress at Baltimore: "It was well that Masonic pseudo-Catholics, compromisers of the papal authority, persecutors of the clergy, anti-Jesuits, social revolutionalists, legal robbers of church property, lay educationists, anti-clericals, should learn once for all, that the *Catholic laymen of America are proud of being pro-papal without compromise;* that they are proud of the Jesuits from whose chaste loins the church in the United States drew its vigorous life." This writer is not quoted as a representative of moderate Romanism, but, as one who very justly expresses the sentiment of loyalty to the Pope, which characterized the Baltimore Congress, and which, so far as we can judge, was shared by all alike.

It is undoubtedly safe to say that there is not a member of the hierarchy in America, who does not accept the infallibility of the Pope and who has not sworn to obey him. Now this dogma of papal infallibility as defined by the Vatican Council and interpreted by Pius IX. and Leo XIII. carries with it logically all of the fundamental principles of Romanism which have been discussed. Infallibility is necessarily intolerant. It can no more compromise with a conflicting opinion than could a mathematical demonstration. Truth cannot make concessions to error. Infallibility represents absolute truth. It is as absolute as God himself, and can no more enter into compromise than God can compromise with sin. And if infallibility is as intolerant as the truth, it is also as authoritative. Truth may be rejected, but even on the scaffold it is king, and has the right and always must have the right to rule absolutely, to control utterly every reasoning being. If I believed the Pope to be the infallible vicar of Christ, I would surrender myself to him as unreservedly as to God himself. How can a true Roman Catholic do otherwise? A man may have breathed the air of the nineteenth century and of free America enough to be out of sympathy with the absolutism and intolerance of Romanism, but if he accepts the Pope's right to dictate his beliefs and acts, of what avail are his liberal sympathies? He is simply the instrument of the absolute and intolerant papal will. His sympathies can assert themselves and control his life only as he breaks with the Pope, that is, ceases to be a Roman Catholic. I fear we have little ground to expect that many would thus break with the Pope, were a distinct issue raised. Everyone born a Roman Catholic is suckled on authority.

His training affects every fiber of his mental constitution. He has been taught that he must not judge for himself, nor trust to his own convictions. If he finds his sympathies, his judgment and convictions in conflict with a papal decree, it is the perfectly natural result of his training for him to distrust himself. His will, accustomed all his life to yield to authority without question, is not equal to the conflict that would follow disobedience. How can he withstand a power able to inflict most serious punishment in this life, and infinite penalties in the next? Only now and then will one resist and suffer the consequences, in the spirit of the Captain in Beaumont and Fletcher's poem "The Sea Voyage." Juletta tells the Captain and his company:

"Why, slaves, 'tis in our power to hang ye."

The Captain replies:

"Very likely,
'Tis in our powers, then, to be hanged and scorn ye."

Modern times afford an excellent illustration of what may be expected when liberal prelates, strongly opposed to ultra-montanism, are brought to the crucial test. Many members of the Vatican Council (1870) vigorously withstood the dogma of papal infallibility, among whom, says Professor Schaff, "were the prelates most distinguished for learning and position." Many of them spoke and wrote against the dogma. Archbishop Kendrick, of St. Louis, published in Naples an "irrefragable argument" against it. The day before the decisive vote was to be taken, more than a hundred bishops and archbishops, members of the opposition, left the council and departed from Rome rather than face defeat. But these moderate and liberal Romanists, including the several American prelates who had belonged to the opposition, all submitted, and published to their respective flocks the obnoxious decree which some of them had shown to be contrary to history and to reason. It must be remembered that these men were the most liberal and among the most able in the church. In view of the fact that their opposition thus utterly collapsed, what reason have we to expect that liberal Romanists in this country, who have already assented to the infallibility of the Pope, will ever violate their oath of obedience to him? If the liberality of avowed opponents of ultramontanism yielded to papal authority, what reason is there to think the liberality of avowed ultramontanists will ever resist it?

Moreover it should be borne in mind that the more moderate Roman Catholics in the United States are generally those who in childhood had the benefit of our public schools, and their intelligence and liberality are due chiefly to the training there received. In the public schools they learned to think and were largely Americanized by associating with American children. But their children are being subjected to very different influences in the parochial schools. They are there given a training calculated to make them narrow and bigoted; and, being separated as much as possible from all Protestant children, they grow up suspicious of Protestants, and so thoroughly sectarianized and Romanized as to be well protected against the broadening and Americanizing influences of our civilization in after life.

We have seen the fundamental principles of our free institutions laid side by side with some of those of Romanism, expressed in the words of the highest pos-

sible authorities in the Roman Catholic Church; and thus presented they have declared for themselves the inherent contradiction which exists between them.

It has been shown that it is the avowed purpose of Romanists to "make America Catholic."

It has been shown that this could not be done without bringing into active conflict the diametrically opposed principles of Romanism and of the Republic, thus forcing all Romanists in the United States to choose between the two masters, both of whom they now profess to serve.

It has been shown that Roman Catholic training, from childhood up, is calculated to disqualify the mind for independent action, and renders it highly improbable that any considerable number of even moderate and liberal Romanists would, in the supposed event, forsake their allegiance to the Pope.

V. The rate of growth, therefore, of Romanism in the United States becomes a matter of vital importance.

Many who are well acquainted with the true character of Romanism are indifferent to it because not aware of its rapid growth among us. They tell us, and truly, that Rome loses great numbers of adherents here through the influence of our free schools, free institutions, and the strong pervasive spirit of independence which is so hostile to priestly authority. But let us not congratulate ourselves too soon. The losses of Romanism in the United States are not necessarily the gains of Protestantism. When a man, born in the Roman Catholic Church, loses confidence in the only faith of which he has any knowledge, instead of examining Protestantism he probably sinks into skepticism, which is even worse than superstition. Romanism is chiefly responsible for German and French infidelity. For, when a mind to which thought and free inquiry have been forbidden as a crime attains its intellectual majority, the largeness of liberty is not enough; it reacts into license and excess. Skepticism and infidelity are the legitimate children of unreasoning and superstitious credulity, and the grandchildren of Rome. Apostate Romanists are swelling our most dangerous classes. Unaccustomed to think for themselves, and having thrown off authority, they become the easy victims of the wildest and most dangerous propagandists.

But, notwithstanding the great losses sustained by Romanism in the United States, it is growing with great rapidity. No one knows what the present Roman Catholic population is, and estimates vary widely. Cardinal Gibbons at the Baltimore Congress in 1889 placed it at 9,000,000. Many Roman Catholic writers think it is larger. Bishop Hogan, of Missouri, estimates it at 13,000,000. But this is wild. No doubt the figures of *Sadliers Catholic Directory* (1890) are large enough. This gives the Romanist population as 8,277,039 (p. 408). These figures are probably as reliable as earlier ones from the same source, and, therefore, serve as a basis for comparison to estimate the rate of growth.

In 1800 the Roman Catholic population was 100,000. There was then in the United States one Romanist to every 53 of the whole population; in 1850, one to 14.3; in 1870, one to 8.3; in 1880, one to 7.7; in 1890, one to 7.5. Thus it appears that, wonderful as the growth of our population has been since 1800, that of the Roman Church in this country has been still more rapid. Dr. Dorchester in his valuable and inspiring work, *Problem of Religious Progress* (New York and Cincinnati, 1881), easily shows that the *actual* gains of Protestantism in the United States, during the century, have been much larger than those of

Romanism, and seems disposed, in consequence, to dismiss all anxiety as to the issue of the race between them. But it is *relative* rather than actual gains which are prophetic. We find that for the first eighty years of the century the *rate* of growth of the Roman Catholic Church was greater than that of any one Protestant church or of all Protestant churches combined. From 1800 to 1880 the population increased nine-fold, the membership of all evangelical churches twenty-seven-fold, and the Romanist population sixty-three-fold. Not much importance, however, should be attached to this comparison, as the Roman Catholic population was insignificant in 1800, and a small addition sufficed to increase it several-fold. But in 1850 that population was nearly one-half as large as the membership of all evangelical churches. Let us, then, look at their relative progress since that time. From 1850 to 1880 the population increased 116 per cent, the communicants of evangelical churches 185 per cent, and the Romanist population 294 per cent. During the same period the number of evangelical churches increased 125 per cent, and the number of evangelical ministers 173 per cent, while Roman Catholic churches increased 447 per cent and priests 391 per cent.

In 1800 priests were 1.9 per cent of the number of evangelical ministers; in 1850, 5.0 per cent; in 1870, 8.3 per cent; and in 1880, 9.1 per cent. In 1850, Roman Catholic churches were 2.8 per cent of the number of evangelical churches; in 1870, 5.4 per cent; and in 1880, 6.8 per cent. In 1800 the Roman Catholic population was 21 per cent of the number of evangelical church members; in 1850, 45 per cent; in 1870, 68 per cent; and in 1880, 63 per cent. Thus we see that for the first eighty years of the century the Roman Catholics gained rapidly both on the population and on the evangelical churches. But the latest statistics show that between 1880 and 1890 the tide turned. In 1880 the Romanist population was 63 per cent of the number of evangelical communicants; in 1890, 61 per cent. In 1880 their priests were 9.1 per cent of the number of evangelical ministers; in 1890, 8.8 per cent. In 1880 their churches were 6.8 per cent of the number of evangelical churches; in 1890, 5.2 per cent. This relative loss since 1880 has not been due to any lack of vitality, for, as we have already seen, Romanism has gained on the population during these ten years, but to the more vigorous growth of the Protestant churches, which during this time have been not a little quickened.

Whether this relative loss, however, marks a permanent or only temporary turn in the tide does not yet appear. It must be remembered, first, that this loss is only slight; and, secondly, that the now pronounced parochial school policy can hardly fail to keep great numbers in the Roman communion, which through the broadening influence of the public school would have left it, thus greatly stimulating the rate of growth of that church in the future.

But this is not all. Rome, with characteristic foresight, is concentrating her strength in the western territories. As the West is to dominate the nation, she intends to dominate the West. In the United States a little more than one-eighth of the population is Catholic; in the territories taken together, more than one-third. In the whole country there are not quite two-thirds as many Romanists as there are members of evangelical churches. Not including Arizona and New Mexico, which have a large native Roman Catholic population, the six remaining territories in 1880 had four times as many Romanists as there were members in all Protestant denominations collectively; and including Arizona and New Mexico, Rome had eighteen times as many as all Protestant bodies. We are told that the native Romanists of Arizona and New Mexico are not as energetic as the

Protestants who are pushing into those territories. True, but they are energetic enough to be counted. The most wretched members of society count as much at the polls as the best, and often *much more*. It is poor consolation which is drawn from the ignorance of any portion of our population. Those degraded peoples are clay in the hands of the Jesuits. When the Jesuits were driven out of Berlin, they declared that they would plant themselves in the western territories of America. And they are there to-day with empires in their brains. Expelled for their intrigues even from Roman Catholic countries, Spain, Portugal, France, Italy, Austria, Mexico, Brazil, and other states, they are free to colonize in the great West, and are there, purposing to Romanize and control our western empire. Rev. J. H. Warren, D.D., writes from California, in which state there are four times as many Romanists as Protestant church members: "The Roman Catholic power is fast becoming an overwhelming evil. Their schools are everywhere, and number probably 2000 in the State. Their new college of St. Ignatius is, we are told, the largest, finest, best equipped of its kind in the United States. They blow no trumpets, are sparing of statistics, but are at work night and day to break down the institutions of the country, beginning with the public schools. As surely as we live, so surely will the conflict come, and it will be a hard one."

Lafayette, born a Romanist, and knowing well the nature of Romanism and its antipathy to liberty, said: "If the liberties of the American people are ever destroyed, they will fall by the hands of the Romish clergy."

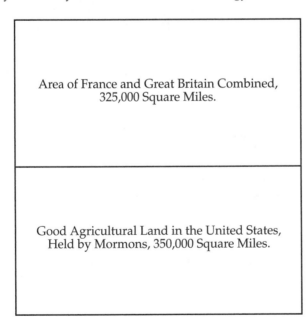

Area of France and Great Britain Combined, 325,000 Square Miles.

Good Agricultural Land in the United States, Held by Mormons, 350,000 Square Miles.

## CHAPTER VII
## PERILS—MORMONISM

The people of the United States are more sensible of the disgrace of Mormonism than of its danger. The civilized world wonders that such a hideous caricature of the Christian religion should have appeared in this most enlightened land; that

such an anachronism should have been produced by the most progressive civilization; that the people who most honor womankind should be the ones to inflict on her this deep humiliation and outrageous wrong. Polygamy, as the most striking feature of the Mormon monster, attracts the public eye. It is this which at the same time arouses interest and indignation; and it is because of this that Europe points at us the finger of shame. Polygamy has been the issue between the Mormons and the United States government. It is this which has prevented the admission of Utah as a state. It is this against which Congress has legislated. And yet, polygamy is not an essential part of Mormonism; it was an afterthought; not a root, but a graft. There is a large and growing sect of the Mormons, not located in Utah, which would excommunicate a member for practicing it. Nor is polygamy a very large part of Mormonism. Only a small minority practice it. Moreover, it can never become general among the "saints," for nature has legislated on that point, and her laws admit of no evasions. In Utah, as elsewhere, there are more males born than females; and, in the membership of the Mormon Church there are several thousand more men than women.

Polygamy might be utterly destroyed, without seriously weakening Mormonism. It has served to strengthen the system somewhat by thoroughly entangling its victim in the Mormon net; for a polygamist is not apt to apostatize. He has multiplied his "hostages to fortune;" he cannot abandon helpless wives and children as easily as he might turn away from pernicious doctrines. Moreover, he has arrayed himself against the government with law-breakers. Franklin's saying to the signers of the Declaration of Independence is appropriately put into the mouths of this class: "If we don't hang together, we shall all hang separately." Still, it may be questioned whether polygamy has added more of strength or weakness; for its evil results doubtless have often led the children of such marriages, and many others, to question the faith, and finally abandon it.

What, then, is the real strength of Mormonism? It is ecclesiastical despotism which holds it together, unifies it, and makes it strong. The Mormon Church is probably the most complete organization in the world. To look after a Mormon population of 165,218 there are 31,577 officials, or one to every five persons. And, so highly centralized is the power, that all of these threads of authority are gathered into one hand, that of the president. The priesthood, of which he is the head, claim the right to control in all things religious, social, industrial, and political. Brigham Young asserted his right to manage in every particular, "from the setting up of a stocking to the ribbons on a woman's bonnet." Here is a claim to absolute and universal rule, which is cheerfully conceded by every orthodox "saint." Mormonism therefore, is not simply a church, but a state; an "*imperium in imperio*" ruled by a man who is prophet, priest, king and pope, all in one—a pope, too, who is not one whit less infallible than he who wears the tiara. And, as one would naturally expect of an American pope, and especially of an enterprising Western pope, he out-popes the Roman by holding familiar conversations with the Almighty, and getting, to order, new revelations direct from heaven; and, another advantage which is more material, he keeps a firm hold of his temporal power. Indeed, it looks as if the spiritual were being subordinated to the temporal. Rev. W. M. Barrows, D.D., after a residence at the Mormon capital of nearly eight years, said: "There is no doubt that it is becoming less and less a religious power, and more and more a political power. The first Mormon

preachers were ignorant fanatics, but most of them were honest, and their words carried a weight that sincerity always carries, even in a bad cause. The preachers now have the ravings of the Sibyl, but lack the inspiration. Their talk sounds hollow; the ring of sincerity is gone. But their eyes are dazzled now with the vision of an earthly empire. They have gone back to the old Jewish idea of a temporal kingdom, and they are endeavoring to set up such a kingdom in the valleys of Utah, and Idaho and Montana, Wyoming, Colorado and New Mexico, Arizona and Nevada."

If there be any doubt as to the designs of the Mormons, let the testimony of Bishop Lunt be conclusive on that point. He said in 1880: "Like a grain of mustard seed was the truth planted in Zion; and it is destined to spread through all the world. Our Church has been organized only fifty years, and yet behold its wealth and power. This is our year of jubilee. We look forward with perfect confidence to the day when we will hold the reins of the United States government. That is our present temporal aim; after that, we expect to control the continent." When told that such a scheme seemed rather visionary, in view of the fact that Utah cannot gain recognition as a state, the Bishop replied: "Do not be deceived; we are looking after that. We do not care for these territorial officials sent out to govern us. They are nobodies here. We do not recognize them, neither do we fear any practical interference by Congress. We intend to have Utah recognized as a state. To-day we hold the balance of political power in Idaho, we rule Utah absolutely, and in a very short time we will hold the balance of power in Arizona and Wyoming. A few months ago, President Snow of St. George, set out with a band of priests, for an extensive tour through Colorado, New Mexico, Wyoming, Montana, Idaho and Arizona to proselyte. We also expect to send missionaries to some parts of Nevada, and we design to plant colonies in Washington Territory.

"In the past six months we have sent more than 3,000 of our people down through the Sevier Valley to settle in Arizona, and the movement still progresses. All this will build up for us a political power, which will, in time, compel the homage of the demagogues of the country. Our vote is solid, and will remain so. It will be thrown where the most good will be accomplished for the church. Then, in some great political crisis, the two present political parties will bid for our support. Utah will then be admitted as a polygamous state, and the other territories we have peacefully subjugated will be admitted also. We will then hold the balance of power, and will dictate to the country. In time, our principles, which are of sacred origin, will spread throughout the United States. We possess the ability to turn the political scale in any particular community we desire. Our people are obedient. When they are called by the Church, they promptly obey. They sell their houses, lands and stock, and remove to any part of the country the Church may direct them to. You can imagine the results which wisdom may bring about, with the assistance of a church organization like ours."

Since these words were uttered the United States government has made itself felt in "Zion," and its officers are no longer "nobodies" in Utah; but the astute bishop does not over-estimate the effectiveness of the Mormon Church as a colonizer. An order is issued by the authorities that a certain district shall furnish so many hundred emigrants for Arizona or Idaho. The families are drafted,

so many from a ward; and each ward or district equips its own quota with wagons, animals, provisions, implements, seed and the like. Thus the Mormon president can mass voters here or there about as easily as a general can move his troops.

By means of this systematic colonization the Mormons have gained possession of vast tracts of land, and now "hold almost all the soil fit for agriculture from the Rocky Mountains to the Sierra Nevada, or an area not less than 500 miles by 700, making 350,000 square miles;" that is one-sixth of the entire acreage between the Mississippi and Alaska. In this extended region it is designed to plant a Mormon population sufficiently numerous to control it. With this in view, the Church sends out from 200 to 400 missionaries a year, most of whom labor in Europe. They generally return after two years of service at their own charges. In 1849 the "Perpetual Emigration Fund" was founded for the purpose of assisting converts who were too poor to reach "Zion" unaided. During the first ten years after the founding of this fund the annual average was 750; for the next decade it was 2,000; from 1880 to 1885 the number ranged from 2,500 to 3000; since 1885 it has gradually decreased. The losses by apostasy are many, but are more than covered by the number of converts, while the natural increase of the Church by the growth of the family is exceedingly large. Furthermore, to the growing power of multiplying numbers is added that of rapidly increasing wealth. The Mormons are industrious—a lazy man cannot enter their heaven—and the tithing of the increase adds constantly to the vast sums already gathered in the grasping hands of the hierarchy. The Mormon delegate to Congress, who carries a hundred thousand votes in one hand, and millions of corruption money in the other, will prove a dangerous man in Washington, unless politicians grow strangely virtuous, and there are fewer itching palms twenty years hence.

Those best acquainted with Mormonism seem most sensible of the danger which it threatens. The pastors of churches and principals of schools in Salt Lake City, in an address to American citizens, say: "We recognize the fact that the so-called Mormon church, in its exercise of political power, is antagonistical to American institutions, and that there is an irrepressible conflict between Utah Mormonism and American republicanism; so much so that they can never abide together in harmony. We also believe that the growth of this anti-republican power is such that, if not checked speedily, it will cause serious trouble in the near future. We fear that the nature and extent of this danger are not fully comprehended by the nation at large."

If the Mormon power had its seat in an established commonwealth like Ohio, such an ignorant and fanatical population, rapidly increasing, and under the absolute control of unscrupulous leaders, who openly avowed their hostility to the State, and lived in contemptuous violation of its laws, would be a disturbing element which would certainly endanger the peace of society. Indeed, the Mormons, when much less powerful than they are to-day, could not be tolerated in Missouri or Illinois. And Mormonism is tenfold more dangerous in the new West, where its power is greater, because the "Gentile" population is less; where it has abundant room to expand; where, in a new and unorganized society, its complete organization is the more easily master of the situation; and where state constitutions and laws, yet unformed, and the institutions of society, yet plastic, are subject to its molding influence.

And what are we going to do about it? Something can be done by legisla-tion, though it has proved less effective than was expected. From the first enact-ment of antipolygamy laws by Congress in 1882 down to September 1, 1889, only twenty-four convictions had been secured while sixty-seven men are known to have entered into polygamy during the single year ending June, 1887. There were, however, 909 convictions for unlawful cohabitation, under the Edmunds Law, from 1882 to 1889. But this number is only five per cent of those known to be guilty. The governor of the territory, Hon. A. L. Thomas, who is thoroughly acquainted with the situation, says, "The government has been for years well represented by able and efficient officers, and the result has been im-portant, but not decisive. This course [vigorous prosecution] has not changed opinion, but has caused greater care in concealing offenses."

Wilford Woodruff, the President of the Mormon Church has recently issued a proclamation in which he says: "Inasmuch as laws have been enacted by Congress forbidding plural marriages, which laws have been pronounced con-stitutional by the court of last resort, I do hereby declare my intention to submit to those laws and to use my influence with the members of the Church over which I preside to have them do likewise."

If this declaration was made in good faith, it would probably mean that polygamy is to be abandoned, at least for a time. It is, however, the well-nigh universal opinion of Gentiles in Salt Lake City that this manifesto was a mere trick intended for obvious reasons to hoodwink the public. We have seen that polygamy might be destroyed without seriously weakening Mormonism; in-deed, its destruction, by allaying suspicion, by creating the impression that the Mormon problem is solved, and by removing the obstacle to Utah's admission as a state, might materially strengthen Mormonism. Any blow to be really effec-tive must be aimed at the priestly despotism.

The political power of the hierarchy has been in some measure curtailed by two decisions of the Supreme Court rendered February 3, 1890. One decision sustains the constitutionality of the law of Idaho which disfranchises all who are "members of any order, organization, or association which teaches, advises, counsels, or encourages its members or devotees or any other persons to com-mit the crime of bigamy or polygamy." A similar law in Utah would undoubt-edly be sustained by the Supreme Court, but of course such a law can never be enacted so long as the Mormons control the territorial legislature.

The other decision of the Court sustained the constitutionality of an act of Congress, passed in 1887, by which the territorial charter of the Mormon Church was repealed, the corporation dissolved and its property, in excess of $50,000, escheated to the United States, to be used for the support of public schools in Utah. Under this law a receiver took possession of nearly $1,000,000 worth of property. The power of the hierarchy has been enhanced by the great wealth of the church. The sequestration of that wealth, therefore, must in some measure disable the hierarchy. But the power of the priesthood existed before that wealth was accumulated. It was their power which made such accumula-tion possible. This blow, therefore, does not go to the root of the matter. Indeed, it is liable to strengthen Mormonism as much on one side as it weakens it on an-other, for the public schools are taught almost wholly by Mormons, and this great sum of money will, therefore, be applied to teach Mormon doctrines

unless Congress places the public schools of the territory under the control of the United States. If this were done and all Mormons were disfranchised as they should be (excepting of course the Josephites, who are loyal), much time and labor would yet be required to complete the work. "Let him who thinks that the Mormon problem is almost solved be undeceived. Even when Congress and the courts shall have done their utmost, it will take half a century yet of the gospel in the hands of missionaries and teachers to dig up the roots of this evil. The public has not yet grasped the proportions of this problem. The present laws and Christian forces at work in Utah still have a problem before them much like that which a single company of sappers and miners would have who should undertake to dig down the Wahsatch Mountain range with pick and spade."

The secret power of the system is the people's belief in the divine inspiration, and hence infallibility of the priesthood. This is a veritable Pandora's box out of which may spring any possible delusion or excess. Said Heber C. Kimball, formerly one of the Apostles:

"The word of our Leader and Prophet is the word of God to this people. We can not see God. We can not hold converse with him. But he has given us a man that we can talk to and thereby know his will, just as well as if God himself were present with us." Special "revelations" to the head of the church, even if directly contrary to the Scriptures, or the Book of Mormon, are absolutely binding. The latter says: "Wherefore I, the Lord God, will not suffer that this people do like unto them of old; wherefore, my brethren, hear me, and hearken to the word of the Lord. For there shall not any man among you have save it be one wife; and concubines he shall have none." Yet a special "revelation" sufficed to establish polygamy. Mormon despotism, then, has its roots in the superstition of the people; and this Congress cannot legislate away. The people must be elevated and enlightened through the instrumentality of Christian education and the preaching of the gospel. This work is being effectively done by the various Christian denominations. It is *chiefly* to such agencies that we must look to break the Mormon power.

# ALEXIS TOTH

Alexis Toth (1854–1909) was a Carpatho-Russian priest in the Eastern Catholic or Uniate tradition, a group of onetime Eastern Orthodox Christians who joined the Roman Catholic Church via a series of "unions" in the late 1500s and 1600s. The Uniates retained many Eastern customs that separated them from other Roman Catholics (allowing priests to be married, for instance), but the Roman Catholic pope had authority over their bishops. Those who, like Toth, came to America encountered severe hostility at the hands of American Catholic leaders, themselves besieged

by Protestants like Josiah Strong. This excerpt comes from Toth's version of his 1889 meeting with Archbishop John Ireland, a leader who wanted Catholic Americans to become more like other Americans and who rejected the priesthood of Toth. As a result, Toth and many other Uniates returned to the Orthodox church.

# Meeting with Archbishop John Ireland

The place of my appointment was Minneapolis, Minnesota, in the diocese of Archbishop John Ireland. As an obedient Uniate, I complied with the orders of my bishop [the bishop of Presov], who at that time was John Valiy, and appeared before Bishop Ireland on December 19, 1889. I kissed his hand, as I should have, according to custom (failing, however, to kneel before him, which as I learned later was my chief mistake), and presented my credentials. I remember well that no sooner did he read that I was a "Greek Catholic" than his hands began to shake! It took him almost 15 minutes to read to the end, after which he asked me abruptly (the conversation was in the Latin language):

"Do you have a wife?"

"No."

"But you had one?"

"Yes. I am a widower."

Hearing this, he threw the paper on the table and loudly shouted: "I have already written to Rome protesting against this kind of priest being sent to me."

"What kind of priest do you mean?"

"Your kind."

"But I am a Catholic priest of the Greek rite. I am a Uniate, and I was ordained by a lawful Catholic bishop."

"I do not consider that either you or that bishop are Catholic. Besides, I do not need any Greek Catholic priests here. A Polish priest in Minneapolis is more than enough. He can also be the priest for the Greeks."

"But he belongs to the Latin Rite. Besides, our people will not understand him and so they will hardly go to him. That was the reason that they built a church of their own."

"I did not give them permission to do that, and I do not grant you jurisdiction to serve here."

I was deeply hurt by this kind of fanaticism of this representative of papal Rome and sharply replied to him: "In that case I neither ask from you a jurisdiction nor your permission. I know the rights of my church. I know the basis on which the Unia was established, and I will act according to them."

The archbishop lost his temper. I lost mine just as much. One word led to another. The thing went so far that it is not worthwhile to reconstruct our entire conversation further.

# MABEL POTTER DAGGETT

Mabel Potter Daggett (1871–1927) was a journalist, temperance activist, and progressive reformer who supported the popular eugenics movement at the turn of the twentieth century for the building of a "better race." This article depicts how some white Protestants interpreted the arrival of Hindu and Buddhist teachers as a "menace" to the purity and order of American society.

## The Heathen Invasion of America

Yoga, that Eastern philosophy, the emblem of which is the coiled serpent, is being disseminated in America. Literally yoga means the "path" that leads to wisdom. Actually, it is proving the way that leads to domestic infelicity and insanity and death. Priests from "east of Suez," with soft-spoken proselyting, have whispered this mysticism into the ears of the American woman.

It was the Congress of Religions, at the Chicago World's Fair, in 1893, that in a spirit of religious toleration beckoned the first "holy" men from the fastnesses in the Himalayas. That benign condescension has proved fraught with far-reaching consequences. The Swamis and Babas who came to America discarded in India the simplicity of their garb for gorgeous robes, more tempered to Western taste. They arrived silken clad and sandal shod, to prove an attraction that outshone the plain American variety of minister in a frock coat and white tie. The Orientals were picturesque personalities, whom American society welcomed in the drawing-room.

Others of their order, hearing of this triumphant reception, combed out their matted hair, allowed to hang uncared for during the years of sacred meditation, and leaving their begging bowls behind, hurried over to this so much more lucrative field.

At Green Acre, Me., in 1896, there was started a summer school of philosophy which was the outgrowth of the World's Fair Congress of Religions, its platform was an open forum, where the Swamis found a welcome. Viâ this New England route from Calcutta nearly every mystic has arrived and established his vogue in this country. With this introduction from Green Acre, Me., the land of the Puritan forefathers, the turbaned teachers from the East set out across the continent. On the banners of many of these cults is emblazoned the serpent that affects the onlooker as a startling reminder of the evil that entered Eden. This symbol on the gold and enameled badge is pinned on the convert's gown. It is on the walls of the assembly rooms, and it appears as the imprint on the literature used at the yoga classes.

The yoga class is like the Browning class, or the Shakespeare class, and is the direct means by which a Swami reaches the public. Placing the Hindu scriptures, the Bhagavadgita, or the Persian scriptures, the Zend Avesta, above their Bible are women who were formerly Baptists and Presbyterians, Methodists, Episcopalians, Catholics, and daughters of Abraham.

It is the promise of eternal youth that attracts woman to yoga, the promise which is found interwined with most of the pagan religions. This yoga philosophy opens the door to subtle mysteries. The yogi, as the student who masters it is termed, is promised the dominance of natural law. Incidentally there is offered, also health and long life, and the power to stay the ravages of time. Small wonder that a Swami's following recruits its largest numbers among women.

Miss Sarah Farmer, a New England spinster with a beautiful ideal of universal brotherhood, gave her fortune in the founding of Green Acre, where for years she was a familiar figure in her flowing gray gown and veil. The study of many religions unbalanced her mind and she has been for several years an inmate of an insane asylum at Waverly, Mass.

In Chicago, a few years since, Miss Aloise Reuss, a woman of culture and refinement, was taken screaming and praying, from the Mazdaznan Temple of the Sun, to be incarcerated, a raving maniac, in an Illinois asylum.

The death of Mrs. Ole Bull, of Cambridge, Mass., widow of the world-renowned violinist, occurred in January last, and her will, bequeathing several hundred thousand dollars to the Vedantist Society, was set aside by the courts on the grounds of mental incapacity and undue influence. On the very day of the decision, her daughter, Mrs. Olea Bull Vaughn, in whose behalf the verdict was rendered, died technically of tuberculosis, but actually, the doctors said, of a broken heart.

Mrs. May Wright Sewell, the club woman of national repute, who spent much time with Mrs. Bull at the latter's Cambridge home, is suffering from ill health, and is said to be a physical wreck through the practise of yoga and the study of occultism.

The relatives of Mrs. Ellen Shaw, of Lowell, Mass., petitioned the courts that a conservator be appointed to prevent her from bestowing her property on the sun worshipers.

Last spring, Dr. William R. C. Latson, a New York physician, was found mysteriously dead in his Riverside Drive apartment, and Alta Markheva, the young Jewish girl, who called him her man-god, or "guru" in the study of yoga, attempted to follow him in suicide. Her sister, Mrs. Rebecca Cohen, moaned: "This new religion seems to me to be of the devil. It has disgraced my sister and taken her from her people."

More recently, the wife of President Winthrop Ellsworth Stone, of Purdue University, at Lafayette, Ind., abandoned home and husband and children to join the sun worshipers in the study of yoga. Dr. Stone says: "I am utterly crusht; I want your prayers and your sympathy. I love my wife. She is as dear to me as she ever was. I hope that she will some time yet come to her senses and return to me and my boys."

Further record of the devastation that follows in the wake of the trailing robes of the "masters" from the East may be read from day to day in the newspapers.

The imported religions of the Orient that sow the subtle seeds of destruction are offered to the uninitiated as beautiful philosophies. On the surface they are that. But they are inevitably sprung from the soil of paganism and are tinctured with its practises.

It is not that the Swamis bring with them the hideous images worshiped at every roadside shrine in India. Here and there, it is true, a little brown Buddha or a green jade Krishna has appeared in an American home; but it is undoubtedly used merely, so its owner will tell you, as an aid to "concentration" in the worship of the ideal that it represents.

A greater menace than that of image worship lurks in the teachings of the Hindu mystics. The casual observer will not discover it. Only those who reach the inner circles become acquainted with the mysteries revealed to the adepts. The descent to heathenism is by such easy stages that the novice scarcely realizes she is led.

How many are followers of the new gods it is difficult to estimate with exactness. The Vedanta Society, established in America by the Swami Vivekenanda, of popular memory, has its headquarters at No. 135 West Eightieth Street, New York, where his successor, the Swami Abhedenanda, lectures. Branch societies, with Swamis in charge, are maintained in Boston, Pittsburgh, Washington, St. Louis, Denver, San Francisco and Los Angeles, to say nothing of the circles in many small towns.

Vedanta proclaims itself a universal religion, and there is generous room in its pantheon for any new god not already listed. Its altar is dedicated to the Supreme Spirit, whose name is the eternal word, "Om." He may be worshiped through any of his incarnations as Ahura Mazda, or Kali the Divine Mother, or Buddha, or Allah, or Vishnu, or Siva, or Krishna, or Ramakrishna, or Christ. You are offered the wide range of personal choice and no divinity objectionable to your Western sensibilities will be forced on your religious attention.

At West Cornwall, Conn., the society maintains its "Ashrama," or peace retreat, planned to become the great summer school of Oriental philosophy for America. It consists of three hundred and seventy acres of forest and field in the heart of the Berkshire Hills.

Julia Ward Howe once gave pause to the flow of Vivekananda's eloquence in a Boston drawing-room:

"Swami," she demanded, "if your gods are so good, let your women come to tell us of them."

"Our women," he evaded modestly, "do not travel."

One of them did, however. It was Pundita [sic] Ramabai, whose tour of the world, proclaiming the wrongs of Indian womanhood, stirred England to lay a heavy hand on some of the religious rites in India. Have American women forgotten Pundita Ramabai?

Baba Bharati, the other day, in a newspaper interview, boasted that of his five thousand converts in this country, the majority are women. Baba Bharati is that Hindu who is more selective in his heathenism than are the Vedantists. At the Rhada-Krishna temple he has built in Los Angeles, his followers concentrate on two divinities.

"Hinduism with the halo of its own brilliancy," is what he calls it. "I have made no effort to Westernize it," he brazenly admits. "It is the eternal Hinduism."

There are in India some three hundred and thirty million gods, ranking in importance below the great Hindu triad composed of Brahma, Vishnu and Siva. It was as Krishna that Vishnu appeared in human form for one of his ten earth incarnations.

With "Salaam-Aleikum," which is "Peace be unto you," again Mazdaznan bids for notice. It is sun worship that takes its name from Ahura Mazda, of whom Zoroaster was the great prophet. There is also a mingling of Hinduism in its strict vegetarianism, and the adaptation of the yoga teaching in breathing and posturing exercises.

This religion was launched in the United States by his humbleness Ottoman Zar-Adusht Hannish, claiming to be the "Mantra-Magie of Temple el Karman, Kalantar in Zoroastrian philosophy, Dastur in the art of breathing and Envoy of Mazdaznan living." He is assisted in dispensing its benefits by Her Blessedness Spenta Maria, otherwise, Marie Elizabeth Ruth Hilton, the wife of Dr. G. W. Hilton, of Lowell, Mass.

Fourteen thousand Americans are said to be joining with them in the worship of the Lord God Mazda and the daily adoration of the sun. There are Mazdaznan centers in thirty cities of the United States, as well as in Canada, South America, England, Germany and Switzerland.

When in 1901, "his humbleness" appeared in Chicago, he said that he had come direct from Tibet, where he had pierced the mysteries of the Dalai Lama, bringing back with him this little novelty in the religious line, which he immediately proceeded to place on the market. It is quite well authenticated that he had come from Salt Lake City, where he was a typesetter on the *Mt. Deseret News*. But it is also probable that he had at some time been in Persia, and rumor says he was born there, the son of a Russian girl and a German music master. Today, among his followers, he stands as the "Little Master," an incarnation of divinity. His headquarters are in Chicago, where the main temple is located, on Lake Park Avenue. The lesser temple stands on the lawn of Dr. Hilton's residence on Columbus Avenue, in Lowell, and ground has been consecrated for a third temple to be erected in Montreal.

The atmosphere of mystery that enwraps Mazdaznan ritual is characteristic of every Eastern cult. The latest importation, arriving within the past years, is sufism, a variety of Mohammedanism dispensed in New York by one Inayat Khan, from Baroda. His chanted prayers sound like the familiar call of the Coney Island Arab to his camel. Sufism frankly admits that its disciples are being gathered into a secret order.

Upon another secret order, that of the Tantrics, which represents the climax of Eastern abominations, and is Hindu religion at its lowest stage, the search light of publicity was recently turned. Tantric initiates in America are under the direction of five gurus, or primates. One of these, who styled himself, "Om the Omnipotent," had his headquarters in New York closed by the police.

The sacred books of the cult are the Tantras, dialogs between the god, Siva, and his consort, Kali, the Divine Mother. The rites have much in common with the worship of Baal and Moloch by the ancient Assyrians. The unmentionable orgies of the Tantrics constitute what is known as the "left hand" worship of Kali. The "right hand" worship of this goddess as the divinity of carnage and slaughter is disgusting enough. Her great temple, which, with its bathing place,

the Kali-ghat at Calcutta, has given its name to that city, is one of the most noted in India, to which thousands of devotees make annual pilgrimage.

There is no more horrible idol in the Hindu pantheon than the figure of Kali. She is represented as a nude, black woman, dancing on the body of her husband, the god Siva. Her huge tongue protrudes from her mouth. For earrings, she has two human heads. She wears a necklace of human skulls and a waistband of human hands, which trophies she is supposed to have taken from the enemies whom she slew during her visit to earth. When she had completed her work of destruction, she danced on the bodies of the fallen until the earth trembled. Her husband, Siva, in the effort to stop the carnage, threw himself beneath her feet. Kali, representing the power and influence of woman, is worshiped as the "Divine Mother."

It is the Hinduism that reaches in the wide span from this heathen idolatry to the heights of the Bhagavad Gita that has brought to America the yoga philosophy. Its leading exponents, the priests of the Vedantist Society, belong to a monastic order founded in the nineteenth century by Ramakrishna, a priest in the temple of Kali.

It is not the worship of images of stone and wood that constitutes the gravest peril in the teaching of the Orientals. It is the worship of men. The guru is the real idol. It is no uncommon proceeding in that country for the disciple on meeting his guru to prostrate himself and take the very dust from his teacher's feet to place upon his own head. When Swami Vivekananda came out from his daily meditation, his devotees were wont to clasp the hem of his robe, and they kissed his sandaled feet!

To bestow gifts upon a guru counts for spiritual merit. The teachers from the East ostentatiously announce themselves under vows of poverty and chastity. Their poverty, at least, is not the suffering sort. No lady's canine darling, combed and curled for a bench show, was ever tended with more assiduous care than is a "Master," whose very name is spoken reverently, and with softened breath.

A guru's bidding is obeyed even when he tells a disciple that the highest spiritual attainment in yoga will require the renouncement of home and family ties. "My husband and children are no more to me than any others equally deserving of regard," Mrs. Stone, the wife of the Purdue College president coldly proclaims. "My religion teaches that they have no claim on me and I am free to seek the perfect life alone."

Is it any wonder that the missionaries from foreign fields are sending to their home offices in New York and Boston the peremptory inquiry: "What do Christian women mean?" They echo the question put to the Swami Abhedenanda's Ashrama: "What has paganism done for the women of the East that the women of the West want aught with it?"

Woman's position in India is the most degraded of anywhere in the world. Shut within the *zenana*, she may not even leave the house without her husband's permission. Her hope of salvation is through him whom she regards as a god. She serves his food and waits until he has finished. Child marriage is required and motherhood is enforced as early as the age of twelve. Twenty-three thousand child widows freed now by English law from suttee, the rite that formerly burned them on a husband's funeral pyre, are reckoned as accurst, and are per-

secuted by social custom. Thousands of girls, twelve thousand in South India alone, are dedicated as Nautch girls to the service of the temple priests in consecrated prostitution.

It is a holy injunction of Manu, the ancient Hindu code, that women shall not be taught the Vedas, and she is forbidden to pronounce even a sacred syllable from them. One hundred and ninety-nine women of every two hundred in India can not read or write. It was one of these little dark women who sorrowfully drew her chudder more closely about her, and said to a missionary: "Oh, Miss Sahib, we are like the animals. We can eat and work and die, but we can not think." Literally, less than a cow is a woman in India, for the cow is held sacred.

The soft-speaking priest from the land of the serpent, who lures the Western woman with his wiles, holds her, also, in like contempt. What did the Swami Vivekenanda, returning to his native land, tell of his fair American proselytes? The missionaries say that he boastfully spread the impression that they were even as the Nautch girls of India.

# JAMES FREEMAN CLARKE

James Freeman Clarke (1810–88) was a reform-minded Unitarian minister who was closely associated with the Transcendental religion of Ralph Waldo Emerson but who remained committed to the institutional church. From 1859 to 1861, he was secretary of the American Unitarian Association. Like many other religious liberals of the period, he evinced considerable interest in and sympathy toward the comparative study of world religions, believing that Christians had much to gain from such study. Such gains notwithstanding, Clarke plainly envisioned Protestant Christianity as the most progressive and advanced among the religions, placing them on a kind of evolutionary scale. His two-volume work, *Ten Great Religions* (1871 and 1883), delineated other religions as "partial" in light of Christianity's universality and reconciling power.

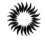

## The Ten Religions and Christianity

§ 1. *General Results of this Survey.* § 2. *Christianity a Pleroma, or Fulness of Life.* §3. *Christianity, as a Pleroma, compared with Brahmanism, Confucianism, and Buddhism.* § 4. *Christianity compared with the Avesta and the Eddas. The Duad in all Religions.* § 5. *Christianity and the Religions of Egypt, Greece, and Rome.* § 6. *Christianity in Relation to Judaism and Mohammedanism. The Monad in all*

*Religions. § 7. The Fulness of Christianity is derived from the Life of Jesus. § 8. Christianity as a Religion of Progress and of Universal Unity.*

## § 1. GENERAL RESULTS OF THIS SURVEY

We have now examined, as fully as our limits would allow, ten of the chief religions which have enlisted the faith of mankind. We are prepared to ask, in conclusion, what they teach us in regard to the prospects of Christianity, and the religious future of our race.

First, this survey must have impressed on every mind the fact that man is eminently a religious being. We have found religion to be his supreme and engrossing interest on every continent, in every millennium of historic time, and in every stage of human civilization. In some periods men are found as hunters, as shepherds, as nomads, in others they are living associated in cities, but in all these conditions they have their religion. The tendency to worship some superhuman power is universal.

The opinion of the positivist school, that man passes from a theological stage to one of metaphysics, and from that to one of science, from which later and higher epoch both theology and philosophy are excluded, is not in accordance with the facts we have been observing. Science and art, in Egypt, went hand in hand with theology, during thousands of years. Science in Greece preceded the latest forms of metaphysics, and both Greek science and Greek philosophy were the preparation for Christian faith. In India the Sánkhya philosophy was the preparation for the Buddhist religion. Theology and religion to-day, instead of disappearing in science, are as vigorous as ever. Science, philosophy, and theology are all advancing together, a noble sisterhood of thought. And, looking at facts, we may ask, In what age or time was religion more of a living force, acting on human affairs, than it is at present? To believe in things not seen, to worship a power above visible nature, to look forward to an unknown future, this is natural to man.

In the United States there is no established religion, yet in no country in the world is more interest taken in religion than with us. In the Protestant denominations it has dispensed with the gorgeous and imposing ritual, which is so attractive to the common mind, and depends mainly on the interest of the word of truth. Yet the Protestant denominations make converts, build churches, and support their clergy with an ardor seemingly undiminished by the progress of science. There are no symptoms that man is losing his interest in religion in consequence of his increasing knowledge of nature and its laws.

Secondly, we have seen that these religions vary exceedingly from each other in their substance and in their forms. They have a great deal in common, but a great deal that is different. Mr. Wentworth Higginson, in an excellent lecture, much of which has our cordial assent, says, "Every race believes in a Creator and Governor of the world, in whom devout souls recognize a Father also." But Buddhism, the most extensive religion on the surface of the earth, explicitly denies creation, and absolutely ignores any Ruler or Governor of the world. The Buddha neither made the world nor preserves it, and the Buddha is the great object of Buddhist worship. Mr. Higginson says: "Every race believes in immortality."

Though the Buddhists, as we have seen, believe in immortality, it is in so obscure a form that many of the best scholars declare that the highest aim and the last result of all progress in Buddhism is annihilation. He continues, "Every race recognizes in its religious precepts the brotherhood of man." The Koran teaches no such doctrine, and it is notorious that the Brahmanical system of caste, which has been despotic in India for twenty-five hundred years, excludes such brotherhood. Mr. Higginson therefore is of opinion that caste has grown up in defiance of the Vedas. The Vedas indeed are ignorant of caste, but they are also ignorant of human brotherhood. The system of caste was not a defiance of the Vedas.

Nothing is gained for humanity by such statements, which are refuted immediately by the most evident facts. The true "sympathy of religions" does not consist in their saying the same thing, any more than a true concord in music consists in many performers striking the same note. Variety is the condition of harmony. These religions may, and we believe will, be all harmonized; but thus far it is only too plain that they have been at war with each other. In order to find the resemblances we must begin by seeing the differences.

Cudworth, in his great work, speaks of "the symphony of all religions," an expression which we prefer to that of Mr. Higginson. It expresses precisely what we conceive to be the fact, that these religions are all capable of being brought into union, though so very different. They may say,

> "Are not we formed, as notes of music are,
> For one another, though dissimilar?
> Such difference, without discord, as shall make
> The sweetest sounds."

But this harmony can only be established among the ethnic religions by means of a catholic religion which shall be able to take each of them up into itself, and so finally merge them in a higher union. The Greek, Roman, and Jewish religions could not unite with each other; but they were united by being taken up into Christianity. Christianity has assimilated the essential ideas of the religions of Persia, Judæa, Egypt, Greece, Rome, and Scandinavia; and each of these religions, in turn, disappeared as it was absorbed by this powerful solvent. In the case of Greece, Rome, Germany, and Judæa, this fact of their passing into solution in Christianity is a matter of history. Not all the Jews became Christians, nor has Judaism ceased to exist. This is perhaps owing to the doctrines of the Trinity and the Deity of Christ, which offend the simplistic monotheism of the Jewish mind. Yet Christianity at first grew out of Judaism, and took up into itself the best part of the Jews in and out of Palestine.

The question therefore is this, Will Christianity be able to do for the remaining religions of the world what it did for the Greeks, the Romans, and the Teutonic nations? Is it capable of becoming a universal religion?

## § 2. CHRISTIANITY A PLEROMA, OR FULNESS OF LIFE

It is evident that Christianity can become the universal human religion only by supplying the religious wants of all the races of men who dwell on all the face of the earth. If it can continue to give them all the truth their own religions contain,

and add something more; if it can inspire them with all the moral life which their own religions communicate, and yet more; and, finally, if it can unite the races of men in one family, one kingdom of heaven,—then it is fitted to be and will become the universal religion. It will then not share the fate of those which have preceded it. It will not have its rise, progress, decline, and fall. It will not become, in its turn, antiquated, and be left behind by the advance of humanity. It will not be swallowed up in something deeper and broader than itself. But it will appear as the desire of all nations, and Christ will reign until he has subdued all his enemies—error, war, sin, selfishness, tyranny, cruelty—under his feet.

Now, as we have seen, Christianity differs from all other religions (on the side of truth) in this, that it is a pleroma, or fulness of knowledge. It does not differ, by teaching what has never been said or thought before. Perhaps the substance of most of the statements of Jesus may be found scattered through the ten religions of the world, some here and some there. Jesus claims no monopoly of the truth. He says, "My doctrine is not mine, but his who sent me." But he *does* call himself "the Light of the World," and says that though he does not come to destroy either the law or the prophets, he comes to fulfil them in something higher. His work is to fulfil all religions with something higher, broader, and deeper than what they have,—accepting their truth, supplying their deficiencies.

If this is a fact, then it will appear that Christianity comes, not as an exclusive, but as an inclusive system. It includes everything, it excludes nothing but limitation and deficiency.

Whether Christianity be really such a pleroma of truth or not, must be ascertained by a careful comparison of its teachings, and the ideas lying back of them, with those of all other religions. We have attempted this, to some extent, in our Introduction, and in our discussion of each separate religion. We have seen that Christianity, in converting the nations, always accepted something and gave something in return. Thus it received from Egypt and Africa their powerful realism, as in the writings of Tertullian, Origen, Augustine, and gave in return a spiritual doctrine. It received God, as seen in nature and its organizations, and returned God as above nature. Christianity took from Greece intellectual activity, and returned moral life. It received from Rome organization, and returned faith in a fatherly Providence. It took law, and gave love. From the German races it accepted the love of individual freedom, and returned union and brotherly love. From Judaism it accepted monotheism as the worship of a Supreme Being, a Righteous Judge, a Holy King, and added to this faith in God as in all nature and all life.

But we will proceed to examine some of these points a little more minutely.

## § 3. CHRISTIANITY, AS A PLEROMA, COMPARED WITH BRAHMANISM, CONFUCIANISM, AND BUDDHISM

Christianity and Brahmanism. The essential value of Brahmanism is its faith in spirit as distinct from matter, eternity as distinct from time, the infinite as opposed to the finite, substance as opposed to form.

The essential defect of Brahmanism is its spiritual pantheism, which denies all reality to this world, to finite souls, to time, space, matter. In its vast unities

all varieties are swallowed up, all differences come to an end. It does not, there-fore, explain the world, it denies it. It is incapable of morality, for morality as-sumes the eternal distinction between right and wrong, good and evil, and Brahmanism knows no such difference. It is incapable of true worship, since its real God is spirit in itself, abstracted from all attributes. Instead of immortality, it can only teach absorption, or the disappearance of the soul in spirit, as rain-drops disappear in the ocean.

Christianity teaches a Supreme Being who is pure spirit, "above all, through all, and in all," "from whom, and through whom, and to whom are all things," "in whom we live, and move, and have our being." It is a more spiritual religion than Brahmanism, for the latter has passed on into polytheism and idolatry, which Christianity has always escaped. Yet while teaching faith in a Supreme Being, the foundation and substance below all existence, it recognizes him as A LIVING GOD. He is not absorbed in himself, nor apart from his world, but a per-petual Providence, a personal Friend and Father. He dwells in eternity, but is manifested in time.

Christianity, therefore, meets the truth in Brahmanism by its doctrine of God as Spirit, and supplies its deficiencies by its doctrine of God as a Father.

*Christianity and the system of Confucius.* The good side in the teaching of Confucius is his admirable morality, his wisdom of life in its temporal limita-tions, his reverence for the past, his strenuous conservatism of all useful institu-tions, and the uninterrupted order of the social system resting on these ideas.

The evil in his teaching is the absence of the supernatural element, which deprives the morality of China of enthusiasm, its social system of vitality, its or-der of any progress, and its conservatism of any improvement. It is a system without hope, and so has remained frozen in an icy and stiff immobility for fif-teen hundred years.

But Christianity has shown itself capable of uniting conservatism with progress, in the civilization of Christendom. It respects order, reveres the past, holds the family sacred, and yet is able also to make continual progress in sci-ence, in art, in literature, in the comfort of the whole community. It therefore ac-cepts the good and the truth in the doctrines of Confucius, and adds to these an-other element of new life.

*Christianity and Buddhism.* The truth in Buddhism is in its doctrine of the re-lation of the soul to the laws of nature; its doctrine of consequences; its assur-ance of a strict retribution for every human action; its promise of an ultimate sal-vation in consequence of good works; and of a redemption from all the woes of time by obedience to the truth.

The evil in the system is that belonging to all legalism. It does not inspire faith in any living and present God, or any definite immortality. The principle, therefore, of development is wanting, and it leaves the Mongol races standing on a low plane of civilization, restraining them from evil, but not inspiring them by the sight of good.

Christianity, like Buddhism, teaches that whatever a man sows that shall he also reap; that those who by patient continuance in well-doing seek for glory, honor, and immortality shall receive eternal life; that the books shall be opened

in the last day, and every man be rewarded according to his works; that he whose pound gains five pounds shall be ruler over five cities. In short, Christianity, in its Scriptures and its practical influence, has always taught salvation by works.

Yet, beside this, Christianity teaches justification by faith, as the root and fountain of all real obedience. It inspires faith in a Heavenly Father who has loved his every child from before the foundation of the world; who welcomes the sinner back when he repents and returns; whose forgiving love creates a new life in the heart. This faith evermore tends to awaken the dormant energies in the soul of man; and so, under its influence, one race after another has commenced a career of progress. Christianity, therefore, can fulfil Buddhism also.

## § 4. CHRISTIANITY COMPARED WITH THE AVESTA AND THE EDDAS. THE DUAD IN ALL RELIGIONS

The essential truth in the Avesta and the Eddas is the same. They both recognize the evil in the world as real, and teach the duty of fighting against it. They avoid the pantheistic indifference of Brahmanism, and the absence of enthusiasm in the systems of Confucius and the Buddha, by the doctrine of a present conflict between the powers of good and evil, of light and of darkness. This gives dignity and moral earnestness to both systems. By fully admitting the freedom of man, they make the sense of responsibility possible, and so purify and feed morality at its roots.

The difficulty with both is, that they carry this dualistic view of nature too far, leaving it an unreconciled dualism. The supreme Monad is lost sight of in this ever-present Duad. Let us see how this view of evil, or the dual element in life, appears in other systems.

As the Monad in religion is an expression of one infinite supreme presence, pervading all nature and life, so the Duad shows the antagonism and conflict between truth and falsehood, right and wrong, good and evil, the infinite perfection and the finite imperfection. This is a conflict actually existing in the world, and one which religion must accept and account for. Brahmanism does not accept it, but ignores it. This whole conflict is Maya, a deception and illusion. Yet, in this form of illusion, it makes itself so far felt, that it must be met by sacrifices, prayers, penances, and the law of transmigration; until all the apparent antagonism shall be swallowed up in the Infinite One, the only substance in the universe.

Buddhism recognizes the conflict more fully. It frankly accepts the Duad as the true explanation of the actual universe. The ideal universe as Nirvana may be one; but of this we know nothing. The actual world is a twofold world, composed of souls and the natural laws. The battle of life is with these laws. Every soul, by learning to obey them, is able to conquer and use them, as steps in an ascent toward Nirvana.

But the belief of Zoroaster and that of Scandinavia regard the Duad as still more deeply rooted in the essence of existing things. All life is battle,—battle with moral or physical evil. Courage is therefore the chief virtue in both systems. The Devil first appears in theology in these two forms of faith. The Persian

devil is Ahriman; the Scandinavian devil is Loki. Judaism, with its absolute and supreme God, could never admit such a rival to his power as the Persian Ahriman; yet as a being permitted, for wise purposes, to tempt and try men, he comes into their system as Satan. Satan, on his first appearance in the Book of Job, is one of the angels of God. He is the heavenly critic; his business is to test human virtue by trial, and see how deep it goes. His object in testing Job was to find whether he loved virtue for its rewards, or for its own sake. "Does Job serve God for naught?" According to this view, the man who is good merely for the sake of reward is not good at all.

In the Egyptian system, as in the later faith of India, the evil principle appears as a power of destruction. Siva and Typhon are the destroying agencies from whom proceed all the mischief done in the world. Nevertheless, they are gods, not devils, and have their worship and worshippers among those whose religious nature is more imbued with fear than with hope. The timid worshipped the deadly and destructive powers, and their prayers were deprecations. The bolder worshipped the good gods. Similarly, in Greece, the Chtonic deities had their shrines and worshippers, as had the powers of Blight, Famine, and Pestilence at Rome.

Yet only in the Avesta is this great principle of evil set forth in full antagonism against the powers of light and love. And probably from Persia, after the captivity, this view of Satan entered into Jewish theology. In the Old Testament, indeed, where Satan or the Devil as a proper name only occurs four times, in all which cases he is a subordinate angel, the true Devil does not appear. In the Apocrypha he is said (Wisdom ii. 24) to have brought death into the world. The New Testament does not teach a doctrine of Satan, or the Devil, as something new and revealed then for the first time, but assumes a general though vague belief in such a being. This belief evidently existed among the Jews when Christ came. It as evidently was not taught in the Old Testament. The inevitable inference is that it grew up in the Jewish mind from its communication with the Persian dualism.

But though the doctrine of a Devil is no essential part of Christianity, the reality and power of evil is fully recognized in the New Testament and in the teachings of the Church. Indeed, in the doctrine of everlasting punishment and of an eternal hell, it has been carried to a dangerous extreme. The Divine sovereignty is seriously infringed and invaded by such a view. If any outlying part of the universe continues in a state of permanent rebellion, God is not the absolute sovereign. But wickedness is rebellion. If any are to continue eternally in hell, it is because they continue in perpetual wickedness; that is, the rebellion against God will never be effectually suppressed. Only when every knee bows, and every tongue confesses that Christ is Lord to the glory of God the Father; only when truth and love have subdued all enemies by converting them into friends, is redemption complete and the universe at peace.

Now, Christianity (in spite of the illogical doctrine of everlasting punishment) has always inspired a faith in the redeeming power of love to conquer all evil. It has taught that evil can be overcome by good. It asserts truth to be more powerful than error, right than wrong. It teaches us in our daily prayer to expect that God's kingdom shall come, and his will shall be done on earth as it is in Heaven. It therefore fulfils the truth in the great dualisms of the past by its untiring hope of a full redemption from all sin and all evil.

## § 5. CHRISTIANITY AND THE RELIGIONS OF EGYPT, GREECE, AND ROME

The Religion of Egypt. This system unfolded the truth of the Divine in this world, of the sacredness of bodily organization, and the descent of Deity into the ultimate parts of his creation. Its defect was its inability to combine with this an open spiritualism. It had not the courage of its opinions, so far as they related to the divine unity, spirituality, and eternity.

Christianity also accepts the doctrine of God, present in nature, in man, in the laws of matter, in the infinite variety of things. But it adds to this the elevated spiritualism of a monotheistic religion, and so accepts the one and the all, unity and variety, substance and form, eternity and time, spirit and body, as filled with God and manifesting him.

*The Religions of Greece and Rome.* The beauty of nature, the charm of art, the genius of man, were idealized and deified in the Greek pantheon. The divinity of law, organizing human society according to universal rules of justice, was the truth in the Roman religion. The defect of the Greek theology was the absence of a central unity. Its polytheism carried variety to the extreme of disorder and dissipation. The centrifugal force, not being properly balanced by any centripetal power, inevitably ends in dissolution. The defect of Roman worship was, that its oppressive rules ended in killing out life. Law, in the form of a stiff external organization, produced moral death at last in Rome, as it had produced moral death in Judæa.

Now Christianity, though a monotheism, and a monotheism which has destroyed forever both polytheism and idolatry wherever it has gone, is not that of numerical unity. The God of Christianity differs in this from the God of Judaism and Mohammedanism. He is an infinite will; but he is more. Christianity cognizes God as not only above nature and the soul, but also as in nature and in the soul. Thus nature and the soul are made divine. The Christian doctrine of the Trinity expresses this enlargement of the Jewish monotheism from a numerical to a moral unity. The God of Christ is human in this respect, that he is conceived of in the image of man. Man is essentially a unit through his will, in which lies the secret of personal identity. But besides will he has intellect, by which he comes into communion with the universe; and affection, by which he comes into communion with his race. Christianity conceives of God in the same way. He is an omnipresent will as the Father, Creator, and Ruler of all things. He is the Word, or manifested Truth in the Son, manifested through all nature, manifested through all human life. He is the Spirit, or inspiration of each individual soul. So he is Father, Son, and Spirit, above all, through all, and in us all. By this larger view of Deity Christianity was able to meet the wants of the Aryan races, in whom the polytheistic tendency is so strong. That tendency was satisfied by this view of God immanent in nature and immanent in human life.

Judaism and Mohammedanism, with their more concrete monotheism, have not been able to convert the Aryan races. Mohammedanism has never affected the mind of India, nor disturbed the ascendency of Brahmanism there. And though it nominally possesses Persia, yet it holds it as a subject, not as a convert. Persian Sufism is a proof of the utter discontent of the Aryan intellect with any monotheism of pure will. Sufism is the mystic form of Mohammedanism, recog-

nizing communion with God, and not merely submission, as being the essence of true religion. During the long Mohammedan dominion in Turkey it has not penetrated the minds or won the love of the Greek races. It is evident that Christianity succeeded in converting the Greeks and Romans by means of its larger view of the Deity, of which the doctrine of the Trinity, as it stands in the creeds, is a crude illogical expression.

## § 6. CHRISTIANITY IN RELATION TO JUDAISM AND MOHAMMEDANISM. THE MONAD IN ALL RELIGIONS

There are three religions which teach the pure unity of God, or true monotheism. These three unitarian religions are Judaism, Christianity, and Mohammedanism. They also all originated in a single race, the Semitic race, that which has occupied the central region of the world, the centre of three continents. It is the race which tends to a religious unity, as that of our Aryan ancestors tended to variety.

But what is pure monotheism? It is the worship of one alone God, separated by the vast abyss of the infinite from all finite beings. It is the worship of God, not as the Supreme Being only, not as the chief among many gods, as Jupiter was the president of the dynasty on Olympus, not merely the Most High, but as the only God. It avoids the two extremes, one of making the Supreme Being head of a council or synod of deities, and the other of making him indeed infinite, but an infinite abstraction, or abyss of darkness. These are the two impure forms of monotheism. The first prevailed in Greece, Rome, Egypt, Scandinavia. In each of these religions there was a supreme being,— Zeus, Jupiter, Ammon, Odin,—but this supreme god was only *primus inter pares*, first among equals. The other impure form of monotheism prevailed in the East,—in Brahmanism, Buddhism, and the religion of Zoroaster. In the one Parabrahm, in the other Zerana-Akerana, in the third Nirvana itself, is the Infinite Being or substance, wholly separate from all that is finite. It is so wholly separate as to cease to be an object of adoration and obedience. Not Parabrahm, but Siva, Vischnu, and Brahma; not Zerana-Akerana, but Ormazd and the Amschaspands; not the infinite world of Nirvana, nor the mighty Adi-Buddha, but the Buddhas of Confession, the finite Sakya-Muni, are the objects of worship in these systems.

Only from the Semitic race have arisen the pure monotheistic religions of Judaism, Christianity, and Mohammedanism. Each of these proclaims one only God, and each makes this only God the object of all worship and service. Judaism says, "Hear! O Israel, the Lord our God is one Lord!" (Deut. vi. 4.) Originally among the Jews, God's name as the "Plural of Majesty" indicated a unity formed from variety; but afterward it became in the word Jahveh a unity of substance. "By my name Jehovah I was not known to them" (i. e. to the Patriarchs). That name indicates absolute Being, "I am the I am."

Ancient Gentile monotheism vibrated between a personal God, the object of worship, who was limited and finite, and an infinite absolute Being who was out of sight, "whose veil no one had lifted." The peculiarity of the Mosaic religion was to make God truly the one alone, and at the same time truly the object of worship.

In this respect Judaism, Christianity, and Mohammedanism agree, and in this they differ from all other religions. Individual thinkers, like Socrates, Æschylus, Cicero, have reached the same conviction; but these three are the only popular religions, in which God is at once the infinite and absolute, and the only object of worship.

Now it is a remarkable fact that these three religions, which are the only pure monotheistic religions, are at the same time the only religions which have any claim to catholicity. Buddhism, though the religion of numerous nations, seems to be the religion of only one race, namely, the Turanic race, or Mongols. The people of India who remain Buddhists, the Singalese, or inhabitants of Ceylon, belong to the aboriginal Tamul, or Mongol race. With this exception then (which is no exception, as far as we know the ethnology of Eastern Asia), the only religions which aim at Catholicism are these three, which are also the only monotheistic religions. Judaism aimed at catholicity and hoped for it. It had an instinct of universality, as appeared in its numerous attempts at making proselytes of other nations. It failed of catholicity when it refused to accept as its Christ the man who had risen above its national limitations, and who considered Roman tax-gatherers and Samaritans as already prepared to enter the kingdom of the Messiah. The Jews required all their converts to become Jews, and in doing this left the catholic ground. Christianity in the mouth of Paul, who alone fully seized the true idea of his Master, said, "Circumcision availeth nothing, nor uncircumcision, but a new creature." In other words, he declared that it was not necessary to become a Jew in order to be a Christian.

The Jewish mind, so far forth as it was monotheistic, aimed at catholicity. The unity of God carries with it, logically, the unity of man. From one God as spirit we infer one human family. So Paul taught at Athens. "God that made the world and all things therein, . . . . hath made of one blood all races of men to dwell on all the face of the earth."

But the Jews, though catholic as monotheists, and as worshipping a spiritual God, were limited by their ritual and their intense national bigotry. Hereditary and ancestral pride separated them, and still separate them, from the rest of mankind. *"We have Abraham to our Father,"* is the talisman which has kept them together, but kept them from union with others.

Christianity and Mohammedanism, therefore, remain the only two really catholic religions. Each has overpassed all the boundaries of race. Christianity, beginning among the Jews, a Semitic people, passed into Europe, and has become the religion of Greeks, Romans, Kelts, Germans, and the Slavic races of Russia, and has not found it impossible to convert the Africans, the Mongols, and the American Indians. So too the Mohammedan religion, also beginning among the Semitic race, has become the nominal religion of Persia, Turkey, Northern Africa, and Central Asia. Monotheism, therefore, includes a tendency to catholicity. But Islam has everywhere made subjects rather than converts, and so has failed of entire success. It has not assimilated its conquests.

The monotheism of Christianity, as we have already seen, while accepting the absolute supremacy of the Infinite Being, so as to displace forever all secondary or subordinate gods, yet conceives of him as the present inspiration of all his children. It sees him coming down to bless them in the sunshine and the shower, as inspiring every good thought, as a providence guiding all human

lives. And by this view it fulfils both Judaism and Mohammedanism, and takes a long step beyond them both.

## § 7. THE FULNESS OF CHRISTIANITY IS DERIVED FROM THE LIFE OF JESUS

Christianity has thus shown itself to be a universal solvent, capable of receiving into itself the existing truths of the ethnic religions, and fulfilling them with something higher. Whenever it has come in contact with natural religion, it has assimilated it and elevated it. This is one evidence that it is intended to become the universal religion of mankind.

This pleroma, or fulness, integrity, all-sidedness, or by whatever name we call it, is something deeper than thought. A system of thought might be devised large enough to include all the truths in all the religions of the world, putting each in its own place in relation to the rest. Such a system might show how they all are related to each other, and all are in harmony. But this would be a philosophy, not a religion. No such philosophy appears in the original records of Christianity. The New Testament does not present Jesus as a philosopher, nor Paul as a metaphysician. There is no systematic teaching in the Gospels, nor in the Epistles. Yet we find there, in incidental utterances, the elements of this many-sided truth, in regard to God, man, duty, and immortality. But we find it as life, not as thought. It is a fulness of life in the soul of Jesus, passing into the souls of his disciples and apostles, and from them in a continuous stream of Christian experience, down to the present time.

The word pleroma (πλήρωμα), in the New Testament, means that which fills up; fulness, fulfilling, filling full. The verb "to fulfil" (πληρόω) carries the same significance. To "fulfil that which was spoken by the prophets," means to fill it full of meaning and truth. Jesus came, not to destroy the law, but to fulfil it; that is, to carry it out further. He fulfilled Moses and the prophets, not by doing exactly what they foretold, in their sense, but by doing it in a higher, deeper, and larger sense. He fulfilled their thought as the flower fulfils the bud, and as the fruit fulfils the flower. The sense of the fulness of life in Jesus and in the Gospel seems to have struck the minds of the early disciples, and powerfully impressed them. Hence the frequency with which they use this verb and noun, signifying fulness. Jesus fulfilled the law, the prophets, all righteousness, the Scriptures. He came in the fulness of time. His joy was fulfilled. Paul prays that the disciples may be filled full of joy, peace, and hope, with the fruits of righteousness, with all knowledge with the spirit of God, and with all the fulness of God. He teaches that love fulfils the law, that the Church is the fulness of Christ, that Christ fills all things full of himself, and that in him dwells all the fulness of the godhead bodily.

One great distinction between Christianity and all other religions is in this pleroma, or fulness of life which it possesses, and which, to all appearance, came from the life of Jesus. Christianity is often said to be differenced from ethnic religions in other ways. They are natural religions: it is revealed. They are natural: it is supernatural. They are human: it is divine. But *all* truth is revealed truth; it all comes from God, and, therefore, so far as ethnic religions contain

truth, they also are revelations. Moreover, the supernatural element is to be found in all religions; for inspiration, in some form, is universal. All great births of time are supernatural, making no part of the nexus of cause and effect. How can you explain the work of Confucius, of Zoroaster, of the Buddha, of Mohammed, out of the existing state of society, and the educational influences of their time? All such great souls are much more the makers of their age than its result; they are imponderable elements in civilization, not to be accounted for by anything outside of themselves. Nor can we urge the distinction of human and divine; for there is a divine element in all ethnic religions, and a broadly human element in Christianity. Jesus is as much the representative of human nature as he is the manifestation of God. He is the Son of man, no less than the Son of God.

One great fact which makes a broad distinction between other religions and Christianity is that *they* are ethnic and *it* is catholic. They are the religions of races and nations, limited by these lines of demarcation, by the bounds which God has beforehand appointed. Christianity is a catholic religion: it is the religion of the human race. It overflows all boundaries, recognizes no limits, belongs to man as man. And this it does, because of the fulness of its life, which it derives from its head and fountain, Jesus Christ, in whom dwells the fulness both of godhead and of manhood.

It is true that the great missionary work of Christianity has long been checked. It does not now convert whole nations. Heathenism, Mohammedanism, Judaism, Brahmanism, Buddhism, stand beside it unmoved. What is the cause of this check?

The catholicity of the Gospel was born out of its fluent and full life. It was able to convert the Greeks and Romans, and afterward Goths, Vandals, Lombards, Franks, Scandinavians, because it came to them, not as a creed, but as a life. But neither Roman Catholics nor Protestants have had these large successes since the Middle Ages. Instead of a life, Christianity became a church and a creed. When this took place, it gradually lost its grand missionary power. It no longer preached truth, but doctrine; no longer communicated life, but organized a body of proselytes into a rigid church. Party spirit took the place of the original missionary spirit. Even the majority of the German tribes was converted by Arian missionaries, and orthodoxy has not the credit of that last grand success of Christianity. The conversion of seventy millions of Chinese in our own day to the religion of the Bible was not the work of Catholic or Protestant missionaries, but of the New Testament. The Church and the creed are probably the cause of this failure. Christianity has been partially arrested in its natural development, first by the Papal Church, and secondly by the too rigid creeds of orthodoxy.

If the swarming myriads of India and Mongolia are to be converted to Christianity, it must be done by returning to the original methods. We must begin by recognizing and accepting the truth they already possess. We must be willing to learn of them, in order to teach them. Comparative Theology will become the science of missions if it help to show to Christians the truth and good in the creeds outside of Christendom. For to the Church and to its sects, quite as much as to the world, applies the saying, "He that exalteth himself shall be abased, but he that humbleth himself shall be exalted."

# § 8. CHRISTIANITY AS A RELIGION OF PROGRESS AND OF UNIVERSAL UNITY

As long as a tree or an animal lives it continues to grow. An arrest of growth is the first symptom of the decline of life. Fulness of life, therefore, as the essential character of Christianity, should produce a constant development and progress; and this we find to be the case. Other religions have their rise, progress, decline, and fall, or else are arrested and become stationary. The religions of Persia, Egypt, Greece, Rome, Scandinavia, have come to an end. As ethnic religions, they shared the fortunes of the race or nation with which they were associated. The systems of Confucius, of the Buddha, of Brahmanism, of Judæa, of Mohammed, are arrested. They remain stationary. But, thus far, Christianity and Christendom advance together. Christianity has developed, out of its primitive faith, several great theologies, the mediæval Papacy, Protestantism, and is now evidently advancing into new and larger forms of religious, moral, and social activity.

The fact of a fulness of divine and human life in Jesus took form in the doctrines of the incarnation and the Trinity. The fact of the reconciling and uniting power of this life took form in the doctrine of the atonement. Both of these doctrines are illogical and false, in their form, as church doctrines. But both of them represent most essential facts. We have seen the truths in the doctrines of incarnation and the Trinity. The truth in the atonement is, as the word itself signifies, the at-one-making power of the Gospel. The reconciliation of antagonist truths and opposing tendencies, which philosophy has always unsuccessfully endeavored to state in theory, Christianity accomplishes in practice. Christianity continually reproduces from its depths of life a practical faith in God, both as law and as love, in man, both as a free and yet as a providentially guided being. It gives us God as unity and as variety, as the substance and as the form of the world. It states the reality of evil as forcibly as any system of dualism, and yet produces a practical faith in good as being stronger than evil and sure to conquer it. In social life it reconciles the authority of human law with the freedom of individual thought and action. In the best Christian governments, we find all the order which a despotism can guarantee, with all the freedom to which a democracy can aspire. No such social organization is to be found outside of Christendom. How can this be, unless it is somehow connected with Christianity?

The civilization of Christendom consists in a practical reconciliation of antagonist tendencies. It is a "pleroma" in social life, a fulness of concord, a harmony of many parts. The harmony is indeed by no means complete, for the millennium has not arrived. As yet the striking feature of Christendom is quantity, power, variety, fulness; not as yet co-operation, harmony, peace, union. Powers are first developed, which are afterward to be harmonized. The sword is not yet beaten into a ploughshare, nor has universal peace arrived. Yet such is the inevitable tendency of things. As knowledge spreads, as wealth increases, as the moral force of the world is enlarged, law, more and more, takes the place of force. Men no longer wear swords by their sides to defend themselves from attack. If attacked, they call the policeman. Towns are no longer fortified with walls, nor are the residences of noblemen kept in a state of defence. They are all

folded in the peaceful arms of national law. So far the atonement has prevailed. Only nations still continue to fight; but the time is at hand when international law, the parliament of the world, the confederation of man, shall take the place of standing armies and iron-clad navies.

So, in society, internal warfare must, sooner or later, come to an end. Pauperism and crime must be treated according to Christian methods. Criminals must be reformed, and punishment must be administered in reference to that end. Co-operation in labor and trade must take the place of competition. The principles by means of which these vast results will be brought about are already known; the remaining difficulties are in their application. Since slavery fell in the United States, one great obstacle to the progress of man is removed. The next social evils in order will be next assailed, and, one by one, will be destroyed. Christianity is becoming more and more practical, and its application to life is constantly growing more vigorous and wise.

The law of human life is, that the development of differences must precede their reconciliation. Variety must precede harmony, analysis must prepare the way for synthesis, opposition must go before union. Christianity, as a powerful stimulus applied to the human mind, first develops all the tendencies of the soul; and afterward, by its atoning influence on the heart, reconciles them. Christ is the Prince of Peace. He came to make peace between man and God, between man and man, between law and love, reason and faith, freedom and order, progress and conservatism. But he first sends the sword, afterward the olive-branch. Nevertheless, universal unity is the object and end of Christianity.

# SWAMI VIVEKANANDA

Swami Vivekananda (1863–1902) was an Indian religious teacher trained by Ramakrishna who came to the United States for the World's Parliament of Religions, held as part of the Chicago World's Fair in 1893. His presence at the gathering generated considerable interest in Hinduism and bestowed international stature upon Vivekananda, along with criticisms such as those voiced by Mabel Potter Daggett (pp. 384–89). A leader in the Vedanta movement that aimed to attract new devotees to Hinduism, Vivekananda received wide attention for his message seeking to unify the best of eastern and western religious wisdom and culture. He lectured widely and wrote several books. The chief document presented here is a version of the speech that he delivered to the World's Parliament, launching widespread interest in Vedanta. The second is his farewell address to the Parliament.

# Hinduism as a Religion

Three religions now stand in the world which have come down to us from time prehistoric—Hinduism, Zoroastrianism, and Judaism. These all have received tremendous shocks and all of them prove by their revival their internal strength, but Judaism failed to absorb Christianity and was driven out of its place of birth by its all-conquering daughter. Sect after sect has arisen in India and seemed to shake the religion of the Vedas to its very foundations, but, like the waters of the seashore in a tremendous earthquake, it has receded only for a while, only to return in an all absorbing flood, and when the tumult of the rush was over these sects had been all sucked in, absorbed, and assimilated in the immense body of another faith.

From the high spiritual flights of philosophy, of which the latest discoveries of science seem like echoes, from the atheism of the Jains, to the low ideas of idolatry, and the multifarious mythologies, each and all have a place in the Hindu's religion.

Where then, the question arises, where then the common center to which all these widely diverging radii converge? Where is the common basis upon which all these seemingly hopeless contradictions rest? And this is the question which I shall attempt to answer.

The Hindus have received their religion through the revelation of the Vedas. They hold that the Vedas are without beginning and without end. It may sound ludicrous to this audience—how a book can be without beginning or end.

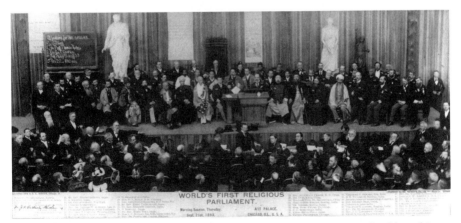

The World's Parliament of Religions, Chicago, 1893. This event, organized by white Protestant leaders, yet religiously diverse for its time, brought personages like Swami Vivekanada to the United States, many for the first time. *Source: Presbyterian Historical Society, Presbyterian Church (USA), Philadelphia.*

But by the Vedas no books are meant. They mean the accumulated treasury of spiritual laws discovered by different persons in different times. Just as the law of gravitation existed before its discovery and would exist if all humanity forgot it, so with the laws that govern the spiritual world; the moral, ethical, and spiritual relations between soul and soul, and between individual spirits and the father of all spirits, were there before their discovery and would remain even if we forgot them.

The discoverers of these laws are called Rishis, and we honor them as perfected beings, and I am glad to tell this audience that some of the very best of them were women.

Here it may be said that the laws as laws may be without end, but they must have had a beginning. The Vedas teach us that creation is without beginning or end. Science has proved to us that the sum total of the cosmic energy is the same throughout all time. Then, if there was a time when nothing existed, where was all this manifested energy? Some say it was in a potential form in God. But, then, God is sometimes potential and sometimes kinetic, which would make Him mutable, and everything mutable is a compound, and everything compound must undergo that change which is called destruction. Therefore God would die. Therefore there never was a time when there was no creation.

Here I stand, and if I shut my eyes and try to conceive my existence, "I," "I," "I," what is the idea before me? The idea of a body. Am I, then, nothing but a combination of matter and material substances? The Vedas declare, "No," I am a spirit, living in a body. I am not the body. The body will die, but I will not die. Here am I in this body, and when it will fail, still I will go on living. Also I had a past. The soul was not created from nothing, for creation means a combination, and that means a certain future dissolution. If, then, the soul was created, it must die. Therefore, it was not created. Some are born happy, enjoying perfect health, beautiful body, mental vigor, and with all wants supplied. Others are born miserable. Some are without hands or feet, some idiots, and only drag out a miserable existence. Why, if they are all created, why does a just and merciful God create one happy and the other unhappy? Why is He so partial? Nor would it mend matters in the least to hold that those who are miserable in this life will be perfect in a future life. Why should a man be miserable here in the reign of a just and merciful God?

In the second place it does not give us any cause but simply a cruel act of an all-powerful being, and therefore it is unscientific. There must have been causes, then, to make a man miserable or happy before his birth, and those were his past actions. Why may not all the tendencies of the mind and body be answered for by inherited aptitude from parents? Here are the two parallel lines of existence—one, that of the mind, the other that of matter.

If matter and its transformation answer for all that we have, there is no necessity for supposing the existence of a soul. But it can not be proved that thought has been evolved out of matter. We can not deny that bodies inherit certain tendencies, but those tendencies only mean the physical configuration through which a peculiar mind alone can act in a peculiar way. Those peculiar tendencies in that soul have been caused by past actions. A soul with a certain tendency will take birth in a body which is the fittest instrument of the display of that tendency, by the laws of affinity. And this is in perfect accord with sci-

ence, for science wants to explain everything by habit, and habit is got through repetitions. So these repetitions are also necessary to explain the natural habits of a new-born soul. They were not got in this present life; therefore, they must have come down from past lives.

But there is another suggestion, taking all these for granted. How is it that I do not remember anything of my past life? This can be easily explained. I am now speaking English. It is not my mother-tongue, in fact, not a word of my mother-tongue is present in my consciousness; but, let me try to bring such words up, they rush into my consciousness. That shows that consciousness is the name only of the surface of the mental ocean, and within its depths are stored up all our experiences. Try and struggle and they will come up and you will be conscious.

This is the direct and demonstrative evidence. Verification is the perfect proof of a theory, and here is the challenge, thrown to the world by Rishis. We have discovered precepts by which the very depths of the ocean of memory can be stirred up—follow them and you will get a complete reminiscence of your past life.

So then the Hindu believes that he is a spirit. Him the sword can not pierce, him the fire can not burn, him the water can not melt, him the air can not dry. He believes every soul is a circle whose circumference is nowhere, but whose center is located in a body, and death means the change of this center from body to body. Nor is the soul bound by the condition of matter. In its very essence it is free, unbound, holy, and pure, and perfect. But somehow or other it has got itself bound down by matter, and thinks of itself as matter.

Why should the free, perfect, and pure being be under the thralldom of matter? How can the perfect be deluded into the belief that he is imperfect? We have been told that the Hindus shirk the question and say that no such question can be there, and some thinkers want to answer it by the supposing of one or more quasi-perfect beings, and use big scientific names to fill up the gap. But naming is not explaining. The question remains the same. How can the perfect become the quasi-perfect, how can the pure, the absolute, change even a microscopic particle of its nature? The Hindu is sincere. He does not want to take shelter under sophistry. He is brave enough to face the question in a manly fashion. And his answer is: "I do not know." I do not know how the perfect being, the soul, came to think of itself as imperfect, as joined and conditioned by matter. But the fact is a fact for all that. It is a fact in everybody's consciousness that he thinks of himself as the body. We do not attempt to explain why I am in this body.

Well, then, the human soul is eternal and immortal, perfect and infinite, and death means only a change of center from one body to another. The present is determined by our past actions, and the future will be by the present. The soul will go on evolving up or reverting back from birth to birth and death to death—like a tiny boat in a tempest, raised one moment on the foaming crest of a billow and dashed down into a yawning chasm the next, rolling to and fro at the mercy of good and bad actions—a powerless, helpless wreck in an ever-raging, ever-rushing, uncompromising current of cause and effect. A little moth placed under the wheel of causation which rolls on, crushing everything in its way and waits not for the widow's tear or the orphan's cry.

The heart sinks at the idea, yet this is the law of nature. Is there no hope? Is there no escape? The cry that went up from the bottom of the heart of despair reached the throne of mercy and words of hope and consolation came down and inspired a Vedic sage, and he stood up before the world and in a trumpet voice proclaimed the glad tidings to the world. "Hear, ye children of immortal bliss, even ye that resisted in higher spheres. I have found the ancient one, who is beyond all darkness, all delusion, and knowing him alone you shall be saved from death again." "Children of immortal bliss," what a sweet, what a hopeful name. Allow me to call you, brethren, by that sweet name—heirs of immortal bliss—yea, the Hindu refuses to call you sinners.

Ye are the children of God. The sharers of immortal bliss, holy and perfect beings. Ye divinities on earth, sinners? It is a sin to call a man so. It is a standing libel on human nature. Come up, live and shake off the delusion that you are sheep—you are souls immortal, spirits free and blest and eternal, ye are not matter, ye are not bodies. Matter is your servant, not you the servant of matter.

Thus it is the Vedas proclaim, not a dreadful combination of unforgiving laws, not an endless prison of cause and effect, but that, at the head of all these laws, in and through every particle of matter and force, stands one "through whose command the wind blows, the fire burns, the clouds rain, and death stalks upon the earth." And what is his nature?

He is everywhere, the pure and formless one, the Almighty and the all-merciful. "Thou art our father, Thou art our mother, Thou art our beloved friend, Thou art the source of all strength. Thou art He that bearest the burdens of the universe; help me bear the little burden of this life." Thus sang the Rishis of the Veda. And how to worship Him? Through love. "He is to be worshiped as the one beloved, dearer than everything in this and the next life."

This is the doctrine of love preached in the Vedas, and let us see how it is fully developed and preached by Krishua, whom the Hindus believe to have been God incarnate on earth.

He taught that a man ought to live in this world like a lotus leaf, which grows in water but is never moistened by water—so a man ought to live in this world—his heart for God and his hands for work.

It is good to love God for hope of reward in this or the next world, but it is better to love God for love's sake, and the prayer goes, "Lord, I do not want wealth, nor children, nor learning. If it will be thy will I will go to a hundred hells, but grant me this, that I may love thee without the hope of reward—unselfishly love for love's sake." One of the disciples of Krishua, the then Emperor of India, was driven from his throne by his enemies and had to take shelter in a forest in the Himalayas with his queen, and there one day the queen was asking him how it was that he, the most virtuous of men, should suffer so much misery, and Yuchistera answered: "Behold, my queen, the Himalayas, how grand and beautiful they are. I love them. They do not give me anything, but my nature is to love the grand and beautiful; therefore I love them. Similarly, I love the Lord. He is the source of all beauty, of all sublimity. He is the only object to be loved. My nature is to love him, and therefore I love. I do not pray for anything. I do not ask for anything. Let him place me wherever he likes. I must love him for love's sake. I can not trade in love."

The Vedas teach that the soul is divine, only held under bondage of matter, and perfection will be reached when the bond shall burst, and the word they use is, therefore, Mukto—freedom—freedom from the bonds of imperfection; freedom from death and misery.

And they teach that this bondage can only fall off through the mercy of God, and this mercy comes to the pure. So purity is the condition of his mercy. How that mercy acts? He reveals himself to the pure heart, and the pure and stainless man sees God, yea, even in this life, and then, and then only. All the crookedness of the heart is made straight. Then all doubt ceases. Man is no more the freak of a terrible law of causation. So this is the very center, the very vital conception of Hinduism. The Hindu does not want to live upon words and theories—if there are existences beyond the ordinary sensual existence, he wants to come face to face with them. If there is a soul in him which is not matter, if there is an all-merciful universal soul, he will go to him direct. He must see him, and that alone can destroy all doubts. So the best proof a Hindu sage gives, about the soul, about God, is, "I have seen the soul, I have seen God."

And that is the only condition of perfection. The Hindu religion does not consist in struggles and attempts to believe a certain doctrine or dogma, but in realizing—not in believing, but in being and becoming.

So the whole struggle in their system is a constant struggle to become perfect, to become divine, to reach God and see God, and in this reaching God, seeing God, becoming perfect, even as the Father in heaven is perfect, consists the religion of the Hindus.

And what becomes of man when he becomes perfect? He lives a life of bliss, infinite. He enjoys infinite and perfect bliss, having obtained the only thing in which man ought to have pleasure—God—and enjoys the bliss with God.

So far all the Hindus are agreed. This is the common religion of all the sects of India, but then the question comes—perfection is absolute, and the absolute can not be two or three. It can not have any qualities. It can not be an individual. And so when a soul becomes perfect and absolute, it must become one with the Brahman, and he would only realize the Lord as the perfection, the reality of his own nature and existence—existence absolute; knowledge absolute, and life absolute. We have often and often read about this being called the losing of individuality as in becoming a stock or a stone. "He jests at scars that never felt a wound."

I tell you it is nothing of the kind. If it is happiness to enjoy the consciousness of this small body, it must be more happiness to enjoy the consciousness of two bodies, or three, four, five—and the ultimate of happiness would be reached when it would become a universal consciousness.

Therefore, to gain this infinite, universal individuality, this miserable, little individuality must go. Then alone can death cease, when I am one with life. Then alone can misery cease, when I am with happiness itself. Then alone can all errors cease, when I am one with knowledge itself. And this is the necessary scientific conclusion. Science has proved to me that physical individuality is a delusion; that really my body is one little, continuously changing body in an unbroken ocean of matter, and Adwaitam is the necessary conclusion with my other counterpart—mind.

Science is nothing but the finding of unity, and as soon as any science can reach the perfect unity it will stop from further progress, because it will then have reached the goal. Thus chemistry can not progress farther when it shall have discovered one element out of which all others could be made. Physics will stop when it shall be able to discover one energy of which all others are but manifestations. The science of religion will become perfect when it discovers Him who is the one life in a universe of death, who is the constant basis of an ever-changing world, who is the only soul of which all souls are but manifestations. Thus, through multiplicity and duality, this ultimate unity is reached, and religion can go no further. This is the goal of all—again and again, science after science, again and again.

And all science is bound to come to this conclusion in the long run. Manifestation and not creation is the world of science of to-day, and the Hindu is only glad that what he has cherished in his bosom for ages is going to be taught in more forcible language and with further light by the latest conclusions of science.

Descend we now from the aspirations of philosophy to the religion of the ignorant? At the very outset, I may tell you that there is no polytheism in India. In every temple, if one stands by and listens, he will find the worshipers apply all the attributes of God—including omnipresence—to these images. It is not polytheism. "The rose called by any other name would smell as sweet." Names are not explanations.

I remember when a boy a Christian man was preaching to a crowd in India. Among other sweet things, he was asking the people, if he gave a blow to their idol with his stick, what could it do? One of his hearers sharply answered, "If I abuse your God what can he do?" "You would be punished," said the preacher, "when you die." "So my idol will punish you when you die," said the villager.

The tree is known by its fruits, and when I have been amongst them that are called idolatrous men, the like of whose morality, and spirituality, and love I have never seen anywhere, I stop and ask myself, "Can sin beget holiness?"

Superstition is the enemy of man, but bigotry is worse. Why does a Christian go to church? Why is the cross holy? Why is the face turned toward the sky in prayer? Why are there so many images in the Catholic Church? Why are there so many images in the minds of Protestants when they pray? My brethren, we can no more think about anything without a material image than we can live without breathing. And by the law of association the material image calls the mental idea up and vice versa. Omnipresence, to almost the whole world, means nothing. Has God superficial area? If not, when we repeat the word we think of the extended earth, that is all.

As we find that somehow or other, by the laws of our constitution, we have got to associate our ideas of infinity with the image of a blue sky, or a sea, some cover the idea of holiness with an image of a church, or a mosque, or a cross. The Hindus have associated the ideas of holiness, purity, truth, omnipresence, and all other ideas with different images and forms. But with this difference. Some devote their whole lives to their idol of a church and never rise higher, because with them religion means an intellectual assent to certain doctrines and doing good to their fellows. The whole religion of the Hindu is centered in realization. Man is to become divine, realizing the divine, and, therefore, idol or temple or church or books, are only the supports, the helps, of his spiritual childhood; but on and on man must progress.

He must not stop anywhere. "External worship, material worship," says the Vedas, "is the lowest stage, struggling to rise high, mental prayer is the next stage, but the highest stage is when the Lord has been realized—" Mark the same earnest man who was kneeling before the idol tell you, "Him the sun can not express, nor the moon nor the stars, the lightning can not express Him, nor the fire; through Him they all shine." He does not abuse the image or call it sinful. He recognizes in it a necessary stage of his life. "The child is father of the man." Would it be right for the old man to say that childhood is a sin or youth a sin? Nor is it compulsory in Hinduism.

If a man can realize his divine nature with the help of an image, would it be right to call it a sin? Nor, even when he has passed that stage, should he call it an error? To the Hindu, man is not traveling from error to truth, but from truth to truth, from lower to higher truth. To him all the religions, from the lowest fetichism to the highest absolutism, mean so many attempts of the human soul to grasp and realize the infinite, each determined by the conditions of its birth and association, and each of these mark a stage of progress, and every soul is a young eagle soaring higher and higher, gathering more and more strength till it reaches the glorious sun.

Unity and variety is the plan of nature, and the Hindu has recognized it. Every other religion lays down certain fixed dogmas, and tries to force society to adopt them. They lay down before society one coat which must fit Jack and Job and Henry, all alike. If it does not fit John or Henry, he must go without a coat to cover his body. The Hindus have discovered that the absolute can only be realized or thought of or stated through the relative, and the images, cross, or crescent are simply so many centers, so many pegs to hang the spiritual ideas on. It is not that this help is necessary for everyone, but for many, and those that do not need it have no right to say that it is wrong.

One thing I must tell you. Idolatry in India does not mean anything horrible. It is not the mother of harlots. On the other hand, it is the attempt of undeveloped minds to grasp high spiritual truths. The Hindus have their faults, but mark this, they are always toward punishing their own bodies, and never toward cutting the throats of their neighbors. If the Hindu fanatic burns himself on the pyre, he never lights the fire of inquisition. And even this cannot be laid at the door of religion any more than the burning of witches can be laid at the door of Christianity.

To the Hindu, then, the whole world of religions is only a traveling, a coming up, of different men and women, through various conditions and circumstances, to the same goal. Every religion is only an evolution out of the material man, a God—and the same God is the inspirer of all of them. Why, then, are there so many contradictions? They are only apparent, says the Hindu. The contradictions come from the same truth adapting itself to the different circumstances of different natures.

It is the same light coming through different colors. And these little variations are necessary for that adaption. But in the heart of everything the same truth reigns. The Lord has declared to the Hindu in his incarnation as Krishna. "I am in every religion as the thread through a string of pearls. And wherever thou seest extraordinary holiness and extraordinary power raising and purifying humanity, know ye, that I am there." And what was the result? Through the

whole order of Sanskrit philosophy, I challenge anybody to find any such expression as that the Hindu only would be saved and not others. Says Vyas, "We find perfect men even beyond the pale of our caste and creed." How, then can the Hindu whose whole idea centers in God, believe in the Buddhism which is agnostic or the Jainism, which is atheist?

The whole force of Hindu religion is directed to the great central truth in every religion; to evolve a god out of man. They have not seen the father, but they have seen the son. And he that hath seen the son hath seen the father.

This, brethren, it a short sketch of the ideas of the Hindus. The Hindu might have failed to carry out all his plans. But if there is ever to be a universal religion it must be one which will hold no location in place or time; which will be infinite, like the God it will preach; whose sun shines upon the followers of Krishna or Christ, saints or sinners, alike; which will not be in the Brahmin or Buddhist, Christian or Mohammedan, but the sum total of all of these, and still have infinite space for development, which in its catholicity will embrace in its infinite arms and find a place for every human being, from the lowest groveling man, from the brute, to the highest mind towering almost above humanity and making society stand in awe and doubt his human nature.

It will be a religion which will have no place for persecution or intolerance in its polity, which will recognize a divinity in every man or woman, and whose whole scope, whose whole force, will be centered in aiding humanity to realize its divine nature.

Aseka's council was a council of the Buddhist faith. Akbar's, though more to the purpose, was only a parlor meeting. It was reserved for America to proclaim to all quarters of the globe that the Lord is in every religion.

May He who is the Brahma of the Hindus, the Ahura Mazda of the Zoroastrians, the Buddha of the Buddhists, the Jehovah of the Jews, the Father in heaven of the Christians, give strength to you to carry out your noble idea.

The star arose in the East, it traveled steadily toward the West, sometimes dimmed and sometimes effulgent, till it made a circuit of the world, and now it is again rising on the very horizon of the East, the borders of the Tasifu a thousand-fold more effulgent than it ever was before. Hail, Columbia, motherland of liberty! It has been given to thee, who never dipped hand in neighbor's blood, who never found out that shortest way of becoming rich by robbing one's neighbors—it has been given to thee to march on in the vanguard of civilization with the flag of harmony.

# Farewell

## SWAMI VIVEKANANDA MADE HIS FAREWELL AS FOLLOWS:

The World's Parliament of Religions has become an accomplished fact, and the merciful Father has helped those who labored to bring it into existence and

crowned with success their most unselfish labor. My thanks to those noble souls whose large hearts and love of truth first dreamed this wonderful dream and then realized it. My thanks to the shower of liberal sentiments that has over-flowed this platform. My thanks to this enlightened audience for their uniform kindness to me and for their appreciation of every thought that tends to smooth the friction of religions. A few jarring notes were heard from time to time in this harmony. My special thanks to them, for they have, by their striking contrast, made the general harmony the sweeter.

Much has been said of the common ground of religious unity. I am not go-ing just now to venture my own theory. But if anyone here hopes that this unity will come by the triumph of any one of these religions and the destruction of the others, to him I say: "Brother, yours is an impossible hope." Do I wish that the Christian would become Hindu? God forbid. Do I wish that the Hindu or Buddhist would become Christian? God forbid.

The seed is put in the ground, and earth and air and water are placed around it. Does the seed become the earth, or the air, or the water? No. It be-comes a plant; it develops after the law of its own growth, assimilates the air, the earth, and the water, converts them into plant substance and grows a plant.

Similar is the case with religion. The Christian is not to become a Hindu or a Buddhist, nor a Hindu or a Buddhist to become a Christian. But each must as-similate the others and yet preserve its individuality and grow according to its own law of growth.

If the Parliament of Religions has shown anything to the world it is this: It has proved to the world that holiness, purity, and charity are not the exclusive possessions of any church in the world, and that every system has produced men and women of the most exalted character.

In the face of this evidence, if anybody dreams of the exclusive survival of his own and the destruction of the others, I pity him from the bottom of my heart, and point out to him that upon the banner of every religion would soon be written, in spite of their resistance: "Help and Not Fight," "Assimilation and Not Destruction," "Harmony and Peace and Not Dissension."

# WILLIAM JAMES

William James (1842–1910) was a philosopher and psychologist of wide-ranging intellectual interests. He taught at Harvard, where he helped to in-augurate the modern study of psychology. In 1901–02, he delivered the Gifford Lectures at the University of Edinburgh, subsequently published as *The Varieties of Religious Experience*. That book, which focused on individual religious experiences, such as conversion and mysticism, has been widely studied by scholars and students alike and has influenced the categories that have organized the academic study of religion. This excerpt summa-rizes some of James's thinking about religion at that point in his life.

## *From* The Varieties of Religious Experience

### LECTURE XX

### Conclusions

The material of our study of human nature is now spread before us; and in this parting hour, set free from the duty of description, we can draw our theoretical and practical conclusions. In my first lecture, defending the empirical method, I foretold that whatever conclusions we might come to could be reached by spiritual judgments only, appreciations of the significance for life of religion, taken 'on the whole.' Our conclusions, cannot be as sharp as dogmatic conclusions would be, but I will formulate them, when the time comes, as sharply as I can.

Summing up in the broadest possible way the characteristics of the religious life, as we have found them, it includes the following beliefs:—

1. That the visible world is part of a more spiritual universe from which it draws its chief significance;

2. That union or harmonious relation with that higher universe is our true end;

3. That prayer or inner communion with the spirit thereof—be that spirit 'God' or 'law'—is a process wherein work is really done, and spiritual energy flows in and produces effects, psychological or material, within the phenomenal world.

Religion includes also the following psychological characteristics:—

4. A new zest which adds itself like a gift to life, and takes the form either of lyrical enchantment or of appeal to earnestness and heroism.

5. An assurance of safety and a temper of peace, and, in relation to others, a preponderance of loving affections. . . .

The pivot round which the religious life, as we have traced it, revolves, is the interest of the individual in his private personal destiny. Religion, in short, is a monumental chapter in the history of human egotism. The gods believed in—whether by crude savages or by men disciplined intellectually—agree with each other in recognizing personal calls. Religious thought is carried on in terms of personality, this being, in the world of religion, the one fundamental fact. To-day, quite as much as at any previous age, the religious individual tells you that the divine meets him on the basis of his personal concerns.

Science, on the other hand, has ended by utterly repudiating the personal point of view. She catalogues her elements and records her laws indifferent as to what purpose may be shown forth by them, and constructs her theories quite careless of their bearing on human anxieties and fates. Though the scientist may individually nourish a religion, and be a theist in his irresponsible hours, the days are over when it could be said that for Science herself the heavens declare the glory of God and the firmament showeth his handiwork. Our solar system, with its harmonies, is seen now as but one passing case of a certain sort of mov-

ing equilibrium in the heavens, realized by a local accident in an appalling wilderness of worlds where no life can exist. In a span of time which as a cosmic interval will count but as an hour, it will have ceased to be. The Darwinian notion of chance production, and subsequent destruction, speedy or deferred, applies to the largest as well as to the smallest facts. It is impossible, in the present temper of the scientific imagination, to find in the driftings of the cosmic atoms, whether they work on the universal or on the particular scale, anything but a kind of aimless weather, doing and undoing, achieving no proper history, and leaving no result. Nature has no one distinguishable ultimate tendency with which it is possible to feel a sympathy. In the vast rhythm of her processes, as the scientific mind now follows them, she appears to cancel herself. . . .

In spite of the appeal which this impersonality of the scientific attitude makes to a certain magnanimity of temper, I believe it to be shallow, and I can now state my reason in comparatively few words. That reason is that, so long as we deal with the cosmic and the general, we deal only with the symbols of reality, but *as soon as we deal with private and personal phenomena as such, we deal with realities in the completest sense of the term.* I think I can easily make clear what I mean by these words.

The world of our experience consists at all times of two parts, an objective and a subjective part, of which the former may be incalculably more extensive than the latter, and yet the latter can never be omitted or suppressed. The objective part is the sum total of whatsoever at any given time we may be thinking of, the subjective part is the inner 'state' in which the thinking comes to pass. What we think of may be enormous,—the cosmic times and spaces, for example,— whereas the inner state may be the most fugitive and paltry activity of mind. Yet the cosmic objects, so far as the experience yields them, are but ideal pictures of something whose existence we do not inwardly possess but only point at outwardly, while the inner state is our very experience itself; its reality and that of our experience are one. A conscious field *plus* its object as felt or thought of *plus* an attitude towards the object *plus* the sense of a self to whom the attitude belongs—such a concrete bit of personal experience may be a small bit, but it is a solid bit as long as it lasts; not hollow, not a mere abstract element of experience, such as the 'object' is when taken all alone. It is a *full* fact, even though it be an insignificant fact; it is of the *kind* to which all realities whatsoever must belong; the motor currents of the world run through the like of it; it is on the line connecting real events with real events. That unsharable feeling which each one of us has of the pinch of his individual destiny as he privately feels it rolling out on fortune's wheel may be disparaged for its egotism, may be sneered at as unscientific, but it is the one thing that fills up the measure of our concrete actuality, and any would-be existent that should lack such a feeling, or its analogue, would be a piece of reality only half made up.

If this be true, it is absurd for science to say that the egotistic elements of experience should be suppressed. The axis of reality runs solely through the egotistic places,—they are strung upon it like so many beads. To describe the world with all the various feelings of the individual pinch of destiny, all the various spiritual attitudes, left out from the description—they being as describable as anything else—would be something like offering a printed bill of fare as the equivalent for a solid meal. Religion makes no such blunder. The individual's

religion may be egotistic, and those private realities which it keeps in touch with may be narrow enough; but at any rate it always remains infinitely less hollow and abstract, as far as it goes, than a science which prides itself on taking no account of anything private at all.

A bill of fare with one real raisin on it instead of the word 'raisin,' with one real egg instead of the word 'egg,' might be an inadequate meal, but it would at least be a commencement of reality. The contention of the survival-theory that we ought to stick to non-personal elements exclusively seems like saying that we ought to be satisfied forever with reading the naked bill of fare. I think, therefore, that however particular questions connected with our individual destinies may be answered, it is only by acknowledging them as genuine questions, and living in the sphere of thought which they open up, that we become profound. But to live thus is to be religious; so I unhesitatingly repudiate the survival-theory of religion, as being founded on an egregious mistake. It does not follow, because our ancestors made so many errors of fact and mixed them with their religion, that we should therefore leave off being religious at all. By being religious we establish ourselves in possession of ultimate reality at the only points at which reality is given us to guard. Our responsible concern is with our private destiny, after all. . . .

The further limits of our being plunge, it seems to me, into an altogether other dimension of existence from the sensible and merely 'understandable' world. Name it the mystical region, or the supernatural region, whichever you choose. So far as our ideal impulses originate in this region (and most of them do originate in it, for we find them possessing us in a way for which we cannot articulately account), we belong to it in a more intimate sense than that in which we belong to the visible world, for we belong in the most intimate sense wherever our ideals belong. Yet the unseen region in question is not merely ideal, for it produces effects in this world. When we commune with it, work is actually done upon our finite personality, for we are turned into new men, and consequences in the way of conduct follow in the natural world upon our regenerative change. But that which produces effects within another reality must be termed a reality itself, so I feel as if we had no philosophic excuse for calling the unseen or mystical world unreal.

God is the natural appellation, for us Christians at least, for the supreme reality, so I will call this higher part of the universe by the name of God. We and God have business with each other; and in opening ourselves to his influence our deepest destiny is fulfilled. The universe, at those parts of it which our personal being constitutes, takes a turn genuinely for the worse or for the better in proportion as each one of us fulfills or evades God's demands. As far as this goes I probably have you with me, for I only translate into schematic language what I may call the instinctive belief of mankind: God is real since he produces real effects.

The real effects in question, so far as I have as yet admitted them, are exerted on the personal centres of energy of the various subjects, but the spontaneous faith of most of the subjects is that they embrace a wider sphere than this. Most religious men believe (or 'know,' if they be mystical) that not only they themselves, but the whole universe of beings to whom the God is present, are secure in his parental hands. There is a sense, a dimension, they are sure, in

which we are *all* saved, in spite of the gates of hell and all adverse terrestrial appearances. God's existence is the guarantee of an ideal order that shall be permanently preserved. This world may indeed, as science assures us, some day burn up or freeze; but if it is part of his order, the old ideals are sure to be brought elsewhere to fruition, so that where God is, tragedy is only provisional and partial, and shipwreck and dissolution are not the absolutely final things. Only when this farther step of faith concerning God is taken, and remote objective consequences are predicted, does religion, as it seems to me, get wholly free from the first immediate subjective experience, and bring a *real hypothesis* into play. A good hypothesis in science must have other properties than those of the phenomenon it is immediately invoked to explain, otherwise it is not prolific enough. God, meaning only what enters into the religious man's experience of union, falls short of being an hypothesis of this more useful order. He needs to enter into wider cosmic relations in order to justify the subject's absolute confidence and peace.

That the God with whom, starting from the hither side of our own extramarginal self, we come at its remoter margin into commerce should be the absolute world-ruler, is of course a very considerable over-belief. Over-belief as it is, though, it is an article of almost every one's religion. Most of us pretend in some way to prop it upon our philosophy, but the philosophy itself is really propped upon this faith. What is this but to say that Religion, in her fullest exercise of function, is not a mere illumination of facts already elsewhere given, not a mere passion, like love, which views things in a rosier light. It is indeed that, as we have seen abundantly. But it is something more, namely, a postulator of new *facts* as well. The world interpreted religiously is not the materialistic world over again, with an altered expression; it must have, over and above the altered expression, *a natural constitution* different at some point from that which a materialistic world would have. It must be such that different events can be expected in it, different conduct must be required.

This thoroughly 'pragmatic' view of religion has usually been taken as a matter of course by common men. They have interpolated divine miracles into the field of nature, they have built a heaven out beyond the grave. It is only transcendentalist metaphysicians who think that, without adding any concrete details to Nature, or subtracting any, but by simply calling it the expression of absolute spirit, you make it more divine just as it stands. I believe the pragmatic way of taking religion to be the deeper way. It gives it body as well as soul, it makes it claim, as everything real must claim, some characteristic realm of fact as its very own. What the more characteristically divine facts are, apart from the actual inflow of energy in the faith-state and the prayer-state, I know not. But the over-belief on which I am ready to make my personal venture is that they exist. The whole drift of my education goes to persuade me that the world of our present consciousness is only one out of many worlds of consciousness that exist, and that those other worlds must contain experiences which have a meaning for our life also; and that although in the main their experiences and those of this world keep discrete, yet the two become continuous at certain points, and higher energies filter in. By being faithful in my poor measure to this over-belief, I seem to myself to keep more sane and true. I *can*, of course, put myself into the sectarian scientist's attitude, and imagine vividly that the world of

sensations and of scientific laws and objects may be all. But whenever I do this, I hear that inward monitor of which W. K. Clifford once wrote, whispering the word 'bosh!' Humbug is humbug, even though it bear the scientific name, and the total expression of human experience, as I view it objectively, invincibly urges me beyond the narrow 'scientific' bounds. Assuredly, the real world is of a different temperament,—more intricately built than physical science allows. So my objective and my subjective conscience both hold me to the over-belief which I express. Who knows whether the faithfulness of individuals here below to their own poor over-beliefs may not actually help God in turn to be more effectively faithful to his own greater tasks?

PART V

# From Fundamentalism to Civil Rights, 1920–65

Intrareligious conflicts had been in evidence very early in American history, but the early twentieth century witnessed a particularly bitter divide between self-identified liberals and fundamentalists. A host of factors contributed to this quarrel, which quickly became an all-out theological conflagration over questions of scriptural interpretation, among others. Liberal thinkers increasingly reinterpreted God as an immanent presence within history, Jesus as an ethical guide, and the Bible as a historical record of humankind's encounter with God's love, rather than the LITERAL TRUTH of creation. Conservatives cried foul and defended what they termed the "fundamental doctrines," such as biblical inerrancy, the authenticity of Jesus' miracles and resurrection, and his second coming. Media publicity exhausted itself in the famous Scopes trial, but the religious question at stake—what does it mean to call oneself a Christian?—only grew in urgency over time.

Meanwhile, Jewish and Catholic thinkers achieved new prominence in the United States, even as Buddhist and Hindu practices gained momentum among disaffected young artists and intellectuals. Attention to religious diversity and ecumenical cooperation continued to grow in liberal religious circles, although many continued to imagine that the mainstream was Protestant-Catholic-Jew.

What had seemed, if only on the surface, to be a genial religious consensus at midcentury soon broke apart in the civil rights movement of the 1950s and 1960s, a movement with deep religious roots. Some African Americans, such as Malcolm X, turned to Islam, while others remained loyal, if dissenting, Christians.

417

# HARRY EMERSON FOSDICK

Harry Emerson Fosdick (1878–1969) was a liberal Protestant minister and faculty member at Union Theological Seminary in New York. A Baptist by training, he became the minister of Manhattan's First Presbyterian Church in 1918. The Presbyterians, among other Protestant groups, were embroiled in a contentious battle between fundamentalist and liberal worldviews. Fosdick's 1922 sermon, "Shall the Fundamentalists Win?" was distributed to Protestant ministers across the country by John D. Rockefeller, Jr., making Fosdick a central symbol in the controversy. A few years later, the interdenominational Riverside Church was built, and Fosdick served as its minister from its 1931 founding until his retirement in 1946.

## Shall the Fundamentalists Win?

This morning we are to think of the fundamentalist controversy which threatens to divide the American churches as though already they were not sufficiently split and riven. A scene, suggestive for our thought, is depicted in the fifth chapter of the Book of the Acts, where the Jewish leaders hale before them Peter and other of the apostles because they had been preaching Jesus as the Messiah. Moreover, the Jewish leaders propose to slay them, when in opposition Gamaliel speaks "Refrain from these men, and let them alone; for if this counsel or this work be of men, it will be overthrown; but if it is of God ye will not be able to overthrow them; lest haply ye be found even to be fighting against God." . . .

Already all of us must have heard about the people who call themselves the Fundamentalists. Their apparent intention is to drive out of the evangelical churches men and women of liberal opinions. I speak of them the more freely because there are no two denominations more affected by them than the Baptist and the Presbyterian. We should not identify the Fundamentalists with the conservatives. All Fundamentalists are conservatives, but not all conservatives are Fundamentalists. The best conservatives can often give lessons to the liberals in true liberality of spirit, but the Fundamentalist program is essentially illiberal and intolerant.

The Fundamentalists see, and they see truly, that in this last generation there have been strange new movements in Christian thought. A great mass of new knowledge has come into man's possession—new knowledge about the

physical universe, its origin, its forces, its laws; new knowledge about human history and in particular about the ways in which the ancient peoples used to think in matters of religion and the methods by which they phrased and explained their spiritual experiences; and new knowledge, also, about other religions and the strangely similar ways in which men's faiths and religious practices have developed everywhere. . . .

Now, there are multitudes of reverent Christians who have been unable to keep this new knowledge in one compartment of their minds and the Christian faith in another. They have been sure that all truth comes from the one God and is His revelation. Not, therefore, from irreverence or caprice or destructive zeal but for the sake of intellectual and spiritual integrity, that they might really love the Lord their God, not only with all their heart and soul and strength but with all their mind, they have been trying to see this new knowledge in terms of the Christian faith and to see the Christian faith in terms of this new knowledge.

Doubtless they have made many mistakes. Doubtless there have been among them reckless radicals gifted with intellectual ingenuity but lacking spiritual depth. Yet the enterprise itself seems to them indispensable to the Christian Church. The new knowledge and the old faith cannot be left antagonistic or even disparate, as though a man on Saturday could use one set of regulative ideas for his life and on Sunday could change gear to another altogether. We must be able to think our modern life clear through in Christian terms, and to do that we also must be able to think our Christian faith clear through in modern terms.

There is nothing new about the situation. It has happened again and again in history, as, for example, when the stationary earth suddenly began to move and the universe that had been centered in this planet was centered in the sun around which the planets whirled. Whenever such a situation has arisen, there has been only one way out—the new knowledge and the old faith had to be blended in a new combination. Now, the people in this generation who are trying to do this are the liberals, and the Fundamentalists are out on a campaign to shut against them the doors of the Christian fellowship. Shall they be allowed to succeed?

It is interesting to note where the Fundamentalists are driving in their stakes to mark out the deadline of doctrine around the church, across which no one is to pass except on terms of agreement. They insist that we must all believe in the historicity of certain special miracles, preeminently the virgin birth of our Lord; that we must believe in a special theory of inspiration—that the original documents of the Scripture, which of course we no longer possess, were inerrantly dictated to men a good deal as a man might dictate to a stenographer; that we must believe in a special theory of the Atonement—that the blood of our Lord, shed in a substitutionary death, placates an alienated Deity and makes possible welcome for the returning sinner; and that we must believe in the second coming of our Lord upon the clouds of heaven to set up a millennium here, as the only way in which God can bring history to a worthy denouement. Such are some of the stakes which are being driven to mark a deadline of doctrine around the church.

If a man is a genuine liberal, his primary protest is not against holding these opinions, although he may well protest against their being considered the fundamentals of Christianity. This is a free country and anybody has a right to hold

these opinions or any others if he is sincerely convinced of them. The question is—Has anybody a right to deny the Christian name to those who differ with him on such points and to shut against them the doors of the Christian fellowship? The Fundamentalists say that this must be done. In this country and on the foreign field they are trying to do it. They have actually endeavored to put on the statute books of a whole state binding laws against teaching modern biology. If they had their way, within the church, they would set up in Protestantism a doctrinal tribunal more rigid than the pope's.

In such an hour, delicate and dangerous, when feelings are bound to run high, I plead this morning the cause of magnanimity and liberality and tolerance of spirit. I would, if I could reach their ears, say to the Fundamentalists about the liberals what Gamaliel said to the Jews, "Refrain from these men and let them alone; for if this counsel or this work be of men, it will be everthrown; but if it is of God ye will not be able to overthrow them; lest haply ye be found even to be fighting against God."

That we may be entirely candid and concrete and may not lose ourselves in any fog of generalities, let us this morning take two or three of these Fundamentalist items and see with reference to them what the situation is in the Christian churches. Too often we preachers have failed to talk frankly enough about the differences of opinion which exist among evangelical Christians, although everybody knows that they are there. Let us face this morning some of the differences of opinion with which somehow we must deal.

We may well begin with the vexed and mooted question of the virgin birth of our Lord. I know people in the Christian churches, ministers, missionaries, laymen, devoted lovers of the Lord and servants of the Gospel, who, alike as they are in their personal devotion to the Master, hold quite different points of view about a matter like the virgin birth. Here, for example, is one point of view that the virgin birth is to be accepted as historical fact; it actually happened; there was no other way for a personality like the Master to come into this world except by a special biological miracle. That is one point of view, and many are the gracious and beautiful souls who hold it. But side by side with them in the evangelical churches is a group of equally loyal and reverent people who would say that the virgin birth is not to be accepted as an historic fact. . . . So far from thinking that they have given up anything vital in the New Testament's attitude toward Jesus, these Christians remember that the two men who contributed most to the Church's thought of the divine meaning of the Christ were Paul and John, who never even distantly allude to the virgin birth.

Here in the Christian churches are these two groups of people and the question which the Fundamentalists raise is this—Shall one of them throw the other out? Has intolerance any contribution to make to this situation? Will it persuade anybody of anything? Is not the Christian Church large enough to hold within her hospitable fellowship people who differ on points like this and agree to differ until the fuller truth be manifested? The Fundamentalists say not. They say the liberals must go. Well, if the Fundamentalists should succeed, then out of the Christian Church would go some of the best Christian life and consecration of this generation—multitudes of men and women, devout and reverent Christians, who need the church and whom the church needs.

Consider another matter on which there is a sincere difference of opinion between evangelical Christians: the inspiration of the Bible. One point of view is that the original documents of the Scripture were inerrantly dictated by God to men. Whether we deal with the story of creation or the list of the dukes of Edom or the narratives of Solomon's reign or the Sermon on the Mount or the thirteenth chapter of First Corinthians, they all came in the same way, and they all came as no other book ever came. They were inerrantly dictated; everything there—scientific opinions, medical theories, historical judgments, as well as spiritual insight—is infallible. That is one idea of the Bible's inspiration. But side by side with those who hold it, lovers of the Book as much as they, are multitudes of people who never think about the Bible so. Indeed, that static and mechanical theory of inspiration seems to them a positive peril to the spiritual life. . . .

Here in the Christian Church today are these two groups, and the question which the Fundamentalists have raised is this—Shall one of them drive the other out? Do we think the cause of Jesus Christ will be furthered by that? If He should walk through the ranks of his congregation this morning, can we imagine Him claiming as His own those who hold one idea of inspiration and sending from Him into outer darkness those who hold another? You cannot fit the Lord Christ into that Fundamentalist mold. The church would better judge His judgment. For in the Middle West the Fundamentalists have had their way in some communities and a Christian minister tells us the consequences. He says that the educated people are looking for their religion outside the churches.

Consider another matter upon which there is a serious and sincere difference of opinion between evangelical Christians: the second coming of our Lord. The second coming was the early Christian phrasing of hope. No one in the ancient world had ever thought, as we do, of development, progress, gradual change as God's way of working out His will in human life and institutions. They thought of human history as a series of ages succeeding one another with abrupt suddenness. The Graeco-Roman world gave the names of metals to the ages—gold, silver, bronze, iron. The Hebrews had their ages, too—the original Paradise in which man began, the cursed world in which man now lives, the blessed Messianic kingdom someday suddenly to appear on the clouds of heaven. It was the Hebrew way of expressing hope for the victory of God and righteousness. When the Christians came they took over that phrasing of expectancy and the New Testament is aglow with it. The preaching of the apostles thrills with the glad announcement, "Christ is coming!"

In the evangelical churches today there are differing views of this matter. One view is that Christ is literally coming, externally, on the clouds of heaven, to set up His kingdom here. I never heard that teaching in my youth at all. It has always had a new resurrection when desperate circumstances came and man's only hope seemed to lie in divine intervention. It is not strange, then, that during these chaotic, catastrophic years there has been a fresh rebirth of this old phrasing of expectancy. "Christ is coming!" seems to many Christians the central message of the Gospel. In the strength of it some of them are doing great service for the world. But, unhappily, many so overemphasize it that they outdo anything the ancient Hebrews or the ancient Christians ever did. They sit still and do nothing and expect the world to grow worse and worse until He comes.

Side by side with these to whom the second coming is a literal expectation, another group exists in the evangelical churches. They, too, say, "Christ is coming!" They say it with all their hearts; but they are not thinking of an external arrival on the clouds. They have assimilated as part of the divine revelation the exhilarating insight which these recent generations have given to us, that development is God's way of working out His will. . . .

And these Christians, when they say that Christ is coming, mean that, slowly it may be, but surely, His will and principles will be worked out by God's grace in human life and institutions, until "He shall see of the travail of His soul and shall be satisfied."

These two groups exist in the Christian churches and the question raised by the Fundamentalists is—Shall one of them drive the other out? Will that get us anywhere? Multitudes of young men and women at this season of the year are graduating from our schools of learning, thousands of them Christians who may make us older ones ashamed by the sincerity of their devotion to God's will on earth. They are not thinking in ancient terms that leave ideas of progress out. They cannot think in those terms. There could be no greater tragedy than that the Fundamentalists should shut the door of the Christian fellowship against such.

I do not believe for one moment that the Fundamentalists are going to succeed. Nobody's intolerance can contribute anything to the solution of the situation which we have described. If, then, the Fundamentalists have no solution of the problem, where may we expect to find it? In two concluding comments let us consider our reply to that inquiry.

The first element that is necessary is a spirit of tolerance and Christian liberty. When will the world learn that intolerance solves no problems? This is not a lesson which the Fundamentalists alone need to learn; the liberals also need to learn it. Speaking, as I do, from the viewpoint of liberal opinions, let me say that if some young, fresh mind here this morning is holding new ideas, has fought his way through, it may be by intellectual and spiritual struggle, to novel positions, and is tempted to be intolerant about old opinions, offensively to condescend to those who hold them and to be harsh in judgment on them, he may well remember that people who held those old opinions have given the world some of the noblest character and the most remembrable service that it ever has been blessed with, and that we of the younger generation will prove our case best, not by controversial intolerance, but by producing, with our new opinions, something of the depth and strength, nobility and beauty of character that in other times were associated with other thoughts. It was a wise liberal, the most adventurous man of his day—Paul the Apostle—who said, "Knowledge puffeth up, but love buildeth up."

Nevertheless, it is true that just now the Fundamentalists are giving us one of the worst exhibitions of bitter intolerance that the churches of this country have ever seen. As one watches them and listens to them he remembers the remark of General Armstrong of Hampton Institute, "Cantankerousness is worse than heterodoxy." There are many opinions in the field of modern controversy concerning which I am not sure whether they are right or wrong, but there is one thing I am sure of: courtesy and kindliness and tolerance and humility and fairness are right. Opinions may be mistaken; love never is.

As I plead thus for an intellectually hospitable, tolerant, liberty-loving church, I am, of course, thinking primarily about this new generation. We have boys and girls growing up in our homes and schools, and because we love them we may well wonder about the church which will be waiting to receive them. Now, the worst kind of church that can possibly be offered to the allegiance of the new generation is an intolerant church. Ministers often bewail the fact that young people turn from religion to science for the regulative ideas of their lives. But this is easily explicable.

Science treats a young man's mind as though it were really important. A scientist says to a young man, "Here is the universe challenging our investigation. Here are the truths which we have seen, so far. Come, study with us! See what we already have seen and then look further to see more, for science is an intellectual adventure for the truth." Can you imagine any man who is worthwhile turning from that call to the church if the church seems to him to say, "Come, and we will feed you opinions from a spoon. No thinking is allowed here except such as brings you to certain specified, predetermined conclusions. These prescribed opinions we will give you in advance of your thinking; now think, but only so as to reach these results."

My friends, nothing in all the world is so much worth thinking of as God, Christ, the Bible, sin and salvation, the divine purposes for humankind, life everlasting. But you cannot challenge the dedicated thinking of this generation to these sublime themes upon any such terms as are laid down by an intolerant church.

The second element which is needed if we are to reach a happy solution of this problem is a clear insight into the main issues of modern Christianity and a sense of penitent shame that the Christian Church should be quarreling over little matters when the world is dying of great needs. If, during the war, when the nations were wrestling upon the very brink of hell and at times all seemed lost, you chanced to hear two men in an altercation about some minor matter of sectarian denominationalism, could you restrain your indignation? You said, "What can you do with folks like this who, in the face of colossal issues, play with the tiddledywinks and peccadillos of religion?" So, now, when from the terrific questions of this generation one is called away by the noise of this Fundamentalist controversy, he thinks it almost unforgivable that men should tithe mint and anise and cummin, and quarrel over them, when the world is perishing for the lack of the weightier matters of the law, justice, and mercy, and faith. . . .

The present world situation smells to heaven! And now, in the presence of colossal problems, which must be solved in Christ's name and for Christ's sake, the Fundamentalists propose to drive out from the Christian churches all the consecrated souls who do not agree with their theory of inspiration. What immeasurable folly!

Well, they are not going to do it; certainly not in this vicinity. I do not even know in this congregation whether anybody has been tempted to be a Fundamentalist. Never in this church have I caught one accent of intolerance. God keep us always so and ever increasing areas of the Christian fellowship; intellectually hospitable, open-minded, liberty-loving, fair, tolerant, not with the tolerance of indifference, as though we did not care about the faith, but because always our major emphasis is upon the weightier matters of the law.

# REINHOLD NIEBUHR

Reinhold Niebuhr (1892–1971) was one of the most influential Protestant theologians of the twentieth century. A onetime socialist, Niebuhr left the Socialist Party to found the Union for Democratic Action and was later active in the Liberal Party of New York. Faith and politics were inseparable in his own life and writings, and he wrote numerous books aiming to mobilize Americans to action while always urging a clear realism about the inevitability of human sin and injustice. His 1952 book, *The Irony of American History*, from lectures given between 1949 and 1951, was his last significant work. The excerpt presented here illuminates Niebuhr's mature political view of American democracy and his hopes for what could be accomplished by a conscientious moral and religious approach.

*From* The Irony of American History

## THE AMERICAN FUTURE

### 1

Nations, as individuals, may be assailed by contradictory temptations. They may be tempted to flee the responsibilities of their power or refuse to develop their potentialities. But they may also refuse to recognize the limits of their possibilities and seek greater power than is given to mortals. Naturally there are no fixed limits for the potentialities of men or nations. There is therefore no nice line to be drawn between a normal expression of human creativity and either the sloth which refuses to assume the responsibilities of human freedom or the pride which overestimates man's individual or collective power. But it is possible to discern extreme forms of each evil very clearly; and also to recognize various shades of evil between the extremes and the norm.

The temptation to disavow the responsibilities of human freedom or to leave human potentialities undeveloped usually assails the weak, rather than the strong. In the Biblical parable it was the "one talent" man who "hid his treasure in the ground." Our nation ought, therefore, not to take too much credit for having mastered a temptation which assailed us for several decades. It was a rather unique historical phenomenon that a nation with our potentialities should have been tempted to isolationism and withdrawal from world respon-

From Reinhold Niebuhr, *The Irony of American History* (New York: Charles Scribner's Sons, 1952).

sibilities. Various factors contributed to the persuasiveness of the temptation. We were so strong and our continental security seemed so impregnable (on cursory glance at least) that we were encouraged in the illusion that we could live our own life without too much regard for a harassed world. Our sense of superior virtue over the alleged evils of European civilization and our fear of losing our innocence if we braved the tumults of world politics, added spiritual vanity to ignoble prudence as the second cause of our irresponsibility. We thought we might keep ourselves free of the evils of a warring world and thus preserve a healthy civilization, amidst the expected doom of a decrepit one. This hope of furnishing the seed-corn for a new beginning persuaded moral idealists to combine with cynical realists in propounding the policy of power without responsibility.

However, human life is healthy only in relationship; and modern technical achievements have accentuated the interdependence of men and of nations. It therefore became apparent, that we could neither be really secure in an insecure world nor find life worth living if we bought our security at the price of civilization's doom. This knowledge came to us during and after the Second World War and marked a fateful turning point in our national life. Some of our friends and allies still profess uncertainty about the reality of our conversion from an irresponsible to a responsible relation to the community of nations. But, whatever may be our future errors, it is fairly safe to predict that we have finally triumphed over the temptation to "hide our talent in the ground."

We will not, however, take too much credit for this achievement if we remember that the temptation, over which we triumphed, is one which assails the weak rather than the strong. Indeed, a part of the resource for our triumph was our gradual realization that we were not weak, but strong; that we had in fact become very strong.

Significantly the same world which only yesterday feared our possible return to adolescent irresponsibility is now exercised about the possibilities of the misuse of our power. We would do well to understand the legitimacy of such fears rather than resent their seeming injustice. It is characteristic of human nature, whether in its individual or collective expression, that it has no possibility of exercising power, without running the danger of overestimating the purity of the wisdom which directs it. The apprehensions of allies and friends is, therefore, but a natural human reaction to what men intuitively know to be the temptations of power. A European statesman stated the issue very well recently in the words: "We are grateful to America for saving us from communism. But our gratitude does not prevent us from fearing that we might become an American colony. That danger lies in the situation of America's power and Europe's weakness." The statesman, when reminded of the strain of genuine idealism in American life, replied: "The idealism does indeed prevent America from a gross abuse of its power. But it might well accentuate the danger Europeans confront. For American power in the service of American idealism could create a situation in which we would be too impotent to correct you when you are wrong and you would be too idealistic to correct yourself."

Such a measured judgment upon the virtues and perils of America's position in the world community accurately describes the hazards of our position in the world. Our moral perils are not those of conscious malice or the explicit lust

for power. They are the perils which can be understood only if we realize the ironic tendency of virtues to turn into vices when too complacently relied upon; and of power to become vexatious if the wisdom which directs it is trusted too confidently. The ironic elements in American history can be overcome, in short, only if American idealism comes to terms with the limits of all human striving, the fragmentariness of all human wisdom, the precariousness of all historic configurations of power, and the mixture of good and evil in all human virtue. America's moral and spiritual success in relating itself creatively to a world community requires, not so much a guard against the gross vices, about which the idealists warn us, as a reorientation of the whole structure of our idealism. That idealism is too oblivious of the ironic perils to which human virtue, wisdom and power are subject. It is too certain that there is a straight path toward the goal of human happiness; too confident of the wisdom and idealism which prompt men and nations toward that goal; and too blind to the curious compounds of good and evil in which the actions of the best men and nations abound.

## 2

The two aspects of our historic situation which tend particularly to aggravate the problems of American idealism are: (a) That American power in the present world situation is inordinately great; (b) that the contemporary international situation offers no clear road to the achievement of either peace or victory over tyranny. The first aspect embodies perils to genuine community between ourselves and our allies; for power generates both justified and unjustified fears and resentments among the relatively powerless. The second aspect embodies the temptation to become impatient and defiant of the slow and sometimes contradictory processes of history. We may be too secure in both our sense of power and our sense of virtue to be ready to engage in a patient chess game with the recalcitrant forces of historic destiny. We could bring calamity upon ourselves and the world by forgetting that even the most powerful nations and even the wisest planners of the future remain themselves creatures as well as creators of the historical process. Man cannot rise to a simple triumph over historical fate.

In considering the perils of our inordinate power it would be well to concede that it embodies some real advantages for the world community. It is quite possible that if power had been more evenly distributed in the non-communist world the degree of cohesion actually attained would have been difficult. Many national communities gained their first triumph over chaos by the organizing energy of one particular power, sufficiently dominant to suppress the confusion of competing forces. Thus, dominant city-states in Egypt and in Mesopotamia were responsible for the order and cohesion of these first great empires of human history. The preponderant power of America may have a similar role to play in the present international scene. There is, furthermore, a youthful belief in historic possibilities in our American culture, a confidence that problems can be solved, which frequently stands in creative contrast with the spiritual tiredness of many European nations as also with the defeatism of Oriental cultures. Our hegemonic position in the world community rests upon a buoyant vigor as well as upon our preponderant economic power.

Nevertheless, great disproportions of power are as certainly moral hazards to justice and community as they are foundations of minimal order. They are hazards to community both because they arouse resentments and fears among those who have less power; and because they tempt the strong to wield their power without too much consideration of the interests and views of those upon whom it impinges. Modern democratic nations have sought to bring power into the service of justice in three ways. (a) They have tried to distribute economic and political power and prevent its undue concentration. (b) They have tried to bring it under social and moral review. (c) They have sought to establish inner religious and moral checks upon it.

Of these three methods the first is not relevant to the international community, as at present inchoately organized. The relative power of particular nations must be accepted as fateful historic facts about which little can be done. The idealists who imagine that these disproportions of power would be dissolved in a global constitutional system do not understand the realities of the political order. No world government could possibly possess, for generations to come, the moral and political authority to redistribute power between the nations in the degree in which highly cohesive national communities have accomplished this end in recent centuries. Furthermore, even the most healthy modern nations must be content with only approximate equilibria of power lest they destroy the vitalities of various social forces by a too rigorous effort to bring the whole communal life under an equalitarian discipline. The preponderance of American power is thus an inexorable fact for decades to come, whether within or without a fuller world constitution than now prevails. If it does disappear it will be eliminated by the emergence of new forces or the new coalition of older forces, rather than by constitutional contrivance.

The strategy of bringing power under social and political review is a possibility for the international community, even in its present nascent form. It is a wholesome development for America and the world that the United Nations is becoming firmly established, not so much as an institution, capable of bridging the chasm between the communist and the non-communist world (in which task it can have only minimal success), but as an organ in which even the most powerful of the democratic nations must bring their policies under the scrutiny of world public opinion. Thus inevitable aberrations, arising from the pride of power, are corrected. It will be even more hopeful for the peace and justice of the world community, if a fragmented Europe should gain the unity to speak with more unanimity in the councils of the nations than is now possible. It is impossible for any nation or individual fully to understand the peculiar circumstances and the unique history of any other nation or individual, which create their special view of reality. It is important, therefore, that the fragmentary wisdom of any nation should be prevented from achieving the bogus omniscience, which occurs when the weak are too weak to dare challenge the opinion of the powerful. Such a tyrannical situation not only within, but between, the communist nations must finally destroy the community of that world.

It is also to be hoped that the Asian world will gain sufficient voice in the councils of the free nations to correct the inevitable bias of western nations in the same manner.

It is now generally acknowledged (to give an example of the salutary character of such discipline) that American policy in regard to the rearmament of

Germany was too precipitate and too indifferent toward certain moral and political hazards of which Europe was conscious in that undertaking. There were, on the other hand, fears in Europe which might have prevented the inclusion of Western Germany in the full community of the non-communist world and the concomitant grant of the right, and acknowledgment of the responsibility, of common defense of that community. The tolerable solution of this problem was achieved by compromises between the American and the European position. Thus a creative synthesis was achieved despite the hazards of disproportionate power.

If there should be, as many Europeans believe, too great a preoccupation in America with the task of winning a war which Europe wants to avoid; and if there should be in Europe, as some Americans believe, so desperate a desire to avoid war that the danger is run of bringing on the conflict by lack of resolution, it is to be hoped that a similar creative synthesis of complementary viewpoints will take place. The real test of such a synthesis will occur at the point in time when American preparedness has reached its highest possibility and the fear of the rapid outmoding of modern weapons and the consequent economic burden of ever-new preparedness efforts might tempt American strategists to welcome a final joining of the issue. In that situation many Americans would, of course, strongly resist the temptation to embark upon a preventive war. But their resolution will be strengthened and their cause have a better prospect of success if the decision lies not with one powerful nation but with a real community of nations.

The third strategy of disciplining the exercise of power, that of an inner religious and moral check, is usually interpreted to mean the cultivation of a sense of justice. The inclination "to give each man his due" is indeed one of the ends of such a discipline. But a sense of humility which recognizes that nations are even more incapable than individuals of fully understanding the rights and claims of others may be an even more important element in such a discipline. A too confident sense of justice always leads to injustice. In so far as men and nations are "judges in their own case" they are bound to betray the human weakness of having a livelier sense of their own interest than of the competing interest. That is why "just" men and nations may easily become involved in ironic refutations of their moral pretensions.

Genuine community, whether between men or nations, is not established merely through the realization that we need one another, though indeed we do. That realization alone may still allow the strong to use the lives of the weaker as instruments of their own self-realization. Genuine community is established only when the knowledge that we need one another is supplemented by the recognition that "the other," that other form of life, or that other unique community is the limit beyond which our ambitions must not run and the boundary beyond which our life must not expand.

It is significant that most genuine community is established below and above the level of conscious moral idealism. Below that level we find the strong forces of nature and nature-history, sex and kinship, common language and geographically determined togetherness, operative. Above the level of idealism the most effective force of community is religious humility. This includes the charitable realization that the vanities of the other group or person, from which we suffer, is not different in kind, though possibly in degree, from similar vani-

ties in our own life. It also includes a religious sense of the mystery and greatness of the other life, which we violate if we seek to comprehend it too simply from our standpoint.

Such resources of community are of greater importance in our nation today than abstract constitutional schemes, of which our idealists are so fond. Most of these schemes will be proved, upon close examination, to be indifferent toward the urgencies and anxieties which nations, less favored than we, experience; and to betray sentimentalities about the perplexing problems of human togetherness in which only the powerful and the secure can indulge.

# 3

The second characteristic of the contemporary situation, which challenges American idealism, is that there are no guarantees either for the victory of democracy over tyranny or for a peaceful solution of the fateful conflict between two great centers of power. We have previously noted how the tragic dilemmas and the pathetic uncertainties and frustrations of contemporary history offer ironic refutation of the dreams of happiness and virtue of a liberal age and, especially, of the American hopes. Escape from our ironic situation obviously demands that we moderate our conceptions of the ability of men and of nations to discern the future; and of the power of even great nations to bring a tortuous historical process to, what seems to them, a logical and proper conclusion.

The difficulty of our own powerful nation in coming to terms with the frustrations of history, and our impatience with a situation which requires great exertions without the promise of certain success, is quite obviously symbolic of the whole perplexity of modern culture. The perplexity arises from the fact that men have been preoccupied with man's capacity to master historical forces and have forgotten that the same man, including the collective man embodied in powerful nations, is also a creature of these historical forces. Since man is a creator, endowed with a unique freedom, he "looks before and after and pines for what is not." He envisages goals and ends of life which are not dictated by the immediate necessities of life. He builds and surveys the great cultural and social structures of his day, recognizes the plight in which they become involved and devises various means and ends to extricate his generation from such a plight. He would not be fully human if he did not lift himself above his immediate hour, if he felt neither responsibility for the future weal of his civilization, nor gratitude for the whole glorious and tragic drama of human history, culminating in the present moment.

But it is easy to forget that even the most powerful nation or alliance of nations is merely one of many forces in the historical drama; and that the conflict of many wills and purposes, which constitute that drama, give it a bizarre pattern in which it is difficult to discern a real meaning. It is even more difficult to subject it to a preconceived order. We have previously considered the ironic nature of the fact that the chief force of recalcitrance against the hopes of a democratic world should be furnished by a political religion, the animus of whose recalcitrance should be derived from its fanatic belief that it can reduce all historical forces to its conception of a rational order. The fact that this religion should have a special appeal to decaying feudal societies, which have been left

behind in the march of technical progress of the western world is one of those imponderable factors in history, which no one could have foreseen but which can be countered only if we do not try too simply to overcome the ambivalence and hesitancies of the nontechnical world by the display of our power, or the claim of superiority for our "way of life."

We have enough discernment as creators of history to know that there is a certain "logic" in its course. We know that recently the development of an inchoate world community requires that it acquire global political organs for the better integration of its life. But if we imagine that we can easily transmute this logic into historical reality we will prove ourselves blind to the limitations of man as creature of history. For the achievement of a constitutional world order is frustrated not merely by the opposition of a resolute foe who has his own conception of such an order. It is impeded also by the general limitations of man as creature. The most important of these is the fact that human communities are never purely artifacts of the human mind and will. Human communities are subject to "organic" growth. This means that they cannot deny their relation to "nature"; for the force of their cohesion is partly drawn from the necessities of nature (kinship, geography, etc.) rather than from the realm of freedom. Even when it is not pure nature but historic tradition and common experience which provides the cement of cohesion, the integrating force is still not in the realm of pure freedom or the fruit of pure volition. Thus, the "Atlantic community" is becoming a reality partly because it does have common cultural inheritances and partly because the exigencies of history are forcing mutual tasks upon it. The assumption of these mutual responsibilities requires a whole series of clear decisions. Yet it is not possible even for such a limited international community to be constituted into an integral community by one clear act of political will. Naturally a more unlimited or global community, with fewer common cultural traditions to bind it and less immediate urgencies to force difficult decisions upon a reluctant human will, will have even greater difficulty in achieving stable political cohesion.

All these matters are understood intuitively by practical statesmen who know from experience that the mastery of historical destiny is a tortuous process in which powerful forces may be beguiled, deflected, and transmuted but never simply annulled or defied. The difficulty, particularly in America, is that the wisdom of this practical statesmanship is so frequently despised as foolishness by the supposedly more "idealistic" science of our age. Thus the conscience of our nation is confused to the point of schizophrenia; and the inevitable disappointments, frustrations and illogicalities of world politics are wrongly interpreted as nothing but the fruit of "unscientific" blundering. A nation with an inordinate degree of political power is doubly tempted to exceed the bounds of historical possibilities, if it is informed by an idealism which does not understand the limits of man's wisdom and volition in history.

4

The recognition of historical limits must not, however, lead to a betrayal of cherished values and historical attainments. Historical pragmatism exists on the edge of opportunism, but cannot afford to fall into the abyss. The difficulty of

sustaining the values of a free world must not prompt us, for instance, to come to terms with tyranny. Nor must the perplexities confronting the task of achieving global community betray us into a complacent acceptance of national loyalty as the final moral possibility of history. It is even more grievously wrong either to bow to "waves of the future" or to yield to inertias of the past than to seek illusory escape from historical difficulties by utopian dreams.

Through the whole course of history mankind has, by a true spiritual instinct, reserved its highest admiration for those heroes who resisted evil at the risk or price of fortune and life without too much hope of success. Sometimes their very indifference to the issue of success or failure provided the stamina which made success possible. Sometimes the heroes of faith perished outside the promised land. This paradoxical relation between the possible and the impossible in history proves that the frame of history is wider than the nature-time in which it is grounded. The injunction of Christ: "Fear not them which kill the body, but are not able to kill the soul" (Matthew 10:28) neatly indicates the dimension of human existence which transcends the basis which human life and history have in nature. Not merely in Christian thought but in the noblest paganism, it has been understood that a too desperate desire to preserve life or to gain obvious success must rob life of its meaning. If this be so, there cannot be a simple correlation between virtue and happiness, or between immediate and ultimate success.

While collective man lacks the capacity of individual man to sacrifice "the body" (*i.e.* historical security) for an end which may not be historically validated, yet nations have proved capable of great sacrifice in defending their liberties against tyranny, for instance. The tendency of a liberal culture to regard the highest human possibilities as capable of simple historical attainment, and to interpret all tragic and contradictory elements in the pattern of history as merely provisional, has immersed the spirit of our age in a sentimentality which so uncritically identifies idealism with prudence that it can find no place in its scheme of things for heroic action or heroic patience. Yet the only possibility of success for our nation and our culture in achieving the historic goals of peace and justice lies in our capacity to make sacrifices and to sustain endeavors without complete certainty of success.

We could not bear the burdens required to save the world from tyranny if there were no prospects of success. The necessity of this measure of historic hope marks the spiritual stature of collective, as distinguished from individual, man. Even among individuals only few individuals are able to rise to the height of heroic nonchalance about historic possibilities. But while the nation cannot fulfill its mission in a given situation without some prospect of success, it also cannot persist in any great endeavor if it is so preoccupied with immediate historic possibilities that it is constantly subjected to distracting alternations of illusion and disillusion.

The fact that the European nations, more accustomed to the tragic vicissitudes of history, still have a measure of misgiving about our leadership in the world community is due to their fear that our "technocratic" tendency to equate the mastery of nature with the mastery of history could tempt us to lose patience with the tortuous course of history. We might be driven to hysteria by its inevitable frustrations. We might be tempted to bring the whole of modern

history to a tragic conclusion by one final and mighty effort to overcome its frustrations. The political term for such an effort is "preventive war." It is not an immediate temptation; but it could become so in the next decade or two.

A democracy can not of course, engage in an explicit preventive war. But military leadership can heighten crises to the point where war becomes unavoidable.

The power of such a temptation to a nation, long accustomed to expanding possibilities and only recently subjected to frustration, is enhanced by the spiritual aberrations which arise in a situation of intense enmity. The certainty of the foe's continued intransigence seems to be the only fixed fact in an uncertain future. Nations find it even more difficult than individuals to preserve sanity when confronted with a resolute and unscrupulous foe. Hatred disturbs all residual serenity of spirit and vindictiveness muddies every pool of sanity. In the present situation even the sanest of our statesmen have found it convenient to conform their policies to the public temper of fear and hatred which the most vulgar of our politicians have generated or exploited. Our foreign policy is thus threatened with a kind of apoplectic rigidity and inflexibility. Constant proof is required that the foe is hated with sufficient vigor. Unfortunately the only persuasive proof seems to be the disavowal of precisely those discriminate judgments which are so necessary for an effective conflict with the evil, which we are supposed to abhor. There is no simple triumph over this spirit of fear and hatred. It is certainly an achievement beyond the resources of a simple idealism. For naïve idealists are always so preoccupied with their own virtues that they have no residual awareness of the common characteristics in all human foibles and frailties and could not bear to be reminded that there is a hidden kinship between the vices of even the most vicious and the virtues of even the most upright.

## 5

The American situation is such a vivid symbol of the spiritual perplexities of modern man, because the degree of American power tends to generate illusions to which a technocratic culture is already too prone. This technocratic approach to problems of history, which erroneously equates the mastery of nature with the mastery of historical destiny, in turn accentuates a very old failing in human nature: the inclination of the wise, or the powerful, or the virtuous, to obscure and deny the human limitations in all human achievements and pretensions.

The most rigorous and searching criticism of the weaknesses in our foreign policy, which may be ascribed to the special character of our American idealism, has recently been made by one of our most eminent specialists in foreign policy, Mr. George Kennan.

He ascribes the weaknesses of our policy to a too simple "legalistic-moralistic" approach and defines this approach as informed by an uncritical reliance upon moral and constitutional schemes, and by too little concern for the effect of our policy upon other nations, and too little anticipation of the possible disruption of policies by incalculable future occurrences. In short, he accuses the nation of pretending too much prescience of an unknown future and of an inclination to regard other peoples "in our own image." These are, of course, precisely the

perils to which all human idealism is subject and which our great power and our technocratic culture have aggravated.

Mr. Kennan's solution for our problem is to return to the policy of making the "national interest" the touchstone of our diplomacy. He does not intend to be morally cynical in the advocacy of this course. He believes that a modest awareness that our own interests represent the limit of our competence should prompt such a policy. His theory is that we may know what is good for us but should be less certain that we know what is good for others. This admonition to modesty is valid as far as it goes. Yet his solution is wrong. For egotism is not the proper cure for an abstract and pretentious idealism.

Since the lives and interests of other men and communities always impinge upon our own, a preoccupation with our own interests must lead to an illegitimate indifference toward the interests of others, even when modesty prompts the preoccupation. The cure for a pretentious idealism, which claims to know more about the future and about other men than is given mortal man to know, is not egotism. It is a concern for both the self and the other in which the self, whether individual or collective, preserves a "decent respect for the opinions of mankind," derived from a modest awareness of the limits of its own knowledge and power.

It is not an accident of history that a culture which made so much of humanity and humaneness should have generated such frightful inhumanities; and that these inhumanities are not limited to the explicitly fanatic politico-religious movements. Mr. Kennan rightly points to the evils which arise from the pursuit of unlimited rather than limited ends, even by highly civilized nations in the modern era. The inhumanities of our day, which modern tryannies exhibit in the $n$th degree, are due to an idealism in which reason is turned into unreason because it is not conscious of the contingent character of the presuppositions with which the reasoning process begins, and in which idealism is transmuted into inhumanity because the idealist seeks to comprehend the whole realm of ends from his standpoint.

A nice symbol of this difficulty in the policy of even "just" nations is the ironic embarrassment in which the victorious democracies became involved in their program of "demilitarizing" the vanquished "militaristic" nations. In Japan they encouraged a ridiculous article in the new constitution which committed the nation to a perpetual pacifist defenselessness. In less than half a decade they were forced to ask their "demilitarized" former foes to rearm, and become allies in a common defense against a new foe, who had recently been their victorious ally.

We cannot expect even the wisest of nations to escape every peril of moral and spiritual complacency; for nations have always been constitutionally self-righteous. But it will make a difference whether the culture in which the policies of nations are formed is only as deep and as high as the nation's highest ideals; or whether there is a dimension in the culture from the standpoint of which the element of vanity in all human ambitions and achievements is discerned. But this is a height which can be grasped only by faith; for everything that is related in terms of simple rational coherence with the ideals of a culture or a nation will prove in the end to be a simple justification of its most cherished values. The God before whom "the nations are as a drop in the bucket and are counted as

small dust in the balances" is known by faith and not by reason. The realm of mystery and meaning which encloses and finally makes sense out of the baffling configurations of history is not identical with any scheme of rational intelligibility. The faith which appropriates the meaning in the mystery inevitably involves an experience of repentance for the false meanings which the pride of nations and cultures introduces into the pattern. Such repentance is the true source of charity; and we are more desperately in need of genuine charity than of more technocratic skills.

# ABRAHAM JOSHUA HESCHEL

Abraham Joshua Heschel (1907–72) was a distinguished Jewish biblical scholar and theologian who emigrated from Europe to the United States in 1940. Upon his arrival, he began teaching at Hebrew Union College in Cincinnati, affiliated with Reform Judaism, then five years later moved to New York to teach at the Conservative Jewish Theological Seminary. There he became the most celebrated interpreter of traditional Judaism in the country and a prolific writer of both scholarly and more popular texts. This excerpt from *God in Search of Man* (1955) expounds upon the significance of Jewish observance and practical commitment to right living and ethical action.

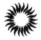

*From* God in Search of Man

## A SCIENCE OF DEEDS

### The Supreme Acquiescence

Knowledge of God is knowledge of living with God. Israel's religious existence consists of three inner attitudes: engagement to the living God to whom we are accountable; engagement to Torah where His voice is audible; and engagement to His concern as expressed in mitsvot (commandments).

Engagement to God comes about in acts of the soul. Engagement to Torah is the result of study and communion with its words. Engagement to His concern comes about through attachment to the essentials of worship. Its meaning is disclosed in acts of worship.

If God were a theory, the study of theology would be the way to understand Him. But God is alive and in need of love and worship. This is why thinking of God is related to our worship. In an analogy of artistic understanding, we sing to Him before we are able to understand Him. We have to love in order to know. Unless we learn how to sing, unless we know how to love, we will never learn how to understand Him.

Jewish tradition interprets the words that Israel uttered at Sinai, "all that the Lord has spoken, we shall do and we shall hear" (Exodus 24:7), as a promise to fulfill His commands even before hearing them, as the *precedence of faith over knowledge.* "When at Sinai Israel said *we shall do and we shall hear* (instead of saying, we shall hear and we shall do), a heavenly voice went forth and exclaimed, "Who has revealed to My children this *mystery*, which the ministering angels enact, to fulfill His word before they hear the voice."

A heretic, the Talmud reports, chided the Jews for the rashness in which he claimed they persisted. "First you should have listened; if the commandments

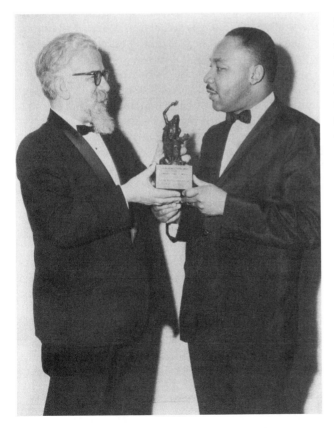

Abraham Joshua Heschel presenting the Judaism and World Peace award to Dr. Martin Luther King, Jr. (1965). *Courtesy of the Library of Congress, Prints & Photographs Division.*

were within your power of fulfillment, you should have accepted them; if beyond your power, rejected them." Indeed, Israel's *supreme acquiescence* at Sinai was an inversion, turning upside down the order of attitudes as conceived by our abstract thinking. Do we not always maintain that we must first explore a system before we decide to accept it? This order of inquiry is valid in regard to pure theory, to principles and rules, but it has limitations when applied to realms where thought and fact, the abstract and the concrete, theory and experience are inseparable. It would be futile, for example, to explore the meaning of music and abstain from listening to music. It would be just as futile to explore the Jewish thought from a distance, in self-detachment. Jewish thought is disclosed in Jewish living. This, therefore, is the way of religious existence. We do not explore first and decide afterwards whether to accept the Jewish way of living. We must accept in order to be able to explore. At the beginning is *the commitment, the supreme acquiescence.*

## A Leap of Action

In our response to His will we perceive His presence in our deeds. His will is revealed in our doing. In carrying out a sacred deed we unseal the wells of faith. *As for me, I shall behold Thy face in righteousness* (Psalms 18:15).

There is a way that leads *from piety to faith*. Piety and faith are not necessarily concurrent. There can be acts of piety without faith. Faith is vision, sensitivity and attachment to God; piety is an attempt to attain such sensitivity and attachment. The gates of faith are not ajar, but the mitsvah is a key. By living as Jews we may attain our faith as Jews. We do not have faith because of deeds; we may attain faith through sacred deeds.

A Jew is asked to take a *leap of action* rather than a *leap of thought*. He is asked to surpass his needs, to do more than he understands in order to understand more than he does. In carrying out the word of the Torah he is ushered into the presence of spiritual meaning. Through the ecstasy of deeds he learns to be certain of the hereness of God. Right living is a way to right thinking.

The sense of the ineffable, the participation in Torah and Israel, the leap of action—they all lead to the same goal. Callousness to the mystery of existence, detachment from Torah and Israel, cruelty and profanity of living, alienate the Jew from God. Response to the wonder, participation in Torah and Israel, discipline in daily life, bring us close to Him.

What commitments must precede the experience of such meaning? What convictions must persist to make such insights possible? Our way of living must be compatible with our essence as created in the likeness of God. We must beware lest our likeness be distorted and even forfeited. In our way of living we must remain true not only to our sense of power and beauty but also to our sense of the grandeur and mystery of existence. The true meaning of existence is disclosed in moments of living in the presence of God. The problem we face is: how can we live in a way which is in agreement with such convictions?

## The Deed Is the Risk

How should man, a being created in the likeness of God, live? What way of living is compatible with the grandeur and mystery of living? It is a problem

which man has always been anxious to ignore. Upon the pavement of the Roman city of Timgat an inscription was found which reads: "To hunt, to bathe, to gamble, to laugh, that is to live." Judaism is a reminder of the grandeur and earnestness of living.

In what dimension of existence does man become aware of the grandeur and earnestness of living? What are the occasions in which he discovers the nature of his own self? The necessity to diagnose and to heal the condition of the soul? In the solitude of self-reflection the self may seem to be a fountain of beautiful thoughts and ideals. Yet thought may be a spell, and ideals may be worn like borrowed diadems.

It is in *deeds* that man becomes aware of what his life really is, of his power to harm and to hurt, to wreck and to ruin; of his ability to derive joy and to bestow it upon others; to relieve and to increase his own and other people's tensions. It is in the employment of his will, not in reflection, that he meets his own self as it is; not as he should like it to be. In his deeds man exposes his immanent as well as his suppressed desires, spelling even that which he cannot apprehend. What he may not dare to think, he often utters in deeds. The heart is revealed in the deeds.

The deed is the test, the trial, and the risk. What we perform may seem slight, but the aftermath is immense. An individual's misdeed can be the beginning of a nation's disaster. The sun goes down, but the deeds go on. Darkness is over all we have done. If man were able to survey at a glance all he has done in the course of his life, what would he feel? He would be terrified at the extent of his own power. To bind all we have done to our conscience or to our mind would be like trying to tie a torrent to a reed. Even a single deed generates an endless set of effects, initiating more than the most powerful man is able to master or to predict. A single deed may place the lives of countless men in the chains of its unpredictable effects. All we own is a passing intention, but what comes about will outlive and surpass our power. Gazing soberly at the world man is often overcome with a fear of action, a fear that, without knowledge of God's ways, turns to despair.

## Our Ultimate Embarrassment

The seriousness of doing surpasses the sensitivity of our conscience. Infinite are the consequences of our actions, yet finite is our wisdom. When man stands alone, his responsibility seems to vanish like a drop in the ocean of necessity. It is superhuman to be responsible for all that we do and for all that we fail to do, to answer for all the causalities of one's activities. How should we reconcile infinite responsibility with finite wisdom? How is responsibility possible?

Infinite responsibility without infinite wisdom and infinite power is our ultimate embarrassment.

Not things but deeds are the source of our sad perplexities. Confronted with a world of things, man unloosens a tide of deeds. The fabulous fact of man's ability to act, *the wonder of doing,* is no less amazing than the marvel of being. Ontology inquires: what is *being*? What does it mean to be? The religious mind ponders: what is *doing*? What does it mean to do? What is the relation between the doer and the deed? between doing and being? Is there a purpose to fulfill, a task to carry out?

"A man should always regard himself as though he were half guilty and half meritorious; if he performs one good deed, blessed is he for he moves the scale toward merit; if he commits one transgression, woe to him for he moves the scale toward guilt." Not only the individual but the whole world is in balance. One deed of an individual may decide the fate of the world. "If he performs one good deed, blessed is he for he moves the scale both for himself and for the entire world to the side of merit; if he commits one transgression, woe to him for he moves to the side of guilt himself and the whole world."

## A Meta-ethical Approach

What ought we to do? How ought we to conduct our lives? These are basic questions of ethics. They are also questions of religion. Philosophy of religion must inquire: why do we ask these questions? Are they meaningful? On what grounds do we state them? To ethics, these are man's questions, necessitated by the nature of human existence. To religion, these are God's questions, and our answer to them concerns not only man but God.

"What ought I to do?" is according to Kant the basic question in ethics. Ours, however, is a more radical, a meta-ethical approach. The ethical question refers to particular deeds; the meta-ethical question refers to all deeds. It deals with doing as such; not only what ought we to do, but what is our right to act at all? We are endowed with the ability to conquer and to control the forces of nature. In exercising power, we submit to our will a world that we did not create, invading realms that do not belong to us. Are we the kings of the universe or mere pirates? By whose grace, by what right, do we exploit, consume and enjoy the fruits of the trees, the blessings of the earth? Who is responsible for the power to exploit, for the privilege to consume?

It is not an academic problem but an issue we face at every moment. By the will alone man becomes the most destructive of all beings. This is our predicament: our power may become our undoing. We stand on a razor's edge. It is so easy to hurt, to destroy, to insult, to kill. Giving birth to one child is a mystery; bringing death to millions is but a skill. It is not quite within the power of the human will to generate life; it is quite within the power of the will to destroy life.

In the midst of such anxiety we are confronted with the claim of the Bible. The world is not all danger, and man is not alone. God endowed man with freedom, and He will share in our use of freedom. The earth is the Lord's, and God is in search of man. He endowed man with power to conquer the earth, and His honor is upon our faith. We abused His power, we betrayed His trust. We cannot expect Him to say, Though thou betrayest me, yet will I trust in thee.

Man is responsible for His deeds, and God is responsible for man's responsibility. He who is a life-giver must be a lawgiver. He shares in our responsibility. He is waiting to enter our deeds through our loyalty to His law. He may become a partner to our deeds.

God and man have a task in common as well as a common and mutual responsibility. The ultimate embarrassment is not a problem of solitary man but an intimate problem for both God and man. What is at stake is the meaning of God's creation, not only the meaning of man's existence. Religion is not a con-

cern for man alone but a plea of God and a claim of man, God's expectation and man's aspiration. It is not an effort solely for the sake of man. Religion spells a task within the world of man, but its ends go far beyond. This is why the Bible proclaimed a law not only for man but for both God and man.

*For Thou wilt light my lamp* (Psalms 18:29). "The Holy One said to man: Thy lamp is in My hand, My lamp in Thine. Thy lamp is in Mine—as it is said: *The lamp of the Lord is the soul of man* (Proverbs 20:27). My lamp is in thine hand, to kindle the perpetual lamp. The Holy One said: If thou lightest My lamp, I will light thine."

## The Partnership of God and Man

Just as man is not alone in what he *is*, he is not alone in what he *does*. A mitsvah is an act which God and man *have in common*. We say: "Blessed art Thou, Lord our God, King of the universe, who has sanctified us with *His* mitsvot." They oblige Him as well as us. Their fulfillment is not valued as an act performed in spite of "the evil drive," but as an act of *communion* with Him. The spirit of mitsvah is *togetherness*. We know, He is a partner to our act.

The oldest form of piety is expressed in the Bible as walking *with God*. Enoch, Noah, walked with God (Genesis 5:24; 6:9) "It has been told thee, O man, what is good, and what the Lord doth require of thee: only to do justly, to love mercy and *to walk humbly with thy God*" (6:8). Only the egotist is confined to himself, a spiritual recluse. In carrying out a good deed it is impossible to be or to feel alone. To fulfill a mitsvah is to be a partisan, to enter into fellowship with His Will.

## Ways, Not Laws

The moral imperative was not disclosed for the first time through Abraham or Sinai. The criminality of murder was known to men before; even the institution to rest on the seventh day was, according to tradition, familiar to Jews when still in Egypt. Nor was the idea of divine justice unknown. What was new was the idea that justice is an obligation to God, *His way* not only His demand; that injustice is not something God scorns when done by others but that which is the very opposite of God; that the rights of man are not legally protected interests of society but the sacred interests of God. He is not only the guardian of moral order, "the Judge of all the earth," but One who cannot act injustly (Genesis 18:25). His favorite was not Nimrod, "the first man on earth to be a hero" (Genesis 10:9), but Abraham: "I have chosen him that he may charge his sons and his household after him to keep the way of the Lord, to do righteousness and justice" (Genesis 18:19). The Torah is primarily *divine ways* rather than *divine laws*. Moses prayed: "Let me know Thy ways" (Exodus 33:13). All that God asks of man was summarized: "And now, Israel, what doth the Lord thy God require of thee . . . but to walk in all His ways" (Deuteronomy 10:12).

What does it mean, asked Rabbi Hama, son of Rabbi Hanina, when said: "Ye shall walk after the Lord your God"? (Deuteronomy 13:5). "Is it possible for a human being to walk after the *Shechinah*; has it not been said: For the Lord thy God is a devouring fire? But the meaning is to walk in the ways of the Lord. As He clothes the naked so do thou also clothe the naked; as He visited the sick, so

do thou also visit the sick; as he comforted mourners, so do Thou also comfort mourners" (*Sotah* 14a).

## The Divinity of Deeds

Not particular acts but all acts, life itself, can be established as a link between man and God. But how can we presume that the platitudes of our actions have meaning to Him? How do we dare to say that deeds have the power to throng to Him? that human triteness can become attached to eternity?

The validity of science is based upon the premise that the structure of events in nature is intelligible, capable of being observed and described in rational terms. Only because of the analogy of the structure of the human mind to the inner structure of the universe is man able to discover the laws that govern its processes. What about events in the inner and moral life of man? Is there any realm to which they correspond? The prophets who knew how to take the divine measure of human deeds, to see the structure of the absolute light in the spectrum of a single event, sensed that correspondence. What a man does in his darkest corner is relevant to the Creator. In other words, as the rationality of natural events is assumed by science, so is the divinity of human deeds assumed by prophecy.

Thus beyond the idea of the imitation of divinity goes the conviction of *the divinity of deeds*. Sacred acts, mitsvot, do not only imitate; they represent the Divine. The mitsvot are of the essence of God, more than worldly ways of complying with His will. Rabbi Simeon ben Yohai states: "Honor the mitsvot, for the mitsvot are My deputies, and a deputy is endowed with the authority of his principal. If you honor the mitsvot, it is as if you honored Me; if you dishonor them, it is as if you dishonored Me."

The Bible speaks of man as having been created in the likeness of God, establishing the principle of *an analogy of being*. In his very being, man has something in common with God. Beyond the analogy of being, the Bible teaches the principle of *an analogy in acts*. Man may act in the likeness of God. It is this likeness of acts—"to walk in His ways"—that is the link by which man may come close to God. To live in such likeness is the essence of imitation of the Divine.

## To Do What He Is

In other religions, gods, heroes, priests are holy; to the Bible not only God but "the whole community is holy" (Numbers 16:3). "Ye shall be unto me a kingdom of priests, a holy people" (Exodus 19:6), was the reason for Israel's election, the meaning of its distinction. What obtains between man and God is not mere submission to His power or dependence upon His mercy. The plea is not to obey what He wills but to *do* what He *is*.

It is not said: Ye shall be full of awe for I am holy, but: Ye shall be holy, for I the Lord your God am holy (Leviticus 19:2). How does a human being, "dust and ashes," turn holy? Through doing His mitsvot, His commandments. "The Holy God is sanctified through righteousness" (Isaiah 5:16). A man to be holy must fear his mother and father, keep the Sabbath, not turn to idols . . . nor deal falsely nor lie to one another . . . not curse the deaf nor put a stumbling-block before the blind . . . not be guilty of any injustice . . . not be a tale-

bearer . . . not stand idly by the blood of your neighbor . . . not hate . . . not take vengeance nor bear any grudge . . . but love thy neighbor as thyself (Leviticus 19:3-18).

We live by the conviction that acts of goodness reflect the hidden light of His holiness. His light is above our minds but not beyond our will. It is within our power to mirror His unending love in deeds of kindness, like brooks that hold the sky.

## Likeness in Deeds

Mitsvot, then, are more than reflections of a man's will or transcripts of his visions. In carrying out a sacred task we disclose a divine intention. With a sacred deed goes more than a stir of the heart. In a sacred deed, we echo God's suppressed chant; in loving we intone God's unfinished song. No image of the Supreme may be fashioned, save one: our own life as an image of His will. Man, formed in His likeness, was made to imitate His ways of mercy. He has delegated to man the power to act in His stead. We represent Him in relieving affliction, in granting joy. Striving for integrity, helping our fellow men; the urge to translate nature into spirit, volition into sacrifice, instinct into love; it is all an effort to represent Him.

## "The Good Drive"

To fulfill the will of God in deeds means to act *in the name* of God, not only *for the sake* of God; to carry out in acts what is potential to His will. He is in need of the work of man for the fulfillment of His ends in the world.

Human action is not the beginning. At the beginning is God's eternal expectation. There is an eternal cry in the world: *God is beseeching man* to answer, to return, to fulfill. Something is asked of man, of all men, at all times. In every act we either answer or defy, we either return or move away, we either fulfill or miss the goal. Life consists of endless opportunities to sanctify the profane, opportunities to redeem the power of God from the chain of potentialities, opportunities to serve spiritual ends.

As surely as we are driven to live, we are driven to serve spiritual ends that surpass our own interests. "The good drive" is not invented by society but is something which makes society possible; not an accidental function but of the very essence of man. We may lack a clear perception of its meaning, but we are moved by the horror of its violation. We are not only in need of God but also in need of serving His ends, and these ends are in need of us.

Mitsvot are not ideals, spiritual entities for ever suspended in eternity. They are commandments addressing every one of us. They are the ways in which God confronts us in particular moments. In the infinite world there is a task for me to accomplish. Not a general task, but a task for me, here and now. Mitsvot are *spiritual ends*, points of eternity in the flux of temporality.

## Ends in Need of Man

Man and spiritual ends stand in a relation of mutuality to each other. The relation in regard to selfish ends is one-sided: man is in need of eating bread, but the

bread is not in need of being eaten. The relation is different in regard to spiritual ends: justice is something that ought to be done, justice is in need of man. The sense of obligation expresses a situation, in which an ideal, as it were, is waiting to be attained. Spiritual ends come with a claim upon the person. They are imperative, not only impressive; demands, not abstract ideas. Esthetic values are experienced as objects of enjoyment, while religious acts are experienced as objects of commitments, as answers to the certainty that something is asked of us, expected of us. Religious ends are *in need of our deeds*.

## A Science of Deeds

Judaism is not a science of nature but a science of what man ought to do with nature. It is concerned above all with the problem of living. It takes deeds more seriously than things. Jewish law is, in a sense, *a science of deeds*. Its main concern is not only how to worship Him at certain times but how to live with Him at all times. Every deed is a problem; there is a unique task at every moment. All of life at all moments is the problem and the task.

## MORE THAN INWARDNESS

### By Faith Alone?

The claim of Judaism that religion and law are inseparable is difficult for many of us to comprehend. The difficulty may be explained by modern man's conception of the essence of religion. To the modern mind, religion is a state of the soul, inwardness; feeling rather than obedience, faith rather than action, spiritual rather than concrete. To Judaism, religion is not a feeling for something that is, but *an answer* to Him who is asking us to live in a certain way. It is in its very origin a consciousness of total commitment; a realization that all of life is not only man's but also God's sphere of interest.

"God asks for the heart." Yet does he ask for the heart only? Is the right intention enough? Some doctrines insist that love is the sole condition for salvation (Sufi, Bhakti-marga), stressing the importance of inwardness, of love or faith, to the exclusion of good works.

Paul waged a passionate battle against the power of law and proclaimed instead the religion of grace. Law, he claimed, cannot conquer sin, nor can righteousness be attained through works of law. A man is justified "by faith without the deeds of the law."

That salvation is attained by faith alone was Luther's central thesis. The antinomian tendency resulted in the overemphasis of love and faith to the exclusion of good works.

The Formula of Concord of 1580, still valid in Protestantism, condemns the statement that good works are necessary to salvation and rejects the doctrine that they are harmful to salvation. According to Ritschl, the doctrine of the merit of good deeds is an intruder in the domain of Christian theology; the only way of salvation is justification by faith. Barth, following Kierkegaard, voices Lutheran thoughts, when he claims that man's deeds are too sinful to be good. There are fundamentally no human deeds, which, because of their significance

in this world, find favor in God's eyes. God can be approached through God alone.

## The Error of Formalism

In trying to show that justice is not identical with our predilection or disposition, that it is independent of our interest and consent, we should not commit the common error of confounding the relation of man to justice with the relation of justice to man. For although it is true that we ought to do justice for its own sake, justice itself is for the sake of man. To define justice as that which is worth doing for its own sake is to define the motive, not the purpose. It is just the opposite: the good, unlike play, is never done for its own sake, but for a purpose. To think otherwise is to make an idol of an ideal; it is the beginning of fanaticism. Defining the good by the motive alone, equalizing the good with the good intention and ignoring the purpose and substance of the good action, is a half-truth.

Those who have only paid attention to the relation of man to the ideals, disregarding the relation of the ideals to man, have in their theories seen only the motive but not the purpose of either religion or morality. Echoing the Paulinian doctrine that man is saved by faith alone, Kant and his disciples taught that the essence of religion or morality would consist in an absolute quality of the soul or the will, regardless of the actions that may come out of it or the ends that may be attained. Accordingly, the value of a religious act would be determined wholly by the intensity of one's faith or by the rectitude of one's inner disposition. The intention, not the deed, the *how*, not the *what* of one's conduct, would be essential, and no motive other than the sense of duty would be of any moral value. Thus acts of kindness, when not dictated by the sense of duty, are no better than cruelty, and compassion or regard for human happiness as such is looked upon as an ulterior motive. "I would not break my word even to save mankind!" exclaimed Fichte. His salvation and righteousness were apparently so much more important to him than the fate of all men that he would have destroyed mankind to save himself. Does not such an attitude illustrate the truth of the proverb, "The road to hell is paved with good intentions"? Should we not say that a concern with one's own salvation and righteousness that outweighs the regard for the welfare of one human being cannot be qualified as a good intention?

Judaism stresses the relevance of human deeds. It refuses to accept the principle that under all circumstances the intention determines the deed. However, the absence of the right intention does not necessarily vilify the goodness of a deed of charity. The good deeds of any man, to whatever nation or religion he may belong, even when done by a person who has never been reached by a prophet and who therefore acts on the basis of his own insight, will be rewarded by God.

## No Dichotomy

The cause of nearly all failures in human relations is this—that while we admire and extol the tasks, we fail to acquire the tools. Neither the naked hand nor the soul left to itself can effect much. It is by instruments that work is done. The soul needs them as much as the hand. And as the instruments of the hand either give

motion or guide it, so the instruments of the soul supply either suggestions or cautions. The meaningfulness of the mitsvot consists in their being vehicles by which we advance on the road to spiritual ends.

Faith is not a silent treasure to be kept in the seclusion of the soul, but a mint in which to strike the coin of common deeds. It is not enough to be dedicated in the soul, to consecrate moments in the stillness of contemplation.

The dichotomy of faith and works which presented such an important problem in Christian theology was never a problem in Judaism. To us, the basic problem is neither what is the right action nor what is the right intention. The basic problem is: what is right living? And life is indivisible. The inner sphere is never isolated from outward activities. Deed and thought are bound into one. All a person thinks and feels enters everything he does, and all he does is involved in everything he thinks and feels.

Spiritual aspirations are doomed to failure when we try to cultivate deeds at the expense of thoughts or thoughts at the expense of deeds. Is it the artist's inner vision or his wrestling with the stone that brings about a work of sculpture? Right living is like a work of art, the product of a vision and of a wrestling with concrete situations.

Judaism is averse to generalities, averse to looking for meaning in life detached from doing, as if the meaning were a separate entity. Its tendency is to make ideas convertible into deeds, to interpret metaphysical insights as patterns for action, to endow the most sublime principles with bearing upon everyday conduct. In its tradition, the abstract became concrete, the absolute historic. By enacting the holy on the stage of concrete living, we perceive our kinship with the divine, the presence of the divine. What cannot be grasped in reflection, we comprehend in deeds.

## Spirituality Is Not the Way

The world needs more than the secret holiness of individual inwardness. It needs more than sacred sentiments and good intentions. God asks for the heart because He needs the lives. It is by lives that the world will be redeemed, by lives that beat in concordance with God, by deeds that outbeat the finite charity of the human heart.

Man's power of action is less vague than his power of intention. And an action has intrinsic meaning; its value to the world is independent of what it means to the person performing it. The act of giving food to a helpless child is meaningful regardless of whether or not the moral intention is present. God asks for the heart, and we must spell our answer in terms of deeds.

It would be a device of conceit, if not presumption, to insist that purity of the heart is the exclusive test of piety. Perfect purity is something we rarely know how to obtain or how to retain. No one can claim to have purged all the dross even from his finest desire. The self is finite, but selfishness is infinite.

God asks for the heart, but the heart is oppressed with uncertainty in its own twilight. God asks for faith, and the heart is not sure of its own faith. It is good that there is a dawn of decision for the night of the heart; deeds to objectify faith, definite forms to verify belief.

The heart is often a lonely voice in the marketplace of living. Man may entertain lofty ideals and behave like the ass that, as the saying goes, "carries gold and eats thistles." The problem of the soul is how to live nobly in an animal environment; how to persuade and train the tongue and the senses to behave in agreement with the insights of the soul.

The integrity of life is not exclusively a thing of the heart; it implies more than consciousness of the moral law. The innermost chamber must be guarded at the uttermost outposts. Religion is not the same as spiritualism; what man does in his concrete, physical existence is directly relevant to the divine. Spirituality is the goal, not the way of man. In this world music is played on physical instruments, and to the Jew the mitsvot are the instruments on which the holy is carried out. If man were only mind, worship in thought would be the form in which to commune with God. But man is body and soul, and his goal is so to live that both "his heart and his flesh should sing to the living God."

## Autonomy and Heteronomy

But how do we know what the right deeds are? Is the knowledge of right and wrong to be derived by reason and conscience alone?

There are those who are ready to discard the message of the divine commands and call upon us to rely on our conscience. Man, we are told, is only under obligation to act in conformity with his reason and conscience, and must not be subjected to any laws except those which he imposes upon himself. Moral laws are attainable by reason and conscience, and there is no need for a lawgiver. God is necessary merely as a guarantee for the ultimate triumph of the moral effort.

The fallacy of the doctrine of autonomy is in equating man with "the good drive," and all of his nature with reason and conscience. Man's capacity for love and self-denial ("the good drive") does not constitute the totality of his nature. He is also inclined to love success, to adore the victors and to despise the vanquished. Those who call upon us to rely on our inner voice fail to realize that there is more than one voice within us, that the power of selfishness may easily subdue the pangs of conscience. The conscience, moreover, is often celebrated for what is beyond its ability. The conscience is not a legislative power, capable of teaching us what we ought to do but rather a preventive agency; a brake, not a guide; a fence, not a way. It raises its voice after a wrong deed has been committed, but often fails to give us direction in advance of our actions.

The individual's insight alone is unable to cope with all the problems of living. It is the guidance of tradition on which we must rely, and whose norms we must learn to interpret and to apply. We must learn not only the ends but also the means by which to realize the ends; not only the general laws but also the particular forms.

Judaism calls upon us to listen *not only* to the voice of the conscience but also to the norms of a heteronomous law. The good is not an abstract idea but a commandment, and the ultimate meaning of its fulfillment is in its being *an answer* to God.

## The Law

Man had to be expelled from the Garden of Eden; he had to witness the murder of half of the human species by Cain out of envy; experience the catastrophy of the Flood; the confusion of the languages; slavery in Egypt and the wonder of the Exodus, to be ready to accept the law.

We believe that the Jew is committed to a divine law; that the ultimate standards are beyond man rather than within man. We believe that there is a law, the essence of which is derived from prophetic events, and the interpretation of which is in the hands of the sages.

We are taught that God gave man not only life but also a law. The supreme imperative is not merely to believe in God but to do the will of God. The classical code, *Turim*, begins with the words of Judah ben Tema: "Be bold as a leopard, light as an eagle, swift as a deer, and strong as a lion *to do* the will of your Father who is in heaven."

What is *law*? A way of dealing with the most difficult of all problems: life. The law is a problem to him who thinks that life is a commonplace. *The law is an answer* to him who knows that *life is a problem.*

In Judaism allegiance to God involves a commitment to Jewish law, to a discipline, to specific obligations. These terms, against which modern man seems to feel an aversion, are in fact a part of civilized living. Every one of us who acknowledges allegiance to the state of which he is a citizen is committed to its law, and accepts the obligations it imposes upon him. His loyalty will on occasion prompt him to do even more than mere allegiance would demand. Indeed, the word loyalty is derived from the same root as legal, *ligo* which means "to be bound." Similarly, the word obligation comes from the Latin *obligo*, to bind, and denotes the state of being bound by a legal or moral tie.

The object of the prophets was to guide and to demand, not only to console and to reassure. Judaism is meaningless as an optional attitude to be assumed at our convenience. To the Jewish mind life is a complex of obligations, and the fundamental category of Judaism is *a demand* rather than *a dogma*, a *commitment* rather than a feeling. *God's will* stands higher than *man's creed*. Reverence for the authority of the law is an expression of our love for God.

However, beyond His will is His love. The Torah was given to Israel as a sign of His love. To reciprocate that love we strive to attain *ahavat Torah*.

A degree of self-control is the prerequisite for creative living. Does not a work of art represent the triumph of form over inchoate matter? Emotion controlled by an idea? We suffer from the illusion of being mature as well as from a tendency to overestimate the degree of human perfectibility. No one is mature unless he has learned to be engaged in pursuits which require discipline and self-control, and human perfectibility is contingent upon the capacity for self-control.

When the mind is sore from bias and presumption, from its inability to halt the stream of overflowing vanity, from the imagination clawing in darkness toward silliness and sin, man begins to bless the Lord for the privilege of serving in faith and in agreement with His will. Time is never idle; life is running out; but the law takes us by our hand and leads us home to an order of eternity.

There are positive as well as negative mitsvot, actions as well as abstentions. Indeed, the sense for the holy is often expressed in terms of restrictions,

just as the mystery of God is conveyed *via negationis*, in *negative theology* which claims we can never say what He is; we can only say what He is not. Inadequate would be our service if it consisted only of rituals and positive deeds which are so faulty and often abortive. Precious as positive deeds are, there are times when the silence of sacred abstentions is more articulate than the language of deeds.

## A Spiritual Order

There is a sure way of missing the meaning of the law by either atomization or generalization, by seeing the parts without the whole or by seeing the whole without the parts.

It is impossible to understand the significance of single acts, detached from the total character of a life in which they are set. Acts are components of a whole and derive their character from the structure of the whole. There is an intimate relation between all acts and experiences of a person. Yet just as the parts are determined by the whole, the whole is determined by the parts. Consequently, the amputation of one part may affect the integrity of the entire structure, unless that part has outlived its vital role in the organic body of the whole.

Some people are so occupied collecting shreds and patches of the law, that they hardly think of weaving the pattern of the whole; others are so enchanted by the glamor of generalities, by the image of ideals, that while their eyes fly up, their actions remain below.

What we must try to avoid is not only the failure to observe a single mitsvah, but the loss of the whole, the loss of belonging to the spiritual order of Jewish living. The order of Jewish living is meant to be, not a set of rituals but an order of all man's existence, shaping all his traits, interests, and dispositions; not so much the performance of single acts, the taking of a step now and then, as the pursuit of a way, being on the way; not so much the acts of fulfilling as the state of being committed to the task, the belonging to an order in which single deeds, aggregates of religious feeling, sporadic sentiments, moral episodes become a part of a complete pattern.

It is a distortion to reduce Judaism to a cult or system of ceremonies. The Torah is both the detail and the whole. As time and space are presupposed in any perception, so is the totality of life implied in every act of piety. There is an objective coherence that holds all episodes together. A man may commit a crime now and teach mathematics effortlessly an hour later. But when a man prays, all he has done in his life enters his prayer.

# THOMAS MERTON

Thomas Merton (1915–68) was a Trappist monk whose autobiographical and spiritual writings have been read by a wide swath of readers, Catholic and non-Catholic alike. Beginning in the mid-1940s, Merton published

numerous books that treated themes of Catholic sacramentalism, asceticism, and contemplation, as well as works that focused on social and political matters, such as war and violence. He also became deeply interested in Zen Buddhism and engaged with a number of monks and other religious leaders in Asia toward the end of his life. This excerpt, from *New Seeds of Contemplation* (1961), describes the practice of contemplative prayer.

## *From* New Seeds of Contemplation

### WHAT IS CONTEMPLATION?

Contemplation is the highest expression of man's intellectual and spiritual life. It is that life itself, fully awake, fully active, fully aware that it is alive. It is spiritual wonder. It is spontaneous awe at the sacredness of life, of being. It is gratitude for life, for awareness and for being. It is a vivid realization of the fact that life and being in us proceed from an invisible, transcendent and infinitely abundant Source. Contemplation is, above all, awareness of the reality of that Source. It *knows* the Source, obscurely, inexplicably, but with a certitude that goes both beyond reason and beyond simple faith. For contemplation is a kind of spiritual vision to which both reason and faith aspire, by their very nature, because without it they must always remain incomplete. Yet contemplation is not vision because it sees "without seeing" and knows "without knowing." It is a more profound depth of faith, a knowledge too deep to be grasped in images, in words or even in clear concepts. It can be suggested by words, by symbols, but in the very moment of trying to indicate what it knows the contemplative mind takes back what it has said, and denies what it has affirmed. For in contemplation we know by "unknowing." Or, better, we know *beyond* all knowing or "unknowing."

Poetry, music and art have something in common with the contemplative experience. But contemplation is beyond aesthetic intuition, beyond art, beyond poetry. Indeed, it is also beyond philosophy, beyond speculative theology. It resumes, transcends and fulfils them all, and yet at the same time it seems, in a certain way, to supersede and to deny them all. Contemplation is always beyond our own knowledge, beyond our own light, beyond systems, beyond explanations, beyond discourse, beyond dialogue, beyond our own self. To enter into the realm of contemplation one must in a certain sense die: but this death is in fact the entrance into a higher life. It is a death for the sake of life, which leaves behind all that we can know or treasure as life, as thought, as experience, as joy, as being.

And so contemplation seems to supersede and to discard every other form of intuition and experience—whether in art, in philosophy, in theology, in liturgy or in ordinary levels of love and of belief. This rejection is of course only apparent. Contemplation is and must be compatible with all these things, for it is their highest fulfilment. But in the actual experience of contemplation all other experiences are momentarily lost. They "die" to be born again on a higher level of life.

In other words, then, contemplation reaches out to the knowledge and even to the experience of the transcendent and inexpressible God. It knows God by seeming to touch Him. Or rather it knows Him as if it had been invisibly touched by Him. . . . Touched by Him who has no hands, but who is pure Reality and the source of all that is real! Hence contemplation is a sudden gift of awareness, an awakening to the Real within all that is real. A vivid awareness of infinite Being at the roots of our own limited being. An awareness of our contingent reality as received, as a present from God, as a free gift of love. This is the existential contact of which we speak when we use the metaphor of being "touched by God."

Contemplation is also the response to a call: a call from Him who has no voice, and yet who speaks in everything that is, and who, most of all, speaks in the depths of our own being: for we ourselves are words of His. But we are words that are meant to respond to Him, to answer to Him, to echo Him, and even in some way to contain Him and signify Him. Contemplation is this echo. It is a deep resonance in the inmost centre of our spirit in which our very life loses its separate voice and re-sounds with the majesty and the mercy of the Hidden and Living One. He answers Himself in us and this answer is divine life, divine creativity, making all things new. We ourselves become His echo and His answer. It is as if in creating us God asked a question, and in awakening us to contemplation He answered the question, so that the contemplative is, at the same time, question and answer.

The life of contemplation implies two levels of awareness: first, awareness of the question, and second, awareness of the answer. Though these are two distinct and enormously different levels, yet they are in fact an awareness of the same thing. The question is, itself, the answer. And we ourselves are both. But we cannot know this until we have moved into the second kind of awareness. We awaken, not to find an answer absolutely distinct from the question, but to realize that the question is its own answer. And all is summed up in one awareness—not a proposition, but an experience: "I Am."

The contemplation of which I speak here is not philosophical. It is not the static awareness of metaphysical essences apprehended as spiritual objects, unchanging and eternal. It is not the contemplation of abstract ideas. It is the religious apprehension of God, through my life in God, or through "sonship" as the New Testament says. "For whoever are led by the Spirit of God, they are the sons of God. . . . The Spirit Himself gives testimony to our own spirit that we are the sons of God." "To as many as received Him He gave the power to become the sons of God. . . ." And so the contemplation of which I speak is a religious and transcendent gift. It is not something to which we can attain alone, by intellectual effort, by perfecting our natural powers. It is not a kind of self-hypnosis, resulting from concentration on our own inner spiritual being. It is

not the fruit of our own efforts. It is the gift of God who, in His mercy, completes the hidden and mysterious work of creation in us by enlightening our minds and hearts, by awakening in us the awareness that we are words spoken in His One Word, and that Creating Spirit (*Creator Spiritus*) dwells in us, and we in Him. That we are "in Christ" and that Christ lives in us. That the natural life in us has been completed, elevated, transformed and fulfilled in Christ by the Holy Spirit. Contemplation is the awareness and realization, even in some sense *experience*, of what each Christian obscurely believes: "It is now no longer I that live but Christ lives in me."

Hence contemplation is more than a consideration of abstract truths about God, more even than affective meditation on the things we believe. It is awakening, enlightenment and the amazing intuitive grasp by which love gains certitude of God's creative and dynamic intervention in our daily life. Hence contemplation does not simply "find" a clear idea of God and confine Him within the limits of that idea, and hold Him there as a prisoner to whom it can always return. On the contrary, contemplation is carried away by Him into His own realm, His own mystery and His own freedom. It is a pure and a virginal knowledge, poor in concepts, poorer still in reasoning, but able, by its very poverty and purity, to follow the Word "wherever He may go." . . .

## WE ARE ONE MAN

One of the paradoxes of the mystical life is this: that *a man cannot enter into the deepest centre of himself and pass through that centre into God, unless he is able to pass entirely out of himself and empty himself and give himself to other people in the purity of a selfless love.*

And so one of the worst illusions in the life of contemplation would be to try to find God by barricading yourself inside your own soul, shutting out all external reality by sheer concentration and will-power, cutting yourself off from the world and other men by stuffing yourself inside your own mind and closing the door like a turtle.

Fortunately most of the men who try this sort of thing never succeed. For self-hypnotism is the exact opposite of contemplation. We enter into possession of God when He invades all our faculties with His light and His infinite fire. We do not "possess" Him until He takes full possession of us. But this business of doping your mind and isolating yourself from everything that lives merely deadens you. How can fire take possession of what is frozen?

The more I become identified with God, the more will I be identified with all the others who are identified with Him. His Love will live in all of us. His Spirit will be our One Life, the Life of all of us and Life of God. And we shall love one another and God with the same Love with which He loves us and Himself. This love is God Himself.

Christ prayed that all men might become One as He was One with His Father, in the Unity of the Holy Spirit. Therefore when you and I become what we are really meant to be, we will discover not only that we love one another perfectly but that we are both living in Christ and Christ in us, and we are all One Christ. We will see that it is He who loves in us.

The ultimate perfection of the contemplative life is not a heaven of separate individuals, each one viewing his own private intuition of God; it is a sea of Love which flows through the One Body of all the elect, all the angels and saints, and their contemplation would be incomplete if it were not shared, or if it were shared with fewer souls, or with spirits capable of less vision and less joy.

I will have more joy in heaven and in the contemplation of God, if you are also there to share it with me; and the more of us there will be to share it the greater will be the joy of all. For contemplation is not ultimately perfect unless it is shared. We do not finally taste the full exultation of God's glory until we share His infinite gift of it by overflowing and transmitting glory all over heaven, and seeing God in all the others who are there, and knowing that He is the Life of all of us and that we are all One in Him.

Even on earth it is the same, but in obscurity. This unity is something we cannot yet realize and enjoy except in the darkness of faith. But even here the more we are one with God the more we are united with one another; and the silence of contemplation is deep, rich and endless society, not only with God but with men. The contemplative is not isolated in himself, but liberated from his external and egotistic self by humility and purity of heart—therefore there is no longer any serious obstacle to simple and humble love of other men.

The more we are alone with God the more we are with one another, in darkness, yet a multitude. And the more we go out to one another in work and activity and communication, according to the will and charity of God, the more we are multiplied in Him and yet we are in solitude.

The more we are alone, the more we are together; and the more we are in society, the true society of charity, not of cities and crowds, the more we are alone with Him. For in my soul and in your soul I find the same Christ who is our Life, and He finds Himself in our love, and together we all find Paradise, which is the sharing of His Love for His Father in the Person of Their Spirit.

My true personality will be fulfilled in the Mystical Christ in this one way above all, that through me Christ and His Spirit will be able to love you and all men and God the Father in a way that would be possible in no one else.

Love comes out of God and gathers us to God in order to pour itself back into God through all of us and bring us all back to Him on the tide of His own infinite mercy.

So we all become doors and windows through which God shines back into His own house.

When the Love of God is in me, God is able to love you through me and you are able to love God through me. If my soul were closed to that love, God's love for you and your love for God and God's love for Himself in you and in me would be denied the particular expression which it finds through me and through no other.

Because God's love is in me, it can come to you from a different and special direction that would be closed if He did not live in me, and because His love is in you, it can come to me from a quarter from which it would not otherwise come. And because it is in both of us, God has greater glory. His love is expressed in two more ways in which it would not otherwise be expressed; that is, in two more joys that could not exist without Him.

Let us live in this love and this happiness, you and I and all of us, in the love of Christ and in contemplation, for this is where we find ourselves and one an-

other as we truly are. It is only in this love that we at last become real. For it is here that we most truly share the life of One God in Three Persons.

God in His Trinity of subsistent relations infinitely transcends every shadow of selfishness. For the One God does not subsist apart and alone in His Nature; He subsists as Father and as Son and as Holy Ghost. These Three Persons are one, but apart from them God does not subsist also as One. He is not Three Persons *plus* one nature, therefore four! He is Three Persons, but One God. He is at once infinite solitude (one nature) and perfect society (Three Persons). One Infinite Love in three subsistent relations.

The One God who exists only in Three Persons is a circle of relations in which His infinite reality, Love, is ever identical and ever renewed, always perfect and always total, always beginning and never ending, absolute, everlasting and full.

In the Father the infinite Love of God is always beginning and in the Son it is always full and in the Holy Spirit it is perfect and it is renewed and never ceases to rest in its everlasting source. But if you follow Love forward and backward from Person to Person, you can never track it to a stop, you can never corner it and hold it down and fix it to one of the Persons as if He could appropriate to Himself the fruit of the love of the others. For the One Love of the Three Persons is an infinitely rich giving of Itself which never ends and is never taken, but is always perfectly given, only received in order to be perfectly shared.

It is because the Love of God does not terminate in one self-sufficient *self* that is capable of halting and absorbing it, that the Life and Happiness of God are absolutely infinite and perfect and inexhaustible. Therefore in God there can be no selfishness, because the Three Selves of God are Three subsistent relations of selflessness, overflowing and superabounding in joy in the Gift of their One Life.

The interior life of God is perfect contemplation. Our joy and our life are destined to be nothing but a participation in the Life that is Theirs. In Them we will one day live entirely in God and in one another as the Persons of God live in one another.

## A BODY OF BROKEN BONES

You and I and all men were made to find our identity in the One Mystical Christ, in whom we all complete one another "unto a perfect man, unto the measure of the age of the fulness of Christ."

When we all reach that perfection of love which is the contemplation of God in His glory, our inalienable personalities, while remaining eternally distinct, will nevertheless combine into One so that each one of us will find himself in all the others, and God will be the life and reality of all. *Omnia in omnibus Deus*.

God is a consuming Fire. He alone can refine us like gold, and separate us from the slag and dross of our selfish individualities to fuse us into this wholeness of perfect unity that will reflect His own Triune Life forever.

As long as we do not permit His love to consume us entirely and to unite us in Himself, the gold that is in us will be hidden by the rock and dirt which keep us separate from one another.

As long as we are not purified by the love of God and transformed into Him in the union of pure sanctity, we will remain apart from one another, opposed to one another, and union among us will be a precarious and painful thing, full of labour and sorrow and without lasting cohesion.

In the whole world, throughout the whole of history, even among religious men and among saints, Christ suffers dismemberment.

His physical Body was crucified by Pilate and the Pharisees; His mystical Body is drawn and quartered from age to age by the devils in the agony of that disunion which is bred and vegetates in our souls, prone to selfishness and to sin.

All over the face of the earth the avarice and lust of men breed unceasing divisions among them, and the wounds that tear men from union with one another widen and open out into huge wars. Murder, massacres, revolution, hatred, the slaughter and torture of the bodies and souls of men, the destruction of cities by fire, the starvation of millions, the annihilation of populations and finally the cosmic inhumanity of atomic war: Christ is massacred in His members, torn limb from limb; God is murdered in men.

The history of the world, with the material destruction of cities and nations and people, expresses the interior division that tyrannizes the souls of all men, and even of the saints.

Even the innocent, even those in whom Christ lives by charity, even those who want with their whole heart to love one another, remain divided and separate. Although they are already one in Him, their union is hidden from them, because it still only possesses the secret substance of their souls.

But their minds and their judgments and their desires, their human characters and faculties, their appetites and their ideals are all imprisoned in the slag of an inescapable egotism which pure love has not yet been able to refine.

As long as we are on earth, the love that unites us will bring us suffering by our very contact with one another, because this love is the resetting of a Body of broken bones. Even saints cannot live with saints on this earth without some anguish, without some pain at the differences that come between them.

There are two things which men can do about the pain of disunion with other men. They can love or they can hate.

Hatred recoils from the sacrifice and the sorrow that are the price of this resetting of bones. It refuses the pain of reunion.

There is in every weak, lost and isolated member of the human race an agony of hatred born of his own helplessness, his own isolation. Hatred is the sign and the expression of loneliness, of unworthiness, of insufficiency. And in so far as each one of us is lonely, is unworthy, each one hates himself. Some of us are aware of this self-hatred, and because of it we reproach ourselves and punish ourselves needlessly. Punishment cannot cure the feeling that we are unworthy. There is nothing we can do about it as long as we feel that we are isolated, insufficient, helpless, alone. Others, who are less conscious of their own self-hatred, realize it in a different form by projecting it on to others. There is a proud and self-confident hate, strong and cruel, which enjoys the pleasure of hating, for it is directed outward to the unworthiness of another. But this strong and happy hate does not realize that, like all hate, it destroys and consumes the self that hates, and not the object that is hated. Hate in any form is

self-destructive, and even when it triumphs physically it triumphs in its own spiritual ruin.

Strong hate, the hate that takes joy in hating, is strong because it does not believe itself to be unworthy and alone. It feels the support of a justifying God, of an idol of war, an avenging and destroying spirit. From such blood-drinking gods the human race was once liberated, with great toil and terrible sorrow, by the death of a God who delivered Himself to the Cross and suffered the pathological cruelty of His own creatures out of pity for them. In conquering death He opened their eyes to the reality of a love which asks no questions about worthiness, a love which overcomes hatred and destroys death. But men have now come to reject this divine revelation of pardon, and they are consequently returning to the old war gods, the gods that insatiably drink blood and eat the flesh of men. It is easier to serve the hate-gods because they thrive on the worship of collective fanaticism. To serve the hate-gods, one has only to be blinded by collective passion. To serve the God of Love one must be free, one must face the terrible responsibility of the decision to love *in spite of all unworthiness* whether in oneself or in one's neighbour.

It is the rankling, tormenting sense of unworthiness that lies at the root of all hate. The man who is able to hate strongly and with a quiet conscience is one who is complacently blind to all unworthiness in himself and serenely capable of seeing all his own wrongs in someone else. But the man who is aware of his own unworthiness and the unworthiness of his brother is tempted with a subtler and more tormenting kind of hate: the general, searing, nauseating hate of everything and everyone, because everything is tainted with unworthiness, everything is unclean, everything is foul with sin. What this weak hate really is, is weak love. He who cannot love feels unworthy, and at the same time feels that somehow *no one* is worthy. Perhaps he cannot feel love because he thinks he is unworthy of love, and because of that he also thinks no one else is worthy.

The beginning of the fight against hatred, the basic Christian answer to hatred, is not the commandment to love, but what must necessarily come before in order to make the commandment bearable and comprehensible. It is a prior commandment *to believe.* The root of Christian love is not the will to love, but *the faith that one is loved.* The faith that one is loved *by God.* That faith that one is loved by God although unworthy—or, rather, irrespective of one's worth!

In the true Christian vision of God's love, the idea of worthiness loses its significance. Revelation of the mercy of God makes the whole problem of worthiness something almost laughable: the discovery that worthiness is of no special consequence (since no one could ever, by himself, be strictly worthy to be loved with such a love) is a true liberation of the spirit. And until this discovery is made, until this liberation has been brought about by the divine mercy, man is imprisoned in hate.

Humanistic love will not serve. As long as we believe that we hate no one, that we are merciful, that we are kind by our very nature, we deceive ourselves; our hatred is merely smouldering under the grey ashes of complacent optimism. We are apparently at peace with everyone because we think we are worthy. That is to say we have lost the capacity to face the question of unworthiness at all. But when we are delivered by the mercy of God the question no longer has a meaning.

Hatred tries to cure disunion by annihilating those who are not united with us. It seeks peace by the elimination of everybody else but ourselves.

But love, by its acceptance of the pain of reunion, begins to heal all wounds. . . .

## THE WRONG FLAME

In any degree of the spiritual life, and even where there is no spiritual life at all, it can happen that a man will feel himself caught up in an emotional religious ferment in which he overflows with sensible, and even sentimental movements of love for God and other people. If he is completely inexperienced he will get the idea that he is very holy because of the holy feelings that are teeming in his heart.

All these things mean very little or nothing at all. They are a kind of sensible intoxication produced by some pleasure or other, and there is only an accidental difference between them and the tears that children sometimes shed when they go to the movies.

In themselves these movements of passion are indifferent. They can be used for good or evil, and for beginners in the spiritual life they are generally necessary. But even a beginner would be foolish to depend on them, because sooner or later he will have to do without them. In fact, his spiritual life will not really begin until he has learned in some measure to get along without the stimulus of emotion.

Even when we enter into the contemplative life we still carry our passions and our sensible nature along with us like a store of unprotected gasoline. And sometimes the sparks that fly in the pure darkness of contemplation get into that fuel by accident and start a blaze in the emotions and the senses.

The whole spirit is rocked and reels in an explosion of drunken joy or a storm of compunction which may be good and healthy, but which is still more or less animal, even though the spark that started the fire may have had a supernatural origin.

This blaze flares up and burns out in a few moments, or a half an hour. Whilst it lasts, you taste an intense pleasure which is sometimes deceptively lofty. But this joy occasionally betrays itself by a certain heaviness that belongs to the sensual level and marks it for what it is: crude emotion. Sometimes it may even produce a good natural effect. A burst of spiritual exuberance can tone you up on a feast day, after weeks of struggle and labour. But generally the effect of this commotion is no better than natural. When it is all over you have no more profit than you might have got from a couple of glasses of champagne or a good swim. So to that extent it is a good thing.

But the danger is that you will attach the wrong kind of importance to these manifestations of religious emotion. Really they are not important at all, and although sometimes they are unavoidable, it does not seem prudent to desire them. And as a matter of fact, everyone who has received any kind of training in the interior life knows that it is not considered good sense to go after these consolations with too heavy an intensity of purpose. Nevertheless, many of those who seem to be so superior to the sensible element in religion show, by their devotions, their taste for sentimental pictures and sticky music and mushy spiri-

tual reading, that their whole interior life is a concentrated campaign for "lights" and "consolations" and "tears of compunction," if not "interior words" with, perhaps, the faintly disguised hope of a vision or two and, eventually, the stigmata.

For anyone who is really called to infused contemplation this taste for "experience" can be one of the most dangerous obstacles in his interior life. It is the rock on which many who might have become contemplatives have ended in shipwreck. And it is all the more dangerous because even in the houses of contemplative orders people do not always clearly understand the difference between mystical contemplation in the proper sense and all these accidentals, these experiences, these manifestations and curiosities, which may or may not be supernatural, and which have no essential connection with sanctity or with the pure love which is at the heart of true contemplation.

Therefore the healthiest reaction to these outbursts is an obscure repugnance for the pleasures and the excitements they bring. You recognize that these things offer no real fruit and no lasting satisfaction. They tell you nothing reliable about God or about yourself. They give you no real strength, only the momentary illusion of holiness. And when you grow more experienced, how much they blind you and how capable they are of deceiving you and leading you astray.

You will try to withdraw from them and to avoid the occasions that bring them on, if you can tell what might be likely to bring them on. But you will not upset yourself by offering a violent resistance; it is enough to remain peacefully indifferent toward them.

And when there is nothing you can do to prevent these feelings of inebriation and spiritual joy you accept them with patience and with reserve and even with a certain humility and thankfulness, realizing that you would not suffer such excitements if there were not so much natural steam left in you. You withdraw your consent from anything that may be inordinate about them, and leave the rest to God, waiting for the hour of your deliverance into the real joys, the purely spiritual joys of a contemplation in which your nature and your emotions and your own selfhood no longer run riot, but in which you are absorbed and immersed, not in this staggering drunkenness of the senses but in the clean, intensely pure intoxication of a spirit liberated in God.

Passion and emotion certainly have their place in the life of prayer—but they must be purified, ordered, brought into submission to the highest love. Then they too can share in the spirit's joy and even, in their own small way, contribute to it. But until they are spiritually mature the passions must be treated firmly and with reserve, even in the "consolations" of prayer. When are they spiritually mature? When they are pure, clean, gentle, quiet, nonviolent, forgetful of themselves, detached and above all when they are humble and obedient to reason and to grace.

## RENUNCIATION

The way to contemplation is an obscurity so obscure that it is no longer even dramatic. There is nothing in it that can be grasped and cherished as heroic or

even unusual. And so, for a contemplative, there is supreme value in the ordinary everyday routine of work, poverty, hardship and monotony that characterize the lives of all the poor, uninteresting and forgotten people in the world.

Christ, who came on earth to form contemplatives and teach men the ways of sanctity and prayer, could easily have surrounded Himself with ascetics who starved themselves to death and terrified the people with strange trances. But His Apostles were workmen, fishermen, publicans who made themselves conspicuous only by their disregard for most of the intricate network of devotions and ceremonial practices and moral gymnastics of the professionally holy.

The surest asceticism is the bitter insecurity and labour and nonentity of the really poor. To be utterly dependent on other people. To be ignored and despised and forgotten. To know little of respectability or comfort. To take orders and work hard for little or no money: it is a hard school, and one which most pious people do their best to avoid.

Nor are they to be entirely blamed. Misery as such, destitution as such, is not the way to contemplative union. I certainly don't mean that in order to be a saint one has to live in a slum, or that a contemplative monastery has to aim at reproducing the kind of life that is lived in tenements. It is not filth and hunger that make saints, nor even poverty itself, but love of poverty and love of the poor.

It is true, however, that a certain degree of economic security is morally necessary to provide a minimum of stability without which a life of prayer can hardly be learned. But "a certain degree of economic security" does not mean comfort, the satisfaction of every bodily and psychological need, and a high standard of living. The contemplative needs to be properly fed, clothed and housed. But he also needs to share something of the hardship of the poor. He needs to be able to identify himself honestly and sincerely with the poor, to be able to look at life through their eyes, and to do this because he is really one of them. This is not true unless to some extent he participates in the risk of poverty: that is to say, unless he has to do many jobs he would rather not do, suffer many inconveniences with patience, and be content with many things that could be a great deal better.

Many religious people, who say they love God, detest and fear the very thought of a poverty that is real enough to mean insecurity, hunger, dirt. And yet you will find men who go down and live among the poor not because they love God (in whom they do not believe) or even because they love the poor, but simply because they hate the rich and want to stir up the poor to hate the rich too. If men can suffer these things for the venomous pleasure of hatred, why do so few become poor out of love, in order both to find God in poverty and give Him to other men?

Nevertheless it must not be thought that no man can become a contemplative unless his whole life is always externally miserable and disgusting. To live frugally and laboriously, depending on God and not on material things which we no longer have, and doing our best to get along with other people who do not, perhaps, treat us with uniform kindness and consideration, all this may add up to an atmosphere of peace and tranquillity and contentment and joy. There may even be a certain natural comeliness about it, and in fact the simplicity of a life of work and poverty can at times be more beautiful than the elaborate life of those who think their money can buy them beauty and surround them with

pleasant things. Anybody who has been in the house of a French or Italian peasant knows that much.

Life in a Trappist monastery is fundamentally peasant life. The closer it conforms to the poverty and frugality and simplicity of those who have to dig their living out of the land, the more it fulfils its essential purpose, which is to dispose men for contemplation.

It is good for a monastery to be poor. It is good for the monks to have to be content with clothes that are worn very thin and covered with patches and to have to depend on their fields more than on Mass-stipends and the gifts of benefactors. However, there is a limit beyond which poverty in a monastery ought not to go. Destitution is not good for monks or for anybody else. You cannot be expected to lead the contemplative life if you are always ill, or starving to death and crushed by the physical struggle to keep body and soul together. And though it may be good for a monastery to be poor, the average monk will not prosper spiritually in a house where the poverty is really so desperate that everything else has to be sacrificed to manual labour and material cares.

It often happens that an old brother who has spent his life making cheese or baking bread or repairing shoes or driving a team of mules is a greater contemplative and more of a saint than a priest who has absorbed all Scripture and Theology and knows the writings of great saints and mystics and has had more time for meditation and contemplation and prayer.

But, although this may be quite true—and indeed it is so familiar that it has become a cliché—it must not make us forget that learning has an important part to play in the contemplative life. Nor should it make us forget that the work of the intellect, properly carried out, is itself a school of humility. The cliché about the "old brother making cheese" in contrast to the "proud intellectual priest" has often been used as an excuse to contemn and to evade the necessary effort of theological study. It is all very well to have many men in monasteries who are humbly dedicated to manual labour: but if they are also and at the same time learned men and theologians, this very fact may make their humility and their participation in manual work all the more significant.

Humility implies, first of all, a dedicated acceptance of one's duty in life. It is not humility for a priest who should know his theology to neglect study and render himself incapable of advising and guiding others, under the pretext of remaining humble and simple. Indeed, one sometimes finds in contemplatives a kind of pride in being unlearned, an intellectual snobbery turned inside out, a self-complacent contempt for theology, as if the mere fact of *not* knowing much of anything automatically raised one to the status of a contemplative.

Contemplation, far from being opposed to theology, is in fact the normal perfection of theology. We must not separate intellectual study of divinely revealed truth and contemplative experience of that truth as if they could never have anything to do with one another. On the contrary they are simply two aspects of the same thing. Dogmatic and mystical theology, or theology and "spirituality" are not to be set apart in mutually exclusive categories, as if mysticism were for saintly women and theological study were for practical but, alas, unsaintly men. This fallacious division perhaps explains much that is actually lacking both in theology and in spirituality. But the two belong together, just as

body and soul belong together. Unless they are united, there is no fervour, no life and no spiritual value in theology, no substance, no meaning and no sure orientation in the contemplative life.

One of the first things to learn if you want to be a contemplative is how to mind your own business.

Nothing is more suspicious, in a man who seems holy, than an impatient desire to reform other men.

A serious obstacle to recollection is the mania for directing those you have not been appointed to direct, reforming those you have not been asked to reform, correcting those over whom you have no jurisdiction. How can you do these things and keep your mind at rest? Renounce this futile concern with other men's affairs!

Pay as little attention as you can to the faults of other people and none at all to their natural defects and eccentricities.

The issue on which all sanctity depends is renunciation, detachment, self-denial. But self-denial does not end when we have given up all our deliberate faults and imperfections.

To keep yourself out of obvious sins; to avoid the things that are evidently wrong because they shame and degrade your nature; to perform acts that are universally respected because they are demanded by our very dignity as human beings: all that is not yet sanctity. To avoid sin and practise virtue is not to be a saint, it is only to be a man, a human being. This is only the beginning of what God wants of you. But it is a necessary beginning, because you cannot have supernatural perfection unless you have first (by God's grace) perfected your own nature on its own level. Before you can be a saint you have got to become human. An animal cannot be a contemplative.

However, it is relatively simple to get rid of faults that we recognize as faults—although that too can be terribly hard. But the crucial problem of perfection and interior purity is in the renunciation and uprooting of all our *unconscious* attachments to created things and to our own will and desires.

In fighting deliberate and evident vices a planned strategy of resolutions and penances is the best way—if not the only way. You plan your campaign and fight it out and reshape the plan according to the changes in the aspect of the battle. You pray and suffer and hang on and give things up and hope and sweat, and the varying contours of the struggle work out the shape of your liberty.

When it ends, and when you have a good habit to work with, do not forget the moments of the battle when you were wounded and disarmed and helpless. Do not forget that, for all your efforts, you only won because of God, who did the fighting in you.

But when it comes to fighting the deep and unconscious habits of attachment which we can hardly dig up and recognize, all our meditations, self-examinations, resolutions and planned campaigns may not only be ineffective but may even sometimes lend assistance to our enemies. Because it may easily happen that our resolutions are dictated by the vice we need to get rid of. And so the proud man resolves to fast more and punish his flesh more because he wants to make himself feel like an athlete: his fasts and disciplines are imposed on him by his own vanity, and they strengthen the thing in him that most needs to be killed.

When a man is virtuous enough to be able to delude himself that he is almost perfect, he may enter into a dangerous condition of blindness in which all his violent efforts finally to grasp perfection strengthen his hidden imperfections and confirm him in his attachment to his own judgment and his own will.

In getting the best of our secret attachments—ones which we cannot see because they are principles of spiritual blindness—our own initiative is almost always useless. We need to leave the initiative in the hands of God working in our souls either directly in the night of aridity and suffering, or through events and other men. This is where so many holy people break down and go to pieces. As soon as they reach the point where they can no longer see the way and guide themselves by their own light, they refuse to go any further. They have no confidence in anyone except themselves. Their faith is largely an emotional illusion. It is rooted in their feelings, in their physique, in their temperament. It is a kind of natural optimism that is stimulated by moral activity and warmed by the approval of other men. If people oppose it, this kind of faith still finds refuge in self-complacency.

But when the time comes to enter the darkness in which we are naked and helpless and alone; in which we see the insufficiency of our greatest strength and the hollowness of our strongest virtues, in which we have nothing of our own to rely on, and nothing in our nature to support us, and nothing in the world to guide us or give us light—then we find out whether or not we live by faith.

It is in this darkness, when there is nothing left in us that can please or comfort our own minds, when we seem to be useless and worthy of all contempt, when we seem to have failed, when we seem to be destroyed and devoured, it is then that the deep and secret selfishness that is too close for us to identify is stripped away from our souls. It is in this darkness that we find true liberty. It is in this abandonment that we are made strong. This is the night which empties us and makes us pure.

Do not look for rest in any pleasure, because you were not created for pleasure: you were created for spiritual JOY. And if you do not know the difference between pleasure and spiritual joy you have not yet begun to live.

Life in this world is full of pain. But pain, which is the contrary of pleasure, is not necessarily the contrary of happiness or of joy. Because spiritual joy flowers in the full expansion of freedom that reaches out without obstacle to its supreme object, fulfilling itself in the perfect activity of disinterested love for which it was created.

Pleasure, which is selfish, suffers from everything that deprives us of some good we want to savour for our own sakes. But unselfish joy suffers from nothing but selfishness. Pleasure is restrained and killed by pain and suffering. Spiritual joy ignores suffering or laughs at it or even exploits it to purify itself of its greatest obstacle, selfishness.

True joy is found in the perfect willing of what we were made to will: in the intense and supple and free movement of our will rejoicing in what is good not merely for us but in itself.

Sometimes pleasure can be the death of joy, and so the man who has tasted the true joy is suspicious of pleasure. But anyone who knows true joy is never

afraid of pain because he knows that pain can serve him as another opportunity of asserting—and tasting—his liberty.

And yet do not think that joy turns pleasure inside out and seeks pleasure in pain: joy, in so far as it is true, is above pain and does not feel pain. And that is why it laughs at pain and rejoices in confounding pain. It is the conquest of suffering by disinterestedness, by unselfishness, by perfect love.

Pain cannot touch this highest joy—except to bring it an accidental increase of purity by asserting the soul's freedom from sense and emotion and self-love, and isolating our wills in a clean liberty beyond the level of suffering.

And so it is a very sad thing when contemplatives look for little more than pleasure in their contemplation. That means that they will waste time and exhaust themselves in harmful efforts to avoid aridity, difficulty and pain—as if these things were evils. They lose their peace. And seeking pleasure in their prayer they make themselves almost incapable of joy.

Fickleness and indecision are signs of self-love.

If you can never make up your mind what God wills for you, but are always veering from one opinion to another, from one practice to another, from one method to another, it may be an indication that you are trying to get around God's will and do your own with a quiet conscience.

As soon as God gets you in one monastery you want to be in another.

As soon as you taste one way of prayer, you want to try another. You are always making resolutions and breaking them by counter-resolutions. You ask your confessor and do not remember the answers. Before you finish one book you begin another, and with every book you read you change the whole plan of your interior life.

Soon you will have no interior life at all. Your whole existence will be a patchwork of confused desires and daydreams and velleities in which you do nothing except defeat the work of grace: for all this is an elaborate subconscious device of your nature to resist God, whose work in your soul demands the sacrifice of all that you desire and delight in, and, indeed, of all that you are.

So keep still, and let Him do some work.

This is what it means to renounce not only pleasures and possessions, but even your own self.

# DOROTHY DAY

Dorothy Day (1897–1980) founded the Catholic Worker movement in America. Like Merton, her early years were not religious; she converted to Catholicism in 1927. Having been a socialist committed to workers' rights and a broader program of social justice, she brought this commitment with her into the church, living a life of voluntary poverty in community with those in need. For her work, she would become the most renowned

Catholic laywoman in the United States. This excerpt from her autobio-
graphical account, *The Long Loneliness* (1952), describes the blending of
Catholic spirituality with the commitment to justice that marked her life.

## *From* The Long Loneliness

I felt even at fifteen, that God meant man to be happy, that He meant to provide
him with what he needed to maintain life in order to be happy, and that we did
not need to have quite so much destitution and misery as I saw all around and
read of in the daily press.

From my earliest remembrance the destitute were always looked upon as
the shiftless, the worthless, those without talent of any kind, let alone the ability
to make a living for themselves. They were that way because of their own fault.
They chose their lot. They drank. They were the prodigal sons who were eating
the swines' husks only because they had squandered their inheritance. Since it
was in the Bible it must be so. Even Our Lord Himself said that the poor we
would always have with us. When two brothers were quarreling over an inher-
itance and He was asked to settle it, He refused to enter into the dispute. He
Himself lived a life of poverty and wandering, "with no place to lay His head."
"My Kingdom is not of this world," He said. He evidently wanted people to re-
main as they were and not to concern themselves about the affairs of this
world—that is, the great mass of poor, the workers, to whom He seemed espe-
cially to speak. They were to seek for PIE IN THE SKY.

This is the way my reasoning finally led me. On the one hand there were the
religious people I had come up against in church, and they were few I must ad-
mit, a sparse congregation meeting on Sunday mornings and Wednesday
evenings. They had enough money so that they did not have to bother about the
things of this world.

There were also the worldlings, the tycoons, the people I read about who
piled up fortunes and cornered wheat, and exploited the workers in the stock-
yards. I did not know such people myself, but I knew the rich were smiled at
and fawned upon by churchgoers. This is all that I could see.

Children look at things very directly and simply. I did not see anyone taking
off his coat and giving it to the poor. I didn't see anyone having a banquet and
calling in the lame, the halt and the blind. And those who were doing it, like the
Salvation Army, did not appeal to me. I wanted, though I did not know it then,
a synthesis. I wanted life and I wanted the abundant life. I wanted it for others
too. I did not want just the few, the missionary-minded people like the Salvation
Army, to be kind to the poor, as the poor. I wanted everyone to be kind. I wanted
every home to be open to the lame, the halt and the blind, the way it had been

Dorothy Day, photo-
graph from 1934.
*Courtesy of the Library
of Congress, Prints &
Photographs Division.*

after the San Francisco earthquake. Only then did people really live, really love
their brothers. In such love was the abundant life and I did not have the slight-
est idea how to find it.

One step I made toward it was joining the Socialist party when I went to the
University of Illinois a year later.

As a result of my early morning hours of study I was able to pass an exami-
nation at the end of my high-school course, which brought me a three-hundred-
dollar scholarship, enabling me to go to the university. The Hearst paper in
Chicago sponsored an examination for three pupils from each high school in
Cook County. The twenty highest of these were to receive cash scholarships, to
be paid in installments, first a hundred dollars followed by ten dollars a week
for twenty weeks. Thanks to my knowledge of Greek and Latin, I ranked fif-
teenth in the test and was announced as one of the winners. Out of my one-hun-
dred-dollar check I was able to pay the matriculation fee of ten dollars and the
twelve dollars a semester at the university. There were books to be bought, the
cost of board and room to be considered, and lab fees and gym fees—all manner
of expenses that I had not taken into account—but the nest egg I received made
me feel rich indeed, and by working for my meals I was able to cover expenses.

The paper my father worked on, *The Inter Ocean*, failed that year, and had it
not been for this scholarship, I would not have had two years at the university.

I was happy as a lark at leaving home. I was sixteen and filled with a sense of great independence. I was on my own, and no longer to be cared for by the family. The idea of earning my own living, by my own work, was more thrilling than the idea of an education. Since I did not intend to teach, I had no desire to follow any particular course or to work for a degree. It was experience in general that I wanted. I did not think in terms of philosophy or sociology. I continued the same course I had been taking, Latin, English, history and science. It was not until a few months later, when the novelty of my surroundings wore off, that I suffered from a terrible homesickness which made me go to bed weeping, wake up weeping, and which filled me with a sense of desolation and loneliness. I missed my baby brother, who was by that time two years old and at a most tender and responsive age. He loved me dearly; I had been a mother to him, so that he clung to me and was bone of my bone and flesh of my flesh. I had never loved anyone or anything as I loved him, with a love that was open and unreserved, entailing hardship but bringing also peace and joy. To know that this love was past, that John would grow up away from me, that I could not hold him, that I too had to go on, filled me with a sense of unutterable grief. I had a terrible sense of loss, and yet with it a sense of the inevitability of such losses in our lives. It never occurred to me to turn back, to try to hold onto him and to my life with him. It was a desolation to be worked through, lived through, and even while I suffered I knew that it would pass.

Fortunately I had much work to do. That first semester I worked for my board with a professor of romance languages. I had breakfast at the Y but at lunch time I went to Professor Fitzgerald and ate with the family that consisted of his wife, mother and three children. They were Methodists and delightful people. I used to talk about books with the professor and faith with the old lady as she washed the lunch dishes and prepared vegetables for the evening meal.

But even as I talked about religion I rejected religion. I had read Wesley's sermons and had been inspired by them. I had sung hymns from the Episcopalian hymnal to put little John to sleep. I had read the New Testament with fervor.

But that time was past. I felt so intensely alive that the importance of the here and now absorbed me. The radicalism which I absorbed from *The Day Book* and Jack London, from Upton Sinclair and from the sight of poverty was in conflict with religion, which preached peace and meekness and joy.

Remembering how much I liked the Fitzgeralds, I know I was happy in their religious atmosphere. And yet I scorned the students who were pious. Youth, I felt, should not be in a state of peace, but of war.

I was acutely conscious of the class war while I paid little attention to the war being fought in Europe. We were not yet involved in it. In my reading I must have absorbed a scorn of religion at that time, a consciously critical attitude toward religious people who were so comfortably happy in the face of the injustices in the world.

There was a real conflict going on in me at the time to overcome my religious sense.

As a matter of fact, I started to swear, quite consciously began to take God's name in vain, in order to shock my friends who were churchgoers. I shocked myself as I did it, but I felt that it was a strong gesture I was making to push religion from me. It certainly was a most conscious gesture. Because I was unhappy and rejoiced in my unhappiness, I felt harsh. Because I was hurt at being

torn from my child, my baby brother, I had to turn away from home and faith and all the gentle things of life and seek the hard. In spite of my studies and my work, I had time to read, and the ugliness of life in a world which professed itself to be Christian appalled me.

I was tearing myself away from home, living my own life, and I had to choose the world to which I wanted to belong. I did not want to belong to the Epworth League which some of my classmates joined. As a little child the happy peace of the Methodists who lived next door appealed to me deeply. Now that same happiness seemed to be a disregard of the misery of the world.

While I was free to go to college, I was mindful of girls who worked in stores and factories through their youth and afterward married men who were slaves in those same factories.

The Marxist slogan, "Workers of the world, unite! You have nothing to lose but your chains," seemed to me a most stirring battle cry. It was a clarion call that made me feel one with the masses, apart from the bourgeoisie, the smug, and the satisfied.

The romanticism and the hardness of Jack London in his stories of the road appealed to me more at that time than the idealism of Upton Sinclair, though I still considered, and do to this day, that *The Jungle* was a great novel. But his romantic, realistic novel, *The Mystery of Love*, repelled me so that I discounted his other books. He had not yet written his other great labor novels. (Sinclair had been called the Dickens of the American scene, and he has always been more of a storyteller than a philosopher.)

The Russian writers appealed to me too, and I read everything of Dostoevski, as well as the stories of Gorki and Tolstoi. Both Dostoevski and Tolstoi made me cling to a faith in God, and yet I could not endure feeling an alien in it. I felt that my faith had nothing in common with that of Christians around me.

It seems to me that I was already shedding it when a professor whom I much admired made a statement in class—I shall always remember it—that religion was something which had brought great comfort to people throughout the ages, so that we ought not to criticize it. I do not remember his exact words, but from the way he spoke of religion the class could infer that the strong did not need such props. In my youthful arrogance, in my feeling that I was one of the strong, I felt then for the first time that religion was something that I must ruthlessly cut out of my life.

I felt at the time that religion would only impede my work. I wanted to have nothing to do with the religion of those whom I saw all about me. I felt that I must turn from it as from a drug. I felt it indeed to be an opiate of the people and not a very attractive one, so I hardened my heart. It was a conscious and deliberate process. . . .

## THE EAST SIDE

My first job in New York was on the New York *Call*, a Socialist daily paper whose offices were on Pearl Street, just off Park Row. I had tried other newspapers but without success, in some cases because my father had told his city editor friends to lecture me on the subject of newspaper work for women.

During the months of job hunting, I walked the streets of New York as I had done in Chicago, exploring various neighborhoods, taking bus rides, subway rides, streetcar rides, walking over the bridges that were strung like jewels over the East River, walking along the waterfront (made more alive for me by reading Ernest Poole's *The Harbor*). Because I had determined not to go back to school but to find a newspaper job, I was released somewhat from the care of my brother, and my household tasks fell to my younger sister Della, who before I went to college had been my constant companion.

Two years' separation had made me a grownup and she was still a child. For a time there was a gap in our ages, and I felt alone. Those five months were months of great suffering in my life. During that time I felt the spell of the long loneliness descend on me. In all that great city of seven millions, I found no friends; I had no work; I was separated from my fellows. Silence in the midst of city noises oppressed me. My own silence, the feeling that I had no one to talk to overwhelmed me so that my very throat was constricted; my heart was heavy with unuttered thoughts; I wanted to weep my loneliness away.

The poverty of New York was appallingly different from that of Chicago. The very odors were different. The sight of homeless and workless men lounging on street corners or sleeping in doorways in broad sunlight appalled me. The sight of cheap lodging houses, dingy restaurants, the noise of subways and elevated railways, the clanging of streetcars jarred my senses. Above all the smell from the tenements, coming up from basements and areaways, from dank halls, horrified me. It is a smell like no other in the world and one never can become accustomed to it. I have lived with these smells now for many years, but they will always and ever affront me. I shall never cease to be indignant over the conditions which give rise to them. There is a smell in the walls of such tenements, a damp ooze coming from them in the halls. One's very clothes smell of it. It is not the smell of life, but the smell of the grave.

And yet, as I walked these streets back in 1917 I wanted to go and live among these surroundings; in some mysterious way I felt that I would never be freed from this burden of loneliness and sorrow unless I did. . . .

## LOVE OVERFLOWS

"Thou shalt love the Lord thy God with thy whole heart and with thy whole soul and with thy whole mind." This is the first Commandment.

The problem is, how to love God? We are only too conscious of the hardness of our hearts, and in spite of all that religious writers tell us about *feeling* not being necessary, we do want to feel and so know that we love God.

"Thou wouldst not seek Him if thou hadst not already found Him," Pascal says, and it is true too that you love God if you want to love Him. One of the disconcerting facts about the spiritual life is that God takes you at your word. Sooner or later one is given a chance to prove his love. The very word "diligo," the Latin word used for "love," means "I prefer." It was all very well to love God in His works, in the beauty of His creation which was crowned for me by the birth of my child. Forster had made the physical world come alive for me and had awakened in my heart a flood of gratitude. The final object of this love

and gratitude was God. No human creature could receive or contain so vast a flood of love and joy as I often felt after the birth of my child. With this came the need to worship, to adore. I had heard many say that they wanted to worship God in their own way and did not need a Church in which to praise Him, nor a body of people with whom to associate themselves. But I did not agree to this. My very experience as a radical, my whole make-up, led me to want to associate myself with others, with the masses, in loving and praising God. Without even looking into the claims of the Catholic Church, I was willing to admit that for me she was the one true Church. She had come down through the centuries since the time of Peter, and far from being dead, she claimed and held the allegiance of the masses of people in all the cities where I had lived. They poured in and out of her doors on Sundays and holy days, for novenas and missions. What if they were compelled to come in by the law of the Church, which said they were guilty of mortal sin if they did not go to Mass every Sunday? They obeyed that law. They were given a chance to show their preference. They accepted the Church. It may have been an unthinking, unquestioning faith, and yet the chance certainly came, again and again, "Do I prefer the Church to my own will," even if it was only the small matter of sitting at home on a Sunday morning with the papers? And the choice was the Church.

There was the legislation of the Church in regard to marriage, a stumbling block to many. That was where I began to be troubled, to be afraid. To become a Catholic meant for me to give up a mate with whom I was much in love. It got to the point where it was the simple question of whether I chose God or man. I had known enough of love to know that a good healthy family life was as near to heaven as one could get in this life. There was another sample of heaven, of the enjoyment of God. The very sexual act itself was used again and again in Scripture as a figure of the beatific vision. It was not because I was tired of sex, satiated, disillusioned, that I turned to God. Radical friends used to insinuate this. It was because through a whole love, both physical and spiritual, I came to know God.

From the time Tamar Teresa was born I was intent on having her baptized. There had been that young Catholic girl in the bed next to me at the hospital who gave me a medal of St. Thérèse of Lisieux.

"I don't believe in these things," I told her, and it was another example of people saying what they do not mean.

"If you love someone you like to have something around which reminds you of them," she told me.

It was so obvious a truth that I was shamed. Reading William James' *Varieties of Religious Experience* had acquainted me with the saints, and I had read the life of St. Teresa of Avila and fallen in love with her. She was a mystic and a practical woman, a recluse and a traveler, a cloistered nun and yet most active. She liked to read novels when she was a young girl, and she wore a bright red dress when she entered the convent. Once when she was traveling from one part of Spain to another with some other nuns and a priest to start a convent, and their way took them over a stream, she was thrown from her donkey. The story goes that our Lord said to her, "That is how I treat my friends." And she replied, "And that is why You have so few of them." She called life a "night spent at an uncomfortable inn." Once when she was trying to avoid that

recreation hour which is set aside in convents for nuns to be together, the others insisted on her joining them, and she took castanets and danced. When some older nuns professed themselves shocked, she retorted, "One must do things sometimes to make life more bearable." After she was a superior she gave directions when the nuns became melancholy, "to feed them steak," and there were other delightful little touches to the story of her life which made me love her and feel close to her. I have since heard a priest friend of ours remark gloomily that one could go to hell imitating the imperfections of the saints, but these little incidents brought out in her biography made her delightfully near to me. So I decided to name my daughter after her. That is why my neighbor offered me a medal of St. Thérèse of Lisieux, who is called the little Teresa.

Her other name came from Sasha's sister Liza. She had named her daughter Tamar, which in Hebrew means "little palm tree," and knowing nothing of the unhappy story of the two Tamars in the Old Testament, I named my child Tamar also. Tamar is one of the forebears of our Lord, listed in the first chapter of Matthew, and not only Jews and Russians, but also New Englanders used the name.

What a driving power joy is! When I was unhappy and repentant in the past I turned to God, but it was my joy at having given birth to a child that made me do something definite. I wanted Tamar to have a way of life and instruction. We all crave order, and in the Book of Job, hell is described as a place where no order is. I felt that "belonging" to a Church would bring that order into her life which I felt my own had lacked. If I could have felt that communism was the answer to my desire for a cause, a motive, a way to walk in, I would have remained as I was. But I felt that only faith in Christ could give the answer. The Sermon on the Mount answered all the questions as to how to love God and one's brother. I knew little about the Sacraments, and yet here I was believing, knowing that without them Tamar would not be a Catholic.

I did not know any Catholics to speak to. The grocer, the hardware storekeeper, my neighbors down the road were Catholics, yet I could not bring myself to speak to them about religion. I was full of the reserves I noted in my own family. But I could speak to a nun. So when I saw a nun walking down the road near St. Joseph's-by-the-Sea, I went up to her breathlessly and asked her how I could have my child baptized. She was not at all reticent about asking questions and not at all surprised at my desires. She was a simple old sister who had taught grade school all her life. She was now taking care of babies in a huge home on the bay which had belonged to Charles Schwab, who had given it to the Sisters of Charity. They used it for summer retreats for the Sisters and to take care of orphans and unmarried mothers and their babies.

Sister Aloysia had had none of the university summer courses that most Sisters must take nowadays. She never talked to me about the social encyclicals of the Popes. She gave me a catechism and brought me old copies of the *Messenger of the Sacred Heart,* a magazine which, along with the Kathleen Norris type of success story, had some good solid articles about the teachings of the Church. I read them all; I studied my catechism; I learned to say the Rosary; I went to Mass in the chapel by the sea; I walked the beach and I prayed; I read the *Imitation of Christ,* and St. Augustine, and the New Testament. Dostoevski, Huysmans (what different men!) had given me desire and background. Huysmans had made me at home in the Church.

"How can your daughter be brought up a Catholic unless you become one yourself?" Sister Aloysia kept saying to me. But she went resolutely ahead in making arrangements for the baptism of Tamar Teresa.

"You must be a Catholic yourself," she kept telling me. She had no reticence. She speculated rather volubly at times on the various reasons why she thought I was holding back. She brought me pious literature to read, saccharine stories of virtue, emasculated lives of saints young and old, back numbers of pious magazines. William James, agnostic as he was, was more help. He had introduced me to St. Teresa of Avila and St. John of the Cross.

Isolated as I was in the country, knowing no Catholics except my neighbors, who seldom read anything except newspapers and secular magazines, there was not much chance of being introduced to the good Catholic literature of the present day. I was in a state of dull content—not in a state to be mentally stimulated. I was too happy with my child. What faith I had I held on to stubbornly. The need for patience emphasized in the writings of the saints consoled me on the slow road I was traveling. I would put all my affairs in the hands of God and wait.

Three times a week Sister Aloysia came to give me a catechism lesson, which I dutifully tried to learn. But she insisted that I recite word for word, with the repetition of the question that was in the book. If I had not learned my lesson, she rebuked me, "And you think you are intelligent!" she would say witheringly. "What is the definition of grace—actual grace and sanctifying grace? My fourth-grade pupils know more than you do!"

I hadn't a doubt but that they did. I struggled on day by day, learning without question. I was in an agreeable and lethargic, almost bovine state of mind, filled with an animal content, not wishing to inquire into or question the dogmas I was learning. I made up my mind to accept what I did not understand, trusting light to come, as it sometimes did, in a blinding flash of exultation and realization.

She criticized my housekeeping. "Here you sit at your typewriter at ten o'clock and none of your dishes done yet. Supper and breakfast dishes besides. . . . And why don't you calcimine your ceiling? It's all dirty from wood smoke."

She brought me vegetables from the garden of the home, and I gave her fish and clams. Once I gave her stamps and a dollar to send a present to a little niece and she was touchingly grateful. It made me suddenly realize that, in spite of Charlie Schwab and his estate, the Sisters lived in complete poverty, owning nothing, holding all things in common.

I had to have godparents for Tamar, and I thought of Aunt Jenny, my mother's sister, the only member of our family I knew who had become a Catholic. She had married a Catholic and had one living child, Grace. I did not see them very often but I looked them up now and asked Grace and her husband if they would be godparents to my baby. Tamar was baptized in July. We went down to Tottenville, the little town at the south end of the island; there in the Church of Our Lady, Help of Christians, the seed of life was implanted in her and she was made a child of God.

We came back to the beach house to a delightful lunch of boiled lobsters and salad. Forster had caught the lobsters in his traps for the feast and then did not

remain to partake of it. He left, not returning for several days. It was his protest against my yearnings toward the life of the spirit, which he considered a morbid escapism. He exulted in his materialism. He well knew the dignity of man. Heathen philosophers, says Matthias Scheeben, a great modern theologian, have called man a miracle, the marrow and the heart of the world, the most beautiful being, the king of all creatures. Forster saw man in the light of reason and not in the light of faith. He had thought of the baptism only as a mumbo jumbo, the fuss and flurry peculiar to woman. At first he had been indulgent and had brought in the lobsters for the feast. And then he had become angry with some sense of the end to which all this portended. Jealousy set in and he left me.

As a matter of fact, he left me quite a number of times that coming winter and following summer, as he felt my increasing absorption in religion. The tension between us was terrible. Teresa had become a member of the Mystical Body of Christ. I didn't know anything of the Mystical Body or I might have felt disturbed at being separated from her.

But I clutched her close to me and all the time I nursed her and bent over that tiny round face at my breast, I was filled with a deep happiness that nothing could spoil. But the obstacles to my becoming a Catholic were there, shadows in the background of my life.

I had become convinced that I would become a Catholic; yet I felt I was betraying the class to which I belonged, the workers, the poor of the world, with whom Christ spent His life. I wrote a few articles for the *New Masses* but did no other work at that time. My life was crowded in summer because friends came and stayed with me, and some of them left their children. Two little boys, four and eight years old, joined the family for a few months and my days were full, caring for three children and cooking meals for a half-dozen persons three times a day.

Sometimes when I could leave the baby in trusted hands I could get to the village for Mass on Sunday. But usually the gloom that descended on the household, the scarcely voiced opposition, kept me from Mass. There were some feast days when I could slip off during the week and go to the little chapel on the Sisters' grounds. There were "visits" I could make, unknown to others. I was committed, by the advice of a priest I consulted, to the plan of waiting, and trying to hold together the family. But I felt all along that when I took the irrevocable step it would mean that Tamar and I would be alone, and I did not want to be alone. I did not want to give up human love when it was dearest and tenderest.

During the month of August many of my friends, including my sister, went to Boston to picket in protest against the execution of Sacco and Vanzetti, which was drawing near. They were all arrested again and again.

Throughout the nation and the world the papers featured the struggle for the lives of these two men. Radicals from all over the country gathered in Boston, and articles describing those last days were published, poems were written. It was an epic struggle, a tragedy. One felt a sense of impending doom. These men were Catholics, inasmuch as they were Italians. Catholics by tradition, but they had rejected the Church.

Nicola Sacco and Bartolomeo Vanzetti were two anarchists, a shoemaker and a fish peddler who were arrested in 1920 in connection with a payroll robbery at East Braintree, Massachusetts, in which two guards were killed. Nobody

paid much attention to the case at first, but as the I.W.W. and the Communists took up the case it became a *cause célèbre*. In August, 1927, they were executed. Many books have been written about the case, and Vanzetti's prison letters are collected in one volume. He learned to write English in prison, and his prose, bare and simple, is noble in its earnestness.

While I enjoyed the fresh breeze, the feel of salt water against the flesh, the keen delight of living, the knowledge that these men were soon to pass from this physical earth, were soon to become dust, without consciousness, struck me like a physical blow. They were here now; in a few days they would be no more. They had become figures beloved by the workers. Their letters, the warm moving story of their lives, had been told. Everyone knew Dante, Sacco's young son. Everyone suffered with the young wife who clung with bitter passion to her husband. And Vanzetti with his large view, his sense of peace at his fate, was even closer to us all.

He wrote a last letter to a friend which has moved many hearts as great poetry does:

I have talked a great deal of myself [he wrote]. But I even forget to name Sacco. Sacco too is a worker, from his boyhood a skilled worker, lover of work, with a good job and pay, a bank account, a good and lovely wife, two beautiful children and a neat little home, at the verge of a wood near a brook.

Sacco is a heart of faith, a lover of nature and man.

A man who gave all, who sacrificed all for mankind, his own wife, his children, himself and his own life.

Sacco has never dreamed to steal, never to assassinate.

He and I never brought a morsel of bread to our mouths, from our childhood to today which has not been gained by the sweat of our brows.

Never.

O yes, I may be more witful, as some have put it, I am a better blabber than he is, but many many times in hearing his heartful voice ringing a faith sublime, in considering his supreme sacrifice, remembering his heroism, I felt small at the presence of his greatness and found myself compelled to fight back from my eyes the tears, and quanch my heart, trobling to my throat to not weep before him,—this man called thief, assassin and doomed. . . .

If it had not been for these things I might have lived out my life talking at street corners to scorning men. I might have died, unmarked, unknown, a failure. This is our career and our triumph.

Never in our full life could we hope to do such work
for tolerance, for justice,
for man's understanding of man,
as we now do by accident.

Our words, our lives, our pains—nothing!

The taking of our lives,—lives of a good shoe maker
and a poor fish peddler—all!

That last moment belongs to us
—that agony is our triumph.

The day they died, the papers had headlines as large as those which proclaimed the outbreak of war. All the nation mourned. All the nation, I mean, that is made up of the poor, the worker, the trade unionist—those who felt most keenly the sense of solidarity—that very sense of solidarity which made me gradually understand the doctrine of the Mystical Body of Christ whereby we are the members one of another.

Forster was stricken over the tragedy. He had always been more an anarchist than anything else in his philosophy, and so was closer to these two men than to Communist friends. He did not eat for days. He sat around the house in a stupor of misery, sickened by the cruelty of life and men. He had always taken refuge in nature as being more kindly, more beautiful and peaceful than the world of men. Now he could not even escape through nature, as he tried to escape so many problems in life.

During the time he was home he spent days and even nights out in his boat fishing, so that for weeks I saw little of him. He stupefied himself in his passion for the water, sitting out on the bay in his boat. When he began to recover he submerged himself in maritime biology, collecting, reading only scientific books, and paying no attention to what went on around him. Only the baby interested him. She was his delight. Which made it, of course, the harder to contemplate the cruel blow I was going to strike him when I became a Catholic. We both suffered in body as well as in soul and mind. He would not talk about the faith and relapsed into a complete silence if I tried to bring up the subject. The point of my bringing it up was that I could not become a Catholic and continue living with him, because he was averse to any ceremony before officials of either Church or state. He was an anarchist and an atheist, and he did not intend to be a liar or a hypocrite. He was a creature of utter sincerity, and however illogical and bad-tempered about it all, I loved him. It was killing me to think of leaving him.

Fall nights we read a great deal. Sometimes he went out to dig bait if there were a low tide and the moon was up. He stayed out late on the pier fishing, and came in smelling of seaweed and salt air; getting into bed, cold with the chill November air, he held me close to him in silence. I loved him in every way, as a wife, as a mother even. I loved him for all he knew and pitied him for all he didn't know. I loved him for the odds and ends I had to fish out of his sweater pockets and for the sand and shells he brought in with his fishing. I loved his lean cold body as he got into bed smelling of the sea, and I loved his integrity and stubborn pride.

It ended by my being ill the next summer. I became so oppressed I could not breathe and I awoke in the night choking. I was weak and listless and one doctor told me my trouble was probably thyroid. I went to the Cornell clinic for a metabolism test and they said my condition was a nervous one. By winter the tension had become so great that an explosion occurred and we separated again. When he returned, as he always had, I would not let him in the house; my heart was breaking with my own determination to make an end, once and for all, to the torture we were undergoing.

The next day I went to Tottenville alone, leaving Tamar with my sister, and there with Sister Aloysia as my godparent, I too was baptized conditionally, since I had already been baptized in the Episcopal Church. I made my first confession right afterward, and looked forward the next morning to receiving communion.

I had no particular joy in partaking of these three sacraments, Baptism, Penance and Holy Eucharist. I proceeded about my own active participation in them grimly, coldly, making acts of faith, and certainly with no consolation whatever. One part of my mind stood at one side and kept saying, "What are you doing? Are you sure of yourself? What kind of an affectation is this? What act is this you are going through? Are you trying to induce emotion, induce faith, partake of an opiate, the opiate of the people?" I felt like a hypocrite if I got down on my knees, and shuddered at the thought of anyone seeing me.

At my first communion I went up to the communion rail at the *Sanctus* bell instead of at the *Domine, non sum dignus,* and had to kneel there all alone through the consecration, through the *Pater Noster,* through the *Agnus Dei*—and I had thought I knew the Mass so well! But I felt it fitting that I be humiliated by this ignorance, by this precipitance.

I speak of the misery of leaving one love. But there was another love too, the life I had led in the radical movement. That very winter I was writing a series of articles, interviews with the workers, with the unemployed. I was working with the Anti-Imperialist League, a Communist affiliate, that was bringing aid and comfort to the enemy, General Sandino's forces in Nicaragua. I was just as much against capitalism and imperialism as ever, and here I was going over to the opposition, because of course the Church was lined up with property, with the wealthy, with the state, with capitalism, with all the forces of reaction. This I had been taught to think and this I still think to a great extent. "Too often," Cardinal Mundelein said, "has the Church lined up on the wrong side." "Christianity," Bakunin said, "is precisely the religion par excellence, because it exhibits, and manifests, to the fullest extent, the very nature and essence of every religious system, which is the impoverishment, enslavement, and annihilation of humanity for the benefit of divinity."

I certainly believed this, but I wanted to be poor, chaste and obedient. I wanted to die in order to live, to put off the old man and put on Christ. I loved, in other words, and like all women in love, I wanted to be united to my love. Why should not Forster be jealous? Any man who did not participate in this love would, of course, realize my infidelity, my adultery. In the eyes of God, any turning toward creatures to the exclusion of Him is adultery and so it is termed over and over again in Scripture.

I loved the Church for Christ made visible. Not for itself, because it was so often a scandal to me. Romano Guardini said the Church is the Cross on which Christ was crucified; one could not separate Christ from His Cross, and one must live in a state of permanent dissatisfaction with the Church.

The scandal of businesslike priests, of collective wealth, the lack of a sense of responsibility for the poor, the worker, the Negro, the Mexican, the Filipino, and even the oppression of these, and the consenting to the oppression of them by our industrialist-capitalist order—these made me feel often that priests were more like Cain than Abel. "Am I my brother's keeper?" they seemed to say in respect to the social order. There was plenty of charity but too little justice. And yet the priests were the dispensers of the Sacraments, bringing Christ to men, all enabling us to put on Christ and to achieve more nearly in the world a sense of peace and unity. "The worst enemies would be those of our own household," Christ had warned us.

We could not root out the tares without rooting out the wheat also. With all the knowledge I have gained these twenty-one years I have been a Catholic, I could write many a story of priests who were poor, chaste and obedient, who gave their lives daily for their fellows, but I am writing of how I felt at the time of my baptism.

Not long afterward a priest wanted me to write a story of my conversion, telling how the social teaching of the Church had led me to embrace Catholicism. But I knew nothing of the social teaching of the Church at that time. I had never heard of the encyclicals. I felt that the Church was the Church of the poor, that St. Patrick's had been built from the pennies of servant girls, that it cared for the emigrant, it established hospitals, orphanages, day nurseries, houses of the Good Shepherd, homes for the aged, but at the same time, I felt that it did not set its face against a social order which made so much charity in the present sense of the word necessary. I felt that charity was a word to choke over. Who wanted charity? And it was not just human pride but a strong sense of man's dignity and worth, and what was due to him in justice, that made me resent, rather than feel proud of so mighty a sum total of Catholic institutions. Besides, more and more they were taking help from the state, and in taking from the state, they had to render to the state. They came under the head of Community Chest and discriminatory charity, centralizing and departmentalizing, involving themselves with bureaus, building, red tape, legislation, at the expense of human values. By "they," I suppose one always means the bishops, but as Harry Bridges once pointed out to me, "they" also are victims of the system.

It was an age-old battle, the war of the classes, that stirred in me when I thought of the Sacco-Vanzetti case in Boston. Where were the Catholic voices crying out for these men? How I longed to make a synthesis reconciling body and soul, this world and the next, the teachings of Prince Peter Kropotkin and Prince Demetrius Gallitzin, who had become a missionary priest in rural Pennsylvania.

Where had been the priests to go out to such men as Francisco Ferrer in Spain, pursuing them as the Good Shepherd did His lost sheep, leaving the ninety and nine of their good parishioners, to seek out that which was lost, bind up that which was bruised. No wonder there was such a strong conflict going on in my mind and heart. . . .

## PAPER, PEOPLE AND WORK

We started publishing *The Catholic Worker* at 436 East Fifteenth Street in May, 1933, with a first issue of 2,500 copies. Within three or four months the circulation bounded to 25,000, and it was cheaper to bring it out as an eight-page tabloid on newsprint rather than the smaller-sized edition on better paper we had started with. By the end of the year we had a circulation of 100,000 and by 1936 it was 150,000. It was certainly a mushroom growth. It was not only that some parishes subscribed for the paper all over the country in bundles of 500 or more. Zealous young people took the paper out in the streets and sold it, and when they could not sell it even at one cent a copy, they gave free copies and left them in streetcar, bus, barber shop and dentist's and doctor's office. We

got letters from all parts of the country from people who said they had picked up the paper on trains, in rooming houses. One letter came from the state of Sonora in Mexico and we read with amazement that the reader had tossed in an uncomfortable bed on a hot night until he got up to turn over the mattress and under it found a copy of *The Catholic Worker*. A miner found a copy five miles underground in an old mine that stretched out under the Atlantic Ocean off Nova Scotia. A seminarian said that he had sent out his shoes to be half-soled in Rome and they came back to him wrapped in a copy of *The Catholic Worker*. These letters thrilled and inspired the young people who came to help, sent by Brothers or Sisters who taught in the high schools. We were invited to speak in schools and parishes, and often as a result of our speaking others came in to help us. On May Day, those first few years, the streets were literally lined with papers. Looking back on it, it seemed like a gigantic advertising campaign, entirely unpremeditated. It grew organically, Peter used to say happily, and not through organization. "We are not an organization, we are an organism," he said.

First there was Peter, my brother and I. When John took a job at Dobb's Ferry, a young girl, Dorothy Weston, who had been studying journalism and was a graduate of a Catholic college, came to help. She lived at home and spent her days with us, eating with us and taking only her carfare from the common fund. Peter brought in three young men from Columbus Circle, whom he had met when discussing the affairs of the world there, and of these one became bookkeeper (that was his occupation when he was employed), another circulation manager, and the third married Dorothy Weston. Another girl came to take dictation and help with mailing the paper, and she married the circulation manager. There were quite a number of romances that first year—the paper appealed to youth. Then there were the young intellectuals who formed what they called Campion Committees in other cities as well as New York, who helped to picket the Mexican and German consulates and who distributed literature all over the city. Workers came in to get help on picket lines, to help move dispossessed families and make demonstrations in front of relief offices. Three men came to sell the paper on the street, and to eat their meals with us. Big Dan had been a truck driver and a policeman. The day he came in to see us he wanted nothing more than to bathe his tired feet. That night at supper Peter indoctrinated him on the dignity of poverty and read some of Father Vincent McNabb's *Nazareth or Social Chaos*. This did not go over so well, all of us being city people, and Father McNabb advocating a return to the fields, but he made Dan Orr go out with a sense of a mission, not worrying about shabby clothes or the lack of a job. Dan began to sell the paper on the streets and earned enough money to live on. He met others who had found subsistence jobs, carrying sandwich signs or advertising children's furniture by pushing a baby carriage, a woman who told fortunes in a tea shop, a man who sold pretzels, which were threaded on four poles one on each corner of an old baby carriage. He found out their needs, and those of their families, and never left the house in the morning without bundles of clothes as well as his papers.

Dan rented a horse and wagon in which to deliver bundles of the paper each month. (We had tried this before he came but someone had to push the horse while the other led it. We knew nothing about driving a wagon.) Dan

loved his horse. He called it Catholic Action, and used to take the blanket off my bed to cover the horse in winter. We rented it from a German Nazi on East Sixteenth Street, and sometimes when we had no money he let us have the use of it free for a few hours. It rejoiced our hearts to move a Jewish family into their new quarters with his equipment.

Dan said it was a pious horse and that when he passed St. Patrick's Cathedral, the horse genuflected. He liked to drive up Fifth Avenue, preferably with students who had volunteered their help, and shout, "Read *The Catholic Worker*" at the top of his lungs. He was anything but dignified and loved to affront the dignity of others.

One time he saw me coming down the street when he was selling the paper in front of Gimbel's and began to yell, "Read *The Catholic Worker!* Romance on every page." A seminarian from St. Louis, now Father Dreisoner, took a leaf from Dan's book and began selling the paper on the corner of Times Square and at union meetings. He liked to stand next to a comrade selling *The Daily Worker*, and as the one shouted "Read *The Daily Worker*," he in turn shouted, "Read *The Catholic Worker* daily." Between sales they conversed.

Another of Peter's friends was an old Armenian who wrote poetry in a beautiful mysterious script which delighted my eyes. He carried his epic around with him always. He was very little and wore a long black overcoat which reached to his heels and a black revolutionary hat over his long white hair. He had a black cat whom he called Social Justice, mimicking Big Dan. She was his constant companion. He used my washrag to wipe her face with after eating. He prepared dishes for us with rice and meat wrapped in grape leaves, held together with toothpicks. He slept on a couch in the kitchen for a time. Once when Tamar was tearing around the house playing with Freddy Rubino, the little boy who lived upstairs, and I told her to be a little more quiet, that Mr. Minas was asleep in the next room, she said mischievously, "I don't care if the Pope is asleep in the next room, we want to play and make noise." Day and night there were many meetings in the converted barber shop which was our office, and Tamar heard plenty of noise from us. When someone asked her how she liked *The Catholic Worker* she wrinkled up her nose and said she liked the farming-commune idea, but that there was too much talk about all the rest.

Peter, the "green" revolutionist, had a long-term program which called for hospices, or houses of hospitality, where the works of mercy could be practiced to combat the taking over by the state of all those services which could be built up by mutual aid; and farming communes to provide land and homes for the unemployed, whom increasing technology was piling up into the millions. In 1933, the unemployed numbered 13,000,000.

The idea of the houses of hospitality caught on quickly enough. The very people that Peter brought in, who made up our staff at first, needed a place to live. Peter was familiar with the old I.W.W. technique of a common flophouse and a pot of mulligan on the stove. To my cost, I too had become well acquainted with this idea.

Besides, we never had any money, and the cheapest, most practical way to take care of people was to rent some apartments and have someone do the cooking for the lot of us. Many a time I was cook and cleaner as well as editor and street seller. When Margaret, a Lithuanian girl from the mining regions of

Pennsylvania came to us, and took over the cooking, we were happy indeed. She knew how to make a big pot of mashed potatoes with mushroom sauce which filled everyone up nicely. She was a great soft creature with a little baby, Barbara, who was born a few months after she came to us. Margaret went out on May Day with the baby and sold papers on the street. She loved being propagandist as well as cook. When Big Dan teased her, she threatened to tell the "pasture" of the church around the corner.

To house the women we had an apartment near First Avenue which could hold about ten. When there were arguments among them, Margaret would report them with gusto, giving us a blow-by-blow account. Once when she was telling how one of the women abused her so that she "felt as though the crown of thorns was pressing right down on her head" (she was full of these mystical experiences), Peter paused in his pacing of the office to tell her she needed to scrub the kitchen floor. Not that he was ever harsh, but he was making a point that manual labor was the cure of all such quarreling. Margaret once told Bishop O'Hara of Kansas City that when she kissed his ring, it was just like a blood transfusion—she got faint all over.

Jacques Maritain came to us during these early days and spoke to the group who were reading *Freedom and the Modern World* at that time. He gave special attention to the chapter on the purification of means. Margaret was delighted with our distinguished guest, who so evidently loved us all, and made him a box of fudge to take home with him when he sailed for France a few weeks later.

Ah, those early days that everyone likes to think of now since we have grown so much bigger; that early zeal, that early romance, that early companionableness! And how delightful it is to think that the young ones who came into the work now find the same joy in community. It is a permanent revolution, this Catholic Worker Movement.

In New York we were soon forced by the increasing rent of three apartments and one store to move into a house on the West Side. We lived on West Charles Street, all together, men and women, students and workers, about twenty of us. In the summer young college girls and men came for months to help us, and, in some cases, returned to their own cities to start houses of hospitality there. In this way, houses started in Boston, Rochester, Milwaukee, and other cities. Within a few years there were thirty-three houses of hospitality and farms around the country.

One of the reasons for the rapid growth was that many young men were coming out of college to face the prospect of no job. If they had started to read *The Catholic Worker* in college, they were ready to spend time as volunteers when they came out. Others were interested in writing, and houses in Buffalo, Chicago, Baltimore, Seattle, St. Louis and Philadelphia, to name but a few cities, published their own papers and sold them with the New York *Catholic Worker*. A *Catholic Worker* was started in Australia and one in England. Both papers are still in existence, but the New York *Catholic Worker* is the only one published in the United States. The English and Australian papers are neither pacifist nor libertarian in their viewpoint, but the Australian paper is decentralist as well as strongly pro-labor. The English paper concentrates on labor organization and legislation. "These papers have part of the program," Peter said, "but ours makes a synthesis—with vision."

The coming of war closed many of the houses of hospitality, but with new ones reopening there are still more than twenty houses and farms. When the young men in the work were released from service, most of them married and had to think in terms of salaries, jobs to support their growing families. The voluntary apostolate was for the unwilling celibate and for the unemployed as well as for the men and women, willing celibates, who felt that running hospices, performing the works of mercy, working on farms, was their vocation, just as definitely a vocation as that of the professed religious.

Voluntary poverty means a good deal of discomfort in these houses of ours. Many of the houses throughout the country are without central heating and have to be warmed by stoves in winter. There are back-yard toilets for some even now. The first Philadelphia house had to use water drawn from one spigot at the end of an alley, which served half a dozen other houses. It was lit with oil lamps. It was cold and damp and so unbelievably poverty-stricken that little children coming to see who were the young people meeting there exclaimed that this could not be a *Catholic* place; it was too poor. We must be Communists. They were well acquainted with the Communist point of view since they were Puerto Rican and Spanish and Mexican and this was at the beginning of the Spanish Civil War.

How hard a thing it is to hear such criticisms made. Voluntary poverty was only found among the Communists; the Negro and white man on the masthead of our paper suggested communism; the very word "worker" made people distrust us at first. We were not taking the position of the great mass of Catholics, who were quite content with the present in this world. They were quite willing to give to the poor, but they did not feel called upon to work for the things of this life for others which they themselves esteemed so lightly. Our insistence on worker-ownership, on the right of private property, on the need to de-proletarize the worker, all points which had been emphasized by the Popes in their social encyclicals, made many Catholics think we were Communists in disguise, wolves in sheep's clothing. . . .

## LABOR

*The Catholic Worker*, as the name implied, was directed to the worker, but we used the word in its broadest sense, meaning those who worked with hand or brain, those who did physical, mental or spiritual work. But we thought primarily of the poor, the dispossessed, the exploited.

Every one of us who was attracted to the poor had a sense of guilt, of responsibility, a feeling that in some way we were living on the labor of others. The fact that we were born in a certain environment, were enabled to go to school, were endowed with the ability to compete with others and hold our own, that we had few physical disabilities—all these things marked us as the privileged in a way. We felt a respect for the poor and destitute as those nearest to God, as those chosen by Christ for His compassion. Christ lived among men. The great mystery of the Incarnation, which meant that God became man that man might become God, was a joy that made us want to kiss the earth in worship, because His feet once trod that same earth. It was a mystery that we as

Catholics accepted, but there were also the facts of Christ's life, that He was born in a stable, that He did not come to be a temporal King, that He worked with His hands, spent the first years of His life in exile, and the rest of His early manhood in a crude carpenter shop in Nazareth. He fulfilled His religious duties in the synagogue and the temple. He trod the roads in His public life and the first men He called were fishermen, small owners of boats and nets. He was familiar with the migrant worker and the proletariat, and some of His parables dealt with them. He spoke of the living wage, not equal pay for equal work, in the parable of those who came at the first and the eleventh hour.

He died between two thieves because He would not be made an earthly King. He lived in an occupied country for thirty years without starting an underground movement or trying to get out from under a foreign power. His teaching transcended all the wisdom of the scribes and pharisees, and taught us the most effective means of living in this world while preparing for the next. And He directed His sublime words to the poorest of the poor, to the people who thronged the towns and followed after John the Baptist, who hung around, sick and poverty-stricken at the doors of rich men.

He had set us an example and the poor and destitute were the ones we wished to reach. The poor were the ones who had jobs of a sort, organized or unorganized, and those who were unemployed or on work-relief projects. The destitute were the men and women who came to us in the breadlines and we could do little with them but give what we had of food and clothing. Sin, sickness and death accounted for much of human misery. But aside from this, we did not feel that Christ meant we should remain silent in the face of injustice and accept it even though He said, "The poor ye shall always have with you."

In the first issue of the paper we dealt with Negro labor on the levees in the South, exploited as cheap labor by the War Department. We wrote of women and children in industry and the spread of unemployment. The second issue carried a story of a farmers' strike in the Midwest and the condition of restaurant workers in cities. In the third issue there were stories of textile strikes and child labor in that industry; the next month coal and milk strikes. In the sixth issue of the paper we were already combatting anti-Semitism. From then on, although we wanted to make our small eight-page tabloid a local paper, that is, covering the American scene, we could not ignore the issues abroad. They had their repercussions at home. We could not write about these issues without being drawn out on the streets on picket lines, and we found ourselves in 1935 with the Communists picketing the German consulate at the Battery.

It was not the first time we seemed to be collaborators. During the Ohrbach Department Store strike the year before I ran into old friends from the Communist group, but I felt then, and do now, that the fact that Communists made issue of Negro exploitation and labor trouble was no reason why we should stay out of the situation. "The truth is the truth," writes St. Thomas, "and proceeds from the Holy Ghost, no matter from whose lips it comes."

There was mass picketing every Saturday afternoon during the Ohrbach strike, and every Saturday the police drove up with patrol wagons and loaded the pickets into them with their banners and took them to jail. When we entered the dispute with our slogans drawn from the writings of the Popes regarding the condition of labor, the police around Union Square were taken aback

and did not know what to do. It was as though they were arresting the Holy Father himself, one of them said, were they to load our pickets and their signs into their patrol wagons. The police contented themselves with giving us all injunctions. One seminarian who stood on the side lines and cheered was given an injunction too, which he cherished as a souvenir.

Our readers helped us when they responded to our call not to trade with a store which paid poor wages and forced workers to labor long hours, and we helped defeat the injunction, one of the usual weapons used by employers to defeat picketing, which was handled down against the strikers. Now there is the Taft-Hartley law.

At that time one of the big Catholic high schools in the city each month received a bundle of three thousand copies of our paper for their students. I had spoken there of the work for the poor and some of the students had worked with us. When we picketed the Mexican consulate to protest the religious persecution which was revived in 1934, the students came and joined us more than two thousand strong. We had set out, half a dozen of us, and, although we had printed an invitation in the paper, we did not expect such a hearty response. The police again were stunned at this demonstration, having met only with Communists in such mass demonstrations before. The students sang, marched and rejoiced in the fact that their pictures appeared on the front page of the *Daily News* the next morning.

Among other readers who joined us that day was a young mate on a Standard Oil tanker who said he first read our paper while sailing in the Gulf. From then on he visited the office between trips and contributed half his salary to the work. Other picketers were Margaret, our cook, and her baby, and my daughter. Most belligerent was a young woman who had been sent to us from a hospital after an unsuccessful operation for tumor on the brain. She was not too well informed as to issues and principles, and when one of the passers-by asked her what the picketing was about, she answered tartly, "None of your business."

She was one of those who liked to get out on the streets and sell the paper with Big Dan and a few others. There were many protests from the young intellectuals that these should seem to the public to represent the work. But they were certainly a part of it—"they belonged"—and they felt it and were fiercely loyal, though often they could make no answer for the faith that was in them.

The picketing of the Mexican consulate went well with the good Sisters who taught in a great Catholic high school, but when the students wanted to go on a picket line in a strike for the unionization of workers and better wages and hours, and were logical enough to extend their sympathy by boycotting the National Biscuit Company products and to inform their family grocers and delicatessens of this intention, then it was time for a stop. We were politely told that individuals could take the paper, but that the bundle order of three thousand must be canceled. There were too many people protesting against our activities with the students.

(On another occasion when I spoke to a high school group in Philadelphia, before I even returned to New York, a cancelation came in. "You must have done a good job down there," our circulation manager said grimly. "They used to take two thousand copies and now they've dropped them.")

Other readers who owned stock in N.B.C. sold their shares and informed the corporation. These acts helped settle the strike. The most spectacular help we gave in a strike was during the formation of the National Maritime Union. In May, 1936, the men appealed to us for help in housing and feeding some of the strikers, who came off the ships with Joe Curran in a spontaneous strike against not only the shipowners but also the old union leaders.

We had then just moved St. Joseph's house to 115 Mott Street and felt that we had plenty of room. Everyone camped out for a time while seamen occupied the rooms which they made into dormitories. There were about fifty of them altogether during the course of the next month or so, and a number of them became friends of the work.

There were O'Toole, a cook on the United States Lines, and Mike, a Portuguese engineer who carried copies of *The Catholic Worker* to Spain when he shipped out later, bringing us back copies of papers and magazines from Barcelona. This same friend brought us a bag full of earth from Mount Carmel after his ship had touched at the Holy Land. Once he asked me what I wanted from India, and I told him the kind of a spindle which Gandhi had sent to Chiang Kai-shek, as a gift and a warning, perhaps against United States industrialism. He and a shipmate searched in several Indian ports for what I wanted and finally found three spindles in Karachi which they brought to me. One was a metal hand spinner shaped like those shown in old pictures which could be carried about in a little box; the other two were most peculiar contraptions, one of them looking like a portable phonograph.

The seamen came and went and most of them we never saw again, but three remained for years and joined in our work. That first strike was called off, but in the fall, after the men built up their organization, the strike call went out again. For the duration of the strike we rented a store on Tenth Avenue and used it as a reading room and soup kitchen where no soup was served, but coffee and peanut butter and apple butter sandwiches. The men came in from picket lines and helped themselves to what they needed. They read, they talked, and they had time to think. Charlie O'Rourke, John Cort, Bill Callahan and a number of seamen kept the place open all day and most of the night. There was never any disorder; there were no maneuverings, no caucuses, no seeking of influence or power; it was simply a gesture of help, the disinterested help of brothers, inspired in great part by our tanker friend, Jim McGovern, who had written an article for the paper telling how he had been treated as a seaman in Russia and the kind of treatment these same men got here.

Jim was a college graduate, had fallen away from his early faith but regained it by reading Claudel. He was so painfully shy that he was no good at all in contacts with the rank and file. He went to sea because he loved it; he loved the ship he served and the responsibility it entailed. Perhaps there was much of romance and youth in his attitude. He wrote to us of the clubs in the Russian port, and how the men were treated as men, capable of appreciating lectures, concerts, dances and meetings with student groups. In this country, he said, the seamen were treated as the scum of the earth; port towns and the port districts in these towns were slums and water-front streets made up of taverns and pawnshops and houses of prostitution. He felt that the Russians treated their

American comrades as though they were creatures of body and soul, made in the image and likeness of God (though atheism was an integral part of Marxism) and here in our professedly Christian country they were treated like beasts, and often became beasts because of this attitude.

Our headquarters were a tribute to the seaman's dignity as a man free to form association with his fellows, to have some share in the management of the enterprise in which he was engaged.

On another occasion, when the Borden Milk Company attempted to force a company union on their workers, *The Catholic Worker* took up their cause, called public attention to the use of gangsters and thugs to intimidate the drivers and urged our readers to boycott the company's products while unfair conditions prevailed. As a result of the story the company attacked *The Catholic Worker* in paid advertisements in the Brooklyn *Tablet* and the *Catholic News*.

Many times we have been asked why we spoke of *Catholic* workers, and so named the paper. Of course it was not only because we who were in charge of the work, who edited the paper, were all Catholics, but also because we wished to influence Catholics. They were our own, and we reacted sharply to the accusation that when it came to private morality the Catholics shone but when it came to social and political morality, they were often conscienceless. Also Catholics were the poor, and most of them had little ambition or hope of bettering their condition to the extent of achieving ownership of home or business, or further education for their children. They accepted things as they were with humility and looked for a better life to come. They thought, in other words, that God meant it to be so.

At the beginning of the organizing drive of the Committee (now the Congress) for Industrial Organization, I went to Pittsburgh to write about the work in the steel districts. Mary Heaton Vorse was there at the time and we stayed at Hotel Pitt together in the cheapest room available, at a dollar and a half a day. It was before we had the house of hospitality in Pittsburgh which now stands on the top of a hill in the Negro district. A student reader of the paper drove us around to all the little towns, talking of his soul, much to Mary's distress; she was especially distracted when he told of practicing penances on our Easton farm by going out at night and rolling in some brambles. He had no interest in the struggles of the workers—it was the spiritual side of our work which appealed to him—and he was driving us through all the complicated districts on either side of rivers not so much to help us, as to help himself. He wanted to talk to us about his problems. There was not the quiet and peace on such trips to make such talk very fruitful.

There had been the big strike in 1919 led by William Z. Foster, which Mary had covered, and she knew some of the old priests who had helped the people by turning the basements of their churches into relief centers. We went to see them, and we attended open-air meetings along the Monongahela and the Allegheny and Ohio Rivers, where we distributed papers.

On that visit Bishop Hugh Boyle said to me, "You can go into all the parishes in the diocese with my blessing, but half the pastors will throw you out." He meant that they did not have that social consciousness which I was seeking among Catholics and that they felt all organizations of workers were dominated by Communists and were a danger to be avoided.

Later in the big steel strikes in Chicago and Cleveland, when "Little Steel" fought it out with the workers, there was tragedy on the picket lines. In what came to be called the Memorial Day massacre, police shot down hundreds out on the prairies in front of the Republic Steel plants in South Chicago. Ten men died, and others were disabled for life. I had just visited their soup kitchens and strike headquarters; in addition to recognizing that the majority of the workers were Catholics, I also recognized an old friend, Elizabeth, the wife of Jack Johnstone, one of the Communist party leaders in this country. Elizabeth and Jack had brought me roast chicken and ginger ale one night as I lay sick with influenza in New York, and Elizabeth had taken care of Tamar for me so that I could go to Mass, and I had taken care of her young son. Elizabeth, whom I had last seen in New York, was there to write a pamphlet on "Women in Steel," a call to the wives and mothers to help their men organize. Her husband had been organizing in India, and they were accustomed to long separations during which both of them worked for the party. Elizabeth used to tease me by saying that it was due to me that she had become a member of the party and had met Jack, because I had obtained a job for her with the Anti-imperialist League, where I was working at the time.

Elizabeth in Chicago, Jack in India—these wives of Communists, dedicated to revolution as Rayna was! Rayna's husband had worked in the Philippines while she was in Hankow. They went where they were sent, had a sense of their world mission and accepted any hardship that it entailed. If I could only arouse Catholics to such zeal, with the spiritual weapons at their disposal, I thought! If they could only be induced to accept voluntary poverty as a principle, so that they would not fear the risk of losing job, of losing life itself. Organizing sometimes meant just that.

It was not only the Communists, however, who had this courage. One winter I had a speaking engagement in Kansas and my expenses were paid, which fact enabled me to go to Memphis and Arkansas to visit the Tenant Farmers' Union, which was then and is still headed by a Christian Socialist group. The headquarters were a few rooms in Memphis, where the organizers often slept on the floor because there was no money for rent other than that of the offices. Those days I spent with them I lived on sandwiches and coffee because there was no money to spend on regular meals either. We needed to save money for gas to take us around to the centers where dispossessed sharecroppers and tenant farmers were also camping out, homeless, in railroad stations, schools and churches. They were being evicted wholesale because of the purchase of huge tracts of land by northern insurance agencies. The picture has been shown in *Tobacco Road, In Dubious Battle* and *Grapes of Wrath*—pictures of such desolation and poverty and in the latter case of such courage that my heart was lifted again to hope and love and admiration that human beings could endure so much and yet have courage to go on and keep their vision of a more human life.

During that trip I saw men, women and children herded into little churches and wayside stations, camped out in tents, their household goods heaped about them, not one settlement but many—farmers with no land to farm, housewives with no homes. They tried with desperate hope to hold onto a pig or some chickens, bags of seed, some little beginnings of a new hold on life. It was a

bitter winter and frame houses there are not built to withstand the cold as they are in the north. The people just endure it because the winter is short—accept it as part of the suffering of life.

I saw children ill, one old man dead in bed and not yet buried, mothers weeping with hunger and cold. I saw bullet holes in the frame churches, and their benches and pulpit smashed up and windows broken. Men had been kidnaped and beaten; men had been shot and wounded. The month after I left, one of the organizers was killed by a member of a masked band of vigilantes who were fighting the Tenant Farmers' Union.

There was so little one could do—empty one's pockets, give what one had, live on sandwiches with the organizers, and write, write to arouse the public conscience. I telegraphed Eleanor Roosevelt and she responded at once with an appeal to the governor for an investigation. The papers were full of the effrontery of a northern Catholic social worker, as they called me, who dared to pay a four-day visit and pass judgment on the economic situation of the state. The governor visited some of the encampments, and sarcastic remarks were made in some of the newspaper accounts about the pigs and chickens. "If they are starving, let them eat their stock," they wrote.

I spoke to meetings of the unemployed in California, to migrant workers, tenant farmers, steelworkers, stockyard workers, auto workers. The factory workers were the aristocrats of labor. Yet what a struggle they had!

There was that migrant worker I picked up when I drove in a borrowed car down through the long valley in California, writing about government aid to the agricultural workers. "Nothing I love so much as jest to get out in a field and chop cotton," he said wistfully.

There was that old Negro living in a little shack in Alabama where the rain fell through on the rags that covered him at night. While I talked to him a little boy ran up and gave him a bone and some pieces of cornbread; the old man was so excited talking to me and the priest who was with me that he dropped the bone on the ground and a hound dog started licking it. The little boy stood by him, pulling at his sleeve and crying. It was his dinner too, his only dinner, and it was being devoured by a dog. If the old man had more, the children would have less. And there was so little.

There was that little girl in Harrisburg, and another in Detroit, sent out by their parents to prostitute themselves on the street. While I talked to the family in Harrisburg, all of whom lived in one room, the little girl sat reading a tattered book, *Dorothy Vernon of Haddon Hall.*

There was Paul St. Marie, who was president of the first Ford local, a tool and die maker, with a wife and eight children. He suffered from unemployment, from discrimination when he was hired. He worked the graveyard shift from twelve to eight, walked a mile from gate to plant, and worked in the cold on stone floors. He fell ill with rheumatic fever at the age of forty-five and died. He knew poverty and insecurity and living on relief—he and his wife were heroic figures in the labor movement, thinking of their fellows more than of themselves. Paul took me around the auto plants and showed me what the assembly line meant. I met the men who were beaten to a pulp when they tried to distribute literature at plant gates, and I saw the unemployed who had fire hoses

turned on them during an icy winter when they hung around the gates of the Ford plant looking for work.

"How close are you to the worker?" Pitirim Sorokin asked me when I was talking with him at Harvard. He himself was the son of a peasant woman and a migrant worker and was imprisoned three times under the Czars and three times under the Soviets. He too had suffered exile in the forests, hunger and imprisonment; he had lived under the sentence of death and was, through some miracle, and probably because of his doctrine of love in human behavior, allowed to go abroad. He had a right to ask such a question and it was a pertinent one.

Going around and seeing such sights is not enough. To help the organizers, to give what you have for relief, to pledge yourself to voluntary poverty for life so that you can share with your brothers is not enough. One must live with them, share with them their suffering too. Give up one's privacy, and mental and spiritual comforts as well as physical.

Our Detroit house of hospitality for women is named for St. Martha. We are always taking care of migrant families in that house, southern families who are lured to the North because they hear of the high wages paid. It is a house of eight large rooms, and each of the bedrooms has housed a family with children, but the congestion has meant that the husbands had to go to the men's house of hospitality named for St. Francis. Sometimes the families overflow into a front parlor and living room downstairs. The colored take care of the white children, and the white the colored, while the parents hunt for homes and jobs. Such an extreme of destitution makes all men brothers.

Yes, we have lived with the poor, with the workers, and we know them not just from the streets, or in mass meetings, but from years of living in the slums, in tenements, in our hospices in Washington, Baltimore, Philadelphia, Harrisburg, Pittsburgh, New York, Rochester, Boston, Worcester, Buffalo, Troy, Detroit, Cleveland, Toledo, Akron, St. Louis, Chicago, Milwaukee, Minneapolis, Seattle, San Francisco, Los Angeles, Oakland, even down into Houma, Louisiana where Father Jerome Drolet worked with Negroes and whites, with shrimp shellers, fishermen, longshoremen and seamen.

Just as the Church has gone out through its missionaries into the most obscure towns and villages, we have gone too. Sometimes our contacts have been through the Church and sometimes through readers of our paper, through union organizers or those who needed to be organized.

We have lived with the unemployed, the sick, the unemployables. The contrast between the worker who is organized and has his union, the fellowship of his own trade to give him strength, and those who have no organization and come in to us on a breadline is pitiable.

They are stripped then, not only of all earthly goods, but of spiritual goods, their sense of human dignity. When they are forced into line at municipal lodging houses, in clinics, in our houses of hospitality, they are then the truly destitute. Over and over again in our work, many young men and women who come as volunteers have not been able to endure it and have gone away. To think that we are forced by our own lack of room, our lack of funds, to perpetuate this shame, is heartbreaking.

"Is this what you meant by houses of hospitality," I asked Peter.

"At least it will arouse the conscience," he said.

Many left the work because they could see no use in this gesture of feeding the poor, and because of their own shame. But enduring this shame is part of our penance.

"All men are brothers." How often we hear this refrain, the rallying call that strikes a response in every human heart. These are the words of Christ, "Call no man master, for ye are all brothers." It is a revolutionary call which has even been put to music. The last movement of Beethoven's Ninth Symphony has that great refrain—"All men are brothers." Going to the people is the purest and best act in Christian tradition and revolutionary tradition and is the beginning of world brotherhood.

# JACK KEROUAC

Jack Kerouac (1922–69) was a poet and novelist who exemplified the Beat Generation of counter cultural artists in the 1950s. Along with other writers and musicians associated with this movement, Kerouac rebelled against the conformity of mass society and sought new forms of artistic expression that celebrated individual freedom and a sort of mystical transcendence. Describing the Beat movement in 1958 as a "great revival of religious mysticism," Kerouac dramatized his interactions with Gary Snyder and other likeminded devotees to eastern religions in *Dharma Bums* the same year. The work presented a different portrait of 1950s America than the traditional view, and such writings have served as an inspiration to later countercultural folks who are seeking independence from social norms and religious institutions or something deeper than the surface pieties of their time.

## *From* Dharma Bums

The little Saint Teresa bum was the first genuine Dharma Bum I'd met, and the second was the number one Dharma Bum of them all and in fact it was he, Japhy Ryder, who coined the phrase. Japhy Ryder was a kid from eastern

Oregon brought up in a log cabin deep in the woods with his father and mother and sister, from the beginning a woods boy, an axman, farmer, interested in animals and Indian lore so that when he finally got to college by hook or crook he was already well equipped for his early studies in anthropology and later in Indian myth and in the actual texts of Indian mythology. Finally he learned Chinese and Japanese and became an Oriental scholar and discovered the greatest Dharma Bums of them all, the Zen Lunatics of China and Japan. At the same time, being a Northwest boy with idealistic tendencies, he got interested in old-fashioned I.W.W. anarchism and learned to play the guitar and sing old worker songs to go with his Indian songs and general folksong interests. I first saw him walking down the street in San Francisco the following week (after hitchhiking the rest of the way from Santa Barbara in one long zipping ride given me, as though anybody'll believe this, by a beautiful darling young blonde in a snow-white strapless bathing suit and barefooted with a gold bracelet on her ankle, driving a next-year's cinnamon-red Lincoln Mercury, who wanted benzedrine so she could drive all the way to the City and when I said I had some in my duffel bag yelled "Crazy!")—I saw Japhy loping along in that curious long stride of the mountainclimber, with a small knapsack on his back filled with books and toothbrushes and whatnot which was his small "goin-to-the-city" knapsack as apart from his big full rucksack complete with sleeping bag, poncho, and cookpots. He wore a little goatee, strangely Oriental-looking with his somewhat slanted green eyes, but he didn't look like a Bohemian at all, and was far from being a Bohemian (a hanger-onner around the arts). He was wiry, suntanned, vigorous, open, all howdies and glad talk and even yelling hello to bums on the street and when asked a question answered right off the bat from the top or bottom of his mind I don't know which and always in a sprightly sparkling way.

"Where did you meet Ray Smith?" they asked him when we walked into The Place, the favorite bar of the hepcats around the Beach.

"Oh I always meet my Bodhisattvas in the street!" he yelled, and ordered beers.

It was a great night, a historic night in more ways than one. He and some other poets (he also wrote poetry and translated Chinese and Japanese poetry into English) were scheduled to give a poetry reading at the Gallery Six in town. They were all meeting in the bar and getting high. But as they stood and sat around I saw that he was the only one who didn't look like a poet, though poet he was indeed. The other poets were either hornrimmed intellectual hepcats with wild black hair like Alvah Goldbook, or delicate pale handsome poets like Ike O'Shay (in a suit), or out-of-this-world genteel-looking Renaissance Italians like Francis DaPavia (who looks like a young priest), or bow-tied wild-haired old anarchist fuds like Rheinhold Cacoethes, or big fat bespectacled quiet boo-boos like Warren Coughlin. And all the other hopeful poets were standing around, in various costumes, worn-at-the-sleeves corduroy jackets, scuffly shoes, books sticking out of their pockets. But Japhy was in rough working-man's clothes he'd bought secondhand in Goodwill stores to serve him on mountain climbs and hikes and for sitting in the open at night, for campfires, for hitchhiking up and down the Coast. In fact in his little knapsack he also had a funny green alpine cap that he wore when he got to the foot of a mountain, usually with a yodel, before starting to tromp up a few thousand feet. He wore

mountain-climbing boots, expensive ones, his pride and joy, Italian make, in which he clomped around over the sawdust floor of the bar like an oldtime lumberjack. Japhy wasn't big, just about five foot seven, but strong and wiry and fast and muscular. His face was a mask of woeful bone, but his eyes twinkled like the eyes of old giggling sages of China, over that little goatee, to offset the rough look of his handsome face. His teeth were a little brown, from early backwoods neglect, but you never noticed that and he opened his mouth wide to guffaw at jokes. Sometimes he'd quiet down and just stare sadly at the floor, like a man whittling. He was merry at times. He showed great sympathetic interest in me and in the story about the little Saint Teresa bum and the stories I told him about my own experiences hopping freights or hitchhiking or hiking in woods. He claimed at once that I was a great "Bodhisattva," meaning "great wise being" or "great wise angel," and that I was ornamenting this world with my sincerity. We had the same favorite Buddhist saint, too: Avalokitesvara, or, in Japanese, Kwannon the Eleven-Headed. He knew all the details of Tibetan, Chinese, Mahayana, Hinayana, Japanese and even Burmese Buddhism but I warned him at once I didn't give a goddamn about the mythology and all the names and national flavors of Buddhism, but was just interested in the first of Sakyamuni's four noble truths, *All life is suffering.* And to an extent interested in the third, *The suppression of suffering can be achieved,* which I didn't quite believe was possible then. (I hadn't yet digested the Lankavatara Scripture which eventually shows you that there's nothing in the world but the mind itself, and therefore all's possible including the suppression of suffering.) Japhy's buddy was the aforementioned booboo big old goodhearted Warren Coughlin a hundred and eighty pounds of poet meat, who was advertised by Japhy (privately in my ear) as being more than meets the eye.

"Who is he?"

"He's my big best friend from up in Oregon, we've known each other a long time. At first you think he's slow and stupid but actually he's a shining diamond. You'll see. Don't let him cut you to ribbons. He'll make the top of your head fly away, boy, with a choice chance word."

"Why?"

"He's a great mysterious Bodhisattva I think maybe a reincarnation of Asagna the great Mahayana scholar of the old centuries."

"And who am I?"

"I dunno, maybe you're Goat."

"Goat?"

"Maybe you're Mudface."

"Who's Mudface?"

"Mudface is the mud in your goatface. What would you say if someone was asked the question 'Does a dog have the Buddha nature?' and said 'Woof!'"

"I'd say that was a lot of silly Zen Buddhism." This took Japhy back a bit. "Lissen Japhy," I said, "I'm not a Zen Buddhist, I'm a serious Buddhist, I'm an oldfashioned dreamy Hinayana coward of later Mahayanism," and so forth into the night, my contention being that Zen Buddhism didn't concentrate on kindness so much as on confusing the intellect to make it perceive the illusion of all sources of things. "It's *mean*," I complained. "All those Zen Masters throwing young kids in the mud because they can't answer their silly word questions."

"That's because they want them to realize mud is better than words, boy." But I can't recreate the exact (will try) brilliance of all Japhy's answers and come-backs and come-ons with which he had me on pins and needles all the time and did eventually stick something in my crystal head that made me change my plans in life. . . .

❂

In Berkeley I was living with Alvah Goldbook in his little rose-covered cottage in the backyard of a bigger house on Milvia Street. The old rotten porch slanted forward to the ground, among vines, with a nice old rocking chair that I sat in every morning to read my Diamond Sutra. The yard was full of tomato plants about to ripen, and mint, mint, everything smelling of mint, and one fine old tree that I loved to sit under and meditate on those cool perfect starry California October nights unmatched anywhere in the world. We had a perfect little kitchen with a gas stove, but no icebox, but no matter. We also had a perfect little bathroom with a tub and hot water, and one main room, covered with pillows and floor mats of straw and mattresses to sleep on, and books, books, hundreds of books everything from Catullus to Pound to Blyth to albums of Bach and Beethoven (and even one swinging Ella Fitzgerald album with Clark Terry very interesting on trumpet) and a good three-speed Webcor phonograph that played loud enough to blast the roof off: and the roof nothing but plywood, the walls too, through which one night in one of our Zen Lunatic drunks I put my fist in glee and Coughlin saw me and put his head through about three inches.

About a mile from there, way down Milvia and then upslope toward the campus of the University of California, behind another big old house on a quiet street (Hillegass), Japhy lived in his own shack which was infinitely smaller than ours, about twelve by twelve, with nothing in it but typical Japhy appurtenances that showed his belief in the simple monastic life—no chairs at all, not even one sentimental rocking chair, but just straw mats. In the corner was his famous rucksack with cleaned-up pots and pans all fitting into one another in a compact unit and all tied and put away inside a knotted-up blue bandana. Then his Japanese wooden pata shoes, which he never used, and a pair of black inside-pata socks to pad around softly in over his pretty straw mats, just room for your four toes on one side and your big toe on the other. He had a slew of orange crates all filled with beautiful scholarly books, some of them in Oriental languages, all the great sutras, comments on sutras, the complete works of D. T. Suzuki and a fine quadruple-volume edition of Japanese haikus. He also had an immense collection of valuable general poetry. In fact if a thief should have broken in there the only things of real value were the books. Japhy's clothes were all old hand-me-downs bought secondhand with a bemused and happy expression in Goodwill and Salvation Army stores: wool socks darned, colored undershirts, jeans, workshirts, moccasin shoes, and a few turtleneck sweaters that he wore one on top the other in the cold mountain nights of the High Sierras in California and the High Cascades of Washington and Oregon on the long incredible jaunts that sometimes lasted weeks and weeks with just a few pounds of dried food in his pack. A few orange crates made his table, on which, one late sunny afternoon as I arrived, was steaming a peaceful cup of tea at his side as he

bent his serious head to the Chinese signs of the poet Han Shan. Coughlin had given me the address and I came there, seeing first Japhy's bicycle on the lawn in front of the big house out front (where his landlady lived) then the few odd boulders and rocks and funny little trees he'd brought back from mountain jaunts to set out in his own "Japanese tea garden" or "tea-house garden," as there was a convenient pine tree soughing over his little domicile.

A peacefuller scene I never saw than when, in that rather nippy late red afternoon, I simply opened his little door and looked in and saw him at the end of the little shack, sitting crosslegged on a Paisley pillow on a straw mat, with his spectacles on, making him look old and scholarly and wise, with book on lap and the little tin teapot and porcelain cup steaming at his side. He looked up very peacefully, saw who it was, said, "Ray, come in," and bent his eyes again to the script.

"What you doing?"

"Translating Han Shan's great poem called 'Cold Mountain' written a thousand years ago some of it scribbled on the sides of cliffs hundreds of miles away from any other living beings."

"Wow."

"When you come into this house though you've got to take your shoes off, see those straw mats, you can ruin 'em with shoes." So I took my softsoled blue cloth shoes off and laid them dutifully by the door and he threw me a pillow and I sat crosslegged along the little wooden board wall and he offered me a cup of hot tea. "Did you ever read the Book of Tea?" said he.

"No, what's that?"

"It's a scholarly treatise on how to make tea utilizing all the knowledge of two thousand years about tea-brewing. Some of the descriptions of the effect of the first sip of tea, and the second, and the third, are really wild and ecstatic."

"Those guys got high on nothing, hey?"

"Sip your tea and you'll see; this is good green tea." It was good and I immediately felt calm and warm. "Want me to read you parts of this Han Shan poem? Want me to tell you about Han Shan?"

"Yeah."

"Han Shan you see was a Chinese scholar who got sick of the big city and the world and took off to hide in the mountains."

"Say, that sounds like you."

"In those days you could really do that. He stayed in caves not far from a Buddhist monastery in the T'ang Hsing district of T'ien Tai and his only human friend was the funny Zen Lunatic Shih-te who had a job sweeping out the monastery with a straw broom. Shih-te was a poet too but he never wrote much down. Every now and then Han Shan would come down from Cold Mountain in his bark clothing and come into the warm kitchen and wait for food, but none of the monks would ever feed him because he didn't want to join the order and answer the meditation bell three times a day. You see why in some of his utterances, like—listen and I'll look here and read from the Chinese," and I bent over his shoulder and watched him read from big wild crowtracks of Chinese signs: "Climbing up Cold Mountain path, Cold Mountain path goes on and on, long gorge choked with scree and boulders, wide creek and mist-blurred grass, moss is slippery though there's been no rain, pine sings but there's no wind, who can leap the world's ties and sit with me among white clouds?"

"Wow."

"Course that's my own translation into English, you see there are five signs for each line and I have to put in Western prepositions and articles and such."

"Why don't you just translate it as it is, five signs, five words? What's those first five signs?"

"Sign for climbing, sign for up, sign for cold, sign for mountain, sign for path."

"Well then, translate it 'Climbing up Cold Mountain path.'"

"Yeah, but what do you do with the sign for long, sign for gorge, sign for choke, sign for avalanche, sign for boulders?"

"Where's that?"

"That's the third line, would have to read 'Long gorge choke avalanche boulders.'"

"Well that's even better!"

"Well yeah, I thought of that, but I have to have this pass the approval of Chinese scholars here at the university and have it clear in English."

"Boy what a great thing this is," I said looking around at the little shack, "and you sitting here so very quietly at this very quiet hour studying all alone with your glasses. . . ."

"Ray what you got to do is go climb a mountain with me soon. How would you like to climb Matterhorn?"

"Great! Where's that?"

"Up in the High Sierras. We can go there with Henry Morley in his car and bring our packs and take off from the lake. I could carry all the food and stuff we need in my rucksack and you could borrow Alvah's small knapsack and carry extra socks and shoes and stuff."

"What's these signs mean?"

"These signs mean that Han Shan came down from the mountain after many years roaming around up there, to see his folks in town, says, 'Till recently I stayed at Cold Mountain, et cetera, yesterday I called on friends and family, more than half had gone to the Yellow Springs,' that means death, the Yellow Springs, 'now morning I face my lone shadow, I can't study with both eyes full of tears.'"

"That's like you too, Japhy, studying with eyes full of tears."

"My eyes aren't full of tears!"

"Aren't they going to be after a long long time?"

"They certainly will, Ray . . . and look here, 'In the mountains it's cold, it's always been cold not just this year,' see, he's real high, maybe twelve thousand or thirteen thousand feet or more, way up there, and says, 'Jagged scarps always snowed in, woods in the dark ravines spitting mist, grass is still sprouting at the end of June, leaves begin to fall in early August, and here am I high as a junkey—'"

"As a junkey!"

"That's my own translation, he actually says here am I as high as the sensualist in the city below, but I made it modern and high translation."

"Great." I wondered why Han Shan was Japhy's hero.

"Because," said he, "he was a poet, a mountain man, a Buddhist dedicated to the principle of meditation on the essence of all things, a vegetarian too by the way though I haven't got on that kick from figuring maybe in this modern world to be a vegetarian is to split hairs a little since all sentient beings eat what they can. And he was a man of solitude who could take off by himself and live purely and true to himself."

"That sounds like you too."

"And like you too, Ray, I haven't forgotten what you told me about how you made it in the woods meditating in North Carolina and all." Japhy was very sad, subdued, I'd never seen him so quiet, melancholy, thoughtful his voice was as tender as a mother's, he seemed to be talking from far away to a poor yearning creature (me) who needed to hear his message he wasn't putting anything on he was in a bit of a trance.

"Have you been meditating today?"

"Yeah I meditate first thing in the morning before breakfast and I always meditate a long time in the afternoon unless I'm interrupted."

"Who interrupts you?"

"Oh, people. Coughlin sometimes, and Alvah came yesterday, and Rol Sturlason, and I got this girl comes over to play yabyum."

"Yabyum? What's that?"

"Don't you know about yabyum, Smith? I'll tell you later." He seemed to be too sad to talk about yabyum, which I found out about a couple of nights later. We talked a while longer about Han Shan and poems on cliffs and as I was going away his friend Rol Sturlason, a tall blond goodlooking kid, came in to discuss his coming trip to Japan with him. This Rol Sturlason was interested in the famous Ryoanji rock garden of Shokokuji monastery in Kyoto, which is nothing but old boulders placed in such a way, supposedly mystically aesthetic, as to cause thousands of tourists and monks every year to journey there to stare at the boulders in the sand and thereby gain peace of mind. I have never met such weird yet serious and earnest people. I never saw Rol Sturlason again, he went to Japan soon after, but I can't forget what he said about the boulders, to my question, "Well who placed them in that certain way that's so great?"

"Nobody knows, some monk, or monks, long ago. But there is a definite mysterious form in the arrangement of the rocks. It's only through form that we can realize emptiness." He showed me the picture of the boulders in well-raked sand, looking like islands in the sea, looking as though they had eyes (declivities) and surrounded by a neatly screened and architectural monastery patio. Then he showed me a diagram of the stone arrangement with the projection in silhouette and showed me the geometrical logics and all, and mentioned the phrases "lonely individuality" and the rocks as "bumps pushing into space," all meaning some kind of koan business I wasn't as much interested in as in him and especially in good kind Japhy who brewed more tea on his noisy gasoline primus and gave us added cups with almost a silent Oriental bow. It was quite different from the night of the poetry reading.

# HOWARD THURMAN

Howard Thurman (1900–81) was a pastor, theologian, and author of several spiritual as well as theological works, most famously *Jesus and the Disinherited* (1949). Ordained a Baptist minister, he cared little for denom-

inational distinctions and devoted much of his life to religious unity. He taught theology at Morehouse and Spelman Colleges and at Howard University and Boston University, as well as serving as the pastor of the first racially integrated, intercultural church in the United States, the Church for the Fellowship of All Peoples in San Francisco. In 1935–36, Thurman led the first black Delegation of Friendship to India, Burma (now Myanmar), and Ceylon (now Sri Lanka), where he and his wife, Sue Bailey Thurman, met with Mahatma Ghandi. The first document presented here is Thurman's initial draft, written immediately after the trip was completed. The second is from an Indian biography of Ghandi.

# What We May Learn from India

## PART ONE: CHRISTIANITY IN INDIA

I have been assigned a topic "What We May Learn From India." I shall discuss the subject under two general headings—some aspects of the central problem of Christianity in India and the problem of colored prejudice. I shall point out certain similarities and differences as they apply to our situation in America. According to the tradition, Christianity through the Syrian Church has been in India since the first century. Whether it is a fact that the church was started by St. Thomas near the close of one A.D. or not, it is well authenticated that the Syrian Church has had a continuous life since the sixth century. The locale of the Syrian Church for the most part is in Travancore and the Malabar area across the ghats on the southwestern coast. The history of the Church has not been impressive for it has concerned itself with its own internal development and has given very little, if any, consideration to questions of expansion among the non-Christian religions. It has taken on some of the customs of its Hindu neighbors such as the recognition of caste and the like. However, I must add that the most independent and forward-looking group of Christians to be found in India are those who are a part of its fellowship. They have more independence and, in my opinion, more fundamental self-regard than the other Christian communities of India. The only Christian college supported outright by Indian funds is the Syrian Christian College at Alway. The staff and its program are largely indigenous.

Western Christianity came into India by way of the Portuguese who established their hierarchy throughout their sphere of influence. The spearhead of this movement was St. Francis Xavier. Under the mission of propaganda in the

seventeenth century the papacy began its large and influential work in the country. Between 1911 and 1923 the Roman Catholic population of India increased by more than three hundred thirty-two thousand; while the Protestants' increase over the same period was five hundred forty-seven thousand. Protestant Christianity came into India about 1813. Protestantism represents many things other than a united front. Let us look at the picture: among the Baptists, there are English, Canadian, and American Baptists; the Methodists include the English Wesleyan, the Free Methodist of America, and the Methodist Episcopal Church; the Lutherans include the United Lutheran of America, the Church of Sweden, the Basel Church, the Leipsig Mission, the Missouri Evangelical Mission, and the Danish Society; there are the Disciples of Christ, the Seventh Day Adventists, the Mennonites: among the Congregationalists the American and the British, the Scandinavian, Swedish, Free Church of Finland, and the London Missionary Society; among the Presbyterians the Irish Presbyterian, the United Presbyterian of America, the American Presbyterian, the United Church of Canada, the Canadian Presbyterian, the Welsh Calvinistic Methodist, and in addition to all these the Salvation Army, a few sects of the Holy Rollers, the Church of Scotland, the Anglican Church and the YM and YWCA—all Protestants. Each one of these groups has its own tenets, doctrinal differences, policies, et cetera. They are united in three important particulars: first, they are all Western and white; second, they all claim loyalty to Christ; third, they all definitely, or ostensibly endorse and cooperate with British rule. Inasmuch as sixty-eight out of every hundred Indians are Hindu, the dominant culture of the land is Hindu. Since the vast Mogul Empire in the North, there has been a sharp cultural and religious conflict between the Moslem and the Hindu. Hinduism is a religion, a culture, and a civilization. Its genius is ordinarily a synthesizing one. In the vast palace of the Hindu faith there are yet many unoccupied rooms. To all and any new faith Hinduism says "your room is ready, come in, make yourself at home." Christianity, therefore, has been compelled, even if it could have acted otherwise, to project itself as a culture, a civilization, and a religion, for the genius of Christianity tends to be exclusive. The result is that it has not been possible for Christianity to extricate itself from the western civilization whose culture patterns it has taken over in the whole process of becoming at home in the West. When the Indian embraces Christianity, he therefore takes over the religion and its framework. He changes his name from an Indian Hindu name to a Christian name. Now precisely what is a Christian name? Obviously the name the missionary bears or a name taken "whole cloth" from the Christian Bible; hence, there are many Mr. Adames, Mr. Tituses, Mr. Moseses, et cetera. His children are likewise named. When he marries he uses the Christian ceremony. He gives his wife a Christian wedding ring and takes her on a Christian honeymoon. His break with Hindu culture is well nigh complete.

When he begins to make his religion at home in the country, he finds that all of his old culture patterns are Hindu and that if his religion becomes indigenous he must make use of certain forms, social and cultural, which according to his profession of faith are anathema to him. So that one finds the Indian Christian today singing Western hymns, wearing Western clothes and inclined to think of the God of the Christian religion in terms of the ideology of the dominant con-

trolling European of his country. The missionary faces a very peculiar dilemma. He comes into the country as a product of Western civilization and such culture as he has been able to absorb. He propagates a faith which to him is personal and ultimate. It is a faith, however, built upon certain definite assumptions relative to the established order of which he is a part. If he is a Britisher it is a faith that is built upon the assumption of empire. I shall return to this in the second half of my discussion. If he is any other kind of European, including the American, it is a faith that is built upon the assumption of the ultimate supremacy of his religion, his civilization, and his race. The missionary cannot ever escape the damaging fact that the conqueror of the people to whom he is going is not only like him as to race, but is also a Christian. Over and over again I encountered the comment: "But you see, Mr. Thurman, our conquerors are Europeans and are Christians." Therefore, the missionary is driven to limit his message by the fact of his race and his kinship in faith with the conqueror.

There are two reasons why the form that Christianity has taken in India tends to be highly theological and orthodox. First, when a particular religion is making converts in the midst of very old religions and cultures, it is necessary for it to establish its position as rapidly as possible by defining its terms and especially its categories in contrast to the definitions and the categories of the faiths by which it is surrounded. The converts must be given formulae that are easily manipulated so as to defend their position on the shortest possible notice. The psychological climate of the converts is charged with antagonism and attacks, very often, and the bullets of his faith must always be available; hence, the tremendous emphasis upon concrete definition. This tendency makes for over simplicity, conservatism and "cock-sureness." Now the second thing that has made for the strict and rigid policy of evangelism of the enterprise is that there is no danger to imperialism if the religionist confines his emphasis primarily to the relationship of the individual human soul to God. Almost everywhere I encountered what amounted to fear, practically, of the social emphasis of Christianity. To be sure, I found many people who were feeding the hungry, administering to the sick, et cetera, but very little fundamental attack was being made on the established order lest the missionaries themselves should become persona non grata to the government. Stanley Jones told me how much anxiety he spent in contemplating possible consequences of the effect of his book *Jesus and the Underprivileged* on the friendly relationship that existed between him and the British government. Two other rather subsidiary but somewhat important factors should be mentioned in this connection. One is the Western supporters of the missionary enterprise must be assured that souls are being saved. There can be no substitute for this. Second, among certain branches of Hinduism a much more comprehensive social service and humanitarian program is being found than the social service program along narrow orthodox Christian lines. Finally, Western Christianity has brought with it its class distinctions which have largely vitiated it in the West. The missionary and the representative of Western Christianity in India has succeeded in bringing home to the Indian one impressive fact, that is, that he is infinitely superior and more worthful than the Indian. Over and over again I found myself saying however kind and benevolent an autocrat is, he is still an autocrat. I visited a church in Jaffna at which twenty years ago there were two pulpits. One high and lifted up; the other on

the ground floor. From the elevated pulpit the missionary and the missionary alone or some other European preached; while from the pulpit on the floor the Indian national was permitted to preach. It was the boast of a Roman Catholic priest, the head of a college, that unlike Protestantism the Roman Catholic Church recognized no class distinction in its clergy as between Indian and European. In my opinion, one of the most hopeful signs in evidence in the ranks of official Christianity is the work toward the union of the Protestant Church in India. I do not see how the Church, which at the moment represents a great vested interest in the country and which must continue its support of British rule, can expect to bring to Indians in any formal sense an interpretation of the Christian religion which springs out of the heart of Jesus of Nazareth, a member of an underprivileged, disinherited group in the Greco-Roman world. Here and there are glorious illustrations of individuals who have transcended to some degree the limitation of cultures and civilizations and have exemplified a quality of life, timeless and all embracing. But they are rare and are not to be included in the same group with the official upholders of the established order. I close this section of my discussion with the rather striking words of Mahatma Gandhi to me: "The greatest enemy that the religion of Jesus has in India is Christianity in India."

## PART TWO: COLORED PREJUDICE

The second day after we arrived in Ceylon a rather brilliant barrister at the close of a lecture before a law society invited me downstairs for coffee. When we were seated we were joined by two other friends, the door was closed, the coffee served and drunk and, then, he opened up as follows: "What are you doing here?" I said, "What do you mean?" He said, "Precisely that. I note what this pamphlet says that your mission is but what are you doing over here?" He said, "More than four hundred years ago your African forebears were taken from the Western coast of Africa by slave traders who were Christians; in fact, not only was the name of one of the English slave vessels *Jesus,* but one of your very celebrated Christian hymn writers was a dealer in the slave traffic. You were sold in America to other Christians. You were held in slavery three hundred years by Christians. You were freed a little more than seventy years ago by a man who, himself, was not a Christian but who was a spearhead of certain political, economic and social forces the full significance of which he, himself, did not quite understand. And for seventy years you have been lynched and burned and discriminated against by Christians; in fact, I read one incident of a Christian church service that was dismissed in order that the members may go join a mob and after the lynching came back to church and now," said he, "here you are over here as a Christian and I think, Sir, you are a traitor to all of the darker peoples of the earth. And I wondered what you, an intelligent man, would have to say for yourself." We discussed this matter for more than three hours.

The question of color prejudice in India for the purposes of our discussion is confined to the relationship that obtains between three groups of people in India—the European, the Anglo-Indian, and the Indian. With the exception of a group of some sixty-five Negroes from the West Indies, with an occasional African who has the status of European, all of the Europeans are white. The

Anglo-Indians are those whose parentage is mixed. The first impetus given to the establishing of such a group is located in the extramarital relationships that obtain between the British tommy and the Indian lady. It seems to be a part of established British imperialism to recognize any adulterated expressions of British blood by giving the offspring a special status which is midway between the top and the bottom. This status perpetuated into an economic class. In South Africa there are Europeans at the top, the colored race in the middle—those of mixed blood—and the African at the bottom. The same thing obtains in India. The Anglo-Indian is not only a separate class socially but is also a separate class economically, for they have been given for many years the exclusive privilege to perform all of the services in connection with the railroad and the telegraph. The Anglo-Indian is much prouder of his Scottish grandmother than he is of his Indian father or Indian mother. The tension, therefore, that exists between the Anglo-Indian and the Indian National is very marked. The Anglo-Indian feeling that he is much better than the Indian and is trying always to get away from him while he is reaching up to be considered a European and his European half-brother is always trying to get away from him. It is only in recent years that the Indian and the Anglo-Indian are beginning to see that the fate of one is the fate of all.

I remember one night traveling through enroute to Calcutta from the Musilapatam and being compelled to spend most of the night at the Bezwaba Junction; an Indian Student Secretary was traveling with us part of the way. In the railway station at the Junction there are rooms in which one may spend the night that are divided one-half for Europeans and one-half for Indians; because the Indian was a part of our party we wanted him to spend the night with us. The Indian attendant refused to permit this saying to the Indian "you know you have no business in the European section." It reminded me a great deal of the "land of the free and the home of the brave." The Britisher is very sure of one thing and that is that he is a brilliant illustration of the favoritism of Divine Providence. All of his religion, ethics, and morality move out from the assumption of empire. Granted the prerogatives of empire the Britisher is a just white man when he is dealing with lesser breeds without the law. As far as my own personal experience is concerned in India I found the Britisher courteous, often generous, sometimes benevolent, always superior. It remained for a great American religious leader from Kentucky who has recently been made a bishop of India by the Methodist Church to give what was meant to be the only real snub during the sixteen thousand miles of travel in the country.

Christianity is powerless to make any inroads on the question of color and race prejudice in India because of the way it has made its peace with color and race prejudice in the West. In America our civilization is too young and there have been so many extenuating circumstances in our past and present situation to make the kind of careful deliberate classification among Negroes that the British have made both in India and South Africa. It may be instructive to examine the background of the situation in this country for a moment. During the days of slavery there were many children of mixed parentage born on the plantation. The master favored his offspring and sometimes their mother by making of them household or yard slaves rather than field hands. They enjoyed certain protecting privileges which were denied their cruder more

African half-brothers in the fields. Among the slaves themselves there grew up a distinction between the house slaves, who for the most part were mulattoes, and the field slaves. Another interesting fact that belongs in the picture is that only about four hundred thousand of the four or five million white people that lived in the South during these years were slaveowners. The others were divided into two classes that were unfortunately referred to as "crackers" and "poor white trash." Those who were dubbed "crackers" were a kind of middle-class businessmen. They ran the stores and things of that sort. The "poor white people" lived often in the hills and on very poor land from which they were forced to wrest an exceedingly precarious livelihood. They naturally looked upon the presence of the slaves as the cause rather than the occasion for their insecurity, for they reasoned that if the slave had not been present in the society they would have tilled the rich soil and would have been the artisans and craftsmen and their economic security would have by that fact been guaranteed. So for nearly ten generations they looked upon the slave with eyes that smouldered with bitterness and hatred.

When the Civil War was fought the economic life of the South was largely destroyed and the flower of that culture lay prostrate on a hundred battlefields. After military rule of the Union army had been withdrawn the people who came into power were these traditional enemies of the slaves, often lacking in culture and refinement even more than the slaves who had through many generations lived under the shadow of aristocracy. So determined were they in their taking over the economic, political and social life of the South to seek revenge upon these slaves and so difficult and precarious were the times, that they did not think about dividing the slaves among themselves by giving prior consideration and preferential treatment to the mulattoes; the net result was that all of the slaves were grouped as a unit. This, in my opinion, from the point of view of white supremacy and control in America was the master blunder in strategy. It did not take very long after Reconstruction had gotten under way for the whole color feeling dating back to slavery time to disintegrate in Negro life, so that today it is more rare than common to find a family of mulatto Negroes who feel that they are superior to their black half-brothers.

The important thing to notice is that as our civilization grows older and our culture ripens it is beginning to be a practice among many policy-making white Americans to make a separate class of mulattoes giving them preferential treatment as to jobs and positions so that in the next one hundred years we may have in America the same sort of thing that obtains wherever the Britisher goes among darker peoples. A friend of mine was telling me the other day about a certain man who had written a paper showing that only one black Negro had ever received a Ph.D. from an American University. Of course, this is not true. It is rather a common experience among certain agencies that find jobs for Negroes that if a darker Negro and a mulatto Negro both apply the preference is given to the mulatto Negro. It is a rather general feeling among certain Negro intellectuals that many of the choice executive positions that are dispensed by people who are professionally interested in Negroes are reserved almost exclusively for those who are mulatto and the end is not yet. To conclude—I was deeply impressed by the fact that the European, (and the American is included here), has spread the rumor wherever he has gone that the race that is at the bot-

tom of all the other races in culture, intelligence, integrity of character is the Negro. Imagine reading in the *Delhi-Statesman* a long article about Joe Louis, an article written by an Englishman in which he talked a great deal about Joe Louis as boxer, about the amazing amount of money he has made in a year and a half and to find that he ends this supposedly critical appraisal with this choice bit of information; to wit: "Joe Louis eats five pounds of meat, one chicken and a container of ice cream at each meal and typical of his race he wears gaudy color shirts, gaudy color suits and light yellow shoes." As I consider the Indian as he faces the question of color prejudice in his own land and compare him with the American Negro as he faces color prejudice in this land, the following things stand out in bold relief: 1. The Indian is the victim of color prejudice at the hands of a white conqueror who is expressing himself in a land which he has stolen. 2. He is a victim of a prejudice which is mixed with fundamental differences in religion and culture. 3. The Indian has no political ideal in an imperialistic regime on which he may bring the Britisher or European to the bar of moral judgment. With reference to the American Negro, we find the following: 1. He, along with the American white man, is a foreigner in a land stolen from the American Indian. They are both, the American Negro and the American white man, trying to become a nation on foreign soil. 2. The political ideal of America is in favor of practices that are democratic in their genius and before which undemocratic practices can be condemned as antithetical and immoral. 3. Both the American Negro and the white man are definitely committed to the same Christian ideal of brotherliness in the light of which unbrotherly practices can be properly classified as sinful and unchristian. May I add a personal word in closing: there seems to me to be one important difference between the brutality and the inhumaneness of the Britisher in lands which he has conquered and the American white man. The brutality of the Britisher seems to me to be deliberate, mature, reflective; while the brutality of the American strikes me as being adolescent and immature. The thing that fills me with complete despair is that as I consider the future in the light of what seems to me to be a crystallization of American mores and folkways in this particular is that he is rapidly becoming mature and reflective in his brutality. The moment that brutality becomes mature and reflective it becomes moral and righteous.

# Howard and Sue Bailey Thurman
# Meet with Mahatma Gandhi

On February 20, he [Gandhi] left for Wardha. On the way he halted at Bardoli, where members of the American Negro delegation came to meet him.

Gandhi asked Dr. Thurman, leader of the delegation, "Is the prejudice against colour growing or dying out?"

"It is difficult to say," said Dr. Thurman, "because in one place things look much improved, whilst in another the outlook is still dark. But the economic

question is acute everywhere, and in many of the industrial centres in the Middle West the prejudice against the Negro shows itself in its ugliest form. Among the workers there is a great amount of tension, which is quite natural, when the white man thinks that the Negro's very existence is a threat to his own."

"Is the union between the Negroes and the whites recognized by law?" he asked.

"Twenty-five states have laws definitely against these unions, and I have had to sign a bond of 500 dollars to promise that I would not register any such union," said Mr. Carrol, a pastor in Salem. "But," said Thurman, "there has been a lot of intermixture of races as, for 300 years or more, the Negro woman had no control over her body."

It was now their turn to ask questions. "Did the South African Negro take any part in your movement?" Dr. Thurman asked.

"No," said Gandhi, "I purposely did not invite them. It would have endangered their cause. They would not have understood the technique of our struggle, nor could they have seen the purpose or the utility of nonviolence."

This led to the discussion of the state of Christianity among the South African Negroes, and Gandhi explained at great length why Islam scored against Christianity there. The talk seemed to appeal very much to Dr. Thurman, a professor of comparative religion. "We are often told," said Dr. Thurman, "that but for the Arabs there would have been no slavery. I do not believe it."

"No," explained Gandhi, "it is not true at all. For, the moment a slave accepts Islam, he obtains equality with his master, and there are several instances of this in history."

And now the talk centred on a discussion which had mainly drawn the distinguished members to Gandhi.

"Is non-violence, from your point of view, a form of direct action?" inquired Dr. Thurman.

"It is not one form, it is the only form," replied Gandhi. "I do not, of course, confine the words 'direct action' to their technical meaning. But without direct active expression of it, non-violence to my mind is meaningless. It is the greatest and the activest force in the world. One cannot be passively non-violent. In fact, 'non-violence' is a term I had to coin in order to bring out the root meaning of ahimsa. In spite of the negative particle 'non', it is no negative force. Superficially we are surrounded in life by strife and bloodshed, like living upon life. But some great seer, who ages ago penetrated the centre of truth, said: it is not through strife and violence, but through non-violence that man can fulfil his destiny and his duty to his fellow creatures. It is a force which is more positive than electricity and more powerful than even ether. At the centre of non-violence is a force which is self-acting. Ahimsa means 'love' in Pauline sense, and yet something more than the 'love' defined by St. Paul, although I know St. Paul's beautiful definition is good enough for all practical purposes. Ahimsa includes the whole creation, and not only human. Besides, love in the English language has other connotations too, and so I was compelled to use the negative word. But it does not, as I have told you, express a negative force, but a force superior to all the forces put together. One person who can express ahimsa in life exercises a force superior to all the forces of brutality."

QUESTION: "And is it possible for any individual to achieve this?"

GANDHI: "Certainly. If there was any exclusiveness about it, I should reject it at once."

QUESTION: "Any idea of possession is foreign to it?"

GANDHI: "Yes. It possesses nothing; therefore, it possesses everything."

QUESTION: "Is it possible for a single human being to resist the persistent invasion of the quality successfully?"

GANDHI: "It is possible. Perhaps your question is more universal than you mean. Is it not possible, you mean to ask, for one single Indian, for instance, to resist the exploitation of 300 million Indians? Or, do you mean the onslaught of the whole world against a single individual personally?"

DR. THURMAN: "Yes, that is one half of the question. I wanted to know, if one man can hold the whole violence at bay?"

GANDHI: "If he can't, you must take it that he is not a true representative of ahimsa. Supposing I cannot produce a single instance in life of a man who truly converted his adversary, I would then say that is because no one had yet been found to express ahimsa in its fulness."

QUESTION: "Then it overrides all other forces?"

GANDHI: "Yes, it is the only true force in life."

"Forgive now the weakness of this question," pleaded Dr. Thurman, "but may I ask how are we to train the individuals or communities in this difficult art?"

Gandhi replied: "There is no royal road, except through living the creed in your life which must be a living sermon. Of course, the expression in one's own life presupposes great study, tremendous perseverance, and a thorough cleansing of one's self of all the impurities. If for mastering of the physical sciences you have to devote a whole lifetime, how many lifetimes may be needed for mastering the greatest spiritual force that mankind has known? But why worry even if it means several lifetimes? For, if this is the only permanent thing in life, if this is the only thing that counts, then whatever effort you bestow on mastering it, is well spent. Seek ye first the Kingdom of Heaven and everything else shall be added unto you. And the Kingdom of Heaven is ahimsa."

Mrs. Thurman inquired, "How am I to act, supposing my own brother was lynched before my very eyes?"

"There is such a thing as self-immolation," he said. "Supposing I was a Negro, and my sister was ravished by a white or lynched by a whole community, what would be my duty?—I ask myself. And the answer comes to me: I must not wish ill to these, but neither must I co-operate with them. It may be that ordinarily I depend on the lynching community for my livelihood. I refuse to co-operate with them, refuse even to touch the food that comes from them, and I refuse to co-operate with even my brother Negroes who tolerate the wrong. That is the self-immolation, I mean. I have often in my life resorted to the plan. Of course, a mechanical act of starvation will mean nothing. One's faith must remain undimmed whilst life ebbs out, minute by minute. But I am a very poor specimen of the practice of non-violence, and my answer may not convince you. But I am striving very hard, and even if I do not succeed fully in this life, my faith will not diminish."

"We want you to come to America," said the visitors. Mrs. Thurman reinforced the request, saying "We want you not for White America, but for Negroes; we have many a problem that cries for solution, and we need you badly."

"How I wish I could, but I would have nothing to give you unless I had given an ocular demonstration here of all that I have been saying. I must make good the message here, before I bring it to you. I do not say that I am defeated, but I have still to perfect myself. You may be sure that the moment I feel that call within me, I shall not hesitate," said Gandhi.

Dr. Thurman explained that the Negroes were prepared to receive the message. "Much of the peculiar background of our own life in America is our own interpretation of the Christian religion. When one goes through the pages of the hundreds of Negro spirituals, striking things are brought to my mind which remind me of all that you have told us today."

"Well," exclaimed Gandhi, "if it comes true, it may be through the Negroes that the unadulterated message of non-violence will be delivered to the world."

# MARTIN LUTHER KING, JR.

Martin Luther King, Jr. (1929–68) was a Baptist minister who led the civil rights movement for racial justice. His "I Have a Dream" speech at the 1963 March on Washington established him as the foremost spokesperson for African Americans; that same year, *Time* magazine named him "Man of the Year," and he received the Nobel Peace Prize a year later. His "Letter from Birmingham City Jail" was written in this period, while he was serving time for civil rights activities in Birmingham, Alabama. He wrote the piece in response to an open letter published by eight white self-styled "liberal" ministers who called upon him to desist from nonviolent resistance and let the justice system determine the future of racial integration.

## Letter from Birmingham City Jail

*My dear Fellow Clergymen,*
While confined here in the Birmingham city jail, I came across your recent statement calling our present activities "unwise and untimely." Seldom, if ever, do I pause to answer criticism of my work and ideas. If I sought to answer all of the

criticisms that cross my desk, my secretaries would be engaged in little else in the course of the day, and I would have no time for constructive work. But since I feel that you are men of genuine good will and your criticisms are sincerely set forth, I would like to answer your statement in what I hope will be patient and reasonable terms.

I think I should give the reason for my being in Birmingham, since you have been influenced by the argument of "outsiders coming in." I have the honor of serving as president of the Southern Christian Leadership Conference, an organization operating in every southern state, with headquarters in Atlanta, Georgia. We have some eighty-five affiliate organizations all across the South— one being the Alabama Christian Movement for Human Rights. Whenever necessary and possible we share staff, educational and financial resources with our affiliates. Several months ago our local affiliate here in Birmingham invited us to be on call to engage in a nonviolent direct-action program if such were deemed necessary. We readily consented and when the hour came we lived up to our promises. So I am here, along with several members of my staff, because we were invited here. I am here because I have basic organizational ties here.

Beyond this, I am in Birmingham because injustice is here. Just as the eighth century prophets left their little villages and carried their "thus saith the Lord" far beyond the boundaries of their hometowns; and just as the Apostle Paul left his little village of Tarsus and carried the gospel of Jesus Christ to practically every hamlet and city of the Graeco-Roman world, I too am compelled to carry the gospel of freedom beyond my particular hometown. Like Paul, I must constantly respond to the Macedonian call for aid.

Moreover, I am cognizant of the interrelatedness of all communities and states. I cannot sit idly by in Atlanta and not be concerned about what happens in Birmingham. Injustice anywhere is a threat to justice everywhere. We are caught in an inescapable network of mutuality, tied in a single garment of destiny. Whatever affects one directly affects all indirectly. Never again can we afford to live with the narrow, provincial "outside agitator" idea. Anyone who lives in the United States can never be considered an outsider anywhere in this country.

You deplore the demonstrations that are presently taking place in Birmingham. But I am sorry that your statement did not express a similar concern for the conditions that brought the demonstrations into being. I am sure that each of you would want to go beyond the superficial social analyst who looks merely at effects, and does not grapple with underlying causes. I would not hesitate to say that it is unfortunate that so-called demonstrations are taking place in Birmingham at this time, but I would say in more emphatic terms that it is even more unfortunate that the white power structure of this city left the Negro community with no other alternative.

In any nonviolent campaign there are four basic steps: (1) collection of the facts to determine whether injustices are alive, (2) negotiation, (3) self-purification, and (4) direct action. We have gone through all of these steps in Birmingham. There can be no gainsaying of the fact that racial injustice engulfs this community.

Birmingham is probably the most thoroughly segregated city in the United States. Its ugly record of police brutality is known in every section of this country. Its injust treatment of Negroes in the courts is a notorious reality. There have been more unsolved bombings of Negro homes and churches in Birmingham

than any city in this nation. These are the hard, brutal and unbelievable facts. On the basis of these conditions Negro leaders sought to negotiate with the city fathers. But the political leaders consistently refused to engage in good faith negotiation.

Then came the opportunity last September to talk with some of the leaders of the economic community. In these negotiating sessions certain promises were made by the merchants—such as the promise to remove the humiliating racial signs from the stores. On the basis of these promises Rev. Shuttlesworth and the leaders of the Alabama Christian Movement for Human Rights agreed to call a moratorium on any type of demonstrations. As the weeks and months unfolded we realized that we were the victims of a broken promise. The signs remained. Like so many experiences of the past we were confronted with blasted hopes, and the dark shadow of a deep disappointment settled upon us. So we had no alternative except that of preparing for direct action, whereby we would present our very bodies as a means of laying our case before the conscience of the local and national community. We were not unmindful of the difficulties involved. So we decided to go through a process of self-purification. We started having workshops on nonviolence and repeatedly asked ourselves the questions, "Are you able to accept blows without retaliating?" "Are you able to endure the ordeals of jail?" We decided to set our direct-action program around the Easter season, realizing that with the exception of Christmas, this was the largest shopping period of the year. Knowing that a strong economic withdrawal program would be the by-product of direct action, we felt that this was the best time to bring pressure on the merchants for the needed changes. Then it occurred to us that the March election was ahead and so we speedily decided to postpone action until after election day. When we discovered that Mr. Connor was in the run-off, we decided again to postpone action so that the demonstrations could not be used to cloud the issues. At this time we agreed to begin our nonviolent witness the day after the run-off.

This reveals that we did not move irresponsibly into direct action. We too wanted to see Mr. Connor defeated; so we went through postponement after postponement to aid in this community need. After this we felt that direct action could be delayed no longer.

You may well ask, "Why direct action? Why sit-ins, marches, etc.? Isn't negotiation a better path?" You are exactly right in your call for negotiation. Indeed, this is the purpose of direct action. Nonviolent direct action seeks to create such a crisis and establish such creative tension that a community that has constantly refused to negotiate is forced to confront the issue. It seeks so to dramatize the issue that it can no longer be ignored. I just referred to the creation of tension as a part of the work of the nonviolent resister. This may sound rather shocking. But I must confess that I am not afraid of the word tension. I have earnestly worked and preached against violent tension, but there is a type of constructive nonviolent tension that is necessary for growth. Just as Socrates felt that it was necessary to create a tension in the mind so that individuals could rise from the bondage of myths and half-truths to the unfettered realm of creative analysis and objective appraisal, we must see the need of having nonviolent gadflies to create the kind of tension in society that will help men to rise from the dark depths of prejudice and racism to the majestic heights of under-

standing and brotherhood. So the purpose of the direct action is to create a situation so crisis-packed that it will inevitably open the door to negotiation. We, therefore, concur with you in your call for negotiation. Too long has our beloved Southland been bogged down in the tragic attempt to live in monologue rather than dialogue.

One of the basic points in your statement is that our acts are untimely. Some have asked, "Why didn't you give the new administration time to act?" The only answer that I can give to this inquiry is that the new administration must be prodded about as much as the outgoing one before it acts. We will be sadly mistaken if we feel that the election of Mr. Boutwell will bring the millennium to Birmingham. While Mr. Boutwell is much more articulate and gentle than Mr. Connor, they are both segregationists, dedicated to the task of maintaining the status quo. The hope I see in Mr. Boutwell is that he will be reasonable enough to see the futility of massive resistance to desegregation. But he will not see this without pressure from the devotees of civil rights. My friends, I must say to you that we have not made a single gain in civil rights without determined legal and nonviolent pressure. History is the long and tragic story of the fact that privileged groups seldom give up their privileges voluntarily. Individuals may see the moral light and voluntarily give up their unjust posture; but as Reinhold Niebuhr has reminded us, groups are more immoral than individuals.

We know through painful experience that freedom is never voluntarily given by the oppressor; it must be demanded by the oppressed. Frankly, I have never yet engaged in a direct action movement that was "well-timed," according to the timetable of those who have not suffered unduly from the disease of segregation. For years now I have heard the words "Wait!" It rings in the ear of every Negro with a piercing familiarity. This "Wait" has almost always meant "Never." It has been a tranquilizing thalidomide, relieving the emotional stress for a moment, only to give birth to an ill-formed infant of frustration. We must come to see with the distinguished jurist of yesterday that "justice too long delayed is justice denied." We have waited for more than 340 years for our constitutional and God-given rights. The nations of Asia and Africa are moving with jetlike speed toward the goal of political independence, and we still creep at horse and buggy pace toward the gaining of a cup of coffee at a lunch counter. I guess it is easy for those who have never felt the stinging darts of segregation to say, "Wait." But when you have seen vicious mobs lynch your mothers and fathers at will and drown your sisters and brothers at whim; when you have seen hate-filled policemen curse, kick, brutalize and even kill your black brothers and sisters with impunity; when you see the vast majority of your twenty million Negro brothers smothering in an airtight cage of poverty in the midst of an affluent society; when you suddenly find your tongue twisted and your speech stammering as you seek to explain to your six-year-old daughter why she can't go to the public amusement park that has just been advertised on television, and see tears welling up in her little eyes when she is told that Funtown is closed to colored children, and see the depressing clouds of inferiority begin to form in her little mental sky, and see her begin to distort her little personality by unconsciously developing a bitterness toward white people; when you have to concoct an answer for a five-year-old son asking in agonizing pathos: "Daddy, why do white people treat colored people so mean?"; when you take a cross-country

drive and find it necessary to sleep night after night in the uncomfortable corners of your automobile because no motel will accept you; when you are humiliated day in and day out by nagging signs reading "white" and "colored"; when your first name becomes "nigger" and your middle name becomes "boy" (however old you are) and your last name becomes "John," and when your wife and mother are never given the respected title "Mrs."; when you are harried by day and haunted by night by the fact that you are a Negro, living constantly at tiptoe stance never quite knowing what to expect next, and plagued with inner fears and outer resentments; when you are forever fighting a degenerating sense of "nobodiness"; then you will understand why we find it difficult to wait. There comes a time when the cup of endurance runs over, and men are no longer willing to be plunged into an abyss of injustice where they experience the blackness of corroding despair. I hope, sirs, you can understand our legitimate and unavoidable impatience.

You express a great deal of anxiety over our willingness to break laws. This is certainly a legitimate concern. Since we so diligently urge people to obey the Supreme Court's decision of 1954 outlawing segregation in the public schools, it is rather strange and paradoxical to find us consciously breaking laws. One may well ask, "How can you advocate breaking some laws and obeying others?" The answer is found in the fact that there are two types of laws: there are *just* and there are *unjust* laws. I would agree with Saint Augustine that "An unjust law is no law at all."

Now what is the difference between the two? How does one determine when a law is just or unjust? A just law is a man-made code that squares with the moral law or the law of God. An unjust law is a code that is out of harmony with the moral law. To put it in the terms of Saint Thomas Aquinas, an unjust law is a human law that is not rooted in eternal and natural law. Any law that uplifts human personality is just. Any law that degrades human personality is unjust. All segregation statutes are unjust because segregation distorts the soul and damages the personality. It gives the segregator a false sense of superiority, and the segregated a false sense of inferiority. To use the words of Martin Buber, the great Jewish philosopher, segregation substitutes an "I-it" relationship for the "I-thou" relationship, and ends up relegating persons to the status of things. So segregation is not only politically, economically and sociologically unsound, but it is morally wrong and sinful. Paul Tillich has said that sin is separation. Isn't segregation an existential expression of man's tragic separation, an expression of his awful estrangement, his terrible sinfulness? So I can urge men to disobey segregation ordinances because they are morally wrong.

Let us turn to a more concrete example of just and unjust laws. An unjust law is a code that a majority inflicts on a minority that is not binding on itself. This is difference made legal. On the other hand a just law is a code that a majority compels a minority to follow that it is willing to follow itself. This is sameness made legal.

Let me give another explanation. An unjust law is a code inflicted upon a minority which that minority had no part in enacting or creating because they did not have the unhampered right to vote. Who can say that the legislature of Alabama which set up the segregation laws was democratically elected? Throughout the state of Alabama all types of conniving methods are used to

prevent Negroes from becoming registered voters and there are some counties without a single Negro registered to vote despite the fact that the Negro constitutes a majority of the population. Can any law set up in such a state be considered democratically structured?

These are just a few examples of unjust and just laws. There are some instances when a law is just on its face and unjust in its application. For instance, I was arrested Friday on a charge of parading without a permit. Now there is nothing wrong with an ordinance which requires a permit for a parade, but when the ordinance is used to preserve segregation and to deny citizens the First Amendment privilege of peaceful assembly and peaceful protest, then it becomes unjust.

I hope you can see the distinction I am trying to point out. In no sense do I advocate evading or defying the law as the rabid segregationist would do. This would lead to anarchy. One who breaks an unjust law must do it *openly, lovingly* (not hatefully as the white mothers did in New Orleans when they were seen on television screaming, "nigger, nigger, nigger"), and with a willingness to accept the penalty. I submit that an individual who breaks a law that conscience tells him is unjust, and willingly accepts the penalty by staying in jail to arouse the conscience of the community over its injustice, is in reality expressing the very highest respect for law.

Of course, there is nothing new about this kind of civil disobedience. It was seen sublimely in the refusal of Shadrach, Meshach and Abednego to obey the laws of Nebuchadnezzar because a higher moral law was involved. It was practiced superbly by the early Christians who were willing to face hungry lions and the excruciating pain of chopping blocks, before submitting to certain unjust laws of the Roman Empire. To a degree academic freedom is a reality today because Socrates practiced civil disobedience.

We can never forget that everything Hitler did in Germany was "legal" and everything the Hungarian freedom fighters did in Hungary was "illegal." It was "illegal" to aid and comfort a Jew in Hitler's Germany. But I am sure that if I had lived in Germany during that time I would have aided and comforted my Jewish brothers even though it was illegal. If I lived in a Communist country today where certain principles dear to the Christian faith are suppressed, I believe I would openly advocate disobeying these anti-religious laws. I must make two honest confessions to you, my Christian and Jewish brothers. First, I must confess that over the last few years I have been gravely disappointed with the white moderate. I have almost reached the regrettable conclusion that the Negro's great stumbling block in the stride toward freedom is not the White Citizen's Counciler or the Ku Klux Klanner, but the white moderate who is more devoted to "order" than to justice; who prefers a negative peace which is the absence of tension to a positive peace which is the presence of justice; who constantly says, "I agree with you in the goal you seek, but I can't agree with your methods of direct action"; who paternalistically feels that he can set the timetable for another man's freedom; who lives by the myth of time and who constantly advised the Negro to wait until a "more convenient season." Shallow understanding from people of good will is more frustrating than absolute misunderstanding from people of ill will. Lukewarm acceptance is much more bewildering than outright rejection.

I had hoped that the white moderate would understand that law and order exist for the purpose of establishing justice, and that when they fail to do this they become dangerously structured dams that block the flow of social progress. I had hoped that the white moderate would understand that the present tension of the South is merely a necessary phase of the transition from an obnoxious negative peace, where the Negro passively accepted his unjust plight, to a substance-filled positive peace, where all men will respect the dignity and worth of human personality. Actually, we who engage in nonviolent direct action are not the creators of tension. We merely bring to the surface the hidden tension that is already alive. We bring it out in the open where it can be seen and dealt with. Like a boil that can never be cured as long as it is covered up but must be opened with all its pus-flowing ugliness to the natural medicines of air and light, injustice must likewise be exposed, with all of the tension its exposing creates, to the light of human conscience and the air of national opinion before it can be cured.

In your statement you asserted that our actions, even though peaceful, must be condemned because they precipitate violence. But can this assertion be logically made? Isn't this like condemning the robbed man because his possession of money precipitated the evil act of robbery? Isn't this like condemning Socrates because his unswerving commitment to truth and his philosophical delvings precipitated the misguided popular mind to make him drink the hemlock? Isn't this like condemning Jesus because His unique God-consciousness and never-ceasing devotion to his will precipitated the evil act of crucifixion? We must come to see, as federal courts have consistently affirmed, that it is immoral to urge an individual to withdraw his efforts to gain his basic constitutional rights because the quest precipitates violence. Society must protect the robbed and punish the robber.

I had also hoped that the white moderate would reject the myth of time. I received a letter this morning from a white brother in Texas which said: "All Christians know that the colored people will receive equal rights eventually, but it is possible that you are in too great of a religious hurry. It has taken Christianity almost two thousand years to accomplish what it has. The teachings of Christ take time to come to earth." All that is said here grows out of a tragic misconception of time. It is the strangely irrational notion that there is something in the very flow of time that will inevitably cure all ills. Actually time is neutral. It can be used either destructively or constructively. I am coming to feel that the people of ill will have used time much more effectively than the people of good will. We will have to repent in this generation not merely for the vitriolic words and actions of the bad people, but for the appalling silence of the good people. We must come to see that human progress never rolls in on wheels of inevitability. It comes through the tireless efforts and persistent work of men willing to be co-workers with God, and without this hard word time itself becomes an ally of the forces of social stagnation. We must use time creatively, and forever realize that the time is always ripe to do right. Now is the time to make real the promise of democracy, and transform our pending national elegy into a creative psalm of brotherhood. Now is the time to lift our national policy from the quicksand of racial injustice to the solid rock of human dignity.

You spoke of our activity in Birmingham as extreme. At first I was rather disappointed that fellow clergymen would see my nonviolent efforts as those of the extremist. I started thinking about the fact that I stand in the middle of two opposing forces in the Negro community. One is a force of complacency made up of Negroes who, as a result of long years of oppression, have been so completely drained of self-respect and a sense of "somebodiness" that they have adjusted to segregation, and, of a few Negroes in the middle class who, because of a degree of academic and economic security, and because at points they profit by segregation, have unconsciously become insensitive to the problems of the masses. The other force is one of bitterness and hatred, and comes perilously close to advocating violence. It is expressed in the various black nationalist groups that are springing up over the nation, the largest and best known being Elijah Muhammad's Muslim movement. This movement is nourished by the contemporary frustration over the continued existence of racial discrimination. It is made up of people who have lost faith in America, who have absolutely repudiated Christianity, and who have concluded that the white man is an incurable "devil." I have tried to stand between these two forces, saying that we need not follow the "do-nothingism" of the complacent or the hatred and despair of the black nationalist. There is the more excellent way of love and nonviolent protest. I'm grateful to God that, through the Negro church, the dimension of nonviolence entered our struggle. If this philosophy had not emerged, I am convinced that by now many streets of the South would be flowing with floods of blood. And I am further convinced that if our white brothers dismiss us as "rabble-rousers" and "outside agitators" those of us who are working through the channels of nonviolent direct action and refuse to support our nonviolent efforts, millions of Negroes, out of frustration and despair, will seek solace and security in black nationalist ideologies, a development that will lead inevitably to a frightening racial nightmare.

Oppressed people cannot remain oppressed forever. The urge for freedom will eventually come. This is what happened to the American Negro. Something within has reminded him of his birthright of freedom; something without has reminded him that he can gain it. Consciously and unconsciously, he has been swept in by what the Germans call the *Zeitgeist*, and with his black brothers of Africa, and his brown and yellow brothers of Asia, South America and the Caribbean, he is moving with a sense of cosmic urgency toward the promised land of racial justice. Recognizing this vital urge that has engulfed the Negro community, one should readily understand public demonstrations. The Negro has many pent-up resentments and latent frustrations. He has to get them out. So let him march sometime; let him have his prayer pilgrimages to the city hall; understand why he must have sit-ins and freedom rides. If his repressed emotions do not come out in these nonviolent ways, they will come out in ominous expressions of violence. This is not a threat; it is a fact of history. So I have not said to my people "get rid of your discontent." But I have tried to say that this normal and healthy discontent can be channelized through the creative outlet of nonviolent direct action. Now this approach is being dismissed as extremist. I must admit that I was initially disappointed in being so categorized.

But as I continued to think about the matter I gradually gained a bit of satisfaction from being considered an extremist. Was not Jesus an extremist in love—"Love your enemies, bless them that curse you, pray for them that despitefully use you." Was not Amos an extremist for justice—"Let justice roll down like waters and righteousness like a mighty stream." Was not Paul an extremist for the gospel of Jesus Christ—"I bear in my body the marks of the Lord Jesus." Was not Martin Luther an extremist—"Here I stand; I can do none other so help me God." Was not John Bunyan an extremist—"I will stay in jail to the end of my days before I make a butchery of my conscience." Was not Abraham Lincoln an extremist—"This nation cannot survive half slave and half free." Was not Thomas Jefferson an extremist—"We hold these truths to be self-evident, that all men are created equal." So the question is not whether we will be extremist but what kind of extremist will we be. Will we be extremists for hate or will we be extremists for love? Will we be extremists for the preservation of injustice—or will we be extremists for the cause of justice? In that dramatic scene on Calvary's hill, three men were crucified. We must not forget that all three were crucified for the same crime—the crime of extremism. Two were extremists for immorality, and thusly fell below their environment. The other, Jesus Christ, was an extremist for love, truth and goodness, and thereby rose above his environment. So, after all, maybe the South, the nation and the world are in dire need of creative extremists.

I had hoped that the white moderate would see this. Maybe I was too optimistic. Maybe I expected too much. I guess I should have realized that few members of a race that has oppressed another race can understand or appreciate the deep groans and passionate yearnings of those that have been oppressed and still fewer have the vision to see that injustice must be rooted out by strong, persistent and determined action. I am thankful, however, that some of our white brothers have grasped the meaning of this social revolution and committed themselves to it. They are still all too small in quantity, but they are big in quality. Some like Ralph McGill, Lillian Smith, Harry Golden and James Dabbs have written about our struggle in eloquent, prophetic and understanding terms. Others have marched with us down nameless streets of the South. They have languished in filthy roach-infested jails, suffering the abuse and brutality of angry policemen who see them as "dirty nigger-lovers." They, unlike so many of their moderate brothers and sisters, have recognized the urgency of the moment and sensed the need for powerful "action" antidotes to combat the disease of segregation.

Let me rush on to mention my other disappointment. I have been so greatly disappointed with the white church and its leadership. Of course, there are some notable exceptions. I am not unmindful of the fact that each of you has taken some significant stands on this issue. I commend you, Rev. Stallings, for your Christian stance on this past Sunday, in welcoming Negroes to your worship service on a non-segregated basis. I commend the Catholic leaders of this state for integrating Springhill College several years ago.

But despite these notable exceptions I must honestly reiterate that I have been disappointed with the church. I do not say that as one of the negative critics who can always find something wrong with the church. I say it as a minister of the gospel, who loves the church; who was nurtured in its bosom; who has

been sustained by its spiritual blessings and who will remain true to it as long as the cord of life shall lengthen.

I had the strange feeling when I was suddenly catapulted into the leadership of the bus protest in Montgomery several years ago that we would have the support of the white church. I felt that the white ministers, priests and rabbis of the South would be some of our strongest allies. Instead, some have been outright opponents, refusing to understand the freedom movement and misrepresenting its leaders; all too many others have been more cautious than courageous and have remained silent behind the anesthetizing security of the stained-glass windows.

In spite of my shattered dreams of the past, I came to Birmingham with the hope that the white religious leadership of this community would see the justice of our cause, and with deep moral concern, serve as the channel through which our just grievances would get to the power structure. I had hoped that each of you would understand. But again I have been disappointed. I have heard numerous religious leaders of the South call upon their worshippers to comply with a desegregation decision because it is the *law*, but I have longed to hear white ministers say, "Follow this decree because integration is morally *right* and the Negro is your brother." In the midst of blatant injustices inflicted upon the Negro, I have watched white churches stand on the sideline and merely mouth pious irrelevancies and sanctimonious trivialities. In the midst of a mighty struggle to rid our nation of racial and economic injustice, I have heard so many ministers say, "Those are social issues with which the gospel has no real concern," and I have watched so many churches commit themselves to a completely otherworldly religion which made a strange distinction between body and soul, the sacred and the secular.

So here we are moving toward the exit of the twentieth century with a religious community largely adjusted to the status quo, standing as a taillight behind other community agencies rather than a headlight leading men to higher levels of justice.

I have traveled the length and breadth of Alabama, Mississippi and all the other southern states. On sweltering summer days and crisp autumn mornings I have looked at her beautiful churches with their lofty spires pointing heavenward. I have beheld the impressive outlay of her massive religious education buildings. Over and over again I have found myself asking: "What kind of people worship here? Who is their God? Where were their voices when the lips of Governor Barnett dripped with words of interposition and nullification? Where were they when Governor Wallace gave the clarion call for defiance and hatred? Where were their voices of support when tired, bruised and weary Negro men and women decided to rise from the dark dungeons of complacency to the bright hills of creative protest?"

Yes, these questions are still in my mind. In deep disappointment, I have wept over the laxity of the church. But be assured that my tears have been tears of love. There can be no deep disappointment where there is not deep love. Yes, I love the church; I love her sacred walls. How could I do otherwise? I am in the rather unique position of being the son, the grandson and the great-grandson of preachers. Yes, I see the church as the body of Christ. But, oh! How we have blemished and scarred that body through social neglect and fear of being nonconformists.

There was a time when the church was very powerful. It was during that period when the early Christians rejoiced when they were deemed worthy to suffer for what they believed. In those days the church was not merely a thermometer that recorded the ideas and principles of popular opinion; it was a thermostat that transformed the mores of society. Wherever the early Christians entered a town the power structure got disturbed and immediately sought to convict them for being "disturbers of the peace" and "outside agitators." But they went on with the conviction that they were "a colony of heaven," and had to obey God rather than man. They were small in number but big in commitment. They were too God-intoxicated to be "astronomically intimidated." They brought an end to such ancient evils as infanticide and gladiatorial contest.

Things are different now. The contemporary church is often a weak, ineffectual voice with an uncertain sound. It is so often the arch-supporter of the status quo. Far from being disturbed by the presence of the church, the power structure of the average community is consoled by the church's silent and often vocal sanction of things as they are.

But the judgment of God is upon the church as never before. If the church of today does not recapture the sacrificial spirit of the early church, it will lose its authentic ring, forfeit the loyalty of millions, and be dismissed as an irrelevant social club with no meaning for the twentieth century. I am meeting young people every day whose disappointment with the church has risen to outright disgust.

Maybe again, I have been too optimistic. Is organized religion too inextricably bound to the status quo to save our nation and the world? Maybe I must turn my faith to the inner spiritual church, the church within the church, as the true *ecclesia* and the hope of the world. But again I am thankful to God that some noble souls from the ranks of organized religion have broken loose from the paralyzing chains of conformity and joined us as active partners in the struggle for freedom. They have left their secure congregations and walked the streets of Albany, Georgia, with us. They have gone through the highways of the South on tortuous rides for freedom. Yes, they have gone to jail with us. Some have been kicked out of their churches, and lost support of their bishops and fellow ministers. But they have gone with the faith that might defeated is stronger than evil triumphant. These men have been the leaven in the lump of the race. Their witness has been the spiritual salt that has preserved the true meaning of the gospel in these troubled times. They have carved a tunnel of hope through the dark mountain of disappointment.

I hope the church as a whole will meet the challenge of this decisive hour. But even if the church does not come to the aid of justice, I have no despair about the future. I have no fear about the outcome of our struggle in Birmingham, even if our motives are presently misunderstood. We will reach the goal of freedom in Birmingham and all over the nation, because the goal of America is freedom. Abused and scorned though we may be, our destiny is tied up with the destiny of America. Before the Pilgrims landed at Plymouth we were here. Before the pen of Jefferson etched across the pages of history the majestic words of the Declaration of Independence, we were here. For more than two centuries our foreparents labored in this country without wages; they made cotton king; and they built the homes of their masters in the midst of brutal in-

justice and shameful humiliation—and yet out of a bottomless vitality they continued to thrive and develop. If the inexpressible cruelties of slavery could not stop us, the opposition we now face will surely fail. We will win our freedom because the sacred heritage of our nation and the eternal will of God are embodied in our echoing demands.

I must close now. But before closing I am impelled to mention one other point in your statement that troubled me profoundly. You warmly commended the Birmingham police force for keeping "order" and "preventing violence." I don't believe you would have so warmly commended the police force if you had seen its angry violent dogs literally biting six unarmed, nonviolent Negroes. I don't believe you would so quickly commend the policemen if you would observe their ugly and inhuman treatment of Negroes here in the city jail; if you would watch them push and curse old Negro women and young Negro girls; if you would see them slap and kick old Negro men and young boys; if you will observe them, as they did on two occasions, refuse to give us food because we wanted to sing our grace together. I'm sorry that I can't join you in your praise for the police department.

It is true that they have been rather disciplined in their public handling of the demonstrators. In this sense they have been rather publicly "nonviolent." But for what purpose? To preserve the evil system of segregation. Over the last few years I have consistently preached that nonviolence demands that the means we use must be as pure as the ends we seek. So I have tried to make it clear that it is wrong to use immoral means to attain moral ends. But now I must affirm that it is just as wrong, or even more so, to use moral means to preserve immoral ends. Maybe Mr. Connor and his policemen have been rather publicly nonviolent, as Chief Pritchett was in Albany, Georgia, but they have used the moral means of nonviolence to maintain the immoral end of flagrant racial injustice. T. S. Eliot has said that there is no greater treason than to do the right deed for the wrong reason.

I wish you had commended the Negro sit-inners and demonstrators of Birmingham for their sublime courage, their willingness to suffer and their amazing discipline in the midst of the most inhuman provocation. One day the South will recognize its real heroes. They will be the James Merediths, courageously and with a majestic sense of purpose facing jeering and hostile mobs and the agonizing loneliness that characterizes the life of the pioneer. They will be old, oppressed, battered Negro women, symbolized in a seventy-two-year-old woman of Montgomery, Alabama, who rose up with a sense of dignity and with her people decided not to ride the segregated buses, and responded to one who inquired about her tiredness with ungrammatical profundity: "My feet is tired, but my soul is rested." They will be the young high school and college students, young ministers of the gospel and a host of their elders courageously and nonviolently sitting-in at lunch counters and willingly going to jail for conscience's sake. One day the South will know that when these disinherited children of God sat down at lunch counters they were in reality standing up for the best in the American dream and the most sacred values in our Judeo-Christian heritage, and thusly, carrying our whole nation back to those great wells of democracy which were dug deep by the Founding Fathers in the formulation of the Constitution and the Declaration of Independence.

Never before have I written a letter this long (or should I say a book?). I'm afraid that it is much too long to take your precious time. I can assure you that it would have been much shorter if I had been writing from a comfortable desk, but what else is there to do when you are alone for days in the dull monotony of a narrow jail cell other than write long letters, think strange thoughts, and pray long prayers?

If I have said anything in this letter that is an overstatement of the truth and is indicative of an unreasonable impatience, I beg you to forgive me. If I have said anything in this letter that is an understatement of the truth and is indicative of my having a patience that makes me patient with anything less than brotherhood, I beg God to forgive me.

I hope this letter finds you strong in the faith. I also hope that circumstances will soon make it possible for me to meet each of you, not as an integrationist or a civil rights leader, but as a fellow clergyman and a Christian brother. Let us all hope that the dark clouds of racial prejudice will soon pass away and the deep fog of misunderstanding will be lifted from our fear-drenched communities and in some not too distant tomorrow the radiant stars of love and brotherhood will shine over our great nation with all of their scintillating beauty.

*Yours for the cause of Peace and Brotherhood,*
*Martin Luther King, Jr.*

# MALCOLM X

Malcolm X (1925–65) was a highly influential leader in the Nation of Islam and a well-known spokesperson for black nationalism. While in prison for larceny in the late 1940s, he became drawn to the teachings of the Nation, led by Elijah Muhammad. The Nation's teachings focused upon the oppression of blacks at the hands of whites (all of whom were seen as "devils") and argued that Christianity was a white man's religion and the chief tool of black subjugation. Malcolm converted, becoming Minister Malcolm X after being paroled in 1952. He was a highly visible and provocative speaker, and he was openly critical of Martin Luther King, Jr., whose nonviolent methods he saw as naively misguided. Eventually Malcolm grew disillusioned with Elijah Muhammad, breaking with him in 1964 and moving toward orthodox Islam. His 1964 trip to Mecca, where he observed Muslims of many colors worshiping together, marked a dramatic turning point in which he rejected the view that all whites are devils and wrote much more hopefully about religious cooperation. Months later, he was assassinated by members of the Nation of Islam.

# Letters from Abroad

*Jedda, Saudi Arabia*
*April 20, 1964*

Never have I witnessed such sincere hospitality and the overwhelming spirit of true brotherhood as is practiced by people *of all colors and races* here in this ancient holy land, the home of Abraham, Muhammad and all the other prophets of the Holy Scriptures. For the past week I have been utterly speechless and spellbound by the graciousness I see displayed all around me by people *of all colors*.

Last night, April 19, I was blessed to visit the Holy City of Mecca, and complete the "Omra" part of my pilgrimage. Allah willing, I shall leave for Mina tomorrow, April 21, and be back in Mecca to say my prayers from Mt. Arafat on Tuesday, April 22. Mina is about twenty miles from Mecca.

Last night I made my seven circuits around the Kaaba, led by a young Mutawif named Muhammad. I drank water from the well of Zem Zem, and then ran back and forth seven times between the hills of Mt. Al-Safa and Al-Marwah.

There were tens of thousands of pilgrims from all over the world. They were *of all colors*, from blue-eyed blonds to black-skinned Africans, but were all participating in the same ritual, displaying a spirit of unity and brotherhood that my experiences in America had led me to believe could never exist between the white and non-white.

America needs to understand Islam, because this is the one religion that erases the race problem from its society. Throughout my travels in the Muslim world, I have met, talked to, and even eaten with, people who would have been considered "white" in America, but the religion of Islam in their hearts has removed the "white" from their minds. They practice sincere and true brotherhood with other people irrespective of their color.

Before America allows herself to be destroyed by the "cancer of racism" she should become better acquainted with the religious philosophy of Islam, a religion that has already molded people of all colors into one vast family, a nation or brotherhood of Islam that leaps over all "obstacles" and stretches itself into almost all the Eastern countries of this earth.

The whites as well as the non-whites who accept true Islam become a changed people. I have eaten from the same plate with people whose eyes were the bluest of blue, whose hair was the blondest of blond, and whose skin was the whitest of white—all the way from Cairo to Jedda and even in the Holy City of Mecca itself—and I felt the same sincerity in the words and deeds of these "white" Muslims that I felt among the African Muslims of Nigeria, Sudan and Ghana.

True Islam removes racism, because people of all colors and races who accept its religious principles and bow down to the one God, Allah, also automatically accept each other as brothers and sisters, regardless of differences in complexion.

You may be shocked by these words coming from me, but I have always been a man who tries to face facts, and to accept the reality of life as new experiences and knowledge unfold it. The experiences of this pilgrimage have taught me much, and each hour here in the Holy Land opens my eyes even more. If Islam can place the spirit of true brotherhood in the hearts of the "whites" whom I have met here in the Land of the Prophets, then surely it can also remove the "cancer of racism" from the heart of the white American, and perhaps in time to save America from imminent racial disaster, the same destruction brought upon Hitler by his racism that eventually destroyed the Germans themselves. . . .

*Lagos, Nigeria*
*May 10, 1964*

Each place I have visited, they have insisted that I don't leave. Thus I have been forced to stay longer than I originally intended in each country. In the Muslim world they loved me once they learned I was an American Muslim, and here in Africa they love me as soon as they learn that I am Malcolm X of the militant American Muslims. Africans in general and Muslims in particular love militancy.

I hope that my Hajj to the Holy City of Mecca will officially establish the religious affiliation of the Muslim Mosque, Inc., with the 750 million Muslims of the world of Islam once and for all—and that my warm reception here in Africa will forever repudiate the American white man's propaganda that the black man in Africa is not interested in the plight of the black man in America.

The Muslim world is forced to concern itself, from the moral point of view in its own religious concepts, with the fact that our plight clearly involves the violation of our *human rights*.

The Koran compels the Muslim world to take a stand on the side of those whose human rights are being violated, no matter what the religious persuasion of the victims is. Islam is a religion which concerns itself with the human rights of all mankind; despite race, color, or creed. It recognizes all (everyone) as part of one human family.

Here in Africa, the 22 million American blacks are looked upon as the long-lost brothers of Africa. Our people here are interested in every aspect of our plight, and they study our struggle for freedom from every angle. Despite Western propaganda to the contrary, our African brothers and sisters love us, and are happy to learn that we also are awakening from our long "sleep" and are developing strong love for them.

*Accra, Ghana*
*May 11, 1964*

I arrived in Accra yesterday from Lagos, Nigeria. The natural beauty and wealth of Nigeria and its people are indescribable. It is full of Americans and other whites who are well aware of its untapped natural resources. The same whites, who spit in the faces of blacks in America and sic their police dogs upon us to keep us from "integrating" with them, are seen throughout Africa, bowing, grinning and smiling in an effort to "integrate" with the Africans—they want to "integrate" into Africa's wealth and beauty. This is ironical.

This continent has such great fertility and the soil is so profusely vegetated that with modern agricultural methods it could easily become the "breadbasket" of the world.

I spoke at Ibadan University in Nigeria, Friday night, and gave the *true* picture of our plight in America, and of the necessity of the independent African nations helping us bring our case before the United Nations. The reception of the students was tremendous. They made me an honorary member of the "Muslim Students Society of Nigeria," and renamed me "Omowale," which means "the child has come home" in the Yoruba language.

The people of Nigeria are strongly concerned with the problems of their African brothers in America, but the U.S. information agencies in Africa create the impression that progress is being made and the problem is being solved. Upon close study, one can easily see a gigantic design to keep Africans here and the African-Americans from getting together. An African official told me, "When one combines the number of peoples of *African descent* in South, Central and North America, they total well over 80 million. One can easily understand the attempts to keep the Africans from ever uniting with the African-Americans." Unity between the Africans of the West and the Africans of the fatherland will well change the course of history.

Being in Ghana now, the fountainhead of Pan-Africanism, the last days of my tour should be intensely interesting and enlightening.

Just as the American Jew is in harmony (politically, economically and culturally) with world Jewry, it is time for all African-Americans to become an integral part of the world's Pan-Africanists, and even though we might remain in America physically while fighting for the benefits the Constitution guarantees us, we must "return" to Africa philosophically and culturally and develop a working unity in the framework of Pan-Africanism.

# WILL HERBERG

Will Herberg (1901–77), was a Marxist disillusioned by Stalinism in the late 1930s when he read Reinhold Niebuhr's *Moral Man and Immoral Society* (1932) and undertook a vigorous exploration of religion. He was inspired by thinkers from his own Jewish tradition as well as Christian theologians. This excerpt is from his second major book, *Protestant-Catholic-Jew: An Essay in American Religious Sociology* (1955), a highly influential critique of American patterns of assimilation to the "triple melting pot" and the simplistic promotion of the "American Way of Life." Mainstream forms of Protestantism, Catholicism, and Judaism in the United States all tended to emphasize this theme in a way that was overly nationalistic, Herberg argued forcefully. The work continues to raise questions about the proper relation between religion and the nation.

# *From* Protestant-Catholic-Jew

## IV. THE CONTEMPORARY UPSWING IN RELIGION

### I

No one who attempts to see the contemporary religious situation in the United States in perspective can fail to be struck by the extraordinary pervasiveness of religious identification among present-day Americans. Almost everybody in the United States today locates himself in one or another of the three great religious communities. Asked to identify themselves in terms of religious "preference," 95 per cent of the American people, according to a recent public opinion survey, declared themselves to be either Protestants, Catholics, or Jews (68 per cent Protestants, 23 per cent Catholics, 4 per cent Jews); only 5 per cent admitted to no "preference." Some differences, one or two perhaps of real significance, are indicated when these figures are broken down according to race, age, sex, education, occupation, income, region, and degree of urbanization; but, by and large, the conclusion seems to be that virtually the entire body of the American people, in every part of the country and in every section of society, regard themselves as belonging to some religious community. The results of the survey are fully borne out by the reports of informed observers of the American scene.

Such information as that which this survey provides is unfortunately not available for earlier times, and so direct comparison is impossible. But it seems safe to assume that these figures, reflecting the situation in the early 1950s, represent an all-time high in religious identification. Through the nineteenth century and well into the twentieth America knew the militant secularist, the atheist or "freethinker," as a familiar figure in cultural life, along with considerably larger numbers of "agnostics" who would have nothing to do with churches and refused to identify themselves religiously. These still exist, of course, but their ranks are dwindling and they are becoming more and more inconspicuous, taking the American people as a whole. The "village atheist" is a vanishing figure; Clarence Darrow and Brann the Iconoclast, who once commanded large and excited audiences, have left no successors. Indeed, their kind of anti-religion is virtually meaningless to most Americans today, who simply cannot understand how one can be "against religion" and for whom some sort of religious identification is more or less a matter of course. This was not always the case; that it is the case today there can be no reasonable doubt. The pervasiveness of religious identification may safely be put down as a significant feature of the America that has emerged in the past quarter of a century.

The figures for church membership tell the same story but in greater detail. Religious statistics in this country are notoriously inaccurate, but the trend is so well marked that it overrides all margins of error. In the quarter of a century between 1926 and 1950 the population of continental United States increased 28.6 per cent; membership of religious bodies increased 59.8 per cent: in other words, church membership grew more than twice as fast as population. Protestants increased 63.7 per cent, Catholics 53.9 per cent, Jews 22.5 per cent. Among Protestants, however, the increase varied considerably as between denominations: Baptist increase was well over 100 per cent, some "holiness" sects grew even more rapidly, while the figure for the Episcopal Church was only 36.7 per cent, for the Methodist Church 32.2 per cent, for the Northern Presbyterians 22.4 per cent, and for the Congregationalists 21.1 per cent. In general, it may be said that "practically all major types of American religion have staged what is popularly called a 'comeback.'"

In 1950 total church membership was reckoned at 85,319,000, or about 57 per cent of the total population. In 1958 it was 109,557,741, or about 63 per cent, marking an all-time high in the nation's history. Indeed, all available information tends to show that the proportion of the American people religiously affiliated as church members has been consistently growing from the early days of the republic. In his address to the Evanston Assembly of the World Council of Churches, President Eisenhower pointed out that: "Contrary to what many people think, the percentage of our population belonging to churches steadily increases. In a hundred years, that percentage has multiplied more than three times."

President Eisenhower was here probably understating the case. Comparisons are difficult, and figures even approximately accurate are not available for earlier times, but it seems to be generally agreed that church membership in the United States at the opening of the nineteenth century was not much more than 10 or 15 per cent of the population; through the century it grew at a varying rate, reflecting many factors, but above all the success of the evangelical movement in bringing religion to the frontier and the vast influx of Roman Catholic immigrants with a high proportion of church membership. At the opening of the present century, church membership stood at something like 36 per cent of the population; in 1926, when the Census of Religious Bodies established a new basis of calculation, it was about 46 per cent; in 1958, 63 per cent. The trend is obvious, despite the lack of precision of the particular figures.

It is not easy to understand just what these figures reveal beyond a steady increase through a century and a half. Church membership does not mean the same today as it meant in the eighteenth or early nineteenth century, when something of the older sense of personal conversion and commitment still remained. Further, such factors as recent population trends and the increased mobility conferred by the automobile cannot be ignored in any serious effort to estimate the reasons for the growing proportion of Americans in the churches. There is also the significant fact that considerably more Americans regard themselves as church members than the statistics of church affiliation would indicate. Asked, "Do you happen at the present time to be an active member of a church or of a religious group?", 73 per cent of Americans over 18 answered in the affirmative: of those identifying themselves as Catholics, 87 per cent said "yes"; of

those identifying themselves as Protestants, 75 per cent; and of those identifying themselves as Jews, 50 per cent. The over-all total of 73 per cent is considerably higher than the percentage indicated in church membership statistics: 57 per cent in 1950 and 63 per cent in 1958. It would seem that many more people in the United States regard themselves as members, even "active" members, of a church than are listed on the actual membership rolls of the churches. The fact of the matter seems to be that: "In America, there is no sharp division between those within the religious fold and those outside, as there tends to be in Europe. It is extremely difficult, in fact, to determine just how many members the churches have, since no clear boundary marks off members from those who participate without formal membership."

About 70 to 75 per cent of the American people, it may be safely estimated, regard themselves as members of churches; another 20 or 25 per cent locate themselves in one or another religious community without a consciousness of actual church membership—they constitute a "fringe of sympathetic bystanders," so to speak. Only about 5 per cent of the American people consider themselves outside the religious fold altogether.

Church attendance constitutes another, and more restrictive, measure of religious "belonging." The survey we have been using also included the question, "Did you happen to attend any Sunday or Sabbath church services during the last twelve weeks?" To this, 68 per cent answered in the affirmative—82 per cent of the Catholics, 68 per cent of the Protestants, and 44 per cent of the Jews. In 1944 an American Institute of Public Opinion (Gallup) poll revealed that 58 per cent of adult Americans stated that they had attended a religious service in the past four weeks; according to more recent surveys church attendance grew considerably between 1952 and 1957. Church attendance in America, while not always very regular, is fairly substantial and is certainly increasing.

The picture no doubt differs considerably in different parts of the country, among various classes and ethnographic groups, but for our purposes, at this point at least, the common features are more important: the pervasiveness of religious "belonging," the relatively high percentage of membership, and the substantial attendance characteristic of American churches.

Along with membership and attendance, Sunday school enrollment has shown a marked rise in recent years. Reports for 241 religious bodies in the United States indicate that the rate of increase in enrollment from 1947 to 1949 "surpassed the rate of increase both of church membership and of general population . . . for the first time in a number of years." In these two years Sunday school enrollment gained 7.3 per cent, total church membership increased 5.8 per cent, while population rose 3.6 per cent. From 1952 to 1953 the increase in enrollment was even greater: 8.1 per cent as against an increase in church membership of 2.8 per cent. Reported Sunday school enrollment in 1953 stood at 35,389,000; in 1958, it stood at 41,197,313.

Virtually all surveys indicate also a very considerable expansion in church construction in the course of the past decade, particularly in the suburbs of the big cities. The value of new "religious buildings" jumped from $76,000,000 in 1946, to $409,000,000 in 1950, to $868,000,000 in 1957. In 1952 it was reported that "since World War II, the Catholics have been opening 150 to 200 churches a year, often averaging nearly four a week." The same report also indicates that

increasing numbers of synagogues were going up all over the country. A good deal of this expansion of church building no doubt reflected the increasing prosperity of large sections of the American people; it was also, however, undeniable testimony to the high valuation Americans placed on religious institutions in the scale of priority of community expenditures. Very much the same conclusion may be drawn from a study of other aspects of church financing in America in the past fifteen or twenty years. Churches rate high in the community picture in every part of the United States.

On the whole, the jubilant declaration of the Methodist Council of Bishops in the spring of 1954 that there was a "great upsurge in church life" under way in the United States was not without its justification. "Our people," the Methodist bishops noted in their message, "are attending public worship in larger numbers than we have ever known. . . . New churches are being enterprised in every area of America. . . . Giving has reached an all-time high. . . . A new spirit has fallen upon our people." With regard to religion, a new spirit was indeed abroad in the land.

The enhanced standing of churches and religion among the American people is strikingly indicated by the enhanced status of religious leaders. According to surveys conducted by Elmo Roper, Americans, in answering the question, "Which one of these groups do you feel is doing the most good for the country at the present time?", placed religious leaders third, after government leaders and business leaders, in 1942, but first in 1947. In the former year (1942), 17.5 per cent thought religious leaders were "doing the most good," as against 27.7 per cent who put more trust in government leaders, and 18.7 per cent in business leaders (6.2 per cent trusted most in labor leaders and another 6.2 per cent in Congress). Five years later, however, in 1947, 32.6 per cent of the people chose religious leaders as those who were "doing most good"; 18.8 per cent chose business leaders; 15.4 per cent, government leaders; 10.6 per cent, labor leaders; and 6.7 per cent, Congress. A similar survey, conducted by Mr. Roper in 1957, found that 46 per cent of the American people picked religious leaders as the group "doing the most good" and most to be trusted. "No other group—whether government, Congressional, business, or labor—came anywhere near matching the prestige and pulling power of the men who are the ministers of God." The picture of the clergyman that Americans have may not be without its ambiguous aspects, but there can be little doubt that the "minister of God" ranks high, and is rising rapidly, in the American scale of prestige. This rise of public confidence in clergymen no doubt reflects the rising status of religion and the church in American social life.

Much the same may be said about the high and growing repute of religion in the American public mind. "Religion is given continued public and political approval. . . . 'Godless' is a powerful epithet. . . . At least nominal public acceptance of religion tends to be a prerequisite to political success . . ." It was not always so; there was a time when an atheist or agnostic like Robert G. Ingersoll, who went around the country defying God and making anti-religious speeches, could nevertheless occupy a respected and influential position in American politics. Today that would be quite inconceivable; a professed "unbeliever" would be anathema to either of the big parties and would have no chance whatever in political life. The contrast between the days of Ingersoll and

our day, when every candidate for public office is virtually required to testify to his high esteem for religion, measures the position that religion as a "value" or institution has acquired in the American public mind. Of the 528 members of the two houses of the 85th Congress, only 4 gave no religious affiliation; 416 registered as Protestants, 95 as Roman Catholics, 12 as Jews, and one as a Sikh.

That public opinion is markedly more favorable to religion today than it has been for a long time is recognized by all observers. "A hostile attitude toward religion as such," Schneider notes, "gets less of a hearing today than a century ago, or even half a century ago." Foreign visitors are almost without exception amazed at the extreme deference paid to religion, religious leaders, and religious institutions in present-day America. It is probably true that "in no other modern industrial state does organized religion play a greater role" than it does in the United States.

With institutional growth and enhanced public status has come a notable increase in the self-assurance of the spokesmen of religion, who no longer feel themselves defending a losing cause against a hostile world. "It [has become] clear that, contrary to what many . . . leading historians and sociologists asserted early in the century, religion has not declined in America since 1900"; very much to the contrary. Spokesmen of religion are now beginning to speak with the confidence of those who feel that things are going their way and that they are assured of a respectful hearing. Indeed, there have lately arisen voices among the "irreligious" minority who profess to see their "freedom *from* religion" threatened by the increasingly pro-religious climate of our culture and the new aggressiveness of the churches. It is a far cry indeed from the 1920s, when religion and the churches were in retreat, faith was taken as a sign of intellectual backwardness or imbecility, and the initiative had passed to the "emancipated" debunkers of the superstitions of the "Babbitts" and the "Bible Belt." That age has disappeared almost without a trace, and the generation that has arisen since finds it well-nigh impossible to imagine what those days were like, so remote from our consciousness have they become.

Particularly significant as reflecting a reversal of trend is the new intellectual prestige of religion on all levels of cultural life. On one level, this means the extraordinarily high proportion of so-called "religious books" on the best-seller lists; on another, the remarkable vogue in intellectual circles of the more sophisticated religious and theological writing of our time. Kierkegaard (rediscovered in this generation), Tillich, Maritain, Reinhold Niebuhr, Buber, Berdyaev, Simone Weil: these writers have standing and prestige with the intellectual elite of today in a way that no religious writers have had for many decades. Religious ideas, concepts, and teachings have become familiar in the pages of the "vanguard" journals of literature, politics, and art. "It is certainly true," a recent English survey of religion in America concludes, "that the intellectual climate for religious thinking and the social climate for religious living are much more congenial than they were in the twenties and thirties."

Indeed, the intellectual rehabilitation of religion has become so pronounced that even observers like Reinhold Niebuhr, who are exceedingly cautious in weighing the claims of a contemporary "revival" of religion, acknowledge the signs in this area to be quite unmistakable. "There is evidence," Dr. Niebuhr

writes, "that in the world of culture, there is at least a receptivity toward the message of the historic faiths which is in marked contrast to the indifference or hostility of past decades." He himself feels that the "increase of interest in religious problems in the academic communities of the nation, in which, for obvious reasons, the 'secular' spirit of the age was . . . pronounced," is particularly noteworthy. He calls attention to the fact that "there is scarcely a college or university which has not recently either created a department of religion or substantially enlarged existing departments," and he stresses the difference in quality and temper that distinguishes so much of current academic teaching in the field of religion from that of earlier decades. "Until very recently, religious studies in our colleges were very much on the defensive. . . . This defensive attitude has been replaced by a type of teaching which avails itself of all the instruments of modern historical scholarship, but is guided by a conviction of the importance and relevance of the 'message' of the Bible, as distinguished from the message of, say, Plato, on the one hand, or Herbert Spencer, on the other."

# II

"Every functioning society," Robin M. Williams, Jr. points out, "has to an important degree a *common* religion. The possession of a common set of ideas, rituals, and symbols can supply an overarching sense of unity even in a society riddled with conflicts." What is this "common religion" of American society, the "common set of ideas, rituals, and symbols" that give it its "overarching sense of unity"? Williams provides us with a further clue when he suggests that "men are always likely to be intolerant of opposition to their central ultimate values." What are these "central ultimate values" about which Americans are "intolerant"? No one who knows anything about the religious situation in this country would be likely to suggest that the things Americans are "intolerant" about are the beliefs, standards, or teachings of the religions they "officially" acknowledge as theirs. Americans are proud of their tolerance in matters of religion: one is expected to "believe in God," but otherwise religion is not supposed to be a ground of "discrimination." This is, no doubt, admirable, but is it not "at least in part, a sign that the crucial values of the system are no longer couched in a religious framework"?

What, then, is the "framework" in which they *are* couched? What, to return to our original question, is the "common religion" of the American people, as it may be inferred not only from their words but also from their behavior?

It seems to me that a realistic appraisal of the values, ideas, and behavior of the American people leads to the conclusion that Americans, by and large, do have their "common religion" and that that "religion" is the system familiarly known as the American Way of Life. It is the American Way of Life that supplies American society with an "overarching sense of unity" amid conflict. It is the American Way of Life about which Americans are admittedly and unashamedly "intolerant." It is the American Way of Life that provides the framework in terms of which the crucial values of American existence are couched. By every realistic criterion the American Way of Life is the operative faith of the American people.

It would be the crudest kind of misunderstanding to dismiss the American Way of Life as no more than a political formula or propagandist slogan, or to

regard it as simply an expression of the "materialistic" impulses of the American people. Americans are "materialistic," no doubt, but surely not more so than other people, than the French peasant or petty bourgeois, for example. All such labels are irrelevant, if not meaningless. The American Way of Life is, at bottom, a spiritual structure, a structure of ideas and ideals, of aspirations and values, of beliefs and standards; it synthesizes all that commends itself to the American as the right, the good, and the true in actual life. It embraces such seemingly incongruous elements as sanitary plumbing and freedom of opportunity, Coca-Cola and an intense faith in education—all felt as moral questions relating to the proper way of life. The very expression "way of life" points to its religious essence, for one's ultimate, over-all way of life is one's religion.

The American Way of Life is, of course, conceived as the corporate "way" of the American people, but it has its implications for the American as an individual as well. It is something really operative in his actual life. When in the *Ladies' Home Journal* poll, Americans were asked "to look within [themselves] and state honestly whether [they] thought [they] really obeyed the law of love under certain special conditions," 90 per cent said yes and 5 per cent no when the one to be "loved" was a person belonging to a different religion; 80 per cent said yes and 12 per cent no when it was the case of a member of a different race; 78 per cent said yes and 10 per cent no when it concerned a business competitor—but only 27 per cent said yes and 57 per cent no in the case of "a member of a political party that you think is dangerous," while 25 per cent said yes and 63 per cent said no when it concerned an enemy of the nation. These figures are most illuminating, first because of the incredible self-assurance they reveal with which the average American believes he fulfills the "impossible" law of love, but also because of the light they cast on the differential impact of the violation of this law on the American conscience. For it is obvious that the figures reflect not so much the actual behavior of the American people—no people on earth ever loved their neighbors as themselves as much as the American people say they do—as how seriously Americans take transgressions against the law of love in various cases. Americans feel they *ought* to love their fellow men despite differences of race or creed or business interest; that is what the American Way of Life emphatically prescribes. But the American Way of Life almost explicitly sanctions hating a member of a "dangerous" political party (Communists and fascists are obviously meant here) or an enemy of one's country, and therefore an overwhelming majority avow their hate. In both situations, while the Jewish-Christian law of love is formally acknowledged, the truly operative factor is the value system embodied in the American Way of Life. Where the American Way of Life approves of love of one's fellow man, most Americans confidently assert that they practice such love; where the American Way of Life disapproves, the great mass of Americans do not hesitate to confess that they do not practice it, and apparently feel very little guilt for their failure. No better pragmatic test as to what the operative religion of the American people actually is could be desired.

It is not suggested here that the ideals Americans feel to be indicated in the American Way of Life are scrupulously observed in the practice of Americans; they are in fact constantly violated, often grossly. But violated or not, they are felt to be normative and relevant to "business and politics" in a way that the for-

mal tenets of "official" religion are not. That is what makes the American Way of Life the "common religion" of American society in the sense here intended.

It should be clear that what is being designated under the American Way of Life is not the so-called "common denominator" religion; it is not a synthetic system composed of beliefs to be found in all or in a group of religions. It is an organic structure of ideas, values, and beliefs that constitutes a faith common to Americans and genuinely operative in their lives, a faith that markedly influences, and is influenced by, the "official" religions of American society. Sociologically, anthropologically, if one pleases, it is the characteristic American religion, undergirding American life and overarching American society despite all indubitable differences of region, section, culture, and class.

Yet qualifications are immediately in order. Not for all Americans is this American religion, this "common religion" of American society, equally operative; some indeed explicitly repudiate it as religion. By and large, it would seem that what is resistive in contemporary American society to the American Way of Life as religion may be understood under three heads. First, there are the churches of immigrant-ethnic background that still cherish their traditional creeds and confessions as a sign of their distinctive origin and are unwilling to let these be dissolved into an over-all "American religion"; certain Lutheran and Reformed churches in this country as well as sections of the Catholic Church would fall into this classification. Then there are groups, not large but increasing, that have an explicit and conscious theological concern, whether it be "orthodox," "neo-orthodox," or "liberal"; in varying degrees, they find their theologies at odds with the implied "theology" of the American Way of Life. Finally, there are the ill-defined, though by all accounts numerous and influential, "religions of the disinherited," the many "holiness," pentecostal, and millenarian sects of the socially and culturally submerged segments of our society; for them, their "peculiar" religion is frequently still too vital and all-absorbing to be easily subordinated to some "common faith." All of these cases, it will be noted, constitute "hold outs" against the sweep of religious Americanism; in each case there is an element of alienation which generates a certain amount of tension in social life.

What is this American Way of Life that we have said constitutes the "common religion" of American society? An adequate description and analysis of what is implied in this phrase still remains to be attempted, and certainly it will not be ventured here; but some indications may not be out of place.

The American Way of Life is the symbol by which Americans define themselves and establish their unity. German unity, it would seem, is felt to be largely racial-folkish, French unity largely cultural; but neither of these ways is open to the American people, the most diverse in racial and cultural origins of any in the world. As American unity has emerged, it has emerged more and more clearly as a unity embodied in, and symbolized by, the complex structure known as the American Way of Life.

If the American Way of Life had to be defined in one word, "democracy" would undoubtedly be the word, but democracy in a peculiarly American sense. On its political side it means the Constitution; on its economic side, "free enterprise"; on its social side, an equalitarianism which is not only compatible

with but indeed actually implies vigorous economic competition and high mo-
bility. Spiritually, the American Way of Life is best expressed in a certain kind of
"idealism" which has come to be recognized as characteristically American. It is
a faith that has its symbols and its rituals, its holidays and its liturgy, its saints
and its sancta; and it is a faith that every American, to the degree that he is an
American, knows and understands.

The American Way of Life is individualistic, dynamic, pragmatic. It affirms
the supreme value and dignity of the individual; it stresses incessant activity on
his part, for he is never to rest but is always to be striving to "get ahead"; it de-
fines an ethic of self-reliance, merit, and character, and judges by achievement:
"deeds, not creeds" are what count. The American Way of Life is humanitarian,
"forward looking," optimistic. Americans are easily the most generous and phil-
anthropic people in the world, in terms of their ready and unstinting response
to suffering anywhere on the globe. The American believes in progress, in self-
improvement, and quite fanatically in education. But above all, the American is
idealistic. Americans cannot go on making money or achieving worldly success
simply on its own merits; such "materialistic" things must, in the American
mind, be justified in "higher" terms, in terms of "service" or "stewardship" or
"general welfare." Because Americans are so idealistic, they tend to confuse es-
pousing an ideal with fulfilling it and are always tempted to regard themselves
as good as the ideals they entertain: hence the amazingly high valuation most
Americans quite sincerely place on their own virtue. And because they are so
idealistic, Americans tend to be moralistic: they are inclined to see all issues as
plain and simple, black and white, issues of morality. Every struggle in which
they are seriously engaged becomes a "crusade." To Mr. Eisenhower, who in
many ways exemplifies American religion in a particularly representative way,
the second world war was a "crusade" (as was the first to Woodrow Wilson); so
was his campaign for the presidency ("I am engaged in a crusade . . . to sub-
stitute good government for what we most earnestly believe has been bad gov-
ernment"); and so is his administration—a "battle for the republic" against
"godless Communism" abroad and against "corruption and materialism" at
home. It was Woodrow Wilson who once said, "Sometimes people call me an
idealist. Well, that is the way I know I'm an American: America is the most ide-
alistic nation in the world"; Eisenhower was but saying the same thing when he
solemnly affirmed: "The things that make us proud to be Americans are of the
soul and of the spirit."

The American Way of Life is, of course, anchored in the American's vision
of America. The Puritan's dream of a new "Israel" and a new "Promised Land"
in the New World, the *"novus ordo seclorum"* on the Great Seal of the United
States reflect the perennial American conviction that in the New World a new
beginning has been made, a new order of things established, vastly different
from and superior to the decadent institutions of the Old World. This convic-
tion, emerging out of the earliest reality of American history, was continuously
nourished through the many decades of immigration into the present century
by the residual hopes and expectations of the immigrants, for whom the New
World had to be really something new if it was to be anything at all. And this
conviction still remains pervasive in American life, hardly shaken by the new
shape of the world and the challenge of the "new orders" of the twentieth cen-

tury, Nazism and Communism. It is the secret of what outsiders must take to be the incredible self-righteousness of the American people, who tend to see the world divided into an innocent, virtuous America confronted with a corrupt, devious, and guileful Europe and Asia. The self-righteousness, however, if self-righteousness it be, is by no means simple, if only because virtually all Americans are themselves derived from the foreign parts they so distrust. In any case, this feeling about America as really and truly the "new order" of things at last established is the heart of the outlook defined by the American Way of Life.

In her *Vermont Tradition,* Dorothy Canfield Fisher lists as that tradition's principal ingredients: individual freedom, personal independence, human dignity, community responsibility, social and political democracy, sincerity, restraint in outward conduct, and thrift. With some amplification—particularly emphasis on the uniqueness of the American "order" and the great importance assigned to religion—this may be taken as a pretty fair summary of some of the "values" embodied in the American Way of Life. It will not escape the reader that this account is essentially an idealized description of the middle-class ethos. And, indeed, that is just what it is. The American Way of Life is a middle-class way, just as the American people in their entire outlook and feeling are a middle-class people. But the American Way of Life as it has come down to us is not merely middle-class; it is emphatically inner-directed. Indeed, it is probably one of the best expressions of inner-direction in history. As such, it now seems to be undergoing some degree of modification—perhaps at certain points disintegration—under the impact of the spread of other-direction in our society. For the foreseeable future, however, we may with some confidence expect the continuance in strength of the American Way of Life as both the tradition and the "common faith" of the American people.

## III

The American Way of Life as the "common faith" of American society has coexisted for some centuries with the historic faiths of the American people, and the two have influenced each other in many profound and subtle ways. The influence has been complex and reciprocal, to the point where causal priority becomes impossible to assign if indeed it does not become altogether meaningless. From the very beginning the American Way of Life was shaped by the contours of American Protestantism; it may, indeed, best be understood as a kind of secularized Puritanism, a Puritanism without transcendence, without sense of sin or judgment. The Puritan's vision of a new "Promised Land" in the wilderness of the New World has become, as we have suggested, the American's deep sense of the newness and uniqueness of things in the Western Hemisphere. The Puritan's sense of vocation and "inner-worldly asceticism" can still be detected in the American's gospel of action and service, and his consciousness of high responsibility before God in the American's "idealism." The Puritan's abiding awareness of the ambiguity of all human motivations and his insight into the corruptions of inordinate power have left their mark not only on the basic structure of our constitutional system but also on the entire social philosophy of the

American people. Nor have other strands of early American Protestantism been without their effect. There can be little doubt that Pietism co-operated with frontier revivalism in breaking down the earlier concern with dogma and doctrine, so that the slogan, "deeds, not creeds," soon became the hallmark both of American religion and of the American Way of Life. These are but aspects of an influence that is often easier to see than to define.

The reciprocal action of the American Way of Life in shaping and reshaping the historic faiths of Christianity and Judaism on American soil is perhaps more readily discerned. By and large, we may say that these historic religions have all tended to become "Americanized" under the pervasive influence of the American environment. This "Americanization" has been the product not so much of conscious direction as of a "diffuse convergence" operating spontaneously in the context of the totality of American life. What it has brought, however, is none the less clear: "religious groupings throughout [American] society [have been] stamped with recognizably 'American' qualities," to an extent indeed where foreign observers sometimes find the various American religions more like each other than they are like their European counterparts.

Under the influence of the American environment the historic Jewish and Christian faiths have tended to become secularized in the sense of becoming integrated as parts within a larger whole defined by the American Way of Life. "There is a marked tendency," Williams writes in his discussion of the relations of religion to other institutions in the United States, "to regard religion as a good because it is useful in furthering other major values—in other words, to reverse the ends-means relation implied in the conception of religion as an ultimate value." In this reversal the Christian and Jewish faiths tend to be prized because they help promote ideals and standards that all Americans are expected to share on a deeper level than merely "official" religion. Insofar as any reference is made to the God in whom all Americans "believe" and of whom the "official" religions speak, it is primarily as sanction and underpinning for the supreme values of the faith embodied in the American Way of Life. Secularization of religion could hardly go further.

As a consequence, in some cases of its own origins, but primarily of the widespread influence of the American environment, religion in America has tended toward a marked disparagement of "forms," whether theological or liturgical. Even the highly liturgical and theological churches have felt the effects of this spirit to the degree that they have become thoroughly acculturated. Indeed, the anti-theological, anti-liturgical bias is still pervasive despite the recent upsurge of theological concern and despite the greater interest being shown in liturgy because of its psychological power and "emotional richness."

American religion is (within the limits set by the particular traditions of the churches) non-theological and non-liturgical; it is activistic and occupied with the things of the world to a degree that has become a byword among European churchmen. With this activism has gone a certain "latitudinarianism," associated with the de-emphasis of theology and doctrine: Americans tend to believe that "ethical behavior and a good life, rather than adherence to a specific creed, [will] earn a share in the heavenly kingdom." The activism of American religion has manifested itself in many forms throughout our history: in the Puritan concern for the total life of the community; in the passionate championing of all

sorts of reform causes by the evangelical movements of the first half of the nine-teenth century; in the "social gospel" of more recent times; in the ill-starred Prohibition "crusade"; in the advanced "progressive" attitudes on social ques-tions taken by the National Council of Churches, the National Catholic Welfare Conference, and the various rabbinical associations; in the strong social empha-sis of American Protestant "neo-orthodoxy." This activism, which many Europeans seem to regard as the distinguishing feature of American religion, both reflects the dynamic temper of the American Way of Life and has been a principal factor in its development.

It is hardly necessary to continue this analysis much farther along these general lines. The optimism, moralism, and idealism of Jewish and Christian faith in America are plain evidence of the profound effect of the American out-look on American religion. Indeed, such evidence is amply provided by any tab-ulation of the distinctive features of religion in America, and needs no special emphasis at this point.

What is perhaps of crucial importance, and requires a more detailed examina-tion, is the new attitude toward religion and the new conception of the church that have emerged in America.

Americans believe in religion in a way that perhaps no other people do. It may indeed be said that the primary religious affirmation of the American peo-ple, in harmony with the American Way of Life, is that religion is a "good thing," a supremely "good thing," for the individual and the community. And "religion" here means not so much any particular religion, but religion as such, religion-in-general. "Our government makes no sense," President Eisenhower recently declared, "unless it is founded in a deeply felt religious faith—*and I don't care what it is*" (emphasis added). In saying this, the President was saying something that almost any American could understand and approve, but which must seem like a deplorable heresy to the European churchman. Every American could understand, first, that Mr. Eisenhower's apparent indifferent-ism ("and I don't care what it is") was not indifferentism at all, but the expres-sion of the conviction that at bottom the "three great faiths" were really "saying the same thing" in affirming the "spiritual ideals" and "moral values" of the American Way of Life. Every American, moreover, could understand that what Mr. Eisenhower was emphasizing so vehemently was the indispensability of re-ligion as the foundation of society. This is one aspect of what Americans mean when they say that they "believe in religion." The object of devotion of this kind of religion, however, is "not God but 'religion.' . . . The faith is not in God but in faith; we worship not God but our own worshiping." When Americans think of themselves as a profoundly religious people, whose "first allegiance" is "re-served . . . to the kingdom of the spirit," this is, by and large, what they mean, and not any commitment to the doctrines or traditions of the historic faiths. . . .

This American culture-religion is the religious aspect of Americanism, con-ceived either as the common ground of the three "faiths" or as a kind of super-religion embracing them. It will be recalled that President Eisenhower declared "recognition of the Supreme Being" to be "the first, the most basic expression," not of our historical religions, although undoubtedly Mr. Eisenhower would

agree that it is, but of . . . *Americanism*. Americanism thus has its religious creed, evoking the appropriate religious emotions; it may, in fact, be taken as the civic religion of the American people.

But civic religion has always meant the sanctification of the society and culture of which it is the reflection, and that is one of the reasons why Jewish-Christian faith has always regarded such religion as incurably idolatrous. Civic religion is a religion which validates culture and society, without in any sense bringing them under judgment. It lends an ultimate sanction to culture and society by assuring them that they constitute an unequivocal expression of "spiritual ideals" and "religious values." Religion becomes, in effect, the cult of culture and society, in which the "right" social order and the received cultural values are divinized by being identified with the divine purpose. Any issue of *Christian Economics*, any pronouncement of such organizations as Spiritual Mobilization, will provide sufficient evidence of how Christian faith can be used to sustain the civic religion of "laissez-faire capitalism." Similar material from Catholic and Jewish sources comes easily to hand, from "liberal" quarters as well as from "conservative." On this level at least, the new religiosity pervading America seems to be very largely the religious validation of the social patterns and cultural values associated with the American Way of Life.

In a more directly political sense, this religiosity very easily comes to serve as a spiritual reinforcement of national self-righteousness and a spiritual authentication of national self-will. Americans possess a passionate awareness of their power and of the justice of the cause in which it is employed. The temptation is therefore particularly strong to identify the American cause with the cause of God, and to convert our immense and undeniable moral superiority over Communist tyranny into pretensions to unqualified wisdom and virtue. In these circumstances, it would seem to be the office of prophetic religion to raise a word of warning against inordinate national pride and self-righteousness as bound to lead to moral confusion, political irresponsibility, and the darkening of counsel. But the contemporary religious mood is very far indeed from such prophetic transcendence. Aside from occasional pronouncements by a few theologians or theologically-minded clergymen, religion in America seems to possess little capacity for rising above the relativities and ambiguities of the national consciousness and bringing to bear the judgment of God upon the nation and its ways. The identification of religion with the national purpose is almost inevitable in a situation in which religion is so frequently felt to be a way of American "belonging." In its crudest form, this identification of religion with national purpose generates a kind of national messianism which sees it as the vocation of America to bring the American Way of Life, compounded almost equally of democracy and free enterprise, to every corner of the globe in more mitigated versions, it sees God as the champion of America, endorsing American purposes, and sustaining American might. "The God of judgment has died."

Insensibly, this fusion of religion with national purpose passes over into the direct exploitation of religion for economic and political ends. A good deal of the official piety in Washington, it is charged, is of this kind, and much of the new religiousness of businessmen and business interests throughout the country. Certainly, when we find great corporations such as U. S. Steel distributing

Norman Vincent Peale's *Guideposts* in huge quantities to their employees, when we find increasing numbers of industrial concerns placing "plant chaplains" on their staffs, we are not altogether unjustified in suspecting that considerations of personnel policy have somehow entered into these good works of religion. On another level, there seems to be a concerted effort to turn President Eisenhower's deep and sincere religious feeling into a political asset. How otherwise are we to interpret the paragraph in the resolution officially adopted by the Republican National Committee on February 17, 1955, in which it is declared: "He [President Eisenhower], in every sense of the word, is not only the political leader, but the spiritual leader of our times"? The fusion of political and spiritual leadership in the person of one national leader is in accord with neither the American democratic idea nor the tradition of Jewish-Christian faith; yet the statement of the Republican National Committee, making explicit the political exploitation of the "President's religion," seems to have aroused no comment in American religious circles. If indeed religion is the "spiritual" side of being an American, why should not the President of the United States be hailed as the "spiritual leader of our times"?

Religion is taken very seriously in present-day America, in a way that would have amazed and chagrined the "advanced" thinkers of half a century ago, who were so sure that the ancient superstition was bound to disappear very shortly in the face of the steady advance of science and reason. Religion has not disappeared; it is probably more pervasive today, and in many ways more influential, than it has been for generations. The only question is: What kind of religion is it? What is its content? What is it that Americans *believe in* when they are religious?

"The 'unknown God' of Americans seems to be faith itself." What Americans believe in when they are religious is, as we have already had occasion to see, religion itself. Of course, religious Americans speak of God and Christ, but what they seem to regard as really redemptive is primarily religion, the "positive" attitude of *believing.* It is this faith in faith, this religion that makes religion its own object, that is the outstanding characteristic of contemporary American religiosity. Daniel Poling's formula: "I began saying in the morning two words, 'I believe'—those two words *with nothing added* . . ." (emphasis not in original) may be taken as the classic expression of this aspect of American faith.

On the social level, this faith in religion involves the conviction, quite universal among Americans today, that every decent and virtuous nation is religious, that religion is the true basis of national existence and therefore presumably the one sure resource for the solution of all national problems. On the level of personal life, the American faith in religion implies not only that every right-minded citizen is religious, but also that religion (or faith) is a most efficacious device for getting what one wants in life. "Jesus," the Rev. Irving E. Howard assures us, "recommended faith as a technique for getting results. . . . Jesus recommended faith as a way to heal the body and to remove any of the practical problems that loom up as mountains in a man's path."

As one surveys the contemporary scene, it appears that the "results" Americans want to get out of faith are primarily "peace of mind," happiness, and success in worldly achievement. Religion is valued too as a means of cultural enrichment.

Prosperity, success, and advancement in business are the obvious ends for which religion, or rather the religious attitude of "believing," is held to be useful. There is ordinarily no criticism of the ends themselves in terms of the ultimate loyalties of a God-centered faith, nor is there much concern about what the religion or the faith is all about, since it is not the content of the belief but the attitude of believing that is felt to be operative.

Almost as much as worldly success, religion is expected to produce a kind of spiritual euphoria, the comfortable feeling that one is all right with God. Roy Eckardt calls this the cult of "divine-human chumminess" in which God is envisioned as the "Man Upstairs," a "Friendly Neighbor," Who is always ready to give you the pat on the back you need when you happen to feel blue. "Fellowship with the Lord is, so to say, an extra emotional jag that keeps [us] happy. The 'gospel' makes [us] 'feel real good.'" Again, all sense of the ambiguity and precariousness of human life, all sense of awe before the divine majesty, all sense of judgment before the divine holiness, is shut out; God is, in Jane Russell's inimitable phrase, a "livin' Doll." What relation has this kind of god to the biblical God Who confronts sinful man as an enemy before He comes out to meet repentant man as a Savior? Is this He of Whom we are told, "It is a fearful thing to fall into the hands of the living God" (Heb. 10.31)? The measure of how far contemporary American religiosity falls short of the authentic tradition of Jewish-Christian faith is to be found in the chasm that separates Jane Russell's "livin' Doll" from the living God of Scripture.

The cultural enrichment that is looked for in religion varies greatly with the community, the denomination, and the outlook and status of the church members. Liturgy is valued as aesthetically and emotionally "rewarding," sermons are praised as "interesting" and "enjoyable," discussions of the world relations of the church are welcomed as "educational," even theology is approved of as "thought provoking." On another level, the "old-time religion" is cherished by certain segments of the population because it so obviously enriches their cultural life.

But, in the last analysis, it is "peace of mind" that most Americans expect of religion. "Peace of mind" is today easily the most popular gospel that goes under the name of religion; in one way or another it invades and permeates all other forms of contemporary religiosity. It works in well with the drift toward other-direction characteristic of large sections of American society, since both see in adjustment the supreme good in life. What is desired, and what is promised, is the conquest of insecurity and anxiety, the overcoming of inner conflict, the shedding of guilt and fear, the translation of the self to the painless paradise of "normality" and "adjustment"! Religion, in short, is a spiritual anodyne designed to allay the pains and vexations of existence.

It is this most popular phase of contemporary American religiosity that has aroused the sharpest criticism in more sophisticated theological circles. The Most Rev. Patrick A. O'Boyle, Catholic archbishop of Washington, has warned that although "at first glance piety seems to be everywhere . . ." many persons appear to be "turning to religion as they would to a benign sedative to soothe their minds and settle their nerves." Liston Pope emphasizes that the approach of the "peace of mind" school is not only "very dubious on psychological grounds," but its "identification [with] the Christian religion . . . is of ques-

tionable validity." Roy Eckardt describes it as "religious narcissism," in which "the individual and his psycho-spiritual state occupy the center of the religious stage" and piety is made to "concentrate on its own navel." I have myself spoken of it as a philosophy that would "dehumanize man and reduce his life to the level of sub-human creation which knows neither sin nor guilt." It encourages moral insensitivity and social irresponsibility, and cultivates an almost lascivious preoccupation with self. The church becomes a kind of emotional service station to relieve us of our worries: "Go to church—you'll feel better," "Bring your troubles to church and leave them there" (slogans on subway posters urging church attendance). On every ground, this type of religion is poles apart from authentic Jewish-Christian spirituality which, while it knows of the "peace that passeth understanding" as the gift of God, promotes a "divine discontent" with things as they are and a "passionate thirst for the future," in which all things will be renewed and restored to their right relation to God.

The burden of this criticism of American religion from the point of view of Jewish-Christian faith is that contemporary religion is so naively, so innocently *man-centered*. Not God, but man—man in his individual and corporate being—is the beginning and end of the spiritual system of much of present-day American religiosity. In this kind of religion there is no sense of transcendence, no sense of the nothingness of man and his works before a holy God; in this kind of religion the values of life, and life itself, are not submitted to Almighty God to judge, to shatter, and to reconstruct; on the contrary, life, and the values of life, are given an ultimate sanction by being identified with the divine. In this kind of religion it is not man who serves God, but God who is mobilized and made to serve man and his purposes—whether these purposes be economic prosperity, free enterprise, social reform, democracy, happiness, security, or "peace of mind." God is conceived as man's "omnipotent servant," faith as a sure-fire device to get what we want. The American is a religious man, and in many cases personally humble and conscientious. But religion as he understands it is not something that makes for humility or the uneasy conscience: it is something that reassures him about the essential rightness of everything American, his nation, his culture, and himself; something that validates his goals and his ideals instead of calling them into question; something that enhances his self-regard instead of challenging it; something that feeds his self-sufficiency instead of shattering it; something that offers him salvation on easy terms instead of demanding repentance and a "broken heart." Because it does all these things, his religion, however sincere and well-meant, is ultimately vitiated by a strong and pervasive idolatrous element.

# Multiplicity, Pluralism, and Conflict after 1965

Inspired in some measure by the civil rights movement, other liberationist movements arose, particularly in Jewish, Catholic, and Protestant circles. Women revisited traditional religious teachings on gender roles in hopes of ridding these faiths of nonessential sexist accretions. Some feminists determined to stay within religious institutions and work for positive changes within them, such as support for women's full access to pastoral leadership. Others abandoned tradition for new varieties of egalitarian spiritual community. African American leaders continued to draw strength from the civil rights movement, as well as from the liberation theology movements in Latin America and other parts of the developing world. Jewish and Christian homosexuals also initiated a movement for thoroughgoing religious inclusion.

Meanwhile, the immigration act of 1965 cleared the way for an explosion of new religions to grow in the United States. Rapid expansion occurred among Asian immigrants, whose movement here had long been restricted, and Asian Americans were the fastest-growing population by the end of the twentieth century. While religious diversity had always been a part of the American landscape, after 1965, traditions such as Buddhism, Hinduism, Sikhism, and Islam became dramatically evident as never before. Growing numbers of African and Afro-Caribbean peoples also shifted the nation's social and religious contours. African-derived religions, such as Yoruba, Vodou, Candomblé, and Rastafarianism, received exposure, if still appearing exotic or even demonic to some onlookers.

September 11, 2001, marked a dramatic moment in American religious history. Fear and anger, spawned by Osama bin Laden's violent

attack, led to intense inter- and intrareligious debates about Islam. Religious communities seemed deeply divided by the presence of George W. Bush, a conservative evangelical with an expressed sense of divine mission, in the White House. Conflict over religious diversity and pluralism appeared certain to endure.

# MARY DALY

Mary Daly (b. 1928) is a radical feminist theologian. She received three doctorates in religion and philosophy and was the first woman at Switzerland's University of Fribourg to receive the highest degree in Sacred Theology possible, and with highest honors. She accepted a teaching position at Boston College before rejecting Roman Catholicism in favor of a position she terms post-Christian, and despite her controversial views, she remained at the college for thirty-three years. Daly is famous for being the first woman to preach in the pulpit of Harvard's Memorial Church (in 1971) and for ending her so-called antisermon by leading hundreds out of the building as a protest against patriarchal religion. Beginning with *The Church and the Second Sex* (1969), she has authored numerous works that denounce Christianity's history of sexism. Her analyses have inspired admiration, even among many who have chosen to remain faithful to their religious traditions while working for greater egalitarianism within them. This excerpt is from her 1973 book, *Beyond God the Father*.

# *From* Beyond God the Father

## THE PROBLEM, THE PURPOSE, AND THE METHOD

> *I want a women's revolution like a lover. I lust for it, I want so much this freedom, this end to struggle and fear and lies we all exhale, that I could die just with the passionate uttering of that desire.* ~ ROBIN MORGAN

*When you are criticizing the philosophy of an epoch, do not chiefly direct your attention to those intellectual positions which its exponents feel it necessary explicitly to defend. There will be some fundamental assumptions which adherents of all the various systems within the epoch unconsciously presuppose. Such assumptions appear so obvious that people do not know what they are assuming because no other way of pulling things has ever occurred to them.* ~ ALFRED NORTH WHITEHEAD

The basic presuppositions of this book have been proposed in detail elsewhere. I shall briefly highlight some of these ideas before proceeding to a discussion of purpose and method.

Recent years have witnessed a series of crescendos in the women's movement. Women of all "types," having made the psychic breakthrough to recognition of the basic sameness of our situation as women, have been initiated into the struggle for liberation of our sex from its ancient bondage. The bonding together of women into a sisterhood for liberation is becoming a widespread feature of American culture, and the movement is rapidly taking on worldwide dimensions.

The bonding is born out of shared recognition that there exists a worldwide phenomenon of sexual caste, basically the same whether one lives in Saudi Arabia or in Sweden. This planetary sexual caste system involves birth-ascribed hierarchically ordered groups whose members have unequal access to goods, services, and prestige and to physical and mental well-being. Clearly I am not using the term "caste" in its most rigid sense, which would apply only to Brahmanic Indian society. I am using it in accordance with Berreman's broad description, since our language at present lacks other terms to describe systems of rigid social stratification analogous to the Indian system.

It may be that the psychological root of selective nit-picking about the use of the term "caste" to describe women's situation is a desire *not* to be open to the insights made available by the comparison. Such rigidity overlooks the fact that language develops and changes in the course of history. The term is the most accurate available. Precisely because it is strong and revealing, many feminists have chosen to employ it. As Jo Freeman points out, caste systems are extremely difficult although not impossible to change. Moreover, since they are composed of interdependent units, to alter one unit is to alter all.

The exploitative sexual caste system could not be perpetuated without the consent of the victims as well as of the dominant sex, and such consent is obtained through sex role socialization—a conditioning process which begins to operate from the moment we are born, and which is enforced by most institutions. Parents, friends, teachers, textbook authors and illustrators, advertisers, those who control the mass media, toy and clothes manufacturers, professionals such as doctors and psychologists—all contribute to the socialization process. This happens through dynamics that are largely uncalculated and unconscious, yet which reinforce the assumptions, attitudes, stereotypes, customs, and arrangements of sexually hierarchical society.

The fact of women's low caste status has been—and is—disguised. It is masked, first of all, by *sex role segregation.* This is more subtle than spatial segregation, as in a ghetto, for it makes possible the delusion that women should be "equal but different." Sexual caste is hidden also by the fact that women have

Mary Daly, the post-Christian feminist philosopher and theologian. *Photo by Gail Bryan©.*

various forms of *derivative status* as a consequence of relationships with men. That is, women have duality of status, and the derivative aspect of this status— for example, as daughters and wives—divides us against each other and en- courages identification with patriarchal institutions which serve the interests of men at the expense of women. Finally, sexual caste is hidden by *ideologies* that bestow false identities upon women and men. Patriarchal religion has served to perpetuate all of these dynamics of delusion, naming them "natural" and be- stowing its supernatural blessings upon them. The system has been advertised as "according to the divine plan."

The history of antifeminism in the Judeo-Christian heritage already has been exposed. The infamous passages of the Old and New Testaments are well known. I need not allude to the misogynism of the church Fathers—for exam- ple, Tertullian, who informed women in general: "You are the devil's gateway," or Augustine, who opined that women are not made to the image of God. I can omit reference to Thomas Aquinas and his numerous commentators and disci- ples who defined women as misbegotten males. I can overlook Martin Luther's remark that God created Adam lord over all living creatures but Eve spoiled it all. I can pass over the fact that John Knox composed a "First Blast of the Trumpet against the Monstrous Regiment of Women." All of this, after all, is past history.

Perhaps, however, we should take just a cursory glance at more recent his- tory. Pope Pius XII more or less summarized official Catholic views on women when he wrote that "the mother who complains because a new child presses

against her bosom seeking nourishment at her breast is foolish, ignorant of herself, and unhappy." In the early 1970s the Roman church launched all-out warfare against the international movement to repeal anti-abortion laws. In 1972, Pope Paul VI assumed his place as champion of "true women's liberation," asserting that this does not lie in "formalistic or materialistic equality with the other sex, but in the recognition of that specific thing in the feminine personality—the vocation of a woman to become a mother."

Meanwhile in other Christian churches things have not really been that different. Theologian Karl Barth proclaimed that woman is ontologically subordinate to man as her "head." Dietrich Bonhoeffer in his famous *Letters and Papers from Prison,* in which he had proclaimed the attack of Christianity upon the adulthood of the world to be pointless, ignoble, and unchristian—in this very same volume—insists that women should be subject to their husbands. In 1972, Episcopal Bishop C. Kilmer Myers asserted that since Jesus was male, women cannot be ordained. Some Protestant churches pride themselves upon the fact that they do ordain women, yet the percentages are revealing. The United Presbyterian Church, for example, has women ministers, but they constitute less than 1 percent of fully ordained ministers in that church.

Theology and ethics which are overtly and explicitly oppressive to women are by no means confined to the past. Exclusively masculine symbolism for God, for the notion of divine "incarnation" in human nature, and for the human relationship to God reinforce sexual hierarchy. Tremendous damage is done, particularly in ethics, when ethicists construct one-dimensional arguments that fail to take women's experience into account. This is evident, for example, in biased arguments concerning abortion. To summarize briefly the situation: the entire conceptual systems of theology and ethics, developed under the conditions of patriarchy, have been the products of males and tend to serve the interests of sexist society. . . .

## AFTER THE DEATH OF GOD THE FATHER

*The first step in the elevation of women under all systems of religion is to convince them that the great Spirit of the Universe is in no way responsible for any of these absurdities.* ~ ELIZABETH CADY STANTON

The biblical and popular image of God as a great patriarch in heaven, rewarding and punishing according to his mysterious and seemingly arbitrary will, has dominated the imagination of millions over thousands of years. The symbol of the Father God, spawned in the human imagination and sustained as plausible by patriarchy, has in turn rendered service to this type of society by making its mechanisms for the oppression of women appear right and fitting. If God in "his" heaven is a father ruling "his" people, then it is in the "nature" of things and according to divine plan and the order of the universe that society be male-dominated.

Within this context a mystification of roles takes place: the husband dominating his wife represents God "himself." The images and values of a given society have been projected into the realm of dogmas and "Articles of Faith," and these in turn justify the social structures which have given rise to them and

which sustain their plausibility. The belief system becomes hardened and objectified, seeming to have an unchangeable independent existence and validity of its own. It resists social change that would rob it of its plausibility. Despite the vicious circle, however, change can occur in society, and ideologies can die, though they die hard.

## The Inadequate God of Popular Preaching

The image of the divine Father in heaven has not always been conducive to humane behavior, as any perceptive reader of history knows. The often cruel behavior of Christians toward unbelievers and toward dissenters among themselves suggests a great deal not only about the values of the society dominated by that image, but also about how that image itself functions in relation to behavior. There has been a basic ambivalence in the image of the heavenly patriarch—a split between the God of love and the jealous God who represents the collective power of "his" chosen people. As historian Arnold Toynbee has indicated, this has reflected and perpetuated a double standard of behavior. Without debating the details of his historical analysis, the insight is available on an experiential level. The character of Vito Corleone in *The Godfather* is a vivid illustration of the marriage of tenderness and violence so intricately blended in the patriarchal ideal. The worshippers of the loving Father may in a sense love their neighbors, but in fact the term applies only to those within a restricted and unstable circumference, and these worshippers can "justifiably" be intolerant and fanatic persecutors of those outside the sacred circle.

How this God operates is illustrated in contemporary American civil religion. In one of the White House sermons given during the first term of Richard Nixon, Rabbi Louis Finkelstein expressed the hope that a future historian may say "that in the period of great trials and great tribulations, the finger of God pointed to Richard Milhous Nixon, giving the vision and the wisdom to save the world and civilization; and also to open the way for our country to realize the good that the twentieth century offers mankind." Within this context, as Charles Henderson has shown, God is an American and Nixon is "his" annointed one. The preachers carefully selected for the White House sermons stress that this nation is "under God." The logical conclusion is that its policies are right. Under God, the President becomes a Christ figure. In 1969, the day the astronauts would set foot on the moon, and when the President was preparing to cross the Pacific "in search of peace," one of these preachers proclaimed:

> And my hope for mankind is strengthened in the knowledge that our intrepid President himself will soon go into orbit, reaching boldly for the moon of peace. God grant that he, too, may return in glory and that countless millions of prayers that follow him shall not have been in vain.

A fundamental dynamic of this "theology" was suggested by one of Nixon's speech writers, Ray Price, who wrote:

> Selection of a President has to be an act of faith. . . . This faith isn't achieved by reason: it's achieved by charisma, by a feeling of trust. . . .

Price also argued that the campaign would be effective only "if we can get people to make the *emotional* leap, or what theologians call 'leap of faith.' " This is,

of course, precisely the inauthentic leap that Camus labeled as philosophical suicide. It is the suicide demanded by a civil religion in which "God," the Savior-President, and "our nation" more or less merge. When the "leap" is made, it is possible simply not to see what the great God-Father and his annointed one are actually doing. Among the chosen ones are scientists and professors who design perverse methods of torture and death such as flechette pellets that shred the internal organs of "the enemy" and other comparable inhumane "anti-personnel" weapons. Also among the elect are politicians and priests who justify and bestow their blessing upon the system that perpetrates such atrocities. "Under God" are included the powerful industrialists who are making the planet uninhabitable.

Sophisticated thinkers, of course, have never intellectually identified God with a Superfather in heaven. Nevertheless it is important to recognize that even when very abstract conceptualizations of God are formulated in the mind, images survive in the imagination in such a way that a person can function on two different and even apparently contradictory levels at the same time. Thus one can speak of God as spirit and at the same time imagine "him" as belonging to the male sex. Such primitive images can profoundly affect conceptualizations which appear to be very refined and abstract. So too the Yahweh of the future, so cherished by the theology of hope, comes through on an imaginative level as exclusively a He-God, and it is consistent with this that theologians of hope have attempted to develop a political theology which takes no explicit cognizance of the devastation wrought by sexual politics.

The widespread conception of the "Supreme Being" as an entity distinct from this world but controlling it according to plan and keeping human beings in a state of infantile subjection has been a not too subtle mask of the divine patriarch. The Supreme Being's plausibility and that of the static worldview which accompanies this projection has of course declined, at least among the more sophisticated, as Nietzsche prophesied. This was a projection grounded in specifically patriarchal societal structures and sustained as subjectivity real by the usual processes of producing plausibility such as preaching, religious indoctrination, and cult. The sustaining power of the social structure has been eroded by a number of developments in recent history, including the general trend toward democratization of society and the emergence of technology. However, it is the women's movement which appears destined to play the key role in the overthrow of such oppressive elements in traditional theism, precisely because it strikes at the source of the societal dualism that is reflected in traditional beliefs. It presents a growing threat to the plausibility of the inadequate popular "God" not so much by attacking "him" as by leaving "him" behind. Few major feminists display great interest in institutional religion. Yet this disinterest can hardly be equated with lack of spiritual consciousness. Rather, in our present experience the woman-consciousness is being wrenched free to find its own religious expression.

It can legitimately be pointed out that the Judeo-Christian tradition is not entirely bereft of elements that can foster intimations of transcendence. Yet the liberating potential of these elements is choked off in the surrounding atmosphere of the images, ideas, values, and structures of patriarchy. The social change coming from radical feminism has the potential to bring about a more

acute and widespread perception of qualitative differences between the conceptualizations of "God" and of the human relationship to God which have been oppressive in their connotations, and the kind of language that is spoken from and to the rising woman-consciousness.

## Castrating "God"

I have already suggested that if God is male, then the male is God. The divine patriarch castrates women as long as he is allowed to live on in the human imagination. The process of cutting away the Supreme Phallus can hardly be a merely "rational" affair. The problem is one of transforming the collective imagination so that this distortion of the human aspiration to transcendence loses its credibility.

Some religious leaders, notably Mary Baker Eddy and Ann Lee, showed insight into the problem to some extent and tried to stress the "maternal" aspect of what they called "God." A number of feminists have referred to "God" as "she." While all of this has a point, the analysis has to reach a deeper level. The most basic change has to take place in women—in our being and self-image. Otherwise there is danger of settling for mere reform, reflected in the phenomenon of "crossing," that is, of attempting to use the oppressor's weapons against him. Black theology's image of the Black God illustrates this. It can legitimately be argued that a transsexual operation upon "God," changing "him" to "her," would be a far more profound alteration than a mere pigmentation change. However, to stop at this level of discourse would be trivialization of the deep problem of human becoming in women. . . .

## THE BONDS OF FREEDOM: SISTERHOOD AS ANTICHURCH

*A woman must never be free of subjugation.*   ~   THE HINDU CODE OF MANU, V

*I thank thee, O Lord, that thou has not created me a woman.*   ~   DAILY ORTHODOX
JEWISH PRAYER

*Creator of the heavens and the earth, He has given you wives from among yourselves to multiply you, and cattle male and female. Nothing can be compared with Him.*
~   HOLY KORAN OF ISLAM

*Wives, submit yourselves unto your husbands . . . for the husband is the head of the wife, even as Christ is the head of the church.*   ~   EPHESIANS 5:23–24

*Religion legitimates so effectively because it relates the precarious reality constructions of empirical societies with ultimate reality.*   ~   PETER BERGER, IN THE SACRED CANOPY

As the victims of a planetary caste system whose very existence has been made invisible to us, women have been divided from each other by pseudo-identification with groupings which are androcentric and male-dominated. Among these are the various religions whose ideologies degrade and mystify women to such an extent that even the fact of this degradation is not perceived by its victims.

Despite deception, women are breaking through to awareness of sexual caste as a universal phenomenon. As women revolt against this, a new sense of

reality is emerging. That is, a counterworld to patriarchy is coming into being which is by the same token counter to religion as *patriarchal*. Sisterhood, then, by being the unique bonding of women against our reduction to low caste is Antichurch. It is the evolution of a social reality that undercuts the credibility of sexist religion to the degree that it undermines sexism itself. Even without conscious attention to the church, sisterhood is in conflict with it. There are, of course, other movements in contemporary society that threaten organized religion. In the case of other movements, however, it is not sexism that is directly under attack. The development of sisterhood is a unique threat, for it is directed against the basic social and psychic model of hierarchy and domination upon which authoritarian religion as *authoritarian* depends for survival. This conflict arises directly from the fact that women are beginning to overcome the divided self and divisions from each other.

Aside from the general way in which the movement, simply by its own dynamics, conflicts with sexist religion by setting up a counterworld to it, there is also a more specific and direct opposition developing to the sexism of the churches. This is related to the fact that some of the movement's leading figures as well as an increasing number of its adherents are women who know personally the experience of authoritarian religious conditioning and the experience of breaking through this. Many now recall in amazement their past acceptance of the exclusion of half the human race from priesthood and ministry as if this were "natural." As long as the mask of role segregation was effective, it was possible to believe firmly that no inequality was involved: men and women were just "different." Women were able to accept the fact that any boy was allowed to serve Mass, whereas a woman with a Ph.D. was absolutely excluded from such a function. They could go through marriage ceremonies in which they promised to "obey" their husbands without reciprocal promises from men, and still think that no inequality was involved: they were "subordinate but not inferior." Now that the implications of role segregation in the wider society have received exposure in the media, however, inevitably more women, even the unradicalized, are seeing through the mystifications of religious sexism and our own resistance to consciousness. These women—whatever may be their relationship now to organized religion—are spiritual expatriates, and they bring to the movement intimate and precise knowledge of religion's role in reinforcing sexual caste, focusing criticism precisely upon it. In a particular way, they constitute sisterhood as Antichurch. . . .

## SISTERHOOD AS COSMIC COVENANT

*My friends, do we realize for what purpose we are convened? Do we fully understand that we aim at nothing less than an entire subversion of the present order of society, a dissolution of the whole existing social compact?* ~ ELIZABETH OAKES SMITH, 1852

*Tyger! Tyger! burning bright*
*In the forests of the night,*
*What immortal hand or eye,*
*Dare frame thy fearful symmetry?* ~ WILLIAM BLAKE

It was a temptation to call this chapter "Sisterhood as Cosmic *Church*," in order to express some of the movement's elements that are in dialectical tension with its mode of being as Antichurch. However, the negative reactions of feminists to the term are warning enough. Betty Friedan expressed this gut feeling by remarking simply that "the church is the enemy." The word is freighted with an archaic heritage in a specifically Christian way, and this may never be shaken off. Yet certain functions that the church claimed to fulfill and never could, essentially because of its sexism, are being more than fulfilled in the new space of feminism. Or, to be somewhat more accurate, something *beyond* the claims of Christianity is coming into being, for the formulation itself of churchly claims has been anemic, couched in a language reflecting the limits of the patriarchal imagination and perpetuating those limits. The church's actualizations of even such shriveled formulations fall far short of what the advertisements have promised. Still, in order to help our new words—our sounds of silence—to emerge, it may be useful to look at some prevalent concepts of "church." The use of these to express analogies can be worthwhile in envisaging sisterhood as *beyond* "church."

## A Space Set Apart

The church often has been envisaged as *a space set apart* from the rest of the world, having a special meaning for people and functioning as haven and sanctuary. It is still not uncommon for people to experience the physical interior of a church building in the way described by Eliade as an experience of sacred space. Even the frankly nonreligious person in our culture tends to value certain "holy places" of her or his private universe, places associated with happy memories, usually. Often it is a ritualized and superstitious sense of specialness that attaches to "holy shrines" that has nothing to do with individual or communal insight and growth. A church construed as space set apart, then—whether the term is intended to mean a building, an institution, or an ideological "sacred canopy"—has certain propensities for serving as an escape from facing the abyss. It then becomes a place for spinning webs of counterfeit transcendence.

Yet the image of a space set apart is not worthless. I have already suggested that this revolution provides a space—mainly a province of the mind—where it is possible to be oneself, without the contortions of mind, will, feeling, and imagination demanded of women by sexist society. But it is important to note that this space is found not in the effort to hide from the abyss but in the effort to face it, as patriarchy's prefabricated set of meanings, or *nomos*, crumbles in one's mind. Thus it is not "set apart" from reality, but from the contrived nonreality of alienation. Discovered in the deep confrontation between being and nonbeing, the space of liberation is sacred.

When sacred space is discovered, the possibility of deterioration into escapism or of absolutizing the space into a particular form is there. However, the real danger is that women will succumb to *accusations* of escapism or single-mindedness by those who do not see the transcendent dimensions of feminism. Reduction of women's liberation to escapism because of "personal hang-ups" is still a potent weapon, especially when couched in psychological jargon. Women are vulnerable to accusations of absolutizing the movement and we are accus-

tomed to listen only too well to the voices of alienation. Yet there is something to be attended to here, since the accusation is a typical *reversal* of the real problem, which is the constant temptation *not* to face the universality of sexual caste and the awesome demands of living in the new space.

Since the new space is set apart precisely from the nonreality of sexist alienation and since we are *in* it only insofar as we confront nonreality, it is not static space but constantly moving space. I have said that its center is on the boundaries of patriarchy's spaces, that is, it is not *contained*. R. D. Laing wrote something that is of help in understanding this:

> The truth I am trying to grasp is the grasp that is trying to grasp it. . . . The Life I am trying to grasp is the me that is trying to grasp it.

Our space is the life source, not the "container" of contrived covers of life. But whereas Laing was writing of an individual leap or journey through inner space that society would call madness, we are engaged in a journey that is not only utterly individual but also ultimately communal. The kind of communality that it has springs from the fact that there is discovery of "the me that is trying to grasp it." Laing, however, while he does perceive the destructiveness of the social setting, remains to some extent caught in an intrapsychic point of view. The problem remains that even if many persons are "cured," this of itself isn't enough. As Chesler remarks, throughout the book *Sanity, Madness, and the Family* "he remains unaware of the universal and objective oppression of women and of its particular relation to madness in women."

Our space set apart does mean individual freedom, but this becomes possible in recognizing and refuting the structures of objective oppression. I have said that our struggle is not on the enemy's terms. It is self-actualization that is communal, that has as a necessary condition deep rejection of the structures of destruction.

The ever moving center of our space—the opposite of "dead" center— moves because it is ourselves and we are moving, becoming, in a "noospheric net" never dreamed of by Teilhard de Chardin or other prophets of male futurism. This center is the Archimedean point of support, the fulcrum from which, if enough women discover it and do not lose courage, it may be possible to move the world.

## Exodus Community

Because of this constantly moving center, the space of the women's revolution can be called an *exodus community*. The church has been characterized by this name, but both the formulations and the social and psychic realizations of the meaning of this image have been limited and limiting to human aspiration. The church as exodus community allegedly has gone forth from bondage toward liberation on the basis of a promise made by Yahweh to the fathers of the people of God. The voyage has not been spectacular, and this is in no small measure due to the fact that there is something contrived about promises handed down from on high. Yet, as in the case of *space set apart*, the image has value when taken out of its paralyzing context and allowed to spark forth our own insight. The moving center which is the energy source of the new sisterhood as exodus

community is the promise in ourselves. It is the promise in our foremothers whose history we are beginning to discover, and in our sisters whose voices have been stolen from them. Our journey is the fruit of this promise—a journey into individualization and participation, leaving behind the false self and sexist society. Since one cannot physically leave the planet, however (and extraterrestrial space trips as programmed by the prevailing society will be super-sexist, with the accommodation of space stewardesses, perhaps), our mode of departure has to be appropriate to the situation. We can depart mentally to some extent by refusing to be blinded by society's myths. We can depart physically and socially to a degree also, but simple withdrawal will not change the wider situation. The adequate exodus requires communication, community, and creation. The truly moving space will not be merely unorthodox or reformist, but will be on its way beyond unorthodoxy as well as orthodoxy, discovering and bringing forth the really new.

To those within patriarchal space, and perhaps especially within its religions, it may look as though radical feminists have broken a "promise" by not "living up" to the expectations that have been outgrown. In fact, by living out our own promise, we are breaking the brokenness in human existence that has been effected by means of the constructs of alienation. To put it another way, we are breaking the dam of sex stereotyping that stops the flow of being, that stops women and men from being integrated, androgynous personalities. The admission of the fact of this brokenness into our consciousness brings to light the promise burning within, the potential toward the "fearful symmetry" that the poet glimpsed, and that our culture keeps hidden in the forests of the night. It also puts us in touch with "the flow of the inexhaustible Encompassing" about which the philosopher Jaspers has written, without which there is only "the random swirling of dead husks of words, producing a semblance of external order and meaning in endless, arbitrary variation."

The dawning of this promise within, this rushing of the waters of life that have been dammed and damned by our culture, since it puts us in touch with ourselves and with the "Encompassing," brings us into the deepest possible community. It is the community that is discovered, rather than "formed," when we meet others who are on the same voyage. There is, then, a "covenant" among us, *not* in the sense of an agreement that is *formed* and precisely formulated, but in the sense of profound *agreement that is found*. The word "covenant," then, cannot fully say the reality—it is part of the language that splits, cuts off, divides and tries to paste back together again. If, however, we can get beyond the limits imposed by our inherited nonspeech, we can use the sound to signal something more. The covenant is the deep *agreement* that is present within the self and among selves who are increasingly in harmony with an environment that is beyond, beneath, and all around the nonenvironment of patriarchal splits and barriers. For lack of a better word, this may be called the "cosmos," and the sense of harmony has its source in participation in being, which means being in touch with the deepest forces in the cosmos. Out of this contact comes new speech. "Covenant" has always been bound up with language. Sisterhood as cosmic covenant means beginning to re-name the cosmos.

"Covenant" also has the meaning of a common-law form of action to recover damages for breach of contract. Women's form of action to recover dam-

ages begins with a declaration. Those women were not joking when they claimed that all you have to do to become a witch is to say three times to yourself: "I am a witch; I am a witch; I am a witch." This is something like speaking an unspeakable word. It is an exorcism of the internalized demon that divides the self against the self. It is a way of saying, "I am, I am, I am." With this declaration one joins the new coven and discovers the covenant.

The moving center of women's new space is on the boundary of the dead circle of archetypes and repetition. Historians of religion, such as Eliade, have made such claims for Christianity. Eliade maintains:

> Christian thought tended to transcend, once and for all, the old themes of eternal repetition, just as it had undertaken to transcend all the other archaic viewpoints by revealing the importance of the religious experience of faith and that of the value of the human personality.

The only words that save this from being a preposterous statement are "tended" and "undertaken." Eliade sees the situation through male lenses. He writes further that Christianity is the religion of "fallen man" [sic] "and this to the extent to which modern man is irremediably identified with history and progress, and to which history and progress are a fall. . . ." For Eliade this "fall" means the final abandonment of the paradise of archetypes and repetition. But has there been real movement out of that "paradise"? The experience of feminists reveals that women feel very much trapped in this "Eden" of endless circles and that Christianity is keeping things this way. The poet William Blake described this paradise very well:

> In Eden, Females sleep the winter in soft silken veils
> woven by their own hands to hide them in the darksom grave.
> But Males immortal live renewed by female deaths.
> (The Four Zoas, 1797)

Within Christianity, males still live renewed by female deaths, and this renewal at female expense may well be a delusion of history and "progress" to those who feel benefited by it. I have already pointed to the Fall that is on its way, hopefully, and that is the Second Coming of women. Those who have always lived renewed by female deaths have every reason to postpone its arrival.

# CORNEL WEST

Cornel West (b. 1953) is a political philosopher and one of the major public intellectuals of our time. He is a professor of religion and African American studies at Princeton University. A Christian and a Marxist, his numerous works of political and cultural criticism have aimed to inspire a liberating vision of the social order that confers dignity on every human being. Besides being a prominent public speaker and commentator, West

has authored numerous articles and books, including *The American Evasion of Philosophy: A Genealogy of Pragmatism, The Cornel West Reader, Race Matters,* and *Democracy Matters.* This essay, which appeared in the progressive religious journal *Christianity and Crisis* (a journal founded by Reinhold Niebuhr) in 1984, rebukes contemporary Christian thinkers for failing to develop a robust response to the social and political problems of the contemporary United States.

# Christian Theological Mediocrity

The distinctive feature of Christian thought in our postmodern times is its mediocrity. We live in the age of theological epigones. The Christian fold presently contains neither a great thinker nor a towering prophet. There indeed are many talented theologians and courageous religious leaders—but none compare with Ernst Troeltsch and Karl Barth or Elizabeth Cady Stanton and Martin Luther King, Jr. Is the present moment the nadir of Euro-American Christian theology? If so, why?

This situation results principally from two brute facts: the failure of nerve of Euro-American Christian thought and the superficial success of liberation theology. The failure of nerve consists of the inability of European and, especially, American religious thinkers to respond creatively to the turbulent 1960s and the eclipse of U. S. world hegemony in the '70s. The modern Christian traditions of liberalism (Whitehead and Wieman), neo-orthodoxy (Barth, Brunner) and realism (Reinhold Niebuhr) were unable to generate powerful and persuasive responses to the issues of racial degradation, patriarchal domination, and imperialist aggression.

The superficial success of liberation theology amounts to a filling of this intellectual vacuum. With the exceptions of Jurgen Moltmann, Mary Daly, James Cone, and a few others, little theological effort has been made to delve into the depth of the European and American experience. For American religious thought, this is not new. Rarely have Americans seriously probed into their own circumstances in order to meet new theological challenges—with the glaring counterexamples of Edwards, Channing, Emerson, Dickinson, Bushnell, Rauschenbusch, and the Niebuhrs exemplifying this rarity.

Instead, Americans have tended to rely on European sources, especially German ones. Yet after Hitler, concentration camps, and national partition, German theology has had little energy to confront the problems of race, gender, and war. Encapsulated French Catholic thought and mutilated British theologies have provided few guides. In short, the European well has run dry, leaving

most American theologians holding an empty pail—hence easily seduced by the mirages of a golden past or a revolutionary future.

Contemporary American religious scholars can be divided roughly into two camps: those who nostalgically harken back to the grand old days of Whitehead, Barth, or the Niebuhrs, and those who naively point to the originary paradigms of Cone, Daly, and Gutierrez. The former camp rightly upholds the great achievements of past intellectual giants yet reinforces the present paralysis by a debilitating deference that diverts attention from the uniqueness of the postmodern challenges. The latter camp correctly directs energies toward the present crisis but possess neither the intellectual patience nor theological scope to respond adequately. These two camps have left American theological education oscillating between a seemingly exhausted liberalism, a perceived discrediting of neo-orthodoxy and realism, and a limited though relevant liberationism. Needless to say, old-style conservative American fundamentalism and evangelicalism (with newly found money!) thrive in such circumstances.

There is little doubt that the decline of highbrow humanist education in Germany—which once transplanted emulations across the American pedagogical landscape—has affected the quality of philosophical, historical, and linguistic

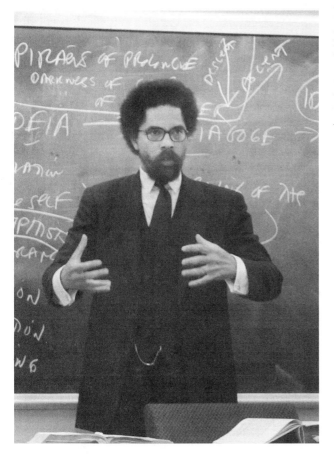

Cornel West, a political philosopher and a public intellectual, teaching a seminar at Princeton University. *Reprinted by permission of West. Photo by Denise Applewhite.*

knowledge in theological education. In addition, the pressures of a leveling mass culture and a shrinking of teaching positions render it more difficult to convince assimilated fourth generation immigrants, mainstream WASPS, and first generation seminary-attending minorities and women that the past educational models are pertinent and productive. Therefore intellectual dilution along with healthy political awareness has occurred in our divinity schools—as in all of our institutions of higher learning. It is important to note that the political awareness is not fully responsible for this intellectual dilution; rather the dilution is caused primarily by the pervasive crisis in theological education and the bureaucratic encroachment of once humanistic centers of learning. In fact, the political awareness has contributed to an honest encounter with the crisis and has enabled resistance to the managerial ethos slowly creeping into these centers.

Our present Christian theological mediocrity will be overcome neither by nostalgic remembrances of past glory nor by naive hopes for future achievements. Both merely satisfy cathartic needs of the present. Only renewed intellectual preoccupation with the challenges of our time, equipped with a firm grounding in the past and a comprehensive vision of the future, can promote a move beyond mediocrity. There is as much talent around today as there has ever been. The question is whether the postmodern realities of education, culture, and politics will permit this talent to flourish. Without this cultivated talent, the Christian presence in this country will not only remain mediocre; this presence also will become, more than it already is, a menace to the Christian faith.

# Stanley Hauerwas

Stanley Hauerwas (b. 1940) is an ethicist working in the United Methodist tradition, one who was dubbed by *Time* magazine as "America's best theologian" in 2001. He is a professor of theological ethics at Duke Divinity School. Famed for his unrelenting critiques of religious complacency in the face of monumental social and political problems, Hauerwas has been a prolific writer whose scope touches areas of biomedical ethics such as partial-birth abortion as well as the ethics of war, passivism and nonviolence, and the role of the church in the world. This essay, from his 1998 book *Sanctify Them in the Truth: Holiness Exemplified*, treats a subject that has roiled Christianity in the United States for at least the past quarter century: homosexuality.

# Gay Friendship: A Thought Experiment in Catholic Moral Theology

## DIFFICULT BEGINNINGS

'Do you believe in the virgin birth?' That was the question we were asked in Texas in order to test whether we were really 'Christian.' At least that was the way the challenge was issued during the time I was growing up in Texas. I confess I was never particularly concerned with how that question should be answered. I was not raised a fundamentalist, but I believed in the virgin birth. The problem for me was not believing in it but what difference it might make one way or the other whether I did or did not believe in it. My preoccupation was not with Mary's virginity, but with my virginity and how I could lose it. In the meantime, of course, we Texans had football to keep us from being too torn up by any anxieties that might come from questioning the virgin birth.

When I began my work as a Christian ethicist my attitude about the so-called 'homosexuality issue' was not unlike my earlier attitude about the virgin birth. I began my work in the midst of war—the Vietnam war—and in such a context sex did not seem to be *the* moral issue. Of course sex played a role in the student rebellion of the 1960s and questions about sex were at the center of debates about situation ethics. But given my concern to develop an ethics of virtue, I thought the concentration on sex, and in particular sexual acts, was a methodological mistake. Moreover the focus on sex as *the* question in ethics seemed to me an indication that any ethic so shaped was too determined by the concerns of the bourgeois. Therefore when homosexuality came along as *the* issue I resisted the presumption that this was a matter on which I had to have a 'position.'

Of course now no one, at least no one who teaches Christian ethics, is allowed to be indifferent about the status of homosexuality. It has become the equivalent to questions about the virgin birth in Texas in the 1950s. No matter where you are or with what subject you are engaged you can count on someone saying something like this: 'That is all well and good but what does what you have said have to do with homosexuality?'

The problem with such questions is not that they are unimportant, but when they are made 'the' question they have a distorting effect on the shape of Christian convictions. For example those who asked about the virgin birth were not concerned with the way questions of Mary's virginity are connected with Christological concerns, but rather were seeking to discover whether you believed the Bible is literally true. When the question of the virgin birth is raised in that context it cannot help but distort how Christian convictions should work, no matter what answer one gives to it. I have often felt the same kind of discomfort

about the way the question of homosexuality is raised as 'the' moral problem to-day, precisely because the question seems wrongly posed.

Moreover, answers given to questions wrongly posed can have unexpected and unwelcome results. For example some of the arguments made on behalf of lessening the onus on homosexuality can also result in lessening the onus on lying and/or war. Moral descriptions are interrelated in manifold ways, not the least being whether our lives make sense. I suspect that part of the concern some have with the approval of homosexuality is how such approval may make practices such as lifelong fidelity in marriage as well as the narratives intrinsic to those practices unintelligible.

Of course many, particularly in liberal cultures, deny a connection between homosexuality and marriage. But that is not an option for Christians, since we must refuse to think of our lives as but the sum of individual decisions since that would result in alienating us from our own lives as well as isolating us from one another. We want our lives at least to make sense retrospectively, as well as to make possible a community called church that constitutes a common story.

Yet the great difficulty is even knowing how and where to begin to think about homosexuality. For example I served for a short time on the United Methodist Commission for the Study of Homosexuality. When we Methodists do not know how to think about an issue we appoint a committee to 'study' the matter, in hopes that some policy statement can be made for the whole church. The results are seldom encouraging since it does little good to pool ignorance in the hope that an outcome will be better than the process. Indeed it is usually the case that the result of a Methodist Commission turns out to be less than the sum of its parts.

I found that I had little to contribute to our deliberations since I did not think the moral status of homosexuality could be or should be determined by whether 'science' could establish the etiology of homosexuality. I had read enough Foucault to be extremely suspicious of that move. I was moreover increasingly suspicious of the very category 'homosexuality,' for the way that description was being used by both sides in the debate seemed to presume what we have come to call 'essentialism'—a position that I find philosophically problematic. I wondered even more what Christian practices would require the description 'homosexuality.'

I asked my colleagues on the commission why as Christians we needed to have a position on homosexuality. Did we not have everything we needed in descriptions like promiscuity and adultery? After all, the current ministry is not under any imminent threat from the ordination of gays, but rather is being undermined by adultery. So why do we not simply report back to the general church that we have in place all the moral language we need to deal with the problem of sexual morality? This recommendation was not only not acted on, it was not even taken seriously. It was assumed by both the anti- and pro-gay sides that the church had to have a position about homosexuality.

Of course we Methodists have to have a position about homosexuality because we do not have an adequate account of marriage. It seems we have to know how to think about homosexuality, else we might have to acknowledge we do not know how to think period. Whether you agree or disagree with Roman Catholics on this matter you at least have to acknowledge they have a consistent position. If every act of sexual intercourse is to be open to conception

then it would seem the matter is fairly clear. Attempts to circumvent this 'conservative' position by describing 'sexual acts' as premoral seem to me to create as much trouble as the position they are trying to avoid. Catholic conservatives and Catholic liberals seem equally to concentrate on 'acts' in the abstract.

I am going to try to provide an alternative way to think about these matters by suggesting the difference it might make if we approach the questions from the perspective of an ethic of virtue and in particular friendship. As my title suggests, I am aware that this way of beginning is 'experimental.' It is often alleged that those of us who work from the perspective of the virtues cannot deal with issues like homosexuality. I hope to show, however, that by beginning with what it means to be a virtuous friend we can better understand how Christians might think about these matters in a way to avoid some of the unhappy alternatives so present today.

Yet my approach is 'experimental' in a manner that is quite unusual for me. Early in my time at Notre Dame I was confronted by a charismatic colleague who tried to convince me I needed to have a 'personal experience of Jesus.' I told her I was raised a Methodist, which meant that by the time I was twelve I had had enough experience to last me a lifetime. Actually my unease with appeals to experience as a warrant for theological language is because I remain an unreconstructed Barthian. I do not think Christian language gains its meaning because it describes 'experiences'. Yet I cannot deny that I begin with questions of friendship because that is the way that the question of homosexuality has come home for me.

For me friendship is not merely an 'experience.' Rather friendship is at the heart of my understanding of the moral life. Indeed, given my reservations about appeals to experience, I am sure I would have never been willing to engage with the issue of homosexuality if I had not discovered that I had friends who are gay. In some of these friendships at least, I did not know in the beginning or even through much of the development of the friendship that my friends were gay. Yet they are gay, and they are among the most faithful Christians I know. It has increasingly become the case, moreover, that I have developed friendship with gays, or better they have sought friendship with me, and that has become very important for my life.

One of the interesting things I have discovered is that my friends do not try to offer 'explanations' why they are gay. They are just gay. Just as the early church had to come to terms with the reality that gentiles, who probably should not have been followers of Jesus, were in the church, so we discover that gays are also in the church. Moreover they are there in a manner that would make us less if they were not there. I take that to be a stubborn theological reality that cries out for thought. I want to try to begin thinking through what such a 'fact' might morally entail by focusing on the moral significance of virtuous friendships.

## PRETENDING TO BE A ROMAN CATHOLIC MORAL THEOLOGIAN

Before I explore the role of friendship for how we might think about homosexuality, I need to establish the context for my reflections. To do that I am going to pretend to be a Roman Catholic moral theologian. I am aware that few contexts

would seem less happy for consideration of the issue of homosexuality as well as for the approach I am taking. Yet I believe that recent discussions by Roman Catholic moral theologians, in particular the promulgation of the encyclical, *Veritatis Splendor,* and the debate it has occasioned, provide one of the richest contexts for the kind of exploration I undertake.

I realize that such a claim will strike most people, and in particular Roman Catholics, as high folly, but at the very least Roman Catholic moral theology provides a context in which argument might count. By beginning with *Veritatis Splendor* I am at least able to begin with a tradition that knows there is more involved in thinking about sex than asking whether what we do with and to one another is an act of love. The problem with 'love,' of course, is that we have no idea how it is to be specified and as a result what might count as an exemplification of loving behavior. This becomes peculiarly problematic when we live in cultures in which some now think it reasonable to think thoughts such as: 'No one has the right to tell me what I can do or not do with my body.' For all of its problems, at least Roman Catholic moral reflection on these matters provides a context in which argument counts.

I need to warn you, however, that my credentials even to pretend to be a Roman Catholic moral theologian have been questioned by some. For example Richard McCormick, SJ criticizes a short essay I coauthored with David Burrell in which we praised the characterization in *Veritatis Splendor* of proponents of proportionalism as seeking an accommodation with the spirit of the age. McCormick says it is 'difficult to find language strong enough to condemn such motivational attribution. This is especially regrettable from authors who have played no significant role in these developments and manifest no realistic grasp of the problems, concepts, and language that surround them.'

In a recent essay Joseph Selling echoes McCormick's complaint against amateurs who want to take sides in the current dispute between proportionalists and their 'conservative' opponents. Selling notes that proportionalists certainly never have doubted that there is such a thing as right and wrong, but rather are pastorally concerned to help individual persons come to terms with serious questions. He acknowledges that to the 'outside observer' such moral theology could appear as a capitulation to the 'individualistic, consumer, "anything goes" spirit of the times, but this would be a false impression.' He then clarifies what he means by 'outside observer'—they are 'anyone who did not follow the development of moral theology with a professional understanding. This would apply to theologians who were not specifically trained in that field or to non-theologians such as philosophers who knew a good deal about natural law theory or legal philosophy but relatively little about theological concepts such as grace (fundamental option), covenant (biblical theology, the meaning of sin as a theological concept) or pastoral care (diminished guilt, internal forum, material sin, or the lesser evil solution to moral dilemmas).'

I know I am supposed to be intimidated by McCormick's and Selling's claims of insider expertise and knowledge, but I am going to 'damn the torpedoes' and try to provide an alternative to the debate as they understand it. I should say in some ways I am quite sympathetic to their claims of expertise. That is, I am sympathetic in the sense that I think part of their problem is they have been encouraged to think of themselves as 'experts.' At least one of the les-

sons we need to learn from recent debates in Catholic moral theology is that it is a dangerously over-determined tradition. For example, when you identify grace with a 'fundamental option,' and specify 'biblical theology' by a concept like 'covenant,' you have an indication that moral theology has become so specialized it is by no means clear what it means for it to be called theology.

Yet it is certainly true that I am an 'outsider' since I am a Protestant. I am also an outsider because I have not tried to participate in the proportionalist controversy, even though over the years I have tried to read the books and articles by proportionalists and their opponents. I have not taken sides mainly because I did not like the way the sides were constituted. I remember years ago that when I first read Louis Janssens, I was quite sympathetic with his concern to avoid a law-like account of morality, but quite unsympathetic with the way he was trying to provide an alternative. 'Fundamental option' seemed to be neither an option nor fundamental. In particular, I was suspicious of the lingering neo-Kantian presumptions about the self that were shaping the way Aquinas was being read. From my perspective, notions like 'fundamental option' could only seem attractive or necessary if one had forgotten how Aquinas understood the nature of practical reason, character, and the virtues.

In other words, what has bothered me about the proportionalists is not their attempt to provide an alternative to the 'old legalistic moral theology,' but that even in their attempt to provide an alternative to the legalist framework they continued to presuppose a law-like framework. Actions continued to be treated in abstraction from the virtues, but now in the name of pastoral sensitivities such actions are assumed to be infinitely re-describable. No doubt some of the ways the proportionalists put their case made them appear to be consequentialist, but that never seemed to me to be the crucial problem. Rather I have not been able to understand where they think descriptions come or what controls their use. Part of the difficulty, of course, is that those who have resorted to devices such as 'pre-moral' seem to have no sense that this is a problem.

The great achievement of *Veritatis Splendor* is to make the virtues central for the way the moral life is understood, as well as to suggest the interrelation between actions and virtues. This encyclical is often criticized for its failure explicitly to draw out the interconnections between Parts I and III and Part II. To be sure, one could have wished for a clearer display of the way the Christology in the first part should make a difference for the critique of the proportionalist in the second, but this encyclical is a remarkable achievement precisely in the manner in which it repositions the issues. Certainly the intent of the encyclical is conservative, but more important are the avenues it opens for fresh considerations of the Christian moral life including even matters such as homosexuality.

Martin Rhonheimer, in his article called ' "Intrinsically Evil Acts" and the Moral Viewpoint: Clarifying a Central Teaching of *Veritatis Splendor*,' has come as close as anyone I know to getting the issue right. He emphasizes the centrality in *Veritatis* of paragraph 78, where we get the characteristic Thomistic claim that the morality of an act depends on the 'object' which has been chosen by a deliberate will. This claim is elaborated in the following manner: 'In order to be able to grasp the object of an act which specifies that act morally, it is therefore necessary to place oneself *in the perspective of the acting person*.' The Encyclical goes on to argue that the object of a moral act cannot be a process or an event of

the 'merely physical order' assessed by the power to bring about a state of affairs in the 'outside world,' but rather the 'object is the proximate end of a deliberate decision which determines the act of willing on the part of the acting person.' Thomas is then quoted to the effect that someone who robs to feed the poor has not acted uprightly since 'no evil done with a good intention can be excused.'

This argument immediately precedes the claim that there are 'intrinsically evil' actions, that is, actions that irrespective of the good intentions of the agent are incapable of being ordered to God. I confess I have always found the phrase 'intrinsically evil' mystifying. In a conversation with David Burrell some years ago I asked him if he thought a certain belief was 'absolutely true.' He challenged my use of the phrase 'absolutely true' by asking what 'absolutely' added if in fact the belief is true. In the same vein I continue to wonder what the qualifier 'intrinsic' adds to an action's being evil.

I realize this seems like a small matter, but I suspect the language of 'intrinsic evil' has led to some of the confusions concerning the character of practical reason—something that it is crucial to understand properly if we are to get these matters right. For 'intrinsic evil' makes it sound like certain actions are 'out there,' abstracted from agents, and they are to be evaluated either by their intrinsic nature or in terms of the consequences they produce. But that is exactly what Rhonheimer is suggesting cannot be done if we are to rightly understand *Veritatis*. That certain actions are evil makes sense only in a view of the moral life as a life shaped by the virtues in which human actions are understood from the perspective of the first person.

An ethic of the virtues requires an account of practical rationality and action in which an agent's 'action' is by its very nature intentional. If, as Aristotle maintains, we become just by acting justly, then the way we are so habituated requires that we must do that which we do in the way in which a virtuous person would do it. Rhonheimer observes that, from the viewpoint of the agent, actions are intentional not in the sense that I am aware of what I am doing, though I may be, but simply that I must be able to claim what I have done as mine. In contrast, from a third person perspective—that is, from the viewpoint of an observer—actions appear as events that are only contingently related to certain causes. Relying on this perspective, the proportionalists construe the moral life from the third person viewpoint and accordingly treat 'actions' as external bits of behavior to be judged good or bad, ironically, as if the agent did not exist.

An ethics of the virtues must insist, therefore, that there are not two states of affairs when we act rationally: that is, an action-event and the resulting state of affairs, but rather that action and agency are inseparable. Accordingly the 'goods' intrinsic to our nature are not simply a set of givens nor are we the sum of our inclinations. Rather the goods sought by our desires 'constitute the proper practical self-experience of persons as a *certain kind* of being.' The claim that certain actions are always wrong is but a way of specifying that they can never be consistent with a good will, that is, with what a person of virtue would choose. To be morally virtuous is not to will to do 'the right thing' time after time, but rather 'moral virtue is the habitual rightness of *appetite* (sensual affections, passions, and of the will, the rational appetite related to the various spheres of human praxis). An act which is *according* to virtue is an act which is

suited to cause this habitual rightness of appetite which produces "the good person."'

The virtue that is central to our ability to make our actions our own Aristotle calls *phronesis*, which Thomas develops as *prudentia*. Alasdair MacIntyre notes that the acquisition of this virtue requires the recognition of the rational authority of the precepts of the natural law and most especially the negative exceptionless precepts. We discover such precepts in the institutions and projects through which we seek variety of goods such as 'enduring relationships in the family and in friendship, goods of productive work, of artistic activity and scientific inquiry, goods of leisure, goods of communal politics and religion.'

MacIntyre notes that an individual will have to learn how to discern and to order specific goods in each of these projects and activities in order to make the choices necessary for the goods to be achieved. Moreover, how those goods will be understood will differ from culture to culture. What according to MacIntyre will not vary is the kind of responsiveness by one human being to others which makes it possible for each to learn from the others' questioning. Such requirements are the preconditions for the kind of rational conversations we must have to discover the goods that come from our engagements with one another in which we need not fear being victimized.

Rhonheimer, whose view of practical reason is quite similar to MacIntyre's, observes that our necessary commitments to promise-keeping and truthfulness require narrative display. For our refusal to break a promise leads us to discover new lines of action, alternatives, and hitherto unseen opportunities. 'To describe this we would need to tell a story. Virtuous actions are, in this sense, rendered intelligible only in a narrative context. But the right thing to do will always be the action which is consistent with the rightness of appetite, with the rightness of our will's relation to concrete persons with whom we live together in defined relationships.'

In a follow-up article, 'Intentional Actions and the Meaning of Object: A Reply to Richard McCormick,' Rhonheimer further specifies the interrelation of the virtues, descriptions of actions, and the need for a narrative display. He criticizes proportionalists for assuming that a basic action can be described and redescribed 'without looking at what the acting person chooses on the level of action (or "means"); rather, they concentrate on what he or she chooses in the order of consequences and on the corresponding commensurate reasons, all of which finally constitute the "expanded object".' Rhomheimer observes, however, that such an expanded notion of object is not really a notion of 'object' at all, but rather its abolition. It is so because for Aquinas 'object' means the basic intentional content of a human act that is distinguishable from further intentions. In short, to speak of the 'object' of an act means that actions are not infinitely redescribable. At least they are not infinitely redescribable if a community is to be capable of sustaining virtuous lives.

Rhonheimer shows that the same behavioral pattern alone cannot decide everything. For example, he contrasts John, a college student who drinks whisky to induce temporary loss of consciousness in order to forget his girlfriend left him, with Fred, a soldier who drinks the same amount of whisky to avoid the pain of an emergency operation. Rhonheimer notes that while the behavioral pattern is identical, without indicating an intention, it is impossible

to describe *what* John and Fred are doing, that is, what they are choosing. Rhonheimer denies that this allows us simply to 'shift intention to and fro' since John cannot reasonably intend his act to be an act of anaesthesia. There are given contexts (shaped by circumstances and recognizable, as a morally significant contextual unity, only by practical reason) 'that *can* have if we choose a determined "kind of behavior," *independently* from *further* intentions.'

When agents choose to act they necessarily do so under a description which is according to Rhonheimer 'precisely the description of an intent formed by reason.' So the intention to have intercourse with someone who is not my spouse cannot be overridden by some further description that may involve doing so for obtaining some information necessary to save the lives of others. 'One can therefore describe concrete choices of kinds of behavior as wrong or evil independently from further intentions. Such descriptions, however, always *include* a basic intention, an intention that itself presupposes a given ethically relevant context without which no intention formed by reason, could come into being. This has nothing to do with the "expanded notion of object." But it includes a certain complexity that is due to the plurality and multiplicity of virtues that in turn reflect human life and its richness in relations between persons, including the differences of ethically relevant contexts.'

Thus, against McCormick Rhonheimer maintains, for example, that it is possible without being a proportionalist to maintain there is a difference in the basic intentional content in the case of the following actions: simple killing for any end whatsoever, killing in self-defense, capital punishment, and killing in battle. These action descriptions differ not only because one might have different reasons for performing them, but because their intentional structure is different in each case. Their *structure* is different. Thus there is a difference between 'self-defense' and 'the choice to kill in order to save my life.' On some abstract level they may be identical, but from the acting person's perspective there is a different choice. 'In legitimate self-defense, what engenders my action is not a will or a choice for the aggressor's death. A sign of this is that I only use violence proportionate to stop his aggression. This may lead me to kill him, but the reason for my action is not wanting him to be dead (for the sake of saving my life); rather it is wanting to stop his aggression. Thus there is a difference of intention on the level of concrete chosen behavior, and that means, on the level of the object.' Rhonheimer's (and MacIntyre's) account of *Veritatis Splendor* deftly opens the door for a fresh consideration of the way moral descriptions work. If, as Rhonheimer maintains, one has to analyze intentional contents as belonging to the structure of the virtues, then one has to consider why certain descriptions are privileged. Rhonheimer quotes the *Catechism's* teaching 'that there are certain specific kinds of behavior that are always wrong to choose, because choosing them involves a disorder of the will, that is, moral evil,' which I have no reason to dispute. Yet the display of such acts requires a much thicker narrative than is usually supplied.

Which finally brings me back to friendship. An ethic of the virtues like that of *Veritatis Splendor* is unintelligible without friendship. That Aristotle devoted two books of the *Ethics* to friendship is hardly accidental. For Aristotle friendship is not just a necessity for living well, but necessary if we are to be people of practical wisdom. Through character-friendships we actually acquire the wis-

dom necessary, and in particular the self-knowledge, to be people of virtue. We literally cannot do good without our friends, not simply because we need friends to do good for but because the self-knowledge necessary to be good comes from seeing ourselves through our friendships.

As Paul Wadell observes, friendship in Aristotle names the relationship by which we become good. The activity of friendship—and it is crucial that we understand it as an activity—is what trains us to be virtuous. 'By spending time together with people who are good, by sharing and delighting with them in our mutual love for the good we are more fully impressed with the good ourselves. Friendship is not just a relationship: it is a moral enterprise. People spend their lives together doing good because that is what they see their lives to be.' In short friendship is an epistemological necessity, for moral goodness is constituted through the ability of friends to name together those activities that constitute virtue as well as vice. Friendship names the practice necessary to sustain ongoing enquiry concerning the descriptions of the objects of our actions. For as MacIntyre suggests above, that which we learn to do and not do is discovered through such practices.

## ON BEING FRIENDS WITH GAY CHRISTIANS

It is often said, 'Some of my best friends are gay, but that does not mean I approve of their being gay.' However, if Aristotle is right about the significance of friendship, then there surely must be something wrong with such a statement. If 'being gay' indicates a morally problematic mode of behavior then those who would be virtuous cannot afford to be friends with gay people. Of course it can be said that we all live morally ambiguous lives, so we should not expect too much of one another in such matters. But if 'being gay' names an immoral practice, then surely being a friend of gay people would not be a wise policy for those who would be moral.

Yet as I observed at the beginning, many of us find ourselves in Christian friendship with gay people. Consider an example, a fictionalized account of a real friendship. I have a friend who is a close friend of a lesbian couple who have lived faithful lives with one another for over twenty-five years. This couple have adopted and raised two children who are profoundly mentally handicapped. They are also committed Roman Catholics. What should we call this relationship? Should my friend be their friend, and should I be his friend? Am I risking corruption through his friendship with gay Christians?

Of course the answer to such questions appears easy: 'It depends on the kind of people they are.' That is, it depends on the question of whether they are virtuous. To be sure, that seems right, but I cannot act as if their being gay is irrelevant to their being virtuous. To distinguish between their being virtuous and being gay threatens to introduce a distinction between public and private which I take to be the destruction of any serious discussion of the virtuous life among Christians. Moreover such a distinction prevents the narrative from being truthfully told.

Of course that does not mean that my gay friends think being gay should determine all they are or do. Indeed they tell me that one of the great problems

with being gay in our current context is that such an identification becomes far too consuming. Sex, after all, just is not all that interesting, particularly as a defining characteristic that colors all of our activity. Gay people, like the rest of us, have more important things to do than to be gay.

Indeed that is one of the reasons I resist the very description 'homosexuality.' If there is something called 'homosexuality' then that must mean I have to be something called 'heterosexual.' I am not, of course, a heterosexual; I am a Texan—a philosophical joke meant to remind us that our identities are given through participation in practices that should serve the purposes of good communities. I remember when I first went to Notre Dame and was filling out the standard forms for employment, one of the forms asked me to indicate whether I was male, female, or religious. Now there is a mode of classification that could have produced a book from Foucault!

I, of course, understand that many will find this tack beside the point for consideration of the ethics of homosexuality. It is not about friendship, stupid— it is about sex and particular kinds of sex. Moreover, as I indicated at the beginning, if you believe that every sexual act must be open to conception then the game is up. I, of course, do not believe that, though I am unsympathetic with the 'spiritualization' of sex that I think informs many of the arguments made against the view that every sexual act must be open to conception. By 'spiritualization' I mean the peculiarly modern presumption that our sexual conduct has no purpose other than the meanings we give it and so are able to derive from it. Such a view seems to make us far too 'sexual.' A seminarian at Notre Dame once told me, 'We celibates can be happily sexually adjusted.' I told him I was married, had my share of sex, but I was sure I would never be happily sexually adjusted. What a terrible burden is put on sex: requiring it always to be fulfilling because it has no other purpose.

Yet the purpose of sex cannot be known from sex. This, of course, locates my disagreement with the presumption that every act of sexual intercourse must be open to conception. Marriage as a practice of the church has as one of its purposes the readiness to receive children, but even that does not entail biological children. That marriage has such a purpose, moreover, I assume is part of the church's commitment to be hospitable to the stranger requiring all the baptized to consider ourselves parents whether we have biological children or not. I have always thought it quite appropriate that celibate priests be called 'Father.' It is a radical judgement on the presumption that biology constitutes fatherhood.

If every sexual act need not be open to conception, then it seems to me that *Veritatis Splendor* offers us a perspective from which to think about how we might narrate the relation between the two women I described. They are not promiscuous. The intimacy they share is oriented to upbuilding their lives for the good of their community. Just as we can discriminate between different kinds of killing through analogous comparisons, I do not see why we cannot see this kind of relationship analogous to what Christians mean by marriage. The church after all does recognize the marriage of people who are beyond the age of childbearing. On what grounds are the women I described above excluded from such recognition?

The quick answer, of course, is that they are the same sex. They are homosexual. But here we see the wisdom of the Catholic tradition and why I spent so

much time discussing *Veritatis Splendor*. Catholic moral theology has never thought that a *theory* about 'homosexuality' would determine these matters, but rather asked what kind of behavior is commensurate with being the virtuous person for the upbuilding of the church. I am suggesting that it would at least be possible to understand the object of the relation between the women I described above as analogous to marriage. I would put the matter more strongly—if gay Christians are to have some alternative to the sexual wilderness that today grips all our lives, gay and non-gay alike, something like what I am suggesting must be found.

Such a suggestion obviously involves a complex account of the interrelation of practices and their correlative virtues, the narratives that render such practices and virtues intelligible, and the institutions necessary to sustain such narratives. I cannot pretend to have done that work adequately in this paper. Rather I have tried to provide a beginning for such work—a beginning that surely begins by entering into enquiry with our gay friends in the hope that together we might discover how to live faithfully as God's people.

I need, however, to be candid. Just as marriage between those past childbearing age may be an exception, so it may be that the recognition of faithful relations between gay people is an exception. But exceptions are not a problem for a community that is secure in its essential practices. The crucial question is how to live in a manner that the exception does not become the rule. Just as the married bear the burden of proof in the church, given the church's presumption that we do not have to be married to be Christians, so among the married those who cannot have biological children may well bear the burden of proof. Such a burden hopefully should be seen as a means for the upbuilding of the community of believers. By asking gays to help us understand how their lives contribute to our presumption as Christians that marriage is constituted by a promise of lifelong monogamous fidelity we might discover what a life-giving promise that is.

I am aware that gay Christians may think that they already have enough burdens. Why should they be asked to justify their lives in such a manner? We certainly do not ask it of those who call themselves 'heterosexuals.' I can only say, 'This can only be asked of you because you are Christian and because we are friends.'

# Avery Dulles, S.J.

Avery Dulles, S.J. (b. 1918) is a celebrated Catholic theologian who has taught at Catholic University of America and Fordham University. The son of former U.S. Secretary of State, John Foster Dulles, Dulles converted from the Presbyterianism of his childhood to Catholicism in 1940 and joined the Jesuits in 1946. At the age of 82, he was named a cardinal by Pope John Paul II. He has authored numerous books and articles, most of which seek in some way to explain the reforms of the Second Vatican

Council (1962–65) and to defend the authoritative office of the pope in an environment in which many Americans have contested the pope's positions on matters pertaining to gender and sexuality, especially. This essay, published in the journal *First Things*, was adapted from a talk given to the Society for Catholic Liturgy in Detroit on September 25, 1997.

# The Ways We Worship

One weekend in that tumultuous year 1968 I was on call at a parish church outside of Baltimore. At the end of my Sunday Mass I came into the body of the church to make my thanksgiving, and as I knelt in the pew I noticed that the pulpit from which I had preached had on its front a banner with the inscription "God is other people." If I had had a magic marker within reach, I would not have been able to resist the temptation to insert a comma after the word "other."

The two forms of the inscription, with and without the comma, sum up two opposed tendencies in contemporary liturgical piety. For present purposes I shall call them otherworldly and this-worldly. For the sake of clarity I shall draw the contrast rather baldly, verging on caricature, while recognizing that less extreme positions are more normal. My immediate concern is with the Catholic situation, but I believe that my arguments apply, mutatis mutandis, in other Christian traditions as well.

For the otherworldly Catholic, liturgy is made in heaven. Given by God, it is received by the Church, which has no power to make substantive changes or substitutions. The ritual is sacred and inviolable. The faithful of any age or place must adapt themselves to it, rather than adapting it to their tastes, interests, or capacities. The celebration should elicit a sense of numinous awe in the presence of the holy, the totally other. God is remote, utterly transcendent, and we sinners are unworthy to stand in his presence. Liturgy is the principal bond between the earthly and the heavenly Church, a frail human participation in the glorious heavenly liturgy. In its official worship the Church achieves its prime purpose, to glorify God. There is no need for the words and gestures to be understood by the members of the assembly.

For the this-worldly believer, on the contrary, successful liturgical practice is a matter of feeling and self-expression. When the community assembles, it should celebrate its religious experience, thereby intensifying and solidifying it. The worshipers may be confident that as they seek to do so they will be assisted by the indwelling Spirit and will be constituted as Church.

In this second perspective, the members of the assembly are urged to find God not in some supercelestial realm beyond space and time, but here and now in the members themselves. Liturgy, it is held, exists for the sake of the worshipers, and only by helping them to sort out their experience and to become

"fully alive" does it glorify God. The style of worship is to be tailored to the particular community so that the worshipers may be motivated to build the Kingdom of God here on earth.

To point up the contrast one may say that in the first view, the liturgy makes the Church and in the second, the Church makes the liturgy. In the first view the members of the Church simply receive what the liturgy has to give. The conduct of the ceremony is entrusted to a divinely ordained hierarchical priesthood, which has responsibility for the strict observance of the prescribed rites. In the second view, the liturgy is produced by the people. The congregation is the responsible agent, and the ministers its delegated representatives. In the first view the sacraments are efficacious *ex opere operato;* in the second, *ex opere operantis.* In the first view the attention of the assembly is directed to the objective mystery of God's saving work in Christ; in the second view, worship must be made relevant to the actual situation. In the style of worship, the first favors formality, the second spontaneity.

The two points of view clash on any number of issues that have been hotly disputed in the past thirty years. For example, there are problems about the design and furnishings of the space. Should there be a sanctuary, an altar rail, a prominent tabernacle, sacred images? Should the people be seated in pews with kneelers, or in chairs arranged in a crescent or circle? How should the ministers be vested? Should the celebrant face the people during the Eucharistic prayer, or should both priests and people be turned eastward toward the coming Lord?

There are further disagreements about bows, genuflections, and the proper posture for Holy Communion. Should the communicants stand or kneel? Should they receive in the hand or on the tongue? Should Holy Communion be preceded by a confession of sins and fasting? Should the reserved sacrament be adored? Should it be exposed for veneration? Should lay people, including women, be allowed to minister at the altar and distribute Holy Communion?

Other debates revolve more about the service of the word. Should the rite begin with an informal greeting? Should the homily be an authoritative word or a sharing of personal faith experiences? Are dialogue homilies permissible? Should the celebrant be bound strictly to the approved texts or be encouraged to extemporize? Should preference be given to the Roman canon above the other authorized eucharistic prayers? Should the use of Latin in the Roman rite be maintained, increased, or eliminated altogether? What principles should govern the translations of the sacramentary and the lectionary into English?

It would be possible to lengthen this list considerably by speaking about other matters, for example, sacred music. What of Gregorian chant, polyphony, and country music? What of pipe organs and guitars? These and other areas of controversy are all too familiar to most worshipers.

There is, in all this, great potential for polarization. Liturgy is a flash point in the culture wars. Partisans of the two tendencies frequently criticize each other in harsh and polemical terms. The advocates of otherworldly liturgy accuse their adversaries of destroying the sense of the sacred, of departing from Catholic tradition, and of lapsing into a vapid congregationalism. The this-worldly school accuses its opponents of turning the Church into a museum piece, of perpetuating a mythical worldview, and of resisting the reforms of the Second Vatican Council.

Each party blames the other for the decline of Mass attendance and the failure of the Church to attract the young. One group holds that modern Catholics are disgusted by the tasteless experiments and pedestrian language currently in use; the other insists that the laity are repelled by a petrified liturgy that is tied to a vanished civilization and removes the Church from active participation in the modern world.

Needless to say, the actual positions of most Catholics do not correspond precisely to either of these two types. An extremist at the otherworldly end of the spectrum would probably join some "traditionalist" movement like that of Marcel Lefebvre and thus end up outside the Catholic Church. An extreme this-worldly outlook would take a person along the path followed by Matthew Fox, who left the Catholic communion because he found it unreceptive to "creative spirituality."

The extreme positions, nevertheless, have a certain inner consistency. The mediating positions, in comparison with them, tend to be weak compromises. Those who elect to stand nearer to the center risk incurring the wrath of both extremes. "Would that you were either hot or cold," they say. Must a mediating position, in seeking to do justice to both sides, be a bag of contradictions that in the end satisfies no one?

I propose that we look to tradition as a principle of discernment in sorting out these matters. That proposal, I realize, is not without difficulty. The term "tradition" might seem to be unsuitable for mediation because it has already been coopted by extreme conservatives, who use it, as did Lefebvre, to denounce even the moderate reforms of Vatican II.

Tradition, however, need not be understood in traditionalist terms. Some liberals have held that Vatican II overcame a rigid, ossified concept of tradition and made it possible to understand tradition in a new light, as a principle of growth and change. This response, however, raises yet another difficulty. The concept of tradition, some object, can be of no help because the battles about tradition simply reproduce on another level the battles about liturgy itself. To invoke tradition is to shift to a new battlefield no more promising than the first.

While recognizing the force of this objection, I would refuse to surrender without an effort. It is possible, I believe, to show that the concept of tradition, as understood in common speech, in biblical usage, and in normative Christian documents, is not so arbitrary. It implies at least three things—a giver, a gift, and a recipient. Tradition passes on some reality or idea between two poles. The content (or the *traditum*) is that which the giver has to give and the receiver can receive. By its very nature, therefore, tradition mediates between two extremes, bringing them into unity.

Tradition, insofar as it takes place in history, binds together past and future. It has been called the living past. Jaroslav Pelikan brilliantly clarified the difference between tradition and traditionalism when he called tradition "the living faith of the dead" and traditionalism "the dead faith of the living." If the gift perishes in the process of transmission, it becomes the dead past, a mere memory. The faith of the dead, if it is to live, must take root in the minds and hearts of those who receive it. Thus tradition, by its very nature, demands attention to the recipient as well as to the gift and the giver.

Liturgy and tradition are not synonyms, but they are closely connected. Tradition is more extensive than liturgy, since, even in the Church, there are other forms of tradition—devotional, doctrinal, catechetical, spiritual, and canonical. Liturgy, however, is recognized as a prime instance of tradition. It was described by Bishop Bossuet as "the principal instrument of the Church's tradition." According to Dom Prosper Guéranger, one of the founders of the modern liturgical movement, "the liturgy is tradition itself, at its highest power and solemnity." Yves Congar makes these words his own and affirms that "liturgy is the privileged locus of tradition, not only from the point of view of conservation and preservation, but also from that of progress or development." What is true of tradition must therefore hold for liturgy. Although liturgy does not coincide with the entirety of the Christian life, the whole life of the Christian should be permeated by the spirit of the liturgy.

Liturgy is described in official documents as the Church's prolongation of, and participation in, Christ's priestly office. This description is valid so far as it goes, but I regard it as incomplete. In the liturgy, as the public action (*leitourgia*) of the Church as such, Christ exercises his threefold office as prophet, priest, and king. In celebrating the liturgy the Church participates in the worship offered by Jesus and at the same time proclaims God's wonderful works and furthers the establishment of the Kingdom. Insofar as it is worship, liturgy has a priestly aspect, but it is not reducible to worship alone. Under a second aspect it is a participation in the prophetic office of Christ, who addresses his people by word and gesture. Under still a third aspect, thanks to the active presence of the risen Christ and the Holy Spirit, liturgy serves to transform the old world into the new creation. It gives fresh actuality to the fruits of Christ's Paschal mystery.

The concept of tradition, as currently understood in theology, includes a number of characteristics that might be significant for the reform and renewal of the liturgy. Presupposing a more thorough study of tradition that cannot be repeated here, I shall briefly summarize ten of these characteristics.

1. Tradition has a divine origin. God is the principal transmitter, the first *tradens* or *traditor*. Christian tradition arises from the action by which the Father handed over his Son for the redemption of the world (Romans 8:32; John 3:16). Without this initiative of the Father everything else in Christian tradition would collapse.

When God acts in history, he does not act alone, but makes use of human agency. Mary, Judas, Pilate, and Jesus in his humanity were involved in very different ways as instruments in bringing about God's supreme redemptive act.

2. Tradition is Christic. Christ goes willingly to his death, surrendering himself for our redemption. Even before his betrayer turned him over to his enemies, Jesus gave himself to his disciples with his own hands. He really hands himself over under the appearances of bread and wine, broken and poured out for our salvation. He instructs the disciples to take, eat, and drink, thus completing the ritual transaction. Having united the disciples to himself, Jesus sends them into the world to proclaim his message and carry on his ministry.

3. Tradition in the theological sense is also pneumatic. Bowing his head before he died, Jesus handed over the Spirit (John 19:30). In a later incident, when the risen Jesus breathes upon the apostles, their reception of the Spirit is mentioned

(John 20:23). From these texts in combination it seems clear that the sending of the Spirit into the hearts of the faithful pertains constitutively to tradition in its theological meaning.

Because of this pneumatic dimension, tradition in the Church is normally epicletic. At the liturgy, at councils, and on other solemn occasions, where the tradition has to be authoritatively passed on, the Church invokes the Holy Spirit, through whom the living Christ continues to give himself actively to the Church. Thanks to the involvement of the Holy Spirit, tradition has a living actuality that prevents it from being a mere hearkening back to the past. Congar has written many pages on the Holy Spirit as "the transcendent subject of tradition." The Orthodox theologian Vladimir Lossky defines tradition as "the life of the Holy Spirit in the Church."

To summarize these first three points we may say that tradition in the theological sense, and hence in the liturgy also, is trinitarian. In the words of Jean Corbon, "The Father gives himself through his Son in his Holy Spirit." In a fuller explication he writes:

> The passionate love of the Father for human beings (John 3:16) reaches its climax in the passion of his Son and is henceforth poured out by his Spirit in the divine compassion at the heart of the world, that is, in the Church. And the mystery of tradition is this joint mission of the Word and the Spirit throughout the economy of salvation; now, in the last times, all the torrents of love that pour from the Spirit of Jesus flow together in the great river of life that is the liturgy.

4. Tradition in its Christian reality is apostolic. The traditionary acts of the divine persons are prolonged and concretized in history by the actions of the apostles and their successors, who pass on the living memory of the Paschal mystery in the normative language of Scripture and the early creeds. Paul reports that he has received from the Lord and passed on to the Corinthians the narrative of the institution of the Eucharist (1 Corinthians 11:23). A little later in the same letter Paul uses once more the technical language of tradition (1 Corinthians 15:3) as giving authority to his account of the mystery of Christ's death and resurrection. The kerygma is not a private message; it is the revelation entrusted to the apostolic body.

The apostolic tradition at its core is liturgical, as the example of the Eucharist serves to indicate. Baptism, likewise, is a prime instance of tradition. By the passing on of the creed the bishop entrusts to the candidate the heritage of the Church, and by echoing the creed the candidate gives assurance that he or she possesses the faith necessary to become a bearer of the tradition.

5. Tradition takes place through symbolic acts and gestures as much as through words. The sacrament of baptism has been called "the kerygma in action." The mystery of Christ's death, burial, and resurrection is transmitted by the immersion of the candidate into the baptismal waters. The use of specially blessed water recalls Old Testament events such as the Flood, the crossing of the Red Sea, and the striking of the rock by Moses (1 Corinthians 10:1-4; 1 Peter 3:20-21) as well as Jesus' own baptism in the Jordan. More proximately the immersion recalls the death, burial, and resurrection of the Lord. The threefold immersion transforms the rite into a proclamation of the Triune God,

according to the baptismal precept of Matthew 28:20. Having been washed in the blood of the Lamb, the neophytes don the white garments of righteousness (Revelation 7:14), thus signifying their induction into the new creation. At the Eucharist, likewise, the action proclaims the death of the Lord with a view to his glorious return (1 Corinthians 11:26). The offering of the elements, the breaking of the host, and the eating and drinking are charged with Christological meaning.

Vatican II mentioned worship as one of the means by which the Church "perpetuates and hands on to every generation all that she is and all that she believes." In the liturgy, as elsewhere, Maurice Blondel's observation holds:

> Tradition in the Church will, thus, not be just a few unwritten truths transmitted by word of mouth, but in a quite special way the Church's ordinary life, its way of acting, its structures, discipline, sacraments, prayer, its faith as lived through the centuries.

For the process of tradition to succeed in its liturgical enactment the participants themselves must be actively engaged. James Hitchcock has made the point effectively:

> Habits of prayer and devotion are fostered and kept alive not only through verbal or mental prayer but also through what might be called "muscular memories"—familiar ritual gestures which summon up for the actor a range of implicit beliefs. Genuflecting before a tabernacle or making the sign of the cross with holy water on entering a church are examples of this. So also is the fingering of rosary beads. Such actions have religious meaning even without conscious reflection, because they operate on a deeper level of the mind.

6. The preferred language of tradition is itself suggestive and symbolic. Jesus taught not so much by clear doctrinal declarations as by stories, parables, and symbolic actions. In the New Testament as well as in the Old, faith is transmitted through "songs, hymns, and inspired canticles" (Colossians 3:16). Scholars have judged that many of the great Christological hymns in the Pauline letters, in the Letter to the Hebrews, in John's Gospel, and in the Revelation of John have their matrix in the liturgy. Pliny in his letter to Trajan informs the emperor that the Christians at their liturgy were singing hymns to Christ as to a god. The ancient creeds fitted into the liturgy because they were rhythmic, poetic, and able to be sung. The same cannot be said of the creeds of later centuries, when rationalism began to affect the processes by which faith was transmitted. While an element of rationality is appropriate for doctrinal teaching, the liturgy should cultivate the suggestive power of tradition.

If faith could be communicated by merely conceptual indoctrination, living tradition would hardly be necessary. But, as Blondel effectively showed, propositional statements do not suffice. "Tradition," he says, "is not a simple substitute for a written teaching. It has a different purpose. . . . It preserves not so much the intellectual aspect of the past as its living reality." In times of crisis, the Church can turn to her tradition to discover elements previously held back in the depths of her unconscious and practiced rather than expressed and systematized. The fallacy of explicitness, as Hitchcock remarks, "has been responsible for much liturgical impoverishment, since some liturgists (and some

worshipers) appeared to assume that once the symbols had been 'explained' there was no longer any need for them."

7. Tradition is transformative. Transmitted predominantly by symbolic actions and symbolic language, it acts on the psyche at a level more fundamental than reflective consciousness. In this way it helps to transform the believer into a new creation (2 Corinthians 5:17; cf. Galatians 6:15)—a person who thinks, feels, speaks, and acts in new ways. Tradition instills in the community an instinctive sense of the faith.

The spontaneous practices and popular devotions of the faithful, while they lack the high authority that belongs to liturgy, constitute subsidiary avenues of tradition, reflecting the people's sense of the faith. While popular religiosity must be critically evaluated for its authenticity, it will be carefully studied by the Church's pastors for its hidden riches. Before defining dogmas such as the Immaculate Conception and the Assumption, the popes consulted the sense of the faithful as manifested in devotional traditions.

Modernism exaggerated the authority of popular devotions, placing them on a par with liturgy as a locus of tradition. But in classical theology the *lex orandi* did not refer to spontaneous manifestations of popular piety but rather to the authorized liturgy of the Church as a whole.

8. Tradition is never static. Blondel protested that the sacred deposit is not an aerolith to be preserved in a glass case but a living and developing organism. Vatican II declared: "The tradition that comes from the apostles develops in the Church with the help of the Holy Spirit. . . . For, as the centuries succeed one another, the Church constantly moves forward toward the fullness of divine truth until the words of God reach their fulfillment in her." Writing after the Council, Henri de Lubac agreed. "Tradition," he said, "according to the Fathers of the Church, is in fact just the opposite of a burden of the past: it is a vital energy, a propulsive as much as a protective force."

Tradition, however, does not grow by sudden leaps and does not radically reverse itself. It develops organically by successive and almost imperceptible modifications. Drastic innovation and abrupt change are antithetical to the genius of tradition and therefore also repugnant to liturgy as a prime instance of tradition.

9. In order to develop along the line of its original inspiration, tradition returns continually to its sources. As critics of art and literature often remark, creativity even in the secular sphere is enhanced by fidelity to traditions handed down from the past. The same is true a fortiori in the theological order, because tradition is the transmission of a divine revelation enshrined in inspired sources. Christian tradition draws its undying vitality from the power of the sources to disclose more than had previously been tapped. Reading sacred Scripture with the help of the same Spirit who inspired it, the Church finds new light for dealing with present problems. In this way Jesus fulfills his promise that the Paraclete would lead the disciples forward into the fullness of truth (John 16:13).

The continued vitality of the Christian sources manifests itself with special force in the liturgy, which is a memorial of the Paschal event. Liturgical worship, according to Frans Jozef van Beeck, is the activity in which "the Church draws closest to the mystery at its center." In the ministry of word and sacrament

Christ is present with singular power and density, bringing the faithful into direct contact with the redemptive mystery.

10. Tradition points forward to the Eschaton. Whereas tradition in its merely human aspect has a necessary reference to the past, Christian tradition has a future reference as well. It transmits the mystery of Christ, who is the Omega as well as the Alpha. It communicates the Holy Spirit, who is the eschatological gift. By receiving Christian tradition we are claimed for the Kingdom of God, inasmuch as the Church on earth is "the initial budding forth of the Kingdom." The more deeply we immerse ourselves in the tradition, the more ineluctably are we borne toward the promised fullness of the Kingdom.

This eschatological aspect of tradition is verified eminently in the worship of the Church, which Vatican II described as a foretaste of the heavenly liturgy. It summons believers to look forward to Christ's return in glory, bringing the Church to its consummation. The Orthodox theologian Alexander Schmemann has made this point emphatically. The essential function of the liturgy, for him, is "to *realize* the Church by revealing her (to herself and to the world) as the epiphany of the Kingdom of God." The Church, since it belongs to the age to come, has as its proper function to bear witness to "the Eschaton—the Lordship of Christ until he comes." Something of this same cosmic and eschatological perspective comes through in the passionate, contorted prose of Teilhard de Chardin, when he writes, for example, of "The Mass on the World." Inspired by the ancient sources, Teilhard was able to perceive the Eucharist as an anticipatory sign of the eschatologically transformed universe.

These observations on tradition do not by themselves settle the debated questions about liturgy, but they provide some principles governing the reform and renewal of the Church's official worship. To indicate some possible applications let me draw eight corollaries from what has already been said.

1. Liturgy is God's gift before it is a human response. It is not something we freely construct according to our own ideas and preferences. As a preeminent form of tradition, it derives from the activity of God through Christ and the apostles. In the liturgy God turns to us, and we receive what he is pleased to give, especially the central mystery of our redemption through Jesus Christ.

2. In liturgy, as in other spheres of tradition, attention must be directed primarily to the reality that is transmitted. The symbols do not function rightly unless they focus our attention on their joint meaning. In this way it makes present the mystery of our redemption, which is too great to be contained in any words or symbols, but is communicated through them as instruments of the Holy Spirit. Liturgy celebrates the *mysterion* in a public way, in the context of new situations. The context, however, must not be allowed to become the theme, lest the liturgy cease to function as tradition.

3. In order to bring about interior union with the mystery being celebrated in it, liturgy should prayerfully invoke the Holy Spirit. Where this invocation is omitted, a false impression of human autonomy can easily arise. The symbols could be misinterpreted or manipulated according to an alien spirit.

4. Making use of its symbolic resources, liturgy should arouse a keen awareness of the truths of faith. Gestures such as the elevation of the host, bows, and genuflections convey the sense of the divine presence more powerfully than does explicit statement. For the dignity and public character of the liturgy, ritual

gestures, vestments, sacred song, and periods of silence should be built into the conduct of worship. In the spoken parts of the liturgy, the language, as I have said, should be suggestive and not overly didactic.

5. Liturgy should be participatory in the sense that it induces the worshipers to interiorize the meanings it conveys and to make personal acts of faith, hope, and love. Vital participation in the mystery of redemption is enhanced by song, gesture, and movement on the part of the congregation. There is no need to choose between the objectivity of the given and the subjectivity of the response. The fidelity of the objective presentation enhances the depth and transformative quality of the response.

6. Pertaining as it does to divine and apostolic tradition, liturgy should be marked by stability. According to Vatican II, it should not be changed without real and manifest necessity. But it should not be static any more than tradition is. Its forms of expression should always take account of the needs and capacities of the worshiping community.

Adaptation does not mean, to be sure, that everything should be stated in plain vernacular English or conducted in a tone of familiarity. On the contrary, attention to the laws of worship may require a certain formality in style and language somewhat removed from ordinary speech. The need to evoke the sense of the sacred may also call for types of chant not heard in secular situations.

7. Because liturgy, like tradition in general, is a living reality, no one stage of its development should be absolutized. As Vatican II declared, undesirable accretions and anachronisms should be removed. Neither the fourth century, nor the thirteenth, nor the era of Trent, nor that of Vatican II represents the unsurpassable high point. Cardinal Ratzinger remarks that since the liturgy is alive, "the Missal can no more be mummified than the Church herself."

Changes in the liturgy should, however, be gradual and organic. Possibly the new texts prepared after Vatican II departed too abruptly from recent tradition and were too harshly imposed. However that may be, these texts have by now won for themselves a certain right of existence. The Catholic faithful have become familiar with them. To banish them and demand a return to preconciliar texts could only provoke further disorientation and turmoil. The first requirement is for a more reverent and sensitive use of the texts and rubrics that we now have.

Since Vatican II much energy has gone into the composition of new liturgical texts, many of them unauthorized. The multiplication of new texts can easily become a distraction. It might be best for the present sacramentary to be kept in place for a reasonable period of years, with improved translations and minor corrections. In a highly secular society such as our own, attempts to compose sacred texts will often be less than successful.

8. The existing liturgy provides no lack of room for creativity, rightly understood. The choice of music, the preparation of the liturgical space, the composition of the homily and the intercessions all place heavy demands on the talents of those concerned. Spontaneity in formal liturgical celebrations should, however, be kept within bounds. Liturgy, as the chief embodiment of perennial tradition, should convey a sense of the objective, the constant, and the universal.

In this essay I may seem to have gravitated toward the otherworldly pole described at the start. If so, it is because liturgy is the principal bearer of a tradition that comes down without a break from Christ and the apostles, and is normative for the universal Church. As the most formal and public manifestation of

tradition, liturgy calls attention to the objectively given, which remains the source of salvation everywhere and for all. It seeks to impart a sense of the divine and to bring the worshiper into the great mystery of our redemption.

Liturgy, however, is not the entire life of the Church. Other forms of traditional and spontaneous worship deserve to be encouraged. In private prayer and popular devotions the particular cultures and customs of diverse peoples, and their present concerns, can find suitable expression. Informality and originality may be encouraged in spontaneous prayer groups, processions, local shrines, popular religious art and music, family devotions, and the like.

The current crisis in liturgy, it would appear, is due in part to the withering away of various nonliturgical styles of piety (such as novena prayers, parish missions, eucharistic adoration, and the rosary) that sustained the faith and commitment of Catholics in the centuries before the Second Vatican Council. After the Council it became common to think that since the liturgy was central, all worship ought to be liturgical, even eucharistic. In the absence of alternatives, celebrants were tempted to bring an informal and spontaneous style into liturgy itself. Some priests seemed to be imitating popular entertainers and talk show hosts to the detriment of the solemnity and formality that by right pertained to liturgy. By promoting a revival of non-eucharistic and paraliturgical forms of piety and instruction, the Church could, I believe, help to safeguard the distinctive values of liturgical worship.

The total worship of the Church, we may say, includes both the formal and the informal. The two are dialectically related. Though not the same, they should reinforce each other. Liturgy, as formal worship, should always have a point of contact with the experience of the community lest it become sterile. Private devotions, though they emanate from popular experience, should always be kept in line with the objective form of revelation lest they become superstitious. But the proportions vary. Liturgy keeps the focus on the exalted mystery of the Transcendent, whereas popular piety gives greater attention to God's accessibility in the here-and-now. Both styles of worship are appropriate because the God of Christian faith is neither absent from his people nor fully identifiable with them. Returning to the example with which I began, we may conclude that neither reading of the inscription on the banner in the parish church does justice to the mystery. God is neither other people nor does he dwell in remote seclusion.

# JOSEPH GOLDSTEIN AND JACK KORNFIELD

Joseph Goldstein and Jack Kornfield cofounded the Insight Meditation Society in Barre, Massachusetts, a center that has drawn numerous Anglo-Americans into Buddhist meditation. Both men spent significant time in Asia studying Buddhist traditions of meditation, with Kornfield living as a Buddhist monk for five years. Their book *Seeking the Heart of Wisdom* (1987) expounds upon the meditative practice that has grown in importance among many American spiritual seekers.

# *From* Seeking the Heart of Wisdom

## WHY MEDITATE?

A question that arises for beginners in meditation and also, at times, for people with years of experience, is "Why do we practice? Why are we doing this?" The effort and commitment needed to pursue meditation is so demanding that it is appropriate to ask what value it has and where it is leading.

Meditation has to do with opening what is closed in us, balancing what is reactive, and exploring and investigating what is hidden. That is the why of practice. We practice to open, to balance, and to explore.

## Opening What Is Closed

What is it that is closed in us? Our senses are closed, our bodies are closed. We spend so much of our time lost in thought, in judgment, in fantasy, and in day-dreams that we do not pay careful attention to the direct experience of our senses—to sight and sound, to smell and taste, to sensations in the body. Because our attention is often scattered, perceptions through the sense doors become clouded. But as awareness and concentration become stronger through meditation, we spend less time lost in thought, and there is a much greater sensitivity and refinement in our sense impressions.

We also begin to open the body. Often there is not a free flow of energy in the body, and as we direct our awareness inward, we experience in a very clear and intimate way the accumulated tensions, knots, and holdings that are present. There are several different kinds of painful feelings that we might experience, and learning to distinguish and relate to these feelings of discomfort or pain is an important part of meditation practice, because it is one of the very first things that we open to as our practice develops.

One kind of pain that we might experience is that of a danger signal. When we put our hand in fire and it starts to hurt, there is a clear message saying, "Take your hand out." There is a story of someone who was meditating in a little hut in the countryside and was sitting watching his breath, "rising, falling, rising, falling," and he began to smell smoke. He noted "smelling, smelling." It was not until he started noting "hot, hot" that he realized that some action was needed. It's helpful to know when things are a signal and when they're not. There is a kind of pain in the body that is a signal, that's telling us something, and these sensations should be recognized and respected.

There is another kind of pain, which can be called "dharma pain." These are the painful sensations that have accumulated in the body, those tensions, knots, and holdings that we carry around all the time but are mostly unaware of because our minds are distracted. As we sit and pay attention and become more inwardly silent, there is a growing awareness of these painful feelings. This is, in fact, a sign of progress, because we are becoming aware of what is always there but usually below the threshold of our sensitivity. What we want to do in meditation is to open to this dharma pain, to experience what is actually present.

As we watch painful feelings, the question arises of how we can distinguish the pain of a danger signal from the pain that appears naturally in our dharma practice. A simple guideline can generally be applied: if the pain goes away when you stand and do some walking, then the experience is not particularly a danger signal. It may be the discomfort of sitting in an unusual posture, or it may be the pain of accumulated tension. If it disappears when the posture is changed, then it's no problem and you can stay with it. If, however, the pain persists or grows, even after some walking, then it may be a sign that there's too much straining, that the posture is being forced in some way, and it might be better to change position or relax the posture.

What's most important in terms of learning how to open is the dharma pain, those unpleasant sensations which go away when we stand or walk, but which may become very intense in the sitting. It can come as strong pain in the back, knees, or some other part of the body. What does the mind do with this pain that starts revealing itself to us? At early stages of practice, the tendency of the mind is to resist; we don't like to feel the pain. This resistance is a pushing away or closing off to the experience, just the opposite of opening to it.

There are different forms of resistance. One form is self-pity. We're feeling the pain, sitting with it for a short while, and then we start feeling sorry for ourselves: "Poor me. Everyone else is in a wonderful blissful state and only *my* knee hurts." It is easy to get lost in a spiral of self-pitying thoughts.

Another form of resistance is fear. We've often been conditioned to be afraid of pain. We're afraid to go into it and feel it, and that fear prevents us from opening, from allowing ourselves to experience what's there. It's helpful to notice whether this kind of resistance is present, to note the fear, to see it, and then to gently soften and open to the fear itself.

Sometimes fear of unpleasantness can take the form of preventive action even before the pain gets very uncomfortable. We do things so that the pain won't come—what could be called the "just in case" syndrome. There is a story related to this tendency of mind.

Some time ago I was sitting at a retreat in England. I would come down for breakfast in the morning, and every day we were served just the same thing: porridge, toast, fruit, and tea. The first day I came to breakfast and took some porridge, two pieces of toast, a piece of fruit, and a cup of tea. I ate everything except for one piece of toast, so I put the second piece back. The second morning I came down, and there was the same breakfast. I took my porridge, two pieces of toast, fruit, and tea. I ate everything, but one piece of toast was enough, so I put the other piece of toast back. The third morning I came down, the same breakfast, and I took the porridge, two pieces of toast, fruit, and tea. It took about a week until I could stop taking that second piece of toast, even

when it was very clear that I wasn't going to eat it. There was that fear in the mind: "I'd better take it, just in case this time I'm hungry."

The "just in case" syndrome arises often in the mind. "I'll move now, just in case it gets too painful and I won't be able to stay with it," or "I'll go to sleep early tonight, just in case I'll be tired tomorrow." This kind of fear functions as a barrier to being with what is actually there, out of fear of what we think might be there if we persist: it is the unwillingness to be uncomfortable and feel pain.

There's self-pity, there's fear. Another kind of resistance, which is more subtle and which can be more undermining of our efforts, is apathy or indifference to what is happening; in this state the mind becomes very uncaring. The noting or labeling becomes very mechanical, without vitality, and is often totally unrelated to what is going on. We may be noting "out" when the breath is coming in, or "in" when the breath is going out. An apathetic mind prevents us from being fully with our experience of the moment.

In this part of our meditation practice, in opening to what is closed, we have to recognize the different forms of resistance that may arise and to understand that at some time or another they will be present for almost everyone. There is no need to judge ourselves for being resistant; rather, we should just recognize the self-pity or fear or apathy, see these states, and remember that there is another possibility, one that has to do with opening, with becoming mindful. Instead of pushing away or closing off, we can soften ourselves, soften the mind, so that it becomes receptive and allowing, more gentle and relaxed. We don't have to be in a struggle, even with things that are painful. When we allow ourselves to be more relaxed and more open, the possibility arises of seeing more clearly exactly what is going on.

For example, if there's a certain pain in the back and we are busy resisting it or pushing it away or afraid of it, then there is no possibility of understanding the nature of that pain, the truth of that experience. If we soften and open, we discover that "My back hurts" simply means that there are certain sensations going on. There may be tightness, pulling, stabbing, searing, burning, pressure. There is a long list of possible sensations.

When the mind is open, we are able to go from the level of "My back hurts," which is a concept, to the level of what is really happening, which are certain sensations, arising and passing. They may be very intense and unpleasant, but we are experiencing what is actually true about them. And we notice not only what the sensations are, but also how they behave. Often, when we resist painful feelings, we have the idea that there is some solid mass of pain in a part of the body. When we allow ourselves to feel the sensations that are there, when we go into them, then we begin to see that pain is not a solid mass but rather a field of vibration, characterized perhaps by tightness or burning or pressure. But what we see clearly is that there is nothing solid. We begin to experience this for ourselves and dissolve the illusion of solidity. As this happens in our practice, it begins a process of untying the energy knots and blocks in our system. We begin to allow for a freer flow of energy, which is very healing.

Learning how to work with the painful sensations that arise in our practice is essential. It is a gateway to deeper levels of understanding, and the very fact that we can become aware of these painful feelings is itself a sign of stronger attention. As we approach this gateway of understanding, we don't want to turn

away. We enter deeper levels by being soft and gentle and aware of what is happening. This is how we begin to fulfill the first aspect of practice: opening what is closed. And it is this openness to experience that is the foundation for the second aspect of practice—balancing what is reactive.

## Balancing What Is Reactive

What is it that is reactive? Our minds are reactive: liking and disliking, judging and comparing, clinging and condemning. Our minds are like a balance scale, and as long as we're identified with these judgments and preferences, likes and dislikes, wants and aversions, our minds are continually thrown out of balance, caught in a tiring whirlwind of reactivity. It is through the power of mindfulness that we can come to a place of balance and rest. Mindfulness is that quality of attention which notices without choosing, without preference; it is a choiceless awareness that, like the sun, shines on all things equally.

Can we make our awareness so inclusive that we're willing to be attentive to the whole range of our experience? It's somewhat like going on a long journey in a strange land, a journey that takes us through many different kinds of terrain—through mountains and jungle, desert and rain forest. If we have the mind of a true explorer, when we're in the mountains we're not thinking, "Oh, if only I were in the desert now." And when we're in the desert we're not daydreaming of rain forests. If there's a real sense of exploration, we're interested in every new place that we come to.

The experience of our meditation is a similar kind of journey; it's the journey into ourselves through every aspect of our experience. There are ups and downs, highs and lows, times when it's pleasant and times of pain. There is nothing at all that is outside of our practice because our practice is to explore the totality of who we are. This takes a tremendous amount of willingness. Are we willing to be with the full range of what's going on?

There is a line from a song written some years ago that relates to this: "Some people say that life is strange, but what I'd like to know is, compared to what?" It's all part of it. There is nothing that is outside of our practice. The different experiences of physical sensation, of pleasure or pain, the different emotions of happiness or sadness, depression or elation, interest or boredom, all are part of the journey. Is it possible to open to each one of these states, to become mindful of each one in a balanced way so that we can begin to understand their true nature?

Meditation practice is neither holding on nor avoiding; it is a settling back into the moment, opening to what is there. And this balance of mind, where there's no preference, no attachment, no clinging or condemning, but just being present for whatever arises, makes possible a connection with a deep rhythm. Every activity has a certain rhythm to it. There are all the rhythms of nature, of night and day, the change of seasons. There is rhythm in music, sport, poetry, and dance. Every activity has a rhythm appropriate to it, and when we find that rhythm, a sense of effortlessness, ease, and grace arises.

There is also a rhythm in our practice, an inner rhythm to the breath, sensations, thoughts, emotions, feelings, images, and sounds. When we are nonreactive, when we open and note just what's happening in each moment, without holding on, without pushing away, without struggle, then we find this inner

rhythm. And when we experience this, we begin to enjoy a certain ease and effortlessness in practice.

In order to find the rhythm, however, a great effort is needed. It's the effort to pay attention, to bring the mind into each moment. In the beginning the mind is scattered, so we have to make an effort to contain and focus it. But as we do this, moment after moment, at times everything will click and we find the balance. It's like learning to ride a bicycle; we get on and pedal and at first are continually falling off one side or the other, until in one moment, the sense of balance is established, and then it's easy. Meditation develops in the same way. It takes effort to be mindful in each moment so that the rhythm can be discovered. In every moment of mindfulness, whatever the object is, whether it is the breath, sensations or sounds, thoughts or emotions, in every moment of simply noting and noticing what's there, there's no reactivity in the mind. There's no clinging and no condemning, just an accepting awareness of what's present. Every moment of mindfulness is helping to establish oneself in this inner balance and rhythm.

## Exploring What Is Hidden

The third aspect of meditation is to investigate or reveal what is hidden. What is hidden is the true nature of our experience. The truth is what is hidden. One of the main ways the truth is camouflaged is through our identification with and tendency to be lost in concepts. To a large extent, we confuse our ideas about things for the experience itself. A very essential part of meditation practice is going from the level of concept to the level of direct experience.

What are some examples of this confusion between concept and reality? If someone holds up his or her hand and asks what we see, most likely we would say, "A hand." Actually, though, we don't see a hand at all. What the eye sees is color and form and light and shadow, and then the mind jumps in and quickly puts a concept on that constellation of perception. We call it "hand," and we think that this is what we are really seeing.

If a bell is rung, what do we hear? Most people hear a "bell," or if there's a noise outside, we might say that we hear a car or a truck going by. But that's not what we hear. We hear certain sounds, certain vibrations, and then immediately the mind names it as "bell," "car," "truck," or "person." We confuse the concepts of the thinking mind with the reality of direct experience.

"My knee hurts." Sit for an hour and pain arises and the knee hurts. But "knee" is a concept. There is no sensation called "knee" or "back" or "muscle." That's not what we feel. We feel tightness, pressure, hardness, softness, tingling. These sensations are what we experience. "Knee," "back," and "muscle" are all concepts.

Why is this so important? The distinction between our concepts and the reality of experience is crucial in terms of understanding where the practice is leading, because concepts cover what is true. The concepts we have of things remain the same. The names that we give to things don't change. My "knee" hurt yesterday, my "knee" hurts today, and it will probably hurt the next time I sit. Not only do we solidify the sense of "knee" through our concept, as if it were something more or less permanent, but this sense of its being static or perma-

nent also makes it much easier for us to identify with it as being "I" or "mine." Now, not only is there a "knee" that hurts, it is "my knee."

When we come to what is truly happening, however, we see that the experience is changing every instant. Things do not stay the same even for two moments. What we are conceiving of as "my knee" is in the reality of direct experience a mass of instantaneously changing sensations, with no solidity or permanence at all. But as long as we stay on the concept level, we are unable to see or understand this momentary nature of phenomena.

Our meditation begins to investigate what is hidden. We go from the level of concept to the level of direct experience, whether it's bodily sensations or sight or sound or smell or taste; we begin to experience the nature and process of thoughts and emotions, rather than being identified with their contents. As we connect with what we are experiencing in each moment, we begin to discover some things that may have been previously hidden or obscure.

First, we discover that everything is changing, that everything we thought was solid, unchanging, or permanent is in a state of flux. People may hear this and think, "I know that everything is impermanent. It doesn't sound so startling to me." It's true that we know it intellectually, but we don't know it deeply, viscerally, we don't know it from the inside out. Meditation is a vehicle for opening to the truth of this impermanence on deeper and deeper levels. Every sensation, every thought, every feeling, every sound, every taste—*everything*, inside and outside, is in a state of continual dissolution.

When we see that, when we really know it, that understanding deconditions grasping in the mind, deconditions our attachments. Have you ever gone to a stream and tried to grasp a bubble in the water with the hope of holding on to it? Probably not, because you clearly know that it's just a bubble, arising and dissolving. Everything is like that. It is possible to see this, to experience it in a deeply integrated way. When we develop this clarity of vision and understanding, then the mind is much less inclined to grasp, because we see that there is nothing to hold on to. And as we are less attached, less grasping, less clinging, there is also less suffering in our lives.

As we see the impermanence of things, we also begin to understand the truth of the basic insecurity about all phenomena. Things are insecure or unsatisfactory in the sense that something that is always changing is incapable of giving us a lasting sense of completion or fulfillment. When we see this deeply in ourselves, it also begins to decondition the strong forces of desire and grasping in the mind. We begin to let go, allowing for the inevitable flow of change, rather than trying to hold on to something, thinking that it will make us happy forever after.

We see the impermanence, we see the insecurity. And we begin to understand what is the unique jewel of the Buddha's enlightenment—insight into the selflessness of the whole process of mind and body, understanding that there is no one behind it to whom it is happening. There is no one to whom this changing process belongs, there is no owner of it. This is a subtle and radical transformation of our normal way of understanding, and it develops into a deep wisdom as we go from the level of concept to the level of direct experience. When we understand in a very intuitive and connected way the essential insubstantiality, emptiness, and selflessness of phenomena, we begin to weaken

the fundamental attachment we have to the sense of "I," of "self," of "me," of "mine," those concepts around which our whole lives have revolved. We see that this "I" is an illusion, a concept that we've created, and we start the journey of integrating the possibility of greater freedom in our lives.

It's only by paying careful attention in each moment to what is true, not to our ideas about it, but to what is actually there, that we are able to know for ourselves in a deeply transforming way the impermanence, insecurity, and selflessness that characterize all our experience.

## Effort and Aim

How to do all this? How to open what is closed, balance what is reactive, and investigate what is hidden? What are the tools of our practice? Two qualities are at the root of all meditation development: right effort and right aim—arousing effort to aim the mind toward the object. Effort and aim. Everything else will come. If there is the effort to aim the mind correctly, then mindfulness, concentration, calm, equanimity, wisdom, and compassion will all follow.

For example, we sit and make the effort to aim the mind toward the breath, either the in and out at the nose or the rise and fall of the abdomen. If there is enough effort and energy, and the aim is correct, then we connect with the sensations of the rise and fall or the in and out; we become mindful of the specific sensations and how they're behaving, and from this our concentration grows and our understanding deepens.

All this is best accomplished with a sense of lightness and willingness, from a place of interest in discovering what is true. If we try to practice from a feeling of obligation or duty, then the mind often becomes rebellious and grim. Mindfulness does not mean grimness, although sometimes in the beginning of meditation practice people may confuse the two.

An image which might suggest the proper quality of right aim and right effort is the Japanese tea ceremony. Every movement is done with extreme care and precision. In the folding of the napkin or the pouring of the tea, there are many separate, distinct movements, and each is done with the same care and attention. They are done with delicacy, lightness, and grace.

Can we make our day, or part of a day, a Japanese tea ceremony, so that every movement—reaching, bending, turning—becomes a ceremony? When we practice in this way, or even practice practicing like this, then it is encouraging and inspiring to see how powerfully and quickly the awareness and understanding deepen and grow.

## MEDITATION INSTRUCTIONS

Keep your attention clearly focused on the sensations and feelings of each breath. Be with the breath at the place in the body where you feel it most clearly and distinctly—the rising and falling of the abdomen, the movement of the chest, or the in and out at the nostrils. See how carefully and continuously you can feel the sensations of the entire inhalation and exhalation, or the entire rising-and-falling movement.

Use a soft mental notation of "rise" and "fall" or "in" and "out" with each breath. If there is a pause or space between the breaths, be aware of some touch point, either the buttocks on the cushion, the knees on the floor, or the lips as they gently touch each other, feeling accurately the particular sensations at that point. If there's a long pause between breaths, you can be aware of several touch sensations in succession until the next breath begins to come by itself, without hurrying or hastening the breathing process. When the next breath arrives, return the attention to the breathing, noting and noticing as carefully as possible.

Be aware and mindful of each breath, the rising and falling movement of the chest or abdomen, or the in and out of the air at the nostrils. Let the awareness be soft and relaxed, letting the breath come and go in its own rhythm. Feel the sensations of each breath accurately, not looking for anything in particular, but simply noticing what is actually there in each moment.

Sometimes the breath will be clear and sometimes indistinct, sometimes strong, sometimes very soft; it may be long or short, rough or smooth. Be with it as it reveals itself, aware of how it goes through various changes.

When sounds become predominant and call your attention away from the breathing, make a note of "hearing, hearing," focusing the attention and the awareness on the experience of the sound, not particularly getting involved in the concept of what's causing the sound, such as "car" or "wind," but just being with the vibration of hearing. See if you can experience the difference between the concept of the sound and the direct intuitive experience of it. Make a note of "hearing," and when it's no longer predominant or calling your attention, come back to the breath.

Often sounds will arise in the background of your awareness: that is, you are aware of them, but they're not particularly calling your attention away from the breath. In that case, there's no need to particularly make a mental note of "hearing." Simply stay with the noting of the breath, allowing the background awareness of sound simply to be there.

The continuity of attention and of mental noting strengthens the mindfulness and concentration. And so, with a gentleness of mind, make the effort to be as continuous in the noting as possible. When you go off, when you forget, when the mind wanders, make a note of "wandering" as soon as you're aware of it and come back to the breathing.

When sensations in the body become predominant and call your attention away from the breathing, focus all of the mindfulness, all of the attention onto that sensation itself. See how carefully you can observe and feel the quality of the sensation: is it hardness or softness, heat or cold, vibration, tingling, burning, pulling, tightness? Feel what the sensation is and notice as accurately as possible what happens to that sensation as you observe it. Does it get stronger, does it get weaker, does it dissolve, does it enlarge in size, does it get smaller?

Sometimes it may be difficult to find an exact word to describe the sensation. Don't spend much time thinking about it. If you can't find the right word intuitively in the moment, even a mental note of "sensation" or "feeling" will serve the purpose.

The awareness is most important. The noting is simply an aid in aiming the mind accurately toward the object in order to feel what the sensation is and to notice what happens to it as you observe it. For example, there may be a strong

pain in the back or the knees. The mind attends to it, and it feels like burning. Notice that it's burning. As you watch it, you may notice that it gets stronger or weaker, expands in area or contracts. Sometimes it may disappear.

When the sensation is no longer predominant, return again to the in and out or rising and falling. Try to keep a balance in the mind of staying soft and relaxed, that quality of being settled back in the moment, and at the same time being alert and precise. Note carefully and gently moment after moment whatever object arises, coming back to the breath as the primary object when nothing else is predominant or calling the mind away.

Also notice any reactions in the mind to the different sensations. If you're observing painful feelings and you notice a reaction of aversion or restlessness or fear, make a note of those mind states, observing them carefully and seeing what happens to them as you note them. As you note "fear" or "aversion" or "restlessness," does it get stronger, does it get weaker, does it disappear? If you're observing pleasant sensations in the body and there's enjoyment or attachment, note that also.

There's no need to go looking for different objects. Keep the awareness very simple, staying grounded in the primary object of the breath, and then notice these different objects as they arise in their own time. The idea in practice is not to look for anything special and not to try to make anything special happen; rather it is to notice carefully what it is that is actually happening.

When thoughts arise in the mind, as soon as you become aware that you're thinking, make a soft mental note of "thinking" or "wandering." Sometimes you'll be aware of thoughts just in the moment of their arising, sometimes in the middle. Sometimes the mind won't be aware of a thought until it is completed. Notice when it is that you have become aware of thinking, without judgment or evaluation. At whatever point the mind becomes aware, make the note of "thinking" and then gently come back to the breathing. There need not be any struggle or conflict with the thought process; simply note it at whatever point you become aware.

Likewise, if images or pictures arise in the mind, make a note of "seeing"; if sounds become predominant, make a note of "hearing." Let the awareness come out of a receptivity of mind, settling back in a soft and open way. As different objects of experience reveal themselves, be mindful and attentive to each object, and notice what happens to it as it is observed.

Sometimes the mind may get confused by too many objects or isn't clearly aware of where to focus. At that time make a note of that kind of confusion or uncertainty and return to the breath as an anchor. The breathing is useful as the primary object because for the most part it's always present. So one can always come back to the breath, settling into it, feeling it, noticing it. When the mind feels centered with the breathing, again notice the different objects that may arise.

When different mind states and emotions become predominant, they too should be made the object of awareness. If we're not aware of them when they arise, they become unconscious filters on our experience and we begin to view everything through the filter of a particular emotion. Sometimes they may come associated with thoughts or images or with certain sensations in the body. There may be feelings of happiness or sadness, frustration, anger, annoyance, joy,

interest, excitement, restlessness, or fear. Many different kinds of mind states may arise.

As soon as you become aware that some mind state or emotion or mood is in the mind, make a specific note of that particular state of mind, so as not to get lost in it and not to be identified with it. These mind states, like all other objects, are arising and passing away. They are not "I," not self, and do not belong to anyone. Note the mind state, be open to the experience of it, and when it's no longer predominant, return to the breath or to sensations in the body.

Be particularly vigilant with respect to the arising of the five hindrances: desire, aversion, sleepiness, restlessness, and doubt. These are strongly conditioned in the mind, and it is easy to get lost in and become identified with them. Make a special effort to notice these particular mind states. The more quickly they can be observed, as close to the beginning as possible, the less their power will be.

In addition to paying attention to the breath, sensations, sounds, thoughts, images, emotions, and mind states, there is one more factor of mind that is important to single out and notice carefully in the meditation practice, because it plays a very critical role in opening the doors of deeper insight. That is becoming aware of and noting the various intentions in the mind. Intention is that mental factor or mental quality that directly precedes a bodily action or movement.

The body by itself doesn't move. It moves as the result of a certain impulse or volition. So before beginning any movement of the body, notice the intention to move, the intention to stand, the intention to shift position, the intention to turn, the intention to reach.

Before each of these movements there will be volition in the mind. Intention or volition is quite subtle. It's not a tangible, discrete object like a thought or an image that you can see clearly having a beginning, middle, and end. At first the intention might be experienced simply as a pause before the movement begins, a moment's pause in which you know that you are about to do something. If you acknowledge the pause and make the note "intending," that will serve the purpose.

It is important to begin to be aware of these intentions, for two reasons. First, it illuminates and reveals the cause-and-effect relationship between mind and body. This is one of the fundamental laws that leads to deeper understanding. The unfolding of the process of mind and body is happening lawfully, and one of the laws that describes this process is the law of cause and effect. By noting "intention," we get a preliminary understanding of how this works. Because of an intention, the body moves. Intention is the cause; movement is the effect. As we note it in our experience, it becomes increasingly clear.

Noting "intention" also helps us to discover and understand the selfless nature of the mind-body process. Even when we are observing the breath, sensations, thoughts, images, and emotions, and we begin to see that all of these objects are simply part of a passing show, we may still be identified with the sense of a doer, the director of it all, the one who is commanding the actions.

When we note intentions and see that they are also passing mental phenomena, that they arise and pass away, that intentions themselves are not "I" and not "mine," when we see that they do not belong to anybody, we begin to

loosen the sense of identification with them. We experience on deeper and deeper levels the selflessness of the whole unfolding process.

We begin the breath, opening to the feeling or the sensation of each breath, each movement of the rise and fall or in and out, without any expectation of how any particular breath should be, not trying to force it into a particular pattern, not thinking that there should be any one kind of sensation. It is a settling back into each moment, with a great deal of care and precision, and being open to what is revealed in that particular breath. What is the sensation of this rising, or this in-breath? What is the feeling of it? Is it long or short, is it rough or smooth, is it deep or shallow, is there heaviness or pressure or tingling?

There is no need to go through a checklist. Just by our being open and paying careful attention, the characteristics of each breath will show themselves. So we settle back and stay open, with a beginner's mind for each rising, each falling, each in-breath, each out-breath.

If there is a space or a pause between the breaths, notice one or more touch-points, making the note "touching, touching." When sensations in the body become predominant, when they're calling the attention away from the breathing, let the mind go to the sensation that is predominant; open to it, feel it. Note what kind of sensation it is. Is it heat or cold, heaviness or lightness, is it vibration or tingling, is it a painful sensation or a pleasant one?

When you open with awareness to each sensation, the characteristics of that sensation will become obvious. Let the mind stay very receptive to the sensations. Note what happens as you observe them. Do they get stronger, do they get weaker, do they disappear, do they increase? Observe what happens, without any model or expectation of what should be there; simply be with what is. When the sensations are no longer predominant, return again to the breath.

Keep a sense of alertness in the mind with respect to different mental phenomena, noting "thinking" or "seeing" as soon as you become aware that a thought or image is present. Observe what happens to that thought or image when you note it. Does it continue or does it disappear? If it disappears, does it disappear quickly or slowly? When a thought or image is no longer predominant, return to the awareness of the breath. Keep this movement from object to object fluid, rhythmic, and relaxed. There's no need to go searching for particular objects; rather, maintain a quality of openness and alertness so that whatever presents itself becomes the object of awareness, and let all objects of body and mind arise and pass away by themselves. Our practice is simply to settle back and note in each moment what is arising, without judgment, without evaluation, without interpretation. It is simple, bare attention to what is happening.

Stay mindful too of the different mind states or emotions. These states are less clearly defined as objects. They don't have such a clear beginning, middle, and end, and yet they can become very predominant objects of experience. So if a mind state or emotion or mood becomes strong—feelings such as sadness or happiness or anger or desire, restlessness or excitement, interest or rapture, joy or calm—make the mental note of that mind state, feeling it and observing how that too is a part of the passing show. It arises, it is there for some time, it passes away.

Use the breathing as a primary object, being with it if nothing else is very predominant and coming back to the breath when other objects disappear. Also, if the mind is feeling scattered or confused, without knowing exactly what to ob-

serve, center the attention on the breathing, either the rise and fall or in and out. When the mind feels more centered and steady, again open the awareness to the entire range of changing objects—the breath, sounds, sensations, thoughts, images, intentions, emotions—noting each in turn as they arise. Keep the mind open, receptive, and alert, so that in each moment there can be an accurate awareness of what is present.

## EXERCISES

### Strengthening Mindfulness

1. *Daily sitting log.* Here is a way to strengthen daily practice and to see its cycles more clearly. For one month or two, keep a small notebook at the place where you sit. Each day note down how long you sit. Then note down in one sentence the general qualities of the sitting such as "sleepy" or "restless and disturbed" or "calm and light" or "filled with many plans" or "easily centered on the breath," or whatever you notice. Then in another sentence or two note the general qualities of your day such as "happy" or "relaxed and spacious" or "overworked and tense" or "frustrated and anxious." At the end of a month or two, review your notes and be aware of the cycles in your daily sitting practice and how they may reflect and be connected to your daily life. Particularly become aware of areas where you may be stuck and those which call for greater mindfulness and acceptance.

2. *Reminders to pay attention: Developing the habit of wakefulness.* This exercise lasts one month. At the beginning of each week choose a simple regular activity of your life that you usually do unconsciously, on automatic pilot. Resolve to make that particular activity a reminder, a place to wake up your mindfulness. For example, you might choose making tea, shaving, bathing, or perhaps the simple act of getting into the car. Resolve to pause for a couple of seconds before each time you begin the activity. Then do it with a gentle and full attention, as if it were the heart of a meditation retreat for you. As you go through the week, try to bring a careful mindfulness to that act each time it arises in your life. Even the simplest acts can be a powerful reminder and bring a sense of presence and grace. If you choose the opening of doors throughout the day, you can open each door as if the Buddha himself were to pass through with you. If you choose the act of making tea or coffee, you can do it as if it were a gracious Japanese tea ceremony.

   At the end of the week add another activity, until by the end of the month you have included four new areas of your life into daily mindfulness. Then, if you wish, continue this exercise for a second and third month, bringing the power of attention into more and more of each day.

3. *Choosing a life of voluntary simplicity.* Do this exercise after a day or more of meditative sitting or after a day or more spent removed

from civilization in nature. Sit and allow yourself to become calm and silent. Then, in a simple way, review your current life. Bring to mind each of several major areas including your schedule, your finances and work, your relationships or family life, your home, your leisure activities, your possessions, your goals, and your spiritual life. As each area comes to mind, ask yourself the question: What would it be like to greatly simplify this area of my life? Continue to sit quietly and reflect, letting the images or answers arise for each area about which you ask. Then, after reflecting in this way, again bring to mind each area and ask a second question: If it became simpler, would I be happy?

The purpose of spiritual life is to discover freedom to live in harmony with the world around us and our own true nature. To do so brings happiness and contentment. If any aspect of your life shows a need for simplification and if the way for this simplification shows itself to you, keep it in mind and begin the process of mindful change.

# JOY HARJO

Joy Harjo (b. 1951) is a poet and a musician who belongs to the Muscogee Nation. She has won numerous awards for her writing as well as for her music, and she serves as the Joseph M. Russo Professor of Creative Writing at the University of New Mexico. "Eagle Poem" explores the mystery of prayer through images of nature, the first focusing on the eagle in flight and the second on the connected web of life.

## Eagle Poem

To pray you open your whole self
To sky, to earth, to sun, to moon
To one whole voice that is you.
And know there is more
That you can't see, can't hear,
Can't know except in moments

Steadily growing, and in languages
That aren't always sound but other
Circles of motion.
Like eagle that Sunday morning
Over Salt River. Circled in blue sky
In wind, swept our hearts clean
With sacred wings.
We see you, see ourselves and know
That we must take the utmost care
And kindness in all things.
Breathe in, knowing we are made of
All this, and breathe, knowing
We are truly blessed because we
Were born, and die soon within a
True circle of motion,
Like eagle rounding out the morning
Inside us.
We pray that it will be done
In beauty.
In beauty.

# LUCILLE CLIFTON

Lucille Clifton (b. 1936) is a well-known poet from Depew, New York, who has served as the Poet Laureate of Maryland and the Distinguished Professor of Humanities at St. Mary's College of Maryland. Her first book of poetry, *Good Times* (1969) was named by the *New York Times* as one of the year's ten best books, while her eleventh, *Blessing the Boats: New and Selected Poems* 1988–2000, won the 2000 National Book Award for Poetry. Clifton attended the Macedonia Baptist Church as a child and would later say that she could "feel the sacred" as a kind of sixth sense (Callaloo interview). These poems evoke the Jesus of her childhood, as well as her more mystical sense of spiritual things.

## spring song

the green of Jesus
is breaking the ground
and the sweet

smell of delicious Jesus
is opening the house and
the dance of Jesus music
has hold of the air and
the world is turning
in the body of Jesus and
the future is possible

# [the light that came to lucille clifton]

the light that came to lucille clifton
came in a shift of knowing
when even her fondest sureties
faded away. it was the summer
she understood that she had not understood
and was not mistress even
of her own off eye. then
the man escaped throwing away his tie and
the children grew legs and started walking and
she could see the peril of an
unexamined life.
she closed her eyes, afraid to look for her
authenticity
but the light insists on itself in the world;
a voice from the nondead past started talking,
she closed her ears and it spelled out in her hand
"you might as well answer the door, my child,
the truth is furiously knocking."

## testament

in the beginning
was the word.

the year of our lord,
amen. i
lucille clifton
hereby testify
that in that room
there was a light
and in that light
there was a voice
and in that voice
there was a sigh
and in that sigh
there was a world.
a world a sigh a voice a light and
i
alone
in a room.

# MEL WHITE

Mel White (b. 1940) was an important speechwriter and confidant to lead-
ers of the Christian Right in America, including Pat Robertson, Jerry
Falwell, Jim Bakker, Oliver North, and Billy Graham. But he lived with the
secret of his homosexuality until 1991, when he came out as an openly gay
man. His 1995 book, *Stranger at the Gate*, describes his struggle to change
his sexual orientation and retain his marriage and his ministry, opening
with his ex-wife's supportive Foreword corroborating his account.
Emerging at a time when American religions across the spectrum faced
growing tensions over sexual matters, this excerpt offers a dramatic ac-
count of one man's attempt to reconcile his faith and his sexuality.

# *From* Stranger at the Gate

## 1980–81, FACING REALITY

Just eight weeks before the new decade began, on November 4, 1979, Moslem fundamentalists seized the U.S. embassy in Tehran. The Ayatollah Khomeini made angry speeches condemning the Carter administration, while militant Islamic students holding forty-nine American hostages screamed, *"Margh bar* [death to] *Carter!"* Across the world Moslem fundamentalists were rising up to join the right-wing Islamic revolution in "purging" their people's religious and moral practices and "cleansing" ethnic and racial impurities from their nations.

About that time, a fundamentalist Christian revolution was stirring to life in America. My clients on the religious right, whom I would serve as ghostwriter in the 1980s, were at the heart of that revolution. One of the reasons I didn't see the dangerous side of their neoconservative movement was that much of what they valued, I valued, too.

When Billy Graham used his television broadcast "The Hour of Decision" to call on all Americans to "turn from their sinful ways and get right with God," I felt moved and convinced. When Jerry Falwell used his "Old Fashion Gospel Hour" to help launch the Liberty Godparent Homes for pregnant teenagers and offered to pay all the expenses for an unwanted pregnancy, I applauded his desire to do more than just oppose abortion. On Pat Robertson's daily television broadcast, "The 700 Club," when he preached against homosexuality and promised that gays and lesbians could be healed, I sent in funds to support their 800 prayer-line ministry.

I wasn't wise enough to anticipate where all this talk of "cleansing the nation" might lead. I didn't foresee that one day those same religious media personalities and the political groups they would organize could become a dangerous threat to me, to my gay brothers and lesbian sisters, and to all persons who might disagree with their political, religious, and social agenda for our country.

In those early days, I never made the connection between the mentality of some Christian fundamentalists and their desire to "purge and cleanse" with the mentality of Islamic or other fundamentalist revolutionary movements. Nor did I dream that in the next few years I would be writing books, sermons, and speeches for those same fundamentalist Christian revolutionaries.

I was still pastoring and teaching in 1978 when the *Wall Street Journal* featured a front-page article on Jerry Falwell's national radio and television ministry. The author labeled this new phenomenon "the Electric Church." In fact, it wasn't a new phenomenon at all.

In December 1956, twenty-two years earlier, Jerry had launched his first live television broadcast from WLVA, Channel 13 in Lynchburg, with a $90 weekly

budget, a guest soloist from the Methodist church, and his wife, Macel, at the upright studio piano. By 1978, Jerry was just one of the handful of powerful preachers on the religious right who were quietly and effectively building multimillion-dollar media empires "to preach the Gospel to every creature."

During 1978 and 1979, Jerry and a group of talented student musicians from his own Liberty University traveled across the country holding patriotic rallies on the steps of forty-four state capitols and in more than one hundred other American cities. The "America, You're Too Young to Die!" rallies featured spine-tingling trumpet fanfares, lively choral anthems, and Jerry's call for the nation to repent. "When God's people cry out for mercy, God sends them a deliverer," Jerry warned. "When they forget God again, their nation falls again. I think our country is now at the point where we could fall."

Over a portable loudspeaker to crowds that grew larger in every city, Jerry called for massive voter registration campaigns and urged the religious right to stand up and be counted. He preached against communism, abortion, pornography, divorce, moral permissiveness, our nation's military unpreparedness, the general breakdown of traditional family values, and as one specific example of that breakdown, Jerry preached against homosexuals and homosexuality.

There was no way for me to understand in those days that Jerry might be dangerous. He was just beginning to exercise his political activist muscles. He still dedicated most of his television sermons to the life, death, and resurrection of Jesus with only an occasional foray into politics. And though I felt restless and sometimes angry when he launched into his new political rhetoric, I still believed that in his heart, Jerry loved Jesus and wanted to make Him known to the nation. And though I was confused by his occasional tirades against homosexuality and homosexuals, they didn't really offend me. In those days, homosexuality was still on my own list of primary "sins" as well. It never crossed my mind to oppose him, let alone to see his words as dangerous and misleading.

In 1979, Jerry Falwell called a group of conservative leaders to meet in his office in Lynchburg, Virginia, to "draw up a plan to save America." At a lunch break, Paul Weyrich, a public-relations and mass-mailing genius, looked across the table and said, "Jerry, there is in America a moral majority that agrees about the basic issues. But they aren't organized. They don't have a platform. The media ignores them. Somebody's got to get that moral majority together."

Immediately, Jerry recognized the powerful possibilities in bringing together the "moral majority" of all Americans who shared his conservative political and social values. But with his lifelong, Bible-based fear of believers being "yoked together with unbelievers," Jerry wondered how he could conscientiously recruit into his fundamentalist army people from evangelical, charismatic, mainline Protestant, Roman Catholic, and Orthodox churches, as well as practicing and nonpracticing Jews, let alone Mormons, agnostics, and atheists.

He found the answer in the teachings of Dr. Francis Schaeffer, the man *Time* magazine called the "Guru of the Evangelicals." About that time, Schaeffer was traveling about this country showing his incredibly successful film series *How Should We Then Live*. Conservatives, Christians and non-Christians alike, packed arenas and large church auditoriums to see the films and hear Dr. Schaeffer's dramatic plea for the nation to turn away from "godless humanism" and return to "moral absolutes."

After the predictable standing ovation, enthusiastic audiences would spend the rest of the evening asking questions of this engaging, goateed guru in a white Nehru jacket and tan knickers, sitting on a table center stage, legs dangling comfortably, the Bible in one hand and *Time* magazine in the other, giving infallible answers with the authoritarian certainty once reserved for prophets and kings.

Francis Schaeffer was my first client on the religious right. In fact, I ghostwrote and directed the final version of that same *How Should We Then Live* film series. On Monday mornings I commuted by United Airlines to Chicago and by Swissair DC-10 to Switzerland where Francis was an expatriate teacher and, on weekends, made the return, ten-thousand-mile journey to Pasadena, California, where I was pastoring the Evangelical Covenant Church.

To complete the series on time, Lyla and I and our two young children lived in Switzerland one summer in a beautiful little chalet overlooking the village of Thun. With Heinz Fussle, an expert filmmaker and my longtime friend, I commuted back and forth to the Schaeffers' study center above Geneva, to interview and film Dr. Schaeffer, and to a studio in Bern to complete our editing of the project.

During my six months with the Schaeffers, I learned to love Francis, Edith, and their artistic, young son, Franky. Their home in Switzerland had become a sanctuary to fundamentalist and evangelical Christians from around the world, who made pilgrimages to seek counsel from this compassionate and winsome man and to eat Edith's freshly baked orange rolls and apple strudel.

But Dr. Schaeffer had a dark, arrogant side as well. At a private "thank-you" luncheon he gave us at the Hotel Hyatt in Los Angeles, Lyla asked Francis what other trustworthy biblical theologians he liked to quote besides himself. After a long pause, Francis answered, "There are none."

During the next ten years of service to the "electronic preachers," I would remember that moment, for it came to symbolize the way all the self-appointed gurus on the religious right saw themselves. They were "special," uniquely called by God to "save the nation." They trusted no one to know or understand the truth as clearly as they themselves understood it. They didn't even trust each other.

In spite of his separatist spirit, it was Francis Schaeffer who taught Jerry Falwell how to mobilize an army of "nonbelievers" to accomplish "God's will for the nation." Jerry admired Schaeffer, and his political strategy was shaped by Francis's notion of "cobelligerents." In his books and speeches, Dr. Schaeffer declared that there was no biblical mandate against evangelical Christians joining hands "with nonbelievers" for political and social causes "as long as there was no compromise of theological integrity." In fact, Schaeffer pointed out, there are many Bible stories about God using pagans "to accomplish His purposes." Imagine the grin on Jerry's face the day he realized the potential for using "pagans" who happened to be political conservatives for raising money and mobilizing volunteers.

Once Jerry had been won over to Schaeffer's position of "cobelligerents," he began to discover the few key issues and/or fears that most if not all conservatives held in common: communism came to mind immediately, of course, but abortion and homosexuality were also at the top of Jerry's list of "national sins." On July 18, 1993, fifteen years after Jerry launched his new Moral Majority organization, Ralph Reed, the president of the Christian Coalition, Pat Robertson's

version of Jerry's old Moral Majority, admitted (to a national convention of the Christian Coalition) that the conservatives shared opposition to gay rights and abortion had "built our movement and remain a vital part of the message." Isn't it ironic that the first political-action committee that Adolf Hitler organized in his successful attempt to conquer Germany was also the Committee Against Abortion and Homosexuality?

Three of the five men selected by Jerry in 1979 to serve on the first board of directors of his Moral Majority were D. James Kennedy, pastor of the Coral Ridge Presbyterian Church in Fort Lauderdale, Florida; Charles Stanley, pastor of the First Baptist Church in Atlanta, Georgia; and Tim LaHaye, pastor of the Scott Memorial Baptist Church in El Cajon, California. These men adapted quickly to the ways of "cobelligerency" and went on to use the issue of homosexuality to mobilize conservative armies of their own.

D. Kennedy, another of my former clients on the religious right, and Charles Stanley learned quickly to build powerful television ministries by uniting generous conservatives, "pagan" and Christian alike, around their mutual disapproval of abortion and homosexuality. Currently, Jim Kennedy is sending out antihomosexual "surveys," antigay petitions to the president, and inflammatory antigay videotapes to help pay his media bills. Charles Stanley regularly condemns gays and lesbians from his electronic pulpit. Tim LaHaye uses antigay rhetoric to support his conservative lobbying organization in the nation's capital, and his wife, Beverly LaHaye, uses her own genteel brand of homophobia and homohatred to mobilize and support her Concerned Women for America, the country's largest and most powerful right-wing women's organization.

In the mid-1980s, after a tense, combative lunch in Washington, D.C., with Tim and Beverly LaHaye, I declined the opportunity to ghost-write Beverly's autobiography. She and her husband seemed obsessed with "the homosexual menace." I wanted so badly to tell them that I was gay, that so many of their friends and coworkers were gay, that they were doing great damage to gay and lesbian people. Instead, I just turned down their offer and walked away.

That same afternoon, on a revealing ride across the capital in the two-phone, one-fax limousine of a high-level executive of the *Washington Times*, I also turned down the opportunity to ghost-write a book defending Sun Myung Moon's "positive contribution" to the neoconservative movement in America. It was during that ride with the *Washington Times* executive, a Christian fundamentalist whom I had met when he was a leader of Falwell's Moral Majority, that I learned that the *Times* was owned by Moon's Unification Church.

Looking back now, I wonder if Jerry is still convinced that he made the right decision to incorporate Francis Schaeffer's notion of "cobelligerents" into the credo of his Moral Majority. However he may feel now about the ethics of using "pagans" and "heretics" to help accomplish his political and religious goals, the results are now a matter of history.

Through his powerful Moral Majority organization, Jerry Falwell established himself as a major player on the nation's political scene. In fact, when I was ghost-writing for Jerry in 1985 and 1986, it was his standing policy to call one senator and two congressmen or women every day. Even when we were flying across the country in Jerry's private jet, nothing kept him from making those two influential phone calls, and never once while I was with him did the people in power refuse or even postpone his calls.

At the last Republican National Convention in 1992, after being warmly embraced by Ronald Reagan and George Bush, and after congratulating the Platform Committee for conforming the party platform to his deeply felt, Christian values, Jerry Falwell sat in his place of honor looking down on the convention floor, grinning his full approval. But in 1979, when Jerry launched the Moral Majority, no one, not even Jerry, ever dreamed how fast or how far his new strategy would take him. Nor did any of us even imagine how important his antihomosexual rhetoric would be for raising funds or for mobilizing his volunteers, "pagans" and Christians alike.

Now, fifteen years later, Jerry is still using homosexuality to raise money and mobilize support. I hate that his ignorance and superstition leads to the suffering and death of my brothers and sisters, but I understand how he was so terribly misled. Like myself, Jerry is a victim of other victims. We both grew up surrounded by well-meaning, Bible-believing Christians who had never really tried to understand in our modern context the ancient passages used now to condemn homosexuality. In those days, we were all victims of blind, unreasoned fear and hatred of homosexuality that had been passed down generation after generation without much thought and almost no careful historical, cultural, or linguistic study of the ancient biblical record, let alone of the new data being gathered by the medical, scientific, and psychological communities.

We didn't know the difference between sexual "preference" and sexual "orientation." We thought homosexuals were perverted heterosexuals who *chose* for some "sick reason" to have sex with men. We didn't realize that homosexuals were mysteriously imprinted with the need for same-sex intimacy and affiliation in their mothers' wombs or in the first few years of childhood, and that, try as they might, their sexuality, like heterosexuality, was a permanent condition.

Because we didn't understand the real nature of homosexuality, we feared the rumors that heterosexuals could be "recruited" into homosexuality, that homosexuals abused children, that homosexuals shouldn't serve in the military, that homosexuals were more promiscuous than heterosexuals, that homosexuals could be "healed" or "cured," that homosexuals who committed their lives to Christ and to heterosexual marriage and family could escape this "terrible sin."

Now, thanks to a host of well-known studies, we know the truth: That heterosexuals (young or old) can't be recruited into homosexuality. That child abuse is primarily a heterosexual phenomenon usually committed by members of the child's own family and close friends. That gay and lesbian soldiers, sailors, marines, and air force personnel have fought with honor and courage in every war and that Pentagon studies reveal that homosexuals are as capable of controlling their sexual needs on leave or under fire as their heterosexual colleagues, maybe more.

We know now that the average homosexual is no more promiscuous or no less responsible sexually than the average heterosexual. That homosexuals are not "healed" by God or by "reparative" therapy, in spite of all the misleading and short-lived testimonials of the current "ex-gay" movement. And that homosexuals who enter into heterosexual marriage to "cure" their homosexuality are more likely to cause terrible suffering and inevitable grief for their partners and for themselves as well.

I believe further that sexuality, homo or hetero, is a permanent part of the mystery of creation; that each of us, gay and nongay alike, is called by our Creator to accept our sexual orientation as a gift; and that we are called to exercise that gift with integrity, creativity, and responsibility. I know all this now, but I didn't know it then.

About the time Jerry Falwell was beginning to discover the benefits of stirring up the ancient homophobic ghost, I was running as fast as I could to escape that same evil spirit. Haunted by the ancient lies, I still believed that homosexuality was evil and that practicing homosexuals were condemned by their "lust" to misery, disease, and death. I was convinced that if I ever "gave in" to the "evil spirit," my life would be ruined, my family would be destroyed, my vocation would be lost, my spiritual journey would be derailed forever, and my soul would be condemned to an eternity in hell. So when I heard Jerry condemn homosexuality and homosexuals, I just piled up more guilt, prayed again that God would heal me, and tried to live a productive life in spite of the growing load of fear and frustration that I carried.

However, in spite of that growing fear, after trying for twenty-five years to change or overcome my sexual orientation, the truth was slowly dawning in my befuddled brain. Homosexuality is not something you change or heal or overcome. After trying desperately to be the world's best son, husband, father, student, professor, pastor, writer, and filmmaker, it was becoming more and more obvious that there was nothing I could accomplish that would replace or end my constant longing to be in a long-term, loving relationship with another man. Lyla and I were both beginning to realize that we could not postpone forever the painful decisions that lay ahead.

In the summer of 1979, just as Jerry Falwell called leaders of the religious right to Lynchburg to launch his Moral Majority political-reform movement, Lyla and I took Erinn, nine, and Michael, eight, to a much deserved vacation on Poipu Beach on the island of Kauai in Hawaii. For one idyllic week, I walked the beaches with my beloved family. Almost every day at dawn, Michael and I hiked out on a spit of sand curving into the Pacific to watch the sunrise and see the dolphins leaping in the morning light. From a wrinkled, old Hawaiian native, Erinn and I learned to weave hats from fallen palm fronds and string shells and colorful Hawaiian beads into leis. Both children learned to snorkel that summer, lying on my back, holding to my neck, and peering through their goggles at the bright yellow tang, the black-and-white-striped sergeant majors, and the rainbow-colored parrot fish.

In the evenings, Lyla and Erinn dressed in matching muumuus while Michael and I put on our white pants and colorful aloha shirts. As the sun set over the Pacific, we walked through the Waiohai Hotel's tropical gardens to the nearby Plantation House Restaurant where we sat on the veranda listening to sudden rain squalls beat on the old tin roof while we ate fresh grilled snapper, fried bananas, and pieces of homemade macadamia-nut pie.

At night, after the children were asleep, or during the day while they splashed in the gentle surf, Lyla and I walked the beaches or sat in the sand and talked and argued, laughed and cried. Even in paradise where everything seemed so picture perfect, we knew in our hearts that something had to be done to resolve the painful, ever-present conflict. I was a homosexual man drawn

inexorably to my own kind for intimacy and affiliation. Lyla was a heterosexual woman. Try as she might, Lyla could not meet my sexual needs or satisfy my longings for intimacy.

We loved each other deeply. We were committed totally to our marriage and to our family. Every day for almost twenty years of marriage we had prayed for God's guidance and for God's strength to see us through; and year after year we thought we saw evidence that the crisis had finally passed, that the victory had been won. Then, little by little, my old needs would reappear, accompanied by fear, guilt, and increasing hopelessness.

During that week in Hawaii in 1979, I felt a growing sense of despair. After a quarter of a century of trying, it was obvious that my sexual orientation could not be changed. After twenty-five years, I knew that celibacy was not possible for me, and occasional secret encounters with a man only left me feeling more dissatisfied, more in need of a long-term, loving relationship. In spite of the on-going conflict, I promised Lyla that I would never leave her or the children, and I made that promise fully believing that I could keep it. My marriage and my family were sacred commitments, and I was determined to keep those commitments until the day I died.

Late at night, during our Hawaiian vacation, after Lyla and the children were asleep, I walked the moonlit beaches struggling to find my way out of this impossible predicament. If I couldn't leave Lyla and my family, and if I couldn't overcome my desperate needs for physical and psychological intimacy with another man, there seemed to be only one solution. If I could die an accidental death, Lyla and the children would get my insurance benefits and we would all be spared the embarrassment and the disgrace that I feared would follow the revelation of my sexual orientation.

Earlier that year, when I mentioned suicide to one of my counselors, he warned me that taking my life would cause my wife and children terrible psychological suffering. But, if I died at the bottom of the sea, or so I told myself in Hawaii, no one would know why or how it happened, and after a time of grieving, my wife and children could move on to new lives in financial security.

At seven-thirty A.M. on our fourth morning in Hawaii, I took my first scuba-diving lesson from a sixty-year-old woman who smoked long, thin cigars and cursed like a sailor. For three days, Mary quizzed me on the scuba-diver's manual and dive charts. She lectured me about Boyle's law and the dangers of diving alone. And she even shamed me into buying my own regulator, air and depth gauges, buoyancy vest, wet suit, and weight belt.

I didn't realize it then, but this short, stocky woman would save my life and lead me into a world of quiet, exquisite beauty where God would speak to me again.

By Saturday, the day our family was scheduled to return to California, I was just a few lessons away from official certification as an open-water diver. Lyla had to get our children back to school, but she urged me to remain a few days alone on Kauai to finish my scuba lessons. After driving my family to the Lihue Airport, I hugged my tanned and happy children, kissed Lyla good-bye, and drove back to Poipu to finish my lessons and end my life.

It wasn't exactly that black-and-white, of course. I didn't really want to die. In fact, I loved life and felt grateful for all the blessings God had given me and

my family. I knew that it wasn't God's will that I should die, and in the back of my brain, I even knew that I could trust God to see me through this nightmare, but momentarily I was blinded to my loving Creator's presence by my fear and depression. I was exhausted from trying too hard. I had run out of hope and I just didn't know how to resolve the endless conflict in any other way.

That evening, as I drove back to Poipu, I thought about Lyla and the children flying somewhere over the Pacific, and for a moment I was almost overwhelmed with the love I felt for them. I wondered if I would ever see my family again. I felt lonely and afraid and lost.

As I walked from the parking lot to my little thatched cottage on the beach, I saw a young man standing in the shadows. He followed me as I walked up on my porch and stood beside me as I fumbled for my key in the semidarkness. I had seen this same young man several times at the Sheraton pool when Lyla and I and the kids had gone there for breakfast or lunch on the open patio. That same afternoon in the parking lot, our eyes had met as I walked the family to our rental car. I had smiled and he had returned my smile. Apparently, he had spent the afternoon watching and waiting for my return.

The stranger was tall, tanned, and built like Mark Spitz, the young Olympian swimmer. He wore white shorts and a white tank top, and his sun-streaked, sandy brown hair was brushed back casually over his ears. He looked slightly embarrassed by this direct encounter. He smiled nervously, held out his hand, and spoke quietly.

"I'm Tony."

He was about twenty-five, a Mormon from Utah who was finishing his second missionary tour to the islands.

"Your family is gone back to the mainland?"

"Yes. I'm staying a few days to finish scuba certification."

"I'm a diver, too. I love the sea."

For a moment we stood beside each other in the silence looking at the waves rolling gently onto the beach just a few steps away. The dancing waters sparkled and glowed with reflected light. I had stepped onto that porch wanting to die from loneliness, but the moment Tony, a stranger, but one of my own kind, stood beside me, I wanted desperately to live again.

"Can I come in?" he asked.

"I'm feeling like a swim," I answered, thinking that I couldn't let him into that cottage without dangerously threatening my resolve.

"Good idea." He stripped off his white shorts and tank top and stood naked beside me on the porch. I started for the door, mumbling something about my bathing suit.

"Have you ever gone for a swim at night, butt-naked in the darkness?" he asked.

"No, I haven't."

"Try it," he said, running down to the sea and diving into the warm, dark waters. Without a moment's hesitation, I stripped off my own shorts and dashed into the sea before any late-night stroller might happen by. Tony swam just a few strokes ahead of me. There was enough reflected light to see his body moving gently through the water. I was swimming hard to catch up when suddenly Tony stopped, rolled over on his back, and floated on the water.

The coastline of Poipu Beach stretched out before us painted in sparkling lights. Music from a live jazz band in the Sheraton bar echoed across the water. The sky was streaked with stars. I backstroked in place beside Tony trying not to think how much I wanted to touch him, feeling the old waves of guilt and fear pulling me down like that dark, black sea.

When the first chill came, I began a long, slow swim back to the beach. Tony swam beside me through the surf and ran behind me up the beach to the cottage. I opened the door, and before I could even think to object, Tony was inside, headed for the shower. While I was puttering awkwardly around the still-darkened bedroom looking for dry underwear and long pants, I could hear Tony adjusting the shower controls. Suddenly, he was standing naked in the doorway, framed by the light from the bathroom.

"Save water. Shower with a friend," he said, turning and at the same time gesturing for me to follow.

Desperate with desire, somehow I managed to decline this fantasy come to life. While Tony showered and dried, I succeeded in getting dressed and was searching through the refrigerator for something to drink when he emerged half-dry and gleaming in his damp, white shorts.

"I want to make love to you," he said, and I almost collapsed with surprise and fear.

"I can't do it, Tony." I felt waves of ambivalence.

"Why not?" He moved me gently toward the king-size bed.

"Because, I have a wife and family. I have commitments . . ."

Tony took both my arms and lowered me gently onto the edge of the bed. He was playful but determined. He knew that I wanted to make love, and he was doing his best to help me get past my guilt and fear.

"I want to make love to you, too," I confessed, "even if I don't know you, but I just can't do it. Please, try to understand."

Gently, playfully, Tony lifted my legs and put them up on the bed. I fell back onto a pillow feeling mixed emotions somewhere on the scale between absolute terror and absolute ecstasy. He crawled across me and lay beside me on the bed.

"I've watched you with your family," he said. "I know you love them and it's pretty obvious that they love you. I'm glad for you and even jealous, but what could be so wrong in making love tonight?"

For two hours I lay there trying to explain why I couldn't make love to Tony and at the same time wanting it desperately. Finally, he just gave up. I remember the exact moment it happened. He had been holding my hand and pleading with me to loosen up and to enjoy life a little. He had leaned up on one elbow and stroked my face trying to explain why he was suddenly worried about me. He had even paced the room, trying to help me understand why making love to strangers is the only option so many gay men have. But after two hours of useless struggle, he suddenly bolted from the bed and walked angrily from the room.

"Will I see you tomorrow?" I asked, feeling suddenly desperate, hoping for another chance.

"I'm leaving for the big island tomorrow," Tony answered, not looking back, and before I could speak, he was gone. I stood at the door praying he would return, but he didn't come back. I never saw Tony again.

About that time, Lyla called to report their safe arrival on the mainland. We chatted for a brief time, and after saying good-night to my wonderful wife and children, I lay back on the bed more certain than ever that death was the only way to end this terrible, secret conflict.

The next morning, I rode in Mary's rusty, war-surplus jeep to Poipu Landing, a tiny harbor on Kauai. After checking and double-checking our gear, after being certain we both understood Mary's dive plan, I climbed into her old Boston whaler and held on for dear life as she gunned the fifty-horse outboard engine down the coast toward the Sheraton Hotel.

Mary checked my equipment one last time and signaled me to follow as she flipped backward out of the boat and moved slowly down the anchor chain. Once I had righted myself, cleared my ears, and moved beyond the curtain of my own escaping bubbles, I could see forever through the light blue water. As I descended, I could count the barnacles growing on the metal bottom of Mary's little dive boat bobbing just above us. Below, it was perfectly clear why this popular dive spot was called the Sheraton Cathedrals. Great craggy clusters of rock loomed up at us like the spires of Notre Dame. As we descended into these towers, the morning sun streaked down through holes in the rocks and reflected off the backs of colorful fish darting about, giving one the sense of stained-glass windows come to life.

Mary hovered just above the anchor watching me descend. Her arms were folded and her fins moved slowly without touching the precious coral or even stirring up sand or silt from the bottom. She signaled, okay? I returned her okay signal. But I was not okay. I had come to the bottom of the sea to die alone in a safe, dark place, but Mary wouldn't leave me and the place she had chosen for my first open-water dive was not a dark cave or sunken freighter suitable for dying, but an underwater cathedral, a place to celebrate life shaped by the Creator's hands with hot volcanic lava cooled by the open sea, with earthquakes, hurricanes, and tidal waves, with tiny growing coral heads and curious, nibbling creatures, and with centuries of silent, moving waters.

Even as I swam slowly through this amazing natural cathedral sixty feet beneath the ocean, I thought of these words from the 139th Psalm: "This is too glorious, too wonderful to believe! I can never be lost to your Spirit. I can never get away from my God. If I go up to heaven, you are there; if I go down to the place of the dead, you go with me. If I ride the morning winds to the farthest oceans, even there your hand will guide me, your strength will support me."

In the absolute silence of that moment, the still, small voice of God was clear. Our Creator didn't abandon us at birth. We are not alone in this amazing universe. God's Spirit goes with us even to the bottom of the sea. And though we be confused and depressed and tired of life, God is still present to comfort and to guide us.

Mary waited to clear the anchor as I ascended slowly to the top of the anchor chain. Just a few feet below the surface, a school of dolphins raced by churning the water playfully. I clung to the ladder and watched them pass, grinning to myself and thanking God for life.

Safely back in Pasadena, several weeks later I walked up a narrow, wooden staircase to the second-floor office of Dr. Phyliss Hart, a psychologist at Fuller Theological Seminary. At the time, I didn't know exactly why I had decided to

see Phyliss. I do know now. After listening patiently to the story of my lifelong battle to overcome my sexual orientation, Phyliss leaned across her desk and said quietly, "Mel, you aren't sick. You're a gay man. You just need to fall in love with another gay man, and get it over with!"

At first, I thought she was just being flip. But she had reviewed my twenty years of counseling, the shock therapy, and the Valium overuse. She had studied my psychological profiles. She had questioned me carefully as I told my story. I was stunned at first, even angry when she called me "gay" and suggested that I accept that fact and try to live my "gay" life with integrity. I walked back down those steps and across the parking lot feeling terribly confused. What about Lyla? What about my family? What about my vocation? Slowly, the truth filtered through all those years of resistance and denial.

"Mel, you aren't sick," Phyliss had said, and those simple words began to breathe new life into my crippled spirit. Suddenly I realized that this was not about Lyla or my family or my vocation. This was about me. For twenty-five years I had been in a kind of bondage, judging myself, hating myself, trying to change something at the heart of me that could not, should not, be changed. All those years feeling dirty, ugly, sinful, sick, rejected by God, by myself, by my community; then in Phyliss's little office, good news broke into my fearful soul with all the light and music of that amazing night in Bethlehem. It has all been a bad dream. I am not sick. I am well. Her words brought liberation.

"You're a gay man," she had said, and she was smiling. Never before had I heard those words spoken without a sneer. She spoke those words as though I could be proud, as though my sexual orientation, too, was a part of God's plan. I didn't see shame or judgment in her eyes. I saw celebration. She was congratulating me. My Creator hadn't made a terrible mistake. I wasn't some kind of tragic deviation from the norm. I was a gay man. There have been millions of gay men and lesbian women before me. Millions more will follow. We are a part of God's mysterious, loving plan for the universe. We, too, have gifts to offer. Her words brought pride!

"You just need to fall in love with another gay man," she had said, and the idea literally exploded in my brain, blowing away all the terrible years of tight-lipped, desperate resistance to what my heart had been telling me from the beginning. I could dance with Darrel. I could hold Peter in my arms. I could kiss Gordon without feeling embarrassed or ashamed. I could fall in love with Mark or Jeffrey or Tony. It didn't matter if people sneered or turned away in disgust or yelled "faggot" when I passed. I could trust my heart, whatever anyone else did or said in response. Phyliss's courageous words brought hope!

"And get it over with!" she had concluded. At first, the urgency of her advice made me angry. Phyliss knew Lyla and my children. How could she set my feet on a course that might take me away from them? Then I remembered that morning in Hawaii just days before, when death seemed the only practical solution. Phyliss was not setting my feet on a course away from them. She was holding life out to me. Choosing life would cost me and my family dearly, but choosing death would cost us more. Ignorance and misinformation had brought us to this painful place. Truth would set us free. She seemed confident that we would all survive. Was it possible? Could this lifelong struggle end? Her words brought joy!

# LETTER TO JERRY FALWELL

*(December 24, 1991)*

*Dear Jerry,*

In 1986 and 1987, when I was ghostwriting your autobiography, *Strength for the Journey*, there was no reason for us to talk about me or about my life story. Your publisher, Simon and Schuster, and your agent, Irving Lazar, had hired me to do a job and I did it. You never asked me about my political beliefs or my personal values. And though we came from two rather different worlds, I liked you immediately and I appreciated your frankness, your sense of humor, and your loyalty to friends and family. For your friendship and for the clients you have sent me, I am grateful.

But in the past few years, Jerry, it has become more and more painful for me not to share with you my own personal journey. Now, in light of your October 1991 letter against homosexuality and homosexuals, I can no longer remain silent.

I am gay. For the past eight years (which include all the time I've been in your employment) I have been in a loving, monogamous relationship with another gay man. I am a member of a Metropolitan Community Church congregation (the only Christian denomination that is truly open to gay and lesbian people) and a member of Evangelicals Concerned (a national Bible study and prayer movement of gay and lesbian evangelical Christians).

I came close to sharing this part of my own story with you one night in a hotel suite in Washington, D.C., when we were celebrating the successful release of your autobiography. During that conversation you admitted that the church needed to do much more to help those who suffered from AIDS, and you confided that one of your own close friends was a gay man in a long-term relationship with another gay man. "I'm not going to put him in a corner," you said quietly, "if he doesn't put me in one."

You seemed compassionate and understanding that night. Then, today, I received a copy of the October 1991 fund-raising letter describing me and millions of men and women like me as "perverts" who "unashamedly flaunt their perversion." The letter declares "homosexuality a sin." It warns that "our nation has become a modern day Sodom and Gomorra" and that you have decided to speak out against this "perversion" for the purpose of "moral decency and traditional family values."

Jerry, I am hoping that staff or agency "ghostwriters" wrote that letter and that you didn't have time to read it before it was signed and mailed on your behalf. Did they realize the immediate and long-term impact of its cloud of misinformation, half-truth, and hyperbole? Did they understand the confusion and the suffering that it helps cause in the lives of American families who have gay or lesbian members? Did they know that the letter's misleading statements fuel bigotry, hatred, and violence?

Closer to home, did anyone consider the tragic consequences of that letter in the lives of the people who see you as their spiritual guide? Certainly you know that in the Thomas Road Baptist Church, in Liberty University, and in the audience of the "Old Time Gospel Hour," there are thousands of Christians struggling with this issue. Did anyone think about the confusion, the anguish, and

the despair that the letter's simplistic, judgmental, and erroneous position creates for them and for their families?

I know personally what it means to be a victim of this uninformed and non-compassionate "Christian" position on homosexuality. I went through twenty-five years of Christian counseling and "ex-gay therapy" including electric shock to try to overcome my sexual and affectional orientation. Finally, feeling abandoned by God, by the church, and by society, I longed to end my life.

Now, looking back, I can see that God was there, all the time, in the midst of my suffering, leading me to a remnant of faithful, well-informed Christians who had the courage to speak the truth whatever it cost them.

My most helpful counselor was fired from Fuller Seminary (where I was a professor for fourteen years) because she dared to tell the truth about homosexuality and the false claims that the "ex-gay" movement makes. And though telling the truth cost her her academic position, she saved a lot of lives and ministries in the process.

If you are really trying to educate the nation about homosexuality as the letter states, you owe it to yourself to look more closely at the scientific, sociological, ethical, and biblical data that is now available to us. The letter mailed in your name was tragically uninformed and dangerously inflammatory in the process. What a wonderful thing it could be if *you* really took this issue seriously and tried to deal with it lovingly, thoughtfully, and in the spirit of Christian truth.

Jerry, we are called by Christ to bear witness to the truth, and yet the October 1991 letter is based on lies. We gay people are not "perverts" nor "degenerates" as the letter claims. My homosexuality is as much at the heart of what it means to be Mel White as your heterosexuality is at the heart of what it means to be Jerry Falwell. The wide array of intimacy and relational needs that you and your wife, Macel, meet for each other are only met for us in same-sex relationships. If you really want to help end promiscuity, tell the truth. We need you to honor and support our relationships, not oppose and condemn them.

The letter also lies when it claims that we gay and lesbian people are a menace to this nation. In fact, we are your fellow pastors, deacons, church musicians, and people in the pew. We write and arrange the songs you sing. We are your studio technicians and members of your staff. We are doctors and scientists, secretaries and clerks. We even write your books.

We are not a threat to the American family, either. We are committed to the family. Millions of us have raised wonderful families of our own. We have adopted the unwanted and the unloved and proved to be faithful, loving parents by anyone's standards.

And we certainly pose no danger to your children. Most child molestation cases are heterosexual. You know that. The truth is we have taught and nurtured your children in schools and Sunday schools without your ever knowing that we are gay.

Most of us gay and lesbian people are just normal folk who try our best to live respectable, productive lives in spite of the hatred and the condemnation heaped upon us.

We didn't choose our sexual orientation, Jerry, and no matter how hard we try, we cannot change it. There is no trustworthy, long-term evidence that sexual

"reorientation" or a lifetime of celibacy is possible for tens of millions of gay and lesbian people. What brings us health is the realization that our sexuality, too, is a gift from God. And to lead a whole, productive life we have to quit struggling against God's gift and learn to lead our lives as responsible gay and lesbian Christians.

Almost every day, I speak with gays and lesbians who are struggling to survive the waves of hatred and self-hatred generated by Christians who write letters like your letter of October 1991, or who make similar statements in sermons, on talk shows, and in interviews. Is it any wonder that gays and lesbians have finally run out of patience and are taking to the streets to protest the prejudice and the bigotry?

In your recent contact with the Act-Up demonstration in Los Angeles, it must have been terrible to realize how many people felt hatred toward you and your position. With the memories still fresh in your mind of those fearful moments in the Hotel Roosevelt kitchen, let me help you understand the bigotry and the violence we face every day, not just on the streets but in our homes, on our jobs, and even in our churches.

Every year, thousands of innocent gay and lesbian people face physical and psychological assault. Dozens are murdered. Tens of thousands are rejected by their families, fired from their jobs, and kicked out of their homes or apartments. Three times I have had rocks or bottles thrown at me from passing cars simply because I was walking with friends near a gay church or restaurant. Fundamentalist Christian extremists hound and harass us, carrying hateful signs and shouting profane and demeaning accusations in the name of "Christian love."

I know that every group has its zealots, and I thank you for stating clearly in your letter that "the majority of gay persons are not violent." But Jerry, we have reasons to demonstrate. And the letter issued in your name, using the same old, tired lies to whip up more bigotry and more hatred against us makes you a primary target for our demonstrations.

Is it any wonder that we are protesting Governor Wilson's veto of AB1O1, a measure that would have protected gays and lesbians from being fired simply because of their sexual orientation? Think about it. Even though you have praised my Christian commitment and my writing skills, would you hire me or recommend me again now that you know I am gay? Don't you find it ironic that if I had made my sexual orientation known, I could not have served the church faithfully these thirty years as pastor, professor, author, filmmaker, and television producer?

At this moment when hysteria and misinformation about gay and lesbian people threaten our most important public and private institutions, you could become a great healing agent. Wise counsel about homosexuality could lead to reconciliation in the family, in the church, and in the nation. Telling the truth that gay and lesbian people are a responsible and productive force in the church and throughout society could lead to understanding where misunderstanding and hatred now grow.

Jerry, I am also worried about the motives behind your letter. I remember clearly in one of our interviews that you described a noisy confrontation you once had with "radical activist gays" in San Francisco. "They played right into

my hands," you said to me. "Those poor, dumb fairy demonstrators gave me the best media coverage I've ever had. If they weren't out there, I'd have to invent them."

Whatever motives caused the letter to be written, antihomosexuality is not an appropriate issue for fund-raising. Too many lives are damaged or destroyed in the process. On behalf of myself and other Christian gays and lesbians in Lynchburg and around the world, please, before you speak or write again about this issue, could we meet face-to-face to talk about the consequences?

I make this proposal, Jerry. Will you meet with me—anytime or anyplace at your convenience—so that I can share with you the other side of the story? I appeal to you as a fellow Christian believer in the name of our Lord, Jesus, who said: "If thy brother do ought against thee, go and tell him between thee and him alone" (Matthew 18:15). I am glad to volunteer my time and travel to serve you. Do what you want with the information I could bring, but please hear it!

Lyla, my wife for twenty-five years of this painful journey, is eager to join in our discussion. As a heterosexual woman, wife, and mother, Lyla knows firsthand what it costs the families and friends of gays and lesbians to go on loving and supporting them when everyone else turns away. Her wisdom and counsel would serve us both well.

Maybe Macel, too, would like to be included in our conversation. Wherever and whenever it takes place, I am confident that in a open, loving dialogue we will both grow in our understanding of the issues and in our determination to contribute to the healing of the Christian church and of the nation.

*Sincerely,*
*Mel White*

# FRANKLIN GRAHAM

Franklin Graham (b. 1952) is the son of Billy Graham, the most prominent American evangelist of the twentieth century, and the CEO of the Billy Graham Evangelistic Association. After the attacks of September 11, 2001, Graham publicly denounced Islam as a "wicked" and "evil" religion in such venues as NBC Nightly News and Fox News. A number of conservative Christian leaders applauded and expanded upon Graham's remarks, even as President George W. Bush sought to distance himself from these critiques and made overtures to Muslims. Graham's book *The Name* came out the following year and attempted to clarify Graham's view of Islam (among other subjects). The first excerpt is from this book.

Graham continued to make more inflammatory public statements, which were closely monitored and countered by groups such as the Council on American-Islamic Relations, which issued articles like

"Franklin Graham Smears Islam Again" and an open letter calling upon Graham to amend his views, the second of which is included here. Together, these excerpts represent the ongoing conflict between some American evangelicals and Muslims in the wake of September 11.

# *From* The Name

But is Jesus the only way to God?

This question has received renewed attention in the wake of the September 11 attacks on the World Trade Center and the Pentagon, because the planners and perpetrators of those wicked deeds were followers of Islam.

As I write these words, the United States is engaged in a war against terrorism. But this war has a unique twist for Americans. We are not fighting to stop a Hitler or godless Communism. In fact, both sides of the current war frequently invoke God's name. Osama bin Laden, just weeks after some of his operatives slammed the planes into the World Trade Center, the Pentagon, and a Pennsylvania field, said the following in a videotaped message: "There is America, hit by god in one of its softest spots. Its greatest buildings were destroyed, thank god for that. There is America, full of fear from its north to its south, from its west to its east. Thank god for that." . . .

With this in view, does bowing down to Allah mean the same thing as worshiping the God of the Bible? What about adherents of the nearly ten thousand other religions? When they pray or call out to some higher essence or being, are they all seeking to make contact with the same divine person? Or are there other gods?

The Bible tells us that there are other gods. Do they really exist? Are they real? They certainly seem real to those who worship them. Even God Almighty Himself acknowledged this was the case in the first commandment: "You shall have no other gods before Me." That is the key point: There are false gods of this world and then there is the one true God, who revealed Himself in the Person of Christ.

. . . This truth is what motivates the ministry of Samaritan's Purse. Everything we do, we do in the Name of the Lord Jesus Christ. Our extensive relief work expands even into predominantly non-Christian countries. I have many friends who follow other religions, and the violent tactics of some of their fellow believers horrify them.

However, I will say pointedly that horrendous intolerance is practiced in some of those faiths. In some Hindu societies, for example, Christian churches are burned, and pastors and missionaries are killed because they testify to the one true God.

Franklin Graham speaking at an evangelistic meeting in Moldova, 2005. Graham has been CEO of the Billy Graham Evangelistic Association since 2000 and president of the organization since 2001, making him one of the most recognized evangelists in the world. *Source: DeMossNewsPond.com.*

Islam—unlike Christianity—has among its basic teachings a deep intolerance for those who follow other faiths. Much is said and published today about how peace-oriented Islam is; however, a little scrutiny reveals quite the opposite. . . .

That does not mean that all Muslims practice this doctrine or seek to harm those of other faiths. Certainly some followers of Islam are peaceloving.

. . . The number one difference between Islam and Christianity is that the god of Islam is not the God of the Christian faith. In the Christian faith, the God that is worshiped is the Almighty God, who has revealed himself in human form in the person of Jesus Christ, God's Son. The god of Islam is not a father and does not have a son, and to a Muslim, that very thought is blasphemous.

The Bible teaches that individuals have a free will in making decisions about God; Islam often relies on force, intimidation, or conquering of entire nations to recruit converts.

Islam takes a hard-line approach to adherents of other faiths. A non-Muslim can easily become one, but if a Muslim decides to convert to Christianity or another religion, under Islamic law—if the individual does not recant—he risks almost certain death. Muslims are free to worship Allah, and even proselytize in the United States, but Christians are not free to worship the Son of God, the Lord Jesus Christ, or openly discuss their faith in most Muslim countries. . . .

To many Muslims, young men and women who strap explosives to their bodies, walk into crowds as human bombs, and take the lives of innocent people

are elevated and revered as martyrs. The hijackers used this same tactic on 9/11. They commandeered American airplanes, cut the throats of the pilots, slashed the passengers and crew, and then slammed the planes into New York sky-scrapers. As President George W. Bush powerfully declared, "They are not mar-tyrs, they are murderers." These "suicide bombers" have gained respect among Muslims due to the lack of condemnation by Muslim clerics. . . .

In summary, the god of Islam is not the God of Christianity. The doctrines of Scripture are not the doctrines of the Koran. Heaven for Christians is not the same place as the paradise sought by Muslims. For anyone to say that the two faiths worship the same God is incredibly uninformed. As someone so elo-quently has said, "The god of Islam requires you to give your son to die for him. The God of the Bible gave His Son to die for you."

The current warfare is a classic struggle that will end with the second com-ing of Christ. Ultimately, the "war against terrorism" is just another conflict be-tween evil and the Name.

# Letter to Franklin Graham from the Council on American-Islamic Relations

*August 15, 2002*

*Dear Rev. Graham:*

I hope this letter finds you in the best of health and spirits.

The Council on American-Islamic Relations is concerned and dismayed at your repeated references to Islam as an 'evil' religion and accusation that Muslims either condoned or supported the September 11 attacks. As a religious leader and spiritual guide for thousands of Americans such comments can only been seen as fomenting religious hatred and division.

Your comments appear to be based on a few Quranic verses quoted entirely out of context, both by people who knowingly intend to misrepresent Islam and by some extreme Muslims who seek to exploit Islam to further their political goals. By repeating such misinformation you are not only encouraging bigotry and ignorance, you are also allying yourself with those who would abuse reli-gion for inhumane purposes.

Your latest accusation that Muslims have not condemned the attacks of September 11 is entirely unfounded. I have enclosed over 40 pages of state-ments, excerpts and articles of Muslim condemnation of these horrific attacks.

We ask that you reflect on your father's words following the September 11 attack when he said, "But now we have a choice: whether to implode and disin-tegrate emotionally and spiritually as a people and a nation or whether we chose to become stronger through all of this struggle to rebuild on a solid foundation."

We again encourage you to learn more about Islam and Muslims before you repeat your erroneous and divisive statements about one of the three great

Abrahamic religions, Judaism, Christianity and Islam. Such statements only sow animosity and mistrust among Americans. As a religious leader you should instead work to rebuild our national foundation instead of trying to tear it down.

*Sincerely,*

*Omar Ahmed*
*Chairman of the Board of Directors*

# RICHARD RODRIGUEZ

Richard Rodriguez (b. 1944) is a well-known writer whose many books and articles focus on the complex ethnic, sexual, and religious conflicts within the United States. He is best known for *Hunger of Memory: The Education of Richard Rodriguez* (1982) and *Days of Obligation: An Argument with My Mexican Father* (1992). A gay Roman Catholic of Mexican descent, Rodriguez writes provocatively about the politics of identity in a nation that remains both deeply religious and deeply conflicted over the role that religion ought to play in American public life. In the essay presented here, he addresses some of the powerful fears and assumptions brought to light in the aftermath of September 11.

## Danger and Grace—Sept. 11
## and America's Religious Moment

SAN FRANCISCO—After the names and the utterances of prime ministers and secretaries of war are forgotten, after the madmen in the desert have been hunted and killed, after the capable youth of today's soldiers has been undermined by the blessing of a long life, history will, I think, remember this time—our lifetime—as a religious moment, both dangerous and capable of great grace.

This is or should be a deeply embarrassing time for anyone in America who claims to be "religious." On videotape, Osama bin Laden celebrates death and

destruction with joyful invocations to God. What we see in the face of our adversary—this Muslim terrorist—is the mad glint of the otherworldly, as ancient as religious belief.

As a Christian, I have been forced by the angry, bearded face of Islam in recent months to wonder about my own religious face.

I believe, through history, organized religion has done more good than harm in the world. That is not a dashed-off piety—I really believe it. My own Roman Catholicism has encouraged me to do good in the world; to prize love above all other emotions.

But Muslims speak of the "Crusades" as a fresh offence, and I cannot forget now that religion—mine certainly—has caused havoc in the world, brought destruction to "infidel" and "heretic" in the name of God.

Not without reason did the founders of America establish a secular society. America, the daughter of the Enlightenment, was imagined as a country where all could worship freely.

The secular state's protection of all religious and non-religious belief has been interpreted by some Americans, in recent decades, as an excuse to remove

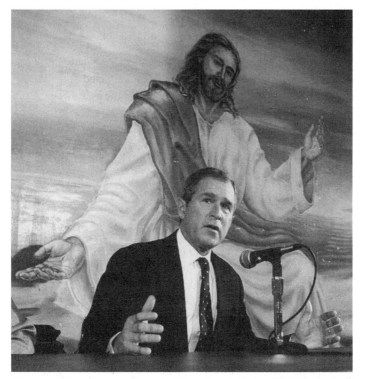

A mural of Jesus set the stage for George W. Bush at a Teen Challenge event in Colfax, Iowa, during the 2000 presidential campaign. Bush's evangelical faith, particularly its possible relation to his political decision making, was the subject of much discussion during the election season and still more after September 11. *Source: Agence France-Presse.*

religion from our public life altogether or denigrate it (as post-modern Hollywood regularly does in its comic portrayals of Christianity). But at its best, the American secular state has protected religious rights in America, and protects, not coincidentally, Muslims today.

It serves Osama bin Laden to ignore the point of our secularism. He is, or portrays himself as, too medieval a man to understand us. He describes America as a "Jewish-Christian" alliance, attempting thereby to separate Muslims from our national company.

President Bush's great patriotism at this time has been his insistence that American military action is not a war against Islam. He has been photographed with American Muslim clerics; has dined with them in the White House; has prayed with them.

Less impressive has been the gaudy parade of American clerics and ministers who seem unable to address the dark implications for religious belief of Sept. 11. Catholic bishops merely assure us now that ours is a "just war." The Rev. Jerry Falwell deciphers the events of Sept. 11 as God's wrath against gays and abortionists. And from Billy Graham's son, Frank, we hear a hymn of Christian triumphalism against Islam.

Confrontation with the darker aspect of religion—thus of ourselves—is difficult for America. Despite 19th century persecution of Mormons on our soil, for example, or the trampling of American Indian spirituality by pioneers, the country has generally been free of religious conflict.

Beyond our borders, we have not cast ourselves as religious warriors. We went to war, for example, against the Empire of Japan, not against an emperor who was said to be a god in the Shinto religion. And after World War II, Americans grew accustomed to a Cold War enemy that was simply "godless."

Now, however, we face a self-proclaimed religious adversary, a circumstance unprecedented in our history. Most embarrassing for me is that this adversary's religious belief causes me to question my own. For the God that he professes is also mine, in a foreign translation.

After Sept. 11, it is oddly pertinent to notice how the three desert religions—Judaism, Christianity and Islam, the three religions that are claimed by most Americans—can become not a way of life, but a cult of death.

Jewish settlers in the West Bank make an eschatological claim on the land; Muslims, dreaming of a paradise that resembles the Playboy Mansion, chant the name of Allah as they slam jetliners into office towers. And some Christians—though not the sort who get polled by Gallup or interviewed on CNN—speak of waiting for the Rapture, the Endtime.

It is, I know, not completely fair to equate these three religions in this way. As a minority faith, a faith of the "chosen," Judaism was not a universalist religion, has never sought to be. It is therefore less inclined than Christianity or Islam to persecute other faiths in the quest for converts.

But from Judaism came a monotheistic theology, crucial for the development of Christianity and Islam, an idea about God both wonderful and dangerous. The idea basic to Judaism is the idea that God acts in history.

If God acts in history, then we are not alone, our lives are not meaningless, our sensibilities are not mockery and our history not mere confusion. This is the overwhelming consolation of Jewish belief that watered all religions of the desert.

But the dangerous aspect of this theological insight is that the God who acts in history becomes decipherable to us, indeed becomes a partner to our wishes (rather than the reverse), even chooses to be on our side. Yahweh or God or Allah ends up a prisoner of his followers who assume his will.

President Bush is not the first among presidents for ending his speeches with the prayer "God bless America"—it has become a sort of platitude of political oratory. Now that invocation sounds differently—and seriously—an echo of Islamic militancy. Now, we should not be unaware of the implications of such a prayer within a political speech, how easily religion can be drafted.

I think of Pope John Paul II, instead, whose papacy may end up most remembered for the litany of apologies he has made for the church's misdeeds in centuries past. In early December, the Pope encouraged Catholics worldwide to fast on the last day of Ramadan, and thus to share the spirituality of the Islamic world.

The Pope's suggestion, though little broadcast in the United States, seems to me a particularly valuable one for the future—and nowhere in the world more so than in the United States, where Methodist lives next door to Jew who lives next door to Muslim who lives next door to atheist.

Precisely because I live in secular America, I find myself able to admire people whose religious faith is not my own. And I feel my own faith burnished by their good example.

I do not forget, however, that secular Europe and North America have inadvertently given birth to dark sons—from John Walker in California to Richard Reid in London—sons who end up warring against the freedom and the religious and irreligious diversity of their neighborhoods.

But the secular state of America might also give birth to a new sort of believer, a new sort of Catholic, a new sort of Baptist, a new sort of atheist. A new sort of Muslim, as well—someone who professes Islam within the cosmopolitan and diverse city.

This American Muslim could end up the bright grace for us all in this dark religious moment.

# ROBERT N. BELLAH

Robert N. Bellah (b. 1927) was the lead sociological investigator in a project on American beliefs, practices, and character that took its inspiration from Alexis de Tocqueville's *Democracy in America*. First published in 1985, *Habits of the Heart* constructed a bleak portrait of American fragmentation and narcissistic individualism while attempting to chart the path toward transformation into a stronger communal order. Without this transformation, the authors warned ominously, "there may be very little future to think about at all" (p. 286). Their interpretation of American life, while

perhaps not of Tocquevillean influence, has nonetheless had a broad impact on any number of sectors, and the coinage of the term *Sheilaism* as a shorthand to convey anything-goes spirituality has been widely used (and perhaps misused) among students, scholars, and followers of religion. The following excerpt is from Chapter 9, "Religion."

# *From* Habits of the Heart

## RELIGION

Religion is one of the most important of the many ways in which Americans "get involved" in the life of their community and society. Americans give more money and donate more time to religious bodies and religiously associated organizations than to all other voluntary associations put together. Some 40 percent of Americans attend religious services at least once a week (a much greater number than would be found in Western Europe or even Canada) and religious membership is around 60 percent of the total population.

In our research, we were interested in religion not in isolation but as part of the texture of private and public life in the United States. Although we seldom asked specifically about religion, time and again in our conversations, religion emerged as important to the people we were interviewing, as the national statistics just quoted would lead one to expect.

For some, religion is primarily a private matter having to do with family and local congregation. For others, it is private in one sense but also a primary vehicle for the expression of national and even global concerns. Though Americans overwhelmingly accept the doctrine of the separation of church and state, most of them believe, as they always have, that religion has an important role to play in the public realm. But as with every other major institution, the place of religion in our society has changed dramatically over time.

### Religion in American History

America itself had religious meaning to the colonists from the very beginning. The conjunction of the Protestant Reformation and the discovery and settlement of a new world made a profound impression on the early colonists. They saw their task of settlement as God-given: an "errand into the wilderness," an experiment in Christian living, the founding of a "city upon a hill." Many early settlers were refugees from persecution in England. They sought religious freedom, not as we would conceive of it today, but rather to escape from a religious

From Robert N. Bellah, *Habits of the Heart: Individualism and Commitment in American Life.* Used by permission of the Regents of the University of California and the University of California Press.

establishment with which they disagreed in order to found a new established church. They were seeking religious uniformity, not religious diversity. Of course there were some, even in the seventeenth century, who had ideas of religious freedom that we would more readily recognize, and down through the centuries, America has been a "promised land" to immigrants in part because it has allowed them to practice their religion in their own way. But religion had been part of the public order for too long in the history of the West for the colonists quickly or easily to give up the idea of an established church.

Indeed, a pattern of establishment characterized most of the American colonies throughout their history. There was one publicly supported church even when others were tolerated. In some states, establishment continued even after the Revolution (the First Amendment only forbade establishment at the federal level), and it was not until 1833 that Massachusetts gave up the last vestiges of establishment. Once religion is disestablished, it tends to become part of the "private sphere," and privatization is part of the story of American religion. Yet religion, and certainly biblical religion, is concerned with the whole of life—with social, economic, and political matters as well as with private and personal ones. Not only has biblical language continued to be part of American public and political discourse, the churches have continuously exerted influence on public life right up to the present time.

In colonial New England, the roles of Christian and citizen, though not fused, were very closely linked. The minister was a public officer, chosen by the town and not only by church members. Even when dissent gradually came to be tolerated, the established Congregational church was the focus of community life and its unifying institution. Sermons were preached annually on election day. What has been called New England "communalism" valued order, harmony, and obedience to authority, and these values centered on the figure of the "settled minister." Such a minister was "both the keeper and purveyor of the public culture, the body of fundamental precepts and values that defined the social community, and an enforcer of the personal values and decorum that sustained it."

Today religion in America is as private and diverse as New England colonial religion was public and unified. One person we interviewed has actually named her religion (she calls it her "faith") after herself. This suggests the logical possibility of over 220 million American religions, one for each of us. Sheila Larson is a young nurse who has received a good deal of therapy and who describes her faith as "Sheilaism." "I believe in God. I'm not a religious fanatic. I can't remember the last time I went to church. My faith has carried me a long way. It's Sheilaism. Just my own little voice." Sheila's faith has some tenets beyond belief in God, though not many. In defining "my own Sheilaism," she said: "It's just try to love yourself and be gentle with yourself. You know, I guess, take care of each other. I think He would want us to take care of each other." Like many others, Sheila would be willing to endorse few more specific injunctions. We will return to Sheila later in this chapter, for her experience and belief are in some ways significantly representative. But first we must consider how it came about that "Sheilaism" somehow seems a perfectly natural expression of current American religious life, and what that tells us about the role of religion in the United States today. How did we get from the point where Anne Hutchinson, a

seventeenth-century precursor of Sheila Larson's, could be run out of the Massachusetts Bay Colony to a situation where Anne Hutchinson is close to the norm?

The tight linkage of religion and public life that characterized the early New England "standing order" was challenged long before the Revolution, although at the local level it survived with remarkable resiliency all through the eighteenth century. The sheer diversity of religious groups, the presence of principled dissenters, and the fact that even those who believed in establishment found themselves dissenters in colonies where another church than their own was established were obstacles to establishment. Diversity of opinion was compounded by a small, but very influential, group of deists and rationalists scattered through the colonies. It would be a mistake to think of them as atheists—they almost all believed in God—but some of them did not accept the authority of biblical revelation and believed that one's religious views could be derived from reason alone. Some of the dissenters opposed establishment on principle, believing that religion involved a direct relationship to God with which no political authority could interfere. Many of the deists believed that religion, while salutary with respect to private morals, was prone to fanaticism and should be kept out of the public sphere except where it converged with beliefs based on reason, such as that "all men are created equal."

It was undoubtedly pressure from the dissenting sects, with their large popular following, on the one hand, and from that significant portion of the educated and politically effective elite influenced by Enlightenment thought on the other, that finally led to the disestablishment of religion in the United States. Yet the full implications of disestablishment were not felt immediately. In the early decades of the republic, American society, particularly in small towns, remained stable and hierarchical, and religion continued to play its unifying public role. George Washington, whatever his private beliefs, was a pillar of the Episcopal church. He was a frequent attender and long served as a vestryman, though he was never observed to receive communion. It was religion as part of the public order that he was thinking of when, in his Farewell Address, he called "religion and morality" the "indispensable supports [of] political prosperity." He doubted that "morality can be maintained without religion" and suggested that these two are the "great pillars of public happiness" and the "firmest props of the duties of men and citizens."

By the early decades of the nineteenth century, the older communal and hierarchical society was rapidly giving way in the face of increasing economic and political competition, and religious change accompanied social change. Even in the longer-settled areas, ministers could no longer count on the deference due to them as part of a natural elite, while in the newer and rapidly growing western states no such hierarchical society had ever existed. With rapid increase in the numbers of Baptists and Methodists, religious diversity became more pronounced than ever. By the 1850s, a new pattern of religious life had emerged, significantly privatized relative to the colonial period, but still with important public functions.

In the preceding chapter, we spoke of the importance of local consensual politics, though we noted that consensus often partly obscures discordant and conflicting realities. The mid-nineteenth-century town, though considerably

more consensual than the suburban town today, was nonetheless very different from the colonial township. No longer unified religiously and politically around a natural elite of "the wise and the good," it was much more publicly egalitarian. For religion to have emphasized the public order in the old sense of deference and obedience to external authorities would no longer have made sense. Religion did not cease to be concerned with moral order, but it operated with a new emphasis on the individual and the voluntary association. Moral teaching came to emphasize self-control rather than deference. It prepared the individual to maintain self-respect and establish ethical commitments in a dangerous and competitive world, not to fit into the stable harmony of an organic community. Religious membership was no longer unified. Even in the smaller communities, it had become highly segmented.

The unity that the old township had sought was now seen as a property of the segmented church community, and so in important respects privatized. Together with segmentation came a sharper distinction between spheres. The religious and secular realms that had appeared so closely intertwined in colonial America were now more sharply distinguished. Churches, no longer made up of the whole community but only of the like-minded, became not so much pillars of public order as "protected and withdrawn islands of piety." Sermons turned more "to Christ's love than to God's command." They came less doctrinal and more emotional and sentimental. By the middle of the nineteenth century the "feminization" of American religion that Ann Douglas has described was fully evident. Religion, like the family, was a place of love and acceptance in an otherwise harsh and competitive society.

It was largely this new, segmented and privatized religion that Tocqueville observed in the 1830s. If Washington's analysis of religion was nostalgic for the old hierarchical society, Tocqueville's analysis recognized its value in the new individualistic one. Tocqueville saw religion primarily as a powerful influence on individual character and action. He suggested that the economic and political flux and volatility of American society was counterbalanced by the fact that "everything in the moral field is certain and fixed" because "Christianity reigns without obstacles, by universal consent." Tocqueville was fully aware of and applauded the separation of church and state, and yet, while recognizing that religion "never intervenes directly in the government of American society," he nevertheless considered it "the first of their political institutions." Its political function was not direct intervention but support of the mores that make democracy possible. In particular, it had the role of placing limits on utilitarian individualism, hedging in self-interest with a proper concern for others. The "main business" of religion, Tocqueville said, "is to purify, control, and restrain that excessive and exclusive taste for well-being" so common among Americans.

Tocqueville saw religion as reinforcing self-control and maintaining moral standards but also as an expression of the benevolence and self-sacrifice that are antithetical to competitive individualism. He said that Christianity teaches "that we must do good to our fellows for love of God. That is a sublime utterance: man's mind filled with understanding of God's thought; he sees that order is God's plan, in freedom labors for this great design, ever sacrificing his private interests for this wondrous ordering of all that is, and expecting no other reward than the joy of contemplating it." Here Tocqueville expressed the hope that the

destructiveness of utilitarian individualism could be countered with a general-ized benevolence, rooted in sublime emotions "embedded in nature," that is, in an expressive individualism. His generalized analysis of religion kept him from noticing within some of the religious traditions those "second languages" that we have argued provide better alternatives to utilitarian individualism than ex-pressive individualism alone can do. But with respect to second languages, Tocqueville offers us little guidance. He is better at posing the problem of indi-vidualism and showing us where to look for alternatives than at close analysis of the alternatives themselves.

American religion has always had a rich treasury of second languages in the Bible itself and the lived traditions descending from it. Yet the relegation of religion to the private sphere after disestablishment tended to replace the speci-ficity of those second languages with a vague and generalized benevolence. Privatization placed religion, together with the family, in a compartmentalized sphere that provided loving support but could no longer challenge the domi-nance of utilitarian values in the society at large. Indeed, to the extent that pri-vatization succeeded, religion was in danger of becoming, like the family, "a haven in a heartless world," but one that did more to reinforce that world, by caring for its casualties, than to challenge its assumptions. In this respect, reli-gion was a precursor of therapy in a utilitarian managerial society.

Yet therapeutic privatization, the shift from casuistry to counseling, was not the whole story. In the very period in which the local church was becoming a "protected and withdrawn island," evangelical Protestantism was spawning an array of institutions and organizations that would have a major impact on pub-lic life. The early nineteenth century saw a great expansion in the numbers of the Protestant clergy as many new functions besides the parish ministry opened up. New educational institutions, both colleges and divinity schools, were cen-tral to this wave of expansive influence. The clergyman as professor exerted in-fluence not only in the classroom but on the lecture circuit and in periodicals and books. Numerous societies were established to distribute bibles and tracts, carry on missionary activities at home and abroad, work for temperance and Sabbath observance, and combat slavery. All of these raised money, hired func-tionaries, issued publications, and spoke to a national audience about the public meaning of Christian ideals. After bitter dissension over the issues of temper-ance and slavery, early in the nineteenth century, most local congregations opted for unity and harmony, either excluding those who differed or suppress-ing controversial issues. But this was not just privatization; it also involved a di-vision of labor. Through societies and voluntary associations, the Christian clergy and laity could bring their concerns about temperance and slavery, or whatever, to the attention of their fellow citizens without disturbing the warm intimacy and loving harmony of the local congregation.

Nor did the churches have a monopoly over religious language in the nine-teenth century any more than in the eighteenth. Abraham Lincoln was known to be skeptical of church religion, yet he found in biblical language a way to ex-press the most profound moral vision in nineteenth-century America. He artic-ulated both the moral justification for emancipation and the grounds for recon-ciliation with unrivaled profundity in prose that drew not only from biblical symbols but from the rhythms of the Authorized Version. In his writings, we

can see that biblical language is both insistently public and politically demanding in its implications.

## Religious Pluralism

The American pattern of privatizing religion while at the same time allowing it some public functions has proven highly compatible with the religious pluralism that has characterized America from the colonial period and grown more and more pronounced. If the primary contribution of religion to society is through the character and conduct of citizens, any religion, large or small, familiar or strange, can be of equal value to any other. The fact that most American religions have been biblical and that most, though of course not all, Americans can agree on the term "God" has certainly been helpful in diminishing religious antagonism. But diversity of practice has been seen as legitimate because religion is perceived as a matter of individual choice, with the implicit qualification that the practices themselves accord with public decorum and the adherents abide by the moral standards of the community.

Under American conditions, religious pluralism has not produced a purely random assortment of religious bodies. Certain fairly determinate principles of differentiation—ethnic, regional, class—have operated to produce an intelligible pattern of social differentiation among religious groups, even though there remains much fluidity. Most American communities contain a variety of churches, and the larger the community the greater the variety. In smaller towns and older suburbs, church buildings draw significant public attention. They cluster around the town square or impressively punctuate the main streets. Local residents know very well who belongs where: the Irish and Italians go to the Catholic church and the small businessmen to the Methodist church, whereas the local elite belong to the Presbyterian and, even more likely, Episcopal churches.

Hervé Varenne has beautifully described the pattern in a small town in southern Wisconsin. Each congregation emphasized its own cultural style, often with implications about social class. Though the Protestant churches tended to be ranked in terms of the affluence and influence of their members, Varenne discovered, it was a relatively small core group that gave them their identity and their actual membership was often diverse. Small fundamentalist sects appealed to the poorest and most marginal townspeople, and the Catholic church had the most diverse membership in terms of class background. Varenne gives an example of the social differentation of religion in "Appleton" in the following paragraph:

> As perceived by many people in Appleton, the Presbyterian church, for example, was supposed to be "intellectual" and "sophisticated"; the Methodist was the church both of older, established small farmers and younger, "up-and-coming" businessmen in the town. Indeed, the Presbyterian church appealed mainly to professionals and high-level civil servants, the Methodist to merchants. The school board was dominated by Presbyterians, the town council by Methodists. There was clearly a feeling of competition between these two churches, the most important ones in Appleton. For the time being, the advantage appeared to lie with the Presbyterian church for the top spot in the ranking system.

In the communities we have studied, all of them larger than Appleton, the relationship between the churches and the social structure was even looser, though the same general principles of differentiation applied.

Most Americans see religion as something individual, prior to any organizational involvement. For many, such as Sheila Larson, it remains entirely individual. Where it does involve organizational commitment, the primary context is the local church. Larger loyalties are not missing, but a recent study indicates that even American Catholics, for whom *church* necessarily has a larger meaning, identify their faith primarily with what goes on in the family and local parish and are much less influenced religiously by the pronouncements of the bishops or even the teachings of the pope than by family members and the local priest.

Yet important as the local church is to many Americans, it is not identical with what is understood by *religion*, which has a meaning that transcends the individual and the local congregation. It is one of those differentiated spheres into which modern life is divided and which is largely handed over to "experts" who profess to understand it. We have already noted the development of a body of religious specialists beyond the local parish ministry in the nineteenth century. Today there are not only denominational bureaucracies and clerical hierarchies, a wide variety of educational and charitable religious institutions, and numerous religious organizations oriented to social and political action, but also religious intellectuals who command the attention of segments of the general public, not to mention media stars of the electronic churches. However private religion may be at the levels of the individual and the local church, at this third, or cultural, level religion is part of public life, even though the way in which it is public and the appropriate content of its public message are subject to controversy.

## The Local Congregation

We may begin a closer examination of how religion operates in the lives of those to whom we talked by looking at the local congregation, which traditionally has a certain priority. The local church is a community of worship that contains within itself, in small, so to speak, the features of the larger church, and in some Protestant traditions can exist autonomously. The church as a community of worship is an adaptation of the Jewish synagogue. Both Jews and Christians view their communities as existing in a covenant relationship with God, and the Sabbath worship around which religious life centers is a celebration of that covenant. Worship calls to mind the story of the relationship of the community with God: how God brought his chosen people out of Egypt or gave his only begotten son for the salvation of mankind. Worship also reiterates the obligations that the community has undertaken, including the biblical insistence on justice and righteousness, and on love of God and neighbor, as well as the promises God has made that make it possible for the community to hope for the future. Though worship has its special times and places, especially on the Sabbath in the house of the Lord, it functions as a model or pattern for the whole of life. Through reminding the people of their relationship to God, it establishes patterns of character and virtue that should operate in economic and political life as

well as in the context of worship. The community maintains itself as a commu-
nity of memory, and the various religious traditions have somewhat different
memories.

The very freedom, openness, and pluralism of American religious life
makes this traditional pattern hard for Americans to understand. For one thing,
the traditional pattern assumes a certain priority of the religious community
over the individual. The community exists before the individual is born and will
continue after his or her death. The relationship of the individual to God is ulti-
mately personal, but it is mediated by the whole pattern of community life.
There is a givenness about the community and the tradition. They are not nor-
mally a matter of individual choice.

For Americans, the traditional relationship between the individual and the
religious community is to some degree reversed. On the basis of our interviews,
we are not surprised to learn that a 1978 Gallup poll found that 80 percent of
Americans agreed that "an individual should arrive at his or her own religious
beliefs independent of any churches or synagogues." From the traditional point
of view, this is a strange statement—it is precisely within church or synagogue
that one comes to one's religious beliefs—but to many Americans it is the
Gallup finding that is normal.

Nan Pfautz, raised in a strict Baptist church, is now an active member of a
Presbyterian congregation near San Jose. Her church membership gives her a
sense of community involvement, of engagement with issues at once social and
moral. She speaks of her "commitment" to the church, so that being a member
means being willing to give time, money, and care to the community it embod-
ies and to its wider purposes. Yet, like many Americans, she feels that her per-
sonal relationship to God transcends her involvement in any particular church.
Indeed, she speaks with humorous disdain of "churchy people" such as those
who condemn others for violations of external norms. She says, "I believe I have
a commitment to God which is beyond church. I felt my relationship with God
was O.K. when I wasn't with the church."

For Nan, the church's value is primarily an ethical one. "Church to me is a
community, and it's an organization that I belong to. They do an awful lot of
good." Her obligations to the church come from the fact that she has chosen to
join it, and "just like any organization that you belong to, it shouldn't be just to
have another piece of paper in your wallet." As with the Kiwanis or any other
organization, "you have a responsibility to do something or don't be there," to
devote time and money, and especially to "care about the people." It is this car-
ing community, above all, that the church represents. "I really love my church
and what they have done for me, and what they do for other people, and the
community that's there." Conceived as an association of loving individuals,
the church acquires its value from "the caring about people. What I like about
my church is its community."

This view of the church as a community of empathetic sharing is related to
another aspect of Nan's thought. Despite her fundamentalist upbringing, her re-
ligiousness has developed a mystical cast. She sees the Christian tradition as
only one, and perhaps not even the best, expression of our relationship to what
is sacred in the universe. It is this mysticism and her sense of empathy with oth-
ers, rather than any particularly Christian vision, that seems to motivate Nan's

extraordinary range of social and political commitments. "I feel we have a commitment to the world, to animals, to the environment, to the water, to the whole thing. It all, in my opinion, is the stewardship of what God has loaned us. The American Indian religion is so fantastic, I think. All those Bible-pounding people came and told them that they were pagans, when they have such a better concept of what religion is all about." For Nan, empathy creates a sense of responsibility because she feels kinship, equality, perhaps even a kind of fusion with all others in the world, and so she suffers for their suffering. Her credo is, "We're all on this earth. Just because I was fortunate to be born in America and white doesn't make me any better than someone that's born in Africa and is black. They deserve to eat just as much as I deserve to eat. The boat people have the same feelings that I do. The same feelings—how can we say no to them?"

In talking to Art Townsend, the pastor of Nan's church, we found views quite consonant with hers. Art is not unaware of the church as a community of memory, though he is as apt to tell a story from the Maharishi or a Zen Buddhist text as from the New Testament. But what excites him are the individuals themselves: "The church is really a part of me and I am a part of the church, and my shift professionally has gone from 'how can I please them and make them like me so that I can keep my job and get a promotion' to 'how can I love them, how can I help these beautiful, special people to experience how absolutely wonderful they are." It is the self—both his and those of others—that must be the source of all religious meaning. In Art's optimistic vision, human beings need to learn to "lighten up" as "one of the steps to enlightenment." His job in turn is to "help them take the scales from their eyes and experience and see their magnificence." Difficulties between people are misunderstandings among selves who are ultimately in harmony. If a couple who are angry or disappointed or bored with each other really share their feelings, "you get into a deeper level, and what happens is that feelings draw together, and you actually, literally feel the feeling the same way the other person feels it. And when you do, there is a shift, there is a zing, and it is like the two become one."

For Art Townsend, God becomes the guarantee of what he has "experienced in my life, that there is nothing that happens to me that is not for the fulfillment of my higher self." His cheery mysticism eliminates any real possibility of sin, evil, or damnation, since "if I thought God were such a being that he would waste a human soul on the basis of its mistakes, that would be a little limiting." In consonance with this primarily expressive individualist ethos, Art's philosophy is remarkably upbeat. Tragedy and sacrifice are not what they seem. "Problems become the playground of consciousness" and are to be welcomed as opportunities for growth.

Such a view can justify high levels of social activism, and Art Townsend's church engages in a wide variety of activities, volunteering as a congregation to care for Vietnamese refugee families, supporting broader understanding of the homosexual minority, and visiting the sick or distressed in the congregation. A member such as Nan Pfautz carries her sense of responsibility further, participating through the church in a range of activities from environmental protection to fighting multinational corporations marketing infant formula in the Third World. But it is clear for her, as for Art Townsend, that the ultimate meaning of the church is an expressive-individualist one. Its value is as a loving community

in which individuals can experience the joy of belonging. As the church secretary says, "Certainly all the things that we do involve caring about people in a loving manner, at least I hope that we do." She puts it succinctly when she says, "For the most part, I think this community is a safe place for a lot of people."

Art Townsend's Presbyterian church would be viewed as theologically liberal. A look at a nearby conservative church brings out many differences but also many similarities. Pastor Larry Beckett describes his church as independent, conservative, and evangelical, and as neither liberal nor fundamentalist. At first glance, this conservative evangelical church is more clearly a community of memory than Art Townsend's. Larry Beckett indicates that its central beliefs are the divinity of Christ and the authority of scripture. A great deal of time is given to the study and exposition of scripture. Larry even gave a brief course on New Testament Greek so that the original text would be to some degree available to the congregation. While Larry insists that the great commandment to love God and one's neighbor is the essence of biblical teaching, his church tries to follow the specific commandments as much as possible. It is, for example, strongly against divorce because of Jesus' injunction (Matt. 19:6) against putting asunder what God has joined together. The firm insistence on belief in God and in the divinity of Christ, the importance of Christ as a model for how to act, and the attempt to apply specific biblical injunctions as far as possible provide the members of this church with a structure of external authority that might make the members of Art Townsend's congregation uneasy. Not so different socially and occupationally from the nearby Presbyterian church, and subject to many of the same insecurities and tensions, the members of this evangelical church have found a faith that is secure and unchanging. As Larry Beckett says, "God doesn't change. The values don't change. Jesus Christ doesn't change. In fact, the Bible says He is the same yesterday, today, and forever. Everything in life is always changing, but God doesn't change."

Despite his religious conservatism, Larry Beckett mixes a liberal dose of humanistic psychology with his strong biblical imagery, telling church members that God's love can be a source of "self-worth." Because God has created them in his image, because he loves them and sent his son to redeem them, they have infinite worth and value. "No matter how a person is performing, no matter how many friends they have, no matter how handsome or ugly, or no matter how much money they have, they have an inherent value base that cannot be changed or altered." But this attempt to make people feel good about themselves is only a first step in persuading them to enter an exclusive Christian community. He distances himself from the view that "basically everybody in America and everybody in Western culture is Christian. That's not what Evangelicals mean. It is that I have made a personal identification with the historic person of Christ in a very simple way. I did that about ten years ago, and before that I was non-Christian."

The community of Larry Beckett's church is a warm and loving one. There is freshly baked zucchini bread sitting out on the counter of the church's modest kitchen, and the whole community has the feeling of a family. Here members practice the virtues of their biblical ethic, learning to put the needs of others before their own. For Larry Beckett and the members of his congregation, biblical Christianity provides an alternative to the utilitarian individualist values of this

world. But that alternative, appealing precisely because it is "real clear," does not go very far in helping them understand their connection to the world or the society in which they live. The Bible provides unambiguous moral answers about "the essential issues—love, obedience, faith, hope," so that "killing or, say, murdering is never right. Or adultery. A relationship outside of your marriage is never right. The Bible says that real simple." To "follow the Scriptures and the words of Jesus" provides a clear, but narrow, morality centered on family and personal life. One must personally, as an individual, resist temptation and put the good of others ahead of one's own. Christian love applies to one-to-one relationships—I may not cheat my neighbor, or exploit him, or sell him something I know he can't afford. But outside this sphere of personal morality, the evangelical church has little to say about wider social commitments. Indeed, the sect draws together those who have found a personal relationship to Christ into a special loving community, and while it urgently seeks to have everyone make the same commitment, it separates its members off from attachment to the wider society. Morality becomes personal, not social; private, not public.

Both Larry Beckett's conservative church and Art Townsend's liberal one stress stable, loving relationships, in which the intention to care outweighs the flux of momentary feelings, as the ideal pattern in marriage, family, and work relationships. Thus both attempt to counter the more exploitative tendencies of utilitarian individualism. But in both cases, their sense of religious community has trouble moving beyond an individualistic morality. In Art Townsend's faith, a distinctively religious vision has been absorbed into the categories of contemporary psychology. No autonomous standard of good and evil survives outside the needs of individual psyches for growth. Community and attachment come not from the demands of a tradition, but from the empathetic sharing of feelings among therapeutically attuned selves.

Larry Beckett's evangelical church, in contrast, maintains a vision of the concrete moral commitments that bind church members. But the bonds of loyalty, help, and responsibility remain oriented to the exclusive sect of those who are "real" Christians. Direct reliance on the Bible provides a second language with which to resist the temptations of the "world," but the almost exclusive concentration on the Bible, especially the New Testament, with no larger memory of how Christians have coped with the world historically, diminishes the capacity of their second language to deal adequately with current social reality. There is even a tendency visible in many evangelical circles to thin the biblical language of sin and redemption to an idea of Jesus as the friend who helps us find happiness and self-fulfillment. The emphasis on love, so evident within the community, is not shared with the world, except through missionary outreach.

There are thousands of local churches in the United States, representing an enormous range of variation in doctrine and worship. Yet most define themselves as communities of personal support. A recent study suggests that what Catholics look for does not differ from the concerns of the various types of Protestants we have been discussing. When asked the direction the church should take in future years, the two things that a national sample of Catholics most asked for were "personal and accessible priests" and "warmer, more personal parishes." The salience of these needs for personal intimacy in American religious life suggests why the local church, like other voluntary communities,

indeed like the contemporary family, is so fragile, requires so much energy to keep it going, and has so faint a hold on commitment when such needs are not met.

## Religious Individualism

Religious individualism, evident in these examples of church religion, goes very deep in the United States. Even in seventeenth-century Massachusetts, a personal experience of salvation was a prerequisite for acceptance as a church member. It is true that when Anne Hutchinson began to draw her own theological conclusions from her religious experiences and teach them to others, conclusions that differed from those of the established ministry, she was tried and banished from Massachusetts. But through the peculiarly American phenomenon of revivalism, the emphasis on personal experience would eventually override all efforts at church discipline. Already in the eighteenth century, it was possible for individuals to find the form of religion that best suited their inclinations. By the nineteenth century, religious bodies had to compete in a consumers' market and grew or declined in terms of changing patterns of individual religious taste. But religious individualism in the United States could not be contained within the churches, however diverse they were. We have noted the presence of individuals who found their own way in religion even in the eighteenth century. Thomas Jefferson said, "I am a sect myself," and Thomas Paine, "My mind is my church." Many of the most influential figures in nineteenth-century American culture could find a home in none of the existing religious bodies, though they were attracted to the religious teachings of several traditions. One thinks of Ralph Waldo Emerson, Henry David Thoreau, and Walt Whitman.

Many of these nineteenth-century figures were attracted to a vague pantheistic mysticism that tended to identify the divine with a higher self. In recent times, what had been a pattern confined to the cultural elite has spread to significant sections of the educated middle class. Tim Eichelberger, a young Campaign for Economic Democracy activist in Southern California, is typical of many religious individualists when he says, "I feel religious in a way. I have no denomination or anything like that." In 1971, when he was seventeen, he became interested in Buddhism. What attracted him was the capacity of Buddhism to allow him to "transcend" his situation: "I was always into change and growth and changing what you were sort of born into and I was always interested in not having that control me. I wanted to define my own self." His religious interest involved the practice of yoga and a serious interest in leading a nonviolent life. "I was into this religious purity and I wanted the earth around me to be pure, nonviolence, nonconflict. Harmony. Harmony with the earth. Man living in harmony with the earth; men living in harmony with each other." His certainty about nonviolence eventually broke down when he had to acknowledge his rage after being rejected in a love relationship. Coming to terms with his anger made him see that struggle is a part of life. Eventually, he found that involvement in CED gave an expression to his ideals as well as his understanding of life as a struggle. His political concern with helping people attain "self-respect, self-determination, self-realization" continues his older religious

concern to define his own self. But neither his religion nor his politics transcend an individualism in which "self-realization" is the highest aspiration.

That radical religious individualism can find its own institutional form is suggested by the story of Cassie Cromwell, a suburban San Diego volunteer a generation older than Eichelberger, who came to her own religious views in adolescence when she joined the Unitarian church. She sums up her beliefs succinctly: "I am a pantheist. I believe in the 'holiness' of the earth and all other living things. We are a product of this life system and are inextricably linked to all parts of it. By treating other living things disrespectfully, we are disrespectful of ourselves. Our very survival depends on the air 'god,' the water, sun, etc." Not surprisingly, she has been especially concerned with working for ecological causes. Like Eichelberger, she began with a benign view of life and then had to modify it. "I used to believe that man was basically good," her statement of her philosophy continues. "I didn't believe in evil. I still don't know what evil is but see greed, ignorance, insensitivity to other people and other living things, and irresponsibility." Unlike most of those to whom we talked, Cassie is willing to make value judgments about religion and is openly critical of Christianity. She believes that "the Christian idea of the superiority of man makes it so difficult to have a proper concern for the environment. Because only man has a soul, everything on the earth can be killed and transformed for the benefit of man. That's not right."

Commoner among religious individualists than criticism of religious beliefs is criticism of institutional religion, or the church as such. "Hypocrisy" is one of the most frequent charges against organized religion. Churchgoers do not practice what they preach. Either they are not loving enough or they do not practice the moral injunctions they espouse. As one person said, "It's not religion or the church you go to that's going to save you." Rather it is your "personal relationship" with God. Christ will "come into your heart" if you ask, without any church at all.

In the cases of Tim Eichelberger and Cassie Cromwell, we can see how mystical beliefs can provide an opening for involvement in the world. Nonetheless, the links are tenuous and to some extent fortuitous. Both had to modify their more cosmic flights in order to take account of evil and aggression and work for the causes they believe in. The CED provides a focus for Eichelberger's activities, as the ecology movement does for Cassie. But their fundamental views were formed outside those contexts and their relation to the respective groups, even Cassie's longstanding connection with the Unitarians, remains one of convenience. As social ideals, neither "self-realization" nor the "life system" provide practical guidance. Indeed, although both Tim and Cassie value "harmony with the earth," they lack a notion of nature from which any clear social norms could be derived. Rather, the tendency in American nature pantheism is to construct the world somehow out of the self. (Again, Emerson is a clue.) If the mystical quest is pursued far enough, it may take on new forms of self-discipline, committed practice, and community, as in the case of serious practitioners of Zen Buddhism. But more usually the languages of Eastern spirituality and American naturalistic pantheism are employed by people not connected with any particular religious practice or community.

## Religion and World

Throughout this chapter, we have seen a conflict between withdrawal into purely private spirituality and the biblical impetus to see religion as involved with the whole of life. Parker Palmer suggests that this apparent contradiction can be overcome:

> Perhaps the most important ministry the church can have in the renewal of public life is a "ministry of paradox": not to resist the inward turn of American spirituality on behalf of effective public action, *but to deepen and direct and discipline that inwardness in the light of faith* until God leads us back to a vision of the public and to faithful action on the public's behalf.

Palmer seems to be asserting with respect to religious individualism something similar to what we argued in chapter 6—namely, that American individualism is not to be rejected but transformed by reconnecting it to the public realm.

Toward the end of the previous chapter, we discussed the social movement as a form of citizenship and pointed out how often in our history religion has played an important role in such movements. Time and again in our history, spiritually motivated individuals and groups have felt called to show forth in their lives the faith that was in them by taking a stand on the great ethical and political issues of the day. During the Revolution, the parish clergy gave ideological support and moral encouragement to the republican cause. Christian clergy and laity were among the most fervent supporters of the antislavery cause, just as Christians involved in the Social Gospel movement and its many ramifications did much to ameliorate the worst excesses of early industrial capitalism. Of course, the churches produced opponents of all these movements— the American religious community has never spoken with one voice. On occasion, a significant part of the religious community has mounted a successful crusade that the nation as a whole later came to feel was unwise—for example, the Temperance movement that led to a constitutional amendment prohibiting the sale of alcoholic beverages in the United States. But without the intervention of the churches, many significant issues would have been ignored and needed changes would have come about much more slowly.

To remind us of what is possible, we may call to mind one of the most significant social movements of recent times, a movement overwhelmingly religious in its leadership that changed the nature of American society. Under the leadership of Martin Luther King, Jr., the Civil Rights movement called upon Americans to transform their social and economic institutions with the goal of building a just national community that would respect both the differences and the interdependence of its members. It did this by combining biblical and republican themes in a way that included, but transformed, the culture of individualism.

Consider King's "I Have a Dream" speech. Juxtaposing the poetry of the scriptural prophets—"I have a dream that every valley shall be exalted, every hill and mountain shall be made low"—with the lyrics of patriotic anthems—"This will be the day when all of God's children will be able to sing with new meaning, 'My country 'tis of thee, sweet land of liberty, of thee I sing'"—King's oration

reappropriated that classic strand of the American tradition that understands the true meaning of freedom to lie in the affirmation of responsibility for uniting all of the diverse members of society into a just social order. "When we let freedom ring, when we let it ring from every village and hamlet, from every state and every city, we will be able to speed up the day when all of God's children, black men and white men, Jews and Gentiles, Protestants and Catholics, will be able to join hands and sing the words of that old Negro spiritual. 'Free at last! Free at last! Thank God almighty, we are free at last!' " For King, the struggle for freedom became a practice of commitment within a vision of America as a community of memory. We now need to look at that national community, our changing conceptions of it, and what its prospects are.

# U.S. DEPARTMENT OF EDUCATION

In 1995 President William Jefferson Clinton commissioned Secretary of Education Richard Riley to clarify the boundaries of religious expression and activity in the public school system. In August, Secretary Riley sent every school superintendent in the country these guidelines, known as *Religious Expression in Public Schools*. The document intended to balance the First Amendment's free exercise clause with the establishment clause, meaning that it aimed to square students' free expression of religious views with the assurance that public schools will neither endorse nor coerce participation in religious activity. Slight modifications were made, and a revised version of the guidelines was released in 1998. The latter version is reprinted here.

## Religious Expression in Public Schools

Student prayer and religious discussion: The Establishment Clause of the First Amendment does not prohibit purely private religious speech by students. Students therefore have the same right to engage in individual or group prayer and religious discussion during the school day as they do to engage in other comparable activity. For example, students may read their Bibles or other scriptures, say grace before meals, and pray before tests to the same extent they may engage in comparable nondisruptive activities. Local school authorities possess substantial discretion to impose rules of order and other pedagogical restrictions on student activities, but they may not structure or administer such rules to discriminate against religious activity or speech.

Generally, students may pray in a nondisruptive manner when not engaged in school activities or instruction, and subject to the rules that normally pertain in the applicable setting. Specifically, students in informal settings, such as cafeterias and hallways, may pray and discuss their religious views with each other, subject to the same rules of order as apply to other student activities and speech. Students may also speak to, and attempt to persuade, their peers about religious topics just as they do with regard to political topics. School officials, however, should intercede to stop student speech that constitutes harassment aimed at a student or a group of students.

Students may also participate in before or after school events with religious content, such as "see you at the flag pole" gatherings, on the same terms as they may participate in other noncurriculum activities on school premises. School officials may neither discourage nor encourage participation in such an event.

The right to engage in voluntary prayer or religious discussion free from discrimination does not include the right to have a captive audience listen, or to compel other students to participate. Teachers and school administrators should ensure that no student is in any way coerced to participate in religious activity.

Graduation prayer and baccalaureates: Under current Supreme Court decisions, school officials may not mandate or organize prayer at graduation, nor organize religious baccalaureate ceremonies. If a school generally opens its facilities to private groups, it must make its facilities available on the same terms to organizers of privately sponsored religious baccalaureate services. A school may not extend preferential treatment to baccalaureate ceremonies and may in some instances be obliged to disclaim official endorsement of such ceremonies.

Official neutrality regarding religious activity: Teachers and school administrators, when acting in those capacities, are representatives of the state and are prohibited by the establishment clause from soliciting or encouraging religious activity, and from participating in such activity with students. Teachers and administrators also are prohibited from discouraging activity because of its religious content, and from soliciting or encouraging antireligious activity.

Teaching about religion: Public schools may not provide religious instruction, but they may teach about religion, including the Bible or other scripture: the history of religion, comparative religion, the Bible (or other scripture)-as-literature, and the role of religion in the history of the United States and other countries all are permissible public school subjects. Similarly, it is permissible to consider religious influences on art, music, literature, and social studies. Although public schools may teach about religious holidays, including their religious aspects, and may celebrate the secular aspects of holidays, schools may not observe holidays as religious events or promote such observance by students.

Student assignments: Students may express their beliefs about religion in the form of homework, artwork, and other written and oral assignments free of discrimination based on the religious content of their submissions. Such home and classroom work should be judged by ordinary academic standards of substance and relevance, and against other legitimate pedagogical concerns identified by the school.

Religious literature: Students have a right to distribute religious literature to their schoolmates on the same terms as they are permitted to distribute other literature that is unrelated to school curriculum or activities. Schools may impose

the same reasonable time, place, and manner or other constitutional restrictions on distribution of religious literature as they do on nonschool literature generally, but they may not single out religious literature for special regulation.

Religious excusals: Subject to applicable State laws, schools enjoy substantial discretion to excuse individual students from lessons that are objectionable to the student or the students' parents on religious or other conscientious grounds. However, students generally do not have a Federal right to be excused from lessons that may be inconsistent with their religious beliefs or practices. School officials may neither encourage nor discourage students from availing themselves of an excusal option.

Released time: Subject to applicable State laws, schools have the discretion to dismiss students to off-premises religious instruction, provided that schools do not encourage or discourage participation or penalize those who do not attend. Schools may not allow religious instruction by outsiders on school premises during the school day.

Teaching values: Though schools must be neutral with respect to religion, they may play an active role with respect to teaching civic values and virtue, and the moral code that holds us together as a community. The fact that some of these values are held also by religions does not make it unlawful to teach them in school.

Student garb: Schools enjoy substantial discretion in adopting policies relating to student dress and school uniforms. Students generally have no Federal right to be exempted from religiously-neutral and generally applicable school dress rules based on their religious beliefs or practices; however, schools may not single out religious attire in general, or attire of a particular religion, for prohibition or regulation. Students may display religious messages on items of clothing to the same extent that they are permitted to display other comparable messages. Religious messages may not be singled out for suppression, but rather are subject to the same rules as generally apply to comparable messages.

## THE EQUAL ACCESS ACT

The Equal Access Act is designed to ensure that, consistent with the First Amendment, student religious activities are accorded the same access to public school facilities as are student secular activities. Based on decisions of the Federal courts, as well as its interpretations of the Act, the Department of Justice has advised that the Act should be interpreted as providing, among other things, that:

General provisions: Student religious groups at public secondary schools have the same right of access to school facilities as is enjoyed by other comparable student groups. Under the Equal Access Act, a school receiving Federal funds that allows one or more student noncurriculum-related clubs to meet on its premises during noninstructional time may not refuse access to student religious groups.

Prayer services and worship exercises covered: A meeting, as defined and protected by the Equal Access Act, may include a prayer service, Bible reading, or other worship exercise.

Equal access to means of publicizing meetings: A school receiving Federal funds must allow student groups meeting under the Act to use the school me-

dia—including the public address system, the school newspaper, and the school bulletin board—to announce their meetings on the same terms as other noncurriculum-related student groups are allowed to use the school media. Any policy concerning the use of school media must be applied to all non-curriculum-related student groups in a nondiscriminatory matter. Schools, however, may inform students that certain groups are not school sponsored.

Lunch-time and recess covered: A school creates a limited open forum under the Equal Access Act, triggering equal access rights for religious groups, when it allows students to meet during their lunch periods or other noninstructional time during the school day, as well as when it allows students to meet before and after the school day.

# JEFFREY L. STOUT

Jeffrey L. Stout (b. 1950) is a prominent philosopher of religion and the author of several important works. His book *Democracy and Tradition* (2004) examines religious and the ethical dimensions of democratic culture. Stout argues that religious voices ought to have full access to reasoned debate in the democratic public sphere, yet he also argues against those antiliberal thinkers who seem to be aiming toward a new theocracy. Insofar as it addresses issues that continue to press on American citizens—secularization, resurgent religious traditionalism, and democratic participation—it is a fitting excerpt with which to end this collection.

## *From* Democracy and Tradition

### RELIGIOUS REASONS IN POLITICAL ARGUMENT

Religious diversity, like racial diversity, has been a source of discord throughout American history. Most Americans claim to be religious, but their convictions are hardly cut from the same cloth. Given that some of these convictions are thought to have highly important political implications, we should not be surprised to hear them expressed when citizens are exchanging reasons for their respective political views. Secular liberals find the resulting cacophony deeply disturbing. Some of them have strongly urged people to restrain themselves from bringing their religious commitments with them into the political sphere. Many religious people have grown frustrated, at the unwillingness of the liberal

Stout, Jeffrey; *Democracy and Tradition*. Princeton University Press. Reprinted by permission of Princeton University Press.

elite to hear them out on their own terms, and have recently had much to say against the hypocrisies and biases of secularism. Freedom of religion now strikes some prominent theologians as a secularist ruse designed to reduce religion to insignificance. Part 2 of this book tries to make sense of this controversy.

Freedom of religion consists first of all in the right to make up one's own mind when answering religious questions. These include, but are not limited to, such questions as whether God exists, how God should be conceived, and what responsibilities, if any, human beings have in response to God's actions with regard to them. Freedom of religion also consists in the right to act in ways that seem appropriate, given one's answers to religious questions—provided that one does not cause harm to other people or interfere with their rights. Among the expressive acts obviously protected by this right are rituals and other devotional practices performed in solitude, in the context of one's family, or in association with others similarly disposed. More controversial, however, is a class of acts that express religious commitments in another way, namely, by employing them as reasons when taking a public stand on political issues. What role, if any, should religious premises play in the reasoning citizens engage in when they make and defend political decisions?

The free expression of religious premises is morally underwritten not only by the value we assign to the freedom of religion, but also by the value we assign to free expression, generally. All citizens of a constitutional democracy possess not only the right to make up their minds as they see fit but also the right to express their reasoning freely, whatever that reasoning may be. It is plausible to suppose that the right to free expression of religious commitments is especially weighty in contexts where political issues are being discussed, for this is where rulers and elites might be most inclined to enforce restraint. Any citizen who chooses to express religious reasons for a political conclusion would seem, then, to enjoy the protection of two rights in doing so: freedom of religion and freedom of expression. And these rights not only have the legal status of basic constitutional provisions, but also hold a prominent place in the broader political culture. Otherwise, the framers of the U.S. Constitution would not have had reason to affirm them explicitly in the Bill of Rights.

I have no doubt that the expression of religious reasons should be protected in these ways. Indeed, I would encourage religiously committed citizens to make use of their basic freedoms by expressing their premises in as much depth and detail as they see fit when trading reasons with the rest of us on issues of concern to the body politic. If they are discouraged from speaking up in this way, we will remain ignorant of the real reasons that many of our fellow citizens have for reaching some of the ethical and political conclusions they do. We will also deprive them of the central democratic good of expressing themselves to the rest of us on matters about which they care deeply. If they do not have this opportunity, we will lose the chance to learn from, and to critically examine, what they say. And they will have good reason to doubt that they are being shown the respect that all of us owe to our fellow citizens as the individuals they are.

Of course, having a right does not necessarily mean that one would be justified in exercising it. Clearly, there are circumstances in which it would be imprudent or disrespectful for someone to reason solely from religious premises

when defending a political proposal. But some philosophers hold, more controversially, that such circumstances are more the exception than the rule. Richard Rorty, the most important contemporary pragmatist, has claimed that reasoning from religious premises to political conclusions is nowadays either imprudent, improper, or both. The late John Rawls, the most distinguished political philosopher of our time, at first defended a similarly restrictive view. He later made a concession to free expression by qualifying that policy somewhat, but still considered it improper to introduce religious reasons into public discussion of matters of basic justice unless those reasons are redeemed in the long run by reasons of a different kind. In this chapter, turning first to Rawls and then to Rorty, I will explain why their arguments for these positions fail to persuade me. The point is not to refute them, but to provide a rationale for approaching the topic differently. . . .

## SECULARIZATION AND RESENTMENT

*Resentment is easy. Theology is hard.* ~ JOHN BOWLIN

In the 1960s Christian theologians made news by extolling the virtues of the secular city. Nowadays, however, they often denounce secularized political culture in vehement terms. John Milbank and his fellow proponents of "radical orthodoxy" hold that "for several centuries now, secularism has been defining and constructing the world. It is a world in which the theological is either discredited or turned into a harmless leisure-time activity of private commitment." The only appropriate response, they conclude, is a theology that "refuses the secular." This means rejecting both "secular reason" and the "secular state" as spheres of discourse not essentially "framed by a theological perspective." While Richard John Neuhaus is more favorably disposed toward modern democracy than Milbank is, he nonetheless bemoans "a religious evacuation of the public square." He declares that "secular humanism has had a pervasive and debilitating effect upon our public life," and warns that "the notion of the secular state can become the prelude to totalitarianism."

Theological resentment of the secular deserves attention from theorists of democracy not only because it gives voice to an animus felt by many religiously oriented citizens, but also because it reinforces that animus and encourages its spread. Radical orthodoxy is currently the hottest topic being debated in seminaries and divinity schools in the United States, and thus a significant part of the subculture within which future pastors are being educated. Neuhaus's journal, *First Things,* takes the case against secularized political culture to an audience that reaches well beyond the seminaries.

In chapter 3, I discussed two forms of liberalism that unwittingly fuel the resentment of the secular expressed in the writings of Milbank and Neuhaus. Rawls's political liberalism holds that religious premises may be used in democratic deliberation and debate of essential matters, but only if they are eventually supplemented by reasoning that appeals to a freestanding conception of justice. Rorty's pragmatic liberalism holds that introducing religious premises into political argument is more or less guaranteed to break off the discussion

and therefore best avoided. Milbank and Neuhaus would reject both of these positions as secularist. That liberalism is secularist in this sense may be a reason for religious believers to reject it as an ideology or political theory. But is this also a reason for them to reject the political culture of which liberals propose to give a theoretical account? Only, I suggested, if that theoretical account is *descriptively* adequate, which it is not.

In this chapter, I want to focus on ambiguities surrounding the notion of secularization and their implications for theological and religious expression. There is a sense in which the ethical discourse of most modern democracies is *secularized,* for such discourse is not "framed by a theological perspective" taken for granted by all those who participate in it. But secularization in this sense is not a reflection of commitment to *secularism.* It entails neither the denial of theological assumptions nor the expulsion of theological expression from the public sphere. And it leaves believers free to view both the state and democratic political culture as domains standing ultimately under divine judgment and authority. That believers view the political sphere in this way does not entail that others will, of course. But this just means that the age of theocracy is over, not that the anti-Christ has taken control of the political sphere.

## How Ethical Discourse Became Secularized and What This Means

Many religious traditions inculcate habitual deference to the expert interpreters of scriptural texts on questions of moral, religious, and political practice. The experts' claim to authority on these questions consists in their ability to interpret and apply the relevant texts. In Judaism, for example, each rabbi establishes his authority to interpret the texts by learning Hebrew, studying Scripture and the commentaries for many years, and debating the fine points of interpretation with others who have spent a significant portion of their lives engaging in these activities. In Catholicism and Islam, priests and imams enjoy a comparable sort of authority. But all of this assumes, first, that particular texts, if properly interpreted, include authoritative answers to the sorts of questions being addressed. Second, it assumes that some interpreters are in a better position to interpret those texts than others are.

Now consider the early-modern debates among Christians of various types over moral and political questions. Here we have numerous groups, all of which were committed to treating the Christian Bible as an authoritative source of normative insight into how such questions should be answered. Yet they did not differ only on what this text says and implies. They also differed on who is entitled to interpret it, on whether it is the sole authoritative source of normative insight into such matters, and on who is entitled to resolve apparent conflicts between it and other putative sources of normative insight. Because they differed on all of these points, they eventually found themselves avoiding appeals to biblical authority when trying to resolve their ethical and political differences. The reason was simple; the appeals did not work. So the differing parties increasingly tried to resolve their differences on other grounds. In this respect, their ethical discourse with one another became secularized.

A case study can illustrate how and why this sort of secularization took place. In his study of appeals to the Bible in seventeenth-century English politics,

the distinguished historian Christopher Hill asserts that the Bible passed from a position of considerable authority in political debate, cited by virtually all parties, to a position of diminished authority and centrality as the century unfolded. By the end of the 1650s, the Bible had essentially been "dethroned." Among many other signs of this decline, Hill reports that in 1657 members of Parliament laughed at one M.P. for repeatedly citing Scripture in support of his conclusions. Why did the other members find him ridiculous? It could have been for any number of reasons. It is unlikely, however, that each jeering M.P. had ceased to ascribe infallible authority to the Bible in forming his own commitments and no longer respected anyone who did. As Hill puts it, "Twenty years of frenzied discussion had shown that text-swapping and text-distortion solved nothing: agreement was not to be reached even among the godly on what exactly the Bible said and meant" (EB, 421). The change seems to have had less to do with each individual's process of commitment-formation than with what they were able to take for granted in their public discourse with one another.

Imagine that you ascribe infallible authority to the Bible and consult it regularly in forming your own opinions. Suppose further that all members of your society are similarly committed to conforming their opinions to what the Bible says, and you know this. It does not follow that it will make sense for you to appeal to the Bible in settling disputed questions in a public forum. Why? Perhaps you know that members of your society do not have compatible views of what the Bible says on political and economic matters. You notice that when members of the group use reasoned discussion to forge consensus on questions of biblical interpretation, they almost always fail. You therefore conclude that it will be unwise for any of you to appeal to the Bible as an infallible authority even though each of you believes that it is. Any such appeal, in this sort of setting, is going to be useless, and anyone who makes it is going to appear foolish.

So we have two things that might be meant by the Bible's authority. The first is a matter of how individuals form their commitments. If a given person is prepared to defer to whatever the Bible says on a moral or political question, call this the Bible's authority over an individual's conscience. The second is a matter of what individuals can reasonably appeal to as an arbiter in disputes with other groups. Call this "public discursive authority." Now that I have drawn this distinction, I want to recommend putting more weight on the second than on the first in telling the story of secularization in general and the story of the Bible in seventeenth-century English politics in particular. Only a few of Hill's examples give clear evidence that the Bible's authority over individual consciences declined. They do not settle the question of how widespread that decline was. But even if the decline of the Bible's authority over conscience was limited to relatively small segments of the English population, as I suspect it was, it still seems plausible to conclude that the Bible's public discursive authority had virtually disappeared by the end of the century.

On the assumption that only a few intellectuals and radical groups abandoned the Bible as an infallible authority in forming their individual consciences on various matters, why did the Bible's role as public discursive authority decline so rapidly and thoroughly? The answer to this question should already be clear. It is that the members of English society were unable to find means of reaching rational agreement on questions of biblical interpretation,

and in the absence of such means, the Bible could not play the public role of ar-
biter it had played earlier in the century. But this answer begets another ques-
tion. Why was it so hard for these particular people to reach rational agreement
on the interpretation of this document?

Hill's examples give hints about how to answer this question. English
Protestants ascribed authority to the Bible because they took it to be a book au-
thored by God. It was the word of God, and it could be trusted as an infallible
authority because God is both morally perfect and omniscient. Many of them
had downgraded church tradition to the status of fallible authority or nonau-
thority on the ground that it had obviously been corrupted, so they were unable
to settle issues of interpretation by appeal to tradition. This left them appealing
for interpretive guidance to what Milton called the "supreme authority . . . of
the Spirit, which is internal and the individual possession of each man." But
while this sort of appeal might leave each individual convinced that he or she
had been guided by the Spirit toward infallibly correct conclusions, it did not
provide a public means for resolving differences between one person's conclu-
sions and another's. Moreover, the explanation one would be inclined to give
for such differences was that anyone disagreeing with one's own conclusions
must have been guided by some force other than the Spirit, most likely a de-
monic one. That sort of explanation of disagreement tends to undermine the ra-
tionale for trying to resolve differences by exchanging reasons. It encourages the
thought that one's opponents need to be fought rather than offered reasons.

Another consequence of viewing the Bible as an infallibly authoritative
book authored by God is a requirement of consistency. Internally, each biblical
passage will need to be read in such a way that its sense can be reconciled logi-
cally with the sense of all other biblical passages. Apparent inconsistency within
the book as a whole—for example, with respect to the birthplace of Jesus—will
need to be explained away. Yet there can also be a requirement of external con-
sistency. Each biblical passage will need to be read in such a way that its sense
can be reconciled with whatever one is firmly committed to regarding as true.
The idea that what the Bible says *must* be true exerts pressure on the interpreter
to read the Bible in such a way that it does not conflict with his or her strongest
commitments. The strongest proponents of biblical authority therefore often
have the strongest reasons, from their own point of view, for being what we
might call "strong" readers of the biblical text. They proclaim the primacy of the
Bible at one moment and then a moment later push the text hard in the direction
of truths with which it must in the end prove compatible, given that God is no
author of falsehoods.

The need for external consistency acquired new force in the sixteenth and
seventeenth centuries, as the idea of the "Book of Nature" became central to the
projects of astrologers, alchemists, and champions of the new science. For here
was another book authored by God, and therefore equally certain to disclose
only truths to those who interpret it correctly. It followed that a correct interpre-
tation had to make everything in both books add up to a set of consistent propo-
sitions, no matter how much the interpreter was required to go beyond or
against the so-called plain sense of Scripture. Even those not captivated by the
idea of a second divinely authored book often found themselves giving read-
ings apparently at odds with the plain sense of the biblical text in trying to

address the problems of internal and external consistency. They then either had to abandon the Protestant commitment to the priority of the Bible's literal sense or they had to engage in special pleading while stretching the plain sense beyond recognition.

Different individuals responded to this set of problems in different ways, as Hill's examples make clear. A few, like Samuel Fisher, abandoned the idea of the Bible as a divinely authored book and formed their own opinions without relying on it essentially. Others, like the radical woman known as M. M., continued to rely on it while drawing a distinction between the essential truths revealed in the text and the merely human vessels into which the divine wine had been poured. The truths were divinely authored, then, but not the book itself, at least as we have it. Both of these moves were meant to dissolve, rather than solve, the problems caused by the quest for internal and external consistency. And both moves relieved the pressure to supply typological and allegorical readings that can be made congruent with the plain sense.

It is not at all clear that most people made these moves. Many people just went on trying to solve the problems that Fisher and M. M. tried to dissolve. The important point, however, is that the plain sense was no longer the sort of thing *anybody*, even a die-hard, Bible-thumping literalist, could appeal to in settling a public dispute over what the Bible meant. The reason for this was not that most people agreed with M. M. or Fisher. Two other reasons appear to have been involved. The first was that the appeal to inner persuasion was not publicly persuasive. The second was that the plain sense had already been stretched beyond the breaking point by the quest for consistency. Readings supposedly grounded in the plain sense of Scripture had multiplied so rapidly that the plain sense could no longer function as a publicly effective constraint on interpretation. And once this had happened, the Bible's public role as arbiter was gone.

My account of secularization concerns what can be taken for granted when exchanging reasons in public settings. A setting is public in the relevant sense if it involves no expectation of confidentiality and if it is one in which citizens address one another qua citizens. What makes a form of discourse secularized, according to my account, is not the tendency of the people participating in it to relinquish their religious beliefs or to refrain from employing them as reasons. The mark of secularization, as I use the term, is rather the fact that participants in a given discursive practice are not in a position to take for granted that their interlocutors are making the same religious assumptions they are. This is the sense in which public discourse in modern democracies tends to be secularized.

Notice that secularization in this sense does not reflect a commitment to secularism, secular liberalism, or any other ideology. It is true that modern democratic discourse tends not to be "framed by a theological perspective," but this does not prevent any of the individuals participating in it from adopting a theological perspective. They are free to frame their contributions to it in whatever vocabulary they please. What they cannot reasonably do is expect a single theological perspective to be shared by all of their interlocutors. But this is not because the discourse in which they and their interlocutors are engaged commits everyone involved to relying solely on "secular reason" when thinking and conversing on political questions. Nor does it involve endorsement of the "secular state" as a realm entirely insulated from the effects of religious convictions, let

alone removed from God's ultimate authority. It is simply a matter of what can be presupposed in a discussion with other people who happen to have different theological commitments and interpretive dispositions.

In my previous work, I have referred to the secularization of public discourse as an effect of the "kinematics of presupposition." To avoid misunderstanding of this point, however, it is necessary to draw a distinction between two senses of the term "presupposition." Suppose Martin Luther King, Jr., asserts that God is love. In making this assertion, King presupposes, but does not explicitly say, that God exists. So it makes sense to say that commitment to the existence of God is one of King's presuppositions. Presuppositions in this first sense are either assumptions that individuals self-consciously make when saying certain things or assumptions that must be true if what they are saying is to make sense.

Now suppose that a Unitarian addresses an argument about same-sex marriage to someone she knows to be a Catholic bishop. Obviously neither the Unitarian nor her interlocutor can in this case take for granted the details of a common theology. They cannot argue with one another on the basis of that as a given. We can put this by saying that the discursive exchange going on *between* these two parties does not presuppose a theology. The exchange no doubt has some presuppositions, which might include the proposition that God exists, but they do not include agreement, for example, on God's triune nature or on the interpretation of his commandments. If an atheist, a Muslim, and an orthodox Jew were now to join the discussion, the overlap in theological assumptions would diminish further, and the discussion would be able to presuppose still less. Here we are talking about "presuppositions" in a second sense of the term. Saying that the Unitarian is now participating in a discursive exchange that lacks theological presuppositions does not entail anything about what theological commitments she herself has made, how important they are to her in her personal deliberations, whether she is justified in accepting them, or whether he is free to express them.

My account of secularized discourses employs the second sense of "presupposition." Secularized discourses, as I am defining them, do not necessarily involve or produce participants who lack religious commitments. Most U.S. citizens profess some sort of belief in God, but their public ethical discourse is secularized in the sense I am trying to specify. This is a major advantage of my account over accounts of secularization that focus on an alleged loss of religious belief or on "disenchantment" of the world. The theory I offer is an account of what transpires between people engaging in public discourse, not an account of what they believe, assume, or resuppose as individuals. It has nothing to do with their experience of the World as a disenchanted universe, emptied of divine intentions and spiritual meaning.

Public ethical discourse in modern democratic societies tends not to presuppose agreement on the nature, existence, and will of God. Nor does it presuppose agreement on how the Bible or other sources of religious insight should be interpreted. As a result, theological claims do not have the status of being "justified by default"—of being something all participants in the discursive practice are effectively obliged to defer to as authoritative or justified. And this consequence of theological plurality has an enormous impact on what our

ethical discourse is like. It means, for example, that in most contexts it will simply be imprudent, rhetorically speaking, to introduce explicitly theological premises into an argument intended to persuade a religiously diverse public audience. If one cannot expect such premises to be accepted or interpreted in a uniform way, it will not necessarily advance one's rhetorical purposes to assert them. And if theological premises therefore receive little discursive attention for this perfectly understandable reason, why would anyone have just cause for resentment of the resulting type of secularized discourse? When people want to exchange reasons with others who differ from them theologically, this type of discourse is likely to increase drastically in significance. Resentment of this fact is indistinguishable from resentment of religious diversity.

It is useful in this context to keep in mind the distinction between saying that a person is justified in believing a claim and saying that a claim is justified. A *person* is justified in believing a claim if he or she is entitled to be committed to it, given his or her discursive context and cognitive conduct. A *claim* is justified in some discursive context if *everyone* in that context is justified in believing it (either because they have no relevant reasons for doubting it or because it has already been successfully defended against all relevant reasons for doubting it). In modern democracies, theological claims tend not to have the default status of being justified in the latter sense when uttered in public settings—for the simple reason that these settings tend to be religiously plural. It is also the case, however, that most modern democracies are liberal in the innocuous sense of treating individuals as (defeasibly) entitled by default to make whatever theological commitments they see fit to make and free to express those commitments in speech or in action.

Ethical discourse in religiously plural modern democracies is secularized, according to my account, only in the sense that it does not take for granted a set of agreed-upon assumptions about the nature and existence of God. This claim pertains to presuppositions in the second sense. It means that no one can take for granted, when addressing a religiously plural audience, that religious commitments have default authority in this context. It does not entail any limitation on what an individual can presuppose in the first sense. To the contrary, the discursive practice in question is secularized, according to my theory, precisely because many of the individuals participating in it do have religious commitments that function as presuppositions in some of their own deliberations and pronouncements. It is because these commitments vary from one citizen to another that they cannot qualify as presuppositions in the second sense. But this leaves open the possibility that citizens who hold one or another set of religious commitments could be rationally entitled to those commitments.

Some theologians hold that the citizenry's common discourse on ethical and political topics suffers from incoherence in the absence of commonly held theological assumptions. They conclude that we should all therefore accept a common stock of theological assumptions in order to restore our shared discourse to coherence. But whose assumptions shall we adopt? And by what means shall we secure agreement on them? The crux of the issue is that nobody currently knows how to bring about by acceptable means what the theological opponents of secularized discourse are suggesting. Their proposals are unrealistic if pursued without resort to coercion and morally harmful if pursued coercively. Some of my

critics say that I overestimate the dangers, but the only dangers I am referring to here are the dangers that *would* obtain *if* an antisecularization strategy were pursued by coercive means. These are the same dangers that did obtain during the state-forming wars of early-modern Europe and today still plague nations where civic trust, tolerance of religious differences, and constitutional democracy have yet to establish themselves. Since my critics are not proposing coercion, my issue with them has more to do with the fact that their program is unrealistic than with any dangers that might be involved. I am not saying that it is dangerous nowadays in the United States to employ religious premises in political reasoning. That is a different issue completely. Neither am I saying that theologians, as individuals, should abandon their theological commitments. That, too, is a different issue, which involves a different sense of secularization.

Our society is religiously plural, and has remained so for several centuries despite constant efforts on the part of its religious members to appeal to their fellow citizens with reasons for converting to a single theology. So when people discuss political issues with one another publicly—say, by addressing a school board meeting or participating in a debate of presidential candidates, as opposed to taking part in a colloquy of co-religionists—the religious differences among them will make it impossible for them to take theological propositions for granted. In such a setting you could of course make a theological assertion, and in making it implicitly commit yourself to a theological presupposition in the first sense. But you could not rightly assume that theological presuppositions in the second sense are already in place, tacitly agreed upon as the framework within which discussion proceeds. What shall we do, then, to achieve the coherence that some theologians believe we lack? I fail to see how the sea change these theologians are calling for is going to happen. There is no point in trying to wish the social reality of religious diversity away, or in resenting this diversity as long as it lasts. Until it does go away, our public discourse will be secularized, in the sense I have specified, whether we want it to be or not. . . .

❈

In Rawlsian terminology, my position might be termed a sort of "modus vivendi" pluralism, for the public philosophy I propose does not insist on the need to ground political discussion in a set of rules no reasonable and rational citizen could reasonably reject. I am trying to articulate a form of pluralism, one that citizens with strong religious commitments can accept and that welcomes their full participation in public life without fudging on its own premises. But I see this pluralism primarily as an existing feature of the political culture, not as a philosophical doctrine needing to be imposed on it. Our political culture is already pluralistic in the relevant sense. What I have tried to supply is a philosophical statement of what this pluralism involves. It is a remarkably widespread and steady commitment, on the part of citizens, to talk things through with citizens unlike themselves. This commitment is there, prior to all theorizing, in the habits of the people. The burden of proof is on those who want to change it. Because it is an aspect of our substantive commitment to the ethical life of democracy, because it coheres with the widely (but not unanimously)

held conviction that no merely human perspective has a monopoly on the truth, it seems inappropriate to think of it as a mere modus vivendi. It is not something we "settle for" in the absence of a real social contract or authentic communitarian unity. . . .

Democracy involves substantive normative commitments, but does not presume to settle in advance the ranking of our highest values. Nor does it claim to save humanity from sin and death. It takes for granted that reasonable people will differ in their conceptions of piety, in their grounds for hope, in their ultimate concerns, and in their speculations about salvation. Yet it holds that people who differ on such matters can still exchange reasons with one another intelligibly, cooperate in crafting political arrangements that promote justice and decency in their relations with one another, and do both of these things without compromising their integrity. Cooperating democratic citizens tend also to be individuals who care about matters higher than politics, and expect not to get their way on each issue that comes before the public for deliberation. It must be said, however, that there are times when anyone with a conscience will be hard-pressed to say why one ought to identify with a nation willing to adopt a policy inconsistent with what seems patently right and true. For me, our use of capital punishment and our excessive use of military force are among the issues that make me wonder whether paying taxes to the state is a form of complicity from which I ought to extricate myself, regardless of the cost. For many others, abortion raises similar doubts. But even if I were to refuse paying my taxes, thus following Thoreau's noble example, I would intend the gesture as an act of communication, as a signal to other members of my community that I intend to hold them responsible for their injustices. So long as I am thinking along those lines, I am still identifying with that community, even as I express my alienation from it. This sort of ambivalent membership has a notable lineage in democratic culture.

It is worth keeping in mind that similar issues arise concerning one's membership in any sizable group, not least of all a religious one. The Christian churches are now torn on numerous doctrinal, practical, and institutional issues, including many of the same issues that divide the rest of us politically. Many Christians have faced hard decisions over whether they could continue in good conscience to remain members in good standing of a group that, say, bans women from the priesthood or permits same-sex couples to marry. It is easy to see how these issues can come to have such a strong bearing on the question of continued identification with the group. But this should remind us that no social body, including the church, provides immunity from the dilemmas and conflicts of membership. Retreating from identification with the American people while intensifying one's identification with the people of God leaves a Christian with roughly the same dilemmas, the same ambivalence, with which he or she started. The only alternative is full-fledged separatism, which involves commitment to a group that is small enough and uniform enough to eliminate ambivalence altogether, at least for a while. But why would I want to confine my *discursive* community to the people who already agree with me on all essential matters? Isn't part of the point of trying to hold one another responsible discursively that we do not agree on everything and therefore *need* to talk things through?